WOMEN IN ARTS, ARCHITECTURE AND LITERATURE: HERITAGE, LEGACY
AND DIGITAL PERSPECTIVES

WOMEN IN THE ARTS: NEW HORIZONS

VOLUME 1

General Editors
Consuelo Lollobrigida, *University of Arkansas Rome Program*
Adelina Modesti, *University of Melbourne*

Editorial Board
Sheila Barker, *The Medici Archive Project*
Julia Dabbs, *University of Minnesota*
Vera Fortunati, *Emerita Alma Mater Studiorum, Bologna*
Carolyn James, *Monash University*
Elena Diez Jorge, *Universidad de Granad*
Nicoletta Marconi, *Università degli Studi di Roma Tor Vergata*
Katherine McIver, *University of Alabam*
Patricia Rocco, *Hunter College CUNY*

Scientific Board Conference
Consuelo Lollobrigida, *University of Arkansas Rome Program*
Laura Iamurri, *Università di Roma Tre*
Laura D'Angelo, *University of Arkansas, Rome Program*
Maria Elena Díez Jorge, *University of Granada*
Felipe Serrano Estrella, *University of Jaen*
Conference curated by Consuelo Lollobrigida

Organizational Team
Elysa Barsotti, *Study Abroad Program UoA Rome Program*
Madison Rard, *Study Abroad Program UoA Rome Program*
Emily Wilcox, *Study Abroad Program UoA Rome Program*
Grace Wilson, *Study Abroad Program UoA Rome Program*

Women in Arts, Architecture and Literature: Heritage, Legacy and Digital Perspectives

Proceedings of the First Annual International Women in the Arts Conference
Rome, 20–22 October 2021

Edited by
CONSUELO LOLLOBRIGIDA AND ADELINA MODESTI

BREPOLS

Every effort has been made to trace the copyright holders of the materials used in this book. We apologise for any omission and invite copyright holders to contact rights@brepols.net if illustrations have been used without their knowledge.

© 2023, Brepols Publishers n.v., Turnhout, Belgium.

All rights reserved. No part of this publication may be reproduced, stored in a retrieval system, or transmitted, in any form or by any means, electronic, mechanical, photocopying, recording, or otherwise without the prior permission of the publisher.

D/2023/0095/180
ISBN 978-2-503-60682-8
eISBN 978-2-503-60722-1
DOI 10.1484/M.WIA-EB.5.134635

Printed in the EU on acid-free paper.

Table of Contents

List of Illustrations — 9

Acknowledgements — 15

Preface. A Reason for a Conference: Methodology and Outlooks
Consuelo Lollobrigida — 17

Introduction
Adelina Modesti — 27

Keynote

From the Palace to the House. Women and Architecture in Sixteenth-Century Spain
María Elena Díez Jorge — 43

Part I
Literature and Illumination

Escribir en la amistad femenina. La sociedad y el discurso sobre la amistad de Mary Beale
Laura Mercader Amigó — 67

L'educazione femminile nelle opere della Marchesa Colombi
Silvia S. G. Palandri — 81

Custodians of Tradition. Reframing and Recycling in a Northern German Prayerbook
Carolin Gluchowski — 91

Part 2
Patrons and Collectors

Labour and Art Succeed where Nature Falls Short. The Patronage and Artistic Networking of Agnes Block
Catherine Powell-Warren 111

Cosmana Navarra (c. 1600–1687). A Case Study on a Female Patron of the Arts in Baroque Malta
Nadette Xuereb 125

Franciszka Wiszowata. A Nun as a Patron of the Art and Artist in Cracow in the Eighteenth Century
Katarzyna Chrzanowska 141

Part 3
Women at Work

Medieval Textile Production in Iceland. Warp Weighted Looms and the Women Who Wove Them
Lynn E. Fitzpatrick 161

Luxury, Status and Subversion. Female Embroidery in the European Renaissance
Ana M. Ágreda Pino and Carolina Naya Franco 179

Maria Mancini. The Woman behind the *Artemisia* Tapestries in the Colonna Collection
Alexandra Massini 195

La pratica dell'architettura al femminile: donne nei cantieri romani di XVI–XVIII secolo
Nicoletta Marconi 217

Part 4
Early Modern

Dalle Parasole a Claudine Bouzonnet Stella. Protagoniste e 'registe' nelle botteghe
Annalisa Rinaldi 237

TABLE OF CONTENTS 7

Su un equivoco storiografico. Ginevra Cantofoli e Luigi Gentile
Caterina BAVOSI e Alessandro SERRANI
243

Per mano della pittrice Caterina Ginnasi (1590–1660) 'piissime ac religiosissime feminae'
Antonio IOMMELLI
259

Suor Maria de Dominici (1645–1703). The First Known Female Artist in the Maltese Islands
Nadette XUEREB
273

***Pazienza e diligenza*. Early Modern Women Artists in the Genre of Natural History**
Tori CHAMPION
287

Women's Hands. Female Art: A Story of Upheaval?
Luana TESTA
303

Part 5
Modern and Contemporary
————

'The Process of Sculpture'. A Defense against Fraud Accusation
Tania ALBA RIOS
317

Art Restoration in Italy in the Second Half of the Twentieth Century. A Woman's Expertise
Eliana BILLI
329

I 'frutti' di Fede, Giovanna, Orsola alla prova della critica di primo Novecento
Paola CARETTA e Margherita FRATARCANGELI
339

Gender-biased Documentation of Women Visual Artists in Early Twentieth Century Greece, or Where did this Chapter go?
Elli LEVENTAKI
351

Valentine Gross-Hugo. The First Female Artist in Surrealism
Elizaveta V. MIROSHNIKOVA
363

List of Contributors
373

List of Illustrations

María Elena Díez Jorge

Fig. 1. Anton van der Wyngaerde, View of Granada, 1567, Wien, Österreichische Nationalbibliothek. — 45

Fig. 2. Ambrosio de Vico's platform of the city of Granada made at the end of the sixteenth century. Engraving by Francisco Heylan in 1613. — 49

Fig. 3. Chapel of the convent of San Francisco, Alhambra (Granada). Queen Isabella I ordered the construction of this convent in the palatine city of the Alhambra and asked to be buried in its chapel. — 51

Fig. 4. Baño de Comares, Alhambra (Granada). In this Nasrid bath, numerous tiled surfaces were laid throughout the sixteenth century, some of them commissioned to the potter Isabel de Robles. — 53

Fig. 5. Detail of a document showing the signature of a woman, María Jiménez, in the lawsuit she filed to defend the property of a house that her children were entitled to by inheritance. In fact, a comparison with all the signatures that appear in this long lawsuit shows that it was not written by her but by the scribe who drafted the petitions made by her in 1565. Her name and surname were written as a signature as she was probably illiterate. — 55

Fig. 6a. Detail of an Alhambra document by which a woman, María Jiménez, takes bodily possession of a house. — 57

Fig. 6b. Detail of an Alhambra document (continue). — 58

Carolin Gluchowski

Fig. 1. Strata in the Prayerbook Oxford, BodLibs, MS. Lat. liturg. f. 4. — 94
Fig. 2. Oxford, BodLibs, MS. Lat. liturg. f. 4, 8r. — 95
Fig. 3. Oxford, BodLibs, MS. Lat. liturg. f. 4, 8v. — 96
Fig. 4. Oxford, BodLibs, MS. Lat. liturg. f. 4, 9r. — 97
Fig. 5. Oxford, BodLibd, MS. Lat. liturg. f. 4, 9v. — 98
Fig. 6. Oxford, BL, MS. Lat. Liturg. f. 4, lower board (colour altered). — 102

Catherine Powell-Warren

Fig. 1. Jan Boskam, *Portrait Medal of Agneta Blok as Flora Batava*, 1700. © Amsterdam Museum. — 112

Fig. 2. Jan Weenix, *Agneta Block, Sybrand de Flines and Two Children at Vijverhof on the Vecht*, c. 1693. © Amsterdam Museum. — 114

LIST OF ILLUSTRATIONS

Fig. 3. Johannes Bronkhorst, *Blue Titmouse*, 1668–1727. Herzog Anton Ulrich Museum, Braunschweig. BPK/Bildagentur. ... 119

Fig. 4. Jan Weenix, *Great Tit*, c. 1650–1719. Rijksmuseum, Amsterdam. ... 120

Fig. 5. Pieter Withoos, *Great Titmouse*, 1670–1693. Metropolitan Museum of Art, New York. ... 121

Nadette Xuereb

Fig. 1. Anonymous seventeenth century Maltese Artist, Full-Length Portrait of Cosmana Navarra, Wignacourt Collegiate Museum, Rabat. ... 127

Fig. 2. Gio Nicola Buhagiar, Portrait of Cosmana Navarra, c. 1735, Sacristy, St Paul's Collegiate Church, Rabat. ... 128

Fig. 3. St Paul's Parish Church, Rabat. ... 130

Fig. 4. Stefano Erardi, *Shipwreck of St Paul in Malta*, 1678, St Paul's Parish Church, Rabat. ... 132

Fig. 5. Michelangelo Marullo, *Virgin and Child with St Philip Neri and St Anthony the Abbot*, c. 1664–1666, Church of St Paul, Rabat. ... 133

Fig. 6. Mattia Preti and Bottega, *Martyrdom of St Stephen*, 1681, St Paul's Parish Church, Rabat. ... 134

Fig. 7. Melchiorre Cafà, Unknown Maltese Silversmith, Silver Sanctuary Lamp, c. 1666, Chapel of St Anthony, Church of St Paul, Rabat. ... 135

Katarzyna Chrzanowska

Fig. 1. Łukasz Orłowski, *Portrait of Franciszka Wiszowata*, 1760, convent of St Joseph of the Bernardine Sisters, Cracow ... 143

Fig. 2. One of the decorative inscriptions in the first parlour room on the ground floor, convent of St Joseph of the Bernardine Sisters, Cracow ... 145

Fig. 3. Andrzej Radwański, *Stigmatisation of St Francis*, 1748, church of St Joseph, Cracow ... 147

Fig. 4. Altar of Saint Jude, 1742–1761, nuns' chapel in the convent of St Joseph, Cracow ... 149

Fig. 5. Łukasz Orłowski (?), *Portrait of Marianna Sierakowska Drozdowska née Ruszkowska*, convent of St Joseph of the Bernardine Sisters, Cracow ... 150

Fig. 6. Wilemówna, *Saint Anne*, first half of the eighteenth century, church of St Joseph, Cracow ... 152

Fig. 7. Wilemówna, *Saint Bonaventure and Saint Thomas Aquinas*, first half of the eighteenth century, church of St Joseph, Cracow ... 154

Lynn E. Fitzpatrick

Fig. 1. Norwegian woman weaving blanket on warp weighted loom c. 1954 as photographed by Marta Hoffman ... 162

Fig. 2. *The Lespugue Venus*, c. 24000 BC found at Lespugue, France. ... 164

Fig. 3. Band weaving using the big toe as a tensioning device; the practice continues in the Peruvian mountains today. Alverez, N., *Secrets of Spinning, Weaving, and Knitting in the Peruvian Highlands* (Cusco Peru: Thrums 2017). ... 165

LIST OF ILLUSTRATIONS 11

Fig. 4 Horizontal ground loom, Weavers, Tomb of Khnumhotep, Middle Kingdom, 12th
 dynasty painting by Norman de Garis Davies (1865–1941) Metropolitan Museum of
 Art, NY. 166
Fig. 5. Horizontal treadle loom, 17th century 170

Ana M. Ágreda Pino and Carolina Naya Franco

Fig. 1. *Portrait of a lady spinning* (*c.* 1531) by Maarten van Heemskerck. 105 × 86 cm. 180
Fig. 2. *Portrait of Madame de Pompadour at her Embroidery Frame* (*c.* 1763–1764) by François-
 Hubert Drouais. 217 × 156.8 cm. 184
Fig. 3. *Interior with women beside a Linen Cupboard* (1663) by Peter de Hooch. 70 × 75 cm. 185
Fig. 4. Drawing of *Carretes de hilo de oro y plata tirados* on laid paper, mastery exam by Vicent
 Mir (1722). 34.8 × 24 cm. *Libro de Dibujos* (1508–1752), fol. 377[v]. 186
Fig. 5. *Venetian coif* (*c.* 1500–1525). Linen embroidered with silk and metal threads.
 22.9 × 19.7 cm. 188
Fig. 6. *English purse* (sixteenth-seventeenth century). Silk satin embroidered with polychrome
 silk, gold metallic threads and seed pearls. 13.3 × 13 cm. 189

Alexandra Massini

Fig. 1. Jacob Ferdinand Voet, *Portrait of Lorenzo Onofrio Colonna, c.* 1670–1675, oil on canvas,
 Appartamento Isabelle, Palazzo Colonna, Rome. 201
Fig. 2. The Great Gallery at Palazzo Colonna, Rome, *c.* 1665–1700. 203
Fig. 3. Carlo Maratta and Gaspard Dughet, *Landscape with the Judgment of Paris,*
 Appartamento Isabelle, Palazzo Colonna, Rome. 204
Fig. 4. Italian painter of the XVII cent. and Benedetto Fioravanti, *Portrait of Maria Mancini as
 Armida, c.* 1669, oil on canvas, Palazzo Colonna, Rome. 207
Fig. 5. *The Riding Lesson of Prince Lygdamis*, tapestry from the *Story of Artemisia* series, woven
 in Paris *c.* 1607–1623, after a design by Antoine Caron. 211

Nicoletta Marconi

Fig. 1. *Carrette, bastarde, barrucole e barozze per il carriaggio del materiale da costruzione* (da
 *Castelli e Ponti di maestro Nicola Zabaglia con alcune ingegnose pratiche e con la
 descrizione del trasporto dell'Obelisco Vaticano e di altri del Cavalier Domenico Fontana,*
 Pagliarini, Roma 1743, tav. XVI). 221
Fig. 2. *Conto di Giovanna Jafrate vedova del quondam Alessandro Lutij vetraro a San Carlo ai
 Catinari* (AFSP, Arm. 43, B, 61, c. 131[r], Liste mestrue dell'anno 1720). 223
Fig. 3. Carri per il trasporto del travertino e 'maniera di caricarli' (da *Castelli e Ponti di maestro
 Nicola Zabaglia con alcune ingegnose pratiche e con la descrizione del trasporto
 dell'Obelisco Vaticano e di altri del Cavalier Domenico Fontana,* Pagliarini, Roma 1743,
 tav. XV). 224
Fig. 4. Palestrina, Monastero del Bambin Gesù, organigramma del cantiere (da ABP, 295/02,
 8 novembre 1733, cc. 24–35). 227
Fig. 5. Palestrina, Chiesa di Santa Rosalia nel palazzo Colonna-Barberini, facciata. 228

12 LIST OF ILLUSTRATIONS

Fig. 6. Palestrina, Chiesa di Santa Rosalia nel palazzo Colonna-Barberini, Sala dei Depositi. Nella nicchia sovrastante l'altare si scorge il solido banco calcareo sul quale è stata fondata la chiesa. 229

Caterina Bavosi e Alessandro Serrani

Fig. 1. Ginevra Cantofoli, *San Tommaso da Villanova*, Bologna, monastero di San Giacomo Maggiore. Olio su tela, 250 × 200 cm. 248

Fig. 2. Luigi Gentile, *Venere e Apollo con le muse*, Collezione privata (già Vienna, Dorotheum, 22 ottobre 2019, n. 275). Olio su tela, 76 × 88 cm, con cornice. 250

Fig. 3. Luigi Gentile, *Galatea*, Roma, Galleria Megna. Olio su tela, 52 × 70 cm. 252

Fig. 4. Luigi Gentile, *Sibilla*, Cambridge, Fitzwilliam Museum. Olio su tela, 66 × 49,2 cm. 253

Fig. 5. Luigi Gentile, *Donna con turbante*, Cremona, Museo Civico Ala Ponzone. Olio su tela, 65,5 × 51 cm. 254

Antonio Iommelli

Fig. 1. Orazio Torriani, *Progetto per la tomba di Caterina Ginnasi e Faustina Gottardi*, Berlino, Staatliche Museen, Kunstbibliothek, 1646 ca. 261

Fig. 2. Caterina Ginnasi, Giovanni Lanfranco, *Martirio di santa Lucia*, Roma, Chiesa di S. Lucia alle Botteghe Oscure, 1633. 262

Fig. 3. Caterina Ginnasi, *Ultima cena*, Roma, Chiesa di S. Lucia alle Botteghe Oscure, 1633 ca. 263

Fig. 4. Caterina Ginnasi, *San Biagio vescovo*, opera dispersa (già Roma, Chiesa di S. Lucia alle Botteghe Oscure, 1633 ca). Tratta da Francesco Saverio Parisi, 'Chiese di Roma che scompaiono', p. 202. 264

Fig. 5. Caterina Ginnasi (?), *Santi Biagio e Agostino*, Velletri, Museo Diocesano. 266

Nadette Xuereb

Fig. 1. Maria de Dominici, *Virgin with Ss Nicholas and Roque*, Attard Parish Museum, *c.* 1678–1680. 276

Fig. 2. Attributed to Maria de Dominici, *Vision of St Maria Maddalena de Pazzi*, Carmelite Priory, Valletta. 277

Fig. 3. Attributed to Maria de Dominici, *Visitation of the Virgin*, Żebbuġ Parish Church Sacristy. 278

Fig. 4. The Chapel of the Visitation, at Wied Qirda. Photographic representation of the Chapel with Maria de Dominici's works. 279

Fig. 5. Attributed to Maria de Dominici, *Crucifixion with Saints*, Private Collection Malta. 280

Fig. 6. Old photograph of the *Immaculate Conception* by Maria de Dominici at Cospicua, *c.* 1680. 282

Tori Champion

Fig. 1. Albrecht Meyer, Heinrich Füllmaurer, and Vitus Rudolph Speckle, *Juniperus minor* in Leonhart Fuchs's *De historia stirpium commentarii insignes* (Basel: 1542). Woodcut, hand-coloured. 37 × 24 cm. U.S. 291

Fig. 2. Giovanna Garzoni (Italian, 1600–1670), *Still Life with Birds and Fruit, c. 1650*. Watercolour with graphite, heightened with lead white, on vellum. 25.7 × 41.6 cm. 293

Fig. 3. Maria Sibylla Merian (German, 1647–1717 [active Holland]), *Convolvulus and Metamorphosis of the Convolvulus Hawk Moth, c. 1670–1683*. Watercolour with touches of opaque watercolour over indications in black chalk or graphite on vellum. 29 × 37.2 cm. 294

Fig. 4. Elizabeth Blackwell (Scottish, 1707–1758), *Garden Succory* from *A Curious Herbal* (London: 1736–1739). Etching and engraving, hand-coloured. 37 × 25 cm. 295

Fig. 5. Barbara Regina Dietzsch (German, 1706–1783), or Maria Sibylla Merian (German, 1647–1717 (active Holland)), *A Sprig of Flowers with Two Insects*, seventeenth – eighteenth century. 297

Fig. 6. Marie-Thérèse Reboul Vien (French, 1735–1806), Plate I in Michel Adanson's *Histoire naturelle du Sénégal, coquillages* (Paris: 1757). 298

Tania Alba Rios

Fig. 1. Harriet Hosmer, *Zenobia in Chains*, Saint Louis, Saint Louis Art Museum. *c.* 1859. 318

Fig. 2. 'The Prince of Wales at Miss Hosmer's Studio', p. 293. Digital version released into public domain by University of Michigan. 320

Fig. 3. Photography showing Harriet Goodhue Hosmer with her assistants and carvers in the courtyard of her studio in Rome, Washington D. C., Department of Image Collections, National Gallery of Art Library. 1867. Digital version released into public domain by National Gallery of Art Library. 323

Fig. 4. Photography showing Harriet Hosmer on ladder with sculpture of Thomas Hart Benton, Cambridge, Schlesinger Library, RIAS, Harvard University. *c.* 1861–1862. 325

Eliana Billi

Fig. 1. *Nerina Neri and Giovanni Urbani restore the Madonna di Coppo di Marcovaldo of the church Santa Maria dei Servi in Siena, 1947* (AFRICR, fasc. AS0850). 331

Fig. 2. *Luigi Pigazzini and Nerina Neri in the restoration site of Leonardo's Last Supper in Milan, 1950* (AFRICR, fasc. AS0012). 333

Fig. 3. *Tarcisio Spini and Nerina Neri (?) restore the mural paintings of the lower basilica of Santa Maria in Via Lata in Rome, 1960* (AFRICR, fasc. AS0600) 335

Fig. 4. *Cesare Brandi and his 'young assistant' (Laura Sbordoni) show the restauration of the Maestà di Duccio, 1957* 336

Elli Leventaki

Fig. 1. Thalia Flora-Karavia, *Portrait of Sophia Laskaridou*, StoART Korai, post-1906. 352

Fig. 2. Makkas Nikolaos, *The Zappeion Megaron*, c. 1905. E.L.I.A. 353

Fig. 3. Syndesmos Ellinon Kallitechnon, Catalogue of *Z' Panellinios Ekthesis* [Seventh Panhellenic Artistic Exhibition], p. 4, The Library and Archive of National Gallery – Alexandros Soutzos Museum. 1929, Athens. 355

Fig. 4. *Katalogos Diethnous Ektheseos Athinon. Tmima Kallitechnias* [Catalogue of International Exhibition of Athens. Department of Fine Arts], p. 22, The Library and Archive of National Gallery – Alexandros Soutzos Museum. 1903, Athens. 357

Fig. 5. *Katalogos Diethnous Ektheseos Athinon. Tmima Kallitechnias* [Catalogue of International Exhibition of Athens. Department of Fine Arts], p. 38, The Library and Archive of National Gallery – Alexandros Soutzos Museum. 1903, Athens. 358

Fig. 6. Elliniki Kallitechniki Etaireia, Catalogue of *Proti Ekthesis* [First Exhibition], p. 5, The Library and Archive of National Gallery – Alexandros Soutzos Museum. 1907, Athens. 359

Elizaveta V. Miroshnikova

Fig. 1. Valentine Hugo dressed as a carousel, 'Bal des Jeux', 1922. 365

Fig. 2. Portrait of Pablo Picasso, 1934–1948, oil on plywood, 140 × 140 cm, Centre Georges Pompidou, Paris. 367

Fig. 3. Valentine Hugo. Drypoint to the book of Paul Éluard 'Les Animaux et leurs Hommes, Les Hommes et leurs Animaux', 1937, Bibliothèque Nationale de France. 369

Acknowledgements

It is with great pleasure that I introduce you to the *Proceedings of the First International Conference on Women in the Arts* (AIWAC), an annual event promoted and organized by the University of Arkansas Rome Center in Rome to celebrate and acknowledge the invaluable contribution of women in the field of the arts.

These Proceedings represent a significant milestone in promoting awareness and gender equity in the art world, providing a platform for dialogue and inspiration for artists, scholars, industry professionals, and enthusiasts.

AIWAC was conceived with the aim of exploring and delving into a wide range of issues related to the presence and influence of women in the arts, and beyond. This culturally and disciplinary diverse event strives to challenge gender stereotypes, highlight talented but often overlooked female artists, and stimulate meaningful discussions on equal opportunities.

The Proceedings of this conference bear witness to the innovative thinking and creative visions that emerge from the richness of the presentations, panel discussions, and shared experiences. They provide an in-depth overview of the ideas and contributions presented by artists, academics, and experts who participated in this notable event.

Within the pages of these Proceedings, you will explore a variety of fascinating topics. From artistic portraits of women who have made their mark in history to the exploration of contemporary aesthetic perspectives, from issues of gender identity to the role of women as agents of social change through art, you will embark on a captivating intellectual journey.

We hope that these Proceedings will serve as a valuable resource for scholars, art enthusiasts, and all those seeking to delve deeper into issues related to women in the arts. Whether you are in search of inspiration, new perspectives, or academic knowledge, we trust that these pages will provide a stimulating starting point for further exploration and reflection.

I would like to express my gratitude to everyone who contributed to the success of this conference, with special thanks to Professor Consuelo Lollobrigida for her visionary creation of this event and meticulous organization. I also extend my thanks to the speakers, participants, organizers, and volunteers who dedicated their time and efforts to make this significant event possible. Your participation has contributed to creating an authentic and connected environment that we hope will continue to influence and inspire future generations.

I wish you all an engaging and enlightening reading experience, with the hope that these contents will stimulate fruitful discussions, promote awareness and action, and drive towards a more equitable and inclusive future for women in the art world.

Francesco Bedeschi, M.Arch.

CONSUELO LOLLOBRIGIDA _____

Preface

A Reason for a Conference: Methodology and Outlooks

In the midst of the disruptive Covid-19 pandemic the University of Arkansas Rome Program was asked from the home campus in Fayetteville to design a new mission plan for the years to come, once the pandemic had abated. As a teaching center we had been providing courses in different disciplines for 30 years, related to four main areas of interest: architecture and design, humanities, language, and fashion. The pandemic gave us the opportunity to also add to our traditional activities a research center, and to give birth to the European hub of the University of Arkansas (US).

To achieve this goal, faculty were asked to envision a new educational and scholarly setting. From my standpoint, I could share my research and commitment to women studies and gendered art history through the organization of an Annual International Women in the Arts Conference (AIWAC). Francesco Bedeschi, our new and enthusiastic Director, supported the idea from the very first moment, enabling us to commence the first symposium which could match scholars' expectations and broaden the discipline's horizon.

2021 saw the first AIWAC, and was also the year that marked the 50th anniversary of *Why have there been no great women artists?*, Linda Nochlin's groundbreaking essay, a text to which all scholars engaged in this field are deeply and foremostly indebted. Nochlin pioneered and founded the discipline together with a group of women who organised from April 20 through 22, 1972, The Conference of Women in the Visual Arts at the Corcoran Gallery of Art in Washington DC, another cornerstone of gendered art history.[1] Nochlin's main argument is the idea that women have been excluded from the mainstream of art, literature, and creativity generally speaking, because of social and institutional constraints: they could not have access to education, or at least to the upper level of it; they could not study anatomy or attend drawing classes from the nude; they could not sign contracts or run a workshop on their own, they could not travel alone.

The article was followed by the pioneering exhibition 'Women Artists. 1550–1950',[2] held at Los Angeles County Museum of Art (1976). Theoretically bound to

1 The conference was organized by Cynthia Bickley, Mary Beth Edelson, Barbara Frank, Enid Sanford, Susan Sollins, Josephine Withers, and Yvonne Wulff. The impetus behind the conference was anger over the complete lack of women represented at the Corcoran Biennial the previous year, 1971. The three day conference consisted of lectures and panels of women artists and art historians. It was attended by over 300 female artists, art historians, critics and museum curators.

2 The first international exhibition of art by female artists opened on December 21, 1976 at a time when the Feminist Art Movement was gaining in support and momentum. The show was curated by Ann Sutherland Harris and Linda Nochlin and included eighty-three artists from twelve countries. The four-city exhibition was organized by the Los Angeles County Museum of Art and was on view there from December 21, 1976 through

feminism, which saw in the patriarchal power of society the founding component of women's subjugation and the root of dividing societal rights, privileges, and power primarily along the lines of sex, and as a result, oppressing women and privileging men, the curators Linda Nochlin and Ann Sutherland-Harris presented eighty-three artists, mostly unknown and original. The names, dates and works of art included both in the exhibition and catalogue opened the path to a revolution and marked the birth of a gendered art history.

It was the radical feminist Germain Greer who foregrounded the constraints of patriarchal society on women artists in her *The Obstacle Race. The Fortunes of Women Painters and Their Work* (1979), which was reviewed by Nochlin in the New York Times, on October 29, 1979.[3] The review highlighted that 'the "obstacle race" [Greer] refers to is in fact the entire life-situation — social, educational, psychological — of women artists from the Middle Ages through the 19th century. Beginning with the central issue of the family and the fact that nearly all pre-19th-century women painters were related to male artists and "ruled by love and admiration not by the exigencies of their own talent and creativity"'.[4] One of the most profound reflections which came out of the first decade of feminism and art history is surely that of Rozsika Parker and Griselda Pollock who in their *Old Mistresses: Women, Art and Ideology* (1981) pointed out another central argument of the debate: 'the concept of femininity born from the stereotyped categorizations imposed upon women's art, to expose the cluster of particular meanings attributed to their art since the Renaissance'.[5] In 1871 the Art Journal wrote that 'women by nature are likewise prompted in the treatment of sculpture to motives of fancy and sentiment rather than realistic portraiture or absolute creative imagination'.[6] In *Old Mistresses* the authors carry out a keen critical reading of the Eighteen-hundreds and of Victorian literature that claimed the works of women to be 'graceful, delicate and decorative', incommensurate with mainstream male art and therefore considered marginal. According to Parker and Pollock 'the legacy of Victorians' views on women and art has been the collapse of history into nature and sociology into biology. They prepared the way for current beliefs about women's innate lack of talent and "natural" predisposition for "feminine" subject'.[7] Parker and Pollock's work has not been a book of the history of women artists, 'but an analysis of the relations between women, art and ideology [...]

March 1977. The exhibition went on to show at the University Art Museum in Austin, Texas, and then to the Carnegie Museum of Art in Pittsburgh, Pennsylvania, after which it completed its run at the Brooklyn Museum in New York.

3 Nochlin, review of *The Obstacle Race. The Fortunes of Women Painters and Their Work*, 'New York Times', 29 October 1979, https://archive.nytimes.com/www.nytimes.com/books/99/05/09/specials/greer-obstacle.html [accessed 25 June 2023].

4 Nochlin, review of *The Obstacle Race. The Fortunes of Women Painters and Their Work*, 'New York Times', 29 October 1979, https://archive.nytimes.com/www.nytimes.com/books/99/05/09/specials/greer-obstacle.html [accessed 25 June 2023].

5 Parker and Pollock, *Old Mistresses*, XVIII.

6 *Art Journal*, 10 (1871), p. 10, as cited in Osborne, 'Book Review: Old Mistresses: Women, Art and Ideology', 108–10.

7 Parker and Pollock, *Old Mistresses*, p. 13.

providing a new theoretical framework for the understanding of the significance of sexual difference in our culture'.[8]

The words of Norma Broude and Mary D. Garrard, the early leaders of the American feminist movement in art professions,[9] resound more than predictive. In 1982, in the introduction to *Feminism and Art History* Broude and Garrard wrote:

> to re-experience art from a feminist perspective will also mean in many cases to divorce it from the ivory tower context of pure, aesthetic, and 'universal' values, and to see it not as a passive reflector of social history but as a tool that can be and has been used in every historical period as a powerful social source [...] art, through its imagery and its associations and through its cultural status, has functioned as an instrument of sex-role socialization, helping to create and reinforce a norm of social behavior for women in a patriarchal world.[10]

That was the time when a feminist viewpoint started questioning the limitations that an elemental reading of the binary gendered system would have produced. It was no longer sufficient to give birth to a list of names and dates to donate voices to all those who had that voice silenced for centuries. One of the risks of such an approach, would have been to create a theory of woman as a biological and out-of-history category, disengaged from social, cultural, political, and economical aspects of period. It was all in all the application of a male gaze and methodology to write the history and the art history of women.

The monograph written by Mary Garrard on Artemisia Gentileschi[11] is the work that shifted the theoretical approach by insisting on the importance of the overall context in which a work of art is created. In the introduction the author states:

> If Artemisia has been ignored by writers touched by a masculinist bias, she has been warmly embraced by those fortified with a feminist sensibility [...] The

8 Pollock and Parker, *Old Mistresses*, xix.

9 Through their collective scholarship, Norma Broude and Mary D. Garrard pioneered and helped to define and shape the field of feminist art history. Their four co-edited volumes of feminist essays include *Feminism and Art History: Questioning the Litany*, *The Expanding Discourse: Feminism and Art History*, *The Power of Feminist Art: The American Movement of the 1970s, History and Impact*, and *Reclaiming Female Agency: Feminist Art History After Postmodernism*. These books have become basic texts in many art history and women's studies courses in American universities and around the world.
Broude and Garrard have also produced groundbreaking feminist scholarship in their separate fields of specialization. Broude, a specialist in nineteenth-century French and Italian painting, is known for critical reassessments of Impressionism, the work of Degas, Caillebotte, Cassatt, Seurat, the Italian Macchiaioli, and G. B. Tiepolo. She is the author of *The Macchiaioli: Italian Painters of the Nineteenth Century*, and *Impressionism, A Feminist Reading: The Gendering of Art, Science, and Nature in the Nineteenth Century*.
Garrard, an Italian Renaissance-Baroque specialist, is known for her pioneering work on the 17th-century Italian painter Artemisia Gentileschi, including three books, *Artemisia Gentileschi: The Image of the Female Hero in Italian Baroque Art*, *Artemisia Gentileschi Circa 1622: The Shaping and Reshaping of an Artistic Identity*, and *Artemisia Gentileschi and Feminism in Early Modern Europe* and several articles. Her scholarship also embraces critical studies of Michelangelo, Leonardo da Vinci, Sofonisba Anguissola, and other Renaissance artists. Garrard's book, *Brunelleschi's Egg: Nature, Art, and Gender in Renaissance Italy* offers a feminist corrective to Renaissance art histories.

10 Broude and Garrard, *Feminism and Art History*, p. 14.

11 Garrard, *Artemisia*, 1989.

present book is an effort to fill a gap that has existed in both conventional and feminist scholarship, for in neither realm has the expressive character of Artemisia Gentileschi's art been given adequate definition. Many feminist writers, though offering the corrective of aesthetic enthusiasm and literary attention, have limited their accounts to biographical celebration, with only perfunctory or non-comparative analysis of the forms and styles of her imagery. On the other hand, scholars oriented to connoisseurship have concentrated on distinguishing the hands of Artemisia and Orazio.[12]

The 80s marked therefore the passage to the interdisciplinary field of 'women's studies' and 'gender studies' over gendered art history as a result of the application of postmodernism to the practice of art history. This conceptual framework enabled scholars to envision new perspectives of research and to see women in a 'relational system' and as a social, and not a biological, construct.

In 1988 Lisa Tickner claimed, indeed, that the question was no longer 'why are there no great women artists?' but 'how are the process of sexual differentiation played out across the representation of art and art history?',[13] predicting women's agency and thus emphasizing that gender is a 'semiotic category'.

From the time gendered art history started existing, scholars have dug out — as fresh archaeologists — an obscured world, giving their utter contribution to revising art history, history of literature, of architecture and so on. And then women artists seemed to be many — with hundreds brought into light over the past fifty years. Just the very last decade has seen an increasingly number of studies on women in art, which have also contributed to a boom in exhibitions dedicated to them, such as Sofonisba Anguissola and Lavinia Fontana,[14] Giovanna Garzoni,[15] Artemisia Gentileschi,[16] Frida Kahlo or the very recent *discovery* of women photographers.[17] Although limits existed and forced women to stay apart from the main stage, some of them were able to break the glass ceiling, and to occupy a social position, which scholars could not have envisioned just a decade earlier. Beginning from their foundational work with the Women's Caucus for Art (1992), in *The Expanding Discourse: Feminism and Art History* (1992) Broude-Garrad affirmed that 'there is no reason, then, in our view, to preserve the theoretical fiction of a "traditional art history", monolithic and intact, when in fact the inherited categories have always yielded and continue

12 Garrard, *Artemisia*, p. 5.

13 Tickner, *Feminism*, p. 92.

14 On Sofonisba and Lavinia see, *Historia de dos pintoras: Sofonisba Anguissola y Lavinia Fontana*, ed. by Leticia Ruiz (22 October 2019 – 2 February, 2020), Museo Nacional del Padro, Madrid; on Lavinia see, *Lavinia Fontana: Trailblazer, Rule Breaker*, ed. by Aoife Brady (6 May – 27 August 2023), National Gallery of Ireland. On Lavinia Fontana the first exhbition was curated by Vera Fortunati in 1994. See note nr. 21.

15 On Giovanna Garzoni see, *La grandezza dell'universo nell'arte di Giovanna Garzoni*, ed. by Sheila Barker (28 May – 28 June 2020) Palazzo Pitti, Florence.

16 Among many on Artemisia see the recent, *Artemisia Gentileschi*, ed. by Letizia Treves (3 October 2020 – 24 January 2021), The National Gallery, London; *Artemisia Gentileschi a Napoli*, ed. by Antonio Ernesto Denunzio and Giuseppe Porzio (2 December 2022 – 19 march 2023), Gallerie d'Italia, Naples.

17 The Musei Reali in Turin (Italy) has organized an exhibition on Vivian Meier (February – 26 June 2022) and one on Ruth Orkin (17 march – 16 July 2023).

to do so, as art history changes and evolves'.[18] In *Reclaiming Female Agency: Feminist Art History after Postmodernism* (2005),[19] Broude and Garrard address this argument more broadly and extensively, asserting:

> the very existence of female artists in the Renaissance was deeply problematic for male artists, as can be seen in the theoretical claims designed to contain them. Women could not produce art, it was said, only children; women were thought to be incapable of divine artistic genius because they were allegedly farther them men from God. When artists sach as Sofonisba Anguissola, Artemisia Gentileschi, and Elisabetta Sirani opposed the socially constituted definitions of their sex, producing paintings that reversed normative female models, they set in motion cultural resistance to their agency.[20]

In Italy the legacy of feminist art history was acknowledged by Vera Fortunati, who right after the Italian edition of Harris and Nochlin's catalogue of LA's exhibiton in 1977 gave origin to a research group, namely the School of Bologna.[21] In 1982, Fortunati published her first contribution on Properzia de' Rossi, followed by her first work on Lavinia Fontana in 1986. Since 1994 Vera Fortunati is the Scientific Director of the 'Centro di documentazione sulla storia delle donne artiste in Europa', housed in Archivi Provinciali, Bologna.[22] In 2007 the School founded the 'Centro di Documentazione sulla Storia delle Donne Artiste di Bologna' an inventory of bio-bibliographic voices of women painters, sculptors, etchers, weavers, and miniaturists from the Middle Ages to the 20th century.

When we were deciding the way to shape the AIWAC, we looked at another influential postmodern principle by which we stand. It was our unyielding agreement that the conversation must be addressed not only to women as authors, but also as patrons, tastemakers and interpreters. Receiving the legacy of the work done in the 1990s, such as for example the research on Isabella d'Este, duchess of Ferrara; or Maria de' Medici, queen of France; we want to launch new compelling stimuli and interests. As it has been estimated that 10 percent of all Renaissance art production was produced in convents, courts, and palaces with women as patrons or supporters,[23] we believe that the conference could be a platform to share new scholarly research, one which would attract scholars and welcome new frontiers of investigation.

18 Broude and Garrard, *The Expanding Discourse*, p. 63.
19 Broude and Garrard, *Reclaiming Female Agency*.
20 Broude and Garrard, *Reclaiming Female Agency*, p. 108.
21 Lollobrigida, '" Così la pittura sarebbe corpo della poesia"', p. 35.
22 In 1986 Vera Fortunati published her first work on Lavinia Fontana, after which she curated a first exhibition on Lavinia Fontanta (1994; Bologna) and in 1998 in Washington, celebrating the 10th anniversary of the National Museum of Women in the Arts. In 2004 she released the volume on the miniatures of Caterina Vigri and curated with Jadranka Bentini the first exhibition in Bologna on Elisabetta Sirani.
23 King, 'Medieval and Renaissance Matrons', 372–92; King, *Renaissance Women Patrons*; Wilkins and Reiss (eds), *Beyond Isabella*.
Roman women have been documented by Carolyn Valone in some groundbreaking essays: 'Roman Matrons as Patrons'; 'Piety and Patronage', pp. 157–84; 'Women on the Quirinal Hill', pp. 129–46.

Hence, one of the principal goals of the conference is, through new philological-historical and methodological perspectives, a comparative exploration on how female intellect and creativity have helped to shape European and American culture in its heterogeneity since the Middle Ages. For instance, the recent attention to the role and function of female patrons from Middle Ages to the Enlightenment is an additional testimony of the complexity and the interwoven cultural aspects which customize the theme.

In particular we started looking at what was (and is) offered in the Western World. It was beyond doubt that our point of reference was the Feminist Art History Conference, supported and biennially organized since 2011 by Norma Broude and Mary Garrard, at the American University in Washington DC.[24] Likewise, we were seeing women's contribution to the arts addressed at specific panels in annual conferences, such as the important annual appointment organized by RSA (The Renaissance Society of America).

Another distinctive research center was founded by the American philanthropist and art collector Jane Fortune in 2009 in Florence (Italy), namely the Jane Fortune Program at the Medici Archive Project.[25]

Nevertless, the work done by Spanish scholars is likewise remarkable, especially that of Elena Díez Jorge, at the University of Granada. Diez Jorge, who served the first AIWAC as a keynote speaker, is leading several research projects focused on the role of women in architecture of the past,[26] and women and peace.[27] Consistent international conferences are part of her promise and are a momentous contribution in the European framework.

We are paying a keen regard to 'Women and Architecture', the topic of the International Congress on Architecture and Gender (ICAG), begun in 2014 in Seville, promoted and organized by the architect Nuria Álvarez Lombardero. Since then, other editions have been held in Lisbon in 2015, Florence in 2017, Brighton in 2019 and Lisbon (online due to the pandemic) in 2021.[28]

Mostly, all these conferences discourse about a discipline which is still divided between a feminist and socio-economical post-modernist approach, even if the scholars' dedication to the topic is witnessing the demand for further multidisciplinary investigation; and this is the ratio we chose as the theoretical premise to our conference. Consequently, the first symposium call was looking for research on women writers, illuminators, poets, painters, embroiders, etchers, sculptors as well as musicians, singers, scientists who were often sharing similar social, economic and cultural backgrounds and formed an international network that contributed to paving women's path and opened a discursive space within a masculine world. We were also

24 'Feminist Art History Conference – Past conferences', *American University*, https://www.american.edu/cas/art-history/femconf/past-conferences.cfm [accessed 25 June 2023].

25 Jane Fortune (7 August 1942 – 23 September 2018) was an American author, journalist, and philanthropist. She dedicated her life to collect art works done by women.

26 Díez Jorge, *Mujeres y arquitectura*.

27 Díez Jorge, *Las mujeres*.

28 '6th International Conference on Architecture and Gender', https://icagvlc.webs.upv.es [accessed 25 June 2023].

willing to advance the contemporary discussion of Gender Digital Humanities, to offer to the scientific community the opportunity to present new digital proposals devoted to works of female creativity, such as digital critical editions, or projects for the virtual display of women's works, and to learn more about some of the newest digital tools used by researchers. Even if we received no proposals on this theme, we are firmly convinced that the digitization of cultural heritage will be the future hub of multidisciplinary investigation of women's work. Literature, illumination, architecture, visual arts will benefit from a 'genderless' and anonymous space — such as that of virtual or augmented reality — of a tool with a potential which let us see from a multifaced perspective a-part-of-the-whole with no limits or constraints.

Bibliography

Secondary Sources

Broude, Norma, *The Macchiaioli: Italian Painters of the Nineteenth Century* (New Haven, 1988)

——, *Impressionism, A Feminist Reading: The Gendering of Art, Science, and Nature in the Nineteenth Century* (Abingdon, 1998)

—— and Mary D. Garrard, *Feminism and Art History: Questioning the Litany* (New York, 1982)

—— and ——, *The Expanding Discourse: Feminism and Art History* (New York, 1992)

—— and ——, *The Power of Feminist Art: The American Movement of the 1970s, History and Impact* (New York, 1994)

—— and ——, *Reclaiming Female Agency: Feminist Art History After Postmodernism* (Berkeley, 2005)

—— and ——, and Judith K. Brodsky, *The Power of Feminist Art: The American Movement of the 1970s, History and Impact* (New York, 1994)

Díez Jorge, Maria Elena, *Mujeres y arquitectura: cristianas y mudéjares en la construcción* [Women and architecture: Christian and Mudejar women in construction] (Granada, 2016)

—— and Cándida Martínez López, *Las mujeres y los discursos de paz en la historia* [Women and Discourses on Peace through History] (Berlín, 2023)

Fortunati, Vera, *Lavinia Fontana* (Milan, 1986)

——, *Lavinia Fontana, 1552–1614* (Milan, 1998)

——, *Vita artistica nel monastero femminile. Exempla* (Bologna, 2002)

——, *Properzia de' Rossi. Una scultrice a Bologna nell'età di Carlo V* (Bologna, 2008)

——, and Jadranka, Bentini,, *Elisabetta Sirani: pittrice eroina, 1638–1665* (Bologna, 2004)

Garrard, Mary, *Artemisia Gentileschi: The Image of the Female Hero in Italian Baroque Art* (Princeton, New Jersey, 1989)

——, *Artemisia Gentileschi Circa 1622: The Shaping and Reshaping of an Artistic Identity* (Berkeley and Los Angeles, 2001)

——, *Brunelleschi's Egg: Nature, Art, and Gender in Renaissance Italy* (Berkely, 2010)

——, *Artemisia Gentileschi and Feminism in Early Modern Europe* (London, 2020)

King, Catherine, 'Medieval and Renaissance Matrons, Italian-Style', *Zeitschrift für Kunstgesgeschicte*, 55 (1992), 372–92

——, *Renaissance Women Patrons: Wives and Widows in Italy, c. 1300–1550* (Manchester, 1998)

Lollobrigida, Consuelo, '"Così la pittura sarebbe corpo della poesia e la poesia anima della pittura". La storiografia artistica femminile in Italia dalle origini alla Scuola di Bologna', *Il capitale culturale, Supplementi* 13 (2022): *Le donne storiche dell'arte tra tutela, ricerca e valorizzazione*, ed. by Patrizia Dragoni and Eliana Carrara, 21–36

Osborne, Caroline, 'Book Review: Old Mistresses: Women, Art and Ideology', *Feminist Review*, 12:1 (1982), 108–10

Parker, Rozsika and Griselda Pollock, *Old Mistresses. Women, Art and Ideology* (London, 1981)

Tickner, Lisa, 'Feminism, Art History, and Sexual Difference', *Gender*, 3 (1988), 92–128

Valone, Carolyn, 'Roman Matrons as Patrons: Various Views of the Cloister Wall', in *The Crannied Wall: Women, Religion and the Arts in Early Modern Europe*, ed. by Craig Monson (Ann Arbor, 1992), pp. 49–72

———, 'Piety and Patronage: Women and the Early Jesuits', in *Creative Women in Medieval and early Modern Italy: A Religious and Artistic Renaissance*, ed. by Ann Matter and John Coakley (Philadelphia, 1994), pp. 157–84

———, 'Women on the Quirinal Hill: Patronage in Rome, 1560–1630', *Art Bulletin*, 76 (1994), 129–46

Wilkins, David and Sheryl Reiss (eds), *Beyond Isabella: Secular Women Patrons of Art in Renaissance Italy* (Kirksville, 2001)

Online Sources

'Feminist Art History Conference – Past conferences', *American University*, https://www.american.edu/cas/art-history/femconf/past-conferences.cfm [accessed 25 June 2023]

'Mary Beth Edelson: Conference of Women in the Visual Arts, Corcoran Gallery of Art, Washington DC, April 20–22, 1972 – The Feminist Institute Digital Exhibit Project', *Google Arts & Culture,* https://g.co/arts/tuG5T5DR9J8Y9XU5A [Retrieved 13 July 2021]

Nochlin, review of *The Obstacle Race. The Fortunes of Women Painters and Their Work*, 'New York Times', 29 October 1979, https://archive.nytimes.com/www.nytimes.com/books/99/05/09/specials/greer-obstacle.html [accessed 25 June 2023]

Shirey, David L., 'Visual Arts Hears From Women's Lib', *The New York Times, (23 April* 1972*)*, https://www.nytimes.com/1972/04/23/archives/visual-arts-hears-from-womens-lib.html [Retrieved 13 July 2021]

'6th International Conference on Architecture and Gender', https://icagvlc.webs.upv.es [accessed 25 June 2023]

ADELINA MODESTI

Introduction

The purpose of the AIWAC annual conference is to showcase the current state of research in the field of women's studies as it relates to the arts broadly speaking. This first volume of proceedings focuses on women in the fine and textile arts, architecture and literature, as creative practitioners, writers and patrons, and presents women's contributions and legacies as a continuing heritage that needs to be re-evaluated and rewritten, recorded for posterity. This introduction aims to highlight the key themes that emerged from the conference papers.

Professionalisation

The professionalisation of women artists has long been a contested one, as they were systematically kept out of the public sphere dominated by men, either through limited access to education and training, patriarchal social expectations that women marry and have children thereby not contributing to the economy or public art, or the misogynist belief that women were inferior beings that lacked ingenuity and creative talent.[1] Since the artistic norm was masculine against which female-produced art was found lacking, and women were confined to the private realm, when women did take up painting and other arts they were often limited to particular genres and subject-matter, such as portraiture and still life, which they could easily access, or the so-called 'minor' or 'decorative arts' and craft (needlework and textile production) that often contained them within their domestic environment. This public/private dichotomy, however, begins to break down as women progressively entered into professional fields that have previously been male domains. As Carolina Naya Franco and Ana Ágreda Pino highlight in their essay on women and embroidery in Renaissance Europe this shift often elicited male anxieties about women exceeding their traditionally assigned roles under patriarchy, as exposed in the conduct literature and moralist writing of the period.

1 Nochlin, 'Why Have There Been No Great Women Artists?' remains fundamental in analysing the institutional and societal obstacles that prevented many women from succeeding in the arts.

Women in Arts, Architecture and Literature: Heritage, Legacy and Digital Perspectives, ed. by Consuelo Lollobrigida and Adelina Modesti, Women in the Arts: New Horizons, 1 (Turnhout: Brepols, 2023), pp. 27–40
BREPOLS ❧ PUBLISHERS 10.1484/M.WIA-EB.5.134733

Though women artists were known to have practiced in the ancient world (Pliny the Elder), it was in the early modern period that saw them stand out as professionals in a male-dominated industry, working alongside men and achieving public success.[2] The majority of the women examined in this volume were all professionals in their field, most of whom were well regarded and successful in their day, but who also had to navigate the obstacles imposed on them by patriarchal society, and centuries of misogyny. The essays collected here examine individual artists [Xuereb, Iommelli, Bavosi and Serrani, Alba Ríos, Miroshnikova] and patrons [Powell-Warren, Xuereb, Chrzanowski, Massini]; but also women printers in family workshops [Rinaldi], women as commercial weavers [Fitzpatrick] and embroiderers [Naya Franco and Ágreda Pino]; women in architecture and building, as practitioners [Marconi] and patrons [Díez Jorge]; and groups or networks of still-life and natural history painters [Powell-Warren, Champion, Caretta and Fratarcangeli]. They offer a retrieval or re-evaluation of these women artists and/or patrons in order to reinstate them and their legacies into art historical contexts and narratives, not necessarily to create new canons, but to challenge the master narratives, in order to reclaim women's voices and write these artists back into history.

Tania Alba Ríos demonstrates how the technical writings of the nineteenth-century American sculptor Harriet Hosmer, raised important questions about women artists' professionalisation. Just like women artists in the pre-modern era who could not study life drawing in the academies, social mores prevented Victorian women from gaining practical knowledge of anatomy, which was fundamental to the representation of the human figure, especially in public sculpture and the painting of historical narratives. Hosmer overcame this obstacle by means of a family friend who assisted her to attend medical school for this purpose, exemplifying how connections (and, as we shall see later, networks) were paramount in enabling women achieve their creative goals. Hosmer, an accomplished practitioner, was like many women artists before and after her, accused of not executing her own works. This Hosmer countered in her artistic practice by 'exposing the process' via which she sculpted, which she codified in a technical text, 'The Process of Sculpture', and also posing for photographs showing her working on her larger-than-life sculptures, demonstrating that women sculptors could be professional artists in the same way as men.

Even when women were trained in professional art institutions and exhibited publicly, they were sometime relegated to amateur status and not documented in the same way as their male counterparts (in reviews, art historical texts and so on, largely written by men) as Elli Leventaki has shown for women artists in early twentieth century Greece. Being omitted from or marginalised in official art histories Leventaki

2 Amongst the pioneers in the field we can cite the sculptor Properzia de' Rossi (*c.* 1490–1530) and the painters Lavinia Fontana (1552–1614) and Elisabetta Sirani (1638–1665), all three from Bologna in Northern Italy, an extremely supportive environment for women creatives, as well as the Roman painter Artemisia Gentileschi (1593–*c.* 1656) and architect Plautilla Bricci (1616–1690). For an examination of the conditions in Bologna that contributed to the city as a centre of the largest school of women artists in the early modern period see Modesti, *Elisabetta Sirani 'Virtuosa'*; Bohn, *Women Artists*; Modesti, 'Lavinia Fontana and Elisabetta Sirani'. For Gentileschi, see Barker, *Artemisia Gentileschi*; for Bricci, Lollobrigida, *Plautilla Bricci*.

argues for a retrieval of these women's 'lost narratives' via digital tools, to produce knowledge and disseminate information on their contribution to the visual arts.

Luana Testa similarly argues that women artists have gradually and systematically been written out of history. She focuses on the 1600s, believing that this *damnatio memoriae* starts in the second half of the century, a period dominated by [masculine] reason, to reach its culmination in the twentieth century, when indeed the master narratives were formulated and written by male art historians, that largely excluded women creatives from the discourse.

Women and Work

Being a professional meant that women entered the public arena as workers and contributors to the economy. Lynn Fitzpatrick explores medieval textile production in Iceland, as it relates to the changing commercial conditions and technical innovations that saw women weavers removed from the commercial sphere to be replaced by men, displacing women's previous engagement with the economy. She argues that women in North Atlantic countries played a much more 'essential role' in textile commerce and trade for a much longer period than other parts of Europe, primarily because the cloth they wove functioned as currency, so their work was central to the economy. Nonetheless, these women also eventually disappeared from commercial textile production, and were erased from the historical record.

Whilst both Leventaki and Fitzpatrick's essays expose the problem of the scarcity of historical sources in documenting women's creative work, Nicoletta Marconi deftly demonstrates the richly documented active engagement of women as architects, labourers (stone masons, bricklayers, mosaicists, and so on) and suppliers of materials in the construction sites of major building programs, like St Peter's Rome, from the middle ages to the beginning of the nineteenth century, after which such documentation of their work disappears. Marconi found from the archival records that women during this period were presented with similar opportunities and working conditions to men, and received the same remuneration for their work. Often they were part of busy family workshops, in which these women played a central role, sometimes even as *bottega* heads. Annalisa Rinaldi makes a similar argument for the enterprising women working in the printing industry in Italy and France. Her essay examines Elisabetta and Gironima Parasole, designers and engravers in their husbands' workshop in Rome. Elisabetta Cataneo Parasole, for example, as well as contributing printed scientific illustrations to botanical treatises, invented her own lace and embroidery designs, which she then engraved and published in women's handbooks that were distributed throughout the Continent.[3] Whilst Claudine Bouzonnet Stella headed the family workshop of printers in Paris, which included her two younger sisters and a brother.

3 Such as *Teatro delle Nobili et Virtuose Donne*, dedicated to Princess Elisabeth Bourbon of France. For Cataneo Parasole as a botanical science illustrator see Tori Champion's contribution in this volume, pp. 287–301.

Artistic Genres and Media

The above example of the original patterns created by Elisabetta Parasole, belies the patriarchal belief that women lacked invention and natural talent, an accusation that emerges in some of the essays [Champion, Alba Ríos]. Invention (*invenzione*), the ability for an artist to come up with original ideas, and not merely copy nature but transform it, was a key concept in Renaissance art theory that posited men as the creative geniuses, and women merely as imitators or copyists,[4] who were thus relegated to 'minor' genres and designated as 'amateurs'.[5] But as many of the essays reveal, women managed to overcome these obstacles and successfully negotiate their professional status.

For example, the needle arts, as demonstrated by Naya Franco and Ágreda Pino, were traditionally practiced in the controlled interior space of domesticity: the home [and the convent], and was considered to be an appropriate activity for women to ward off idleness and sin. Renaissance elite women turned more to embroidery, as it simultaneously came to be considered an 'art', employing luxury materials such as precious silks, silver and gold thread, and pearls. Requiring more skill and inventiveness to create these sophisticated thread paintings, women began creating their own designs (as we saw with Parasole) or inventing new techniques. For a woman to appropriate such conceptual and creative skills, rivalling male artists was seen to go beyond her socially assigned place in the domestic sphere, and risked encroaching onto the public space of men. Indeed, we find Renaissance and Baroque women beginning to work as professional and court embroiderers, a role previously monopolised by men.[6]

When women did engage in artistic genres to which they were believed to be more suited, such as floral painting and still life, they developed these to a very high level and excelled. As Tori Champion has demonstrated, the 'feminisation' of the still life genre saw women artists not only dominate the field but eventually become major proponents of a new genre at the intersection of art and science, natural history and botanical illustration, thereby challenging received notions of what women were capable of, both as artists and scientists.

The Renaissance heirarchy of genres and media, positioned history painting [*istoria* — narrative painting of significant historical subjects from antiquity and the bible], fresco, altarpieces, public sculpture and architecture, as the most elevated

4 Such thinking was a legacy of Aristotle's conception of women as 'imperfect' men and his metaphysical split between mind and body, in which reason and the world of the intellect was a male preserve. According to this binary concept, women were inferior beings who lacked the capacity for genius because of their association with the corruptible body, and all that it is associated with: desire, emotions, senses and the passions, the irrational. As Luana Testa, using a psychoanalytical and anthropological methodology, concludes this split between mind and body in which the senses are to be dominated and controlled by the intellect, is the basis of centuries of misogyny and hostility towards women artists and makers.

5 See Panofsky, *Idea*; Lee, *Ut Pictura Poesis*; Barasch, *Theories of Art*. For the gendered dimension and implications for women artists of such a theory see Jacobs, *Defining the Renaissance Virtuosa*.

6 Professional women embroiderers who received payment for their work were active at the court of the Tuscan Grand Duchess Vittoria della Rovere; Modesti, *Women's Patronage*, p. 161.

and lucrative. These were considered exclusively a male domain from which women should be excluded. Yet as the papers by Xuereb, Iommelli, Bavosi and Serrani, and Alba Ríos, demonstrate, women over the centuries did become active in major public projects and commissions, whether as patrons (Cosmana Navarra, Franciszka Wiszowata), history painters producing altarpieces in public churches and chapels (Ginevra Cantofoli), or sculptors (Harriet Hosmer). Suor Maria de Dominici, a tertiary nun from Malta, who also worked in Rome, and the Roman Caterina Ginnasi were both history painters and sculptors, with the latter even working in fresco and architecture. Ginnasi and the determined and independent de Dominici may not have been brilliant artists, yet they were popular and well received, gaining many important commissions, public and private.

The twentieth century witnessed a dismantling of the Renaissance hierarchy and mode of representation, with the development of modern abstraction. New modes of expression emerged, with movements such as Cubism, Dada, and Surrealism, in which women artists also played a part. Valentine Gross-Hugo, the subject of Elizaveta Miroshnikova's essay, was a designer, engraver, graphic artist, illustrator, painter and writer, engaging with the Surrealists, also collaborating in her early years with Diaghilev's *Ballets Russes*. Miroshnikova argues that although she was not a major figure, Hugo's artistic practice and involvement with the Surrealists and their philosophies and creative methods, deserves attention and gives a more complete understanding of the Surrealist movement, and women's role within it.

Women and Architecture

We have already encountered the historical presence of women in architecture and building with Marconi's essay, whilst in the Keynote Maria Elena Díez Jorge examines Renaissance Spanish women as patrons of architecture. Palace building and monumental architectural projects were more commonly associated with men, whilst women were believed to have been involved only in small scale or domestic architectural patronage. Díez Jorge's essay reveals this as not the case as women also engaged in palace, church and convent building. Likewise Cosmana Navarra [Xuereb] and Franciszka Wiszowata [Chrzanowska], women philanthropists from the upper echelons of Maltese and Polish society respectively, were primarily patrons of architecture, restructuring and building churches and convents, also embellishing them with paintings and frescoes. The latter, a nun-artist, as Mother Superior of her convent was able to exercise a great deal of patronage power, as too was the noblewoman Navarra, considered the most important female patron of Baroque Malta.

Navarra and Wiszowata preserved their memory through architectural patronage, a cultural activity undertaken primarily by men in the early modern period as a means of making permanent statements about lineage, spiritual and political identity, class and status. Women, in particular those of means but also middling women, similarly used domestic and public architecture to mark out their civic presence and affiliation

to family, religion and state. As Díez Jorge concludes, 'Women wanted to act in the same way as men and ensure their memory persisted in the city; they did not want to go unnoticed and exploited architecture as a form of empowerment', however their role and impact on the urban structure of the city was different from that of men, enacting what has been termed 'civic patronage' that led to significant social changes.[7]

Memory and History: Heritage and Legacy

The role of women as carers of human and social capital and of the 'special products of human activity' (i.e. cultural patrimony) is the subject of Eliana Billi's essay on Italian women art restorers of the twentieth century. Initially led by men since its inception in 1939, for some time now women have been at the helm of the ICR, Italy's central restoration institute. Billi addresses the possible reasons for this by relating the experiences of some early female restorers who studied and worked at the Centre, asking the question if restoration as a methodological concept and the transmission of cultural memory and patrimony and its guardianship are typical values of an intrinsically female vocation.

Indeed women have been historically associated with the guardianship of cultural heritage as well as of the sacred. Medieval and early modern women both lay and religious were entrusted with the caretaking of sacred miraculous images (e.g. Madonna di San Luca, the most important Marian cult in Bologna)[8] and were custodians of holy relics which they collected and protected in reliquaries in their family chapels (such as the important Medici relic collection at the chapel at Palazzo Pitti in Florence, initiated by Archduchess Maria Maddalena d'Austria, then inherited and maintained by her daughter-in-law, Vittoria della Rovere).[9] Thus cultural capital could be passed onto future generations via the female line as Naya Franco and Ágreda Pino have also noted about the 'matrilineal existence' of the domestic embroidered piece. This reflects the shift in the early modern period to a matrilineal transmission of knowledge and culture, via women patrons, female artists who taught other women, and female teachers.[10]

Historical memory was also transmitted by women writers who published their work, or those women who contributed to *Zibaldoni* collections or *Libri di ricordi*, bequeathing these family memoirs to their heirs. Nuns worked as manuscript illuminators and scribes in convents, functioning as gatekeepers and transmitters of not only cultural and historical memory but also political and social change. Carolin Gluchowski's essay addresses scribal culture and female agency in a north-German convent. The author demonstrates how physical alterations over the years to a Latin liturgical text reveal women to be historical actors in the changing religious reforms of

7 Díez Jorge, pp. 43–64 of this volume.
8 See Fanti and Roversi, eds, *La Madonna di San Luca in Bologna*.
9 For the Archduchess see Hoppe, 'Maria Maddalena d'Austria e il culto delle reliquie', Sanger, *Art, Gender and Religious Devotion*, Ch. 4; for Granduchess Vittoria, Modesti, *Women's Patronage*, pp. 208–18.
10 Modesti, *Elisabetta Sirani 'Virtuosa'*; Modesti, *Women's Patronage*.

the fifteenth and sixteenth centuries, especially the Lutheran Reformation. By examining the material processes by which such major church reforms were incorporated by the convent sisters in their revisions of this manuscript, Gluchowski highlights the theological and political role of these women as church reformers. The prayerbook thus remains as a historical record of women's reformative agency as well as their creative practices.

It is evident that legacy, the desire to preserve one's own memory via art, architecture or patronage, was paramount for many of the women examined in this volume. For example, via their patronage activities Agnes Block, Cosmana Navarra and Franciszka Wiszowata each fashioned their identity as patron and benefactor. As Catherine Powell-Warren has shown, Block wished to visually memorialise her collections by commissioning the most important artists of the age, male and female, to produce watercolours of her collection of exotic floral specimens and fauna, which she gathered into bound volumes, and she was commemorated as Flora Batava in a medal. All three women had their portraits painted that included inscriptions and/or visual cues to their projects and achievements. Navarra even incorporated her family coat of arms in the artworks she commissioned, and a plaque identifying her as the founder of the church at Rabat, is also located at St Paul.

Documentation: Primary and Archival Sources

Some of the essays highlight the problem of sources and lack of documentation, especially in secondary (art) historical literature, in regards to women artists and their work, which has led to their *damnatio memoriae*, not being recorded by history [as we have already noted with Fitzpatrick, Leventaki, Testa]. Many of the authors, on the other hand, have successfully mined the archives to uncover a wealth of primary material that offers new information that illuminates women's lives and their creative work and patronage [e.g. Marconi, Díez Jorge].

One of the most significant primary documents is the artwork itself. A fate befalling a number of women artists is that many of their paintings or sculptures have been lost, as in the case of Caterina Ginnasi, examined by Antonio Iommelli, and Suor Maria de Dominici [Xuereb], whose work, mainly for private collectors, is no longer extant or cannot be physically traced [they remain 'lost' in unknown collections]. This creates methodological problems for scholars trying to reconstruct these women artists' oeuvres or trace stylistic developments and influences. This is when archival documentation proves crucial. In Ginnasi's case, inventories have uncovered further works by her hand, with Iommelli also locating an unpublished painting identified by him in the artist's own post-mortem inventory.

Paola Caretta and Margherita Fratarcangeli likewise have examined a number of inventories[11] to uncover the works of three early modern female still-life painters

11 On the importance of inventories as historical sources and in uncovering women's lives see Bues, 'Inventories and the Movement of Objects'.

(Fede Galizia, Orsola Maddalena Caccia and Giovanna Garzoni). They note that in the published literature on *natura morte* by male art historians during first half of the twentieth century, when still-life painting was gaining critical respectability, these women hardly appear, yet they were pioneers in the genre, as Tori Champion has shown in her contribution. The authors aim to redress this imbalance by charting inventory entries on these artists, that are replete with mentions of these women's still lifes from 1617 onwards, when the genre became very popular amongst collectors of the period.

Methodological issues are also highlighted by the essay on Ginevra Cantofoli by Caterina Bavosi and Alessandro Serrani. They argue for a revision of Cantofoli's oeuvre, believing that most of the paintings currently attributed to the artist by various scholars, based primarily on stylistic grounds, should now be reassigned to the Flemish painter Luigi Gentile, who worked in Italy during the seventeenth century.[12] Their essay exposes the problem of assigning works purely on stylistic similarities without the support of other primary documentation. But the reverse is also to be avoided, warn the authors: the use of documentary evidence alone, without taking into consideration stylistic discrepancies, as is the case of one particular altarpiece assigned to Cantofoli in the primary sources, but which Bavosi and Serrani believe shows the intervention of a second more accomplished hand. The authors conclude that Ginevra Cantofoli's oeuvre should now be reconstructed on the basis of the only documented work entirely by her hand, the *San Tommaso di Villanova* of 1658, and on the historical sources that cite her as a public history painter, not as a portraitist or allegorical painter as her oeuvre has up till now been presented.

Patronage and Networks

A field of study that has seen a burgeoning of scholarly interest over the last thirty years is female patronage, especially as it was enacted during the early modern period.[13] The significance of networks in particular in driving patronage, and providing support for artists, including women, is illustrated by Catherine Powell-Warren in her contribution on the patronage and networks of the seventeenth-century Dutch amateur botanist Agnes Block, a woman of considerable knowledge and resources. Block created a network of still life and natural history painters that relied on her for patronage as much as she mobilised them to commemorate herself and her collection.

Being well-connected opened doors, as we saw earlier with Harriet Hosmer in nineteenth-century America, and Antonio Iommelli demonstrates how family connections and networks were crucial to the professional development and success of Caterina Ginnasi. Her uncle, the influential Cardinal Domenico Ginnasi, was instrumental in promoting her and expanding Ginnasi's patronage networks. He actively

12 The authors do not question that the works gathered together stylistically by scholars are by the same hand, but why they should be assigned to Ginevra Cantofoli, and not to another artist.

13 For an overview of the field see Reiss, '*Beyond Isabella* and Beyond'.

encouraged her decision to become an artist, financed her artistic education, and patronised her works. These revolved around embellishing Palazzo Ginnasi and the Church of Santa Lucia in Rome, as well as the family palazzo at Velletri, and frescoing the Main chapel at the town's cathedral, all commissioned by the cardinal. Ginnasi's other public documented altarpieces for Roman confraternities and churches, would also have been facilitated by her uncle. Thus family networks centred around the key figure of the cardinal, including patrons associated with him such as publishers and musicians, supported Ginnasi, and ensured that she received continuing work in Rome and Velletri well into the 1600s.

A significant aspect of women's patronage and networks that has emerged from recent studies is their support of other women, politically, spiritually, economically and artistically, and through education.[14] Ginevra Cantofoli, for example, was a member of the entourage of the extremely successful and influential Bolognese artist Elisabetta Sirani, a circle that included Sirani's two younger sisters, also professional painters, a number of female followers, and a large coterie of supportive patrons, both men and women (what Bavosi and Serrani term a 'transversal network').[15] Cantofoli, a married noblewoman and already an established artist when she met Sirani, became friends with the younger artist, and her pupil, then workshop assistant, as she moved from producing miniatures for a private market to large-scale altarpieces for the churches of Bologna. Sirani's biographer Carlo Cesare Malvasia, a close family friend, confirms that the artist 'sustained and aided' Cantofoli, assisting her in the production of her public altarpieces.[16]

Female patronage was often important in supporting the creative work of women. Eliana Billi refers to the countess Cecilia Mahony, Irish consort of Prince Benedetto Giustiniani in eighteenth-century Rome, who promoted the career of Margherita Bernini, a restorer who took over her husband's business when he became ill. The countess hired Bernini to restore the most prestigious works of the Giustiniani family collection, which included paintings by Caravaggio, Veronese, and Domenichino, and Artemisia Gentileschi's recently discovered *David with the Head of Goliath*.

Whilst Cosmana Navarra did not employ women painters,[17] two altarpieces commissioned by Franciszka Wiszowata at her Cracow convent were painted by the 'skilled' Wilemówna, the daughter of a talented local painter, and who appears to have specialised in public religious subjects. Like Agnes Block, Navarra and Wiszowata were well aware of the importance of appointing the most significant architects, artists and artisans of the period to execute their projects, both for prestige and stylistic continuity. Navarra employed the Italian painter Mattia Preti, who was working in Malta at the time. When Wiszowata replaced an old altarpiece in the Church of St Joseph she chose Cracow's best painter, Andrzej Radwański, whilst for the rebuilding of

14 See, for example, Modesti, *Women's Patronage*, especially Chapters 8 and 12.

15 See p. 245 of this volume. On Sirani, her female 'school' and her artistic and patronage networks, see most recently Modesti, *Elisabetta Sirani*.

16 Malvasia, *Felsina Pittrice*, II, p. 407.

17 For example, she could have commissioned work from Suor Maria de Dominici, the first Maltese female artist, but did not do so. See the essay by Nadette Xuereb in this volume, pp. 273–86.

her convent she appointed the Italian court architect to the Polish King, Francesco Placidi. The painting commissions in both Cracow and Malta were considered by contemporaries to be the best works in their respective churches, just as Block's was the 'most important collection of watercolours commissioned by an individual for the purposes of memorializing an actual collection of *naturalia*, certainly in the Dutch Republic'.[18]

Patronage requires wealth and financial autonomy, which Block, Navarro and Wiszowata certainly possessed due to their privileged social status. As Katarzyna Chrzanowska has shown through a careful examination of Wiszowata's own testimony in the convent archives, the finance for the Cracow architectural projects and their decoration came primarily from the nun-artist herself. But they were also funded in part by donations from the convent nuns and their relatives, and other senior ecclesiastical and lay patrons, many of them women, which the entrepreneurial Wiszowata secured and managed with shrewd business acumen. The funding of various art works and altars by the nuns and laywomen, reveal that Wiszowata was at the centre of a large female network, whose relationships and patronage deserve further study. That is not to say that male networks were unimportant, for these women also were supported by or developed professional relationships with a number of significant men, both clerical and lay.

I wish to say something about conjugal patronage,[19] for even though women like Wiszowata were financially independent, Navarra began her patronage in Malta whilst still married to her second husband, and they jointly funded the initial stages of the restructuring of St Paul. It was after his death in 1660 that Navarra, as a widow, was able to truly come into her own, providing funding and the conceptual ideas for the church's rebuilding and extension, evidence that Nadette Xuereb has traced in the noblewoman's wills and inventories. Her position as a widow gave her a newfound autonomy, authority and economic control, as was often the case for former married women.[20] In order to extend the new church Navarra managed to procure, after much negotiation and at her own expense, the land to the left side that belonged to the Knights of the Order of Saint John, revealing her to be a persistent and savvy business woman.

Finally Alexandra Massini examines the impact on Roman baroque society and the patronage of Maria Mancini, one of the five nieces of Cardinal Mazzarino, Chief Minister to the French King. Massini proposes that it was through Maria and her Mazarin legacy that a set of eight tapestries — woven in Paris and representing the life and deeds of two ancient Queens of Caria both named Artemisia — entered the Colonna Collection, after Maria's marriage to Lorenzo Onofrio Colonna and arrival in the papal city in 1661. In another example of conjugal patronage the couple refurbished their palace, located at the base of the Quirinal Hill, with lavish

18 Catherine Powell-Warren, pp. 111–24 in this volume.

19 A striking example of joint patronage by married couples is Isabella d'Este and Francesco II Gonzaga at the Court of Mantua. See Bourne, 'Renaissance Husbands and Wives as Patrons of Art'; James, *A Renaissance Marriage*.

20 See Levy, *Widowhood and Visual Culture*.

decorations and expensive furnishings designed by local artists, and an impressive collection of paintings. They were also patrons of music and theatre, which they hosted at Palazzo Colonna. It was Maria, however, who stole the scene, literally, by staging extravagant theatrical spectacles and masques, in which she performed as femmes fortes or femmes fatales: ancient goddesses (Venus), legendary queens (Circe) or seductive female characters from chivalric literature. She even appeared as these characters in paintings she commissioned, and in one such portrait Maria is shown exotically dressed as the Muslim sorceress Armida (from Tasso's *Gerusalemme Liberata*), complete with trousers. Maria, who was used to the extravagance and conviviality of the French court, also introduced *conversazioni* in the papal city, salons where men and women could gather for sociability and witty conversation. A spirited ('bizzara') woman Maria eventually left her husband and Rome in 1671, and after many peregrinations on the Continent, died penniless in Pisa in 1715.

Literature and Education as Female Agency

The harnessing of Literature as female agency is the final theme I would like to address. Through their writing, both published and in manuscript form such as epistles, women created networks of friendship and patronage, championed for female equality and education, and passed on technical knowledge and expertise.

Laura Mercader Amigó examines Mary Beale's 'Discourse on Friendship' (1666), a manuscript copy of which the painter sent to her friend Elizabeth Tillotson in 1667. While the nature and definition of friendship became a popular literary theme in Restoration England, male writers on the subject since antiquity largely omitted women from the discourse. Beale's aim was to give importance to relationships between women, highlighting the value of female friendships in a utopian egalitarian society based on reciprocal collaboration. As Helen Draper has shown, for Beale true friendship is the basis of all social alliances, for the 'good of Mankind'.[21] Challenging recent studies on Beale such as those by Draper, who sees the 'Discourse' primarily as the artist's attempt to gain the patronage of important men,[22] Mercader Amigó argues the fact that the first recipient of the essay was a woman is significant. The 'Discourse' extended Beale's network of female friends, so that the work is essentially an exploration of female sociability, the roots of which can be found in the period's *Querelle des Femmes*, an on-going literary phenomenon that defended the worth of women and promoted equality of the sexes.[23]

Beale also penned the first technical and instructional art text by a woman 'Observations by MB' (1663), in which she outlined her technique for painting apricots in oils. It took another 200 years before a female sculptor, Harriet Hosmer similarly wrote a technical manual, the afore-mentioned 'The Process of Sculpture' (1862),

21 Draper, '"Her Painting of Apricots"', p. 399.
22 Draper, '"Her Painting of Apricots"', p. 399.
23 The literature on the *Querelle* is vast; for a recent discussion see Garrard, *Artemisia Gentileschi and Feminism*, esp. Ch. 1 'Artemisia and the Writers: Feminism in Early Modern Europe', pp. 13–68.

which can also be considered, argues Alba Ríos, a defence of the equality of women, as are the literary writings of Marchesa Colombi (Maria Antonietta Torriani), the topic of Silvia Palandri's essay. Turning our attention to nation building in post-unification Italy, Palandri highlights Torriani's importance in creating a new 'cultural identity' for Italians that included women. Torriani's varied writings on education and marriage, her journalism, conduct manual and novels (often times ironic and satirical), form the basis for a concerted claim for women's education that would lead to their emancipation, thereby improving the female condition. Like Mary Beale in her 'Discourse on Friendship', Torriani presents 'new social models' in which women are the foundation of a new ideal society. The theme of female education as a means to gain social independence is fundamental in the work of Torriani, who believed Literature to be the vehicle of this instruction, constantly citing the classics in her writings. With fellow feminist Anna Maria Mozzoni, Torriani founded a female college in Milan where she herself taught Literature. Her feminist and pedagogical philosophy culminated in the publication in 1871 of *Della letteratura nell'educazione femminile*.

Bibliography

Primary Sources

Malvasia, Carlo Cesare, *Felsina Pittrice. Vite de' pittori bolognesi* (Bologna 1678), ed. by Giampietro Zanotti et al., 2 vols (Bologna: Guidi all'Ancora, 1841)

Teatro delle Nobili et Virtuose Donne, dove si rappresentano vari Disegni di Lavoro novamente Inventati, et disegnati da Elisabetta Catanea Parasole Romana (Rome: Mauritio Bona, 1616)

Secondary Studies

Barasch, Moshe, *Theories of Art from Plato to Winckleman* (New York: New York University Press, 1985)

Barker, Sheila, *Artemisia Gentileschi* (London: Lund Humphries, 2022)

Bohn, Babette, *Women Artists, Their Patrons and Their Publics in Early Modern Bologna* (University Park, PA: Penn State University Press, 2021)

Bourne, Molly, 'Renaissance Husbands and Wives as Patrons of Art: the "Camerini" of Isabella d'Este and Francesco II Gonzaga', in *Beyond Isabella: Secular Women Patrons of Art in Renaissance Italy*, ed. by Sheryl E. Reiss and David G. Wilkins (Kirkville: Truman State University Press, 2001), pp. 93–123

Bues, Almut, 'Inventories and the Movement of Objects', in *Telling Objects. Contextualizing the Role of the Consort in Early Modern Europe*, ed. by Jill Bepler and Svante Norrhem (Weisbaden: Harrassowitz, 2018), pp. 35–62

Draper, Helen, '"Her Painting of Apricots": The Invisibility of Mary Beale (1633–1699)', *Forum for Modern Language Studies*, 48, No. 4 (October 2012), 389–405. doi: 10.1093/fmls/cqs023

Fanti, Mario and Giancarlo Roversi, eds, *La Madonna di San Luca in Bologna. Otto secoli di storia, di arte e di fede* (Bologna: Silvana, 1993)

Garrard, Mary D., *Artemisia Gentileschi and Feminism in Early Modern Europe* (London: Reaktion Books, 2020)

Hoppe, Illaria, 'Maria Maddalena d'Austria e il culto delle reliquie alla corte dei Medici. Scambi di modelli dinastici ed ecclesiastici', in *Medici Women as Cultural Mediators (1533–1743)*, ed. by Christina Strunck (Cinisello Balsamo, Milan: Silvana, 2011), pp. 227–51

Jacobs, Fredrika H., *Defining the Renaissance Virtuosa: The Language of Art History and Criticism* (Cambridge: Cambridge University Press, 1997)

James, Carolyn, *A Renaissance Marriage: The Political and Personal Alliance of Isabella d'Este and Francesco Gonzaga, 1490–1519* (Oxford: Oxford University Press, 2020)

Lee, Rensselaer W., *Ut Pictura Poesis: The Humanistic Theory of Painting* (New York: Norton, 1967)

Levy, Allison, ed., *Widowhood and Visual Culture in Early Modern Europe* (Aldershot: Ashgate, 2003)

Lollobrigida, Consuelo, *Plautilla Bricci. Pictura et Architectura Celebris. L'Architettrice del Barocco Romano* (Rome: Gangemi, 2017)

Modesti, Adelina, *Elisabetta Sirani* (London: Lund Humphries, 2023)

———, *Elisabetta Sirani 'Virtuosa'. Women's Cultural Production in Early Modern Bologna* (Turnhout: Brepols, 2014)

———, 'Lavinia Fontana and Elisabetta Sirani', in *Observations: Women in Art and Design History* (Melbourne: National Gallery of Victoria, 2023), pp. 16–23

———, *Women's Patronage and Gendered Cultural Networks in Early Modern Europe. Vittoria della Rovere, Grand Duchess of Tuscany* (London: Routledge, 2020)

Nochlin, Linda, 'Why Have There Been No Great Women Artists?' (1971), repr. in her *Women, Art, and Power, and Other Essays* (London: Thames & Hudson, 1989), pp. 145–78

Panofsky, Erwin, *Idea: A Concept in Art Theory* (New York: Harper & Rowe, 1968)

Reiss, Sheryl E., '*Beyond Isabella* and Beyond: Secular Women Patrons of Art in Early Modern Europe', in *The Ashgate Research Companion in Women and Gender in Early Modern Europe*, ed. by Allyson M. Poska, Jane Couchman, and Katherine A. McIver (Farnham: Ashgate, 2013), pp. 445–67

Sanger, Alice E., *Art, Gender and Religious Devotion in Grand Ducal Tuscany* (Farnham: Ashgate, 2014)

Keynote

MARÍA ELENA DÍEZ JORGE

From the Palace to the House[*]

Women and Architecture in Sixteenth-Century Spain

▼ **ABSTRACT** This text analyses and visualizes the agency of women in the architecture of the sixteenth century, whether by acquiring property, developing new building projects, or participating in the actual on-site construction process. This objective forces us to rethink the history of architecture. To this end, I focused on a case study such as the city of Granada in the sixteenth century. Undoubtedly, recovering this historical experience contributes to a fairer society, capable of recognizing the active role of women in architecture, including them as actors in the cartographic memory of our cities.

Recovering the Architectural Practices of Women

When we look at studies on the Renaissance, we find names of male architects, many of them great geniuses. We also find great patrons: monarchs and great nobles, mostly men, who appear as patrons of architecture. At first glance this is not surprising, since we are used to associating architecture with an eminently masculine facet.

Traditionally, the active participation of women in architecture throughout history has not been acknowledged. There are very important studies of some of the most important buildings and spaces of the sixteenth century in which the analysis of patronage and the uses of spaces have always been present, but in which the gender perspective has hardly been applied. This is not only true for the sixteenth century but also for the entire history of architecture, as I have already shown for large palace complexes such as Madinat al Zahara or the Alhambra, both from the period of al-Andalus.[1] This situation also occurs in contemporary architecture, albeit with

[*] *Vestir la casa: espacios, objetos y emociones en los siglos XV y XVI* (Project PGC2018–093835-B-100, funded by the Spanish Ministry of Science and Innovation — National Research Agency and the ERDF — 'A Way to Build Europe'), 2019–2022. *Las Mujeres y los Discursos de Paz. Orígenes y Transformaciones en las Sociedades Occidentales* (R+D+I project B-HUM-058-UGR18, ERDF Andalusia Operational Program), 2020–2022. Translated by Wendy Caroline Byrnes.

1 Díez, 'Women and the Architecture of al-Andalus'.

Women in Arts, Architecture and Literature: Heritage, Legacy and Digital Perspectives, ed. by Consuelo Lollobrigida and Adelina Modesti, Women in the Arts: New Horizons, 1 (Turnhout: Brepols, 2023), pp. 43–64
BREPOLS ⚇ PUBLISHERS 10.1484/M.WIA-EB.5.134642

a few differences, as the emergence of female architects in recent decades has made research on women and architecture somewhat more evident.

Applying the gender perspective to the historical analysis of buildings makes it possible to visualize the rooms occupied by women, to reflect on the cooperation and patronage shared between men and women, and simply to compare the strategies and areas that men and women developed in architectural patronage. The absence of women from historiography makes it necessary to visualize them and to recover their historical experience, that is, to rethink the history of architecture.[2]

Despite the above, I must clarify that, in the following pages, although the main point of interest is to make women visible, I do not wish nor intend to build a partial history that focuses only on the female subject. The role of women in architecture can only be understood by establishing connections with the roles played by and assigned to men. I have only been able to understand the reflections made on women in architecture and construction in this way: the different or similar artistic developments of women and men; the different salaries that women and men may have received in construction; and the different approach and design of the spaces reserved for women. In this regard, I apply the gender perspective in its full dimension and also relate it to other categories of historical analysis, such as social status, ethnicity, and religion. In other words, I introduce intersectionality in order to approach the study in a more comprehensive way that better reflects the complexity of societies.

Although both are closely related, a distinction must be made between studies on women — which do not always deconstruct patriarchal narratives — and those that introduce the gender perspective in an effort to deconstruct these discourses. However, while it is true that gender studies should not be based solely on including 'illustrious women' in a general history, it is undeniable that visualizing them represents a separation from patriarchal academicism. My motivation is not the desire to find women architects, which I have not found to date in sixteenth-century Spain, but the fact of raising questions about architecture including the gender perspective.

I am aware of the need to recover the role played by women as actors, but without falling into the trap of looking only for 'female geniuses of architecture' and avoiding a critique of patriarchal ideology. It is a bonus if along the way and in the searches we find names and news of women architects such as Plautilla Bricci in Baroque Rome.[3]

It is not a question of obsessively tracking down possible names of female authors, who in the case of architecture in certain periods had to overcome social difficulties to study, learn and perform that profession, but of reflecting on the capacity of patronage, of doing, creating, and building of both women and men. To recover these practices of women in architecture, all possible facets must be analysed. This involves both the artistic promotion made by the powerful classes and the interventions of the less wealthy classes, without forgetting the analysis of the participation of women in construction as foundry workers, stonemasons, whitewashers or tile makers, among

2 Díez, *Women and Architecture*. Díez, ed., *Arquitectura y mujeres en la historia*; Roff, 'Did Women Design or Build Before the Industrial Age?'.

3 Lollobrigida, *Plautilla Bricci*.

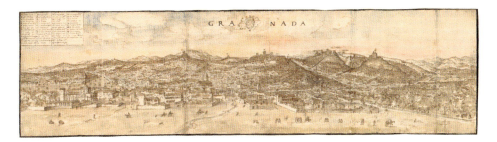

Fig. 1. Anton van der Wyngaerde, View of Granada, 1567, Wien, Österreichische Nationalbibliothek. Photo courtesy of the Nationalbibliothek.

others. This area of women's agency in architecture is the focus of the following pages.

It would be pretentious to address the multiple situations that occurred in sixteenth-century Spain; therefore, I will focus on a case study that can also be applied to other Spanish cities, given their similar situations. Specifically, I will deal with the city of Granada, which was in the hands of the Nasrid sultanate until 1492 and was conquered by the Christian kingdoms. An interesting architectural aspect developed there during the sixteenth century, ranging from the reuse and transformation of old buildings from the period of al-Andalus — the case of the Alhambra — to the construction of new and iconic buildings such as the palace of Charles V (Fig. 1).

The Imprint of Women in Urban Planning

In Granada and other sixteenth-century municipal councils, municipal decisions were taken mainly by men. Women were excluded from this process and had no power or decision-making capacity in matters that involved the whole city and ultimately affected them as well. For example, the position of city worker fell exclusively to men — Mudejares, Old Christians or New Christians — with ethnic-religious considerations being more flexible in this case than gender: a Morisco could be a city builder, but a woman never could.[4]

The government of the city fell to the so-called *caballeros veinticuatro* (knights twenty-four); these were aldermen who belonged to a middle nobility and attained great power. The decisions made by the men were implemented both in the urban planning of the city and in public buildings, even those that were intended for women. This was the case of the women's quarters in the jail, whose location and adaptation corresponded to the municipal officials (all male, specifically: Hernando Sánchez de Zafra, Juan de Contreras, and the jurors Diego de Lezana and Francisco de Molina, together with the mayor, had to decide if the women's quarters in the public jail

4 *Ordenanzas que los muy ilustres y muy magníficos señores Granada mandaron guardar para la buena governación de su Republica, impresas año de 1552.*

should be on the mezzanine floor or in the corridor, and they ordered that they be built where they thought best).[5]

Despite this, it cannot be denied that women must have found ways of defending their interests. For example, it is not implausible to think that the mothers or wives of the *caballeros venticuatro* could have pressured them in municipal decisions on more than one occasion to obtain some benefit.

There is more documentation on women in the case of private properties. At the beginning of the sixteenth century, some private houses began to be demolished in the city of Granada to widen the squares and streets, thus adapting to the new norms of urban aesthetics of the sixteenth century. The documentation of the minutes of the city council records agreements with private individuals, especially men, although women also appear. They were generally widows or women whose husbands were absent. However, there were cases in which they were not widows and others in which their status was not specified. An example is the deal that the city council made with the newly converted (i.e., Morisco) Leonor, daughter of Bexin Agebiz, for a property that had been expropriated from her; it was a storage facility that the city took from her for the construction of the courthouse next to the city hall and for which the council owed her 8000 maravedis; the price was paid to her and everything indicates that it must have been negotiated with her as well.[6] Another example is the payment to Angelina de la Plata of 19,100 maravedis, their estimated value, for the purchase of some possessions of hers in Bibarrambla square that the city council demolished to enlarge one of the main squares of the city.[7] The council must also have had dealings with Juana Hernández, glove maker, for a store that was demolished to enlarge Hatabín square and for which it paid her 25,000 maravedis in several annual instalments.[8] The demolition of a shed was negotiated with María Jibira; she was paid 666 maravedis and a half, of which one third was paid by the council for 'the general benefit that the town receives' and the other two thirds by the neighbours 'for the benefit that their houses received from the demolition of the shed'.[9] In one of the minutes, several men were sent to talk to Catalina de Moncada and see the *ajimez* (balcony, box window) that she owned in order to: 'settle with her as they see fit on the wall that goes out to the street'.[10] These were women mentioned with their names and surnames with whom for various reasons the city council negotiated and dealt directly about their properties. Such was their position, dealing with the council not only about matters that affected their properties, but also the decorum and aesthetics of the streets.

5 AMG, Libro de las Actas del Cabildo, II, fol. 301r, 1515, 10 July.

6 AMG, Libro de las Actas del Cabildo, I, fol. 259r, 1502, 10 May.

7 AMG, Libro de las Actas del Cabildo, IV, fol. 109v, 1519, 11 October.

8 AMG, Libro de las Actas del Cabildo, II, fol. 179v (1514, 1 August) and fol. 301r (1515, 10 July). AMG, Libro de las Actas del Cabildo, III, fols 40r (1516), 107v (1517), 235r and 267r (1518).

9 AMG, Libro de las Actas del Cabildo, II, fol. 374r, 1516, 11 March.

10 AMG, Libro de las Actas del Cabildo, III, fol. 255v, 1518, 27 April.

Of course, women from the elites were permanently acting on the buildings that they owned, enlarging and transforming their houses and palaces, and influencing the image of the city, as I have already pointed out in other studies.[11]

The properties of these women of the elite were affected by municipal decisions and therefore they negotiated with the crown or the municipal authorities, especially if the women were widowed. For example, Beatriz Galindo, Spanish writer and humanist, wife of Francisco Ramírez de Madrid, the secretary of the Catholic Monarchs, mentioned in her will as a widow the houses she owned in Granada and that King Ferdinand the Catholic took to build the public jail; she was compensated with 200,000 maravedis, which she invested by building some properties outside Granada, mainly in Madrid. She also obtained the not inconsiderable amount of 50,000 maravedis for a small house that she owned in Granada and that was bought to build the Royal Chapel.[12] Beatriz Galindo's ability to manage rents and properties was evident, so it is not far-fetched to think of her involvement in the deals for these urban development actions that affected her assets. The competence and ability that this woman showed to defend her interests are noteworthy, as happened with the lawsuits she filed against her husband's will, of which she finally managed to be the main beneficiary.[13]

All these women, of diverse social status, defended their interests to obtain the best benefit from these expropriations of real estate that the city council recognized as their property; the council negotiated directly with them and paid them.

But there was a more active agency, with proposals made by some women to the municipal council. These were enterprising women, who applied for licenses to build mills and to create new hydraulic infrastructures, among other projects. An example of these enterprising women who managed properties such as mills can be found in María de Peñalosa. She must have been the wife of Francisco de Bobadilla, head butler and captain with the Catholic Monarchs, who died in 1496. Her will, in the first years of the sixteenth century, lists several real estate properties in Granada: a number of houses, two stores, an inn and a complex formed by a mill, an orchard, and some houses on the banks of the Darro River. She also had nineteen contracts that generated significant income.[14] In documentation of the sixteenth century, it is quite common to find women defending and managing works and distributions of water from irrigation ditches and branches of the city for their houses by even going to court if necessary.[15] A very evident case of an entrepreneur and developer of this type of infrastructure was that of Ana de Gutiérrez, or Ana de Contreras after her husband's surname, who in the early seventeenth century applied for a license from the council of Motril, in Granada province, to build a bread mill and carry out works to divert an irrigation ditch that would power the mill.[16]

11 Díez and Hernández, 'Construyendo la ciudad'.

12 Beatriz Galindo's will of 1534 in Serrano, *Escritoras españolas*, pp. 431–40.

13 Arroyal and others, 'Beatriz Galindo'.

14 Peinado, *Aristócratas nazaríes y principales castellanos*, p. 115.

15 See various examples in Quesada, 'Infraestructuras domésticas', specifically the chapter 'Hombres y mujeres en la gestión del agua para sus casas'.

16 Hernández, 'De piedra, harina y papel'.

Other important infrastructures for the city because of the service they provided were convents, of which women were great developers in Spain. Women from the well-positioned noble classes focused their efforts on sponsoring and founding convents, most of which were intended for women; rarely did they erect one for men. Yet, there are some cases such as that of Leonor de Herrera in Guadix (Granada province), possibly a convert of Jewish origin, who left money and instructions in her will to build a convent of Discalced Carmelites for men.[17] But this was not usual: men founded convents for men and women. The data we currently have hardly suggests that the foundation of women's convents by women was a matter of protectionism among them or for them, although it is worth noting that a significant number of religious foundations were established by widowed women who became part of the congregation.

Undoubtedly, the foundation of convents for women by women reveals a social role of appropriateness, as opposed to the peculiar nature of a male convent being founded by a woman. It is enough to check the enumeration made by Francisco Henríquez de Jorquera in a seventeenth-century manuscript he wrote about the city of Granada, which remained unpublished at the time.[18] We are interested in seeing what this scholar of Granada emphasized and what memory he constructed of the city. In his enumeration he mentioned eighteen convents for men[19] and nineteen for women.[20] In these female convents, almost all of them founded after the Christian conquest in the period between the late fifteenth century and the early seventeenth century, the patronage of women was predominant. Reference was made to the agency of these patrons, recording for posterity the memory of their imprint on the city. He cited two convents founded by a married couple, four by men, three unspecified and ten exclusively by women, although in reality there were more, such as the Convent of Sancti Spiritus, which the author attributed to Alvaro de Bazán but was actually founded by his wife, María de Manuel.[21]

Let us give names and surnames to these women: Luisa de Torres, widow of Constable Miguel Lucas de Iranzo, founder of the Convent of Santa Isabel la Real; María de San Sebastián, founder of the Convent of Nuestra Señora del Carmen; the nun known as 'la madre de San Francisco', founder of the Convent of la Concepción; Sister Ana de Jesús, companion of Santa Teresa de Jesús, founder of the Convent of San José de las Descalzas; the Duchess of Sesa, founder of the Monastery of the Virgen de la Piedad; two 'venerable and devout pious ladies', who founded the Convent of Santa Clara; María de Córdoba y Centurión, daughter of the Marquis of Estepa, who founded the Convent of Santo Angel Custodio; Ana de Mendoza, founder of the Monastery or Colegio de las Doncellas; Mother Potenciana de Jesús, founder of the nunnery known as Beaterio de las Potencianas; and two noble daughters of the city, who founded the Beaterio de las Melchoras.

17 Hernández, 'El matronazgo y la fundación de Leonor de Herrera en Guadix'.
18 Henríquez, *Anales de Granada*.
19 Henríquez, *Anales de Granada*, chapter 34.
20 Henríquez, *Anales de Granada*, chapter 35.
21 López, 'Los Bazanes de Granada'.

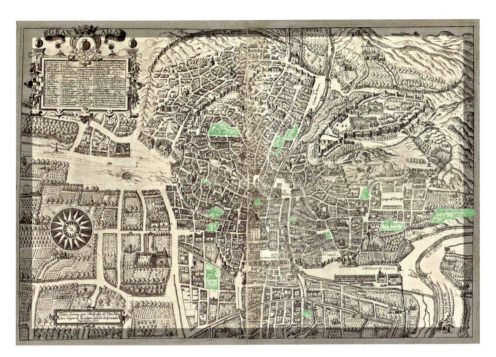

Fig. 2. Ambrosio de Vico's platform of the city of Granada made at the end of the sixteenth century. Engraving by Francisco Heylan in 1613. Courtesy of Archivo Municipal de Granada, reference number 05.001.01. Edited by the author to highlight the women's convents drawn by Ambrosio de Vico in sixteenth-century Granada.

I have taken the map drawn by Ambrosio de Vico at the end of the sixteenth century, known as the Vico platform, and marked the female convents included in it. As can be seen, they are scattered all over the urban fabric of the city (Fig. 2). Of the convents for women, at least eight were founded by a woman; others were founded by married couples, and others still were erected by men. The female convents founded exclusively by women and that are represented on the Vico platform are: Sancti Spiritus, La Piedad, Santa Isabel la Real, Colegio de Doncellas, Nuestra Señora del Carmen, Carmelitas Descalzas (mentioned by Henríquez de Jorquera as San José de las Descalzas), Capuchinas (Henríquez de Jorquera identified it as the Convent of Santa Clara), and la Concepción (founded by Leonor Ramírez). We should not think that the pious foundations were limited exclusively to economic donations; on more than one occasion they also implied orders by these women on the organization of the convent and on the building process. All this gives us an idea of the cartography of women in the city and of the importance and imprint of their architectural development work.

With this I do not intend to construct a partial history, since it is obvious that both men and women participated in the conventual landscape of the city at the time. In some cases, they did this as married couples and in others men were the visible heads of these foundations, but, as I pointed out, the proportion of women involved was not

The Agency of Women in Palace Architecture

Let us continue the tour of Granada, shifting the focus now from the city to the royal household. The conquest of Granada was used politically at the time as the definitive victory of Christianity over Islam in the Iberian Peninsula, enhancing this triumph with the idea of the 'recovery' of the territory of ancient Hispania. However, it seems that the goal of Queen Isabella was not so much this unity of 'Spain', which perhaps responds more to a historiographic cliché, but rather an alliance between different kingdoms, especially Castile and Aragon. The Christian conquest of Granada represented this desired unity or alliance.

In all the interventions carried out by the Catholic Monarchs, we must consider the greater or lesser involvement that King Ferdinand and Queen Isabella may have had separately. According to the documentation that has reached us, it seems that Queen Isabella of Castile played a stronger role in the promotion of the arts in Granada, although this hypothesis needs to be further explored.

Isabella I (1451–1504) was very aware of the symbolic potential of the Alhambra in Granada, where the Catholic Monarchs lived intermittently from 1492 to 1501. Hence, some of her architectural actions and developments are not surprising. In addition to maintaining the Islamic legacy, some of her wishes can be translated into an attempt to enhance the symbolic power of the Alhambra, such as her initial attempt to establish the Convent of Santa Isabel la Real, although this could not be implemented.[22] Along the same lines, it is worth mentioning the desire that the Queen expressed to create a hospital in the Alhambra, and for which she left 20,000 maravedis to Iñigo López de Mendoza, Count of Tendilla, as documented in a letter written on 9 December 1500; we must not forget that with the Queen came the Hospital de la Concepción or Hospital of the Poor, which had a fixed and a mobile part. This hospital led to the emergence later on of the hospitals of Toledo and Granada and especially of the Hospital de la Reina to care for the wounded in combat during the war of Granada.[23] Finally, the Royal Hospital was built on the outskirts of the city of Granada.[24]

It is also worth noting the role given to the Franciscan order with the foundation by the Queen of the Convent of San Francisco in 1495 on an old Nasrid palace of the Alhambra. Undoubtedly, this convent must have been an important reference point for Isabella I. Her grandson, Prince Miguel, who died in the Alhambra on 20 July 1500, was buried there, and she also left the order that she wished to be buried

22 Liss, *Isabel la Católica*, p. 250.

23 Fernández de Córdova, *La Corte de Isabel I*, p. 153. Regarding the hospital for the war of Granada, it is worth mentioning the Hospital in Santa Fe, on which there is documentation in the *Cuentas de Gonzalo de Baeza*.

24 Cambil, *Los Hospitales de Granada*.

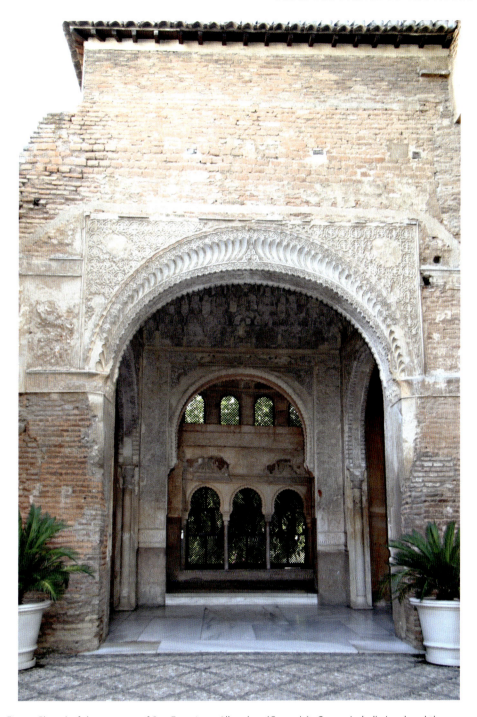

Fig. 3. Chapel of the convent of San Francisco, Alhambra (Granada). Queen Isabella I ordered the construction of this convent in the palatine city of the Alhambra and asked to be buried in its chapel. Photograph by the author.

provisionally there herself. In a clause of her will she left a record of how she wanted to be buried; the tomb should be low and without any bulk except for a low flat slab on the ground with her letters carved in it.[25] In the subsequent orders given by the Count of Tendilla, he maintained these wishes, although he gave specifications for other details such as the grille and especially the chapel with the muqarnas vault and the carved and gilded wood ceilings[26] (Fig. 3).

The project of the tomb itself was relatively simple, without any images or decoration, but symbolically very relevant. However, the ultimate idea was to build the tombs in the cathedral, a project that led to the current Capilla Real or Royal Chapel. Ferdinand II of Aragon was clear that he should be buried next to his first wife, Isabella I of Castile, and in Granada, thus leaving a record of his participation in the conquest of the Kingdom of Granada.

Everything was surrounded by symbolism, since the occupation of the Alhambra as the royal dwelling of the Christian monarchs was a symbol of the surrender of the Nasrid kingdom of Granada to the Christian kingdoms of Castile and Aragon and also of the projected alliance between the two Christian kingdoms. However, in this alliance, the roles assigned to and executed by King Ferdinand and Queen Isabella were different, as corresponded to their origins in different courts and kingdoms, because of their different characters, and also because what was expected of each of them was preconceived and designed by gender differences. Symbolically, the military aspect was monopolized by King Ferdinand, while the consolidation of the faith and conversion seems to have corresponded more to the role expected of Isabella I. However, I do not believe that gender played a major role in the greater involvement that Isabella I seems to have had in the Alhambra interventions; rather, this is likely to have been a matter of political strategy skilfully understood by her.

However, not only queens had agency in court: another very diverse form of agency was that of women who were directly present on construction sites. Much remains to be explored on this subject, although I have already conducted some research on it.[27] I have examined much documentation from the sixteenth and early seventeenth centuries about the Alhambra, both that included in the archives of the Patronato de la Alhambra y Generalife (Alhambra and Generalife Trust) and the Archivo General de Simancas (General Archive of Simancas). Not many women were actually recorded as being present on the building site, but there were some.

In these pages I would like to focus on their participation as potters, providing materials for the royal dwelling, for these palaces of the Alhambra that passed into Christian hands. They usually appeared in the documentation when they were widowed and their sons were not of age; it is in these circumstances that the records mention the names of these widowed women who knew the trade, who worked daily

25 *El testamento de Isabel la Católica*.

26 The document of the Count of Tendilla, dated 1504, is recorded in Szmolka and others, *Epistolario del Conde de Tendilla*, vol. I, p. 218.

27 Díez, *Women and Architecture*, especially Section III, 'Women as Subjects: Crafswomen in Construction'. For the Italian case I would like to highlight Nicoletta Marconi's work on women who worked in construction: Marconi, 'Carrettiere, fornitrici e "mastre muratore"'; Marconi, 'Giovanna Jafrate "vetrara"'.

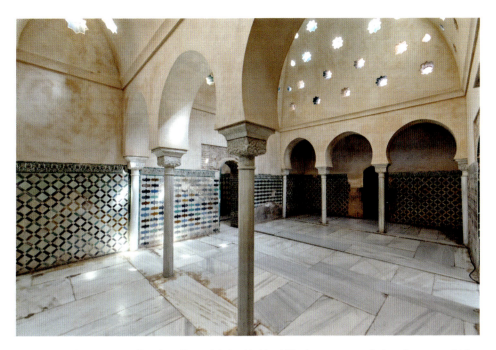

Fig. 4. Baño de Comares, Alhambra (Granada). In this Nasrid bath, numerous tiled surfaces were laid throughout the sixteenth century, some of them commissioned to the potter Isabel de Robles. Photograph by the author.

in the family pottery workshop and, in short, who contributed in this case to the architectural decoration of the Alhambra.

In this regard, I have already written several texts on one of the women who supplied glazed pieces to cover the architecture of the Christian Alhambra during the sixteenth century; I am referring to Isabel de Robles.[28] I have pointed out that she was married to Alonso Hernández, a Morisco potter, and that she started appearing in the documentation of payroll and payments when she must have been widowed. There are records of the payments made to her from 1537 to 1546, according to the documentation found to date in the Archive of the Alhambra; however, the General Archive of Simancas has information up to 1553.[29] When the record mentions a male tile maker such as Pedro Tenorio, his skills as a potter are not questioned. However, as Isabel de Robles predictably cannot appear as a tile maker, from a historiographical point of view it could be questioned whether she actually knew about pottery techniques, or if her skills rather applied to running a business. The fact that she ran the workshop well indicates that she must have known the trade; besides,

28 Díez, 'La mujer y su participación en el ámbito artesanal'. Díez, 'Mujeres en la Alhambra'. I am preparing a revision of what was then proposed, on the basis of new data that I have collected about the Hernández, Robles and Tenorio families, especially with regard to kinship and family ties between them.
29 Payments to Isabel de Robles are recorded in the years 1552 and 1553, according to the Archivo General de Simancas, Contaduría Mayor de Cuentas, 1ª época, leg. 1120, in Casares, 'La ciudad palatina de la Alhambra'.

why would she not have knowledge about pottery if she had been married to a potter and lived in a potter's environment? It is worth noting that the Robles saga of potters was related to the Tenorio and Hernández families. There is no reason to deny her knowledge of the trade: the fact that women were not master potters, or that there were very few of them, was not due to any lack of ability on their part but rather to an administrative issue that hindered their access to the master's examination (Fig. 4).

Based on the Alhambra documentation, it is evident that there were a significant number of male potters throughout the sixteenth and early seventeenth centuries. Regarding female potters, a common trait among many of them is that they were widows. For example, in the sixteenth century, the aforementioned Isabel de Robles, who was married to Alonso Hernández; in the seventeenth century, and probably with good knowledge of the trade, María Romera, widow of Antonio Tenorio, potter and master tile maker, and who also lived in the Alhambra.[30] The same applies to Mariana Contreras, widow of the potter Pedro Tenorio; it might be thought at first that she left the business when she was widowed, but on examining the accounts of the Alhambra we see that she supplied pieces to the Alhambra from the time her husband died in 1637 until October 1645.[31]

From queens to potters, women acted and had agency, although in very different ways, since the capacity of a queen to promote and manage these projects was not the same as that of a craftswoman.

Building the House: Women and Domestic Architecture

In domestic architecture, a large number of women had a considerable agency in the field of architecture. I will address some reflections about aspects linked to ownership and sponsorship.

In the sixteenth century, in the case of entailed estates, the main houses passed preferentially to the sons, normally the first-born male; however, the other houses were transmitted to the rest of the sons and also as dowry to the daughters. It was not infrequent for real estate to be left to wives or daughters in the wills, so that these women became owners of these properties. This was the case not only for the great families of the noblest birth, but also for other lineages of the middle nobility and for a municipal oligarchy that had numerous properties and profitable prebends in the city. The dowry of Catalina Méndez, daughter of Esteban Muñoz and Juana Méndez, of the Salazar lineage, is a good example of this: her husband, Francisco Quiñones, had stipulated that he did not want to receive movable goods as dowry, but that the entire dowry should be in real estate: a part of a farmhouse, tax income from the main houses of her parents, half of a vineyard, and a house in the town of Colomera, among others.[32] In the same vein, the dowry of María de Medrano, when she married Diego

30 APAG, Libro de Protocolos, nᵒ 4, 1613, 12 June. This is a letter of contract acknowledgement dated 12 June 1613.

31 Díez, *Hecha de barro y vestida de color*, pp. 66–71.

32 AHPNG, G-30, fols 179ᵛ–181ʳ, 1528, 11 December.

FROM THE PALACE TO THE HOUSE 55

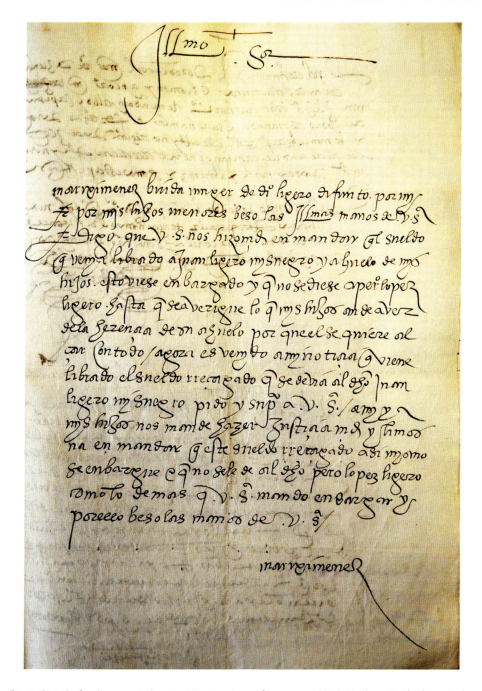

Fig. 5. Detail of a document showing the signature of a woman, María Jiménez, in the lawsuit she filed to defend the property of a house that her children were entitled to by inheritance. In fact, a comparison with all the signatures that appear in this long lawsuit shows that it was not written by her but by the scribe who drafted the petitions made by her in 1565. Her name and surname were written as a signature as she was probably illiterate. Courtesy of the Archivo del Patronato de la Alhambra y Generalife, L-221-13, fol. 50ʳ, year 1565.

de la Fuente, included not only some movable goods but also a vineyard with a house on the grounds and some trees.[33]

Another way for women to own property was through grants. After the conquest of Granada, the monarchs gave grants, awarding various properties to their supporters and to those who had participated in an outstanding way in the war against the Muslims. These properties were normally granted to men, although some women were also honoured in this way. I must insist on the fact that these grants were not given to their husbands, but directly to them for their diverse services to the crown. For example, María de Medina, the Queen's maid, was given houses in the Alhambra. This grant was awarded directly to her, without being a widow as in the other cases, and therefore became part of her patrimony earned through her services. This was one of the possessions of María de Medina, but it was not the only one, as she received other grants and properties for her own position in the Queen's royal chamber.[34]

A third way to own properties was to buy them. It is true that, in early sixteenth-century Granada, men had a dominant presence in the transactions concerning houses, as they were the ones expected to make agreements and deals of leases, purchases, and sales, and had the freedom to sign these deals. However, women were also present in these transactions: although I have documented women appearing as agents in about one third of the documentation of that time, heading the acquisition or sale of a house, women were present in half of the agreements, as they appeared both alone and jointly with their husbands. Whether widowed or married, they participated actively, although they were more visible when they were widows, as the request had to be made in their own name.[35]

On this point, an important aspect to take into account in the context of sixteenth-century Spain is the *Leyes de Toro* (Laws of Toro), drafted in 1505; specifically, laws 54 to 61, which regulated what married women could or could not do. These laws dealt with issues such as the acceptance or repudiation of an inheritance and the fact that married women could not enter into contracts or terminate them without marital license, nor could they appear in court without marital license. These restrictions could be lifted by virtue of Law 56 which, for the first time in Castilian law, allowed married women to have a general marital license: 'We command that the husband may give general license to his wife to contract, and to do everything that she could not do without his license: And if the husband gives it to her, everything that the wife does by virtue of the said license shall be valid'. Other favourable measures were Law 60, which admitted that if the wife renounced the community of property system, then she could not be obliged to assume her husband's debts, and Law 61, which stated that a wife should not be obliged to be her husband's guarantor.[36]

33 AHPNG, G-30, fols 815ᵛ–817ʳ, 1530, 15 October.
34 AGS, CCA, CED, 5, grant from 1500.
35 Díez, 'El género en la arquitectura doméstica'.
36 Muñoz, 'Limitaciones a la capacidad de obrar de la mujer casada'.

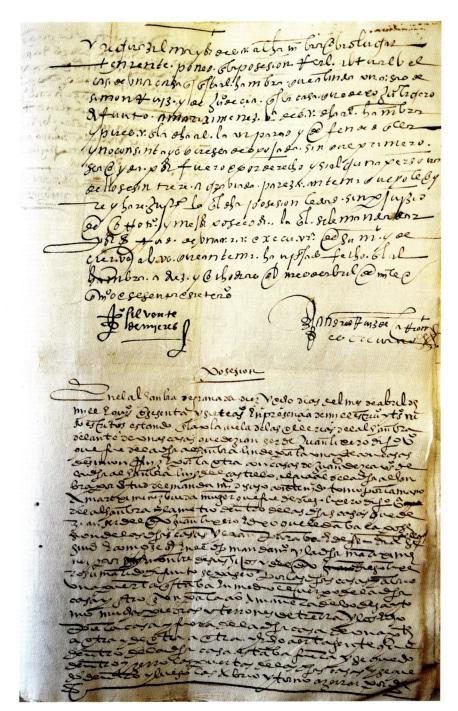

Fig. 6a. Detail of an Alhambra document by which a woman, María Jiménez, takes bodily possession of a house. Courtesy of the Archivo del Patronato de la Alhambra y Generalife, L-221-13, fol. 46, year 1565.

Fig. 6b. Detail of an Alhambra document (continue).

A last way to achieve ownership was through construction projects, as sponsors of new buildings. It has been possible to thoroughly explore the initiatives of certain noble women, for example in the Bazán family in Granada, in which María Manuel, widow of Alvaro de Bazán, began to rearrange and group several small properties in 1500 to build some main houses in Granada. Nearby, María Manuel also founded the Church of Sancti Spiritus, blessed in 1504 as the burial place of the lineage, placing the body of her deceased husband in the main chapel. She also commissioned the construction of a convent for Dominican nuns. This enterprising woman lived in that house with her granddaughters; one of them, also named María Manuel, was the one who later kept part of that house, perpetuating the prestige and lineage of the Bazán family.[37]

The concern that men and women had for main houses as an image of their lineages is evident. This aspect was not neglected by women: on the contrary, whether married or widowed, they were involved in leaving the mark of their lineage and in ensuring their houses were inherited following the rules for entailed estates, although once again the condition of widow makes their names more visible in the documentation. These were women who were visible in the society of their time and

37 López, 'Los Bazanes de Granada'.

who left their mark in the sponsorship of architectural works, contributing to the expansion and fame of their lineage, which they felt responsible for and proud of.[38]

These were the four ways for women to become property owners: four ways of having very diverse agency and social projection, with both purchase and sponsorship showing the entrepreneurial aspect of women, as active subjects who were clearly aware that architecture was a means of achieving social prestige.

I do not wish to focus only on women of a certain social status, who had possessions and were important architectural patrons in some cases: ordinary women were also actors and property owners. María Jiménez, a widow, went to court to defend the inheritance that her children were entitled to from their paternal grandparents, which included a house (Fig. 5). Her brother-in-law had entered the house and taken possession of it, along with a large amount of movable assets inside. María Jiménez filed a lawsuit in 1565 and won it. She took possession of the house: in the presence of the notary and witnesses, the bailiff took the hand of María Jiménez and led her inside the house; she walked through all the rooms, opening and closing doors, grabbing some stones and clods of earth, and throwing out the people who were occupying it. She did this in exactly the same way as was the custom with men, by being bodily led into the property by the bailiff as the person who was to take possession.[39] In this way, it was made clear to all that she was the owner (Figs 6a and 6b).

By Way of Conclusion: Architectural Matronage

After all that has been said, it is worth concluding with a reflection on many of these actions that can be included under the term *matronage*. This concept is intended to define the sponsorship exercised by women and that influenced the city, including convents, hydraulic works and mills that improved the infrastructure and services of a city and, by extension, its economic activity. These constructions were of benefit to the city, and it was recognized at the time that they were managed and sponsored by women. This gave them and their lineage prestige and recognition before the rest of the citizens.

Women wanted to act in the same way as men and ensure their memory persisted in the city; they did not want to go unnoticed and exploited architecture as a form of empowerment. To this end, they left their name in the inscription on the facade of buildings, in chapels or through their coat of arms. However, their role was different from that of men and, consequently, so was their impact on the city: it was not a mere patronage, but 'a civic patronage exercised by the women of the city elites that led to changes in gender relations and, therefore, in social and civic relations'.[40]

Some of these women did not hide and knew that they deserved to be remembered. This explains the burial programmed by María Manrique, Duchess of

38 Díez, 'Power and Motherhood'.
39 APAG, L-221-13.
40 Martínez and Estrella, 'Matronazgo arquitectura y redes de poder', p. 13.

Terranova, who, after the death of her husband, Gonzalo Fernández de Córdoba, the Gran Capitán, commissioned the construction of the main chapel for her and her husband in the monastery of San Jeronimo in Granada.[41] She left some instructions on how she wanted to be buried. The final result shows us that the purpose of the main chapel was not only to praise her husband for his military exploits, but that she occupied the same place: half of the chapel, her effigy and a whole iconographic cycle of illustrious women with whom to compare her life. It is evident that she was aware of the power of architecture to honour her memory and lineage and to perpetuate her exemplary life. For this reason, she asked the monarchy for permission to have a burial of such beauty and prestige and thus not go unnoticed.

In their own way, other women of less wealthy classes also exerted an agency to perpetuate their memory. Quiteria Ramírez left a house in the Alhambra in 1540 to the beneficiaries of the Church of Santa María de la Alhambra.[42] Undoubtedly, this donation had a devotional connotation as well as a social projection. In exchange, the ecclesiastical beneficiaries were to say mass on the anniversaries of the death of Quiteria Ramírez. We must understand that the house was donated not only with a devotional character, but also with the purpose of perpetuating her memory before the rest of the parishioners on each anniversary of her death; after all, it was a way of being remembered. Both men and women evidently made donations with a devotional character, but women clearly understood that this was a way of perpetuating their memory.

At this point I would like to point out an aspect that is not trivial: the memory of these women in the city. An interesting aspect is to analyse under whose name the dwelling was recognized. To do so, I have analysed the survey of houses in Granada in 1527.[43] This survey listed the properties endowed to mosques and other charitable Muslim institutions that passed to the Crown after the conquest of 1492; the Catholic Monarchs distributed these properties among the city council, the Church and the Crown itself and also donated some of them to private individuals. The survey covered seventeen parts of the city, which gives us a fairly approximate idea of what the situation was like at that time. It included more than four hundred properties, most of which were used as dwellings. Of these, fifty-two were inventoried at the time under the name of a woman. Of these women, twenty were widows and nine were married; there is no specific information about the rest. The differences between the number of men and women heading households were huge, but it is interesting to see that certain properties were associated with women, and that they had a place in the imagination and in the present memory of the city, in the same way as the mill of María Peñalosa was remembered, or some houses in the Alhambra that were

41 Hernández, *Rescatadas del olvido*.

42 Transcribed document in García, 'Bienes habices de la iglesia de Santa María de la Alhambra', document 28, year 1540, pp. 222–28.

43 *Casas, mezquitas y tiendas de los habices*.

mentioned as the houses of 'la Latina', the nickname with which the aforementioned Beatriz Galindo was known.[44]

The image and roles assigned to women in sixteenth century society meant that their actions had a different projection from those of men, and had a different impact on the memory of the city. In this regard, the concept of matronage emphasizes the need to explore this diversity. This diversity is what I wished to visualize in these pages, from the noble palace to the most modest house. In both cases we find a multitude of evidence that women were agents of architecture and contributed to build the city, either by sponsoring the works or with their own on-site labour, thus contributing to create the urban and architectural landscape in such a way that we cannot ignore their actions if we want to be objective with history.

44 AGS, CCA, 190,41 Description of the house of Juan de Montealto and its boundaries, on one side with the Calle Real and on the other with houses belonging to 'la Latina'.

Bibliography

Manuscripts and Archival Sources

Granada, Biblioteca del Hospital Real, Caja A 27, *Ordenanzas que los muy ilustres y muy magníficos señores Granada mandaron guardar para la buena governación de su Republica, impresas año de 1552. Que se han vuelto a imprimir por mandado de los señores Presidente, y Oidores de la Real Chancillería de esta ciudad de Granada, año de 1670 añadiendo otras que no estaban impresas, impresas en Granada en la imprenta real de Francisco Ochoa en la calle de Abencerrajes*

Granada, Archivo Municipal de Granada (AMG), Libros de las Actas de Cabildo, 1. L.00001 (years 1497–1502)

Granada, Archivo Municipal de Granada (AMG), Libros de las Actas de Cabildo, 2. L.00002 (years 1512–1516)

Granada, Archivo Municipal de Granada (AMG), Libros de las Actas de Cabildo, 3. L.00003 (years 1516–1518)

Granada, Archivo Municipal de Granada (AMG), Libros de las Actas de Cabildo, 4. L.00004 (years 1518–1522)

Granada, Archivo del Patronato de la Alhambra y Generalife (APAG), Libro de Protocolos, nº 4 (year 1613)

Granada, Archivo del Patronato de la Alhambra y Generalife (APAG), L-221–13 (year 1565)

Granada, Archivo Histórico de Protocolos Notariales de Granada (AHPNG), G-30 (years 1528–1530)

Simancas (Valladolid), Archivo General de Simancas, Cámara de Castilla, Libros de Cédulas (AGS, CCA,CED), 5 (year 1500)

Simancas (Valladolid), Archivo General de Simancas, Cámara de Castilla (AGS, CCA), 190, 41 (year 1527)

Primary Sources

Casas, mezquitas y tiendas de los habices de las Iglesias de Granada, ed. by María del Carmen Villanueva Rico (Madrid: Instituto Hispano-Árabe de Cultura, 1966)

Cuentas de Gonzalo de Baeza. Tesorero de Isabel la Católica, transcribed by Antonio de la Torre and E. A. de la Torre (Madrid: Consejo Superior de Investigaciones Científicas, 1956)

El testamento de Isabel la Católica y otras consideraciones en torno a su muerte, ed. by Vidal González Sánchez (Madrid: Instituto de Historia Eclesiástica 'Isabel la Católica', 2001)

Epistolario del Conde de Tendilla (1504–1506), ed. by José Szmolka Clares, María Amparo Moreno Trujillo, and María José Osorio Pérez (Granada: Universidad de Granada, 1998)

Escritoras españolas desde el año 1401 al 1833, ed. by Manuel Serrano y Sanz (Madrid: Impresores sucesores de Rivadeneyra, 1903)

Francisco Henríquez de Jorquera, *Anales de Granada. Descripción del Reino y Ciudad de Granada. Crónica de la Reconquista (1482–1492). Sucesos de los años 1588 a 1646*, ed. by Antonio Marín Ocete (Granada: Universidad, 1987)

Secondary Studies

Arroyal Espigares, Pedro J., Esther Cruces Blanco, and María Teresa Martín Palma, 'Beatriz Galindo: fortuna y poder de una humanista en la corte de los Reyes Católicos', *Baetica. Estudios de Arte, Geografía e Historia*, 28 (2006), 299–324

Cambil Hernández, María de la Encarnación, *Los Hospitales de Granada: siglos XVI–XXI. Tipología, catálogo e historia* (Granada: Universidad, 2010)

Casares López, Matilde, 'La ciudad palatina de la Alhambra y las obras realizadas en el siglo XVI a la luz de sus libros de cuentas', *De Computis: Revista Española de Historia de la Contabilidad*, 6, 10 (2009), 3–129

Díez Jorge, María Elena, 'La mujer y su participación en el ámbito artesanal', *Cuadernos de Arte de la Universidad de Granada*, 29 (1998), 173–81

——, 'Mujeres en la Alhambra: Isabel de Robles y el Baño de Comares', *Cuadernos de Arte de la Universidad de Granada*, 37 (2006), 45–55

——, 'El género en la arquitectura doméstica. Granada en los inicios del siglo XVI', in *Arquitectura doméstica en la Granada Moderna*, ed. by Rafael López Guzmán (Granada: Fundación Albayzín, 2009), pp. 153–91

——, 'Women and the Architecture of al-Andalus (711–1492): A Historiographical Analysis', *Reassessing the Roles of Women as 'Makers' of Medieval Art and Architecture*, vol. I, ed. by Therese Martin (Leiden: Brill, 2012), pp. 479–521

——, ed., *Arquitectura y mujeres en la historia* (Madrid: Síntesis, 2015)

——, *Women and Architecture: Christian and Mudejar Women in Building* (Granada: Universidad, 2016) e-book (epub), <https://editorial.ugr.es/libro/women-and-architecture_132056/>

—— and María Encarnación Hernández López, 'Construyendo la ciudad: mujeres, poder y arquitectura en la Granada del siglo XVI', in *Entre la política y las artes. Señoras del poder*, ed. by Miguel Ángel Zalama (Madrid: Iberoamericana – Frankfurt: Vervuert, 2022), pp. 221–47

——, ed., *Hecha de barro y vestida de color. La cerámica arquitectónica en la Alhambra* (Granada: Patronato de la Alhambra y Generalife, 2022)

——, 'Power and Motherhood in the 16th century: Perpetuity and Memory through Architecture', *Feminismo/s*, 41 (January 2023), 75–101

Fernández de Córdova Miralles, Álvaro, *La Corte de Isabel I. Ceremonias de una reina (1474–1594)* (Madrid: Dykinson, 2002)

García Guzmán, María del Mar, 'Bienes habices de la iglesia de Santa María de la Alhambra en la primera mitad del siglo XVI' (unpublished minor thesis, University of Granada, 1979)

Hernández López, María Encarnación , 'El matronazgo y la fundación de Leonor de Herrera en Guadix en los albores del siglo XVII', *Boletín Centro de Estudios Pedro Suárez*, 31 (2018), 151–62

——, 'De piedra, harina y papel. El proyecto de Ana Gutiérrez (Motril, s. XVIII)', *Revista del Centro de Estudios Históricos de Granada y su Reino*, 32 (2020), 93–110

————, *Rescatadas del olvido. Promotoras de arquitectura en la Granada moderna* (Granada, Universidad, 2023)

Liss, Peggy K., *Isabel la Católica: su vida y su tiempo* (Madrid: Nerea, 2004, second edition)

Lollobrigida, Consuelo, *Plautilla Bricci: Pictura et Architectura Celebris. L'architettrice del Barocco Romano* (Roma: Gangemi Editores, 2017)

López Torrijos, Rosa, 'Los Bazanes de Granada y el monasterio de Sancti Spiritus', *Cuadernos de Arte*, 37 (2006), 371–83

Marconi, Nicoletta, 'Carrettiere, fornitrici e "mastre muratore" nella Fabbrica di S. Pietro e in altri cantieri dello Stato Pontificio', in *Donne a lavoro. Artiste, artigiane e operaie nel cantiere della Basilica di San Pietro in Vaticano*, ed. by Assunta Di Sante and Simona Turriziani (Foligno: Il Formichiere, 2017), pp. 21–43

————, 'Giovanna Jafrate "vetrara"', in *Donne a lavoro. Artiste, artigiane e operaie nel cantiere della Basilica di San Pietro in Vaticano*, ed. by Assunta Di Sante and Simona Turriziani (Foligno: Il Formichiere, 2017), pp. 105–19

Martínez López, Cándida and Felipe Serrano Estrella, 'Matronazgo, arquitectura y redes de poder', in *Matronazgo y arquitectura. De la Antigüedad a la Edad Moderna*, ed. by Cándida Martínez López and Felipe Serrano Estrella (Granada: Editorial Universidad de Granada, 2016), pp. 12–26

Muñoz García, María José, 'Limitaciones a la capacidad de obrar de la mujer casada en el Derecho Histórico Español. Especial referencia a las leyes 54 a 61 del ordenamiento de Toro y a su proyección', *Anuario de la Facultad de Derecho. Universidad de Extremadura*, 7 (1989), 433–56

Peinado Santaella, Rafael, *Aristócratas nazaríes y principales castellanos* (Málaga: Diputación Provincial, 2008)

Quesada Morales, Daniel, 'Infraestructuras domésticas dentro y fuera de la casa en la Granada de los siglos XV y XVI: agua, sociedad y género' (unpublished doctoral thesis, University of Granada, 2022)

Roff, Shelley E., 'Did Women Design or Build Before the Industrial Age?', in *The Routledge Companion to Women in Architecture*, ed. by Anna Sokolina (New York: Routledge, 2021), pp. 21–31

PART I

Literature and Illumination

LAURA MERCADER AMIGÓ

Escribir en la amistad femenina

La sociedad y el discurso sobre la amistad de Mary Beale

▼ **ABSTRACT** In 1667, Mary Beale, an English painter, poet, essayist, collector, and art teacher, wrote a discourse on friendship that she sent, along with a letter, to her friend Elizabeth Tillotson. The relationship between the content of the two texts and the very act of sending them serve as a starting point for interpreting Mary's treatise as a response to the conversations between the two of them about founding a society based on friendship. This hypothesis is supported by a close reading of the two sources and a feminist look at the context. By attending to some aspects of female life in seventeenth-century England: the particular vicissitudes of women's writing, sociability among women, and the framework of the literary political debate of the Friend's Quarrel, we will be able to understand the political and social context in which Mary's treatise was written.

El día 9 de marzo de 1667, Mary Cradock – Beale de casada –, pintora inglesa especializada en retratos, también poeta, coleccionista, maestra de arte y ensayista, escribe una carta, sincera y sentida, que dirige a Elizabeth (Betty) French – Tillotson de casada.[1] La carta sirve a la vez de dedicatoria y presentación de un breve e inédito discurso manuscrito sobre la amistad.[2] La carta, que es en sí misma una declaración de amor filial, convierte el *Discurso sobre la amistad* de Mary Beale en un verdadero acto de amistad femenina. La relación entre la misma carta, su contenido y el del discurso

1 En el original consta el año 1666, según el calendario juliano. Uso la reproducción de la carta publicada en Hunting, *My Dearest Heart*, p. 78.

2 Existen dos copias manuscritas del discurso, una se conserva en la British Library de Londres, Harley MS 6828, fols 510–23, y la otra en la Folger Shakespeare Library de Washington DC, MS.V.a.220. Aquí utilizo la transcripción de Hunting del manuscrito de la British Library (*My Dearest Heart*, pp. 187–99), según la cual se trata de una copia de su mano (p. 186), en cambio para Barber fue copiado por algún otro en su nombre (Barber, *Mary Beale*, p. 66).

Women in Arts, Architecture and Literature: Heritage, Legacy and Digital Perspectives, ed. by Consuelo Lollobrigida and Adelina Modesti, Women in the Arts: New Horizons, 1 (Turnhout: Brepols, 2023), pp. 67–80

BREPOLS ❦ PUBLISHERS 10.1484/M.WIA-EB.5.134643

– sobre la cual la historiografía nunca ha prestado atención más allá de su registro –,[3] permite interpretar el tratado como un proyecto compartido, en el que Mary implica a su querida amiga Betty. 'My Dear friend' ('Mi querida amiga') es la expresión que encabeza la misiva.

Mary involucra a Betty en tres sentidos. Comparte con ella sus ideas, la hace partícipe del plan de fundación de una sociedad de la amistad y, lo más importante, la hace coautora de su empresa. El tratado parece una respuesta a las conversaciones de ambas. La amistad también interesa a Betty. Lo dice la carta. Después de disculparse por la osadía de tratar tan 'divina cosa', Mary admite que: 'sin embargo, lo que me sostiene no es la convicción de vuestra aceptación, aunque con la esperanza de vuestro perdón, <sino que> es esa alta estima que estoy segura de que vos tenéis por este tema' ('Divine thing' [...] 'yet that which bears me up is not in the belief of your acceptance, yet in the hopes of your pardon, is, that high esteem which I am assured you have for this subject').[4]

No existe información alguna sobre las razones del origen del tratado, su destino o función. La respuesta de Betty no se ha conservado y no queda rastro alguno de la correspondencia de Mary.[5] Las conjeturas que propongo nacen de mi compromiso con la autoridad femenina, esa noción de autoridad vinculada a la etimología latina del verbo *augere*, que significa hacer crecer.[6] En este contexto, la autoridad femenina significa reconocer la importancia y dar sentido a las relaciones entre mujeres. También resultan de la convicción de que el patriarcado nunca ha ocupado la realidad entera de las mujeres en la historia.[7] Mi hipótesis se bifurca en dos ejes. El primero es el que se refiere a la implicación de Betty en el tratado; el segundo presupone que el tratado es un manual práctico, fruto del diálogo entre las dos, en el que Mary transcribe el deseo común de fundar una sociedad basada en la amistad.

Los argumentos que sostienen ambas teorías proceden de tres apuestas metodológicas. En primer lugar, de la aplicación de la hermenéutica feminista de la sospecha, la que advierte de no dar credibilidad plena a las fuentes masculinas cuando de mujeres se trata. Por otro lado, de la lectura pormenorizada del texto, atendiendo a los tiempos verbales o a los cambios de voz de enunciación, señales, según mi opinión, de la incursión de Betty como principal interlocutora. Por otro, de una mirada feminista sobre el contexto. Esto es, teniendo en cuenta algunos aspectos de la vida de las mujeres inglesas de la segunda mitad del siglo XVII: las vicisitudes particulares de la escritura femenina, la sociabilidad entre mujeres y el marco de los textos femeninos – tratados, novelas y poemas – que tratan la amistad en la conocida como Querella de

3 Agradezco el trabajo de todas las autoras que han estudiado la vida y la obra de Mary Beale y han rastreado las fuentes primarias, aunque en ocasiones esté en desacuerdo con ellas. Sin sus estudios, mis hipótesis no tendrían fundamento: Walsh y Jeffrey, Barber, Campbell, Gibson-Wood, Hunting, Draper, Ross, McGee. Mis referencias son ellas, aunque he comprobado las fuentes que cito a través suyo.

4 Hunting, *My Dearest Heart*, p. 78. Todas las traducciones al castellano del discurso en inglés son de Caroline Wilson. La revisión y adaptación lingüística al femenino genérico es mía.

5 Hunting admite abiertamente no saber la respuesta en *My Dearest Heart*, p. 86.

6 Muraro, 'Autoridad sin monumentos', p. 87.

7 Rivera Garretas, 'El cuerpo femenino', p. 304.

la amiga,[8] una derivación de la Querella de las mujeres que tiene lugar en las cortes europeas de los siglos XVI al XVIII, para debatir el valor de la amistad femenina, cuya capacidad es negada en los tratados masculinos occidentales sobre la amistad, tanto los antiguos como los modernos.

Amistad, ofrenda y escritura femeninas

El discurso de Mary transcribe el amor por la amistad compartido con Betty en un período de distanciamiento entre ambas. Durante su estancia en la casa de campo de Allbrook, en el condado de Hampshire, donde vive durante cinco años (1665–1669), con sus dos hijos, Bartholomew y Charles, y su marido Charles. Alejada del trajín de Londres, Mary aprovecha para reflexionar sobre la pintura y desarrollar sus dotes de escritora. De esta época también son algunos de sus poemas.[9]

Apenas se han conservado datos de la relación entre Mary y Betty. Esta carta es su único testimonio fehaciente. Puede que se conozcan en Londres, en el estudio de Hind Court, en 1664, cuando Mary retrata por primera vez al marido de Elizabeth, John Tillotson. Aunque puede que a John lo conozca en 1661.[10] Desde la primera sesión de posado, Elizabeth y John pasan a formar parte del círculo íntimo de amigos de Mary y Charles, en cuyo salón doméstico se cena, se leen la Biblia y los clásicos y se cantan salmos.[11] Mary pinta cuatro veces más a John en su taller de Pall Mal (1672, 1677, 1681 y 1687). A Betty y a su única hija Elizabeth solo las retrata en 1681, se desconoce el paradero de estos cuadros.[12]

La carta de Mary abre un escenario de relación entre las dos mujeres. Es ofrenda en sí misma y anunciación de otra, el *Discurso*. Las cartas pueden acompañar un regalo o publicitarlo, es una de las funciones que asumen en el tejido de relaciones de la sociedad inglesa de la época. La economía relacional de la Inglaterra del siglo XVII todavía mantiene la cultura del don, a pesar de la introducción cada vez con más fuerza del intercambio mercantil.[13] La práctica del don, en cuyo seno se encuentra la correspondencia íntima, conecta directamente con el ejercicio de la amistad. Según Draper, Mary, con la ayuda de Charles, crea alrededor de sus diferentes casas taller de Londres un espacio relacional de promoción artística, patrocinio y sociabilidad cargado de afectos, regalos literarios, pictóricos y amistad.[14] Han quedado algunos testimonios de ello. El poema de Woodford, 'To Belisa', en el que describe el autorretrato desaparecido de Mary como Pallas Atenea, es un gesto de agradecimiento al apoyo prestado tras la muerte de Alice.[15] El poema que Mary envía a Thomas Flatman

8 La expresión es de Bock en *La mujer en la historia de Europa*, p. 19.

9 Cuatro se publican en el libro de Woodford, *Paraphrase upon the Psalms*, 13, 52, 70 y 130.

10 Walsh y Jeffree, *The Excellent Mrs Mary Beale*, p. 12; Hunting, *My Dearest Heart*, pp. 70 y 72.

11 Hunting, *My Dearest Heart*, pp. 65–77; Ross, *Birth of Feminism*, pp. 261–72.

12 Hunting, *My Dearest Heart*, pp. 73, 186; Barber, *Mary Beale*, cat. n° 13, p. 66.

13 Brown, *Friendship and its Discourses in the Seventeenth Century*, pp. 1–2.

14 Draper, *Mary Beale (1633–1699)*, capítulos III y IV.

15 Draper, *Mary Beale (1633–1699)*, pp. 101–02.

en 1666, su maestro en el arte la miniatura y que él le devuelve con un autorretrato, junto a una carta de elogio del poema.[16] Durante sus primeros años en Londres, en Covent Garden o Hind Court, Mary regala muchos de sus retratos.

Draper insiste en la relación entre la práctica del regalo en el círculo de Mary, la amistad y la creación de una red de patrocinio y comisiones para su negocio pictórico. Tanto ella como Hunting atribuyen a este entorno de cohabitación el sentido de la amistad que se expone en el tratado.[17] No niego que la relación con la clientela masculina, no muy poderosa, pero con contactos en el poder, tenga esta función. Tampoco contradigo la idea de que sea en su salón doméstico mixto donde madure el concepto de amistad, sin embargo, no considero una casualidad que la destinataria del discurso sea una mujer. No se puede descuidar la importancia de la sociabilidad femenina en la vida de las mujeres de la Europa moderna; tampoco el horizonte simbólico en el que se ubican las relaciones femeninas sin la mediación masculina.

Mary define la amistad como una 'llama generosa' que no entiende de intereses sino de apertura a lo otro. A diferencia de la tratadística masculina clásica y moderna, no cree que la amistad se funde en la semejanza de las almas sino en su disparidad. La concibe como apertura a lo otro, una otredad nada abstracta. En el tratado afirma que los consejos en lugar de recetas establecidas deben ser sugerencias que se adapten a la condición de cada cual.

La amistad de Mary obedece al régimen del dos, al igual que la economía del don, a la que incluye y ejemplifica la carta a Betty junto al tratado. Genevieve Vaughan recuerda que la economía del don, a diferencia del intercambio, es la que tiene en cuenta la necesidad ajena.[18] El don da existencia a la otra al reconocerla en la carencia. La raíz de la economía del don está en el simbólico de la madre. Las madres dan alimento, cuidados y palabras solo esperando el bienestar de la criatura. El placer de la madre no termina en sí misma sino en relación con la criatura.

La carta de Mary a Betty responde a otras particularidades de la vida femenina inglesa de la época. La circulación de los textos entre amistades es una práctica habitual que tiene la función de comprobar la idoneidad de estos, tanto para ser impresos como para ser mostrados fuera del ámbito familiar o íntimo. En 1667, año del discurso, la impresión aún no se ha convertido en signo de calidad o éxito.[19] Que muchos de los escritos de las mujeres hayan quedado en versión manuscrita no significa que no tengan un público lector. Existen tres formas femeninas de producción de manuscritos: la composición de libros, la circulación de hojas sueltas o la inclusión de escritos en la correspondencia.[20]

El discurso de Mary se adecua a la última modalidad, al igual que cumple al detalle las normas patriarcales del buen comportamiento femenino. El decoro impuesto por los hombres prohíbe la inclusión del nombre en un texto con vocación pública. Las estrategias de las mujeres para esquivarlo son hasta jocosas. Mary emplea una

16 Hunting, *My Dearest Heart*, p. 96; Draper, *Mary Beale (1633–1699)*, p. 99.
17 Hunting, *My Dearest Heart*, p. 86; Draper, *Mary Beale (1633–1699)*, p. 32.
18 Vaughan, *Per-donare*, pp. 25–39.
19 Ostovich y Sauer, *Reading Early Modern Women*, p. 3.
20 Ostovich y Sauer, *Reading Early Modern Women*, p. 7.

de las más recurrentes: acompañar las obras de comentarios negativos sobre sus destrezas, con disculpas a su incompetencia o a la pobreza del contenido. También en este sentido la carta de Mary es un auténtico acto de la política sexual de la era moderna europea. Las primeras palabras apelan a la vergüenza de haberle enviado su 'muy imperfecto borrador acerca de esa belleza inmortal de la Amistad' para, acto seguido, proponer que la misma Betty defina su discurso como una muestra de sus inaptitudes: 'pensé que podrías llamar a estas concepciones mías más bien el Retrato de mis propias incapacidades' (my very imperfect draft after that immortal Beauty Friendship [...] So thought you may call these my conceptions rather the Portraiture of my own inabilities).[21] Mary desea ser leída por Betty, lo otro – las normas patriarcales de conducta – es mera estratagema.

Ambas son mujeres cultas, procedentes de familias adineradas, vinculadas a la iglesia anglicana, con una buena educación. Sus padres y madres se aseguran de que reciban una formación humanista como sus hermanos. Mary aprende latín, griego y hebreo de su padre John Cradock, reverendo de la iglesia de Barrow, su pueblo natal, y aficionado a la pintura. Nada se sabe de la aportación de su madre Dorothy Brunton o Brinton – muerta a los 10 u 11 años de Mary –, aparte de enseñarle a hablar y escribir inglés. Elizabeth, por su parte, es hija de Peter French, un teólogo de Oxford, y de Robina Cromwell, hermana menor de Oliver Cromwell. Tras la prematura muerte de Peter, Robina se casa con el religioso y naturalista John Wilkins, quien oficia la boda de Betty.[22]

La sociabilidad femenina y la Sociedad de la amistad

Ambas amigas comparten, además, una predisposición a favorecer a otras mujeres. Los pocos datos registrados sobre sus relaciones femeninas son elocuentes al respecto. Gracias al libro de notas de Charles, se sabe que por su taller de Pall Mal pasaron al menos dos alumnas y una modelo. En 1681 consigna la presencia de una tal Kate Trioche como aprendiz, cuya hermana, Molly, ejerce de modelo. En 1691 entra en el estudio la joven Sarah Curtis – Hoadlay de casada –, futura retratista en Covent Garden.[23] De Elizabeth se tienen menos noticias. Asume un papel principal en la gestión del patrimonio material y literario de su marido, tras la muerte de este en 1694. Su nombre aparece en una de las portadas del libro de los sermones de John (*Of Sincerity and Constancy in the Faith: In Several Sermons by the Most Reverend Dr John Tillotson, Late Lord Arch-Bishop of Canterbury* (Londres: Richard Chiswell, 1695), de cuya recopilación y supervisión se encarga personalmente.[24] Consta asimismo que quiere que sea su nieta, en lugar de los nietos, la destinataria del legado literario del abuelo.[25]

21 Hunting, *My Dearest Heart*, p. 78.
22 Toda la información sobre la vida de Elizabeth procede de Ross, *Birth of Feminism*, p. 270.
23 Hunting, *My Dearest Heart*, p. 147.
24 Ross, *Birth of Feminism*, p. 270.
25 Ross, *Birth of Feminism*, p. 270.

La sociabilidad femenina es una realidad de la vida de las mujeres que cuesta rastrear cuando son los maridos o los amigos los que inventarían los datos de sus vidas. Si bien Mary Beale es una de las pintoras inglesas mejor documentadas del XVII,[26] solo se conoce su vida por el testimonio de ellos: por el libro de notas y diario de Charles, las cartas de sus amigos dirigidas a él, y los libros de algunos autores de la época.[27] En estos documentos no aparecen las relaciones femeninas, las preocupaciones, pensamientos o deseos de Mary, solo su red de patronos y amigos – no amigas –, las visitas que recibe o su papel de anfitriona. En sus notas, Charles no se centra en Mary sino en sus amigos, clientes y referentes artísticos masculinos. Apenas habla de su carácter, experiencia o sentir, solo de sus transacciones pictóricas y económicas.

Las cartas que se conservan del período de Allbrook son las que Charles recibe de sus amigos de Londres, Thomas Flatman, Francis Knollys y John Cooke.[28] Ellos la recuerdan, preguntan por su salud,[29] pero no por sus proyectos. Guardan silencio en torno al discurso sobre la amistad, compuesto en esa época, o a su obra pictórica. Aunque la tienen en alta estima, la definen en relación con lo que hace para o con ellos. En una carta, Flatman la nombra como 'My incompareble scholar' ('Mi alumna incomparable').[30] La sociabilidad y la cultura femeninas no tienen espacio simbólico en los escritos de los hombres. Las biógrafas y especialistas contemporáneas siguen esta tradición sin más.[31]

No es difícil imaginar a Mary en un contexto relacional femenino. Durante su infancia y juventud en Barrow, seguro que se relaciona con las mujeres de la familia paterna – de la materna no se conocen nombres –, como Emme Cradock, prima de su abuelo Richard Cradock,[32] o sus tías Priscilla, Mary y Abigail, las cuales deben ejercer un importante papel al morir su madre; o con su prima segunda Elizabeth Cradock Finch o la otra prima Dorothy, Cradock por matrimonio.[33] En los primeros años de casada con Charles, entre 1852 – fecha de la boda – hasta 1655–1656, Mary comparte casa con todas las mujeres de su familia nuclear en el pueblo de Walton: su suegra Katherine Beale y sus cuñadas, Margaret y Katherine y Elizabeth Beale, esposa del hermano Bartholomew.[34]

Al poco de la muerte de su primer hijo Bartholomew y dadas las escasas oportunidades de trabajo en Walton, Mary y Charles se trasladan a Londres a finales de 1655, a Covent Garden. En la ciudad la familia consanguínea se amplía gracias a las amistades elegidas.[35] En la década de 1660, convive con Alice Woodford (1661–

26 Barber, *Mary Beale*, p. 11.

27 Véase, por ejemplo: Sanderson, *Graphice* o Woodford, *The Diary of Samuel Woodford*.

28 Hunting, *My Dearest Heart*, pp. 87–97.

29 Hunting, *My Dearest Heart*, p. 90.

30 Hunting, *My Dearest Heart*, p. 91.

31 Walsh y Jeffrey, *The Excellent Mrs Mary Beale*; Barber, *Mary Beale*; Renaud, *Mary Beale (1633–1699)*; Draper, *Mary Beale (1633–1699)*; Hunting, *My Dearest Heart*, o McGee, *Constructing Images*.

32 Draper, *Mary Beale (1633–1699)*, p. 25.

33 Draper, *Mary Beale (1633–1699)*, p. 48.

34 Hunting, *My Dearest Heart*, p. 25.

35 Hunting, *My Dearest Heart*, pp. 43–77.

1664) y sigue frecuentando a sus cuñadas, Elizabeth y Katherine.[36] A este grupo se suman las esposas de sus clientes, la misma Betty y Andrea Dobyns, casada con Edward Stillingfleet. En diciembre de 1664, Woodford anota en su diario la felicidad que reina en los encuentros vespertinos del salón de Mary junto a estas parejas.[37]

Si en algún contexto vital se puede enmarcar el discurso de Mary creo que es en este complejo de relaciones que entabla con las mujeres de su entorno, no en el de la narrativa de su marido y sus amigos. No es un azar que, de los dos manuscritos, uno sea para una mujer.[38] El silencio de Woodford, con el que convivió en Allbrook durante el período de redacción del tratado,[39] no puede ser un descuido, tampoco el de Charles.

Es Betty la que estimula la escritura del tratado porque es con ella con la que, según se deduce del discurso, ha hablado sobre la posible creación de una sociedad basada en la amistad. La mención en el texto de una sociedad, de cuya existencia no hay más rastros, provoca una disrupción en la lectura. Con ella se abre la posibilidad de pensar que el tratado tiene como objetivo dar cobertura conceptual a su fundación. El hecho de que tenga un formato de manual práctico, como el de Plutarco, arroja más luz a esta hipótesis.

En tres ocasiones se refiere a una sociedad de la amistad. La primera vez aparece en un párrafo independiente, sin previo aviso y sin marco para ser interpretada fuera del texto. Mary cita una sociedad restringida, cuya admisión se somete al cumplimiento de las condiciones de la verdadera amistad:

> Otra atención de aquellas que quieran ser admitidas miembros de esta Sociedad, debe ser una seria investigación sobre la naturaleza de esta, qué es y en qué consiste la Amistad, a menos que por ignorancia de ella den este nombre sagrado a aquello que la verdadera Amistad más aborrece; Adulación y disimulo que no es más que una especie de Amistad fingida.
>
> > (Another care of those who would be admitted members of this Society, ought to be a sober inquiry into the nature of it, what it is, & wherein Friendship consists, least through ignorance thereof they give this sacred name to that which true Friendship most of all abhors; Flattery & dissimulation which is but a kind of mock Friendship.)[40]

El uso de la expresión 'otra atención', al inicio, indica la alusión anterior a otro requisito, de modo que la voz narrativa se abre a la complicidad de su interlocutora, posiblemente informada sobre este propósito. Las únicas palabras anteriores que pueden dar sentido a esta locución y a la referencia implícita a una sociedad son las

36 Draper, *Mary Beale (1633–1699)*, p. 32.

37 Hunting, *My Dearest Heart*, p. 73.

38 El manuscrito conservado en Washington, DC puede que se quedara con los Beale, Barber, *Mary Beale*, n. 2, p. 40.

39 Hunting, *My Dearest Heart*, p. 90.

40 Hunting, *My Dearest Heart*, p. 190.

que traen a colación la necesidad de que la amistad se base en un sistema de reglas o leyes para evitar vicios y ferocidades.

Unas líneas más abajo vuelve sobre ello, en este caso incluyendo otra disposición para su acceso, la capacidad de adaptación a los problemas ajenos: '[…] esa persona que no esté dispuesta a compartir con su amiga todas las condiciones y bajones en todos los tiempos, es indigna de ser aceptada en esta sociedad, y honrada con un título tan ilustre' ([…] that person who is not willing to share with his friend in all conditions & lows not at all times, is unworthy to be admitted into this society, & to be honoured with so illustrious a title).[41] La última mención se da casi al final del discurso. Mary confiesa la alegría que le genera la fundación de una sociedad de la amistad. Cree firmemente en la función social de esta alianza amorosa y en la multiplicación de sus virtudes si se pone en sociedad:

> la amistad real, como es la mayor promotora de virtud en quienes la siguen, también es un motivo potente para persuadir a otras por el amor a ella. Porque, aunque la virtud puede ser admirada por algunas cuando encontrada en una persona singular, no obstante, se hace más espléndida cuando se une en una excelente y numerosa Sociedad de amigas donde sus varias virtudes constituyen un perfecto concierto y generan en otras una admiración, sino un deseo, de una alianza tan noble.

> > (Now real friendship as it is the greatest promote of vertue in its followers, so it is a powerful motive to persuade others for ye love of it. For though vertue may be admired by some when found in a single person, yet it becomes more splendid when united in an excellent and numerous Society of friends, where their several vertues make up one perfect concert and beget in others an admiration if not a desire, of so noble an alliance.)[42]

Según Barber y Renaud la sociedad referenciada es la Royal Society de Londres, fundada en 1662, muchos de cuyos miembros son clientes suyos y amigos de Charles y su primo John Beale.[43] El diplomático William Godolphin, por ejemplo, le encarga su retrato en 1664 para celebrar su entrada en la Royal Society. John Wilkins, su primer secretario, es el segundo marido de la madre de Betty. Las memorias de Woodford comparan las conversaciones del salón de Mary con las de la Royal Society.[44] Este símil habla de la profundidad de las discusiones que tenían lugar allí, pero no dice toda la verdad. La sociedad científica londinense prohíbe las mujeres. En mi opinión, Mary no alude a la Royal Society, creada en el modelo de las academias italianas de ciencias y artes, en cuyo seno se dibuja un nuevo perfil de masculinidad intelectual misógina, eminentemente anti materna,[45] basada en alianzas sólo de hombres para hombres.[46]

41 Hunting, *My Dearest Heart*, p. 191.
42 Hunting, *My Dearest Heart*, p. 198.
43 Barber, *Mary Beale*, p. 26; Renaud, *Mary Beale (1633–1699)*, p. 89.
44 Hunting, *My Dearest Heart*, p. 86.
45 Fox Keller, *Reflexiones sobre género y ciencia*, p. 46.
46 Rivera Garretas, *La diferencia sexual en la historia*, pp. 142–49.

En la sociedad de Mary y Betty, mujeres y hombres intercambian palabras, escritos y lecturas.

Su modelo de sociedad está más cerca de los círculos femeninos nacidos en las cortes europeas de los siglos XVI y XVII, el más próximo de los cuales es el de la poeta Katherine Philips, activo en Londres entre 1651 y 1661.[47] La Sociedad de la Amistad de Katherine es un cenáculo literario mixto, concebido a imagen y semejanza del círculo parisino de las Preciosas, introducido en la corte inglesa por Enriqueta María de Francia y su amiga filósofa Margaret Cavendish. Es probable que Mary conociera la Katherine Society por su prima segunda, la filósofa Anne Finch Conway, emparentada con Francis Finch, uno de sus socios, y autor de un tratado sobre la amistad.[48] La sociedad de Mary y Betty sigue este modelo, pero se distingue por su carácter eminentemente cristiano. Está basada en principios religiosos más que filosóficos, aunque guiados por la razón. Según Hunting se trata del primer discurso femenino sobre la amistad del entorno de la iglesia latitudinaria.[49]

La amistad según Mary Beale y la Querella de la amiga

Si el contexto vital del relato de los hombres no sirve para interpretar el tratado, tampoco vale en su totalidad el medio literario masculino de la tratadística clásica y cristiana sobre la amistad (Platón, Aristóteles, Cicerón, Plutarco, la Biblia o Santo Tomás) o el de los discursos de sus contemporáneos modernos (Montaigne, Bacon, Breme, Rogers o Taylor), aunque parece que Mary los ha leído a casi todos, ya que su tratado recoge muchas de sus ideas.[50] Menciona explícitamente a Sócrates, Platón y Plutarco. Aristóteles está detrás de la idea de virtud y felicidad ligada a la amistad y Cicerón de los principios de armonía doméstica que conlleva. En el discurso Mary también muestra conocer la filosofía moral clásica masculina y estar al corriente de los debates salvíficos de la iglesia latitudinaria, uno de cuyos representantes contemporáneos es el marido de Betty, John Tillotson.[51] El mundo literario masculino, en el que también se encuentran los tratados sobre el matrimonio que lo vinculan con la amistad – como los de Juan Luis Vives o Erasmus –, han servido a las especialistas en Mary Beale para dar autoridad histórica e importancia a su tratado.

Pero si se desplaza el foco de la tradición masculina a la genealogía literaria femenina, el discurso de Mary conecta con otro corpus literario. Un conjunto de textos femeninos, entre tratados, novelas, obras de teatro o poemas, en el que la amistad se convierte en uno de los asuntos clave de la política sexual de los siglos XVI al XVIII en Europa, al poner en discusión, desde posiciones distintas, tres argumentos: la capacidad de amistad de las mujeres, el valor de la amistad femenina y la posibilidad de amistad dentro y fuera del matrimonio. La disparidad de opiniones

47 Draper relaciona los dos cenáculos sin prestar atención a la amistad, *Mary Beale (1633–1699)*, p. 138.

48 Anderson, *Friendship's Shadows*, pp. 153–88.

49 Hunting, *My Dearest Heart*, p. 86.

50 Barber, *Mary Beale*, p. 27; Renaud, *Mary Beale (1633–1699)*, p. 88; Hunting, *My Dearest Heart*, p. 87.

51 Barber, *Mary Beale*, pp. 23–26.

entre las mismas mujeres es un signo de riqueza conceptual y de independencia simbólica. Algunas no creen que los hombres sean capaces de amistad (Moderata Fonte). Las misóganas convencidas solo ven posible la amistad fuera del matrimonio (Madeleine de Souvré, Madeleine de Scudéry o Mary Astell). Otras, instan a los maridos a hacer de amigos (Margaret Cavendish o Lucy Hutchinson). Según Snyder, las autoras francesas creen firmemente que la amistad entre hombres y mujeres puede influir positivamente en la concepción masculina de las mujeres y en las relaciones entre ellos.[52] El discurso de Mary aborda las tres vías del debate de la querella, aunque solo atiende al último. Los dos primeros los pone en acto con su gesto de mandar el manuscrito a Betty junto con la carta de anunciación.

Esta controversia político-literaria de la Europa moderna nace el siglo anterior en la corte humanista de Margarita de Angulema a raíz de la publicación de *L'Amie de Court* de Bertrand de La Borderie en 1542, en el que se describen con cinismo las actitudes superficiales de las mujeres en la corte. La reina de Navarra, Margarita, inaugura la reacción femenina anti misógina en el mismo año con la obra de teatro *La comédie de quatre femmes* y en 1547 con su largo poema *La Coche*, en los que celebra la amistad femenina.[53]

Mary entiende la amistad como una virtud basada en el amor ajeno, sin olvidar el propio, fundada en la confianza, la ejemplaridad, la sinceridad, la emulación y la disparidad. La define como una experiencia esencial en la vida humana, comparándola con la altura de Dios, bajo la denominación de 'relación divina'. En este punto, Barber señala que Mary aplica la moral ligada a la iglesia latitudinaria de la que eran miembros sus amigos Tillotson, Stillingfleet y Taylor.[54] Muchas ideas del tratado de Jeremy Taylor, *Discourse of the Nature Offices and Measures of Friendship* (1657), Mary las adopta y adapta en su discurso. También considera que la amistad es la unión entre dos almas y el gran vínculo en el mundo. En el contexto cristiano, muchos moralistas temen que la amistad entre los hombres limite la relación con Dios. Taylor lo resuelve atribuyendo a la amistad un reflejo divino y fomentando la responsabilidad cristiana de crear tantas amistades como sea posible.[55] El tratado de Mary y su proyecto societario responden a esta llamada.

Taylor, sin embargo, solo reconoce la capacidad de amistad de las mujeres dentro del matrimonio y en relación con las actividades domésticas. A partir del siglo XVI, la tratadística masculina patriarcal convierte la relación entre amistad y matrimonio en una estrategia clave de renovación del contrato sexual, la sustitución del poder del padre por el del marido, cuyo modelo en lugar de la monarquía autoritaria es la república civil.[56]

52 Snyder, 'L'amitié femme-homme entre 1600 et 1750', p. 107.

53 No existe bibliografía sobre el fenómeno de la Querella de la amiga desde la versión de las mujeres, a parte de los estudios particulares sobre las autoras que participaron en el debate. Un estudio clásico sobre la literatura masculina es el de Screech, 'An interpretation'.

54 Barber, *Mary Beale*, pp. 23–31.

55 Barber, *Mary Beale*, pp. 23–31.

56 Bock, *La mujer en la historia de Europa*, pp. 40–45.

Mary, dueña de su propia economía a través de su trabajo pictórico conoce las consecuencias que acarrea para las mujeres interpretar el matrimonio como un contrato amistoso. Contesta a Taylor y a todos su seguidores con la vida, la escritura y la pintura.[57] El discurso sobre la amistad se abre, significativamente, con la advertencia de la complementariedad de los sexos a través de una relectura del libro del Génesis:

> La amistad es la unión más estrecha de que son capaces las Almas distintas […], el hombre no parece hecho para nada más. Porque cuando Dios lo hubo creado en el primer momento, no está bien que haya dicho, que el Hombre debe estar solo, entonces le dio a Eva, para que fuera un encuentro de ayuda […]. Una esposa y una amiga, pero no una esclava.
>
> > (Friendship is the nearest union which distinct Souls are capable of […] man seems to be made for nothing more. For when God had at first created him, it is not fit said he, that Man should be alone, so then he gave him Eve, to be a met help […] A wife and friend but not a slave.)[58]

Si el tratado vincula a Mary con la Querelle de la amiga, este párrafo la conecta con la Querella de las mujeres. Muchas escritoras de la Querella – Christine de Pizan, Marie de Gournay o Lucy Hutchinson – se esfuerzan por encontrar argumentos que liberen a Eva de la condena masculina, sea del mal o la servidumbre.

En el siglo XVII muchas mujeres se apropian del concepto de amistad. Reformulan la amistad femenina antes de que los principios universales de la filosofía moral kantiana y la sentimentalidad de Rousseau la transformen, sobre todo la amistad femenina, en algo íntimo, sentimental, doméstico, desconectado de la vida política. Anderson afirma que este cambio se produjo tras la inclusión de las mujeres en el debate sobre la naturaleza de la amistad. Antes de fines del siglo XVII, la amistad era masculina, ética y pública; a partir del siglo XVIII se vuelve femenina, insignificante y reservada.[59] La sociedad de la amistad imaginada por Mary y Betty y el discurso de Mary marcan los límites de esta transformación. Para ambas la amistad es un lazo sagrado que sirve para mantener la vida política en armonía.

57 Sobre la pintura ver, Mercader, 'Custodiar la soberanía de la generación'.
58 Hunting, *My Dearest Heart*, p. 187.
59 Anderson, *Friendship's Shadows*, p. 2.

Bibliografía

Fuentes primarias

Taylor, Jeremy, *Discourse of the Nature Offices and Measures of Friendship* (Londres: R. Royston, 1657)

Sanderson, William, *Graphice, The Use of The Pen and Pensil, or, The Most Excellent Art of Painting: in Two Parts* (Londres: Robert Crofts, 1658)

Woodford, Samuel, 'To Belisa', en *A Paraphrase Upon the Canticles, and Some Select Hymns of the New and Old Testament, With Other Occasional Compositions in English Verse* (Londres: John Baker & Henry Brome, 1679), pp. 162–63

Fuentes secundarias

Anderson, Penelope, *Friendship's Shadows: Women's Friendship and the Politics of Betrayal in England, 1640–1705* (Edinburgh: Edinburgh University Press, 2012)

Barber, Tabitha, *Mary Beale: Portrait of a Seventeenth-Century Painter Her Family and Her Studio* (Londres: Geffrye Museum, 1999)

Bock, Gisela, *La mujer en la historia de Europa. De la Edad Media a nuestros días* (Barcelona: Crítica, 2001)

Brown, Cedric C., *Friendship and Its Discourses in the Seventeenth Century* (Oxford: Oxford University Press, 2016)

Draper, Helen, 'Mary Beale (1633–1699) and her "paynting oome" in Restoration London' (tesis doctoral, University of London, 2020)

Fox Keller, Evelyn, *Reflexiones sobre género y ciencia* (Valencia: Alfons el Magnànim. Institució Valenciana d'Estudis i Investigació, 1991)

Hunting, Penelope, *My Dearest Heart. The Artist Mary Beale (1633–1699)* (Londres: Unicorn, 2019)

McGee, Jessica, 'Constructing Images: The Significance of Mary Beale (1633–1699)' (tesis de máster, Binghamton University, 2020)

Mercader Amigó, Laura, 'Custodiar la soberanía de la generación femenina. Meditaciones sobre los autorretratos maternos de Mary Beale', en *Ser madre es un placer. Historias de libertad femenina en Europa*, ed. de Laura Mercader Amigó (Barcelona: Icaria, 2021), pp. 71–105

Miller, Naomi J. y Naomi Yavneh, eds, *Maternal Measures. Figuring Caregiving in the Early Modern Period* (Nueva York: Routledge, 2019)

Muraro, Luisa, 'Autoridad sin monumentos', *Duoda. Revista de estudios feministas*, 7 (1994), 86–100

Ostovich, Helen y Elizabeth Sauer, eds, *Reading Early Modern Women: An Anthology of Texts in Manuscript and Print, 1550–1700* (Londres: Routledge, 2004)

Renaud, Emma, *Mary Beale (1633–1699). Première femme peintre professionnelle en Grande-Bretagne* (París: L'Harmattan, 2010)

Rivera Garretas, María-Milagros, *La diferencia sexual en la historia* (Valencia: Universitat de València, 2005)

———, 'El cuerpo femenino: genealogías de libertad', en *Desvelando El cuerpo. Perspectivas desde las ciencias sociales y humanas*, ed. de Josep Martí i Pérez y Yolanda Aixelà Cabré (Madrid: CSIC, 2010), pp. 301–16

Ross, Sarah Gwyneth, *Birth of Feminism: Woman as Intellect in Renaissance Italy and England* (Cambridge: Harvard University Press, 2009)

Screech, Michael Andrew, 'An Interpretation of the Querelle des Amyes', *Bibliothèque d'Humanisme et Renaissance*, 21.1 (1959), 103–30

Synder, Patrick, 'L'amitié femme-homme entre 1600 et 1750: dénonciation de l'inégalité et dialogue égalitaire', en *Revisiter La 'Querelle des Femmes': Discours Sur L'égalité*, ed. de Danielle Haase-Dubosc y Marie-Elisabeth Henneau (Saint-Étienne: Publications de l'Université de Saint-Étienne, 2013), pp. 107–37

Vaughan, Genevieve, *Per-donare. Una critica femminista dello scambio* (Roma: Meltemi, 2005)

Walsh, Elizabeth y Richard Jeffree, *The Excellent Mrs Mary Beale* (Londres: Inner London Education Authority, 1975)

SILVIA S. G. PALANDRI

L'educazione femminile nelle opere della Marchesa Colombi

▼ **ABSTRACT** This study aims to analyze the literary works of Marchesa Colombi, a late nineteenth-century Italian journalist and fiction writer. This chapter will focus on analysing some of her best-known works, including the popular education essay *Gente per bene* or *A Marriage in the Province*, as well as other documents produced by her reforming action towards education such as newspaper articles, stories and less famous novels. The aim is to determine how literary aspects, including the presence of famous books and titles in her writing, form the basis of female education, which was essential to the emancipation of women in the late nineteenth century.

Subito dopo l'Unità d'Italia ci si trovò di fronte alla necessità di creare anche un popolo. Nel periodo postunitario infatti molti aspetti, anche della vita quotidiana, vengono ripensati con la finalità di creare un nuovo immaginario collettivo che però fu dimentico della preziosa compresenza e partecipazione femminile alla causa unitaria.

Le italiane difatti furono ben presenti ed attive anche in questa fase embrionale e tra queste Maria Antonietta Torriani che nell'Italia appena nata volle partecipare attivamente all'iniziativa di creare una identità comune differente, una cultura che includesse le donne. Tentò di sfruttare la nascente situazione per migliorare la condizione femminile, quella condizione che conosceva bene, che viveva e osservava e che altrettanto bene sapeva trascrivere nei suoi libri. E se ne accorse anche Italo Calvino che nel 1973 volle proporre, per Einaudi, *Un matrimonio in provincia*, opera che la consacra tra le grandi firme dell'Ottocento anche se rimarrà nell'ombra nonostante la prefazione di Natalia Ginzburg, presente nell'edizione 'calviniana', che le riconoscerà uno stile suo, nuovo, diverso da tutte le altre e gli altri, senza che ciò tuttavia le potrà garantire quel giusto lustro al pari dei grandi scrittori del suo periodo.

Di lei Natalia Ginzburg scrive:

Vidi però che i personaggi qui non si potevano dire buoni o cattivi ma veniva usato per portarli avanti un sistema diverso e nuovo per me. Ciò che trovavo strano qui,

era un modo di presentare le persone e i fatti senza colorarli di rosa né sollevarli in una sfera nobile, un modo ruvido, allegro e sbadato a cui non ero abituata nei libri.[1]

Lo stesso Calvino scriverà:

Dalle prime pagine si riconosce una voce di scrittrice che sa farsi ascoltare qualsiasi cosa racconti, perché è il suo modo di raccontare che prende, il suo piglio dimesso ma sempre concreto e corposo, con un fondo di sottile ironia.[2]

Proprio nel romanzo *Un matrimonio in provincia* si ritrova descritto quello che per l'autrice è il mezzo d'istruzione eletto per l'educazione femminile: la letteratura. La sorella della protagonista, Titina, a proposito delle loro cugine che frequentano un collegio e che riescono a tenere conversazione e a partecipare delle citazioni letterarie che il loro padre fa per intrattenerle, dice: 'E quelle ragazze ridevano, capivano, suggerivano e sapevano anche loro i nomi degli eroi di quei poemi del babbo, come se fossero stati dei loro amici. La Titina diceva: "E' perché loro hanno già fatta la loro educazione letteraria"'.[3]

Di contro, proprio per sottolineare la realtà più comune e meno ridente che toccava alla maggioranza delle donne nello stesso romanzo le protagoniste non verranno mai avviate agli studi se non con qualche rudimento basico dello scrivere e del leggere, anzi dopo il secondo matrimonio del padre, la matrigna ben contenta di essersi riuscita a maritare seppur in tarda età, tronfia del suo agognato traguardo redarguisce padre e figlie a proseguire poiché le ragazze dovevano piuttosto imparare i mestieri di casa per poter trovare un buon marito, come lei era riuscita a fare.

Ancora in *Un matrimonio in provincia*, Denza, la protagonista, vorrebbe leggere un romanzo ma sa già che non potrà averne il permesso dal padre e abbandona anche solo l'idea di poterglielo chiedere:

Quello che allora desideravo ardentemente era di leggere 'I tre Moschettieri' [...] Ma questa gioia non l'ottenni. La Maria voleva prestarmi il romanzo, ma la Giuseppina si oppose formalmente. Sapeva che il babbo era molto rigido in fatto di letture, e non voleva assolutamente né per se né per sua sorella la responsabilità di farmi leggere un romanzo di nascosto e mi disse: 'Domanda al tuo babbo, e se lui lo permette...' Figurarsi se osavo domandarglielo! E se lui l'avrebbe permesso![4]

Ecco quindi proprio Denza ad un certo punto del romanzo essere presentata come 'vana' e non frivola o vanitosa come comunemente verrebbe da pensare ma proprio 'vana' con il significato precipuo di vuota, un'identità cioè senza aspettative né ideali propri di una sfera intima e personale, una mancanza di maturità interiore

1 Marchesa Colombi, *Un Matrimonio in provincia*, p. v.
2 Marchesa Colombi, *Un Matrimonio in provincia*.
3 Marchesa Colombi, *Un Matrimonio in provincia*, p. 5.
4 Marchesa Colombi, *Un Matrimonio in provincia*, p. 27.

che Torriani fa risalire proprio alla mancanza di istruzione della protagonista.[5] Una protagonista quindi incapace di interpretare il mondo, la realtà che la circonda per la mancanza di uno strumento fondamentale per costruirsi una propria identità, un'istruzione adeguata che vada ben oltre il saper far di conto.

Ritroviamo nelle sue opere tutto il realismo di una società lontana da quella che vorrebbe instillare nel popolo italiano e che analizza nelle vicissitudini sociali, cogliendo l'occasione per descrivere la condizione delle donne nelle sue varie forme, come quella in campo lavorativo, della figura professionale tipica del tempo: la mondina, nell'opera *In Risaia* del 1877 o dell'operaia delle fabbriche tessili dove il rumore continuo e penetrante ha reso inebetita l'Amata, rinominata dai contadini dove vive La Matta, nel romanzo *Il tramonto di un ideale* del 1882.

I racconti della Marchesa Colombi sono volti a mettere in guardia le donne dalle illusioni derivanti dalle aspettative sociali, prettamente quelle di moglie e madre, a cui sono sottoposte e a cui è facile cedere, sempre Denza in *Un matrimonio in provincia* ad esempio si trova ad ammettere 'Dacché sapevo che questo piaceva a lui, dimenticavo tutte le mie lagnanze passate per le abitudini patriarcali della nostra casa, e mi pareva d'aver scelto io stessa quel genere di vita, e d'amarlo'.[6]

Ma Maria Antonietta Torriani è anche divulgatrice di nuovi modelli sociali, si propone infatti nella neo-Italia come un'educatrice di costumi, si veda *La Gente per bene: leggi di convenienza sociale*[7] del 1877, un codice di bon-ton per la nascente classe media italiana.

La non attualità del manuale cinquecentesco di buone maniere per eccellenza, quello di Della Casa, faceva nascere infatti il bisogno di un'altra opera più consona alla società nascente e di qui l'esigenza soddisfatta dall'opera di Torriani che ne esalta la contemporaneità e la sua attualità. E lo fa sempre e comunque con il suo stile, asciutto, preciso e sempre velato di una forte ironia, eccola lodare l'intelligenza e le capacità delle donne nell'istruzione e partecipazione a ciò che compone il mondo:

> A' miei tempi – tempi delle vecchie mamme, delle nonne, bisnonne, le donne non ricevevano l'istruzione che si dà ora alle fanciulle. Ora le giovinette escono dalle scuole come tanti piccoli professori. E non hanno paura di parlar di storia né di letteratura e neppur d'algebra. E se non parlano di politica, è perché sanno che è cosa uggiosa, l'hanno imparato studiando gli uomini [...] Se volessero con quelle menti intelligenti ed erudite, terrebbero testa agli uomini anche in politica.

Ma aggiunge anche subito dopo quasi a sdrammatizzare, con ironia:

> Fanno bene a non tentarlo, del resto.[8]

Torriani, che scrive con lo pseudonimo di Marchesa Colombi, usa spesso quegli stessi strumenti proposti dalla tradizione in realtà per cercare di scardinare l'abitudine,

5 Pierobon, 'L' "enormità" del reale', p. 299.
6 Marchesa Colombi, *Un matrimonio in provincia*, p. 29.
7 Marchesa Colombi, *La Gente per bene: leggi di convenienza sociale*.
8 Marchesa Colombi, *La Gente per bene: leggi di convenienza sociale*, p. 27.

sempre grazie alla maschera dell'ironia; usa quel modello del manuale caro alla tradizione quale metodo di indottrinamento femminile ma lo usa come sempre a modo suo, ironico, sferzante, dissacrante dedicando il suo manuale di buone maniere *La Gente per Bene* alle donne anche se si appella formalmente agli uomini e sempre con il suo fare sarcastico, poiché: 'Non si mettano sulle difese, Signori. Io non ho la menoma intenzione di dare degli insegnamenti agli uomini sul modo di vivere. Figurarsi! So bene che nella divisione dei doni della Provvidenza, l'intelligenza è toccata tutta a loro!'.[9]

Il tono sarcastico, che pervade le sue opere, da molti citato e celebrato crea intorno a lei, e ha creato, l'impressione di una scrittrice che si nasconde dietro l'arma dell'ironia solo per non inimicarsi la cultura dominante maschile, di chi usa l'ironia come strumento per scardinare gli spazi letterari dedicati alle donne (galatei, libri per l'infanzia…)[10] o come un atteggiamento di ambiguità, di chi ha una volontà ancora non troppo matura di emancipazione, probabilmente invece usa lo strumento dell'ironia come un mezzo per cogliere l'occasione di rivolgersi alle donne e proporre loro delle soluzioni emancipatrici proprio come dice essa stessa in *La Gente per Bene*.[11]

Torriani plausibilmente infatti non voleva essere più deflagrante, usa un'arma sottile, quella dell'ironia e non quella dello scontro diretto per cercare di creare una migliore condizione per le donne e per l'intera società usando semplicemente il rigore e i mezzi consoni all'epoca in cui viveva e non invece quella violenza intellettuale che ha caratterizzato altre figure che nel tempo prima di lei hanno reclamato un'educazione diversa per le donne.[12] Ecco quindi un manuale di buone maniere per le signore della piccola, media ed alta borghesia, articoli di costume e sempre e comunque ragguagli sociali come strumenti di difesa ma anche di attacco per le donne nella società.

Torriani riesce magistralmente a farci credere di rientrare perfettamente nel pensiero che ci propone Virginia Woolf sul romanzo femminile ottocentesco quando dice:

> L'intera struttura del romanzo dell'Ottocento veniva dunque eretta, se era una donna a scrivere, da una mente leggermente sviata e indotta ad alterare la sua chiara visione per una forma di deferenza all'autorità esterna. E' sufficiente sfogliare quei vecchi romanzi dimenticati e ascoltare il tono di voce con cui furono scritti […] nel dire questa cosa si dimostrava aggressiva, nel dire quell'altra conciliante. Ammetteva di essere 'soltanto una donna' o rivendicava il fatto di 'valere quanto un uomo'.[13]

9 Marchesa Colombi, *La Gente per bene: leggi di convenienza sociale*, p. 89.

10 Si veda in questo senso il saggio di Franchini, 'Cultura nazionale e prodotti d'importazione: alle origini di un archetipo italiano di "stampa femminile"', in *Editori, Lettrici e stampa di moda*, p. 106.

11 Marchesa Colombi, *La Gente per bene: leggi di convenienza sociale*, p. 2.

12 Si veda ad esempio la figura di Arcangela Tarabotti, monaca forzata del XVI secolo che rivendicava un'istruzione adeguata per le donne. Panizza, *Che le donne siano della spezie degli uomini. Women are No Less Rational than Men*; Palandri, *L'istruzione femminile nel pensiero di Arcangela Tarabotti*.

13 Woolf, *Una stanza tutta per sé*, p. 160.

La Marchesa Colombi infatti già nella prima edizione de *La Gente per bene* nell'Introduzione afferma: 'Il galateo di Monsignor Della Casa è completo, ragionato, tanto da elevarsi quasi all'altezza d'un trattato di morale. Io sono certa e rassegnata a priori, di non poter fare un lavoro, non dirò migliore – sarebbe una pretesa ridicola – ma neppure che si avvicini al merito di quello'.[14]

Quindi solo dopo aver ammesso questa irraggiungibilità e dopo aver spiegato che la sua è solo un'opera didascalica che affronta le nuove convenzioni sociali e che non ha e non vuole assolutamente avere nulla di morale, conclude affermando che: 'E' per questo soltanto – non per fare meglio di nessuno ma per fare tutt'altro – che imprendo a scrivere il mio galateo moderno'.[15] D'altronde come detto la Marchesa Colombi si rivolge alle signore, almeno dichiaratamente, destinatarie dell'opera.[16]

Ma la realtà è ben diversa, come detto sappiamo che se ciò di cui parla Woolf può essere vero per le scrittrici dell'Ottocento per la Marchesa Colombi sono meri strumenti per poter dire quello che altrimenti sarebbe solo attaccato e rifiutato ad oltranza e lo maschera con un'arma innovativa, unica: l'ironia, per dire ciò che in realtà con i suoi scritti spera di migliorare nella neo società italiana.

Il suo reale intento lo si ritrova come filo conduttore nella sua produzione letteraria e giornalistica, così come anche negli articoli dedicati ad un aspetto ritenuto frivolo ed esclusivamente per le donne: la moda.[17] Solo esaminando la sua produzione si colgono i semi che nel tempo e nelle sue opere ha voluto lasciare. Dissacrante è anche il suo continuo, deliberato, giudizio sulle emancipatrici e le loro rivendicazioni definite volutamente sempre come pretestuose, vaneggianti ed esagerate come nell'articolo del *Corriere della Sera* quando recensendo un romanzo di Pompeo Molmenti su Erminia Fuà Fusinato nella rubrica *Lettera aperta alle Signore* dice di non ritenerla una rivoluzionaria perché anch'essa biasima le emancipatrici, soprattutto nel richiedere la candidabilità delle donne alle elezioni.[18] Così con fare faceto, scansona colui che porta la lotta delle donne fin in Parlamento, l'amico Salvatore Morelli in *La Gente per bene*.[19]

La Marchesa Colombi, non paga di essersi già scusata nell'introduzione del libro, torna a giustificarsi e ad abbonire l'intelletto forte, quello che ha la sola capacità di occuparsi e di scrivere di cose importanti, come la politica, la dottrina, la finanza, non nasconde mai il suo pensiero su chi abbia quella sola intelligenza che legittima un'espressione educatrice, formativa della società, ed afferma: 'Dunque io non ho punto, ma punto, la presunzione di voler insegnar loro la menoma cosa Mi limito ad osservare quello che vedo ogni giorno in società, ed a dirne il mio debole parere'.[20]

Il suo debole parere quindi, perché chi ha la voce forte, ed è legittimato a farlo, poiché così è ed è sempre stato è l'uomo si sa, così si esprime scrivendo alla scrittrice

14 Marchesa Colombi, *La Gente per bene: leggi di convenienza sociale*, p. 6.

15 Marchesa Colombi, *La Gente per bene: leggi di convenienza sociale*, p. 6.

16 Marchesa Colombi, *La Gente per bene: leggi di convenienza sociale*, p. 2.

17 Si veda ad esempio il capitolo di Franchini, '"Democratizzazione" della moda e dinamiche editoriali', in *Editori, Lettrici e stampa di moda*, p. 304.

18 Cometto, *La Marchesa Colombi. La prima giornalista del Corriere della Sera*, p. 85.

19 Marchesa Colombi, *La Gente per bene: leggi di convenienza sociale*, p. 89.

20 Marchesa Colombi, *La Gente per bene: leggi di convenienza sociale*, p. 89.

Neera: 'Le donne non hanno la forza fisica dell'uomo, non hanno la sua energia di carattere, né la sua serietà, né la sua intelligenza. Questo lo dicono tutti; sarà vero'.[21]

Ma è altrettanto vero che Torriani sa che il rapporto tra i sessi è un perenne stato di tensione, di belligeranza e nelle sue parole tornano riferimenti espliciti alla guerra[22] ora nei suoi romanzi, ora negli articoli come quello in cui rispondendo a Neera parla delle donne simili a Corazzieri, scudate ed armate, capeggiate da Salvatore Morelli che entrano a Montecitorio per rivendicare diritti alle donne;[23] ma l'arma più forte in questa guerra che la Marchesa Colombi riconosce alle donne è l'istruzione e nella fattispecie un'educazione che deriva dalla letteratura. Molte delle sue opere infatti vedranno citazioni di romanzi celebri a cui lega un ruolo particolare all'interno delle trame come in *Il tramonto di un ideale* in cui il libro dei *Promessi Sposi* è lo strumento di seduzione e comunicazione di due giovani alle prime armi con i propri sentimenti o come visto in *Un Matrimonio in provincia* il romanzo dei *Tre Moschettieri* o *ancora* in *Prima morire*[24] dove i libri sono sempre in primo piano nelle parole e negli atteggiamenti dei due protagonisti, una donna e un uomo, due vicini di casa o ancora l'opera dal titolo tutt'altro che casuale *Une page d'amour* di Émile Zola che diventa per un gioco del destino il mezzo di contatto tra i protagonisti del romanzo.

Nella prefazione di *Serate d'inverno* Maria Antonietta Torriani ci racconta il suo rapporto intimo con i libri nelle sue serate infantili in cui il nonno ha in casa solo le opere di Goldoni che ritiene un autore reale, veritiero e affatto drammatico, l'unico degno di stare in biblioteca perché i romanzi e tutte le altre opere esasperate dalla retorica e dalle passioni potevano essere deleterie per le donne 'Se leggono questa roba, addio lista del bucato, diceva, addio note della spesa, addio testa! Si mettono in mente di sposare un eroe e non si maritano più'.[25]

E proprio in uno dei racconti di *Serate d'inverno* intitolato *Impara l'arte e mettila da parte* la protagonista Odda spiega cosa è per lei che è pittrice, l'arte 'Se fossi infelice, verrebbe a consolarmi [...], a darmi un valore personale'[26] e fa dire alla cugina di Odda pronta a sposarsi uno sconosciuto piuttosto di non rimanere zitella quando Odda cerca di farla ragionare in merito che: 'Non ho un'arte come te [...] m'hanno dato soltanto l'educazione d'una signora. Non ho risorse in me stessa'.[27]

In questo racconto troviamo ora non più una protagonista vuota, vana come Denza di *Un matrimonio in provincia* ma qui un esempio positivo di donna che si dedica ad un lavoro per se stessa e che ha un valore a prescindere dal suo status sociale, la Marchesa Colombi lancia il messaggio per cui 'imparare l'arte' significa strutturarsi, da qui la necessità di dedicarsi ad un'attività stabile figlia di un'istruzione soddisfacente, poiché

21 Marchesa Colombi, 'La donna povera', p. 398.
22 Pierobon, 'L' "enormità" del reale', p. 307.
23 Marchesa Colombi, 'La donna povera', p. 398.
24 Marchesa Colombi, *Prima morire*, 1881.
25 Marchesa Colombi, *Serate d'inverno. Racconti*, p. 15.
26 Marchesa Colombi, *Serate d'inverno. Racconti*, p. 113.
27 Marchesa Colombi, *Serate d'inverno. Racconti*, p. 124.

Diamo loro un'occupazione stabile e seria, che le appassioni per se stessa, indipendentemente dall'idea di un marito. Se il marito verrà lo ameranno malgrado la loro occupazione; se non verrà continueranno a lavorare e ad amare il loro lavoro. Avranno sempre un amore nella vita[28]

perché

le ragazze che non fanno nulla di serio, si mettono in testa d'essere al mondo soltanto per trovare un marito e non pensano che a quella x incognita e sospirata. Si fanno belle per piacere alla x; acquistano una certa cultura per interessare la x, non ne acquistano troppa per non adombrare la x; sono casalinghe, economiche, oneste per rassicurare la x. E quando invecchiano senza averla trovata, non sanno più per chi serbare tutte le qualità coltivate per la x e le lasciano andare. E si persuadono che hanno fallito lo scopo della vita e diventano stizzose, sfiduciate, invidiose.[29]

Il tema dell'istruzione quindi è fondamentale nell'opera di Torriani-Marchesa Colombi che come visto contempla nei suoi romanzi e racconti la letteratura e la lettura come veicolo d'istruzione. La letteratura infatti per Torriani rispecchia quella chiarezza strutturale propria della natura femminile[30] e questo atteggiamento lo ritroviamo d'altronde già anni prima di diventare la Marchesa Colombi quando si impegnerà a fianco di un'altra grande sostenitrice dei diritti femminili. Torriani infatti è convinta che alla base della partecipazione ed emancipazione da quei condizionamenti sociali che bene descriverà poi nei suoi libri, c'è l'educazione delle donne. Condivise questa sua visione con Anna Maria Mozzoni; le due si conobbero a Milano nel *Giardino d'infanzia*,[31] entrambe infatti frequentavano questo ambiente come conferenziere e incontrandosi daranno vita ad un'intensa per quanto breve amicizia che le porterà l'anno seguente in varie città italiane per una serie di conferenze e di incontri proprio sul tema della necessità di un'istruzione diversa per le donne. Queste conferenze verranno in seguito pubblicate a puntate sulla rivista *Il Passatempo*.[32]

Da questa esperienza nascerà anche la volontà di fondare una scuola femminile, sempre a Milano, dove Torriani stessa deciderà di insegnare Letteratura. La scuola che fonderà a Milano insieme a Mozzoni verrà ricavata in alcuni locali di Via Pantano, la strada dove nacque una grande scienziata italiana un secolo prima ed ancora poco nota perfino ai nostri giorni: Maria Gaetana Agnesi a cui verrà intitolato l'istituto.

Maria Antonietta Torriani capisce che la cultura, l'istruzione passa anche per la visibilità nei luoghi e negli spazi pubblici come luoghi di ricordo ma anche di esempio e di memoria per le generazioni successive. Potremmo allora forse dire di poter trarre anche un'altra lezione dalla Marchesa Colombi, e cioè quella per cui anche i

28 Marchesa Colombi, *Serate d'inverno. Racconti*, p. 109.

29 Marchesa Colombi, *Serate d'inverno. Racconti*, p. 109.

30 Si veda a proposito l'argomentazione del binomio, donna-scrittura Pierobon in 'L' "enormità" del reale', p. 291 e nota 5.

31 Scaramuzza, a cura di, *Politica e amicizia*, p. 64.

32 Cometto, *La Marchesa Colombi. La prima giornalista del Corriere della Sera*, p. 143.

luoghi sono spazi di formazione e conoscenza. Spazi come scuole, strade, piazze sono simboli di formazione identitaria personale ma anche collettiva.

Proprio il giorno dell'inaugurazione del liceo Gaetana Agnesi, Torriani patrocina la causa della Letteratura e quella di un'istruzione più accurata per le donne con un discorso di prolusione con queste parole:

> Che la letteratura sia possente strumento di progresso; che eserciti un'influenza vitale sulla civiltà dei popoli, lo vedemmo in tutti i tempi, e la storia è là per provarlo. Quanto possa fare l'intelligenza femminile, congiunta ad una seria istruzione, lo prova tutta intera la storia del passato [...] Se attraverso tante opposizioni, e tante difficoltà, la donna giunse ad imporre alle letterature di tutti i tempi e di tutti i paesi un grande numero di nomi femminili che descrissero luminose parabole sull'orizzonte letterario, che non potrà ella fare allorché un'istruzione profonda ed incontesa, la porrà in grado di fornire all'umana civiltà tutto il contingente di cui il suo ingegno è capace?[33]

E continua nel suo discorso di inaugurazione osservando: 'Ma l'istruzione femminile sulle basi e coi programmi attuali, è realmente l'istruzione seria che si reclama, quella che prepara e matura la mente a più vasti studi...? No, o signori'.[34] Concludeva quindi lei stessa il suo discorso al Liceo Agnesi sostenendo che 'le generazioni future, per cui avremo sudato tutta la vita, se non ci encomieranno pei nostri successi, benediranno le nostre intenzioni'.[35]

Questo discorso diventerà un saggio, dato alle stampe con il titolo *Della letteratura nell'educazione femminile*[36] nel 1871.

33 Cometto, *La Marchesa Colombi. La prima giornalista del Corriere della Sera*, pp. 140–41.
34 Cometto, *La Marchesa Colombi. La prima giornalista del Corriere della Sera*, p. 142.
35 Cometto, *La Marchesa Colombi. La prima giornalista del Corriere della Sera*, p. 143.
36 Torriani, *Della letteratura nell'educazione femminile*.

Bibliografía

Bibliografia principale

Bortolotti, Franca Pieroni, *Alle origini del movimento femminile in Italia (1848–1892)* (Turin: Einaudi, 1975)

Cometto, Maria Teresa, *La Marchesa Colombi. La prima giornalista del Corriere della Sera* (Turin: B.L.U. Editoriale, 1996)

———, *La Marchesa Colombi* (Milan: Solferino, 2020)

Franchini, Silvia e Simonetta Soldani, a cura di, *Donne e giornalismo: percorsi e presenze di una storia di genere* (Milan: Franco Angeli, 2004)

Marchesa Colombi, 'La donna povera. Lettera della Marchesa Colombi alla Signora Neera', *L'Illustrazione Italiana*, III, n. 25 (16 aprile 1876)

———, *La Gente per bene: leggi di convenienza sociale* (Turin: per i tipi del 'Giornale delle Donne', 1877)

———, *La Cartella n. 4* (Cesena: Libreria editrice G. Gargano, 1880)

———, *Prima morire* (Naples: Ed. Morano, 1881)

———, *Umani errori* (Milan: Remo Sandron Editore, 1899)

———, *Serate d'inverno. Racconti* (Sesto San Giovanni: Casa Editrice Madella, 1914)

———, *I più cari bambini del mondo* (Milan: L. Trevisini, IV edizione)

———, *Un Matrimonio in provincia* (Turin: Einaudi, 1973)

Pierobon, Ermenegilda, 'L'enormità del reale: una lettura de "Un Matrimonio in provincia" della Marchesa Colombi', *Forum Italicum*, 30.2 (1996), 291–310

Scaramuzza, Emma, a cura di, *Politica e amicizia. Relazioni, conflitti e differenze di genere (1860–1915)* (Milan: Ed. Franco Angeli Storia, 2010)

Torriani, Maria Antonietta, *Della letteratura nell'educazione femminile* (Genoa: Stabilimento Artisti Tipografi, 1871)

Woolf, Virginia, *Una stanza tutta per sé*, a cura di Egle Costantino (Milan: Ed. BUR, 2013)

Bibliografia secondaria

Franchini Silvia, *Editori, Lettrici e stampa di moda. Giornali di moda e di famiglia a Milano dal Corriere delle Dame agli editori dell'Unità d'Italia* (Milan: Franco Angeli, 2002)

Palandri Silvia, *L'istruzione femminile nel pensiero di Arcangela Tarabotti* (tesi di laurea, Rome, Università degli Studi Roma Tre, a.a. 2003–2004)

Panizza Letizia, *Che le donne siano della spezie degli uomini. Women are No Less Rational than Men* (London: University of London, 1994)

CAROLIN GLUCHOWSKI

Custodians of Tradition

Reframing and Recycling in a Northern German Prayerbook

▼ **ABSTRACT** The revision of prayerbooks is a widespread yet understudied phenomenon of church reform. This article uses the Easter prayerbook MS. Lat. liturg. f. 4 in the Bodleian Library, Oxford, as an example to demonstrate its significance. The Latin/Low-German Easter prayerbook, written on paper and parchment, was produced in the Cistercian convent of Medingen near Lüneburg, Germany. 64 manuscripts have so far been attributed to the Medingen convent, dating from the beginning of the fifteenth to the mid-sixteenth century. During this time, the Medingen convent underwent two church reforms: the Northern German monastic reform (1479) and the Lutheran Reformation (1524/1544). More than half of the known Medingen manuscripts have been revised in a similar way to the Easter prayerbook MS. Lat. liturg. f. 4. I argue that that the revisions demonstrate how the Medingen nuns curated their convent's devotional profile according to changes introduced by the two church reforms. Using the Easter prayerbook MS. Lat. liturg. f. 4 as a case study, this article aims to examine the nuns' role as *reformatrices* (female reformers). To achieve this, the article uses the concepts of reframing and recycling as analytical tools to illuminate the nuns' role in the late medieval church reforms.

Revising prayerbooks is a widespread yet understudied sign of church reforms.[1] To demonstrate the significance of this phenomenon, I will use the Latin/Low-German Easter prayerbook MS. Lat. liturg. f. 4 from the Bodleian Library Oxford as a case

1 My DPhil project 'Revising Private Prayerbooks. The Latin/Low-German Prayerbooks from the Cistercian Convent of Medingen in the Context of Late-Medieval Church Reforms' (working title) at the University of Oxford investigates this phenomenon in more detail.

Women in Arts, Architecture and Literature: Heritage, Legacy and Digital Perspectives, ed. by Consuelo Lollobrigida and Adelina Modesti, Women in the Arts: New Horizons, 1 (Turnhout: Brepols, 2023), pp. 91–108

BREPOLS ⁂ PUBLISHERS 10.1484/M.WIA-EB.5.134645

study.[2] The small prayerbook (12.5 × 9.3 cm), written on 292 parchment and paper leaves, was produced in the Cistercian convent of Medingen near Lüneburg, Germany.[3] The prayerbook is an 'all-rounder' for the Easter season, containing texts for the period from Holy Saturday to the Second Sunday After Easter. The texts were intended for both, communal activities such as services of worship or the Divine Hours, and private devotion and were drawn from the Latin church tradition and the Low German popular culture. It is not entirely clear how the prayerbook made its way from the Medingen convent into the Bodleian collection. It is believed that the prayerbook was among the 'unnecessary precious things'[4] sold by Abbess Elisabeth Katharina von Stöterogge (1722–1741) in the early 18th century. Thereafter, the provenance of the prayerbook is unknown, but the small label attached to the front cover suggests that it may have been part of a larger collection at some point. More than a century later, the prayerbook re-emerged at the James Brice Sale (lot 535) in 1887 where it was acquired by the Bodleian Library for £8.[5]

The prayerbook is part of a larger corpus of 64 Medingen prayerbooks. More than half of the Medingen prayerbooks have been revised in a similar way to the prayerbook O1. What sets this prayerbook apart is the extent of the revision process. Several generations of Medingen scribes have revised it in response to changes in the convent's devotional profile, prompted by the Northern German monastic reform (1479) and the Lutheran Reformation (1524/1554). By making use of the flexible nature of the medium 'manuscript',[6] the nuns removed outdated texts and inserted updated versions. Investigating the revisions in the prayerbook is crucial to gain a more nuanced understanding of the nuns' active role in both church reforms. The revisions demonstrate how the Medingen nuns enacted church reform through the long-term transformation of the convent's devotional profile, materialized in their prayerbooks. Through an in-depth examination of the prayerbook O1, I aim to illuminate the nuns' agency as *reformatrices* (female reformers),[7] negotiating between convent tradition and reform innovation. To achieve this, I will utilize analytical tools such as reframing and recycling.[8]

The Medingen Easter Prayerbook in Oxford

With help of the high-resolution digital facsimile of the prayerbook, made available through the Polonaky Foundation Digitalization Project *Manuscripts from German*

2 Oxford, Bodleian Library, MS. Lat. liturg. f. 4, referenced in the following O1. I will use the sigla of the comprehensive list of all known Medingen manuscripts, <medingen.seh.ox.ac.uk>.

3 For a comprehensive bibliography on Medingen see the Medingen blog, <medingen.seh.ox.ac.uk>.

4 Lyßmann, *Historische Nachrichten*, p. 173.

5 This probably refers to the William Brice Sale. William Brice (1813–1887), son of a Bristol merchant family. Sotheby's London, *Catalogue of the Choice*.

6 Ryley, *Reusing Manuscripts in late Medieval England*; Shermann, *Used Books*.

7 Hotchin, 'Reformatrices and Their Books'.

8 Oldenziel and Weber, 'Introduction', p. 347.

Speaking Lands (2019–2021),[9] it is now possible to conduct a close-up inspection of O1. In addition to the two main scribal hands identified,[10] I would like to add three further hands working with the manuscript. Each scribe represents a distinct production or editing layer (stratum). This approach draws on book archaeology[11] but has been adapted and refined to describe and analyze the revisions in this prayerbook. In order of their appearance, the scribes are identified as hands 1 to 5 in the following (Fig. 1).

The strata do not occur in chronological order. As I will demonstrate for the folia 8r–9v (Figs 2–5), the chronological order of the strata needs to be reconstructed by the succession of different hands. Hand 2 wrote a Salutatio to Easter Vigil on folio 8r, which is introduced by a penwork initial. The Salutatio continues onto folio 8v, followed by several chants. However, upon closer inspection, it becomes apparent that the first two chants were written by hand 2 on a palimpsest over a former rubric, which was probably written by hand 3. The third chant and the praise on folios 9r–9v were written by hand 3. Therefore, based on the succession of hands, it can be deduced that hand 2 needs to be dated later than hand 3.

9 For further information see the Manuscripts from German-Speaking Lands – A Polonsky Foundation Digitization Project Blog, <https://hab.bodleian.ox.ac.uk/en/about/>.

10 Madan, *Summary Catalogue*, vol. v, p. 683, no. 29743.

11 Poirters, *Preserving the Spirit of Windesheim*.

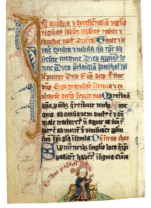
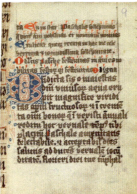

Unit 1

- fol. 1–178, quires 1–16
- parchment
- Holy Saturday and Easter Sunday
- bulk of the text was written by hand 2 (red), hand 2 integrated texts written by hand 3 (green) into the Oxford Easter prayerbook, and was itself revised by hands 1 (blue) and 4 (yellow).

Unit 2

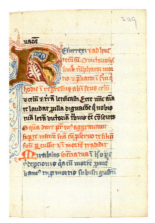

- fol. 179–292, quires 17 to 27
- mainly paper, with a few parchment leaves in between (fol. 183–184, 189, 283)
- Easter Monday and the First and Second Sundays after Easter.
- almost entirely written by hand 4 (yellow) which reframed parts written by hand 5 (purple).

Fig. 1. Strata in the Prayerbook Oxford, BodLibs, MS. Lat. liturg. f. 4.

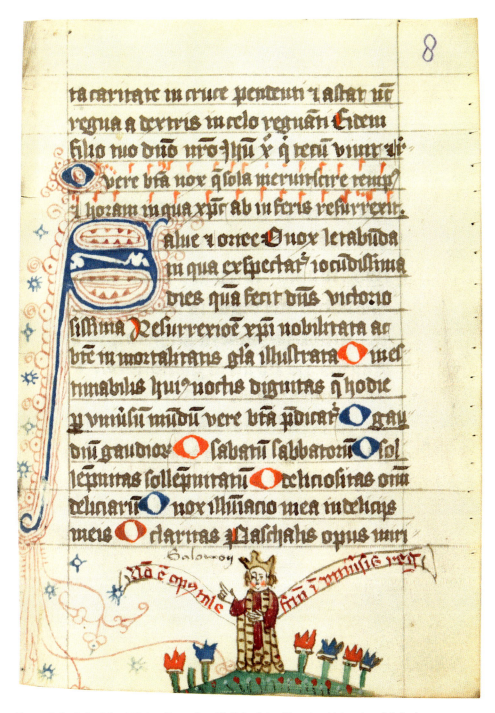

Fig. 2. Oxford, BodLibs, MS. Lat. liturg. f. 4, 8ʳ. © Bodleian Libraries, University of Oxford.

Fig. 3. Oxford, BodLibs, MS. Lat. liturg. f. 4, 8ᵛ. © Bodleian Libraries, University of Oxford.

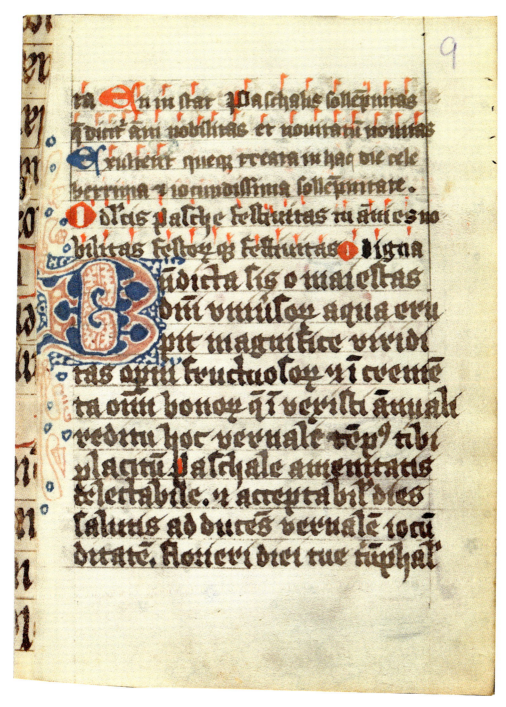

Fig. 4. Oxford, BodLibs, MS. Lat. liturg. f. 4, 9ʳ. © Bodleian Libraries, University of Oxford.

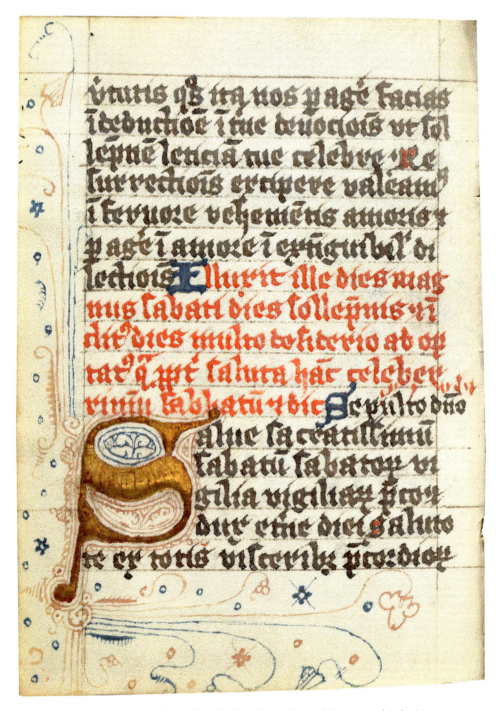

Fig. 5. Oxford, BodLibd, MS. Lat. liturg. f. 4, 9ᵛ. © Bodleian Libraries, University of Oxford.

Reframing: Old Texts in New Contexts

Folios 8^v–9^r demonstrate reframing in action. The concept of (re)framing has gained traction across disciplines since the 1970s and refers to the reuse of objects or parts of objects in a new context.[12] Recently, the concept has gained more and more influence, especially in the study of literature and art. My understanding of the concept is influenced by the work of Susanne Wittekind and Stefanie Seeberg.[13]

As the convent's devotional profile changed, the nuns revised the prayerbook to reflect these changes. In the revision process, the nuns had to assess which parts of the prayerbook complied with the new devotional profile and which did not. The relevant parts were retained, and in some cases, such as folios 9^r–9^v, they were reframed and used in a different liturgical context. As demonstrated above, hand 2 erased the former rubric written by hand 3, so that the text was removed from its original context and granted 'liturgical mobility' to be incorporated into a new textual environment. As a result, the praise written by hand 3 was reframed. The nuns were eager to conceal the traces of this reframing process, so that both strata blend seamlessly into one another.

Dating the Different Prayerbook Strata

Applying the method described above to the entire prayerbook, the different hands can be established in chronological order as follows: hand 3 (the earliest, 9^r–18^v; 33^r–38^v; 40^r–40^v; 41^v; 90^r–95^v; 97^r–97^v; 154^r–154^v; 158^r–159^v), followed by hand 2 (2^r–9^r; 19^r–32^v; 33^r–39^v; 41^r–41^v; 71^r–71^v; 74^r–87^v; 96^r–97^v; 98^r–133^v; 138^r–141^v; 146^r–153^v; 159^v–178^v), hand 1 (1^v; 88^r–90^r), hand 5 (183–84, 189, 283), and hand 4 (the latest, 68^v–71^r; 72^r–74^r; 134^r–138^r; 142^r–146^r; 155^r–158^r; 179^r–173^v; 274–290^r). The distribution of hands is uneven. The first part of the prayerbook (folios 1–178, quires 1–16) contains texts for Holy Saturday and Easter Sunday, the main feast days of the Medingen calendar. This part was predominantly written by hand 2 and revised by hands 1 and 4. The second part (folios 179–292, quires 17 to 27) contains texts for Easter Monday and the First and Second Sundays after Easter and was primarily written on paper by hand 4. Hand 2 later inserted a few parchment leaves (folios 183–84, 189, 283) written by hand 5.

Each startum provides insight into a particular phase of the Medingen devotional profile. However, dating each stratum proves to be challenging. This is also true for the entire corpus. Despite being the subject of research by scholars from various disciplines, dating the Medingen prayerbooks has been difficult due to their imitation of older models, presumably from the 13th century.[14] Conrad Borchling,[15] Robert

12 With, 'Rahmenbrüche, Rahmenwechsel'.
13 Wittekind and Seeberg, '"Reframing" in the Middle Ages and the Early Modern Period'.
14 Schneider, *Handschriftenkunde*.
15 Borchling, *Mittelniederdeutsche Handschriften*.

Priebsch,[16] and Axel Mante[17] independently grouped the corpus but were unable to locate the corpus. Walter Lipphardt was the first to succeed in this challenging task. In a series of publications from 1969 onwards, Lipphardt attributed the corpus to the Medingen convent and dated the manuscripts to the period between 1290 and 1523.[18] Subsequent studies deemed Lipphardt's production period as too broad. Gerard Achten's analysis of the watermarks in the Medingen paper manuscripts dated those pages to between 1470 and 1520,[19] which Regina Cermann linked to the upswing of the scriptorium under the reform provost Tilemann von Bavenstedt (1467–1494).[20] Together, these suggestions prompted the idea that the corpus is a testimony to the intensified devotion that followed the Northern German monastic reform.[21] More recently, new insights into prayerbook production in the Medingen convent suggest that the corpus may be dated between the beginning of the 15th and the mid-16th century. Most notably, the Easter prayerbook Ms GKS 3452–8° in the Royal Library of Copenhagen, which was completed in 1408 by the Medingen nun and later prioress Cecilia de Monte (140r),[22] shows an active production of prayerbooks in the Medingen convent long before the Northern German monastic reform.[23]

For the prayerbook O1, two potential dates have been discussed so far. The first suggestion comes from Lipphardt, who attributed the prayerbook to the Medingen convent and dated it to the aegis of Abbess Elisabeth von Elvern (1513–1524), the last Catholic abbess of the Medingen convent.[24] He attributed the unique characteristics of the prayerbook, such as the 'shortening of the repertoire' and the 'decrease in German intersections', to the 'humanistic tendency of this abbess.'[25] Brigitte Uhde-Stahl disagreed with Lipphardt's dating and proposed that the prayerbook was produced a few decades earlier.[26] Uhde-Stahl argued that the prayerbook must have been created after the introduction of the abbess office in 1494, as there is a text in the prayerbook that mentions the Medingen abbess (28v). She also pointed to three paper cuttings in the margins of O1, interpreting the two lions (217r) as a reference to the coat of arms of the reform provost Tilemann von Bavenstedt, who died in 1497. Consequently, Uhde-Stahl concluded that the prayerbook was created in the late 1490s.[27] Nigel Palmer later challenged Uhde-Stahl's interpretation, suggesting

16 Priebsch, *Deutsche Handschriften.*
17 Mante, *Ein niederdeutsches Gebetbuch.*
18 Lipphardt, 'Medinger Gebetbücher', col. 982.
19 Achten, *De Gebedenboeken.*
20 Cermann, 'Ms. germ. Oct. 48', pp. 272–75.
21 Lähnemann and Hascher-Burger, *Liturgy and Reform*, p. 15.
22 Copenhagen, RL, Ms GKS 3452-8°; Gluchowski, *Medingen Manuscript Production.*
23 Gluchowski, *Handschriftenüberlieferung.*
24 Lipphardt, 'Die liturgische Funktion', p. 164.
25 All quotations, Lipphardt, 'Die liturgische Funktion', p. 164.
26 Uhde-Stahl, 'Figürliche Buchmalereien', pp. 45–46.
27 Uhde-Stahl, 'Figürliche Buchmalerei', pp. 57–59.

that the paper cuts were signs of the resurrection rather than references to Tilemann von Bavenstedt.[28]

The question of dating the prayerbook is now further complicated by the complex intertwining of different strata. Both Lipphardt's and Uhde-Stahl's suggestions appear to be valid not for the entire prayerbook, but for individual strata. A comprehensive analysis of material, codicological, palaeographical, textual, arthistorical, and theological evidence suggests that hand 2 worked within the context of the Northern German monastic reform, whereas hand 4 worked within the context of the Lutheran Reformation. In the following section, I will briefly discuss both strata.

The Northern German Monastic Reform (1479)

The North German monastic reform aimed to enforce stricter enclosure, renew community life, renounce private property, and consolidate monastic finances. It was accompanied by a noticeable shift towards the Cistercian order, although Medingen was never officially incorporated.[29] The reform was completed with the introduction of the office of abbess in 1494.[30] The nuns also obtained right to elect their provost.[31] These changes increased the convent's authority and power over their own affairs.

Hand 2 worked within this context, as this stratum contains a text which references the Medingen abbess, as Uhde-Stahl pointed out. It appears that hand 2 was the first to revise the former prayerbook written by hand 3. Contrary to what the Summary Catalogue of the Bodleian Library claims,[32] hand 3 likely predates hand 2, as it bears great similarities to the Easter prayerbook K4 in Copenhagen which dates to the early fifteenth century. The revision of prayerbook therefore most likely began in the context of the Northern German monastic reform and its subsequent events which coincided with the nuns' new 'leading position in upholding the principles of reform'[33] and their new role as custodians of the reform heritage. The revision suggests that the Northern German monastic reform not only stimulated the production of new prayerbooks but also prompted the revision of existing ones. Through this process, the innovations of the reform became embedded in the convent tradition.

The Lutheran Reformation (1524/1554)

In the following decades, the power of the Medingen nuns was challenged by the Lutheran Reformation. In 1524, Duke Ernst von Braunschweig-Lüneburg (1497–1546) attempted to impose the new faith on the convent, but the nuns were unwilling

28 Palmer, 'Blockbooks', p. 45.
29 Schlotheuber, 'Die Zisterzienserinnengemeinschaften im späten Mittelalter'.
30 Lähnemann and Hascher-Burger, *Liturgy and Reform*, pp. 32–35.
31 Lähnemann and Hascher-Burger, *Liturgy and Reform*, pp. 32–35.
32 Madan, *Summary Catalogue*, vol. v, p. 683, no. 29743.
33 Lähnemann and Hascher-Burger, *Liturgy and Reform*, pp. 32–35.

Fig. 6. Oxford, BL, MS. Lat. Liturg. f. 4, lower board (colour altered). © Bodleian Libraries, University of Oxford.

to convert as it would have weakened their authority. This resulted in a 30-year-long conflict, known as the 'Medingen Nuns' War'. It was only in 1554 that a compromise was reached, with Abbess Margarete von Stöterogge (1524–1567) publicly taking holy communion in both forms, symbolizing the convent's acceptance of the new faith.[34]

Despite the nuns' resistance to the Lutheran Reformation, the changes made by hand 4 suggest a gradual transformation of the convent's devotional profile before the nuns' eventual acceptance of the new faith. The paper used this stratum to the 1510s/1520s.[35] The Renaissance binding (13.9 × 9.9 × 8.3 cm) of the prayerbook (Fig. 6), which shows Prudentia (PRVDEN), Lucretia (LVCRECIA), and Venus (VENVS), probably dates to the first half of the 16th century. This aligns with Lipphardt's suggestion for the dating of the prayerbook.

34 Lähnemann, 'Medinger Nonnenkrieg'; Felsberg, *Der Nonnenkrieg von Kloster Medingen*.
35 Fol. 223: *Piccard Online*, reference number DE4500-PO-31279. Fol. 268: *Piccard Online*, reference number DE7635-PO-155356. Lyßmann, *Historische Nachricht*, p. 135.

It is unclear whether the revisions made by hand 4 were initiated by the nuns themselves or in response to the changing religious environment and the conflict with the Duke. It is possible that the revisions were made to conform to the Duke's liturgical reforms, which were imposed on the Medingen convent in 1529.[36] A comparison of the stratum with the Ester prayerbook in Hildesheim (Ms. J 29), produced as a model prayerbook for the Northern German monastic reform, provide a basis for the premises behind the revisions made by hand 4.[37] Hand 4 made minimal use of structural elements, such as rubrics at the beginning of a text or Marian prayers at the end of a section.[38] Contrary to Lipphardt's hypothesis, the repertoire was not shortened but was more focused on Jesus Christ.

Recycling: Waste not, want not

Outdated prayerbook parts that no longer aligned with the convent's devotional were recycled. At first glance, the term 'recycling' appears to be a technological anachronism, as it was coined in 1925 in reference to a technology that repurposed raw materials for reuse.[39] In its modern sense, the term 'recycling' refers to the practice 'of finding a new use for goods that have already passed through the production cycle once.'[40] Today, recycling has become a central tool of an efficient economy in the spirit of environmental protection[41] with markedly complex recycling cycles.[42]

While few studies have explored this phenomenon prior to the 20th century,[43] recycling has always been a common practice throughout various cultures and historical eras,[44] often referred to as 'reuse'.[45] During times of limited resources, valuable materials that were expensive to produce or difficult to obtain were frequently repurposed. This practice was also common in the Middle Ages and the Early Modern Period. For example, street collectors (Italian strazzaroli/straccivendolo, French chiffonniers) collected valuable materials,[46] such as metal, glass, or rags,[47] which were then recycled.[48]

Recycling was an essential part of the material culture of the Lüneburg convents, including Medingen, as it was for many other medieval and early modern

36 Lyssmann, *Historische Nachricht*, p. 215.

37 Henrike Lähnemann is currently preparing an edition of the Easter prayerbook Dombibliothek Hildesheim, MS J. 29.

38 Lähnemann, 'Andachtsanweisungen'.

39 *Oxford English Dictionary Online*; Ayoto, 'Words from the 1920s'.

40 Clapp, *An Environmental History*, p. 190.

41 Worrell and Reuter, 'Definitions and Terminology'.

42 Lienig and Brümmer, *Elektronische Gerätetechnik*.

43 An exception is the pioneering work of Woodward, 'Swords into Ploughshares'.

44 Stöger and Reith, 'Western European Recycling', p. 288.

45 *Oxford English Dictionary Online*.

46 Stöger and Reith, *Western European Recycling*, p. 273.

47 Bayerl, *Die Papiermühle*, p. 374; Coleman, *The British Paper Industry*, p. 107 and p. 215; Meyer, Schultz, and Schneidmüller, eds, *Papier im mittelalterlichen Europa*; Stöger and Reith, *Western European Recycling*, pp. 276–77.

48 Reith, 'altgewender, humpler, kannenplecker'.

communities. It was a way for the nuns to manage their resources effectively. The nuns were experts in the field of recycling waste, demonstrating a remarkable 'recycling mentality'.[49] However, the nuns were not 'proto-greens or eco-warriors'[50] driven by an environmental awareness unique to our time, but rather by a practical and material concern for their community and their devotional practices. For the nuns, recycling was a means to curate their devotional profile and remove outdated elements from their religious practices. The fact that recycled material was mostly kept within the sacred sphere demonstrates the importance of the materials themselves, as well as the reverence in which they were held. Binder's waste in paste-downs is the most frequent use of recycling material which is also done in O1. Glued into the inside upper board is a fragment from a former missal with prayers for Epiphany which now supports the Renaissance binding.[51] In other cases, for example, in the Easter prayerbook Ms. germ. oct. 48 in Berlin, recycled parchment leaves were palimpsested and reused as writing material.[52] In the convent of Wienhausen, the nuns used recycled material to reinforce the hems of dresses for sculptures.[53]

Conclusion

The revisions made to the Oxford Easter prayerbook MS. Lat. liturg. f. 4 offer intriguing insights into the involvement of women in church reforms. Through the modifications made to the prayerbook, the Medingen nuns instigated a gradual transformation of their convent's devotional profile. The prayerbook's flexible medium allowed the nuns to carefully curate their convent's devotional profile, while actively negotiating between the convent's tradition and the reform innovation. Therefore, the revision process itself is where the church reforms happens, and the decisions made by the nuns demonstrate their agency as active *reformatrices* rather than passive recipients of reform. By analyzing the role of the nuns as active agents in the reform process, this article illuminates their significant contributions to the late medieval church reforms.

49 Reith, 'altgewender, humpler, kannenplecker'.

50 Ryley, 'Waste not, want not', p. 63.

51 Stöger and Reith, *Western European Recycling*, pp. 276–77.

52 Schneider, *Handschriftenkunde für Germanisten*, p. 109; Dauven-van Knippenberg and Meyer, 'Wienhausen Hs 80'.

53 Lähnemann, *Verhüllte Schrift*.

Bibliography

Manuscripts

Berlin, State Library, Ms. germ. oct. 48
Copenhagen, Royal Library, Ms GKS 3452 8°
Oxford, Bodleian Library, MS. Lat. liturg. f. 4

Primary Sources

Lyßmann, Johann Ludolf, *Historische Nachricht von dem Ursprunge, Anwachs und Schicksalen des im Lüneburgischen Herzogthum belegenen Closters Meding* [...] (Halle: Johann Jacob Gebauer, 1772)

Secondary Studies

Achten, Gerard, 'De Gebedenboeken van de Cistercienserinnenkloosters Medingen en Wienhausen', *Miscellanea Neerlandica*, 3 (1987), 173–88

Ayoto, John, 'Words from the 1920s', <https://public.oed.com/blog/words-from-the-1920s/> [accessed 19 September 2022]

Bayerl, Günter, *Die Papiermühle. Vorindustrielle Papiermacherei auf dem gebiet des alten deutschen Reiches – Technologie, Arbeitsverhältnisse, Umwelt* (Frankfurt a.M.: Lang 1987)

Borchling, Conrad, *Mittelniederdeutsche Handschriften. Reiseberichte I–IV, Nachrichten der Königlichen Gesellschaft der Wissenschaften zu Göttingen* (Göttingen: Commissionsverlag der Dietrich'schen Universitätsbuchhandlung L. Horstmann 1899–1913)

Cermann, Regina, 'Kat.-Eint. „Ms. germ. oct. 48" [Nr. 138]', in *Aderlaß und Seelentrost. Die Überlieferung deutscher Texte im Spiegel Berliner Handschriften und Inkunabeln*, ed. by Jörg Becker (Mainz: Walter de Gruyter 2003), pp. 272–75

Clapp, Brian William, *An Environmental History of Britain since the Industrial Revolution* (London: Longman 1994)

Coleman, Donald Cuthbert, *The British Paper Industry, 1495–1860. A Study in Industrial Growth* (Oxford: Clarendon Press 1958)

Dauven-van Knippenberg, Carla and Elisabeth Meyer, 'Wienhausen Hs 80: Reflections on the Context and Performance of the Object', *Amsterdam Contributions to German Studies*, 78.1 (2018), 75–101

Felsberg, Eduard, *Der Nonnenkrieg von Kloster Medingen: die Dokumentation der Aufführung eines heimatgeschichtlichen Laienspiels in Medingen im Jahre 1934* (Bevensen: Siebenstern 1989)

Gluchowski, Carolin, *Medingen Manuscript Production in the Age of Monastic Reform (1479) and Lutheran Reformation (1524–1544): How the Project Contributes to Understanding the Genesis of the Oxford Prayerbook MS. Lat. liturg. f. 4*, 2019 <https://hab.bodleian.ox.-ac.uk/en/blog/blog-post-18/> [accessed 13 September 2022]

————, 'Neue Perspektiven auf die Handschriftenüberlieferung aus dem Zisterzienserinnenkloster Medingen. Zur Datierung der Medinger Handschriften zwischen bestehender Tradition, erneuernder Reform und allmählicher Reformation' (M.A. Freiburg 2019)

Hotchin, Julie, 'Reformatrices and Their Books: Religious Women and Reading Networks in Fifteenth-Century Germany', in *Communities of Learning: Networks and the Shaping of Intellectual Identity in Europe, 1100–1500*, ed. by John N. Crossley and Constant Mews (Turnhout: Brepols, 2011), pp. 251–91

Lähnemann, Henrike, 'Der Medinger "Nonnenkrieg" aus der Perspektive der Klosterreform. Geistliche Selbstbehauptung 1479–1554', *Ons Geestelijk Erf*, 87 (2016), 91–116

————, 'So do du ok. Andachtsanweisungen in den Medinger Handschriften', in *Text und Normativität*, ed. by Franz-Josef Holznagel and Elke Brüggen (Berlin: De Gruyter, 2012), pp. 437–53

————, 'Pergamentmakulatur aus den Lüneburger Klöstern', in *Codex und Material*, ed. by Patrizia Carmassi and Gia Toussaint (Wiesbaden: Harrassowitz Verlag, 2018), pp. 119–36

Lienig, Jens and Hand Brümmer, *Elektronische Gerätetechnik. Grundlagen für das Entwickeln elektronischer Baugruppen und Geräte* (Berlin: Springer, 2014)

Lipphardt, Walther, 'Die liturgische Funktion deutscher Kirchenlieder in den Klöstern niedersächsischer Zisterzienserinnen des Mittelalters', in *Zeitschrift für katholische Theologie*, 94.2 (1972), 158–98

————, 'Medinger Gebetbücher (Nachtrag)', in *Verfasserlexikon*, 2nd ed., 11 (2004), col. 982

Madan, Falconer, ed., *Summary Catalogue of Western Manuscripts in the Bodleian Library at Oxford*, vol. v: Collections received during the second half of the 19th century and miscellaneous MSS. acquired between 1695 and 1890 (Oxford: Oxford University Press 1905)

Mante, Axel, *Ein niederdeutsches Gebetbuch aus der zweiten Hälfte des XIV. Jahrhunderts* (Lund: Gleerup 1960)

Manuscripts from German-Speaking Lands – A Polonsky Foundation Digitization Project Blog https://hab.bodleian.ox.ac.uk/en/ [accessed 13 September 2022]

Medingen Blog <http://medingen.seh.ox.ac.uk/index.php/manuscripts/> [accessed 13 September 2022]

Meyer, Carla, Schultz, Sandra, and Bernd Schneidmüller, *Papier im mittelalterlichen Europa: Herstellung und Gebrauch* (Berlin: De Gruyter, 2015)

Oldenziel, Ruth and Heike Weber, 'Introduction: Reconsidering Recycling', *Contemporary European History*, 22.3 (2013), 347–70

Oxford English Dictionary Online <https://ezproxy-prd.bodleian.ox.ac.uk:2446/view/ Entry/ 160131?result=1&rskey=QxpRsy&> [accessed 13 September 2022]

Palmer, Nigel, 'Blockbooks, Woodcut and Metalcut Single Sheets', in *A Catalogue of Books Printed in the Fifteenth Century now in the Bodleian Library*, ed. by Alan Coates (Oxford: Oxford University Press, 2005), pp. 1–50

Piccard Online <https://www.piccard-online.de/start.php> [accessed 13 September 2022]

Poirters, Ad, 'Preserving the Spirit of Windesheim. An Archaeological Interpretation of the Traces of Rector Arnoldus Beckers (1772–1810) in Books from the Convent of Soeterbeeck' (unpublished doctoral dissertation, Radboud University Nijmegen, 2017)

Priebsch, Robert, *Deutsche Handschriften in England* (Erlangen, 1896)

Reith, Reinhold, '"altgewender, humpler, kannenplecker" – Recycling im späten Mittelalter und der frühen Neuzeit', in *Recycling in Geschichte und Gegenwart*, ed. by Roland Ladwig (Freiberg: Georg-Agricola-Gesellschaft, 2002), pp. 41–75

Röckelein, Hedweig, 'Schriftenlandschaften – Bildungslandschaften – religiöse Landschaften in Norddeutschland', in *Schriftkultur und religiöse Zentren im norddeutschen Raum*, ed. by Patrizia Carmassi, Eva Schlotheuber, and Almut Breitenbach (Wiesbaden: Harrassowitz Verlag, 2014), pp. 19–39

Ryley, Hannah, *Re-using Manuscripts in Late Medieval England. Repairing, Recycling, Sharing* (York: York Medieval Press, 2022)

———, 'Waste not, want not: The Sustainability of Medieval Manuscripts', *Green Letters. Studies in Ecocriticism*, 19 (2015), 63–74

Schlotheuber, Eva, 'Die Zisterzienserinnengemeinschaften im späten Mittelalter', in *Norm und Realität. Kontinuität und Wandel der Zisterzienser im Mittelalter*, ed. by Franz J. Felten and Werner Rösner (Berlin: Lit, 2009), pp. 265–84

Schneider, Karin, *Paläographie und Handschriftenkunde für Germanisten. Eine Einführung* (Tübingen: Niemeyer, 1999)

Shermann, Wiliam, *Used Books. Marking Readers in Renaissance England* (Philadelphia: University of Pennsylvania Press, 2008)

Sotheby's London, ed., *Catalogue of the Choice Library of the Late William Brice of Bristol: Valuable Autograph Manuscripts of Pope, Rosetti and others* (London: Sotheby's, 1887)

Stöger, Georg and Reinhold Reith, 'Western European Recycling in a Long-term Perspective. Reconsidering Caesuras and Continuities', *Jahrbuch für Wirtschaftsgeschichte*, 56.1 (2015), 267–90

Uhde-Stahl, Brigitte, 'Figürliche Buchmalereien in den spätmittelalterlichen Handschriften der Lüneburger Frauenklöster', *Niederdeutsche Beiträge zur Kunstgeschichte*, 17 (1978), 25–60

Wehking Sabine, ed., *The Inscriptions of the Lüneburg Monasteries. Ebstorf, Isenhagen, Lüne, Medingen, Walsrode, Wienhausen* (Wiesbaden: Reichert 2009)

Wirth, Uwe, 'Rahmenbrüche, Rahmenwechsel. Nachwort des Herausgebers, welches aus Versehen des Druckers zu einem Vorwort gemacht wurde', in *Rahmenbrüche. Rahmenwechsel*, ed. by Uwe Wirth (Berlin: Kunstverlag Kadmos, 2014), pp. 15–60

Wittekind, Susanne and Stefanie Seeberg, '"Reframing" in the Middle Ages and the Early Modern Period', *Journal of Art History*, 80.2 (2017), 171–75

Worrell, Ernst and Markus A. Reuter, 'Definitions and Terminology', in *Handbook of Recycling: State-of-the-Art for Practitioners, Analysts, and Scientists*, ed. by Ernst Worell and Markus A. Reuter (London: Elsevier, 2014), pp. 9–16

Woodward, Donald, '"Swords into Ploughshares". Recycling in Pre-industrial England', *The Economic History Review*, 38.2 (1985), 171–91

PART 2

Patrons and Collectors

CATHERINE POWELL-WARREN

Labour and Art Succeed where Nature Falls Short[*]

The Patronage and Artistic Networking of Agnes Block

▼ **ABSTRACT** In her time, the amateur botanist and collector Agnes Block (1629–1704) became celebrated as Flora Batava — the goddess of flowers of the Batavians, mythical ancestors of the Dutch Republic. This reputation was carefully curated. This essay posits that Block's successful self-fashioning as Flora Batava was due in part to her engagement with a network of artists. Membership in this network, together with her wealth and keen appreciation of art, contributed to her becoming one of the most important and influential patrons in a genre that fused art and science.

A portrait medal of Agnes Block (1629–1704), dating from 1700, shows her aged profile, like that of a Roman emperor (Fig. 1). On the verso, she is the personification of Flora Batava. She is not an ordinary goddess of flowers: she belongs with the Batavians, mythical ancestors of the Dutch Republic. Her personal motto, 'labour and art succeed where nature falls short', appears on the verso of the medal. It could be interpreted as the improvements upon nature that experience and invention, together with hard work, could make. For Block, however, the motto arguably took on at least one additional meaning: thanks to her art collection, she succeeded in preserving her rare botanical specimens, included in the iconographic program of the medal, for posterity, in a way that nature alone could not.

This essay posits that Block's successful self-fashioning as Flora Batava was due in part to her engagement with a network of artists.[1] Membership in this network,

[*] This essay is drawn from the author's doctoral dissertation, entitled 'Cross-Pollination: Agnes Block (1629–1704) and her Network of Artists and Botanical Experts: Self-Fashioning at the Intersection of Art and Science' (University of Texas at Austin, 2021 [unpublished]).

[1] As the author has argued elsewhere, another important part of Block's success in self-fashioning as Flora Batava was her participation of a so-called 'garden circle', a network of botanical experts and amateurs, which enabled her to circumvent many of the obstacles she experienced due to her gender. See Powell, 'Locating Early Modern Women's Participation in the Public Sphere of Botany'.

Women in Arts, Architecture and Literature: Heritage, Legacy and Digital Perspectives, ed. by Consuelo Lollobrigida and Adelina Modesti, Women in the Arts: New Horizons, 1 (Turnhout: Brepols, 2023), pp. 111–124
BREPOLS ❧ PUBLISHERS 10.1484/M.WIA-EB.5.134646

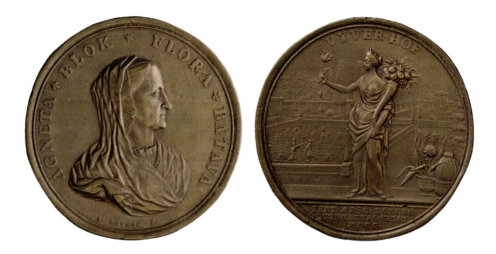

Fig. 1. Jan Boskam, *Portrait Medal of Agneta Blok as Flora Batava*, 1700. © Amsterdam Museum.

together with her wealth and keen appreciation of art, contributed to her becoming one of the most important and influential patrons in a genre that fused art and science.

Agnes Block and Vijverhof

Agnes Block was born in 1629 in an affluent Mennonite family. It was a rich environment, literally and metaphorically: she was exposed to the arts and literature. She married twice but did not have children of her own. In 1670, after the death of her first husband (but four years before marrying her second husband) she purchased a country estate along the river Vecht, near Utrecht.[2] She named the estate Vijverhof, meaning 'pond court'. Although no plans or representations of the grounds of the estate survive, we can infer from the 1702 poem *Vyver-Hof van Agneta Blok* (which Block commissioned from her cousin) that the estate included an orchard, a vegetable garden, ornamental gardens, hedges, an aviary filled with exotic birds, and an orangery.[3] From the moment she acquired it in 1670, Vijverhof and its rich botanical world became an inextricable part of Block's identity. It was her passion for botany and, in particular, her collection of rare and exotic plants that attracted attention and established her reputation as a 'Botanic Sybil'.[4] Visitors to her garden laid eyes on plants from the Americas, the Caribbean, Africa, and Asia, including lemon trees, jasmine, and oleander.[5]

2 Van de Graft, *Agnes Block*, p. 64.
3 Blok, *Vyver-Hof van Agneta Blok*.
4 Breyne, *Prodromus Secundus*, pp. 61–62.
5 Hermann, *Paradisus Batavus*, pp. 95–99; Breyne, *Prodromus Secundus*, pp. 61–62; Blok, *Vyver-Hof*.

Not uncommon for her socio-economic background, Block maintained a non-commercial artistic practice. She is believed to have produced watercolours and paper-cuttings of plants and flowers. This practice, much like the works by the artists she commissioned, would have been intertwined with Vijverhof. In addition to a collection of insects, shells, and other *naturalia*, she amassed more than four hundred watercolors of plants, flowers, insects, and animals (particularly although not exclusively birds), by some of the best artists of the time.

Self-Fashioning as Flora Batava

Block engaged in self-fashioning, meaning the conscious shaping of 'a distinctive personality, a characteristic address to the world, a consistent mode of perceiving and behaving.'[6] She was not the only woman to do so (one need only think of Petronella de la Court and her renowned dollhouse); but her self-fashioning was inextricably intertwined with Vijverhof and botany. The persona through which she 'negotiated her place' in the world of botany and artistic patronage would have been inflected by her socio-economic class, the cultural and religious institutions to which she belonged.[7]

The culmination of Block's self-fashioning is embodied in a medal designed and cast by Jan Boskam in 1700, memorializing Block as Flora Batava.[8] As noted at the outset, the medal bore Block's motto, 'labour and art succeed where nature falls short', which could be interpreted as 'art improves upon nature'.[9] Not coincidentally, the pineapple that Block successfully grew in 1687, together with a Melocactus, feature prominently in the iconography of the medal. For Block, art and nature, in the guise of her engagement with artistic networks, also succeeded in preserving her rare botanical specimens for posterity — stopping time, as it were — something that nature could not do.

An Unconventional Portrait by Jan Weenix

Block was not shy about having her portrait painted. In addition to the *médailleur* Jan Boskam, the painters Jan Weenix (1641/2–1719) and Adriaen van der Werff (1659–

6 Greenblatt, *Renaissance Self-Fashioning*, p. 2.

7 I am guided here by Laura York, who notes that for art historians, examining early modern women's self-fashioning can be a 'useful tool for early modern historians who, in the absence of autobiographical evidence, want to look at how an individual negotiated family, friendship, and business relationships.' York, 'Spirit of Caesar', p. 499; Greenblatt, *Renaissance Self-Fashioning*, p. 254.

8 Although no records of the commission exist, the highly personalized iconographic program suggests that Block herself commissioned the medal. There are at least six surviving units of the Block portrait medal in Dutch museums, including three silver ones: Amsterdam, Utrecht, and Haarlem. Van de Graft mentions a gold exemplar, but I have been unable to locate it. Van de Graft, *Agnes Block*, p. 122.

9 Jan van der Groen referred to experience, inventions, and arts in reminding his readers that nature could be transformed into a beautiful, orderly, garden. Van der Groen, *Den Nederlandtsen Hovenier*. See also Fleisher, *Beemster Polder*, p. 149 and De Jong, *Nature and Art*, p. 18.

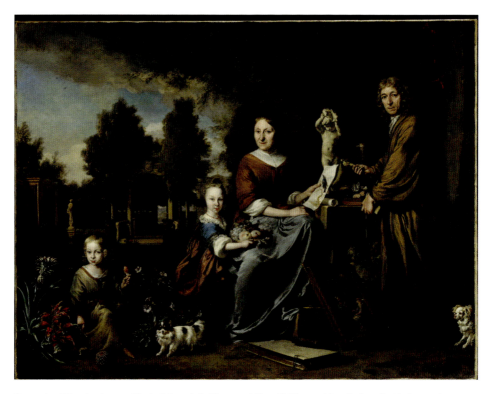

Fig. 2. Jan Weenix, *Agneta Block, Sybrand de Flines and Two Children at Vijverhof on the Vecht*, c. 1693. © Amsterdam Museum.

1722) and the draftsman Johannes Thopas (1626–1688/1695) produced portraits of Block. In each artwork, Block's likeness is unmistakable. Her features age across the portraits, but there is an immediate familiarity upon encountering her gaze. In each case, Block's passion for botany, her estate, and her watercolours make an appearance, as much part of Block's identity as her dress.

In or about 1693, Jan Weenix painted a large portrait of Block and her husband in front of Vijverhof (Fig. 2). Weenix depicts Block unfurling a drawing of a bird, almost certainly from her collection (possibly a red-legged honeycreeper or a bird from the bee-eater family) above a stone ledge on which are displayed her collections of shells, insect specimens, and a statue.[10] Her feet rest on a large portfolio, most likely containing her watercolours. Her husband stands to the right of the composition, with his back to the viewer and his head turned over his shoulder, as if casting a glance back at the viewer. A potted pineapple, in the left foreground, is impossible to miss.

10 The bird has frequently been identified as a kingfisher. I am grateful to Dr Sheila ffolliott for suggesting the possibility of a bird from the bee-eater family. Similarly, I wish to acknowledge Deniz Martinez's suggestion of a red-legged honeycreeper, a bird native to the Neotropical Americas, which would confirm that Block was not only a pioneer in botany, but also in ornithology.

It was not unusual for successful men to commission portraits of themselves with their prized possessions, in a bid to make a statement about their financial success and worldliness. Strikingly, however, the focus of this portrait is Block: her garden, her art collection, her books, and her watercolours. The artist's unconventional composition reflects an uncommon individual. Seated, her gaze directed at the viewer, she presents herself as a successful and admired patron and amateur botanist — as a woman of impressive achievement. This was a carefully curated image.

A close examination of the Weenix portrait yields helpful information regarding Block's artistic network, as seen for example with the inclusion of the pineapple. Pineapples were known in Europe from the time of Christopher Columbus's travels to America.[11] Attempts to grow them in Europe, however, were unsuccessful for nearly two centuries, the cold climate being suboptimal to the cultivation of exotic fruits. Against the odds, Block did manage to grow a pineapple in 1687, which she asked the artist Alida Withoos (1661/2–1730) to immortalize — 'from life', albeit slightly smaller than the original.[12] Block would have been proud of her accomplishment, hence the Withoos commission and the fruit's prominence in the Weenix portrait. The same is true of the several other rare plants included in the painting.

Some of these specimens are in the foreground and highly visible, while others are in the middle ground and more difficult to identify. Sam Segal identified eleven species, including: trumpet vine; St Joseph's coat; rose of Sharon; *heliocereus* (a flowering cactus); bitter orange; agave; and pomegranate. These were meaningful plants, although not in the usual emblematic manner. They were most likely purposefully selected for their rarity and because Block cultivated them. At least two of the specimens in the painting can be linked to surviving drawings that belonged to Block, namely the bright scarlet and lime green of the St Joseph's coat and the trumpet vine, illustrated by Monogrammist A.B. and Withoos, respectively. These specimens embody Block's self-fashioning as Flora Batava. They also serve as a visual manifestation of the various artists Block commissioned, brought together by Block and Vijverhof.

11 Avery and Calaresu, eds, *Feast & Fast*, p. 73. On the history of the cultivation of pineapple in Western Europe, see also Levitt, 'A Noble Present of Fruit'. I am grateful for the insight provided by Julie Hochstrasser on the occasion of her presentation entitled '"Familiar Exotic": The Pineapple in Seventeenth-Century Dutch Painting', at the conference *Power, Promise, Politics: The Pineapple from Columbus to Del Monte* at the University of Cambridge on 21 February 2020. Portions of this discussion on the pineapple and Block's cultivation of one are drawn from my essay 'Pineapple Lady'.

12 Letter from Block to Trionfetti, Amsterdam, 16 January 1688. Block's success in growing a pineapple is also discussed briefly in Kooij, ed., *Kassen in Nederland 1650–1950*, pp. 73–78. The artwork by Withoos does not seem to have survived. Inventory of Valerius Röver, Special Collections, MS II A 18, University of Amsterdam (hereinafter simply referred to as the Röver Inventory). Röver acquired a portion of Block's collection of watercolours after her death. See also Van de Graft, *Agnes Block*, p. 138. In all likelihood, the pineapple raised by Block was of the Queen variety, which is the sort of pineapple exported from the Dutch Republic to England in the early eighteenth century and by far the most common in Europe by the eighteenth century.

Block's Watercolours as a Manifestation of an Artistic Network

Block's superlative collection of watercolours included representations of flowers, plants, birds, and insects.[13] Of this collection, one volume (referred to herein as the *Bloemenboek*) survives intact, the other works having been separated and now being part of collections in museums around the world.[14] The title page of this volume informs us that it contains 'Plusieurs espèces de Fleurs dessinées d'après le Naturel' — many species of flowers drawn after nature. Block's collection of watercolors was of enormous significance to her, as evidenced by its reference in her portraits.[15] We also know from Block's various testaments and codicils that she prized her collection and that she conceived of it as a whole with Vijverhof. Her testament of 1694 specifies that 'All of the testatrix's artworks of birds, plants, herbs, and other watercolours and paintings' are to remain at Vijverhof.[16]

Arguably, hers was the most important collection of watercolors commissioned by an individual for the purposes of memorializing an actual collection of *naturalia*, certainly in the Dutch Republic. The *Bloemenboek* exemplifies the best botanical art of the seventeenth-century: it represents not only the merger between nature and art — Juliette Ferdinand's 'profound interaction, or in some cases real fusion', but also the intersection between art and science.[17] The collection is noteworthy for its size, but more particularly for its quality. Block was a wealthy patron and she would have spent a great deal of money on the watercolours. The artists who produced them were among the best of the time. They included, among others: Herman Henstenburg (1609–1685), Johanna Helena Herolt (1668-after 1723), Jan Moninckx (*c.* 1656–1714), Maria Moninckx (1673–1757), Herman Saftleven (1609–1685), Otto Marseus van Schrieck (1619–1678), Alida Withoos, Pieter Withoos (1655–1692), Johannes Withoos (1648–1688), Johannes Bronkhorst (1648–1727), and Maria Sibylla Merian (1647–1717).[18]

Vijverhof provided the backdrop for Block and these artists. Working together in building the collection, they formed an artistic network based on the relationships they brought with them at Vijverhof and the contacts that they made at the estate,

13 I use the generic term 'watercolours' in this essay even though, strictly speaking, the works to which I refer also included from time to time gouache, graphite, and gum Arabic.

14 Multiple Artists, *Bloemenboek* 'Plusieurs Espèces de Fleurs dessinées d'après le Naturel', *c.* 1680–1700. Rijksmuseum, RP-T-1948–119.

15 Although not discussed here, the portrait of Block by Adriaen van der Werff (*c.* 1693) also shows her holding a drawing, this time of a trumpet vine, possibly by Alida Withoos. The whereabouts of this portrait are unknown. See RKD IB number 102673.

16 Agneta Blok, testament of 18 December 1694. SA, Notarial Archives 5075, Notary Jac. Van den Ende, inv. 202, no. 5118, folios 86 and following.

17 Ferdinand, ed., *From Art to Science*, p. 10.

18 This list is based on observations of works known to have belonged to Agnes Block (due to the notes she made on the works) as well as based on the Röver Inventory. Based on extensive discussions with Henrietta Ward of the Fitzwilliam Museum, for which I am immensely grateful, I have concluded that the attributions made by Röver are frequently unreliable.

thereby establishing a network of artists with expertise in an artistic genre that combined art and science. Block was a central figure in this network, which solidified her legacy as Flora Batava.

Artistic 'Clusters'

Some of the artists whom Block commissioned would have known each other prior to or apart from their connection to Vijverhof. These 'artistic clusters' — meaning small groups of individual artists who evolved within the same circles — were based on family, geography, and/or training.

The first such cluster existed around Van Schrieck. Van Schrieck belonged to the *Bentvueghels*, a group of Netherlandish artists who were active in Rome during the seventeenth century. He travelled to and spent several years in Italy with Matthias Withoos (1627–1703), the father of Alida, Pieter, and Johannes Withoos, where they both worked for Ferdinand II de'Medici.[19] Both Van Schrieck and Matthias came to specialize in the genre of *sotto bosco*, or forest floor, a genre with which that Alida and her siblings would also experiment. Given the bond between their father and Van Schrieck, it would seem natural that the siblings would have known him, or at the very least been familiar with his work.

Another cluster existed around Bronkhorst and Henstenburgh. Bronkhorst trained Henstenburgh, thereby marking the existence of a strong relationship be-tween the two men.[20] Both lived in Hoorn, the town where the Withoos family moved to from Amersfoort in 1672.[21] Alida remained in Hoorn until 1703, while Pieter lived there until 1686.[22] This supports the inference that the two siblings, Bronkhorst, and Henstenburgh would likely have known each other and certainly known of each other. They could have crossed paths either in Hoorn or at Vijverhof. Once again, given the fact that they specialized in the illustrations of *naturalia*, particularly flowers, insects, and birds, it seems highly unlikely that they should have operated unaware of each other.

When Pieter Withoos left Hoorn, he spent one year in Utrecht (where Saftleven lived), and after 1687 established himself in Amsterdam, where Jan and Maria Mon-inckx (likely his niece) also lived. Merian and Herolt arrived in 1691 and Alida in 1703.[23] Amsterdam, of course, was a large, bustling city. Given the expertise of these artists and their shared commissions, however, it seems unlikely that they would not have known each other, or at least been familiar with each other's work. It is also highly probable that they would have come into contact at the Amsterdam *hortus medicus*, which was open to the public, observing and sketching.

19 Boersma, *Ander licht op Withoos*, pp. 42–53; Segal and Allen, *Dutch and Flemish Flower Pieces*, pp. 467–68 and 544.
20 Segal and Allen, *Dutch and Flemish Flower Pieces*, p. 506.
21 Segal and Allen, *Dutch and Flemish Flower Pieces*, p. 544; Boersma, *Ander licht op Withoos*, pp. 59–64.
22 Missel, *De wereld van Alida Withoos*.
23 Segal and Allen, *Dutch and Flemish Flower Pieces*, pp. 546 and 549; Powell, 'Alida Withoos'.

Artists Working in situ

Vijverhof was an 'experimental laboratory' as well as an artistic community.[24] In order to present the most faithful representation of plants, flowers, insects, and birds, artists needed to be near their models in order to render them 'after nature'.[25] Producing images that conveyed the texture and volume of leaves, petals, and feathers could only be achieved from dead and dried specimens with difficulty. Rather, artists most likely came to Vijverhof and stayed for periods of time during the spring and summer months, in order to be on hand to illustrate specimens as their life cycles unfolded. The artists that Block commissioned came from Rotterdam, Hoorn, Amsterdam, Utrecht, and Haarlem. Travelling to Vijverhof would have taken a fair amount of time even with regular and reliable water transportation services.[26] It only makes sense that the artists would have stayed at Vijverhof (a property sufficiently large to accommodate guest facilities) or close nearby when working on commissions from Block.

Herman Saftleven, with 'his artful way / so soft and alive on canvas and on paper', was Block's favorite artist.[27] During the relevant time, he lived in Utrecht, not far from Vijverhof. Saftleven scrupulously signed his works with the date on which he made them. Thanks to his careful notations, we know that he would have been at Vijverhof in July, August, and September 1682.[28] He returned to Vijverhof in April, September, and October of 1683, and returned in 1684 and 1685, the year he died.[29] Saftleven's many returns to Vijverhof suggest a very close relationship between him and Block. He was a successful artist who had a long and distinguished career. Presumably, he accepted Block's commissions because she was a generous patron and/or he liked her and enjoyed spending time at the country estate. He is unlikely to have been the only artist to feel this way.

24 The concept of 'garden as laboratory' is now well researched. Fabrizio Baldassarri, in his discussion of gardens as laboratories, refers to them as 'spaces of practical knowledge'. Baldassarri, 'Introduction: Gardens as Laboratories. A History of Botanical Sciences?', p. 11.

25 Having said that, multiple art historians have noted the liberality with which early modern artists applied the label 'after nature' or 'after life'. See Claudia Swan's seminal work, '*Ad vivum, naer het leven*, from the life: defining a mode of representation'. See also Egmond, *Eye for Detail*.

26 Israel, *The Dutch Republic*, p. 871.

27 Blok, *Vyver-Hof*, lines 78–79.

28 Herman Saftleven, *Bladder Senna and Sticky Catchfly*, 10 July 1682, Rijksmuseum, RP-T-1948–93. Herman Saftleven, *Three Branches of Digitalis Virginiana With Blooms*, 21 July 1682, Klassik Stiftung Weimar, KK5369. Herman Saftleven, *Botanical Study: Four Pink Carnations*, 27 July 1682, British Museum, 1881,0709.77. Herman Saftleven, *Bladder Senna (Colutea Arborescens)*, 15 August 1682, Rijksmuseum RP-T-1948–92. Herman Saftleven, 23 August 1682, *Lisymachia and Pomegranate*, Klassik Stiftung Weimar, KK5368. Herman Saftleven, *Laburnum*, 17 September 1682, Sotheby's London, 1999-04-14, no. 102. Image RKD. Herman Saftleven, *Hollyhock*, September 21, 1682, Getty Museum, 2014.42.

29 Herman Saftleven, *Study of Three Fritillaries*, 14 April 1683, Metropolitan Museum of Art, 2019.276.10. Herman Saftleven, *Succulent*, 18 September 1683, Rijksmuseum, RP-T-1948-94. Herman Saftleven, *Flowering Cactus*, 20 September 1683, Rijksmuseum, RP-T-1902-A-4578. Herman Saftleven, *Botanical Study: Solanum (Nightshade) Indicum Maximum (Madagascar Potato)*, 10 October 1683, British Museum 1836,0811.504. See also Röver Inventory.

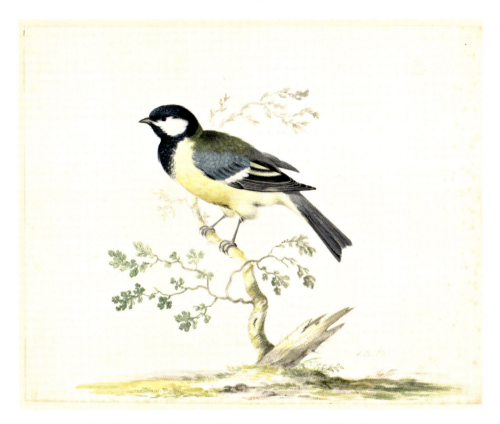

Fig. 3. Johannes Bronkhorst, *Blue Titmouse*, 1668–1727. Herzog Anton Ulrich Museum, Braunschweig. BPK/Bildagentur.

Unfortunately, none of the other artists whom Block commissioned were as careful as Saftleven in dating their works. It is therefore not possible to determine with certainty who would have overlapped at Vijverhof. Given the large number of watercolours that the artists produced for Block, however, it is most likely they stayed at Vijverhof for extended periods of time, and/or made frequent visits. The period during which the garden was at its best for illustrating was relatively short. Encounters between artists would have been inevitable. When meeting, they might have exchanged technical tips, materials, or other information about patrons and opportunities. Considering drawings of titmouse by Pieter Withoos, Bronkhorst, and Weenix, for example, one can only wonder whether the three artists shared insights as to the combination of scientific accuracy and aesthetic idiom that might best please their patron (Figs 3, 4, and 5).

The notion of 'influence' in art history is fraught.[30] Bearing this in mind and with caution, the expression influence here is used to mean an inchoate series of

30 Amongst other concerns, using influence as an analytical framework suggests the existence of discernable causes with traceable effects, while glossing over the speculative nature of these links. Furthermore, it risks

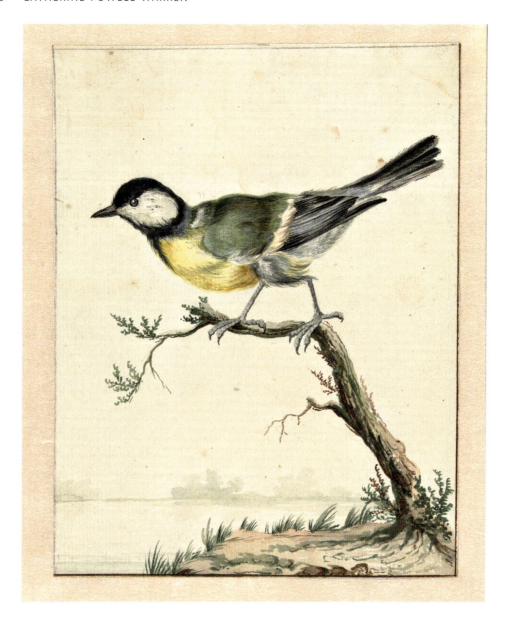

Fig. 4. Jan Weenix, *Great Tit*, c. 1650–1719. Rijksmuseum, Amsterdam.

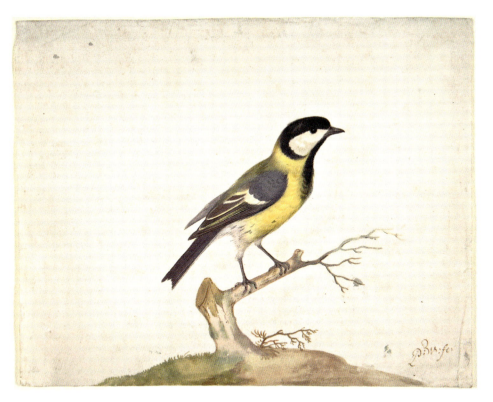

Fig. 5. Pieter Withoos, *Great Titmouse*, 1670–1693. Metropolitan Museum of Art, New York.

'mechanisms of transmission'.[31] Such mechanisms permeated the artistic community of Vijverhof. There, influence was at turns technical, based on shared resources, economic and geographic. The artists that Block commissioned worked from shared resources that included the gardens, the aviary, Block's insect collection, and each other. Influence also came in the form of Block's preferences. It was these 'constellation of causes' that 'coalesced within and informed' Block's watercolours.[32]

Thus, the illustrations of titmouse by Withoos, Bronkhorst, and Weenix are different and betray individual artistic sensibilities and agency. All three birds are illustrated in detail, making identification possible. All three sit on crooked branches planted into a slight mound of soil. Withoos's and Bronkhorst's birds grip the branch with their claws, while Weenix's balances oddly on it, without holding on, suggesting that the branch may have been added after the bird was completed. Notwithstanding their individuality, however, the watercolours share a sense of compositional harmony,

overshadowing artistic agency, something which frequently does a disservice to the study of female artists and other marginalized or peripheral figures. See Baxandall's critical work *Patterns of Intention*.
31 I owe the expression 'mechanisms of transmission' to Kirk Ambrose. Ambrose, 'Influence', p. 198.
32 Ambrose, 'Influence', p. 198.

edging on uniformity. These artworks were the product of the 'mechanisms of transmission' through which scientific information, together with Block's preferences, the resources she offered, as well as geography and artistic currents, were manifested.

Conclusion

Block's engagement with the artistic network discussed in this essay was critical in establishing her reputation and shaping her public persona as Flora Batava. She provided financial support by way of patronage to at least twenty artists. She opened Vijverhof to many of them, where a community of exchange developed and where artists could gain access to further commissions. The Weenix portrait and Block's watercolours delineate an artistic network and provide us with a vision of Block as a source of influence for many of the late seventeenth-century's best regarded artists. Block, Vijverhof, and the artists were nodes in a network worked together to preserve Flora Batava and her specimens for posterity.

Bibliography

Manuscripts and Archival Sources

Inventory of Valerius Röver, Special Collections, MS II A 18, University of Amsterdam
Agneta Blok, testament of 18 December 1694. SA, Notarial Archives 5075, Notary Jac. Van den Ende, inv. 202, no. 5118, folios 86 and following

Primary Sources

Blok, Gualtherus, *Vyver-Hof van Agneta Blok* (Amsterdam: For the Author, 1702)
Breyne, Jacob, *Prodromi fasciculi rariorum plantarum primus et secundus* (Gdansk: Thom. Joh. Schreiberi, 1680 and 1689)
Groen, Jan van der, *Den Nederlandtsen hovenier* (Amsterdam: M. Doornick, 1670)
Hermann, Paul, *Paradisus batavus, continens plus centum plantas affabré aere incisas & descriptionibus illustratas* (Leiden: Abraham Elzevier, 1698)

Secondary Studies

Ambrose, Kirk, 'Influence', *Studies in Iconography*, 33 (2012), 197–206
Avery, Victoria and Melissa Calaresu, eds, *Feast & Fast: The Art of Food in Europe, 1500–1800* (Cambridge: University of Cambridge; Fitzwilliam Museum, 2019)
Baldassarri, Fabrizio, 'Introduction: Gardens as Laboratories. A History of Botanical Sciences?', Special Issue: *Gardens as Laboratories. The History of Botany through the History of Garden*, ed. by Fabrizio Baldassarri and Oana Matei, *Journal of Early Modern Studies*, 6.1 (2017), 9–19
Baxandall, Michael, *Patterns of Intention: On the Historical Explanation of Pictures* (New Haven: Yale University Press, 1985)
Boersma, Albert, with a contribution by Miriam Kolk, *Ander licht op Withoos: Drie generaties Withoos* (Amersfoort: Uitgeverij Boiten Boekproject Amersfoort, 2022)
De Jong, Erik A., 'Earthly Stars: On the Worship of Flora', in *In Full Bloom*, ed. by Ariane van Suchtelen et al. (Zwolle: Waanders; The Hague: Mauritshuis, 2022), pp. 67–81
———, *Nature and Art: Dutch Garden and Landscape Architecture 1650–1740* (Philadelphia: University of Pennsylvania Press, 2001)
Egmond, Florike, *Eye for Detail: Images of Plants and Animals in Art and Science 1500–1630* (London: Reaktion Books, 2017)
Ferdinand, Juliette, ed., *From Art to Science: Experiencing the European Garden 1500–1700* (Treviso: ZeL Edizioni, 2016)
Fleischer, Alette, 'The Beemster Polder: Conservative Invention and Holland's Great Pleasure Garden', in *The Mindful Hand: Inquiry and Invention from the Late Renaissance to Early Industrialisation*, ed. by Lissa Roberts, Simon Schaffer, and Peter Dear (Amsterdam: Koninklijke Nederlandse Akademie van Wetenschappen, 2007), pp. 145–67
Greenblatt, Stephen, *Renaissance Self-Fashioning, From More to Shakespeare* (Chicago; London: The University of Chicago Press, 2005)

Israel, Jonathan, *The Dutch Republic its Rise, Greatness, and Fall: 1477–1806* (Oxford: Clarendon Press, 2007)

Kooij, Ben, ed., *Kassen in Nederland 1650–1950: Studie over de geschiedenis, de ontwikkeling en het behoud van planten kassen* (Amersfoort: Stichting in Arcadië, 2019)

Levitt, Ruth, '"A Noble Present of Fruit": A Transatlantic History of Pineapple Cultivation', *Garden History*, 42.1 (Summer 2014), 106–19

Missel, Liesbeth, *De wereld van Alida Withoos (1662–1730): Botanisch tekenares in de gouden eeuw* (2000) <https://edepot.wur.nl/333155> [accessed 7 September 2022]

Poelhekke, Jan Joseph and H. C. J. Oomen, eds, *Elf brieven van Agnes Block in de Universiteitsbibliotheek te Bologna* (The Hague: Staatsdrukkerij- en Uitgeverijbedrijf, 1963)

Powell-Warren, Catherine, 'Pineapple Lady: Expertise and Exoticism in Agnes Block's Self-Representation as Flora Batava', in *Women, Collecting, and Cultures Beyond Europe*, ed. by Arlene Leis (London: Routledge, 2023), pp. 95–99

Powell, Catherine, 'Locating Early Modern Women in the Public Sphere of Botany: Agnes Block (1629–1704) and Networks in Print', *Early Modern Low Countries*, 4.2 (December 2020), 234–58

———, 'Alida Withoos: Creator of Beauty and of Visual Knowledge', *ArtHerstory.net*, 5 December 2020

Swan, Claudia, '*Ad vivum, naer het leven*, From the Life: Defining a Mode of Representation', *Word & Image*, 11.4 (October-December 1995), 353–72

Van de Graft, C. Catharina, *Agnes Block, Vondels nicht en vriendin* (Utrecht: A. W. Bruna & zoon, 1943)

York, Laura, 'The "Spirit of Caesar" and His Majesty's Servant: The Self-Fashioning of Women Artists in Early Modern Europe', *Women Studies*, 30 (2001), 499–520

NADETTE XUEREB

Cosmana Navarra (c. 1600–1687) *

A Case Study on a Female Patron of the Arts in Baroque Malta

▼ **ABSTRACT** During the second half of the seventeenth century, the Maltese noblewoman Cosmana Navarra funded the reconstruction and embellishment of St Paul's Church in Rabat, Malta, on the site that St Paul was held to have been imprisoned. This article discusses Navarra during the Baroque period, within the context of Malta and Europe, and analyses her commissions and contribution as the first known Maltese female patron of the arts. The patterns of her patronage fits into the study of intermediary patrons.

Cosmana Navarra was a noblewoman who lived in Malta during the seventeenth century, whose role as a philanthropist, and a benefactor of works of art, particularly in her maturity and older age, earned her positive acclaim over the years. She was a notable Maltese figure, commissioning work from artists in the Maltese Islands, yet she does not seem to have been a collector. Her commissions seem to be mostly limited to the reconstruction and embellishment of her parish church of St Paul in Rabat, which was the borgo of the old city of Mdina. Her significance as a patron mostly emerges in her role in this project.[1]

During the seventeenth century, visual culture impinged on women's lives and the manner in which their gender was perceived, yet women had a consequential role in the production and consumption of art.[2] As in the case of female artists, there have been many instances in which female patrons were given less significance than their male counterparts.[3] Nevertheless, many women, especially aristocrats, such as the sixteenth century patron Catherine de' Medici,[4] resisted this, and used this to make

* This paper is based on the research done by the author for her M.A. in History of Art (by Research) thesis at the University of Malta in 2021, under the supervision of Professor Keith Sciberras. Acknowledgements: Professor Keith Sciberras.
1 Xuereb, 'Cosmana Navarra (1600–1687)'.
2 Johnson and Grieco, 'Introduction' in *Picturing Women*.
3 Haskell, *Patrons and Painters*, p. 64.
4 Lawrence, *Women and Art in Early Modern Italy*.

Women in Arts, Architecture and Literature: Heritage, Legacy and Digital Perspectives, ed. by Consuelo Lollobrigida and Adelina Modesti, Women in the Arts: New Horizons, 1 (Turnhout: Brepols, 2023), pp. 125–140
BREPOLS ॐ PUBLISHERS
10.1484/M.WIA-EB.5.134647

a proclamation on family, religion, power and cultural heritage through the art they commissioned.

In the Maltese context, there have been a small number of female patrons of the arts, most notably Cosmana Navarra, who rose to prominence during the Baroque age. She cannot be compared to the level that contemporary international patrons reached, however, considering the size, and financial and artistic limitations of the Maltese Islands, the work that she carried out was impressive, even more so since she was a woman in a small island dominated by men. This makes her study even more fascinating from the view of gender studies, wherein in this respect, she is a newcomer to literature in the field. Previous references to her were restricted to the context of village patronage.[5]

The works that Cosmana Navarra commissioned also show that she wanted to present herself as a patron. Her coat of arms is commemorated on the artworks, and she is also referred to as the founder in a plaque in the Church of St Paul. She is also commemorated in two portraits.

Donna Cosmana Navarra (Figs 1–2) was born around 1600,[6] and lived in Mdina and Rabat,[7] close to the seat of the bishop, and in the vicinity of the parish church of St Paul. She was the fourth sibling from five out of Dr Giovanni Cumbo's marriage to Cornelia Navarra. Navarra's father was a lawyer, from the Cumbo family of judges and jurists, whilst her mother was of Spanish noble origin,[8] from the Navarra family which had settled in the Maltese Islands during the fourteenth century.[9]

In 1615, Cosmana Navarra married Dr Melchior Vella Cagliares,[10] a lawyer with relations to the Curia and the nephew of Bishop Fra Baldassare Cagliares (1575–1633). This marriage bore one son, Ignazio, who died prematurely in 1640. Cosmana was widowed in 1624, at around twenty-four years old, and remarried a year later, in 1625, to Lorenzo Cassar. Despite her still young age, she did not bear any more children.[11]

Born into a noble family and having also married into nobility, Navarra lived as a benevolent woman throughout her life.[12] With the support of her second husband, she financed many artistic projects. Most of her commissions were continued or finalised after his death in 1660, as was typical in female patrons, who mostly emerged as significant artistic benefactors after the death of their husbands.[13]

5 Most of the preliminary research on Cosmana Navarra within the context of Rabat was made by the late Mgr. John Azzopardi. See: Azzopardi, 'Il-Knisja ta' S. Pawl tar-Rabat fis-1680'; 'L-Istorja tal-Bini tal-knisja ta' San Pawl tar-Rabat'; 'Iz-Zuntier jew ċimiterju ta' San Pawl fir-Rabat'; *St Paul's Grotto, Church and Museum at Rabat*.

6 Cosmana Navarra's birth date is undocumented. It is presumed that she was born around 1600, since her parents were married in 1597.

7 Navarra's residences were located at Casa Cosmana Navarra, opposite the Church of St Paul, and Palazzo Falson in Mdina.

8 Cornelia Navarra retained her maiden name in honour of its noble status. This may have also been the reason Cosmana was referred to by her mother's surname after she was widowed for the second time.

9 Azzopardi, 'Cosmana Navarra Fundatriċi u Benefattriċi'.

10 Mdina, Archives of the Cathedral Museum, *Liber Matrimoniorum*, I, 978.

11 Azzopardi, 'Cosmana Navarra Fundatriċi u Benefattriċi', p. 9.

12 Hoe, 'Cosmana Navarra', p. 113.

13 Xuereb, 'Cosmana Navarra', p. 13.

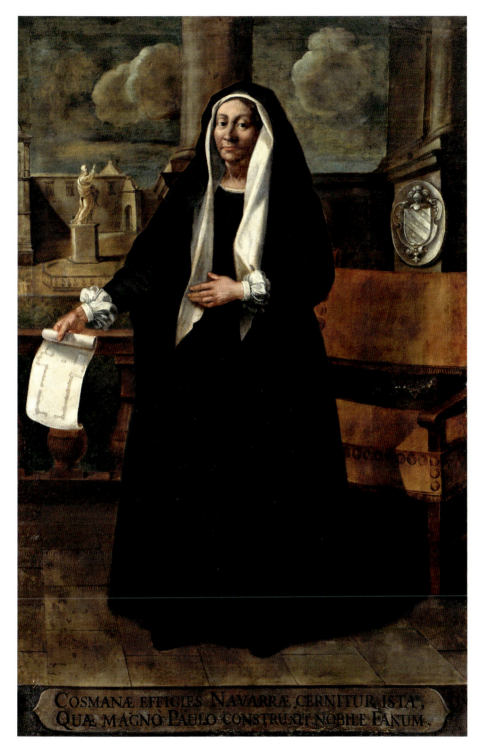

Fig. 1. Anonymous seventeenth century Maltese Artist, Full-Length Portrait of Cosmana Navarra, Wignacourt Collegiate Museum, Rabat. Photo credits: Joe P. Borg.

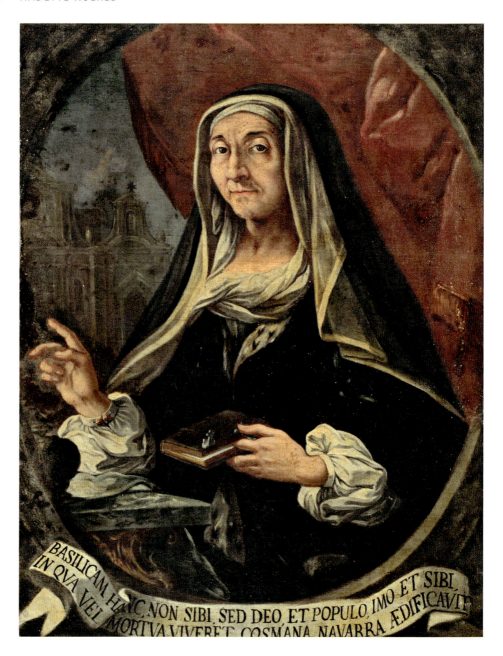

Fig. 2. Gio Nicola Buhagiar, Portrait of Cosmana Navarra, *c.* 1735, Sacristy, St Paul's Collegiate Church, Rabat. Photo credits: Joe P. Borg.

The early demise of Cosmana's husband and son meant that she had control of her finances. This gave her the opportunity to dedicate more time towards the restructuring of St Paul's parish church, and the rebuilding of her Rabat townhouse. Most of her contributions to the construction of the church may be found in her wills and notarial inventories rediscovered through archival research.[14]

The Church of St Paul and Works Commissioned by Cosmana Navarra

According to tradition, the historic town of Rabat was the ground on which the earliest Christian community was founded at around 60 AD, whilst the Grotto of St Paul was the sacred location in which St Paul was imprisoned during his brief sojourn in Malta.[15] Rabat was also defined by the walls of the old city of Mdina, and thus was close to the epitome of Maltese elitism and the seat of the Christian religion prior to the arrival of the Order of the Knights of St John.

Cosmana Navarra lived during a fascinating period, mostly based on the political and religious influence that the Knights impinged on its community. The Roman Catholic diocese was also an authoritative force in the Maltese social and cultural context, and left a significant impact on patronage and artistic production.[16] Private patrons, like Navarra, also played an important role, by supporting the church and funding independent projects.[17]

During the seventeenth century, Rabat welcomed a pivotal change due to its emergence as a thriving suburb of the Civitas, and the flourishing of the Pauline Complex, made up of the parish church, the church of St Publius, the Collegio which led to the Grotto, the cemetery, the crypt and the catacombs.[18] Around the year 1645, Cosmana and her husband took on the project for the enlargement of the Church of St Paul (Fig. 3).[19] She thus became the financial mastermind of the project and should have participated in the conceptual part of its rebuilding and embellishment. This was also the same time in which the Knights of St John were embellishing the Church of St Publius, to the right of the Church of St Paul, and directly above St Paul's Grotto.[20]

Through collaboration with church procurators, Navarra appointed the Italian architect based in Malta, Francesco Buonamici (1596–1677), for its new design, and engaged the expertise of the Maltese architect Lorenzo Gafà (1639–1703) for the continuation of the project. The choice of Buonamici, the architect that the Knights had already used for the Church of St Publius, may indicate that the idea was to maintain harmony in the Rabat piazza, in the style of the building and through

14 Xuereb, 'Cosmana Navarra', p. 54.
15 Buhagiar, *The Christianisation of Malta*.
16 Sciberras, *Caravaggio to Mattia Preti*, p. 10.
17 Montalto, *The Nobles of Malta 1530–1800*, p. 165.
18 Thake, *Baroque Churches in Malta*, p. 66.
19 Valletta, Notarial Archives, MS 17, fols 120ᵛ–131ᵛ.
20 Sciberras, *Mattia Preti: The Triumphant Manner*, p. 72.

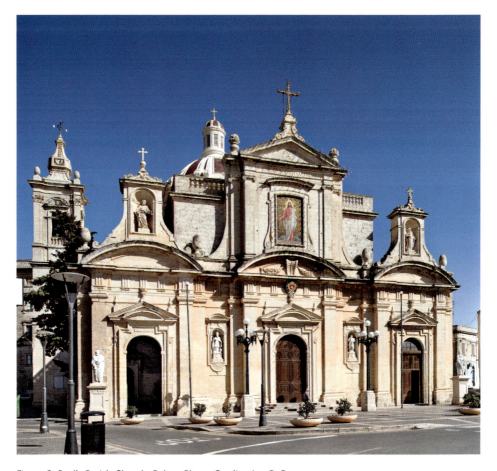

Fig. 3. St Paul's Parish Church, Rabat. Photo Credits: Joe P. Borg.

a unified façade. This choice may have also come through an inspiration from the Order.[21] Nonetheless, through this, Cosmana was also able to show her relevance and connoisseurship as a patron.

The plan of the church as designed by Buonamici was in a Latin-cross shape; with three main altars, and nine more altars within its perimeter.[22] On its left, a large parvis was meant to be integrated, whilst on the right was a church dedicated to St Publius. The Church of St Paul had an issue with the construction of its plan: the left side of the Latin-cross belonged to the Order of St John. For Cosmana to extend the church and give it the Latin-cross shape planned for it, she communicated directly with Grand Master Nicholas Cotoner, requesting the sale of the land; a request which was denied repeatedly. Navarra's perseverance as a patron emerges here: following Cotoner's passing in 1680, Grand Master Gregorio Carafa conceded in selling the

21 Galea, 'The Architecture and Spatial-dynamics of the Pauline Complex', p. 63.
22 There is no scope for formal analysis of the works here, but it must be underlined that the quality is major.

COSMANA NAVARRA (C. 1600–1687) 131

property to her,[23] through money as well as through an agreement that she would also fund the embellishments within the Church of St Publius.

Navarra spent more than 30,000 Maltese scudi on the reconstruction and embellishment of the Church of St Paul;[24] an impressive sum by a patron of the arts in Malta, especially for a woman.[25] She also embellished the interior of the church, commissioning the Maltese painter Stefano Erardi (1630–1716) for the titular of the *Shipwreck of St Paul in Malta* (1678) (Fig. 4), and the Rome-based Michelangelo Marullo and Mattia Preti (1613–1699) for the paintings of the *Virgin and Child with St Philip Neri and St Anthony the Abbot* (c. 1664–1666) (Fig. 5) and the *Martyrdom of St Stephen* (1681) (Fig. 6) within the side chapels respectively; potentially to create a deliberate paragon among the three artists.[26] Navarra also ordered two silver sanctuary lamps: one by the celebrated Maltese sculptor Melchiorre Cafà (1636–1667) at around 1666 (Fig. 7), and the other by an unknown artist who followed his style, based on Navarra's request, carried out posthumously in the late 1680s to early 1690s. She also ordered three sets of two candlesticks (1617, 1635, *sine die*), six altar ledge candlesticks (1675), and an ewer and basin.[27]

The mechanics of patronage employed by Navarra impacted the production of the works she commissioned. She must have commissioned some works of art directly from artists, taking on the role of patron and procurator for the church. It is also most likely that she collaborated with the church procurators of Rabat, and encouraged them to commission the works of art, acting as the benefactor behind the stance of the procurators or in direct collaboration with them. There are also instances where she would have donated works to the church procurators, to be utilised for the embellishment of the Church of St Paul.

23 Ferres, *Descrizione Storica*, p. 102.
24 Dal Pozzo, *Historia della Sacra Religione*, p. 548.
25 For more information on pricing of artworks, see: Sciberras, 'Rome – Naples – Malta: Patterns'.
26 Sciberras, *Baroque Painting in Malta*, p. 156.
27 Xuereb, 'Cosmana Navarra', pp. 126–35.

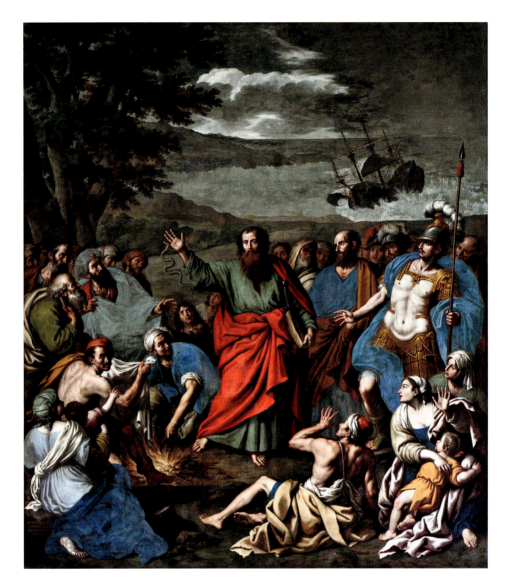

Fig. 4. Stefano Erardi, *Shipwreck of St Paul in Malta*, 1678, St Paul's Parish Church, Rabat. Photo credits: Joe P. Borg.

Fig. 5. Michelangelo Marullo, *Virgin and Child with St Philip Neri and St Anthony the Abbot*, c. 1664–1666, Church of St Paul, Rabat. Photo credits: Joe P. Borg.

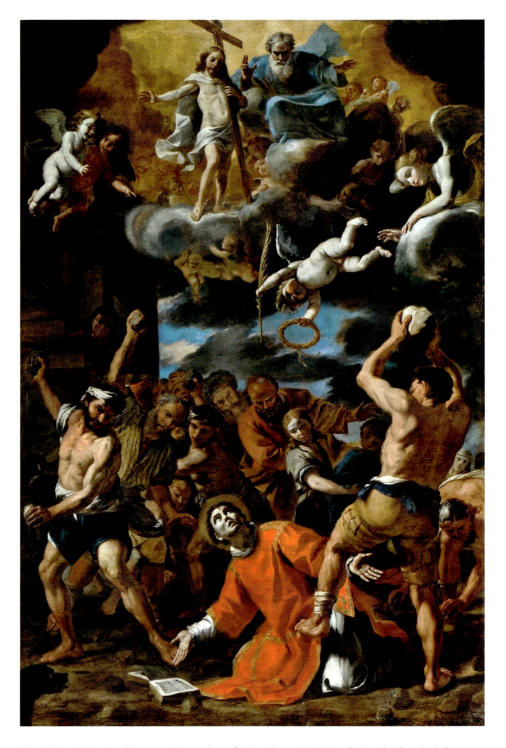

Fig. 6. Mattia Preti and Bottega, *Martyrdom of St Stephen*, 1681, St Paul's Parish Church, Rabat. Photo credits: Joe P. Borg.

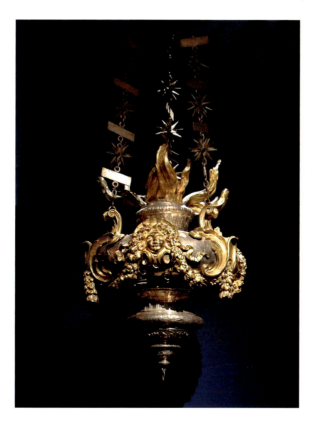

Fig. 7. Melchiorre Cafà, Unknown Maltese Silversmith, Silver Sanctuary Lamp, c. 1666, Chapel of St Anthony, Church of St Paul, Rabat. Photo credits: Joe P. Borg.

The Portrayal of Cosmana Navarra and other Female Patrons in Malta

Although most commissions were religious, secular commissions, such as portraiture, were also continuously prominent during the period in which Cosmana lived.[28] As denoted above through the presence of her coat of arms in the works she commissioned, Navarra also placed importance on her own depiction and the preservation of her memory. Her image, immortalised in various formats,[29] aided in the construction of her identity, and established her prominence in the art world.

The *Full-Length Portrait of Donna Cosmana Navarra*, at the Wignacourt Collegiate Museum, Rabat, gives an insight on the manner she was viewed, as a patron of the

28 Female patrons of the arts often commissioned female artists, supporting other women in their line of work. However, there is no evidence that Navarra did this. At the time, Suor Maria de Dominici, the subject of another paper, was a prominent, if somewhat limited female artist working in the bottega of Mattia Preti. Yet, Navarra seemed to strive to commission works from the best artists, without being reliant on their gender.
For more information on de Dominici, see Xuereb, 'Suor Maria de Dominici', and her essay in this volume, pp..
29 Navarra is also survived by a death-mask, which emphasises her relevance at the time.

arts and a noblewoman. Painted by an unknown artist, a feeling of pride is emitted from the standing female figure, who looks directly at the viewer, as if showing her dignified status.[30] She is depicted at a mature age and holds a plan of the church of St Paul in her right hand, which emphasises her link to the rebuilding and setting up of the church. In her background, the church, together with its parvis and the statue of the patron saint, all of which were commissioned by Cosmana, are depicted, together with her coat of arms. The inscription at the bottom of the painting identifies her as the noblewoman who built for St Paul.[31]

A posthumous half-length portrait, attributed to Gio Nicola Buhagiar (1698–1752),[32] also survives at the Church of St Paul, Rabat; the only portrait of a woman which is displayed prominently in this sacristy. In this portrait, Navarra wears the same dignified expression and is also accompanied by an inscription which identifies her achievements. The painting was commissioned to occupy the space in which it still is in today, abutting the chapel in which she is buried.

Although Cosmana was the female patron who spent the most, and the first to have a full-length portrait of herself, she was not the only female patron in Malta during the Baroque period. There were a few other female patrons, some of whom were also commemorated in portraits. In the *Portrait of Pietro Rosselli* and the *Portrait of Aloisietta Massa*, who were responsible for the embellishment of the Rosselli Chapel decorated by Mattia Preti,[33] Aloisietta is depicted with her husband, however she is humbler in execution, both when compared to Rosselli and to the *Full-Length Portrait of Cosmana*.[34] Yet, her depiction shows that she was respected in this regard.

The *Portrait of Flaminia Valenti* depicts a courtesan who repented from her sins, and built a hospital for prostitutes in Valletta for this reason.[35] She is displayed prominently, yet is still depicted in a humbler manner than Cosmana. Her sister, Caterina Valenti, worked for the embellishment of the St Paul Shipwrecked Church,[36] and in her portrait is depicted in half-length in the interior of the church;[37] like Cosmana's own half-length portrait.

The images that depict Cosmana Navarra remain testimony to her relevance and the way she was perceived during her lifetime and posthumously. In comparison to other patrons, she emerges as a prominent patron and benefactor who donated money and works of art for the church, especially in the later stages of her life, out of her own benevolence, rather than for repentance.[38]

30 Xuereb, 'Cosmana Navarra', p. 74.
31 De' Piro, *Lost Letters*, p. 31.
32 This attribution was made by Keith Sciberras by personal communication in June 2018.
33 Depasquale, 'Mattia Preti and the Rosselli-Massa Chapel'.
34 Delia, 'Secular Portraits'.
35 For more information, see Muscat, 'Female Prostitution'.
36 Ciantar, *Malta illustrata*, pp. 209–10.
37 Delia, 'Secular Portraits', p. 353.
38 Xuereb, 'Cosmana Navarra', pp. 87–100.

Conclusion

Before her death in 1687, Cosmana Navarra managed to successfully witness the ending of the ambitious project of St Paul's Church. She was independent in her own right, emerging as the most prominent female patron of the arts, and one of the most significant private patrons of the arts during the Baroque period in the Maltese Islands. Despite this, she was essentially a parochial patron, and nearly all her commissions were dedicated to the Church of St Paul, within her hometown.

This study singles out Cosmana Navarra for her project for the Church of St Paul, which, within a local context, was a notable undertaking that was successfully carried out despite her being widowed and with difficulties in acquiring land. Her emergence as a matriarch in her mature age meant that she was at liberty to make financial choices. This essay has analysed Cosmana Navarra's relevance for the world of art, as a female patron and as a benefactor, together with the image she fashioned as a patron, and the works of art she commissioned for the Church of St Paul at Rabat, despite the exclusivity of one parish. She emerges as the strongest female patron of Baroque Malta, who quickly became one of the most prominent patrons and benefactors of her time and remains one of the major female patrons in the story of Maltese art and architecture. Her story is a most welcome addition to the complex study of the roles that many women played throughout history.

Bibliography

Manuscript and Archival Sources

Mdina, Archives of the Cathedral Museum, *Liber Matrimoniorum*
Valletta, Notarial Archives, MS 17

Primary Sources

Dal Pozzo, Bartolomeo, *Historia della Sacra Religione Militare di San Giovanni*, I, Libro X (Verona, 1703)

Secondary Studies

Azzopardi, John, 'Cosmana Navarra Fundatriċi u Benefattriċi', *Il-Festa Tagħna*, 1995

———, 'Il-Knisja ta' S. Pawl tar-Rabat fis-1680', *Il-Festa Tagħna*, 1980

———, 'Iz-Zuntier jew ċimiterju ta' San Pawl fir-Rabat', *Il-Festa Tagħna*, 1985

———, 'L-Istorja tal-Bini tal-knisja ta' San Pawl tar-Rabat', *Il-Festa Tagħna*, 1983

———, ed., *St Paul's Grotto, Church and Museum at Rabat* (Malta, Progress Press, 1990)

Buhagiar, Mario, *The Christianisation of Malta: Catacombs, Cult Centres and Churches in Malta to 1530* (Oxford: Archaeopress, 2007)

Ciantar, Giovannantonio, *Malta illustrata, ovvero Descrizione di Malta isola del mare Siciliano e Adriatico: con le sue antichità, ed altre notizie* (expansion of Giovanfrancesco Abela's volumes), III-IV (Malta: Stamperia del Palazzo di S.A.S., 1780)

De' Piro, Nicholas, *Lost Letters: An Ostensibly Historical Divertimento* (Malta: Pedigree, 1986)

Delia, Romina, 'Secular Portraits of the Maltese Nobility, Gentry and Prominent Personalities (1600–1800)' (unpublished B.A. Honours thesis, University of Malta, 2005)

Depasquale, Andrea, 'Mattia Preti and the Rosselli-Massa Chapel at the Jesuit Church in Valletta' (unpublished B.A. Honours thesis, University of Malta, 2018)

Ferres, Achille, *Descrizione Storica della Chiese di Malta e Gozo* (Malta, 1866)

Galea, Lisa, 'The Architecture and Spatial-dynamics of the Pauline Complex, Rabat – within the Political Religious Context' (unpublished M.A. [by Research] thesis, University of Malta, 2019)

Haskell, Francis, *Patrons and Painters: Art and Society in Baroque Italy* (New Haven and London: Yale University Press, 1980)

Hoe, Susanna, 'Cosmana Navarra', in *Malta: Women, History, Books and Places* (Oxford: The Women's History Press, 2015), p. 113

Johnson, Geraldine A. and Sarah F. Matthews Grieco, *Picturing Women in Renaissance and Baroque Italy* (Cambridge: Cambridge University Press, 1997)

Lawrence, Cynthia, ed, *Women and Art in Early Modern Italy: Patrons, Collectors and Connoisseurs* (Pennsylvania: Pennsylvania State University Press, 1997)

Montalto, John, *The Nobles of Malta 1530–1800*, IV: *Maltese Social Studies* (Valletta: Midsea Books, 1979)

Muscat, Christine, 'Female Prostitution and Entrepreneurship in Valletta, *c.* 1630–*c.* 1798' (unpublished doctorate thesis, University of Malta, 2016)

Sciberras, Keith, *Baroque Painting in Malta* (Valletta: Midsea Books, 2009)

———, *Caravaggio to Mattia Preti* (Valletta: Midsea Books, 2015)

———, *Mattia Preti: Life and Works* (Valletta: Midsea Books, 2020)

———, *Mattia Preti: The Triumphant Manner* (Valletta: Midsea Books, 2012)

———, 'Rome – Naples – Malta: Patterns of Patronage and Pricing', in *Mattia Preti: Life and Works* (Valletta: Midsea Books, 2020), pp. 247–62

Thake, Conrad, *Baroque Churches in Malta* (Malta: Arcadia Publishers, 1995)

Xuereb, Nadette, 'Cosmana Navarra (1600–1687): The Role of a Female Patron of the Arts in Baroque Malta' (unpublished M.A. (by Research) thesis, University of Malta, 2021)

———, 'Suor Maria de Dominici: The First Maltese Female Artist and Her Presence in Late Baroque Malta and Rome' (unpublished B.A. Honours thesis, University of Malta, 2017)

KATARZYNA CHRZANOWSKA

Franciszka Wiszowata

A Nun as a Patron of the Art and Artist in Cracow in the Eighteenth Century

▼ **ABSTRACT** This chapter focuses on female religious art patronage and production in the eighteenth century, a topic that has long been overlooked by traditional scholarship. The Convent of St Joseph of the Bernardine Sisters of the Third Order of St Francis in Cracow proves to be an exemplary case to study the active role of women religious in the arts. This chapter will focus on one nun, Franciszka Wiszowata (1701–1777), who funded various works of art for the convent using her own resources, renovated and constructed new parts of the convent, and found donors who contributed gifts and provided financial support for her initiatives. Her notes and chronicles provide us with further insights into her artistic foundations and initiatives for her convent. By exploring her role as a patron and artist in the convent, this chapter sheds new light on female religious art patronage and production in eighteenth-century Cracow.

Artistic patronage in eighteenth-century Cracow, and the daily lives of female religious and their artistic endeavors have long been overlooked by scholarship. The history and functioning of the Convent of St Joseph of the Bernardine (Observant Franciscan) Sisters of the Third Order of St Francis in Cracow was the subject of a book by Romuald Gustaw published in 1947,[1] and an updated version of this book was published in 2013.[2] However, still many questions remain unanswered and the contributions of various individuals involved in artistic commissions for the church and nunnery have received inadequate attention. Among the most interesting, yet intriguing nuns, who lived in the Convent of St Joseph in the eighteenth century, is Franciszka Wiszowata.

1 Gustaw, *Klasztor i kościół św. Józefa ss. Bernardynek w Krakowie*.

2 Gustaw and Sitnik, *Klasztor i kościół*. New edition of the book is extended (but not amended) version of the book written by Romuald Gustaw and published in 1947. In this paper I cite only the second edition as it was not changed in any way in chapters included in the first edition.

Women in Arts, Architecture and Literature: Heritage, Legacy and Digital Perspectives, ed. by Consuelo Lollobrigida and Adelina Modesti, Women in the Arts: New Horizons, 1 (Turnhout: Brepols, 2023), pp. 141–158
BREPOLS ❧ PUBLISHERS 10.1484/M.WIA-EB.5.134648

The Convent of St Joseph of the Bernardine (Observant Franciscan) Sisters of the Third Order of St Francis in Cracow was founded in 1646 on the initiative of sister Teresa (lay name Katarzyna Zadzikówna), who was a nun in the convent of St Agnes of the Bernardine Sisters in the same city.[3] The convent's church of Saint Joseph was built in 1694–1702 at the expense of the nuns with the help of the voivode of a nearby city of Sandomierz Michał Warszycki and after his death, with the help of Fr Franciszek Leśniewicz.[4]

Sister Franciszka Wiszowata was born in 1701 and was given the name of Eufrozyna at her baptism (Fig. 1).[5] Her parents were Benedykt Wiszowaty, most probably identical with an Arian author and publisher,[6] and Katarzyna née Przypkowska.[7] According to her own notes made in the chronicle of the convent in 1732, she was raised by a childless woman, Teresa Szemittchowa, a wife of a castellan.[8] Additionally, she has noted that the sons of the castellan of Radom Franciszek Morsztyn were her cousins.[9]

Franciszka Wiszowata joined the convent of St Joseph as a 'profeska' [profess] after taking her first vows on 4 January 1722, at the age of 21.[10] Wiszowata took her religious habit from curator of the Convent of St Bernardino of Siena in Cracow of the Province of the Immaculate Conception of the Blessed Virgin Mary of the Order of the Friars Minor in Poland.[11] She made her perpetual vows on 6 January of the following year.[12] It was at the time when Anna Koniecpolska was the mother superior.[13]

Franciszka Wiszowata had a long and significant career in the community of the convent. In 1725, when Wiszowata was still a novice, she became a refectorer[14] and in August 1730 she was elected mistress 'of lay girls'.[15] In September 1732 she was elected mother superior for the first time and performed this function until August 1735.[16] Wiszowata was elected mother superior again in August 1741.[17] Her next election for the office in August 1744 required obtaining special dispensation from the Holy See, because the laws of the order forbade an election of the same person for two consecutive terms.[18] In August 1747 she was chosen a nun 'dyskretka',[19] that is,

3 Gustaw and Sitnik, *Klasztor i kościół*, p. 41.
4 Gustaw and Sitnik, *Klasztor i kościół*, p. 159.
5 Archiwum Klasztoru Sióstr Bernardynek w Krakowie [Cracow, AKSBK], MS 129, p. 25.
6 Ornacki, *Słownik biograficzny Warmii*, p. 211.
7 Cracow, AKSBK, MS 129, p. 25.
8 Cracow, AKSBK, MS 2, p. 47.
9 Cracow, AKSBK, MS 2, p. 46.
10 Cracow, AKSBK, MS 129, p. 25.
11 Cracow, AKSBK, MS 129, p. 25.
12 Cracow, AKSBK, MS 129, p. 25.
13 Cracow, AKSBK, MS 129, p. 25.
14 Cracow, AKSBK, MS 2, p. 45.
15 Cracow, AKSBK, MS 131, pp. 15–16. In her memoirs (Cracow, AKSBK, MS 2, p. 46) Wiszowata recorded, that she was elected mistress in 1729.
16 Cracow, AKSBK, MS 131, pp. 16–18; Gustaw and Sitnik, *Klasztor i kościół*, p. 210.
17 Cracow, AKSBK, MS 131, pp. 20–21; Gustaw and Sitnik, *Klasztor i kościół*, p. 210.
18 Cracow, AKSBK, MS 131, pp. 22–23.
19 Cracow, AKSBK, MS 131, pp. 24–25.

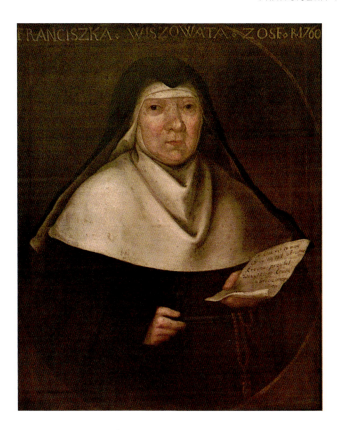

Fig. 1. Łukasz Orłowski, *Portrait of Franciszka Wiszowata*, 1760, convent of St Joseph of the Bernardine Sisters, Cracow, photo: K. Chrzanowska.

one of the nuns who decided about the most important matters of the nunnery.[20] In July 1750 Wiszowata was once again elected mother superior,[21] and re-elected to this office twice in August 1753[22] and in August 1756.[23] Both re-elections again required obtaining special dispensation from the Holy See. In August 1762 she was appointed a writer.[24] During the election in August 1765, due to the lack of a sufficient number of votes required in the dispensation from the Holy See to re-elect Eleonora Gołuchowska as mother superior, Wiszowata was appointed as 'prezydentka', that is a nun who headed the convent until the next election,[25] which took place in November of that year.[26] For the last time Wiszowata became mother superior in October 1768

20 Sutowicz, 'Przyczynek do badań nad życiem', p. 8.
21 Cracow, AKSBK, MS 131, p. 25; Gustaw and Sitnik, *Klasztor i kościół*, p. 210.
22 Cracow, AKSBK, MS 131, p. 26; Gustaw and Sitnik, *Klasztor i kościół*, p. 210.
23 Cracow, AKSBK, MS 131, pp. 29–31; Gustaw and Sitnik, *Klasztor i kościół*, p. 210.
24 Cracow, AKSBK, MS 131, pp. 34, 37.
25 Cracow, AKSBK, MS 131, pp. 37–41; Gustaw and Sitnik, *Klasztor i kościół*, p. 210.
26 Cracow, AKSBK, MS 131, pp. 41–42.

and she held this position until August 1770.[27] In 1771, on the 50th anniversary of her perpetual vows, Wiszowata retook her vows.[28]

As early as 1725 Franciszka Wiszowata, then a novice and a refectorer, carried out a renovation of the refectory.[29] According to her own words, the room was in such a poor state of repair that plaster was falling off the walls.[30] She not only hired people who plastered the room anew, but also bought new furniture, glasses, wooden plates and five tin candlesticks, among other things.[31] However, the most important and interesting artistic interventions in the refectory included a painted decoration on the walls and decorative wooden paneling with images of the Apostles.[32] Wiszowata decided that a 'Great Passion', i.e. most probably a Crucifixion, with the Virgin Mary and Saint John, should be depicted on the wall.[33] It is worth mentioning that although the paneling with depictions of the Apostles was changed, and the walls of the refectory were repainted, one of the short walls currently features a sculpted Crucifixion group with the Virgin Mary and Saint John the Apostle against a painted image of Saint Mary Magdalene kneeling in the landscape.

After becoming the mistress of the 'lay girls' Franciszka Wiszowata bought drawers and a case for lamps, lined with green fabric, for the priests sacristy.[34] Next year she persuaded her cousins from the wealthy Morsztyn family to donate white dresses, described as 'rich', and decorated with golden flowers, to the nunnery.[35] The dresses were converted into a chasuble, an unknown number of dalmatics and three altar frontals.[36] Additionally Wiszowata mentioned that she had donated earlier to her convent black chasubles made of damask, two altar frontals, also made of black damask, and another altar frontal made of moire.[37] In 1731 she commissioned painted 'stations', most probably Stations of the Cross, to the church of Saint Joseph.[38] Interestingly, she noted not only the total amount paid for the commission, which was as high as 84 złoty, but also the fact that she paid 6 złoty for each painting.[39]

When she became mother superior for the first time, Franciszka Wiszowata had annexes built and part of the convent with cells for novices remodelled; she further commissioned a new roof over these buildings and increased the height of chimney stacks.[40] Probably around 1733 Wiszowata acquired a significant personal donation of 13,000 złoty from her former carer Teresa Szemittchowa and decided to invest most of the money into an unknown venture, except for the sum of 4500 złoty that she

27 Cracow, AKSBK, MS 131, pp. 43–44; Gustaw and Sitnik, *Klasztor i kościół*, p. 211.
28 Cracow, AKSBK, MS 129, p. 143.
29 Cracow, AKSBK, MS 2, p. 45.
30 Cracow, AKSBK, MS 2, p. 45.
31 Cracow, AKSBK, MS 2, p. 45.
32 Cracow, AKSBK, MS 2, p. 45.
33 Cracow, AKSBK, MS 2, p. 45.
34 Cracow, AKSBK, MS 2, p. 46.
35 Cracow, AKSBK, MS 2, p. 46.
36 Cracow, AKSBK, MS 2, p. 46.
37 Cracow, AKSBK, MS 2, p. 46.
38 Cracow, AKSBK, MS 2, p. 46.
39 Cracow, AKSBK, MS 2, p. 46.
40 Cracow, AKSBK, MS 2, pp. 42–44; Gustaw and Sitnik, *Klasztor i kościół*, p. 142.

Fig. 2. One of the decorative inscriptions in the first parlour room on the ground floor, convent of St Joseph of the Bernardine Sisters, Cracow, photo: K. Chrzanowska.

donated to the nunnery.[41] It was probably between August 1735 and August 1738 that Wiszowata, along with the mother superior Anna Koniecpolska, co-financed the whitewashing of the walls in the convent's church.[42]

When Wiszowata was mother superior for the second time, in 1743, she decided to erect a new wing of the convent with the main entrance and parlour on the ground floor.[43] The design of this wing has been ascribed to the Italian architect Francesco Placidi.[44] He was then working in Cracow, having been appointed the architect to the King of Poland, and from 1746 was the architect to bishop of Cracow Andrzej Stanisław Kostka Załuski.[45] Before coming to Cracow, he had worked with Gaetano Chiaveri on the Hofkirche in Dresden.[46] Earlier, Sister Aniela Grottówna had attempted to replace the old, wooden main entrance to the nunnery, which was in very poor state of repair, with a new one.[47] She acquired a donation of 7000 złoty from

41 Cracow, AKSBK, MS 2, p. 47.
42 Cracow, AKSBK, MS 2, p. 47.
43 Cracow, AKSBK, MS 2, p. 47; *Katalog zabytków sztuki*, p. 155.
44 Lepiarczyk, 'Architekt Franciszek Placidi', p. 86; *Katalog zabytków sztuki*, p. 155.
45 For the life and artistic output of Francesco Placidi see: Lepiarczyk, 'Architekt Franciszek Placidi', pp. 64–126; Banacka, *Biskup Andrzej Stanisław Kostka Załuski*, pp. 29–32; Bernatowicz, *Placidi Francesco*, pp. 259–64.
46 Lepiarczyk, 'Architekt Franciszek Placidi', p. 71; Kowalczyk, 'Rola Rzymu w późnobarokowej architekturze', p. 229; Bernatowicz, *Placidi Francesco*, p. 259.
47 Cracow, AKSBK, MS 2, p. 48.

her nephew, but unfortunately died before the works began.[48] The Canon of Cracow Cathedral, Samuel Szwykowski, received 216 złoty as another donation for this purpose from Józef Potocki, a voivode of Kiev.[49] With this sum Wiszowata decided to start the construction of a new wing of the convent.[50] Since it was impossible to obtain money promised to Grottówna due to the financial problems of the donor, Wiszowata decided to acquire new funds for her initiative.[51] She used 4000 złoty from dowries of two nuns, acquired donations of 1000 złoty from Fr Jacek Augustyn Łopacki, the archpriest of St Mary's church in Cracow, and of 1500 złoty from the bishop of Przemyśl, Wacław Hieronim Sierakowski.[52] Additionally, prince bishop of Cracow Cardinal Jan Aleksander Lipski donated iron worthy of 500 złoty for the construction.[53] Wiszowata paid the remaining cost, amounting to 4000 złoty, with her own money.[54] The ground floor of the new wing encompassed the main entrance to the convent, a room for the poor and a room for servants — outside of enclosure — followed by a room for the nun responsible for opening the gate, three parlour rooms, office of the mother superior with an adjacent room, and a dormitory — within enclosure. Additionally, there were seven cells, a dormitory and cells for spiritual retreat on the first floor. What is more, special space on the first floor was assigned for a replica of the Scala Santa, decorated with wooden figures of the Virgin Mary and Jesus Wiszowata purchased at her own expense and painted herself.[55] It is worth of note that nuns obtained ten years of indulgence for their copy of the Scala Santa from the Holly See.[56] Wiszowata probably placed a sculpture of Jesus described in the nunnery's chronicle as 'merciful' in the cell for spiritual retreat.[57] The walls of the parlours on the ground floor were decorated with inscriptions painted by Wiszowata herself (Fig. 2).[58] Unfortunately the decoration was partly destroyed by humidity still during Wiszowata's lifetime.[59] In 1745 Wiszowata took up the construction of a new nunnery building.[60] She decided to demolish a wooden bakery and baths which were in poor state of repair and raise — most probably at her own expense — a new building to hold the cells, bakery, school for the novices and pharmacy, among others.[61]

48 Cracow, AKSBK, MS 2, p. 48; Gustaw and Sitnik, *Klasztor i kościół*, p. 143.

49 Cracow, AKSBK, MS 2, pp. 47–48.

50 Cracow, AKSBK, MS 2, p. 48.

51 Cracow, AKSBK, MS 2, p. 48.

52 Cracow, AKSBK, MS 2, p. 48; Cracow, AKSBK, MS 4, pp. 4–5.

53 Cracow, AKSBK, MS 2, an unnumbered page between pages 48 and 49; Cracow, AKSBK, MS 4, p. 5.

54 Cracow, AKSBK, MS 2, an unnumbered page between pages 48 and 49.

55 Cracow, AKSBK, MS 2, p. 49; Cracow, AKSBK, MS 4, p. 17.

56 Cracow, AKSBK, MS 2, p. 49; Cracow, AKSBK, MS 4, p. 17.

57 Cracow, AKSBK, MS 2, p. 49; Cracow, AKSBK, 4, p. 17.

58 Cracow, AKSBK, MS 2, p. 49; Gustaw and Sitnik, *Klasztor i kościół*, p. 143.

59 Cracow, AKSBK, MS 2, p. 49.

60 Cracow, AKSBK, MS 2, p. 50.

61 Cracow, AKSBK, MS 2, p. 50; Gustaw and Sitnik, *Klasztor i kościół*, p. 143.

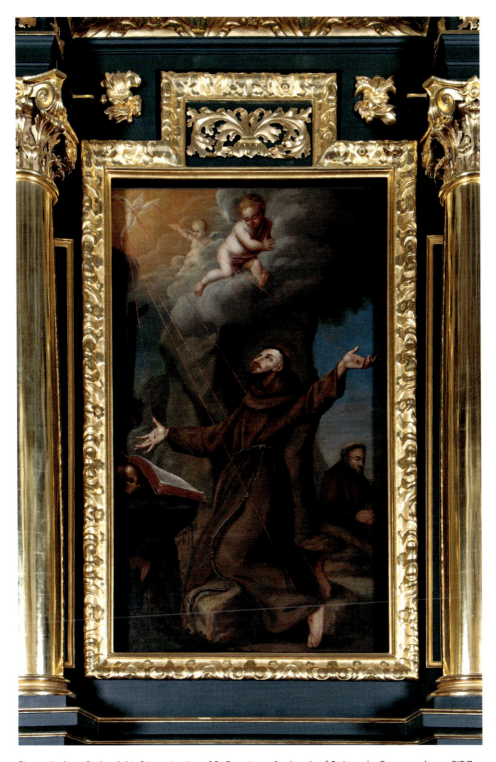

Fig. 3. Andrzej Radwański, *Stigmatisation of St Francis*, 1748, church of St Joseph, Cracow, photo: PIDZ UPJPII, project: SDM, CC-BY-NC-SA 4.0 PL.

Three years later Wiszowata replaced an old altarpiece on the altar of Saint Francis in the nunnery's church with a new one, recorded in the sources, as executed by Cracow's best painter of that time (Fig. 3).[62] It has been suggested that it must have been painted by Andrzej Radwański, a highly valued artist, active in the city from 1749 to 1762.[63] The new *Stigmatisation of Saint Francis* was highly appreciated by Francesco Placidi who stated that the altarpiece was the most beautiful painting both in the church and in the nun's choir.[64]

In 1750 Wiszowata built a woodshed,[65] and next year she had a small, wooden manor located on a cemetery within the convent grounds and used by the confessor of the nuns, among others,[66] renovated, and in 1752 she had the roofs and gutters of the convent and windows of the dormitory replaced, and a stone gate to the cemetery made.[67] Wiszowata pursued further works from 1754, when she replaced windows in the church.[68] Next year she had a new floor laid before the refectory, among other things,[69] and in 1756 she had a roof over unspecified part of the nunnery replaced.[70] She also removed a wall dividing the convent and a building called 'pustynka' (literally 'a desert') to make room for a space for spiritual retreat.[71]

In 1757 Franciszka Wiszowata took up another significant undertaking. She built, on her own expense, an annex with rooms intended for the confessor of the nuns and journeymen, among others.[72] In the same year she redeemed the altar of Saint Jude pawned by a carpenter and paid from her own funds for unspecified sculptures for this altar (Fig. 4).[73] The altar located in the nuns' chapel was funded by the aforementioned Fr Jacek Augustyn Łopacki.[74] He funded also another altar in this chapel, dedicated to Saint John of Nepomuk, and an imposing doorway between the chapel and the church.[75] The doorway was funded between 1737 and 1738.[76] Wiszowata mentioned also an unexecuted contract between Łopacki and Placidi for decorative wall paneling in the chapel and for new pews.[77]

62 Cracow, AKSBK, MS 2, p. 51.

63 Jóźkiewicz, 'Andrzej Radwański – malarz krakowski', p. 188; *Katalog zabytków sztuki*, p. 152. Recently on Radwański, see Koziara-Ochęduszko, *Mistrzostwo rysunku*; Michalczyk, 'Painting in the Polish-Lithuanian Commonwealth', p. 135; Koziara, 'Realizacje malarskie'.

64 Cracow, AKSBK, MS 2, p. 51; Cracow, AKSBK, MS 4, p. 12.

65 Cracow, AKSBK, MS 2, p. 51; Gustaw and Sitnik, *Klasztor i kościół*, p. 143.

66 Cracow, AKSBK, MS 2, p. 51; Gustaw and Sitnik, *Klasztor i kościół*, pp. 143–44.

67 Cracow, AKSBK, MS 2, p. 51.

68 Cracow, AKSBK, MS 2, p. 52.

69 Cracow, AKSBK, MS 2, p. 52.

70 Cracow, AKSBK, MS 2, p. 52.

71 Cracow, AKSBK, MS 2, pp. 52–53.

72 Cracow, AKSBK, MS 2, p. 53; Gustaw and Sitnik, *Klasztor i kościół*, p. 144.

73 Cracow, AKSBK, MS 2, p. 54; Cracow, AKSBK, MS 4, p. 14.

74 Cracow, AKSBK, MS 4, p. 14; Kuś, 'Działalność kulturalno-artystyczna', p. 224.

75 Cracow, AKSBK, MS 4, p. 14. About doorway see Gustaw and Sitnik, *Klasztor i kościół*, p. 161 and Kuś, 'Działalność kulturalno-artystyczna', pp. 223–24.

76 Kuś, 'Działalność kulturalno-artystyczna', pp. 224, n. 3.

77 Cracow, AKSBK, MS 4, p. 14; Kuś, 'Działalność kulturalno-artystyczna', p. 224.

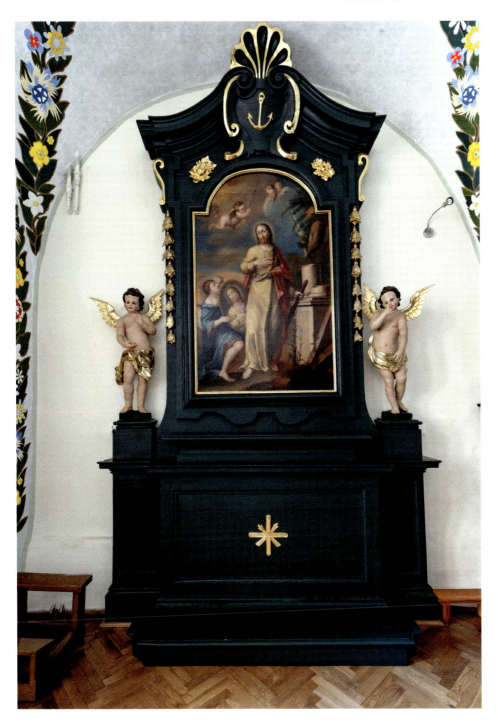

Fig. 4. Altar of Saint Jude, 1742–1761, nuns' chapel in the convent of St Joseph, Cracow, photo: PIDZ UPJPII, project: SDM, CC-BY 3.0 PL.

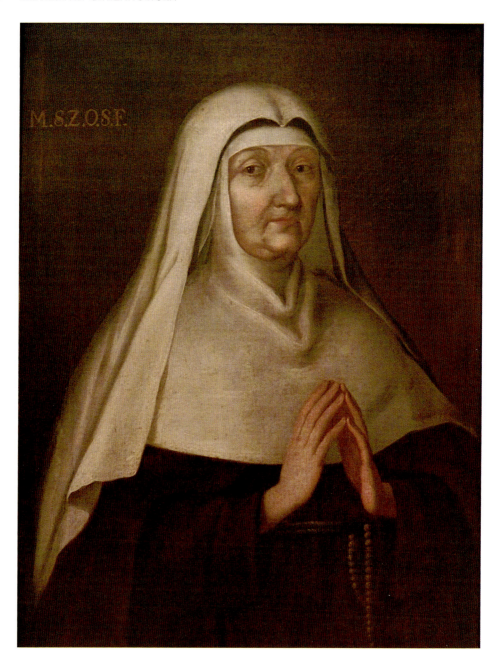

Fig. 5. Łukasz Orłowski (?), *Portrait of Marianna Sierakowska Drozdowska née Ruszkowska*, convent of St Joseph of the Bernardine Sisters, Cracow, photo: K. Chrzanowska.

At an unspecified time Wiszowata had funded a frame for the painting of Jesus in one of the altars and she painted this frame herself.[78] Also at an unspecified time, Wiszowata commissioned a portrait of Marianna Sierakowska Drozdowska, née Ruszkowska, a mother of the bishop of Przemyśl and benefactor of the convent, Wacław Hieronim Sierakowski (Fig. 5).[79] This painting, hung in the chapter house, could have been painted by Łukasz Orłowski,[80] a highly valued painter active in Cracow and many-times alderman of the city's guild of painters.[81] It is worth mentioning that Orłowski had painted at least two other portraits of the same person, probably copies of earlier paintings, which were commissioned most likely by bishop Sierakowski for his gallery of family portraits.[82]

In 1760 Łukasz Orłowski painted a portrait of Wiszowata now in the chapter house.[83] Worthy of note is the fact that it is one of only four portraits of mothers superior hanging in the convent's chapter house. The choice of Łukasz Orłowski might have been determined not only by his connection to the Sierakowski family, but also by the fact that he had painted the *Marriage of the Virgin Mary* in one of the altars in the St Mary's church at the time when Łopacki was the archpriest of this church.[84] Additionally, Orłowski was a painter whose work was most probably accepted by Łopacki, which might be another reason to justify this choice.

Almost all of the above information is based on the chronicle of the convent written down by Franciszka Wiszowata. She recorded her initiatives and financial deeds for the convent in a bound volume of the chronicle and in additional notes scattered among other manuscripts. Moreover, it is also thanks to the notes made by Wiszowata that we are aware of the accounts of the artistic foundations made by both lay people, mostly women, and nuns themselves, in the convent of St Joseph in Cracow. Suffice it to mention the gilding of the altar of the Virgin Mary and Saint Bonaventure carried out at the expense of Sister Marta Łęcka who funded also two silver paxes, among other things,[85] and the fact that Józefa Wilska funded an altar of Jesus and Apolonia Jastrzempska an Easter Sepulchre for the liturgy of Good Friday executed by the architect Francesco Placidi in collaboration with 'the best painter in this time'.[86] Of great historical import is a detailed description of donations made for the convent by both lay people and nuns recorded on 13 May 1747.[87] In this description Wiszowata noted that sister Charytas Mudrzejowska funded altars

78 Cracow, AKSBK, MS 4, p. 16.

79 Cracow, AKSBK, MS 4, p. 16; Cracow, AKSBK, MS 5, p. 383.

80 Attribution of the painting after Chrzanowska, 'Twórczość krakowskiego malarza', pp. 81–82, 148, 216–17.

81 Samek, *Orłowski Łukasz*, pp. 236–37; Samek and Bernatowicz, *Orłowski Łukasz*, pp. 316–18; Gąsiorowski, *Cechy krakowskie*, pp. 7–8.

82 Samek, *Orłowski Łukasz*, p. 236; Samek and Bernatowicz, *Orłowski Łukasz*, p. 317; Adamski and others, *Katedra łacińska*, p. 219; Szelest, *Lwowska Galeria Obrazów*, p. 24.

83 Samek and Bernatowicz, *Orłowski Łukasz*, p. 317.

84 Chrzanowska, 'Twórczość krakowskiego malarza', pp. 176–77; Chrzanowska, 'Biografia i twórczość', forthcoming.

85 Cracow, AKSBK, MS 2, p. 63.

86 Cracow, AKSBK, MS 2, p. 64, Kuś, 'Działalność kulturalno-artystyczna', p. 224.

87 Cracow, AKSBK, MS 4, p. 3.

Fig. 6. Wilemówna, *Saint Anne*, first half of the eighteenth century, church of St Joseph, Cracow, photo: PIDZ UPJPII, project: SDM, public domain.

of the Merciful Virgin Mary and another one of the Virgin Mary, both of them in the convent's dormitories,[88] Ms Le Bron née Niedźwiecka funded the altars of Saint Onuphrius and of the Annunciation to the Virgin Mary,[89] Elżbieta Wilska née Rusecka founded an altar for a miraculous painting of Christ.[90] Wiszowata had recorded information that paintings in the altars of Saint Anne (Fig. 6), founded by Anna Koniecpolska, and Saint Bonaventure (Fig. 7), founded by a certain Marta, both in the convent's church, were painted by Wilemówna, a daughter of a talented painter.[91] Wilemówna was active in Cracow and is known for commissions executed for only two convents. The first encompassed the two altarpieces mentioned above and the second was for the convent of Saints Peter and Paul of the Norbertine Sisters in Imbramowice.[92] She seems to have been a skilled painter, but her life and oeuvre require further research. Records of artistic foundations made for the convent by nuns and lay women and described by Wiszowata are too many to mention and alone deserve an in-depth study.

Franciszka Wiszowata died on 20 May 1777, after a three-week-long illness, with paralysis as one of the symptoms.[93]

During the activity of Franciszka Wiszowata the Convent of St Joseph with its church became a place of intensive work, which involved the most important and interesting of Cracow's personalities. On the one hand her undertakings, gained support of Jacek Augustyn Łopacki, and on the other, Wiszowata hired the best artists available to execute her commissions. Łopacki had spent some time in Rome, pursuing there a career as a doctor, and after his return to Cracow was very active as a patron of the arts.[94] He remodelled the interior of St Mary's church in a baroque style[95] and supervised similar alterations made to the interior of Cracow Cathedral,[96] among his other undertakings. He acquired four altarpieces painted by the Venetian painter Giovanni Battista Pittoni for St Mary's church.[97] From among artists active in Cracow at that time, he employed both Francesco Placidi[98] and Andrzej Radwański[99] to executed works in the aforementioned church. It is worth noting that Placidi not only worked for Łopacki in St Mary's church but also executed his commissions for

88 Cracow, AKSBK, MS 4, p. 8

89 Cracow, AKSBK, MS 4, p. 13; Gustaw and Sitnk, *Klasztor i kościół*, p. 162.

90 Cracow, AKSBK, MS 4, p. 12.

91 Cracow, AKSBK, MS 4, p. 13; *Katalog zabytków sztuki*, p. 152; Gustaw and Sitnik, *Klasztor i kościół*, p. 164.

92 Grothówna, *Kronika klasztorna*, pp. 115, 209; Pieńkowska, 'Dzieje i fabryka kościoła', p. 89; Nowak, '*Fabrica Ecclesiae* of the Church', p. 139.

93 Cracow, AKSBK, MS 129, p. 143.

94 Kuś, 'Działalność kulturalno-artystyczna', pp. 198, 206–30.

95 Kuś, 'Działalność kulturalno-artystyczna', pp. 206–19; Skrabski, 'Modernizacja i renowacja', pp. 87–103; Kurzej, 'Uwagi o aranżacji', pp. 161–68.

96 Kuś, 'Działalność kulturalno-artystyczna', pp. 220–23; Lepiarczyk and Przybyszewski, 'Katedra na Wawelu', p. 27.

97 Kuś, 'Działalność kulturalno-artystyczna', pp. 210–11; Kurzej, 'Uwagi o aranżacji', p. 164.

98 Kuś, 'Działalność kulturalno-artystyczna', pp. 213, 218; Bernatowicz, *Placidi Francesco*, p. 261. Works of Placidi for the St Mary's church were recently revised by Skrabski, 'Modernizacja i renowacja', pp. 111–12.

99 Jóźkiewicz, 'Andrzej Radwański – malarz krakowski', p. 173; Kuś, 'Działalność kulturalno-artystyczna', p. 216; Bernatowicz, *Radwański Andrzej*, p. 182; Koziara, 'Autorstwo i przeznaczenie czterech rysunków', pp. 52–54; Koziara, 'Realizacje malarskie', pp. 171–78; Koziara-Ochęduszko, *Mistrzostwo rysunku*, pp. 22, 152–58.

Fig. 7. Wilemówna, *Saint Bonaventure and Saint Thomas Aquinas*, first half of the eighteenth century, church of St Joseph, Cracow, photo: PIDZ UPJPII, project: SDM, CC-BY-NC-ND 3.0 PL.

Cracow Cathedral.[100] Additionally, Łopacki was responsible for payments for Łukasz Orłowski for the painting commissioned from him by the chapter of the collegiate church in Sandomierz for the main altar of this church.[101] The architect was closely linked to the convent of St Joseph not only by several commissions but also by personal connections, as both his first wife and his mother-in-law were buried in the convent's church.[102]

The undertakings of Franciszka Wiszowata were very significant for the functioning of the convent. Her work changed the buildings and facilitated the life of nuns. Active as a foundress, she furnished the convent with works of art of the highest artistic value available to her at the time in Cracow. Also her output as an artist, although probably mostly not preserved, shows her ambition and a self-esteem that enabled her to take up such initiatives. As a mother superior, she diligently wrote the convent's chronicle, recording her own deeds and donations of both lay people and nuns made for the convent. Her multifaceted activity, undoubtedly exceptional, is a fine example of how women managed to change their surrounding through the activities in the field of arts and made sure they would not be forgotten.

100 Kuś, 'Działalność kulturalno-artystyczna', pp. 220–23; Lepiarczyk and Przybyszewski, 'Katedra na Wawelu', pp. 24–28, Bernatowicz, *Placidi Francesco*, p. 261; Przybyszewski, *Katedra krakowska*, p. 32.

101 Dworzak, *Fabrica ecclesiae sandomiriensis*, pp. 80–81.

102 Lepiarczyk, 'Architekt Franciszek Placidi', p. 76, Gustaw and Sitnik, *Klasztor i kościół*, p. 242.

Bibliography

Manuscripts and Archival Sources

Archiwum Klasztoru Sióstr Bernardynek w Krakowie [Cracow, AKSBK], MS 2, *W imie Panskie Amen Nawieczną Pamiatke Kronika Klasztoru s: Josepha Opisanie Fundacieÿ Klasztoru Panien za konu s: Franciszka Trzecieÿ regulÿ Przykosciele pod tytułem s: Jozepha w Krakowie*

Archiwum Klasztoru Sióstr Bernardynek w Krakowie [Cracow, AKSBK], MS 4

Archiwum Klasztoru Sióstr Bernardynek w Krakowie [Cracow, AKSBK], MS 5, *Kronika SS. Bernardynek przy kościele św. Józefa r. 1927. Część 1sza*

Archiwum Klasztoru Sióstr Bernardynek w Krakowie [Cracow, AKSBK], MS 129, I. *Księga Zmarłych Zakonnic S. S. Bernardynek przy kościele Św. Józefa. Metryka profesji*

Archiwum Klasztoru Sióstr Bernardynek w Krakowie [Cracow, AKSBK], MS 131, L. J. C. *Księga Związek jednostaynych Głosow, Przeświętnego Zgromadzenia, pod Regułą Seraficznego Oyca y Patryarchy Franciszka Swiętego w Klasztorze Krakowskim Jozefa Swiętego zostającego, na Kanoniczną Elekcyą NayPrzewielebnieyszych Panien Matek tegoz Klasztoru w sobie Zamykajaca*

Secondary Studies

Adamski, Jakub, Marcin Biernat, Jan K. Ostrowski, and Jerzy T. Petrus, eds, *Katedra łacińska we Lwowie*, Materiały do dziejów sztuki sakralnej na ziemiach wschodnich dawnej Rzeczypospolitej, part 1: Kościoły i klasztory rzymskokatolickie dawnego województwa ruskiego (Kraków: Międzynarodowe Centrum Kultury w Krakowie, 2013)

Banacka, Marianna, *Biskup Andrzej Stanisław Kostka Załuski i jego inicjatywy artystyczne* (Warszawa: Wydawnictwo SBP, 2001)

Bernarowicz, Aleksandra, *Placidi Francesco*, in *Słownik artystów polskich i obcych w Polsce działających (zmarłych przed 1966 r.) Malarze, rzeźbiarze, graficy*, vol. VII, ed. by Urszula Makowska (Warszawa: Instytut Sztuki Polskiej Akademii Nauk, 2003), pp. 259–64

——, *Radwański Andrzej*, in *Słownik artystów polskich i obcych w Polsce działających (zmarłych przed 1966 r.) Malarze, rzeźbiarze, graficy*, vol. VIII, ed. by Urszula Makowska and Katarzyna Mikocka-Rachubowa (Warszawa: Instytut Sztuki Polskiej Akademii Nauk, 2007), pp. 181–84

Chrzanowska, Katarzyna, 'Biografia i twórczość Łukasza Orłowskiego w świetle źródeł archiwalnych', *Barok. Historia–Literatura–Sztuka*, forthcoming

——, 'Twórczość krakowskiego malarza Łukasza Orłowskiego' (unpublished M.A. thesis, Jagiellonian University, 2018)

Dworzak, Agata, *Fabrica ecclesiae sandomiriensis. Dzieje modernizacji wnętrza kolegiaty sandomierskiej w XVIII wieku w świetle źródeł archiwalnych* (Kraków: Wydawnictwo Attyka, 2016)

Gąsiorowski, Wilhelm, *Cechy krakowskie: ich dzieje, ordynacye, listy, swobody, zawyczaje itp.: jako materaya do historyi sztuk, rzemiosł, przemysłu dawnej Polski, a mianowicie wzrostu, kwitnienia i upadku tychże w Karakowie: z aktów cechowych i innych rekowpisów* (Kraków: Czcionkarnia Z. J. Wywiałkowskiego, 1860)

Grothówna, Zofia, *Kronika Klasztorna Sióstr Norbertanek w Imbramowicach 1703–1741*, ed. by Włodzimierz Bielak and Waldemar Witold Żurek SDB (Kielce: JEDNOŚĆ, 2011)

Gustaw, Romuald, *Klasztor i kościół św. Józefa ss. Bernardynek w Krakowie 1646–1946* (Kraków: Księgarnia Stefana Kamińskiego i Towarzystwo Miłośników Historii i Zabytków Krakowa, 1947)

——— and Aleksander Sitnik, *Klasztor i kościół św. Józefa ss. Bernardynek w Krakowie 1646–2009* (Kalwaria Zebrzydowska: CALVARIANUM, 2013)

Jóźkiewicz, Krystyna, 'Andrzej Radwański – malarz krakowski 1711–1762. Rys życia i twórczości', *Biuletyn Krakowski*, 3 (1961), 160–200

Katalog zabytków sztuki w Polsce, vol. IV *Miasto Kraków*, part II *Kościoły i klasztory śródmieścia 1*, ed. by Adam Bochnak and Jan Samek (Warszawa: Instytut Sztuki Polskiej Akademii Nauk, 1971)

Kowalczyk, Jerzy, 'Rola Rzymu w późnobarokowej architekturze polskiej', *Rocznik Historii Sztuki*, 20 (1994), 215–308

Koziara, Natalia, 'Autorstwo i przeznaczenie czterech rysunków ze zbioru Gabinetu Rysunków i Grafiki Muzeum Książąt Czartoryskich', *Rozprawy Muzeum Narodowego w Krakowie*, Seria nowa, 12 (2019), 47–62

Koziara-Ochęduszko, Natalia, *Mistrzostwo rysunku. Andrzej Radwański (1711–1762)* (Kraków: Zamek Królewski na Wawelu – Państwowe Zbiory Sztuki, 2022)

Koziara, Natalia, 'Realizacje malarskie Andrzeja Radwańskiego dla kościoła Mariackiego', in *Jako serce pośrodku ciała… Kultura artystyczna kościoła Mariackiego w Krakowie*, ed. by Marek Walczak and Agata Wolska (Kraków: Societas Vistulana, 2020–2021), pp. 171–78

Kurzej, Michał, 'Uwagi o aranżacji kościoła Mariackiego w czasach ks. Jacka Łopackiego', in *Jako serce pośrodku ciała… Kultura artystyczna kościoła Mariackiego w Krakowie*, ed. by Marek Walczak and Agata Wolska (Kraków: Societas Vistulana, 2020–2021), pp. 161–69

Kuś, Jan, 'Działalność kulturalno-artystyczna ks. Jacka Augustyna Łopackiego (1690–1761)', *Nasza Przeszłość: studia z dziejów Kościoła i kultury katolickiej w Polsce*, 40 (1973), 195–246

Lepiarczyk, Józef, 'Architekt Franciszek Placidi około 1710–1782', *Rocznik Krakowski*, 37 (1965), 64–126

——— and Bolesław Przybyszewski, 'Katedra na Wawelu w wieku XVIII. Zmiany jej wyglądu architektonicznego i urządzenia wnętrz na podstawie badań historyczno-archiwalnych', in *Sztuka baroku. Materiały sesji naukowej ku czci śp. profesorów Adama Bochnaka i Józefa Lepiarczyka zorganizowanej przez krakowski oddział Stowarzyszenia Historyków Sztuki i Instytut Historii Sztuki UJ Kraków, 8–9 czerwca 1990 roku* (Kraków: Klub Inteligencji Katolickiej, 1991), pp. 21–38

Michalczyk, Zbigniew, 'Painting in the Polish-Lithuanian Commonwealth in the Time of Szymon Czechowicz: Main Problems and Artistic Centres, with Particular Emphasis on Easel Painting', in *Genius of the Baroque. Szymon Czechowicz 1689–1775*, ed. by Andrzej Betlej and Tomasz Zaucha (Kraków: Muzeum Narodowe w Krakowie, 2020) pp. 120–43

Nowak, Weronika, '*Fabrica Ecclesiae* of the Church and Convent of Norbertine Nuns in Imbramowice in 1711–1740. New Findings Regarding the Financing and Organization of the Works, and the Artists Contracted', *Modus. Prace z historii sztuki*, 19 (2019), 105–40

Ornacki, Tadeusz, *Słownik biograficzny Warmii, Prus Książęcych i Ziemi Malborskiej od połowy XV do końca XVIII wieku*, vol. II (Olsztyn: Pojezierze, 1988)

Pieńkowska, Hanna 'Dzieje i fabryka kościoła oraz klasztoru Norbertanek w Imbramowicach', *Folia Historiae Artium*, 14 (1978), 67–92

Przybyszewski, Bolesław, *Katedra krakowska w XVIII stuleciu* (Kraków: Archiwum i Biblioteka Krakowskiej Kapituły Katedralnej, 2012)

Samek, Jan, *Orłowski Łukasz*, in *Polski Słownik Biograficzny*, vol. 24/2 (Wrocław – Warszawa – Kraków – Gdańsk: Wydawnictwo Polskiej Akademii Nauk, 1979), pp. 236–37

——— and Aleksandra Bernatowicz, *Orłowski Łukasz*, in *Słownik artystów polskich i obcych w Polsce działających (zmarłych przed 1966 r.) Malarze, rzeźbiarze, graficy*, vol. VI, ed. by Katarzyna Mikocka-Rachubowa and Małgorzata Biernacka (Warszawa: Instytut Sztuki Polskiej Akademii Nauk, 1998), pp. 316–18

Skrabski, Józef, 'Modernizacja i renowacja kościoła Mariackiego w czasach archiprezbitera Jacka Łopackiego. Między Kacprem Bażanką a Franciszkiem Placidim', *Rocznik Krakowski*, 74 (2008), 87–114

Sutowicz, Anna, 'Przyczynek do badań nad życiem wewnętrznym klasztoru klarysek we Wrocławiu w okresie średniowiecza', *Saeculum Christianum: pismo historyczno-społeczne*, 10.1 (2003), 5–22

Szelest, Dimitrij, *Lwowska Galeria Obrazów: malarstwo polskie* (Warszawa: Auriga, 1990)

PART 3

Women at Work

LYNN E. FITZPATRICK

Medieval Textile Production in Iceland

Warp Weighted Looms and the Women Who Wove Them

▼ **ABSTRACT** Textile archeologists and historians have found relationships between weave structures, loom types, and the cultural role of women as they affected women's production of textiles. The vertical warp weighted loom, used by women to produce textiles for the home and community, as well as for commercial trade persisted from 7000 BC to 1050 BC when it was replaced by a floor loom that operated horizontally, much like those used today. Europeans adopted this new loom for its ability to hold longer warps (the vertical loom was limited by the distance from the top bar to the floor) and the efficiency with which cloth could be woven by a single weaver. The invention of the horizontal treadle loom correlates with the replacement of women weavers in the commercial realm. While women continued to weave for the household, commercial weaving became a professional skill that was transferred to men.

In Iceland and parts of Norway, warp weighted looms continued to be used through the eighteenth century, though, long after the horizontal treadle loom became the primary weaving technology across Medieval Europe. Archaeologists have unearthed thousands of textile fragments in Iceland that date to this period, but researchers have only recently begun analyzing them. What is becoming clear is the extent to which a particular type of cloth, *vaðmál*, was essential to the trade and the survival of Viking settlements. This chapter focuses on women weavers from the North Atlantic who wove *vaðmál*, a form of currency valued against silver, and therefore remained engaged in the textile economy into early modern times. Previous research suggests that loom innovations were primarily responsible for women's changing roles in Europe. I argue that child rearing and the commodification of cloth played as large a role as the development of new textile tools and loom technology in the unknowing of these female artisans.

Women in Arts, Architecture and Literature: Heritage, Legacy and Digital Perspectives, ed. by Consuelo Lollobrigida and Adelina Modesti, Women in the Arts: New Horizons, 1 (Turnhout: Brepols, 2023), pp. 161–178

BREPOLS ❧ PUBLISHERS 10.1484/M.WIA-EB.5.134649

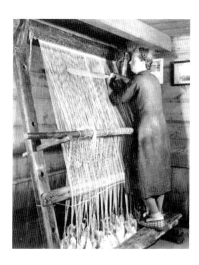

Fig. 1. Norwegian woman weaving blanket on warp weighted loom c. 1954 as photographed by Marta Hoffman (See video at <https://www.facebook.com/456572831067411/videos/warp-weighted-loom/1834551209936226/>).

There is a great deal of research on women spinning and weaving cloth from the Bronze Age Mediterranean to the Near East. More recently some textile historians and archeologists have turned their attention to Neolithic and Bronze Age textile tools and production in Northern Europe. Harder to find is information about weaving in Iceland during the Viking Age into Medieval Era and beyond. This is surprising given that women's textile work here was essential to the local economy, and that woman played an essential role in textile commerce much longer here than in the rest of Europe. Some of the greatest innovations in weaving technology occurred during this time, yet these were not adopted in Iceland until the modern age. Little recorded history focuses on women. Most knowledge of their work is from secondhand sources like early vessel paintings showing women working at spinning and weaving. Later cuneiform tiles, texts, and, more directly, preserved cloth fragments and loom parts show the work of women weavers was communal and creative, and their products were of value to the home and their society. Spinning and weaving represented full-time work managed simultaneously with other demands. While women were also involved in child rearing, garden-based food production, and small animal husbandry, this contribution focuses on the changing role of women's work in textiles based on societal shifts and the development of textile tools and technologies.

The physical looms, specifically vertical warp weighted looms, used by women to produce textiles for the home, community, and commercially, persisted in Europe until about 1050 BC when the vertical loom type was replaced by a floor loom that operated horizontally, much like those weavers use today. The warp weighted loom relied on gravity for tension and was able to be moved while dressed. The treadle loom used a mechanical system for tension and was not easily portable. Textile archeologists have constructed replicas of vertical looms to test their possibilities.

Researchers point to the relationship between these early looms, women's bodies, and physical work areas as an explanation for the shift to male-dominated commercial weaving. This explanation is complicated by the fact that textile archaeologists have demonstrated the ability to weave both fine and coarse cloth on replicas of vertical looms. In Iceland and parts of Norway, warp-weighted looms continued to be used beyond the Middle Ages up through the eighteenth century, after the horizontal treadle loom became the primary weaving technology across continental Europe. Vestiges of the practice and the looms were witnessed in the early twentieth century as practiced by women in Norway as late as 1954 by textile historian, Marta Hoffman. (Fig. 1) What caused these women to retain this technology in the home? And why have women weavers, their textile arts, and their vertical looms been mostly sidelined and forgotten? This research suggests that child rearing and commerce, as much as loom construction, played a role in the unknowing of these female artisans.

Birthing and Bodies (25000–8300 BC)

In *Women's Work: The First 20,000 Years,* archeologist Elizabeth Wayland Barber writes, '[T]he issue of whether or not the community *relies* upon women as the chief providers of a given type of labor depends upon "the compatibility of the pursuit with the demands of child care."'[1] While the nature of women's work and its usefulness to the larger community have changed over the course of human history, consistently children, fiber, and textiles have been at the heart of women's domain.

According to Barber, (who is also the author of *Prehistoric Cloth*), the earliest representation of spun thread is believed to be that found in the Lespugue Venus (Fig. 2) interpreted as a skirt hanging from a hip band made of twisted fibers which are frayed at the ends. Fibers at this time were plant-based, from trees, vines, and grasses, most likely gathered at nomadic sites where women also cared for children and gathered edible plants. The childbearing Venus clothed in an early form of textile shows the relationship between women and fiber started during the Paleolithic Age. Later textile discoveries reveal patterned bands, woven on a narrow band loom, bearing symbols of fertility. This belted skirt begins a period of creative exploration in twining and weaving both for ceremony and survival. Comparing methods of twining and weaving in Peruvian, Indian, and Bedouin cultures, it is possible to imagine how paleolithic women devised ways to use their bodies to provide tension to ensure the strength and stability of rope and clothing bands (Fig. 3).

Further evidence that Paleolithic women were twining fiber for use as tools, clothing, rituals, and perhaps weapons, comes from the painted caves of Lascaux,

1 Barber, *Women's Work*, p. 29. Speaking of Judith Brown's 'Note on the Division of Labor by Sex' who claims that the productivity of women depended on the work's compatibility with child rearing.

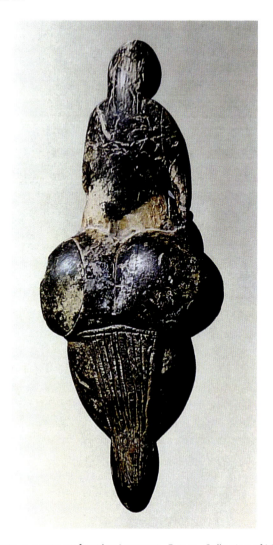

Fig. 2. *The Lespugue Venus*, c. 24000 BC found at Lespugue, France. Collection of Musée de l'Homme in Paris. Photograph by Leroi-Gourhan, 1982. <https://donsmaps.com/lespuguevenus.html>.

France, where archeologists discovered a fossilized imprint of a heavy cord twisted from three two-ply strings dated c. 17000 BC.[2] Women weaved for survival and to express beliefs and traditions.

[2] Wong, 'Stone Age String'.

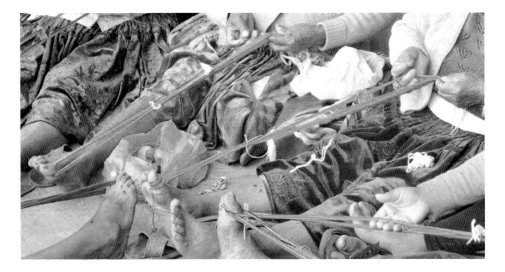

Fig. 3. Band weaving using the big toe as a tensioning device; the practice continues in the Peruvian mountains today. Alverez, N., *Secrets of Spinning, Weaving, and Knitting in the Peruvian Highlands* (Cusco Peru: Thrums 2017).

Settlements, Cloth, and Early Looms (8300–2500 BC)

Toward the end of the Paleolithic and into the Neolithic Age the division of labor between men and women changed as nomadic hunter gatherer groups began to settle. Women continued to watch and care for children, gather plant foods, and eventually establish gardens. The need for twisted and woven textiles grew, and women collaborated on the effort it took to find, spin, and weave fibers. As settlements grew the need for labor expanded and women were expected to birth and raise more children — easier to do now that they were not moving from place to place. This division of labor necessitated women work on tasks that did not endanger the increasing number of children in their care.

One of the earliest textile discoveries from this period (7000–6000 BC) were imprints on two pieces of clay. The imprints reveal that weaving craft was firmly established by this time as they were made from wider widths of fabric than earlier. The two types of weaves indicate knowledge of multiple weave structures. Plain weave is constructed in an over one- under one method and produces a balanced weave with a checkerboard pattern. Twill weave, constructed in an over two- under two method results in a slightly smoother surface with a diagonal pattern.[3] It is interesting to note that women were experimenting with texture and weave pattern at a time we usually associate with subsistence living. Early settlement living inspired creative textile techniques that went beyond necessity. Examples of stripes and patterns suggest that women were motivated by a desire to express their aspirations in

3 Adovasio, 'Textile and Basketry Impressions', pp. 223–30.

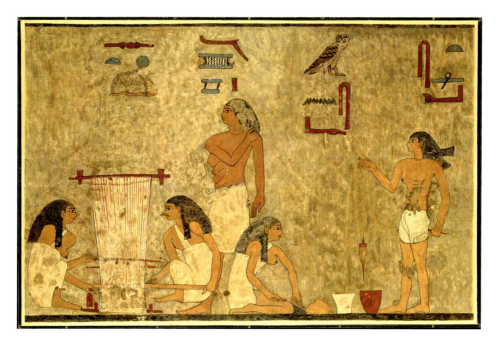

Fig. 4 Horizontal ground loom, Weavers, Tomb of Khnumhotep, Middle Kingdom, 12th dynasty painting by Norman de Garis Davies (1865–1941) Metropolitan Museum of Art, NY.

life and beyond. Over time though, as communities grew so did their acquisitional nature. Time was no longer free and abundant, but something measured and limited. Weaving was now valued against other commodities.

More fiber (including flax, hemp, and wool) was produced at this time, and new uses for textiles required weaving widths wider than a belt or band. The challenge to meet these new demands resulted in the simultaneous development of two large loom types in the regions of Jarmo and Çatal Hüyük (c. 7000 BC) in present-day Iraq and Turkey. 'One of these is the horizontal ground loom still used today by Bedouin women in North Africa and the Middle East. This device migrated mainly south and southeast… evidence for it comes from representations of its use.'[4] (Fig. 4) Pictured here in a foreshortened view the ground loom is compatible for weaving outside if the weather remains dry and temperate for most of the year. The loom can be moved if needed and reset in the ground at a different location.

The other type of wide loom is the vertical, warp-weighted loom which spread north and west across Europe. Confirmation for this loom comes from literature and representations of women weaving together on the loom, and in archeological excavations.

Because the warp was held in tension by rock or fired clay loom weights, proof of its use is more easily traced in the form of loom weights found in rows in the

4 Barber, *Women's Work*, p. 81.

interior of building sites. While the wooden parts of the loom do not often survive, the weights did.[5] This loom can be traced northward into Iceland, Norway, and Sweden.

New weaving structures indicate that these wider looms spurred a new method of manipulating warp threads. Small-width border or strap looms required the weaver to use fingers or a needle to intertwine weft threads with warp threads thereby producing a complexity of patterns and structures. As looms became wider weavers incorporated heddles to speed the process.

Warp threads were tied to the heddles in different combinations so that as the heddles were lifted, the weft thread could be passed through the shed formed in the process. Images from this period show women working together to pass the weft thread across the greater width of the loom. Textiles found preserved in the alkaline boglands of northern Europe reveal that complicated patterns were being woven by 3000 BC. Several of these textile fragments have been found in preserved grave sites. It is assumed that multiple color weft threads were used to make pattern visible, and this would have required several women holding and passing bobbins of different weft threads back and forth across the width of the loom.[6]

Demand for cloth grows between 4000 and 2500 BC with the shift toward agricultural society. We see an increased production of weaving that is not about fulfilling household or community subsistence. Instead, preserved textile fragments from household and grave sites reveal a preponderance of decorative weave patterns that symbolised the importance of fertility. The monetization of time had not yet been triggered and leftover time, especially during the winter months, was used to produce finer and more sophisticated textiles. 'Time was…constantly available for use to promote survival, whether directly (e.g., by preparing food and building shelter) or indirectly — that is, by trying to elicit symbolically what was wanted.'[7]

Archeological evidence shows that most weaving took place in households or communal courtyards. The warp weighted loom could easily be set up near the best light source — an entryway or firepit — and then moved to give over the dwelling space to other activities of family life. This allowed women the opportunity to work together while watching children and preparing food. 'One can imagine the women working together and egging each other on as they finished off the bottom edges of their cloths.'[8]

Around this time humans also began domesticating animals as a steady source of meat, milk, muscle strength, and fiber. Records show that, in addition to plant-based fibers, women were carding, spinning, and weaving wool. The increase in available fibers for spinning and weaving meant that women began weaving cloth in excess of local needs to be traded for improved tools like obsidian blades for scythes and metal plows for planting and maintaining larger, domesticated crops.

5 Strand, 'Tools and Textiles'.
6 Strand and Nosch, 'The Wool Zone'.
7 Barber, *Women's Work*, p. 94.
8 Barber, *Women's Work*, p. 93.

By 3300 BC, men were traveling again in search of metals, especially tin and obsidian, leaving women at home to rear children and grow food. The Bronze age ushered in an era of new ideas, technologies, and trade. The roles of men and women remained symbiotic, but changes brought them into their own domains: men in the contractual aspects of trade and women in the essential role of textile production for trade. New economic and social frameworks set the stage for the textile economy that followed. '[By 2500 BC] the old days of simple Neolithic courtyards were gone. Ahead lay the heady chemistry of new and far-ranging human contacts, catalysts for yet other developments in women's contribution to society through their textile arts.'[9]

Caravans and Production Weaving (2000–1200 BC)

Textiles were central to commerce throughout the Bronze Age. Large caravans of men traveling and trading throughout the Near East and Central Europe relied upon the cloth that women, left behind in settlements, provided to them to exchange for goods. A cuneiform letter from a woman named Lamassi to her husband, Pūsu-kēn, reveals the expectations of the women who were doing their best to keep up with the demand for textiles they spun and wove to be traded for goods far from their home.

> Kulumāya is bringing you nine textiles. Iddin-Sîn is bringing you three textiles… Why do you always write to me, 'The textiles that you send me each time aren't good!' Who is this person living in your house and denigrating the cloth that I sent to you? For my part, I do my best to make and send you textiles so that for every trip at least ten shekels of silver can reach your house.[10]

Other cuneiform tablets found in the Middle East reveal complaints women had about men asking for cloth with more wool or less wool, more threads per inch or fewer threads per inch, etc. It is clear that the days of free experimentation with weave structures and patterns were over; creative experimentation took a back seat to textile production directed by the preferences of places and populations outside the homestead. A thriving regional trade network and larger, more populous settlements were made possible by the increasingly specialized work taken on by men and women.

Textiles, Trade, and Technology across Continents (500–1500 AD)

There were important differences between the textile trade in the south by way of the Mediterranean Sea, and the textiles traded across the North Atlantic during this period. Textiles in the south were primarily linen and hemp traded for slaves, gold, and horses. In the north, 'after the Norman Conquest of Britain in 1066 AD, [British islanders] expanded their territory and trade from the North Atlantic into

9 Barber, *Women's Work*, p. 100.
10 Postrel, *The Fabric of Civilization*, p. 148.

southern Europe and along the Mediterranean.'[11] They traded wool and grains for wine and cloth. The cloth economy had long gone from necessity to commodity. Legal definitions standardizing items for trade allowed them to be valued as currency. Beginning in the tenth century as groups from Iceland and Norway entered into trade with groups in the British Isles, cloth dimensions were standardized with one ell equaling the length of the king's arm. This standardized cloth, called *vaōmál,* was traded as commensurate with silver and in time, it replaced silver as actual currency.

Textile Qualities: Techniques, Spaces of Production, and Standardization (900–1800 AD)

Changes in the name of efficiency typically began with the consolidation of women into servitude or collective work, but eventually transferred women's work to men. Take note that the introduction of the horizontal treadle loom to the British Isles (1050 AD), and soon after the spinning wheel, coincides with their reach into northern and central Europe and further south. The first known representation of the loom dates to the thirteenth century. The treadle loom allowed more complex weave structures and patterns and more rapid textile production. It did not require frequent warp changes (often the most time-consuming part of weaving.) It was not long before weaving, now more efficient and easier to standardize, becomes the purview of men working in weaving 'factories' to produce more cloth for the commodities markets. The number of weavers required was reduced by mechanization and it was to their economic advantage to weave finer cloth for trade to the south. Heavy woolens could be woven abroad and sold to the poor in the British Isles — no need to waste men's time in the weaving guilds (factories) on such coarse fabrics.

Marta Hoffman notes how it must be more than coincidence that the shift from the simple, portable, warp-weighted loom to the more complex, heavy, floor loom resulted in a shift from female to primarily male weavers in the commodities arena. (Fig. 5) 'This loom must form the technical basis for the tremendous expansion of the cloth trade; it must also be this that lies behind the transition from domestic weaving to a flourishing craft carried out by men.'[12]

Textiles exported across the North Atlantic, following the establishment of Iceland as an independent republic in 930AD, tended to be heavy weight woolens. These were produced by women in the households of Icelandic sheep farmers and on larger farms outside port cities, and then traded with Norway in exchange for silver, timber, meat, grains, and animal feed. The Nordic regions sought wool for warmth, as farmers tended to raise cattle and crops rather than sheep. 'The period 930–1262 AD…witnessed the proliferation of a body of medieval literature and documents from which much of our knowledge about the Viking Age Scandinavian culture, and early medieval Icelandic society, comes from. [This period] is also responsible for the

11 Cartwright, 'Trade in Medieval Europe'.
12 Hoffman, *The Warp-weighted Loom*, p. 258.

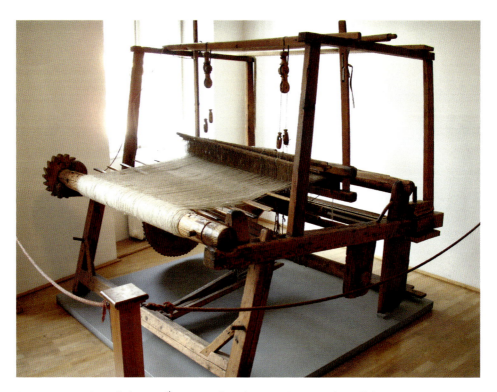

Fig. 5. Horizontal treadle loom, 17th century, photo by Javier Carro, Tiroler Volkskunst-Museum, Innsbrook, Austria. <https://commons.wikimedia.org/wiki/File:Webmaschine_in_Tirolervolkskunstmuseum.JPG>

propagation of a new form of currency — *vaðmál* — or legal cloth. By the thirteenth century, and perhaps earlier, this became the main currency in Iceland with which all economic transactions were carried out.'[13]

Archaeologists have found loom weights in Iceland and in other northern European regions during this period. There are weights of varying size suggesting that women were weaving fine cloth using lighter weights and coarser cloth using heavier weights. Drop spindles from this time also reveal a variety of weight sizes. Eva Andersson Strand, textile researcher and archeologist, whose research has focused on two specific sites in Norway found that the smaller, lighter drop spindles can spin fine thread that could have been woven locally on warp weighted looms. Though wool was the primary export from Iceland, the archeological record shows that fine linens were also woven during the Viking Age (874–1050 AD) This challenges the earlier belief that high quality woven cloth found in north central Europe and Iceland was imported from the Far East or northwards along the Danube. Strand observes,

13 Hayeur Smith, 'Vaðmál and Cloth Currency', p. 23.

'Whether the [Nordic] settlement was large or small, textile manufacture for everyday use must have taken up a great deal of time.'[14]

Women were responsible for spinning and weaving cloth for household use, for ceremonial use, and for the large sails that powered the ships that continued to expand Viking territory. Women wove the cloth currency, *vaðmál*, that supported the Icelandic economy. The value of textiles during this period is hard to overestimate. Archeological evidence in the trade regions surrounding the Mediterranean and the Near East supports some of the same conclusions, but it is the evidence in North Atlantic trade, particularly the Viking trade in Iceland, that points to women maintaining their position in the textile economy long after they'd been replaced by men in other regions. 'Technologically, Iceland remained somewhat anachronistic compared to the rest of Europe in the speed with which it integrated new technologies, such as horizontal looms and spinning wheels. These were adapted in the rest of Europe circa the eleventh century, but Iceland's history was characterized by the used of warp weighted loom and the drop…[spindle] well into the modern period.'[15] Women's continued role in Iceland's textile economy may have contributed to this prolonged use of vertical looms.

The settlers who populated Iceland were from Norway and brought with them their warp weighted looms and textile traditions including the ability to weave a range of fine to rugged cloth. Textile fragments excavated in Iceland show that from the ninth and into the early eleventh century, textile quality and weave structure vary suggesting a creativity spurred by adaptations to a new environment as well as the variations of techniques brought in from Ireland and the British Isles. To understand the trajectory of Icelandic weaving from its original diversity during the Viking Age to the highly standardized production of *vaðmál* during the Medieval era, archeologists (including Michele Hayeur Smith, Marta Hoffman, and Penelope Walton Rogers) have begun to analyse changes in weave structure.

The textile record shows a predominance of warp and weft thread twisted in the Z- direction and the use of tabby weave structure. On the arrival of Celts, familiar with the British Isles, it is apparent that both the spinning direction and the weaving structure begins to change. S-twist threads begin to show up in textiles. Weave structures shift from tabby or plain weave to twill. We see the development of multiple twills including decorative patterned twills. Both weave structures date back to the Neolithic era, but twill is the pattern that is preferred in the British Isles.

A study led by Michèle Hayeur Smith has examined '4,588 [textile fragments] and more continue to be added…' from Viking and Medieval Iceland. 'They clearly show that throughout the medieval period, 2/2 twills dominated textile production, except during the [earlier] Viking Age where more diversity in weaves was noted. From AD 1200 onward, only a small number of plain weaves are present, there is no evidence for patterned twills of any sort after the Viking Age, there are very

14 Andersson Strand, 'Tools and Textiles Production', p. 2.
15 Hayeur Smith, 'Weaving Wealth', pp. 23–24.

Household Production	Household Industry/ putting out system
The production solely covered the household's own needs	The production scale was beyond the needs of the producers
Household members possessed general knowledge and skills	It was organized at household level
Raw materials were commonly accessible	The household members possessed general knowledge and skills
They did not work full time on the production of textiles	There was a surplus of raw materiel and/or the buyers gave them raw material
	They did not work full time on the production of textiles
Attached Specialist Production	Workshops
High quality products, such as those used for desirable gifts were produced	Production for direct market
Production was performed by craft specialists and their skills were enhanced by full time occupation within textile production	That the items were practical and standardized
Craftsmen/women were supported by and dependent on patrons	The production volume was high
They worked on a full time basis	There was a great demand for products
The raw materials were of a better and/or higher quality	Craftsmen/women worked on a full time basis

few 2/1 twills, and *vaðmál* became the focus of Icelandic textile production.'[16] By this time, Norwegian and Icelandic legal records show a change in the makeup of *vaðmál* to resemble the cloth preferred in the Isles: '2/2 twill spun with z/s yarns and with a thread-count range of four to fifteen warp yarns per centimetre…'[17] This research suggests that by the late medieval period, creative weaving was losing ground to woven cloth currency. Women were the sole weavers of this legal tender. Much like in central Europe before weaving was transferred to men, in the Nordic regions, women labored in multiple types of environments. Eva Andersson Strand put forth a widely accepted outline for the ways in which women worked to produce the vast amounts and types of cloth required[18] (See chart above showing categories of Viking Age workplace and textile production in the Nordic regions by Eva Andersson Strand, 'Textile Production, Organization'.)

The classifications indicate the spaces of production and the role of women in these spaces. *Household weavers* produced cloth from available materials for the use of the household. They balanced weaving with other household responsibilities. *Household industry* was organized at the household level but dealt with materials in excess

16 Hayeur Smith, 'Weaving Wealth', p. 25.
17 Hayeur Smith, 'Vaomal and Cloth Currency', p. 272.
18 Andersson Strand, 'Textile Production, Organization', p. 16.

of what was needed to support the home. These materials were given to women who then wove cloth for others. Again, weaving did not represent their full occupation. *Attached specialist production* involved women with weaving experience and high craft. They were responsible for weaving finer textiles for religious rituals or for gifts to royalty. The materials used were of higher quality and came from patrons who supported this specialist work. Women worked full time, often in the company of others, in sunken buildings on large landowner property. Finally, *Workshop weavers* produced cloth for the direct market, products were standardized, and volume was high. Here craftsmen and women worked together in workshops in port settlements. In the latter category, single women or slaves were occupied with these full-time efforts. These diverse settings reveal evidence that *vaōmál* was being woven in a dispersed system throughout Iceland to produce currency to replace dwindling supplies of silver. 'Post Medieval Icelandic thread counts do suggest that medieval Icelanders were weaving woolen cloth to quasi-industrial standards in households all over Iceland. Plotting thread counts…reveals different patterns for understanding transformations in the production of Icelandic *vaōmál*… [The record] is marked by significant changes in cloth occurring at the end of the Viking Age, at the end of the Medieval period, at the beginning of the early modern period, and finally around AD 1740, following the introduction of horizontal looms into Iceland'.[19]

These findings point to the fact that women, as the only weavers, were weaving to strict legal standards well into the eighteenth century using warp weighted looms. The size of *vaōmál*, also regulated and adjusted over time, first measured one ell wide, then two ells wide, so that after the cloth had reached the point where it was of too poor quality to serve as legal cloth, it could be made into cloaks and worn directly. Legal records indicate punishment for legal cloth, offered for trade, that did not meet currency standards. By the late 11th century, *vaōmál* dominated textile production in Iceland.

The relationship between men and women at this time is characterized by a cooperative division of labor. Men were tending and shearing sheep, seafaring, and fishing. Men also established trade relationships and enforced legal standards for cloth. The production quantities had increased for sails, clothing, and *vaōmál* in the growing nation. Women still managed the vast amount of spinning, weaving, and childrearing responsibilities from the household, but it seems men understood the value of textiles to the colony. '[W]omen were at the root of the Icelandic economic system, ensuring at a very basic level the survival of their people in this harsh land.'[20] This cooperation was likely encouraged by the relatively small size of the colony in Iceland and the extremely cold climate where they lived. Whatever the case, women and men worked collaboratively, though not equally, in the textile economy. How and why Icelandic women maintained their position of power for so long is a matter of speculation. We know from Norse mythology that spinning, weaving, and textiles were used as metaphors for birth, life, and death (see *Njál's Saga*). Archeologist

19 Hayeur Smith, 'Weaving Wealth', p. 33.
20 Hayeur Smith, 'Weaving Wealth', p. 38.

Summary: Beyond the Warp Weighted Loom

As in the rest of Europe, the advances in technology changed women's work and their role in Icelandic society. When the treadle loom and the spinning wheel were adopted in the eighteenth century it sent women back to weaving for the household and community (e.g., clothing, sails, nets, and rope). It is unclear whether highly skilled weavers continued to work as specialists weaving fine cloth for burials and other ceremonial vestments. Men now wove the cloth destined for other countries and managed all aspects of trade and finances.

While there is no doubt that the horizontal loom accounted for the rapid shift in Icelandic society, I argue that this is not the only factor in women losing their power and place in the economy. The dispersed household workforce was beginning to change as the economy grew from one of subsistence to one of the primary providers of woolens and legal cloth to the Nordic region and the British Isles. Single women and women whose children were grown were moved into the realm of servitude to meet the growing demands for *vaðmál* and specialty fabrics. They worked in centralized buildings closer to ports or on large farmsteads.

Women of childbearing age were tethered to the household and worked in community to spin and weave. Women shared weaving and childrearing responsibilities that were and had been forever intertwined. Birthrates were balanced between needing more workers (Viking children contributed to the farm and house at a young age) and having too many mouths to feed. Women were responsible for birthing, raising, feeding, and clothing their young. While the bulk of their work was spinning and weaving, it could not be a full-time occupation with so many other tasks essential to the household and ultimately the community.

At the start of the Viking era women were weaving more complex and patterned cloth for the home. During the medieval era, that changed as more and more time was spent weaving standardized cloth. Time for creativity was lost to the demand for legal cloth. If this creativity reflected the inner beliefs and aspirations of women, then this connection to the world of their imagination was lost.

As warp weighted looms became wider to accommodate wider widths of *vaðmál* they were tended by more than one woman. Many researchers suggests that the reason women could not take up the horizontal treadle loom was because it was heavier,

21 Hayeur Smith, 'Vaomal and Cloth Currency', p. 271.
22 Hayeur Smith, 'Thorir's Bargain', pp. 730–46.

required strength, was a one-person operation, and was complex in its mechanics. But there are other factors to consider: Women had been using looms that required great bodily strength, especially to weave heavy woolens. The fact that the horizontal loom was heavy and complex primarily affected its inability to be moved around as required in the small household setting. Mechanization of the loom was necessary to increase the amount of cloth that could be woven per day; the loom was invented by men whose primary concern was efficiency. The operation of the horizontal treadle loom with its moving parts was incompatible with babies and children.

Why didn't women, who intimately understood spinning and weaving, invent the spinning wheel or the treadle loom? In the end women did not have the time or incentive to develop a better loom as the warp weighted loom had fit perfectly within their realm for the past eight thousand years. It met their demands and supported the collective work essential for householding. Men's desire for efficiency led them to develop a tool only they could use, disrupting thousands of years of women's work. It is perhaps easy to see why remote Iceland, home of the Vikings, did not immediately adapt this new technology. It is around this time that women took up knitting as a creative and productive outlet in addition to continuing to weave for the household. But they never regained what they lost before the commodification of cloth nor the power they held in the textile economy. The fact the women in the Nordic countries were still holding on to the warp weighted loom and weaving heavy woolen blankets into the 1950s suggests that women's bond with this loom calls them to it as a means of mythical and creative expression and productivity.

Bibliography

Primary Sources

Andersson, Eva, *Tools for Textile Production from Birka and Hedeby* (Stockholm: Birka Project for Riksantikvarieämbetet, 2003)

Andersson Strand, Eva, 2009. 'Tools and Textiles: Production and Organisation in Birka and Hedeby', in *Viking Settlements and Viking Society: Papers from the Proceedings of the Sixteenth Viking Congress (Reykjavík and Reykholt 16th – 23rd August 2009)*, ed. by Svavar Sigmundsson (Reykjavic: University of Iceland Press, 2009), pp. 1–17

———, 'Textile Production, Organization and Theoretical Perspectives on Trade in the Scandinavian Viking Age', in *Textiles and the Medieval Economy: Production, Trade and Consumption of Textiles, 8th-16th Centuries* (Oxford, England: Oxbow Books, 2015), pp. 10–15

———, Eva and Marie Louise, Nosch, 'The Wool Zone in Prehistory and Protohistory', in *The Textile Revolution in Bronze Age Europe: Production, Specialization, Consumption* (Cambridge, England: Cambridge University Press, 2019), pp. 15–37

Barber, Elizabeth Wayland, *Prehistoric Cloth: The Development of Cloth in the Neolithic and Bronze Ages with Special Reference to the Aegean* (Princeton, New Jersey: Princeton University Press, 1992)

———, *Women's Work: The First 20,000 Years* (New York: W. W. Norton & Co., 1994)

Hayeur Smith, Michèle, 'Vaðmál and Cloth Currency in Iceland', in *Silver, Butter, Cloth: Monetary and Social Economies in the Viking Age*, ed. by Jane Kershaw and others (Oxford: Oxford Academic, 2018), pp. 251–77

———, 'Weaving Wealth: Cloth and Trade in Viking Age and Medieval Iceland', in *Textiles and the Medieval Economy: Production, Trade, and Consumption for Textiles, 8th-16th Centuries* (Oxford, England: Oxbow Books, 2015), pp. 23–40

———, 'Thorir's Bargain: Gender, Vaðmál and the Law', *World Archaeology*, 45.5 (2014), 730–46

Hoffman, Marta, *The Warp Weighted Loom Studies in the History and Technology of an Ancient Implement* (Oslo: Universitets Forlaget, 1964)

Postrel, Virginia, *The Fabric of Civilization: How Textiles Made the World* (New York: Basic Books, 2020)

Secondary Studies

Adovasio, James M., 'The Textile and Basketry Impressions from Jarmo', *Paléorient*, 3 (1975), 223–30. < http://www.jstor.org/stable/41489842>.

Alverez, Nilda, *Secrets of Spinning, Weaving, and Knitting in the Peruvian Highlands* (Cusco Peru: Thrums, 2017)

Cartwright, Mark, 'Trade in Medieval Europe', *World History Encyclopedia*, 2019 <https://www.worldhistory.org/article/1301/trade-in-medieval-europe/> [accessed 20 May 2021]

Frei, Karin, Ulla Mannering, Ina Vanden Berghe, and Kristian Kristiansen, 'Bronze Age Wool: Provenance and Dye Investigations of Danish Textiles', *Antiquity*, 91 (2017), 640–54

Hanson, Viveka, 'Textile Traditions: The Later Nordic Iron & Viking Age', *iTextilis* (2015). <https://www.ikfoundation.org/itextilis/the-later-nordic-iron-viking-age.html> [accessed 28 May 2023]

Jorgensen, Lisa Bender, *North European Textiles until AD 1000* (Aarhus: Aarhus University Press, 1992)

Sabatini, Serena and Sophie Bergerbrant, *The Textile Revolution in Bronze Age Europe: Production, Specialization, and Consumption* (Cambridge: Cambridge University Press, 2020)

Wong, Kate, 'Stone Age String Strengthens Case for Neandertal Smarts', *Scientific American* (April 9, 2020) <https://www.scientificamerican.com/article/stone-age-string-strengthens-case-for-neandertal- smarts/> [accessed 28 May 2023]

ANA M. ÁGREDA PINO AND
CAROLINA NAYA FRANCO

Luxury, Status and Subversion

Female Embroidery in the European Renaissance

▼ **ABSTRACT** Throughout history, textile work has been used to construct the feminine ideal of the virtuous woman, as it was useful to prevent idleness and encourage honesty and industriousness. But, compared to the simplicity of spinning, embroidery acquired a profane dimension linked to luxury and feminine inventiveness in the Renaissance that moralist criticism was quick to judge regarding its artifice and alleged vanity. The mistrust of the treatises reveals the worry that women would go beyond the limits of domesticity imposed on them by the patriarchal society.

Textile Work and Virtue: Moral Values of the Domestic Woman

Throughout history, textile work, especially spinning, sewing and embroidery were considered typical women's work, appropriate to their nature and the spaces in which they spent their lives. They were used to construct a feminine ideal, that of the domestic woman.

The connection between women and textile work has a long-lasting tradition. Boccaccio, in his work *De Mulieribus Claris* (1361–1362) pointed out that the 'artes mecánicas, quales son filar, texer [...] todas fueron por ellas inventadas' (mechanical arts, which are spinning, weaving [...] were all by them invented). It is also Boccaccio who refers to the main textile work associated with women: spinning. It was invented by Eve, the first woman. He presents the task of spinning as a consequence of sin and the expelling from Paradise for which only she is responsible. All women are heirs to Eva, her stain and her judgement. Therefore, they all must spin with the sweat of their brow.[1]

But in fact, the association between spinning and women goes as far back as the classical world. Spinning women can be found on some Greek ceramic vessels, such as the well-known *Amasis terracotta lekythos* (c. 550–530 BC. The Metropolitan

1 Giovanni Boccaccio, *De las mujeres ilustres en romance*, chapter VI and ending of the book.

Women in Arts, Architecture and Literature: Heritage, Legacy and Digital Perspectives, ed. by Consuelo Lollobrigida and Adelina Modesti, Women in the Arts: New Horizons, 1 (Turnhout: Brepols, 2023), pp. 179–194
BREPOLS ☙ PUBLISHERS
10.1484/M.WIA-EB.5.134650

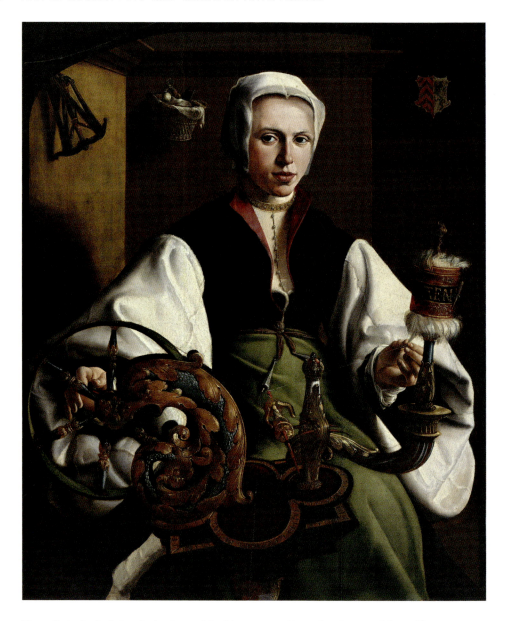

Fig. 1. *Portrait of a lady spinning* (c. 1531) by Maarten van Heemskerck. 105 × 86 cm. Photo courtesy of Museo Thyssen-Bornemisza (Madrid).

Museum of Art, New York). This work had an economic dimension, but also a moral one. Spinning and textile work in general are linked in Greece to the feminine virtue par excellence, the quality of *ergatis* or laborious. In Rome the virtuous woman also occupies herself spinning wool. Tanaquil, known as Gaya Caecilia, wife of the fifth king of Rome, Tarquinius Priscus (616–579 BC), or Lucretia, a Roman matron mentioned in Ovid's *Fasti*, became models of industrious women, busying themselves in

LUXURY, STATUS AND SUBVERSION 181

profitable and honest work. Work which also guaranteed female chastity. It must be remembered that Lucretia, after being raped by Sextus Tarquinius, son of the Roman king Lucius Tarquinius Superbus (534–510 BC), unable to bear the humiliation to her honour, stabbed herself with a dagger putting an end to her life. For this reason, it is not surprising that Tanaquil, and especially Lucretia, were remembered by the treatise and moral writers of the Modern Age in the numerous praises they dedicated to spinning. In Spain, one of the greatest defenders of spinning work was Friar Luis de León. In *La Perfecta Casada* (1583), he maintained that spinning helped fight a particularly dangerous female vice: idleness. The spindle and the spinning wheel were the weapons that women had to use to defend themselves from temptations and sin.[2] And Father Carmona, in the book *Carro de las donas* of 1542, the Castilian translation and adaptation of the *Llibre de les dones* by Francesc Eiximenis (1392), advocated that women had to be able to spin, sew and weave to prevent inactivity which was the origin of all type of vices and excesses (Fig. 1).[3]

However, in the Christian world, the model of virtue for all women is the Virgin Mary. Some of the New Testament apocrypha show her spinning from an early age. The same happens in the Gospel of Pseudo-Matthew 6. 1–2, in the Protoevangelium of James 10. 1–2 and in the Armenian Gospel of the Infancy 4. 8. The circle that began with Eve closes with Mary: if with Eve spinning symbolized work and suffering, with Mary it becomes a spiritual asset, an incarnation of virtue and of a decorous and withdrawn life. By imitating Mary women were able to persevere down that path of honest life, as the religious and moral texts constantly reminded them.[4]

However, at the dawn of the Modern Age, women, at least those of high social status, seemed determined to leave behind the arduous task of spinning. The response of writers and moralists was not far behind. Their position varied between a persistence on the benefits of spinning and a more direct and incisive criticism. Friar Antonio de Guevara would fall into this first scenario, who in his *Epístolas familiares* (1542) argued that spinning was the flag and banner of virtue for any woman, regardless of her place on the social scale.[5] His arguments coincided with those of other European writers such as Francesco Barbaro, author of the text *De Re Uxoria* (Florence 1416), Gionvanni Bruto, to whom we owe *Institutione di una fanciulla nata nobilmente* of 1555, or Richard Brathwaite, whose ideas on this issue were summarized in *The English Gentlewoman* (1631).[6] More explicit was the judgment of the doctor Andrés Laguna, physician to Pope Julius III, Emperor Charles V and his son King Philip II. In his translation into Spanish of Dioscorides' *Materia Medica* (c. AD 40–90), published in 1554, he develops the comment made by the latter on the plant called *atractyl* by the Greeks and *fusus agrestis* by the Romans. In this gloss, Laguna explains that the spindle was called *atractos* in Greek, because the women made tools with the atractyl with which, however, they 'hilavan harto mas delgado' (spun much thinner) than

2 Fray Luis de León, *La Perfecta Casada*, pp. 97–99.
3 Padre Carmona, *Carro de las donas*, vol. I, pp. 186–88, pp. 191–92.
4 Ágreda, *Vivir entre bastidores*, p. 61.
5 Antonio de Guevara, *Libro primero y segundo de las epístolas familiares*, First book, Epistle 55.
6 Jones and Stallybrass, *Renaissance Clothing*, pp. 107–08.

the women of the sixteenth century, who 'para hilar una hebra de lino en cien años, quieren ya las ruecas de plata, o marfil, como personas que aviendo perdido el gusto a semejante exercicio, han menester mil apetitos y falsas para le despertar de suerte que al cabo del año, cuestan mas los instrumentos que lo que importa el hilado' (to spin a thread of linen in a hundred years, they already want silver or ivory spinning wheels, like people who, having lost the taste for such a work, have needed a thousand false appetites to wake them up so that after a year, the instruments cost than more than what the thread matters).[7]

There are different reasons that explain the apathy that queens, noblewomen and great ladies showed towards spinning. Firstly, it was not a socially valued task. A Spanish saying stated: 'Holgar sin vergüenza es hilar rueca' (To rest without shame is to spin a spinning distaff).[8] However, other Hispanic sayings or paroemias collect the complaints of anonymous women tired of leading a life tied to a job that was hard and painful: 'Rueca y huso, mal fuego te arda, que no hay madera tan poca que tanto mal me haga' (Distaff and spindle, bad fire may burn you, that there is no wood so little that it does me so much harm).[9] In addition, spinning was associated with women of low social status. Spinning meant a dishonour for those great ladies who, at the dawn of the Renaissance, were more inclined towards a different textile work: embroidery.

Embroidery in the Renaissance: Inventiveness, Status and Wealth

Apparently, spinning and embroidery served a similar purpose in setting the moral values of the domestic woman. Embroidery also avoided idleness and allowed women to spend their time carrying out a regulated activity, in a space inside walls, which was also controlled. A benefit that was greater if the works produced were used for the service of churches and monastic institutions, as advocated by writers such as Gaspar Astete (1597).[10] This is the reason why embroidery and spinning were likened or mentioned alternatively in some sources when referring to positive female role models. Thus, when Boccaccio tells the story of the Roman woman Lucretia in *De mulieribus Claris*, the first thing he says is that she was spinning, to then add that she was engaged in 'honestos y matronales ejercicios' (honest and matronly exercises), such as 'labrar' (work), that is, embroidering, or sewing.[11] Another author, Juan Luis Vives, when referring to Queen Isabella the Catholic as a model woman and mother, stressed that she wanted all her daughters to be able to spin, sew and plough.[12]

7 Andrés Laguna, *Pedacio Dioscorides Anazarbeo*, p. 333.

8 Gonzalo Correas, *Vocabulario de refranes*, pp. 244, 371.

9 Gonzalo Correas, *Vocabulario de refranes*, p. 439.

10 Gaspar Astete, *Quarta Parte de las obras del Padre Gaspar Astete*. Book II, Part IV, Document XI, pp. 197–98.

11 Giovanni Boccaccio, *De las mujeres ilustres en romance*, chapter XLIIII.

12 Juan Luis Vives, *Instrucción de la mujer cristiana*, p. 46.

But of all textile occupations, embroidery is the most appropriate for a lady. An idea that will take hold in the Modern Age, a time when the art of the needle performed in the domestic sphere will spread progressively. When Alonso Remón wrote his work *Entretenimientos y juegos honestos, y recreaciones cristianas* in 1623, he divided women into two social groups, on the one hand, princesses and powerful and rich ladies, and on the other, women of 'mediano estado en las ciudades, y de labradoras en las aldeas' (intermediate status in the cities, and of farmers in the villages). In his opinion, this condition determines the entertainment which either group has to focus on. And in the case of a lady, embroidery is the activity that he considers the most appropriate.[13] Also Francisco Cascales in his *Cartas Filológicas* (1634) details the textile occupations of a main maid, among them the execution of various embroidery, lace and fraying tasks.[14] Both of them coincide in this idea with Eiximenis, who already in *Dotzé del Crestiá* (1379–1392), presented a division of textile work based on the social class of women. Thus, 'les mjjanes e les simples deuen saber de cosir e de tallar çò que ès necessari al marit, e a elles, e als infants, de roba de lli' (the middle ones and the simple ones must be able to sew and work that which is necessary for the husband, and for them, and for the children, the linen clothes), while 'les dones majors se deuen ocupar de cosir de seda e d'aur, e de perles' (the higher ones must be busy sewing silk and gold and pearls).[15] Also in the *Libro de buen amor* (fourteenth century), by Juan Ruiz, Arcipreste de Hita, it is said that a 'dueña' (lady) of quality, that is, a great lady, must know about 'toda nobleza de oro e de seda' (all nobility of gold and silk),[16] or in other words, she must be capable of embroidering selected works and important ones with rich materials.

Both Eiximenis and Juan Ruiz emphasize on a characteristic of the embroidery practiced by great ladies: the use of sumptuous materials such as silk, gold or pearls. It was these materials that made embroidery an art that, according to Suárez de Figueroa, author of *Plaza Universal de todas Ciencias y Artes* (1615), 'agradó asi mismo a muchas emperatrices y Princesas' (also pleased many empresses and princesses) and that, in the opinion of Antonio Palomino, was characterized as being 'arte antiquisima y muy ilustre, como favorecida y blasonada de princesas y señoras de mucha clase' (ancient and very distinguished art, as favoured and emblazoned by princesses and ladies of high class).[17] Catherine de' Medici, who spent much of her time embroidering with her daughters and the exiled Mary Stuart, or Marguerite d'Angoulême, known as Marguerite de Navarre, have been cited as examples of great Renaissance ladies devoted to the practice of the needle. Pierre de Ronsard dedicated an ode to the latter in which he praised her skills with the needle and the rich materials she used for her work, since she was able to 'hacer muchas hermosas obras/

13 Alonso Remón, *Entretenimientos y juegos honestos*, fols 87ᵛ–89ʳ.

14 Francisco Cascales, *Cartas Filológicas*, t. III, pp. 13–16.

15 Vinyoles, 'Hilar, cocinar, cuidar', p. 85.

16 Juan Ruiz, *Libro de buen amor*, p. 30.

17 Christoval Suárez de Figueroa, *Plaza Universal de todas Ciencias y Artes*, fol. 219ʳ⁻ᵛ; Antonio Palomino, *El Museo Pictórico y Escala Óptica*, t. I, pp. 124–25.

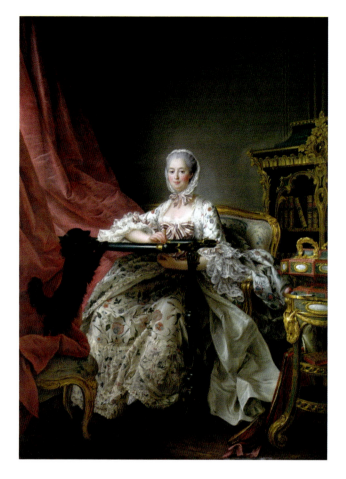

Fig. 2. *Portrait of Madame de Pompadour at her Embroidery Frame* (c. 1763–1764) by François-Hubert Drouais. 217 × 156.8 cm. Photo courtesy of National Gallery (London).

sobre lienzo, y además/ á mezclar la seda y el oro' (make many beautiful works/ on canvases, and also/ how to mix silk and gold) (Fig. 2).[18]

But, which were those rich materials used by women in their embroidery works? Women's domestic embroidery has traditionally been linked to the ornamentation of linen canvas fabrics with which *white clothes*, for household use — tablecloths, towels, sheets or pillows —, or to dress — shirts or headdresses — were made. Some of these linen fabrics can be considered a rich material in their own right. This is the case with the *holland*, a very fine canvas fabric, plain knit and milky white. A fabric that was made in Holland, Friesland and other areas of the (seven) United Provinces, hence its name. The same can be said of *chambray*, a very delicate linen fabric, white, finer and thinner than the *holland*, so called because it was produced in the French

18 Lefébure, *El bordado y los encajes*, p. 131.

LUXURY, STATUS AND SUBVERSION 185

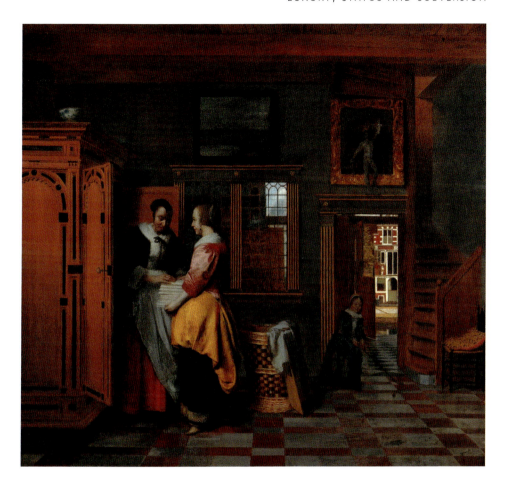

Fig. 3. *Interior with women beside a Linen Cupboard* (1663) by Peter de Hooch. 70 × 75 cm. Photo courtesy of Rijksmuseum (Amsterdam).

city of Cambrai. Holland and chambray were luxurious textiles, worn by the upper classes of European Renaissance society. It is enough to go through the inventories of King Philip II to see the large number of goods and garments made and decorated with these luxurious fabrics. Their value was only surpassed in the Modern Age by the most exquisite silk fabrics (Fig. 3).[19]

In addition, these textile pieces could be delicately decorated with embroidered work in which highly valued materials were also used. The different colour silk threads were a basic material in needlework. There were different types. Loose twist filament silk, also called *seda lasa* or *seda flor*, was highly appreciated, a fine silk, slightly twisted, with a smooth and velvety surface texture, quite suitable for certain embroidery stitches, such as the *satin stitch*. The embroidered motifs were filled

19 Ágreda, *Vivir entre bastidores*, pp. 207–08.

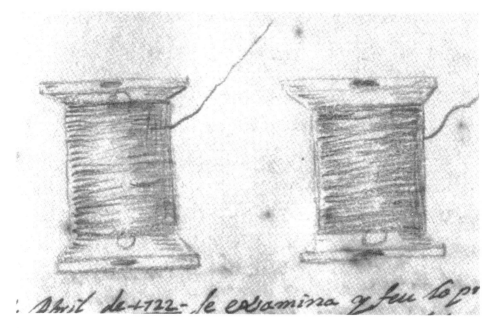

Fig. 4. Drawing of *Carretes de hilo de oro y plata tirados* on laid paper, mastery exam by Vicent Mir (1722). 34.8 × 24 cm. *Libro de Dibujos* (1508–1752), fol. 377v. Photo courtesy of the Arxiu Històric (Ajuntament de València).

in with this variety of silk, until a subtle and delicate surface was obtained, with naturalistic modelling effects.

The use of precious metals, gold and silver yarns that were kept wrapped in paper or arranged around skeins, reels, bobbins and even in playing cards was frequent in the needlework carried out by great ladies of the European monarchy and nobility.[20] A goldsmith guild access exam in Valencia reveals how there were some silversmiths who were specialized in making gold thread which they would then wind on bobbins (Fig. 4).

Metal threads from Italy, gold and silver from Milan which are mentioned in various royal inventories, in those of Isabella of Portugal or in those of her children, King Philip II and Joanna of Austria, Princess of Portugal, were highly valued.[21] There were different varieties of metal threads used by these women: *canutillos* — in which a fine gold thread was wound on itself in the shape of a helix and which the

20 Historical Archive of Notarial Protocols of Zaragoza (from now on A.H.P.Z.), *Jerónimo Andrés, mayor*, 1585, fols 428r y 443r; *Pedro López*, 1561, fol. 184r; Pérez de Tudela, *Los inventarios de doña Juana de Austria*, pp. 63, 469, 470.

21 Checa, *Los inventarios de Carlos V y la familia imperial*, vol. II, p. 1764; Sánchez Cantón, *Archivo Documental Español publicado por la Real Academia de Historia*, vol. I, p. 195; Pérez de Tudela, *Los inventarios de doña Juana de Austria, princesa de Portugal*, pp. 469–70.

women themselves made thanks to small lathes that appear in some inventories —,[22] *torzales redondos* — which consisted in a silk core then covered by a metal one — and *cordoncillos* which, as their name states, had the shape of a thin cord.[23] There is also mention in these documentary sources of works decorated with gold and silver *argentería*, which possibly consisted in small openwork and pierced plates forming scales or links, although the paucity of the documentary descriptions does not allow us to know the exact characteristics of these metallic applications (Fig. 5).[24]

The use of these threads or metal plates depended on the type of embroidery work that was being performed. The combination of metal and silk threads was common, as happens in one of the most complex embroidery stitches of the Modern Age, what is known as *or nué*. In this type of embroidery, the canvas background was covered with round *torzales*, which were completely hidden by polychrome silk stitches. However, the glitter of the metal could be seen through some spaces in between, causing subtle sparkles that covered the motifs in an aura of golden light. In *Fieras afemina amor* (1677) by Pedro Calderón de la Barca, Iole tells Hercules that she and her ladies cover various drawings or motifs 'hilados copos de oro' (threaded gold flakes), 'matizados à merced' (embroided in or nué nuanced at will), which, with the help of the spool and the needle, tools used at this point, become 'flores de rosicler' (translucent red enamelled flowers).[25] The comparison of or nué with the translucent red enamel gives an idea of the richness and complexity of this embroidery technique. The 'rochicler' in Spain (*smalto roggio* in Italy, *rogia chlero* in France) is considered the most beautiful enamel of all, red and translucent, which sets well on gold. Benvenuto Cellini (1568) explains that this colour was discovered by chance by an alchemist who was a goldsmith, while trying to create gold by mixing many minerals. There was a beautiful red glass was left in the crucible, which he was able to reproduce with great difficulty. Cellini differentiates the *smalto roggio* from the *rosso*, which is not transparent, nor does it have a beautiful colour and which sets well on silver.[26] There are mentions of the use of enamelled pieces of jewellery in some of the linen pieces embroidered by women, which are sewn to the textile base for decoration and ornamentation. Among the assets of Joanna I of Castile are splendid shirt collars adorned with gold pendant jewels, pinned or sewn to the ruffs with translucent red enamelled letters.[27]

The lavishness and luxury of the translucent red enamel (or 'trasflor') was enhanced by the use of pearls, especially the variety known as *aljófar* (seed pearls). Sebastián de Covarrubias in his work *Tesoro de la lengua castellana o española* (1611),

22 A.H.P.Z., *Jerónimo Andrés, mayor*, 1585, fol. 426ʳ, 449ᵛ. Other mentions to this type of thread in *canutillo* in the A.H.P.Z., *Miguel de Segovia*, 1553, fol. 963ᵛ; Mateo *Villanueva*, 1554, fol. 981ʳ; *Luis Navarro*, 1578, fol. 384ᵛ; *Jerónimo Andrés, mayor*, 1585, fol. 426ʳ; *Diego Miguel Malo*, 1595, fol. 236ʳ.

23 A.H.P.Z., *Jerónimo Andrés, mayor*, 1585, fol. 446ʳ; *Pedro López*, 1561, fol. 176.

24 A.H.P.Z., *Miguel Villanueva*, 1517, fol. 448ᵛ; *Jerónimo Andrés, mayor*, 1585, fols 429ᵛ, 430ʳ; *Diego Miguel Malo*, 1595, fol. 232ᵛ. Various ounces of *argentería* are mentioned in the inventory of Joanna of Austria from 1573. Pérez de Tudela, *Los inventarios de doña Juana de Austria*, p. 470.

25 Pedro Calderón de la Barca, *Fieras afemina amor*, p. 197.

26 Benvenuto Cellini, *Dve Trattati vno intorno alle otto principal arti dell oreficeria*. p. 15.

27 Checa, *Los inventarios de Carlos V y la familia imperial*, vol. I, pp. 1065, 1067, 1071.

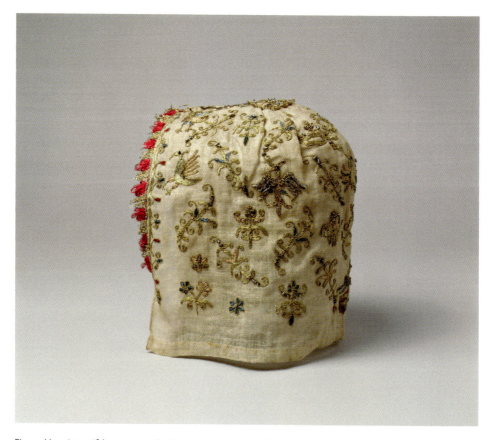

Fig. 5. *Venetian coif* (c. 1500–1525). Linen embroidered with silk and metal threads. 22.9 × 19.7 cm. Photo courtesy of the Metropolitan Museum of New York.

points out that the aljófar was a pearl 'menudica que se halla dentro de las conchas que las crian' (small and found inside the shells that grow it).[28] The *Diccionario de Autoridades* (1726–1739), introduces an annotation regarding the quality of these pearls. Thus, *aljófar* was described as those 'granos menos finos y desiguales; à distinción de la perla, que es mas clara y redonda, yá sea grande, ò pequeña' (less fine and unequal grains; as opposed to the pearl, which is clearer and rounder, whether it be large or small).[29] Juan de Arfe in *el Quilatador* (1572) pointed out that these pearls 'solían juzgarse por el bulto y no por el peso' (used to be judged by their shape and volume and not by their weight). Many were hollow and some had traits that reduced their value. These seed pearls were worth much less, unless they were 'grandes y de buen lustre' (large and with lustre), as in this case they could be used to make the decorations in fashion in the last third of the sixteenth century.[30] The *aljofar*, as Covarrubias

28 Covarrubias, *Tesoro de la lengua castellana y española*.
29 Real Academia Española, *Diccionario de Autoridades*.
30 Juan de Arfe y Villafañe, *Quilatador de la plata*, fols 62v–63r.

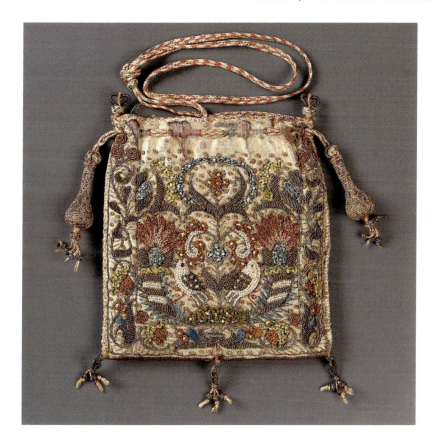

Fig. 6. *English purse* (sixteenth-seventeenth century). Silk satin embroidered with polychrome silk, gold metallic threads and seed pearls. 13.3 × 13 cm. Photo courtesy of Museum of Fine Arts Boston.

explains, was bored into to pass the thread with which it was affixed to the textile surfaces.[31] Sometimes seed pearls were combined with precious stones such as emeralds, but also with garnets. Both stones are present in the classical world and now are taken up again when this tradition is imitated. Pearls and emeralds without transparency were combined in Roman jewellery, while garnets, together with pearls, were among the few gems present in Hellenistic jewellery. The use of these rich materials was only available to women of high status. As a character in Sebastián Fernández's *Tragedia Policiana* (1547) points out, only great ladies were allowed to 'string seed pearls' (Fig. 6).[32]

31 Covarrubias, *Tesoro de la lengua castellana y española*.
32 Esteban, 'Edición y estudio de la *Tragedia Policiana*', p. 183.

Submission or Subversion: Vanity as an Argument for Moralistic Criticism

The use of all these expensive materials gave embroidery a mundane point of view and transformed it into an expression of the rank and wealth of a great lady. And it was also this secular dimension of embroidery that created the most mistrust. Through embroidery, it was possible for women to design motifs and invent new techniques. The art of the needle was seen as a skilful exercise, compared to the simplicity of spinning. As Luigini pointed out in *Il Libro dell bella Donna*, embroidery was not only a reflection of feminine virtue, but also a means by which a lady could demonstrate a certain inventiveness and skill.[33] Embroidery, unlike spinning, was a creative task, a true 'needle painting' which produced works that were susceptible of being appreciated and inherited through the matrilineal line. Embroidery was considered a feminine art par excellence, in which, as Cristóbal Villálón pointed out in *Ingeniosa comparación entre lo antiguo y lo presente* (1539), that women were able to produce works 'de tanta biueza y delicadez, que muy famosos artífices no pueden en la plata & oro esculpir más sotilmente que ellas lo labran en sus lienços, telares y bastidor' (of such beauty and delicacy, that very famous craftsmen cannot sculpt more subtly in silver & gold than they work it on their canvases, looms and embroidery frame).[34]

In Spain, the mistrust towards the notions of wealth, class and luxury which were linked to embroidery was expressed in the moral and behavioural treatises. It must be remembered that even in a medical treatise that we have already referred to, written by Andrés Laguna from the translation and comments of the work of Dioscorides, the censorship towards the Renaissance women is clearly seen, who in his opinion are too inclined towards tools and delicate and expensive materials. Laguna blamed his contemporaries for their resistance to spin, work which they were only willing to undertake if they had splendid tools made from precious materials.[35] Along the same lines, it is worth including Luis de León's speech in *La Perfecta Casada*. The friar and humanist complains that what women 'hacen y labran ha de venir todo de casa del joyero y del mercader, o fiado, o comprado a mayores precios' (make and embroider all has to come from the house of the jeweller and the merchant, or on credit, or bought at higher prices). And he continues, that women make use of 'oro estirado en hilos delgado' (gold stretched out in thin threads) or 'perlas que se esconden en el abismo del mar' (pearls that are hidden in the abyss of the sea), to create works that he considers vain and of dubious profit or merit, since, 'quiere la ventura después que, habiendo venido mucho del oro y mucho de la seda y aljófar, termina todo el artificio y trabajo en una red de pájaros o en otra cosa semejante de aire' (fortune wants that after having come a long way from the gold and much from the silk and seed pearls,

33 Parker, *The Subversive Stitch*, p. 62.

34 Cristóbal Villalón, *Ingeniosa comparación entre lo antiguo y lo presente*, p. 165.

35 Andrés Laguna, *Pedacio Dioscorides Anazarbeo*, p. 333.

all the artifice and work ends up in a net of birds or in another similar thing of air).[36] Not only Luis de León thought in this way. In Great Britain, Thomas Powell, in his work *Art of Thriving, or the plaine pathway to preferment* (1635), addresses the fathers of bourgeois families, warning them against some needlework tasks, which made use of excessively burdensome silver and gold threads. This capricious side of embroidery was as dangerous as reading frivolous and love stories.[37] It was believed that these jobs incited women to public display, to go beyond the limits of domestic discretion, to walk down the dangerous paths of vanity that could lead to the sin of lust. The control of the volatility attributed to females passed through the very vigilance of embroidery, to control its onerous materials and formal variations. To achieve this, moralistic writers appealed to economic and moral arguments, while at the same time they disregarded women's creativity and their ability to devise new designs or procedures.

36 Fray Luis de León, *La Perfecta Casada*, pp. 77, 116–17.
37 Jones and Stallybrass, *Renaissance Clothing and the Materials of Memory*, p. 144.

Bibliography

Primary Sources

Alonso Remón, *Entretenimientos y juegos honestos, y recreaciones christianas, para que en todo genero de estados se recreen los sentidos, sin que se estrague el alma* (Madrid: Viuda de Alonso Martín, 1623)

Andres Laguna, *Pedacio Dioscorides Anazarbeo, acerca de la materia medicinal y de los venenos mortíferos, traduzido de lengua griega, en la vulgar castellana, & ilustrado con claras y substanciales Annotaciones, y con las figuras de innumeras plantas exquisitas y raras, por el Doctor Andres de Laguna* (Amberes: Casa de Iuan Latio, 1555)

Antonio de Guevara, *Libro primero y segundo de las epístolas familiares* (Biblioteca Virtual Universal) <https://biblioteca.org.ar/libros/131733.pdf> [accessed 3 June 2022]

Antonio Palomino, *El Museo Pictórico y Escala Óptica. Tomo I Theorica de la Pintura* (Madrid: Editorial Aguilar, 1988)

Benvenuto Cellini, *Dve Trattati vno intorno alle otto principal arti dell oreficeria. L'altro in materia dell Árte della Scultura; doue si veggono infiniti segreti nel la uorar le figure di marmo, & nel gettarle di bronzo* (Fiorenza: Valente Panizzij & Marco Peri, 1568)

Christoval Suárez de Figueroa, *Plaza Universal de todas Ciencias y Artes* (Madrid: Luis Sánchez, 1615)

Cristóbal Villalón, *Ingeniosa comparación entre lo antiguo y lo presente* (Madrid: Sociedad de Bibliófilos Españoles, 1898)

Francisco Cascales, *Cartas Filológicas*, ed. by Justo García Soriano (Madrid: Espasa Calpe, 1954)

Fray Luis de León, *La Perfecta Casada*, ed. by José López Navarro (Madrid: Ediciones Rialp, 1968)

Gaspar Astete, *Quarta parte de las obras del Padre Gaspar Astete. Tratado del govierno de la familia y estado del matrimonio* (Valladolid: Alonso de Vega, 1597)

Giovanni Boccaccio, *De las mujeres ilustres en romance*, ed. by José Luis Canet (Zaragoza: Paulo Hurus, Aleman de Constancia, 1494)

Gonzalo Correas, *Vocabulario de refranes y frases proverbiales y otras fórmulas comunes de la lengua castellana* (Madrid: Tipografía de la 'Revista de Archivos, Bibliotecas y Museos', 1924)

Juan de Arfe y Villafañe, *Quilatador de la plata, oro y piedras* (Madrid: Servicio de Publicaciones del Ministerio de Educación y Ciencia, 1976)

Juan Luis Vives, *Instrucción de la Mujer Cristiana*, ed. by Elizabeth Teresa Howe, trad. by Juan Justiniano (Madrid: Fundación Universitaria Española. Universidad Pontificia de Salamanca, 1995)

Juan Ruiz, *Libro de buen amor*, ed. by Alberto Blecua (Madrid: Ediciones Cátedra, 1992)

Padre Carmona, *Carro de las donas*, vol. 1, ed. by C. Clausell (Madrid: Fundación Universitaria Española / Universidad Pontificia de Salamanca, 2007)

Pedro Calderón de la Barca, *Fieras afemina amor*, ed. by Edward M. Wilson (Kassel. Edition Reichenberger, 1984)

Secondary Studies

Ágreda Pino, Ana M., *Vivir entre bastidores: bordado, mujer y domesticidad en la España de la Edad Moderna* (Santander, Ediciones Universidad de Cantabria, 2022)

Covarrubias, Sebastián, *Tesoro de la Lengua Castellana o Española según la impresión de 1611, con las adiciones de Benito Remigio Noydens publicadas en la de 1674*, ed. by Martín de Riquer, facsímil of 1943 (Barcelona: Alta Fulla, 4ª ed., 1998)

Checa, Fernando, dir. *Los inventarios de Carlos V y la familia imperial* (Madrid: Fernando Villaverde Ediciones, 2010)

Esteban Martín, Luis Mariano, 'Edición y estudio de la *Tragedia Policiana* de Sebastián Fernández' (unpublished doctoral thesis, Universidad Complutense de Madrid, 2002)

Jones, Ann Rosalind and Peter Stallybrass, *Renaissance Clothing and the Materials of Memory* (Cambridge: Cambridge University Press, 2000)

Lefébure, Ernest, *El bordado y los encajes* (Valladolid: Editorial Maxtor, 2006)

Parker, Rozsika, *The Subversive Stitch. Embroidery and the Making of the Feminine* (London: The Women's Press Ltd, 1986)

Pérez de Tudela, Almudena, *Los inventarios de doña Juana de Austria, princesa de Portugal (1535–1573)* (Jaén: Editorial Universidad de Jaén, 2017)

Real Academia Española, *Diccionario de Autoridades*, edición facsímil, 3 vols (Madrid: Gredos, 1984)

Sánchez Cantón, Francisco Javier, *Archivo Documental Español publicado por la Real Academia de Historia. Inventarios Reales. Bienes Muebles que pertenecieron a Felipe II*, Tomo X, vol. I (Madrid: Real Academia de la Historia, 1956–1959)

Vinyoles, Teresa M., 'Hilar, cocinar, cuidar, cultivar, curar, educar, amar… quehaceres de las mujeres medievales', in VV. AA: *Trabajo, creación y mentalidades de las mujeres a través de la historia* (Valladolid: Universidad de Valladolid. Secretariado de Publicaciones e Intercambio Editorial, 2011), pp. 81–93

ALEXANDRA MASSINI

Maria Mancini

The Woman behind the Artemisia *Tapestries in the Colonna Collection*

▼ **ABSTRACT** At the age of 22 in 1661, Marie Mancini, one of the Mazarinettes (as the nieces of the powerful Cardinal Mazzarino were collectively known), arrived in Rome as the bride of Lorenzo Onofrio Colonna. Leaving behind Paris and the young Luis XIV, whose heart she had inappropriately conquered, Marie detested the eternal city. She criticized the papal entourage, lack of entertainment, poor conversation, and modest fashion. Marie therefore proceeded to transform the Roman scene with extravagant performances and masquerades. The couple renovated Palazzo Colonna with the help of skilled artists and adorned it with lavish decorations, paintings, and furnishings. They acquired a set of tapestries depicting the life of Queen Artemisia, that had been woven in the Boutique d'or of the Faubourg Saint-Marcel in Paris. The series, illustrating the life of Queen Artemisia, had first been commissioned by Henry IV of France to honour his wife Marie de' Medici and the late Caterina de' Medici, who, like Artemisia, had reigned in place of her deceased husband. The acquisition of the tapestries and inevitable comparison between Marie Mancini and the Italian-born queens of France was presumably intentional. However, unlike her powerful predecessors, Marie's life took a different path. She ended up in poverty after abandoning her husband, disguising herself as a man, and fleeing Rome. Rejected by the French court, she sought refuge in a Madrid convent with only a pearl necklace gifted by Louis XIV. This contribution reassesses Marie Mancini's role and artistic patronage.

Paris

On 22d June 1659, the nineteen-year-old king Louis XIV of France received special treatments for his incurable melancholy. The court's doctors prescribed eight blood-letting therapies and four purges, but nothing seemed to relieve the sovereign's pain

Women in Arts, Architecture and Literature: Heritage, Legacy and Digital Perspectives, ed. by Consuelo Lollobrigida and Adelina Modesti, Women in the Arts: New Horizons, 1 (Turnhout: Brepols, 2023), pp. 195–216

BREPOLS ∰ PUBLISHERS

10.1484/M.WIA-EB.5.134651

of the soul.[1] The reason for his *malaise* was the departure from Paris of his first love, Maria Mancini, a girl of equal age but far unequal status. Maria was one of the famous *Mazarinettes*, as the seven nieces of the powerful Cardinal Giulio Mazzarino, or Jules Mazarin, were collectively known.[2] The girls had arrived to Paris in successive stages, along with their brothers and respective mothers, as soon as their uncle had won the trust and, as malicious rumours reported, also the heart of the Queen. The Cardinal had indeed succeeded Richelieu as prime minister in 1642 and, at the death of King Louis XIII in 1643, had become *de facto* regent, together with Queen Anne of Austria, to her son Louis XIV, then a child aged five.

The first *Mazarinettes* to reach Paris, unaccompanied by their parents, were the three eldest, including Anna Maria Martinozzi, daughter of Mazarin's sister Laura Margherita, and her cousins Laura Vittoria and Olimpia Mancini, together with their brother Paolo, who were all born from the Cardinal's younger sister Girolama and Lorenzo Mancini.[3] The latter, a Baron and amateur astrologer, was defined by the sharp-tongued Louis de Saint-Simon as an individual 'with no role, no property of note, as little lustre as his ancestors, and living, like they all had, as an obscure citizen of Rome, hardly known to anyone'.[4] Yet Lorenzo in Rome owned a grand palace, built by Carlo Rainaldi, which then was the seat of the French embassy and later of the French Academy. The palace was also close to that of the Colonna princes in whose service Mazarin's own father Pietro had been active as intendent to Filippo I, duke of Paliano and Tagliacozzo, and in whose household Maria Mancini was soon to triumphantly enter.

Mazarin himself would be denigrated for his humble and shady origins: in the later words of Saint-Simon (yet to be born when the Cardinal was prime minister, but strongly adverse to any royal counsellor not belonging to the *noblesse d'èpèe*) 'it has never been possible to trace beyond his father the ancestry of this famous Eminence'.[5] Thus his relatives were described as the 'half-breed Mazarins' (*razza semi-mazzarina*). The Italian girls were not spared by the Parisian populace either, for soon after their arrival they became the target of many an infamous *Mazarinade* (the libels against the minister's severe tax regime that circulated during the Fronde). One of the favourites recited: *Elles ont les yeux d'un hibou / L'écorce blanche comme un chou / Les sourcils d'une âme damnée / Et le teint d'un cheminée*.[6]

1 Galateria, 'Le Perle del Re Sole', p. 167.

2 See Combescot, *Les petites Mazarines*; Hillairet, *Les Mazarinettes*; Renée, *Les nièces de Mazarin*.

3 Paolo died in Paris, at fifteen, on 2d July 1652, during the combats at the Porte Saint-Antoine, which juxtaposed the greatest French generals of the time, the Grand Condé (Luis II of Bourbon) and the Maréchal Turenne (Henri de La Tour d'Auvergne), respectively leading the factions of the Fronde and their Spanish allies, and the French troops loyal to Mazarin and the King.

4 My translation from Saint-Simon, *Mémoires*, year 1714, vol. VII, pp. 64–65.

5 Saint-Simon, *Mémoires*, year 1714, vol. VII, pp. 66.

6 'They have the eyes of an owl / The peel of a white cabbage / The eyebrows of a damned soul / And the complexion [as dark as] a chimney'. See Bordeaux, 'Le Premier Amour de Louis XIV', p. 17; Guth, *Mazarin*, pp. 638–39. On the Mazarinades see also Carrier, *La Presse de la Fronde* and the digitized Projet Mazarinades / Corpus textuel préparé par l'équipe R.I.M. (Recherches Internationales sur les Mazarinades).

Even worse, in the words of the *Curé* Jacques Brousse, a *frondeur* and Jansenist who authored a scorching pamphlet against Mazarin, the Cardinal had brought from Rome a bunch of fishwives and had them educated among royal princesses by the king's governess.[7] This indeed was true for the girls were entrusted to the care of Marie-Catherine de La Rochefoucauld, Marquise de Senecey, who had raised Louis XIV and his brother Philippe.

The court in general was not impressed by the debut of Mazarin's nieces: as the assembled aristocrats flocked around them, the Marquise de Villeroi commented to the king's uncle Gaston d'Orleans, 'here come some little damsels with no riches nor means, who soon will own castles, revenues, precious jewellery, fine silverware and great rank'.[8] Indeed, she proved to be farsighted, for the Cardinal had brought the girls to France to facilitate advantageous marriages for them and thereby secure his own standing in an entourage filled with enemies.

In her diaries Madame de Motteville, chief lady in waiting of the Queen mother, recorded more accurately the introduction, on 11 September 1647, of the first *Mazarinettes*: Laura she described as a pleasant brunette of twelve or thirteen years of age, Olimpia, as a dark-haired girl with a long face, pointed chin but vivacious eyes, whose appearance could improve once she turned fifteen, and their cousin, Mademoiselle Martinozzi, as a pretty, sweet-eyed blonde approximately aged nine. In her case, Motteville added, one could even hope for the development of greater beauty.[9] In the same factual tone, further on in her *Mémoires*, Motteville also reported about the stupefied reaction of her own Roman friends at the news of the great marriages of the girls. Indeed, given their provenance — she relates — in their own country they could hardly be frequented, let alone hope for any suitors.[10]

In spite of such unfavourable comments, the *Mazarinettes* did indeed marry well: Laura Vittoria Mancini conquered the heart of Louis of Bourbon-Vendôme, duc de Mercoeur (a nephew of the late Henry IV and his mistress Gabrielle d'Estrées) who even left his family, siding for the Fronde, to follow his beloved Laura and Mazarin in exile at Brühl, near Colone, where the couple was married in 1651. As soon as Mazarin was reinstated into power he organized the wedding, in 1654, of Anna Maria Martinozzi and Armand de Bourbon, Prince of Conti who, like his brother, the Grand Condé (and France's most valiant general) had joined the last phase of the Fronde but had just been rehabilitated to the court. Olimpia Mancini, for her part, married in 1657 Eugene Maurice of Savoy Carignano, Count of Soissons, and gave birth to Prince Eugene of Sayoy, the future field marshal of the Holy Roman Empire during the Ottoman siege of Vienna (1683) and one of the best military strategists of the next century.

7 Brousse, *Lettre d'un religieux*, pp. 9–10.

8 'Voilà des petites demoiselles qui présentement ne sont point riches, mais qui bientôt auront de beaux châteaux, de bonnes rentes, de belles pierreries, de bonne vaisselle d'argent, et peut-être de grandes dignités'. See Renée, *Les nièces de Mazarin*, p. 37; Chantelauze, *Louis XIV et Marie Mancini*, p. 11.

9 Motteville, *Mémoires*, ch. XVII, p. 367. See also Renée, *Les nièces de Mazarin*, p. 35.

10 Motteville, *Mémoires*, ch. XVII (year 1647), p. 371.

In 1653, after the Fronde's upheavals, Mazarin called to Paris both of his recently widowed sisters and a second cohort of children, including Filippo Giuliano Mancini, who became Duke of Névers in 1660, and Laura Martinozzi, who was wedded in 1658 to Alfonso IV d'Este, Duke of Modena, becoming mother to Beatrice, future consort of James II Stuart. Maria Mancini and her sister Ortensia (hitherto in a Benedictine convent in Rome and supervised by their aunt, the abbess Clelia Mazzarino), arrived to Paris a year later. The last to depart were the youngest Mancini offspring, Alfonso (who died in 1658) and Maria Anna, the future wife of Godefroy Maurice de La Tour d'Auvergne, Duc de Bouillon and nephew of Maréchal Turenne.

From beginning to end, Marie and Ortensia Mancini shared similar destinies: they received the same education, travelled together, married in the same year (1661), eventually abandoned their husbands, and then recounted their adventures in their autobiographies. Ortensia's *Mémoires* were published in Colone in 1675 and encountered substantial favour, to the extent that the editor Pierre Marteau also published, a year later, an apocryphal biography of her sister Maria, to which the latter responded with the *Apologie ou Les véritables mémoires de Madame Marie Mancini, écrits par elle-même* (Leyden, 1678). This had originally appeared in a Spanish translation entitled *La Verdad en su luz* (Saragoza, 1677), for Maria, at that time, resided in Spain.[11]

Nevertheless, the two sisters were rather different. Madame de La Fayette counted the somewhat younger Ortensia among the greatest beauties of the court and added that her perfection only lacked some intelligence, a want that, however, was not perceived as such, for many found her languid and carefree airs to be quite amiable.[12] These characteristics also charmed Armand Charles de La Porte, Duc de La Meilleraye, who preferred Ortensia over Maria because of her looks but also her substantial dowry, since she was the designated heiress of her uncle's palace, land property, and title as Duchesse de Mazarin. For her part, Ortensia, in her words 'the richest heiress and the unhappiest woman in Christendom', eventually fled the stifling jealousy and religious fanaticism of her senile husband, to later become the lover of King Charles II of England. Roger de Bussy-Rabutin, cousin to Madame de Sévigné and author of the satirical pamphlet *Catéchisme des courtisans de la cour de Mazarin*, and the *Histoire amourese des Gaules*, wrote that 'no cuckold has ever been so deserving of the title as the Duke Mazarin, and every day of his life gives me more admiration for his wife, who prefers to take to the road rather than suffer his presence any longer.'[13]

11 On the autobiographies of the two sisters see Doscot, *Memoires d'Hortense et de Marie Mancini*; Mancini, *Memoirs*, ed. Nelson. See also Beckmann, *Inszenierter Skandal*; Cholakian, *Women and the Politics of Self-representation*, pp. 85–121.

12 La Fayette, *Histoire de madame Henriette d'Angleterre*, p. 16: 'C'était, comme nous avons dit, non-seulement la plus belle des nièces du cardinal, mais aussi une des plus parfaites beautés de la cour. Il ne lui manquait que de l'esprit pour être accomplie, et pour lui donner la vivacité qu'elle n'avait pas; ce défaut même n'en était pas un pour tout le monde, et beaucoup de gens trouvaient son air languissant et sa négligence capables de se faire aimer'.

13 Goldsmith, *The Kings' Mistresses*. Bussy Rabutin was banned from the court for participating, during Holy Week in 1659 in the 'orgy of Roissy' where in the company of Filippo Giuliano Mancini and others he had composed satirical verses about the king. From his exile, in his estate in Burgundy, he wrote the *Histoire amourese des Gaules* (1661) which exposed all the scandals of the court and eventually landed him in the Bastille. The love-letters of

By comparison to her beautiful sister, Maria passed off as having little to offer, except for the witty *esprit* that was lacking in the former. The caustic Motteville dismissed her as tall, thin and ugly, with no feature to be appreciated except for her teeth.[14] Conversely Bussy-Rabutin described her as 'short, stout, with the looks of an innkeeper, yet the sharp spirit and intelligence of an angel'.[15] A similar, albeit more positive, remark also came from Saint-Simon, who defined Maria *la plus folle et toutefois la meilleure* (the maddest and yet the best) of the Mancini girls.[16] 'As for judging the most shameless among them', he added, 'one would encounter some considerable difficulty'.

In fact, due to the death of her mother Girolama in 1656 and her sister Laura Vittoria in 1657, Maria initially remained with the latter's lady in waiting, Madame de Venel, studying French, astrology and more.[17] When eventually she joined the court, she displayed a liveliness that charmed Luis XIV, then a shy teenager. The two started more assiduously frequenting in June 1658, after Louis had returned in a feverish state from Marshal Turenne's campaign in Flanders. His progress had been anxiously followed by the devoted Maria, who had prayed day and night for his recovery. In September 1658, during a sojourn at Fontainebleau, their friendship grew along with the concerns of the Cardinal and the Queen mother, who were, in the meantime, negotiating a marriage with the Infanta of Spain (the king's double first cousin) thereby consolidating a peace that in the financial drainage and the tense aftermath of the Fronde and the Thirty Years War had become a serious necessity.[18]

Mazarin's diplomatic interventions to prevent the *mésalliance* were unsuccessful and he finally resolved to send Maria as far away as possible, initially to Brouage, near La Rochelle, where he was governor, and then to Rome, where he had several allies.[19] As a token of his love, Louis gifted Maria with a fabulous necklace of thirty-five pearls

Louis XIV and Marie were published in vol. II of the same work and are digitized in Project Gutenberg #28789 (May 13, 2009). See also Jurewitz-Freischmidt, *Galantes Versailles*.

14 'Marie, sœur cadette de la comtesse de Soissons, étoit laide. Elle pouvoit espérer d'être de belle taille, parce qu'elle étoit grande pour son âge et bien droite; mais elle étoit si maigre, et ses bras et son col paroissoient si longs et si décharnés, qu'il étoit impossible de la pouvoir louer sur cet article. Elle étoit brune et jaune; ses yeux, qui étoient grands et noirs, n'ayant point de feu, paroissoient rudes. Sa bouche étoit grande et plate, et, hormis les dents, qu'elle avoit très belles, on la pouvoit dire alors toute laide … Malgre sa laideur, qui, dans ce temps-là, étoit excessive, le roi ne laissa pas de se plaire dans sa conversation. Cette fille étoit hardie et avoit de l'esprit, mais un esprit rude et emporté. Sa passion on corrigea la rudesse … Ses sentimens passionnés et ce qu'elle avoit d'esprit, quoique mal tourné, suppléèrent à ce qui lui manquoit du côté de la beauté.' See Petitot, *Collection complete des mémoires*, t. 39, pp. 400–01.

15 Bussy-Raboutin, *La France Galante*, pp. 286–87. Galateria, 'Le Perle del Re Sole', p. 169.

16 Saint-Simon, *Mémoires*, vol. XIII, p. 104.

17 Maria's father had been an astrologer, and Maria herself produced a yearly astrological almanac from 1670 to 1672. The last in the series, a treatise, bore the title *Discorso Astrosofico Delle Mutationi De' Tempi, E d'altri accidenti mondani dell'anno MDCLXXII. Di Madama Maria Mancini Colonna, Principessa Romana, Duchessa di Paliano, di Tagliacozzo, di Marino, &c.e Gran Contestabilessa del Regno di Napoli* (Modena, 1672).

18 On the love affair between Louis XIV and Marie Mancini see Bordeaux, 'Le Premier Amour de Louis XIV', pp. 3–30; Perey, *Le Roman Du Grand Roi*; Chantelauze, *Louis XIV et Marie Mancini*.

19 Mazarin was a childhood friend and protégé of the Cardinal Girolamo Colonna (the son of Filippo I Colonna who had employed Giulio's father Pietro Mazzarino). In 1634–1636, before his dazzling career, Mazarin had also been *nunzio apostolico* in Paris for Pope Urban VIII Barberini and advised, in matters of taste and art collecting, the pope's nephew Antonio.

acquired for 78000 francs from the impoverished Queen of England Henrietta Maria of Bourbon (the last daughter of Henry IV and Marie de' Medici), then in exile at St Germain after the execution, ten years prior, of Charles I of England.

Maria Mancini's departure from Paris, on 22 June 1659, was recorded as a tragic affair: the king was in tears and cried without restraint as he accompanied his beloved to her carriage. Her last words for him 'Vous êtes roi, Vous pleurez et je pars' (you cry, you are the king, and I have to leave) were to be quoted by Jean Racine whose grief-stricken *Berenice* (1670) would be forced to leave the emperor Titus.[20] To provide the king with some consolation, the scheming Mazarin facilitated several encounters with Maria's consenting sister Olimpia, now Countess of Soissons, who in the past had already found the sovereign's favour. The cure seemed to work: in spite of all his grief Louis XIV accepted his political marriage in 1660 to the Infanta Maria Teresa.

A few months later, on 11 April 1661, Maria was wedded by proxy to Lorenzo Onofrio Colonna, the young Contestabile of the kingdom of Naples, Prince of Paliano and Duke of Tagliacozzo (Fig. 1). His family residence in Rome, at the Piazza Santi Apostoli, was close to the Mancini palace and the Church of Saints Vincent and Anastasius (by the Trevi fountain) which had been completed for the Jubilee year of 1650 through Mazarin's generous patronage.[21]

The benefits of the match were mutual: on the one hand Maria was removed from the orbit of the French king, on the other the Colonna's, who were already close to the Hapsburgs and the Spanish crown, also secured their political ties with France. Mazarin's role as intermediary in this context bore distant echoes of his first diplomatic success, when his negotiations between Spain and France led to the resolution, in the latter's favour, of the war of succession over the Duchy of Mantova and the Monferrato which was sealed by the Treaty of Cherasco (1631). Lorenzo Onofrio, for his part, must have appreciated the prestige and riches that Maria Mancini would bring, not to mention the fact that marrying the first love of the most powerful sovereign of Europe would have piqued his self-esteem. In fact, at his first intimate encounter with the bride, he was surprised at discovering her virginity.[22] Maria's dowry, as recorded by the Venetian witness Alvise Grimani, included a bequest from Mazarin of 200,000 *scudi*, jewels and 'precious items', as well as 600,000 *livres* (and an additional 50,000 for Maria's personal expenses) agreed upon in the matrimonial contract signed by Mazarin and his former protector Cardinal Girolamo Colonna on

20 'Vous êtes empereur, Seigneur, et vous pleurez'. See Goldsmith and Zanger, 'The Politics and Poetics of the Mancini Romance', pp. 341–72; Dulong, *Marie Mancini: la première passion de Louis XIV*.

21 The Cardinal's coat of arms was prominently placed on the church-façade along with a female bust which, allegedly, portrayed Maria Mancini.

22 In the very words of Ortensia, *Mémoires, op. cit.*, the stupefied husband could not believe that there could be innocence in the love affairs of a king (*Ne croyat pas qu'il pût y avoir de l'innocence dans les amours des rois*) and thereafter happily accepted not to have been 'the first master of her heart' (*le premier maître de son Coeur*).

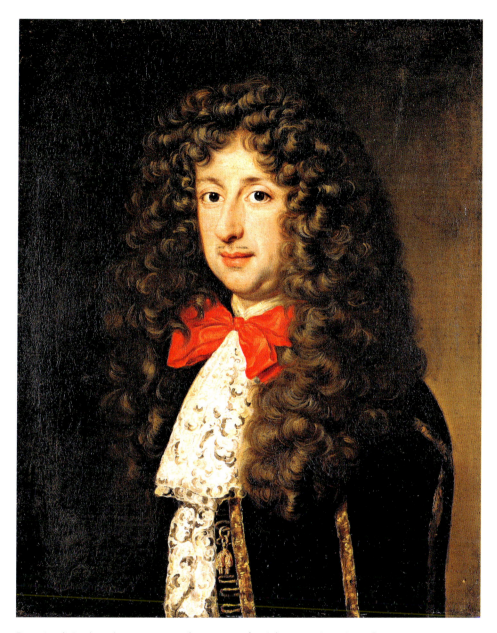

Fig. 1. Jacob Ferdinand Voet, *Portrait of Lorenzo Onofrio Colonna*, c. 1670–1675, oil on canvas, Appartamento Isabelle, Palazzo Colonna, Rome. Reproduced by courtesy of Galleria Colonna, Rome.

21 February 1661.[23] Three days later, on 23 February 1661, Mazarin died. As reported by her sister Ortensia, Maria saluted the event with the comment 'Dieu merci, il est crevé' (thank God he finally died).[24]

Rome

Maria Mancini's husband Lorenzo Onofrio Colonna was the scion of one of the oldest aristocratic families of Rome, whose fortunes had begun in the twelfth century and continued over time with twenty-three cardinals and a pope.[25] The latter was Oddone Colonna, elected as pope Martin V in 1417 and responsible for ending the Western Schism and restoring the papacy to Rome after a century-long absence. He had also famously begun the *renovatio* of the city after witnessing, the 'fetid and rotting cadavers' that the Romans were throwing into the streets.[26] Except for a brief interlude in 1303, when Pope Boniface VIII was humiliated at Anagni by the impudent Sciarra Colonna, then ally of the French King Philip the Handsome, the Colonna's had always been a papal family, one that provided the pontiffs with troops and unshakable loyalty. In compensation for their services, they were raised to the status of princes and, in the sixteenth century under Julius II, gained the privilege of becoming assistants to the papal see, the highest lay role at the Vatican court and a charge they shared with their archenemies, the Orsini's.

Among Lorenzo Onofrio's distinguished ancestors was also Marcantonio II Colonna, the Admiral of the papal fleet in the naval Battle of Lepanto of 1571, where the Christian allies, including Venice, Genua, Rome, and the Hapsburg's with Don Juan of Austria, had defeated the Ottoman sultans and the formidable Mehmed Pasha. This, to that day, had been the greatest battle in the Mediterranean, with nearly two hundred-fifty galleys on either side, and one that kept the Ottomans in check until the siege of Vienna (1683).

When Maria Mancini returned to the eternal city, nearly a century after Lepanto, she was well-drilled in matrimonial etiquette and quite conscious of the family's standing and the role of her husband as papal ambassador at the court of Naples. He, in turn, initially welcomed Maria with every attention. One evening, for instance, he took her to Piazza Navona, which had been flooded for the occasion (as was customary on hot summer Sundays) while boats paraded lamps and flags with her monogram and fabrics with her coat of arms hung from the balconies that had been dearly rented for the evening.

23 Gozzano, *La Quadreria di Lorenzo Onofrio Colonna*, pp. 67–68; Benzoni, 'Lorenzo Onofrio Colonna', *Dizionario Biografico degli Italiani*, <https://www.treccani.it/enciclopedia/lorenzo-onofrio-colonna>.

24 Marie's comment to Mazarin's death — whether spurious or not — is recorded in Ortensia's *Mémoires*: 'À la première nouvelle que nous en eûmes, mon frère et ma sœur pour tout regret se dirent l'un à l'autre: Dieu merci il est crevé. À dire vrai, je n'en fus guère plus affligée; et c'est une chose remarquable qu'un homme de ce mérite, après avoir travaillé toute sa vie pour élever et enrichir sa famille, n'en ait reçu que des marques d'aversion, même après sa mort'. See also Goubert, ed., *L'avènement du Roi-Soleil*, p. 15.

25 On the history of the Colonna family see Colonna, *I Colonna*.

26 This is recorded in the Bull *Etsi in cunctarum orbis* of March 30, 1425.

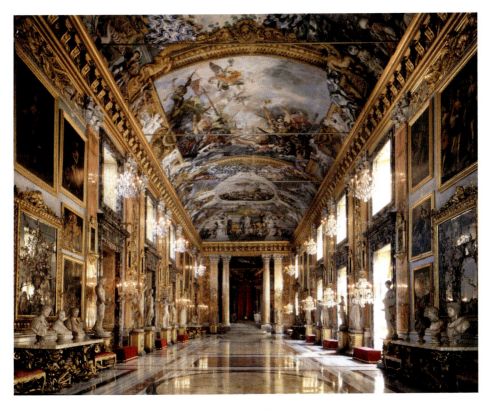

Fig. 2. The Great Gallery at Palazzo Colonna, Rome, c. 1665–1700.

Despite such attentions, and although Maria had spent in Rome the first decade of her life, she detested the city's austerity, the lack of good conversation and the modest fashion of the local ladies. This she immediately proceeded to change, to judge from Pope Innocent XI's alarmed complaints of a few years later over women dressed *alla francese*, with their arms and bosoms half naked.[27] The portraits of Maria Mancini indeed illustrate her audaciously dressed with low *décolletés* quite unlike the stiff, high-collared costumes of the local princesses.

In general, Marie's arrival to Rome generated a considerable upheaval for, aside from her dresses, even her living habits were rather 'French'. With her husband's compliance she would exit the palace unaccompanied and quickly became the protagonist of a sophisticated and hedonistic lifestyle, quite different from the restraint traditionally expected of the Roman society. Among the novelties she introduced were the gatherings known as *precieuses* in Paris and *conversazioni* in Rome, where women and men, 'from different backgrounds and nations', with or without their

27 'che la maggior parte delle donne vestono alla francese, portando la metà delle braccia nude e il petto scoperto', as written by Paolo Negri on 25 October 1679 from Turin: see citation in Monaldi, *I teatri di Roma negli ultimi tre secoli*, p. 55.

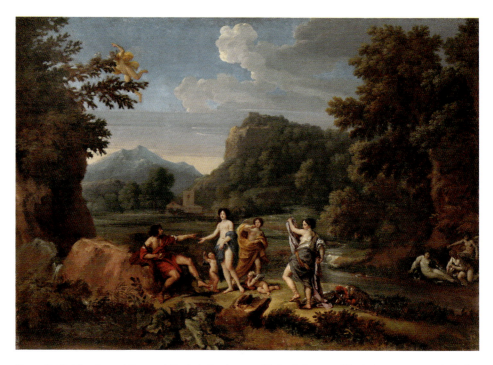

Fig. 3. Carlo Maratta and Gaspard Dughet, *Landscape with the Judgment of Paris*, Appartamento Isabelle, Palazzo Colonna, Rome. Reproduced by courtesy of Galleria Colonna, Rome.

spouses, could meet to converse.[28] Although such events were considered hotbeds for libertine behaviour, they became very fashionable and were copied by many a Roman princess, such as Olimpia Aldobrandini Borghese Pamphilj, wife to the papal nephew Camillo Pamphilj, and, like the Colonna's, a great patron of music.[29]

Despite her gloomy expectations, Maria soon recovered from her sadness. The early years of her marriage were indeed happy, as testified by the frescoes in the main hall of the summer apartment at Palazzo Colonna, where Maria, metaphorically represented as Venus, is juxtaposed to Hercules/Lorenzo Onofrio on the shorter walls, while on the ceiling the allegorical figures of Fame, Glory, Flora/Aurora and Amor/Sun announce to the world the couple's happy union.[30] The same grand tone of self-representation appeared throughout the palace, which in those years was being refurbished by the architect Antonio Del Grande, possibly advised by Gianlorenzo Bernini, along with a host of painters and decorators[31] (Fig. 2).

As they restyled the palace, the princely couple also staged dazzling masquerades. On one such instance, during the Carnival of 1668, Maria made her entry as Venus mounted on a carnival float themed after the planets. The event, and her passion for

28 De Lucca, 'Strategies of Women Patrons', p. 383, n. 29.
29 De Lucca, 'Strategies of Women Patrons', pp. 384–85.
30 Natale, ed., *Palazzo Colonna, Appartamento Principessa Isabelle*, p. 306.
31 The history of the palace is discussed at length in Safarik, *Palazzo Colonna*.

mythological roles, is recorded in a painting by Carlo Maratta and Gaspard Dughet, illustrating the *Judgment of Paris*, where the judging shepherd is Lorenzo Onofrio himself, and Venus bears the likeness of his wife, even though, to defuse the shocking nudity, her body is modelled on a statue of the Venus Pudica[32] (Fig. 3).

During the Carnival of the following year, in 1669, Maria topped all expectations dressing up three times to interpret different women who were famous for their beauty, strength and seductive power. Her first disguise was inspired by Torquato Tasso's *Gerusalemme Liberata*, completed after Lepanto (in 1575) and the most popular epic of the time, narrating the deeds of the crusaders. On that occasion Maria appeared as Clorinda, the brave heroine of the Saracens, dressed in manly costumes and surrounded by forty Turkish soldiers. This she regarded as an appropriate answer to the malicious criticisms against her 'free lifestyle in a country ruled by formalities'.[33] Indeed, to stress the point, during the masquerade she threw to the audience pieces of paper with verses especially composed by her brother, Filippo Giuliano, the Duke of Névers then in Rome: *Of forgotten decorum / Let this warrior lover be not suspected / Because even though I have a virile look / I preserve intact the treasure of virtue. / So many [women] in the world / Have the face of Penelope, but the heart of Phryne!*[34]

For her second masquerade Maria chose the Odyssey and personified the sorceress Circe who fatally enchanted all men. On the float she was joined by Lorenzo Onofrio in the guise of Ulysses leashing his companions, whom his sorceress-wife had transformed into pigs. The fact that Maria played an enchantress, a role that lent itself to multiple interpretations, was remarkable, considering that carnivals and the lascivious jests that accompanied them were frequently prohibited in papal Rome, and that women could not perform on stage. While a restrictive ban had been passed by Sixtus V in 1587 and was still in effect in Maria Mancini's time, its enforcement varied from one papacy to the other, and women actresses, within limits and cautions, were active in the eternal city.[35]

The *Contestabilessa*'s own performance, albeit justified by the carnival, was a memorable show. Maria Mancini's choice to interpret Circe, the seductive sorceress, on a float and on public display, was a very conscious one and fully embodied her disregard of Rome's social etiquettes. Yet Lorenzo Onofrio's presence at her side at once validated her behaviour and stifled any disapproving rumour that he could not control his wife. After all he was interpreting Ulysses who was both enticed by a woman's spell and still able to resist her charm.[36] At any rate, while the two were fond

32 Natale, ed., *Palazzo Colonna*, pp. 268–70.

33 'pour faire taire ceux qui murmuraient de la liberté que l'on me voyait prendre'. See De Lucca, 'Strategies of Women Patrons', p. 375. Mancini, *I dispiaceri del Cardinale*, p. 53.

34 As translated in De Lucca, 'Strategies of Women Patrons', p. 375. The original text reads: *D'obliato decoro / Questo amante guerrier non dia sospetto / Che s'ho viril aspetto / Intatto d'onestà serbo il Tesoro; / Quante in ogni confine / Son Penelope al volto, al cor, son Frine*. The latter was a fifth-century Athenian courtesan.

35 De Lucca, 'Strategies of Women Patrons', p. 376, n. 6.

36 De Lucca, *The Politics of Princely Entertainment*, p. 151.

of publicity, if not outright scandal, Maria may have wished to assert a freedom that Roman ladies were not normally granted.

That Maria had a real penchant for dressing up and playing seductive roles is also testified by the theatre impresario Jacques d'Alibert who called her *Mère des amours* and remarked 'son palais était celui d'Armide' (her palace is that of Armida), in reference to her third masquerade of 1669, where she enacted another character from Torquato Tasso's *Gerusalemme Liberata*, and again a sorceress who turned men into animals. As recorded by Federico Raggi, on February 21, 1669, Maria appeared this time without her husband's escort, 'riding a horse in the most bizarre costume, attended by twenty-four knights dressed in the Turkish fashion, with turbans, drums and trumpets and surrounded by a Sultan and six pages'.[37] In that costume, she was portrayed holding a staff like a magic wand, wearing a gloriously embroidered dress and ermine coat, as well as a half-moon on her head, among lush curtains, Ottoman carpets, an exotic palm tree and a mischievous monkey, itself a symbol of curiosity[38] (Fig. 4). The lady of the house dressed up as a Muslim heroine would have elicited some irony in the face of the distinguished Colonna's, whose victory at Lepanto of a century earlier still resounded throughout the palace. In the painting, and scandalous for the time, was also the display underneath Armida/Maria's gown, of her ankles and a pair of trousers, even if Rome had already been accustomed to such audacity by the indomitable Queen Christina of Sweden, who had arrived in the city only six years earlier, after abdicating the Swedish throne and converting to Catholicism.

In fact, in competition with the art-loving Christina, Maria Mancini and Lorenzo Onofrio became active patrons of music and theatre. Inspired by the taste for musical entertainment that Maria had brought from France, and despite the restrictions imposed by Alexander VII, Lorenzo Onofrio employed the tenor Nicola Coresi and his soprano wife Antonia, respectively as 'gentleman' attendant to himself and lady in waiting to Maria.[39] Lorenzo Onofrio also financed the construction of a personal theatre inside his residence and a second one at Piazza Scossacavalli, near St Peter's. He further invited composers, like Alessandro Stradella, and stage designers, like Filippo Acciaioli, and eventually joined forces with Queen Christina to promote the opening of the first opera house in Rome, at Tor di Nona, in 1672.[40]

The impact of all these endeavours at Palazzo Colonna was praised far and wide. As Jacques de Belbeuf, son of a parliamentary counsellor from Normandy, annotated in his travel diary in December 1669 'without that house the foreigners in Rome and above all the French, would spend their time in utter misery... here on the other hand one can dance, play, converse and very pleasantly pass the evening'.[41] Lorenzo Onofrio ultimately pursued the same splendour that Maria had been accustomed

37 De Lucca, *The Politics of Princely Entertainment*, p. 152.

38 Natale, ed., *Palazzo Colonna*, pp. 91–93.

39 De Lucca, 'Strategies of Women Patrons', p. 380.

40 De Lucca, *The Politics of Princely Entertainment*; Cf. Howard and Moretti, eds, *The Music Room in Early Modern France and Italy*; Elena Tamburini, *Due teatri per il principe*.

41 *Sans cette maison les étrangeres et sortout les français passeroient fort mal leur temps ... on y danse, on y joue, on y cause et on y passe assez bien la soirée.*

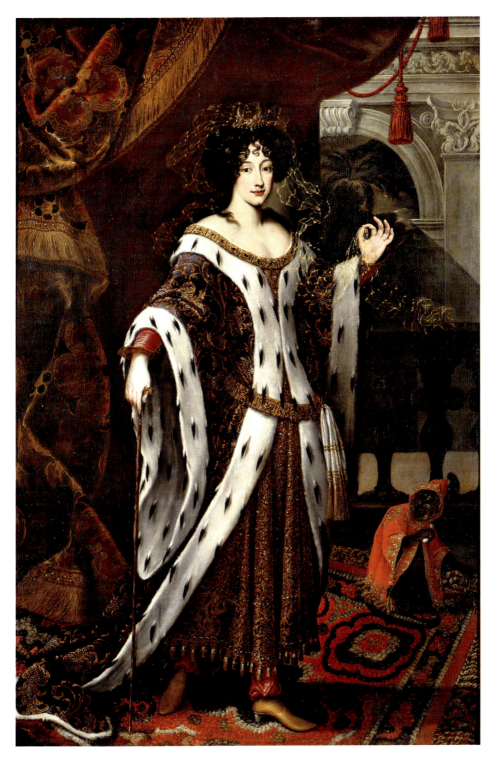

Fig. 4. Italian painter of the XVII cent. and Benedetto Fioravanti, *Portrait of Maria Mancini as Armida*, c. 1669, oil on canvas, Palazzo Colonna, Rome. Reproduced by courtesy of Galleria Colonna, Rome.

to in Paris. The inventories drawn up in 1679 and 1689 (when he passed away) indicate that in the twenty-five years as title bearer of the house (1664), the prince had acquired more than 900 paintings. Among these were several *vedute* or landscape views by Gaspard Van Wittel which are still in the collection, and eight canvasses by Claude Lorraine which he commissioned himself and which today are no longer in the collection.[42] Then there were the antique sculptures from the ruins of the temple of Serapis, still surviving in the gardens of the property, and the frescoes by Giovanni Coli and Filippo Gherardi in the Great Gallery, which, according to Charles de Brosses writing a century later, even vied with the Galerie des Glaces in Versailles. Finally, there were the splendid furnishings designed by Johann Paul Schor, the talented woodcarver from Innsbruck who moved to Rome in the 1640s to become Bernini's assistant and main scenographer of events and festivities.[43]

Along with floats, fireworks, ephemera, and aristocratic furniture, Schor also designed the staggering bed of state for the presentation of Filippo II Colonna, the first son of Lorenzo and Maria, born on 7 April 1663.[44] The bed was enormous and took up an entire room. Inside a giant shell, as if she were a precious pearl, lay Maria with her baby-boy waiting for the Roman aristocracy and clergy who came to congratulate her. The visual reference to Botticelli's *Birth of Venus* was probably intentional, especially in the light of the frequent comparisons of the princess with the goddess, that were prompted both by her beauty and the two fish, sea-creatures like Venus herself, of her coat of arms. The shell was pulled by seahorses and sirens which had been adopted as a Colonna emblem since Lepanto, and the ensemble was admired as one of the most grandiose *apparati* ever produced for the presentation of a new-born prince in the eternal city. Too big to be preserved intact, the bed was eventually cut in parts and re-employed in some of the commodes still adorning the palace.

Among the artifacts embellishing the lives of the princely couple were numerous tapestries. The inventory of 1689 lists in fact 188 pieces, including fifteen sets of narratives. Pride of place among these held the stories of the Queen Artemisia, known as the series 'of the wonders' (*delle maraviglie*), because the seven wonders of the ancient world appeared in the background. Two of these tapestries are today in the Fine Arts Institute in Minneapolis, five are at Palazzo Colonna in Rome, and another two are lost.[45] The iconography combined the deeds of two different Queens of ancient Caria (a region of western Anatolia), both named Artemisia, respectively ruling in the fifth and fourth centuries BC. The former Artemisia had fought together with the Persian Xerses against the Greeks in the battle of Salamina (480 BC). The latter, a widow in 353 BC, erected at Halicarnassus (in modern day Bodrum) an enormous funerary monument in honour of her husband Mausolus, which became the byword of any subsequent monumental tomb.

42 See Gozzano, *La Quadreria di Lorenzo Onofrio Colonna*, pp. 278–80.

43 It was probably Schor (rather than Gianlorenzo Bernini who got the credit), who authored the famous silver carriage that was donated to Queen Christina upon her arrival to Rome on 23 December 1655.

44 Maria later gave birth to Marcantonio (b. 1664), and Carlo (b. 1665).

45 See Patrizi, 'The Colonna Tapestries', pp. 232–73, especially pp. 242–50.

The text that inspired the series had been published by the Parisian apothecary Nicolas Houel in 1562 with the title *Histoire de la Rayne Artémise* and a dedication to Caterina de' Medici, Queen of France, then regent for her son Charles IX after the death in 1559 of King Henry II. The illustrations complementing the story had been produced by Antoine Caron and were turned into tapestries forty years later, at the behest of Henry IV, consort to Maria, the other great Medici queen of France. By requesting a tapestry-set that, directly and indirectly, paid homage to both queens, Henry IV, the first Bourbon king of France, intended to reaffirm his dynastic ties with the last of the Valois rulers.[46] Unknowingly, the commission foreboded Maria de Medici's own fate since she too had to act as regent for her son Louis XIII, after the assassination of her husband in 1610.

Following Henry IV's *editio princeps*, comprising fifteen pieces, the *Artemisia* series became very popular both in France and abroad and was repeated several times. To the original designs provided by Antoine Caron were added ten new compositions, five of which attributed to the designer Henri de Lerambert, representing trophy- and standard bearers along with horses, and sometimes referred to as *suite du triomphe*.[47] Simpler in design and less expensive to weave, these had a square or vertical format (rather than horizontal) and were more easily adaptable to the measurements requested by the patrons.[48]

One of the early sets, woven in the Louvre workshop, was seen at Fontainebleau in 1606 by Cardinal Maffeo Barberini (the future Pope Urban VIII).[49] His subsequent advice to Cardinal Alessandro Peretti Montalto to purchase a version for himself resulted in a commission of a set of twelve. In the wake of the admiration this elicited, a further set of eight pieces, with the arms of Louis XIII and now also in Minneapolis, had been acquired in 1635 by Mazarin, then acting in the service of Urban VIII's nephew Antonio Barberini.[50] One can only infer that this purchase would have instilled in the young Mazarin the desire to possess his own.

On the whole, the Louvre looms produced six early sets of *Artemisia* (for a total of about forty pieces), none of which included metallic threads. The use of the latter was introduced with the establishment, in 1607, of a new and larger workshop at the Faubourg Saint Marcel, which operated sixty low-warp looms and a special branch, the so-called Boutique D'Or, dedicated to the manufacture of luxury items with thread wrapped in gold. The factory only remained active until 1623, when it was closed and absorbed by the Gobelins workshop. In the sixteen years of its existence, more than twenty-two sets of tapestries of the *Story of Artemisia* (about two hundred pieces) were manufactured in the Faubourg Saint Marcel, two-thirds of them woven in gold thread, and purchased by various royals of Europe.[51] The price of these was

46 Denis, 'Henri Lerambert et l'Histoire d'Artemise', pp. 33–50; Denis, 'The Parisian Workshops', pp. 140–46, nr. 12.
47 Denis, 'The Parisian Workshops', p. 143.
48 Two such tapestries are in Palazzo Colonna.
49 Cardinal Maffeo Barberini, then *nunzio apostolico* for Pope Paul V, was a guest at the baptism in 1606 of the dauphin Louis XIV and his sisters.
50 See Adelson, *European Tapestry in the Minneapolis Institute of Arts*.
51 Denis, 'The Parisian Workshops', p. 146.

astronomical, reaching 270 *livres* per square ell, while tapestries without metal threads cost around 75 *livres*.[52]

It is certainly likely that the art-loving Mazarin also purchased his own set after becoming prime minister of France and turning into a voracious collector, even though his *post-mortem* inventory does not mention tapestries with gold threads, nor, specifically, the series of *Artemisia*. Mazarin's fabulous belongings, estimated to forty million *livres tournoises* and administered by Jean-Baptiste Colbert, were divided among his nieces after his death in 1661, and for the greater part sold off to the crown at a devalued price.[53] Among the most significant treasures were 114 tapestries, some of which were bequeathed to his relatives, but also to friends, former allies and the king.[54] A set with the *Acts of the Apostles*, produced in England for Charles II, which Mazarin had obtained from the exiled Queen Henrietta, was left to his nephew, the Duke of Névers, while a tapestry illustrating *Roboham* was destined to Anna Maria Martinozzi, Princess of Conti.[55] The extant records do not precisely list all the tapestries and their subjects, but it can be inferred that some of these would have been distributed among the other nieces too. It is indeed possible that an *Artemisia* series was not listed in Mazarin's *post-mortem* inventory because it had already been gifted to his niece Maria Mancini before his death, and that this series arrived to Rome following her wedding to Lorenzo Onofrio.

In all likelihood it was through Maria Mancini and the Mazarin legacy that eight *Artemisia* tapestries entered Palazzo Colonna in Rome, and not as a later acquisition by Lorenzo Onofrio or as a gift from Louis XIV, who, nonetheless, aside of the pearl necklace donated to his former love 200,000 francs.[56] Among the motivations for the choice, at least on the part of the late Mazarin and possibly of Maria too, was the comparison between the Mancini princess and the Italian-born Medici queens of France, which to viewers must not have gone unnoticed. Unfortunately, the series is not listed in the dowry agreements and is first recorded in the collection of Lorenzo Onofrio Colonna in 1670 when he ordered a ninth piece representing Queen Artemisia approving the construction plans of the Mausoleum. This latter tapestry was designed by the Italian Francesco Rossi and woven by Lorenzo Castellani and Lamberto della Mancia. It was completed before 1678 when Lorenzo Onofrio brought it Spain after his nomination as Viceroy of Aragon by King Charles II of Spain.

The most magnificent tapestry of the *Artemisia* set in the Colonna collection is the recently restored *Riding Lesson of Prince Lygdamis* (Fig. 5) which, as testified by the gold thread and the presence of the initials FM and the red lily, had been

52 Denis, 'The Parisian Workshops', p. 137, relates these prices to the yearly wage of 36 livres paid by Michel Corneille to his woman servant.

53 Mazarin's post-mortem inventory is published in Cosnac, *Les richesses du palais Mazarin*, see especially pp. 271–76. On his collections in general see Michel, *Mazarin, Prince Des Collectionneurs*. For his tapestry collection see Campbell, 'Collectors and Connoisseurs', pp. 325–39, especially pp. 335–36.

54 Cosnac, *Les richesses du palais Mazarin*, p. 261.

55 Cosnac, *Les richesses du palais Mazarin*, p. 250 and p. 261.

56 Patrizi, 'The Colonna Tapestries', p. 246 proposes that Lorenzo Onofrio purchased them second-hand. For the suggestion that the Artemisia tapestries were donated by Louis XIV see Stendhal, *Correspondance*, p. 422.

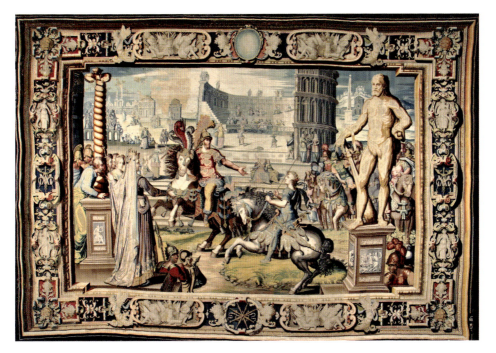

Fig. 5. *The Riding Lesson of Prince Lygdamis*, tapestry from the *Story of Artemisia* series, woven in Paris c. 1607–1623, after a design by Antoine Caron. Reproduced by courtesy of Galleria Colonna, Rome.

woven in the Boutique d'Or at Faubourg Saint Marcel. The monogram AM appearing in the cartouches of the borders refers to Artemisia and Mausolus. The annotation *P.pe con oro* discovered on the backside of the piece seems to indicate that the commission came from a 'Principe' who had insisted on the presence of gold. It seems possible then that Mazarin purchased this *Artemisia* set second-hand, after it had been destined to another patron.

For all the splendour and their seemingly happy life, the marriage of Lorenzo Onofrio and Maria deteriorated after the difficult birth of their third son Carlo in 1665, when Maria nearly lost her life. Lorenzo's increasing unfaithfulness, in response to Maria's request for a period of chastity, as well as his bouts of rage and purported uxoricide attempts led Maria to flee from Rome on the night of 29 May 1672 (eleven years after her arrival), dressed as a man, in the company of a servant and Ortensia, who in the meantime had abandoned her own husband. The scandal for the Colonna's was unbearable, nothing else was talked about ('cessate… tutte le voci delle altre novità' so the Venetian envoy Pietro Mocenigo). An anonymous *avviso* of that time further commented: 'these are the effects produced by women who are too free spirited and who live by ideas derived from romantic literature'.[57]

57 *ecco gli effetti che sanno produrre le donne di spirito troppo libero e che vivono con l'idee ricavate dalla lettura de romanzi.*

While Maria landed in Provence and attempted to reach Paris, her husband demanded from the minister Colbert that her wife be returned or else locked in a convent. Louis XIV, for his part, refused to see her and she took refuge in Lyons, then at the Savoy court in Turin, near her sister Olimpia, then in Antwerp, in Bruxelles, in Colone, only to end up in Spain by 1674, where three years later she published her *Mémoirs* in defence against all slander.

Despite living a retreated life, Maria was again pursued by her husband, then Viceroy of Aragon, who had her imprisoned in the Alcázar of Segovia. It was only thanks to the intervention of the Mancini's that she was eventually transferred to a convent in Madrid. When her husband died, in 1689, she returned to Rome to see her children and only briefly visited Paris in 1705 where she refused, in her turn, to see the king, despite his repeated invitations to join him at Versailles.

Her last years were punctuated by grievances, including the death of her first son Filippo in 1714. Her own life ended in Pisa, in 1715, just months before the death of Louis XIV himself. Utterly impoverished, with the sole possession of the famous pearl necklace that she had received from the king and her husband's wedding-diamond, Maria was buried, with no pomp and little mention, in the church of the Holy Sepulchre in Pisa, where a stark epitaph still bears the words: *Maria Mancinia Columna / pulvis et cinis* (dust and ashes) just as she wished.

Bibliography

Primary Sources

Bussy-Rabutin, Roger de, *La France Galante*, ed. by A. Poitevin (Paris: Delahais, 1857)

Brousse, Jacques, *Lettre d'un religieux envoyée a mons. le prince de Condé, à St Germain-en-Laye, contenant la vérité de la vie et mœurs du card. Mazarin, avec exhortation audit seigneur prince d'abandonner son party* (Paris: Rolin de la Haye, 1649)

Chantelauze, Régis de, *Louis XIV et Marie M. d'après de nouveaux documents* (Paris: Didier, 1880)

Cosnac, Gabriel Jules, comte de, *Les richesses du palais Mazarin. Correspondance inédite de M. de Bordeaux, ambassadeur en Angleterre. État inédit des tableaux et des tapisseries de Charles premier, mis en vente au palais de Somerset en 1650. Inventaire inédit dressé après la mort du cardinal Mazarin en 1661* (Paris: Renouard, 1884, digitized by the Getty Research Institute)

Doscot, Gérard, *Mémoires d'Hortense et de Marie Mancini* (Paris: Mercure de France, 2003 [1965])

La Fayette, Marie Madeleine de, *Histoire de madame Henriette d'Angleterre*, ed. by G. Sigaux (Paris: Hachette, 1856)

Mancini, Maria, *I dispiaceri del Cardinale*, Italian transl. of *Apologie, ou le véritables mémoires de madame la Connétable de Colonna Maria Mancini, écrits par Elle-même*, 1678), ed. by Daria Galateria (Palermo: Sellerio, 1991 [1987])

——, *Cendre et poussière. Mémoires*, ed. by Maurice Lever (Paris: Le Comptoir, 1997), reprint of *Mémoires de M.L.P.M.M. Colonne, G. Connétable du Royaume de Naples* (Colone: Pierre Marteau, 1676)

Mancini, Hortense and Maria, *Memoirs: Hortense Mancini and Marie Mancini*, ed. and transl. by Sarah Nelson (Chicago: University of Chicago Press, 2008).

Motteville, Françoise Bertaut de, *Mémoires de mme. de Motteville sur Anne d'Autriche et sa cour*, ed. by F. M. Riaux (Paris: Charpentier, 1855)

Perey, Lucien, *Le Roman Du Grand Roi: Louis XIV Et Marie Mancini, D'Après Des Lettres Et Documents Inédits* (Paris: Calmann Lévy, 1894)

——, *Une princesse romaine au XVIIᵉ siècle: Marie Mancini Colonna* (Paris: Calmann Lévy, 1896)

Petitot, Claude Bernard, *Collection complète des mémoires relatifs a l'histoire de France, depuis le règne de Philippe-Auguste, jusqu'au commencement du dix-septième siècle: avec des notices sur chaque auteur, et des observations sur chaque ouvrage par Petitot, continuée par Monmerque: Mémoires de Madame de Motteville, Tome III* (Paris: Petitot, 1824)

Renée, Amédée, *Les nièces de Mazarin: Études de mœurs et de caractères au XVIIᵉ siècle* (Paris: Firmin Didot, 1856)

Saint-Simon, Louis de Rouvroy, duc de, *Mémoires du duc de Saint-Simon*, ed. by A. de Chéruel (Paris: Hachette 1856–1858)

Stendhal, *Correspondance*, ed. by H. Martineau and V. Del Litto, III (Paris: Gallimard, 1968)

Secondary Studies

Adelson, Candace J., *European Tapestry in the Minneapolis Institute of Arts* (Minneapolis: Minneapolis Institute of Art, 1994)

Beckmann, Kirsten, 'Inszenierter Skandal als Apologie? Die Memoiren der Hortense und Marie Mancini' (unpublished doctoral dissertation, University of Trier, 2004)

Benzoni, Gino, 'Lorenzo Onofrio Colonna', in *Dizionario Biografico degli Italiani*, Enciclopedia Treccani, vol. 27 (1982) <https://www.treccani.it/enciclopedia/lorenzo-onofrio-colonna> [8 September 2022]

Bordeaux, Henri, 'Le Premier Amour de Louis XIV: Première Partie', *Revue des Deux Mondes*, 77.1 (1943), 3–30

Colonna, Prospero, *I Colonna* (Rome: Campisano, 2019)

Craveri, Benedetta, *Amanti e regine. Il potere delle donne* (Milan: Adelphi, 2005)

Cholakian, Patricia Francis, ed., 'Marie and Hortense Mancini', in *Women and the Politics of Self-Representation in Seventeenth Century France* (Newark-London: University of Delaware Press, 2000), pp. 85–121

Combescot, Pierre, *Les petites Mazarines* (Paris: Grasset, 1999)

De Lucca, Valeria, *The Politics of Princely Entertainment: Music and Spectacle in the Lives of Lorenzo Onofrio and Maria Mancini Colonna* (Oxford: Oxford University Press, 2020)

——, 'Strategies of Women Patrons of Music and Theatre in Rome: Maria Mancini Colonna, Queen Christina of Sweden, and Women of their Circles', *Renaissance Studies*, 25.3 (2011), 374–92

Denis, Isabelle, 'L'Histoire d'Artemise, commanditaires et ateliers: Quelques précisions apportées par l'étude des bordures', *Bulletin de la Société de l'Histoire de l'Art Français* (1992), 21–36

——, 'Henri Lerambert et l'Histoire d'Artemise: Des dessins d'Antoine Caron aux tapisseries', in *La tapisserie au XVIIᵉ siècle et les collections européennes, actes du colloque international de Chambord, 18 et 19 octobre 1996* (Paris: Éditions du Patrimoine, 1999), pp. 33–50

——, 'The Parisian Workshops, 1590–1650', in *Tapestry of the Baroque. Threads of Splendor*, ed. by Thomas P. Campbell (New York: Metropolitan Museum of Art and New Haven: Yale University Press, 2007), pp. 123–69

Dulong, Claude, *Marie Mancini: la première passion de Louis XIV* (Paris: Librairie Académique Perrin, 2002 [1993])

Goldsmith, Elizabeth C. and Abby Zanger, 'The Politics and Poetics of the Mancini Romance: Visions and Revisions of the Life of Louis XIV', in *The Rhetorics of Life Writing in Early Modern Europe*, ed. by Thomas Mayer and Daniel Woolf (Ann Arbor: University of Michigan Press, 1995), pp. 341–72

Goubert, Pierre, ed., *L'avènement du Roi-Soleil* (Paris: Juillard, 1971)

Gozzano, Natalia, *La quadreria di Lorenzo Onofrio Colonna. Prestigio nobiliare e collezionismo nella Roma barocca* (Rome: Bulzoni 2004)

Guth, Paul, *Mazarin* (Paris: Flammarion, 1999 [1972])

Hillairet, Jacques, *Les Mazarinettes ou, Les sept nièces de Mazarin* (Paris: Éditions de Minuit, 1976)

Howard, Debora and Laura Moretti, eds, *The Music Room in Early Modern France and Italy: Sound, Space and Object* (London: The British Academy, 2012)

Jurewitz-Freischmidt, Sylvia, *Galantes Versailles. Die Mätressen am Hofe der Bourbonen* (Munich: Piper, 2002)

Mamone, Sara, 'Caterina e Maria: due Artemisie sul trono di Francia', in *Caterina e Maria de' Medici donne al potere*, Exhibition Catalogue (Florence, Palazzo Strozzi, 24 October–8 February 2009), ed. by Clarice Innocenti (Florence: Mandragora, 2008), pp. 31–41

Michel, Patrick, *Mazarin, Prince Des Collectionneurs: Les Collections Et L'Ameublement Du Cardinal Mazarin (1602–1661): Histoire Et Analyse* (Paris: Réunion Des Musées Nationaux, 1999)

Monaldi, Gino, *I teatri di Roma negli ultimi tre secoli* (Naples: Ricciardi, 1928)

Natale, Mauro, ed., *Palazzo Colonna, Appartamento Principessa Isabelle, Catalogo dei Dipinti* (Rome: De Luca, 2019)

Patrizi, Florence, 'The Colonna Tapestries', in *Tapestry in the Baroque: New Aspects of Production and Patronage* (New York: Metropolitan Museum of Art, 2010), pp. 232–73

Safarik, Eduard A., *Palazzo Colonna* (Rome: De Luca, 2022)

Savoie-Carignan, Guy de, *The Seven Richest Heiresses of France* (London: J. Long, 1911)

Tabacchi, Stefano, 'Maria Mancini', in *Dizionario Biografico degli Italiani*, Enciclopedia Treccani, vol. 68 (2007) <https://www.treccani.it/enciclopedia/maria-mancini_(Dizionario-Biografico)/> [8 September 2022]

Tamburini, Elena, *Due teatri per il principe. Studi sulla committenza teatrale di Lorenzo Onofrio Colonna (1659–1689)* (Rome: Bulzoni, 1997)

Vittet, Jean, 'Les tapisseries de la Couronne à l'époque de Louis XIV. Du nouveau sur les achats effectués sous Colbert', *Versalia. Revue de la Société des Amis de Versailles*, 10 (2007), 182–201

NICOLETTA MARCONI

La pratica dell'architettura al femminile:
donne nei cantieri romani di XVI–XVIII secolo

▼ **ABSTRACT** Historiography has largely overlooked the contributions of women on Italian building sites throughout history, and their involvement in these sites remains unclear despite the growing amount of scholarship on the societal and cultural roles of women in early modern Europe. However, scientific literature does hint at women's contributions to art and architecture, and women were employed in various capacities, including as labourers, bricklayers, carters, stonemasons, and apprentices, as well as in various other handicraft activities associated with the building industry, not only in several European regions but also in Rome and its hinterland. This study focuses on women's documented presence on the building site of St. Peter's Basilica and other construction sites, particularly those associated with the Barberini family, in Rome and the fiefdoms of Latium. In doing so, this chapter sheds new light on the role of women in art and architecture in sixteenth- to eighteenth-century Italy.

L'atavico distinguo tra 'mestieri più di ornamento che di commodo, e più da femine che da uomini'[1] appartiene a radicate strutture mentali difficili da debellare, le quali, per lungo tempo, hanno fatto sì che l'identità di genere prevalesse sull'identità lavorativa. Tale ostracismo ha comportato l'obliterazione del ruolo svolto dalle donne nell'ambito della professione edilizia, tutt'altro che rapsodico, almeno fino all'avvento del 'rivoluzionario' codice napoleonico e alla conseguente sistematizzazione del diritto. Invero, le donne hanno sempre lavorato nei cantieri edili, anche se raramente il loro contributo è stato ricordato dalla storiografia e sporadiche sono le testimonianze rintracciabili nei repertori archivistici e nel pur ampio florilegio iconografico della prima età moderna.[2] Questo vale anche per il noto precedente di Ambrogio

1 Garzoni, *La piazza universale*, p. 365.
2 L'omissione delle donne dalle descrizioni del cantiere ha origine in età post-medievale. Fino ad allora, il coinvolgimento femminile nell'arte del costruire fu consuetudine diffusa e, come tale, venne descritta o

Women in Arts, Architecture and Literature: Heritage, Legacy and Digital Perspectives, ed. by Consuelo Lollobrigida and Adelina Modesti, Women in the Arts: New Horizons, 1 (Turnhout: Brepols, 2023), pp. 217–234
BREPOLS ❦ PUBLISHERS 10.1484/M.WIA-EB.5.134652

Lorenzetti (1290ca-1348) nel palazzo Pubblico di Siena, dove di recente si è ritenuto di riconoscere donne impegnate sui ponteggi, forse ingannati dal copricapo bianco indossato da uno di questi.[3] Si tratta in realtà di un fazzoletto comunemente usato per proteggere la testa degli operai durante il trasporto a spalla di mattoni e materiali sciolti. Analogo silenzio si riscontra nella trattatistica di architettura, ove la pratica edilizia risulta coniugata esclusivamente al maschile, e in parte nella letteratura scientifica, più interessata al contribuito femminile all'arte e all'architettura.[4] Di recente, però, il risvegliato interesse per l'effettivo ruolo svolto dalle donne nella società e nella cultura ha portato alla moltiplicazione di iniziative, convegni e pubblicazioni dedicati al lavoro femminile.[5] Rimane però ancora in ombra l'impegno femminile nei settori più umili, specie nelle costruzioni, solo episodicamente documentato in età moderna.[6] Eppure, in diverse regioni europee, molte donne furono assunte come semplici operaie, retribuite a giornata, oppure impegnate nelle molte attività artigianali connesse all'indotto edilizio. L'ingaggio è stato spesso associato dalla storiografia a fenomeni eccezionali, conseguenza di crisi sociali o economiche, come guerre ed epidemie, cause di carenza di manodopera maschile, quando lo scarto tra salari era tale da rendere il lavoro femminile economicamente conveniente. Agricoltura, servizio domestico e commercio al dettaglio risultano le occupazioni più diffuse; esistono però diverse attività praticate all'interno delle botteghe artigiane a conduzione familiare, complementari all'attività edilizia, raramente registrate nei censimenti fiscali della popolazione e parzialmente rintracciabili negli atti testamentari. Si tratta di un'autentica economia sommersa, nella quale, a parità di lavoro svolto, i salari femminili, considerati 'salari di complemento' rispetto a quello del capofamiglia, sono rimasti a lungo inferiori a quelli maschili, anche nei casi in cui essi costituirono l'unica fonte di sostentamento famigliare.

Se in ambito artistico la distinzione di genere fu più sfumata, nella dura realtà dei cantieri edili operò uno stuolo 'invisibile' di donne forti nel corpo e nello spirito, che seppero inserirsi in un comparto da sempre considerato appannaggio esclusivo degli uomini, tanto per l'impegno fisico richiesto, quanto per la promiscuità.[7]

Nei cantieri pubblici e privati di diverse città francesi, svizzere, fiamminghe e spagnole, la presenza di donne è attestata senza soluzione di continuità in età medievale e moderna;[8] tra le mansioni documentate – seppur a regime retributivo differenziato

rappresentata; dalla prima età moderna, in un crescente distinguo di genere, solo alcuni mestieri furono ritenuti 'accettabili' per le donne, più consoni alla costituzione e al fisico femminile, mentre altri, più rudi e non in linea con la perdurante ideologia del tempo, vennero sottaciuti e perfino obliterati. Anche per tale ragione, è raro trovare raffigurazioni di donne operaie nei cantieri edili di età moderna.

3 Lorenzetti, *Allegoria del Buono*, 1337–1339; Calenne e Granata, 'L'impiego delle donne nei cantieri romani'.

4 Lollobrigida, *Plautilla Bricci*.

5 Frommel e Dumas, *Bâtir au féminin?*.

6 Groppi, *Il lavoro delle donne*; Zanoboni, *Donne al lavoro*; Bellavitis, *Il lavoro delle donne*; Chemotti, *Donne al lavoro*.

7 'Versacci da cani fanno i muratori e le muratrici…sicuro! Moltissime sono le donne che qui esercitano su per le bertesche questo mestiere, non altrimenti che gli uomini. E muratrici e muratori si fan pagar salato e pepato' (Helfy, 'Lettere da Pest', p. 70).

8 'Il [primo] sodalizio massonico o di muratori [...] fu stabilito in Francia [...]. Furonvi pure ammesse le donne; però formavano un sodalizio a parte, detto delle muratrici' (Buttà, *I Borboni di Napoli*, 1, p. 115).

per regione – figurano anche quelle più defatiganti, come il taglio della pietra e lo scavo della terra per le opere di fondazione, il trasporto di acqua, detriti e materiali di risulta, il confezionamento della calce, nonché ruoli sussidiari alle opere murarie e attività artigianali di complemento. In Italia il lavoro edile femminile è documentato fin dal XIII secolo, da Messina alla provincia di Pavia. Qui, nel 1475 è attestato il contributo di 284 donne, coordinate da una 'capitanea', assegnate allo scavo di un canale artificiale con retribuzione pari ai due terzi di quella corrisposta ai 356 uomini loro colleghi.[9] Occorre altresì ricordare, che, se nel cantiere del duomo di Siena operarono a giornata 'chalcinaiuole, donne che rechano rena, manovagli e femine', nelle pur prestigiose fabbriche del duomo di Milano e del duomo di Firenze non risultano ingaggiate donne.[10]

L'occupazione femminile interessò anche l'ambito imprenditoriale dell'indotto edilizio, come documentato da alcuni atti notarili milanesi di primo Cinquecento relativi a produzione e commercio di laterizi,[11] oltre che da analoghe attività svolte nello Stato Pontificio.[12] La professione edile fu dunque una realtà poliedrica, nella quale consuetudine e necessità concorsero a emancipare la condizione femminile, sconfessando il pregiudizio storico di alcuni impieghi preclusi alle donne e, viceversa, di esclusivi 'mestieri da donne' e questo non tanto per pregiudizio, quanto piuttosto per una temuta concorrenza da parte degli uomini, specie nelle fabbriche urbane.[13] Fin dall'epoca medievale, infatti, la manodopera femminile rappresentò una risorsa irrinunciabile per l'abbattimento dei costi di produzione, più forte anche dell'inevitabile invisa promiscuità del cantiere. La distinzione tra ruoli maschili e femminili fu assai meno netta e definita di quanto comunemente ritenuto, pur nella persistente esclusione delle donne dalle organizzazioni corporative.[14]

La presenza di operaie nei cantieri cinque, sei e settecenteschi di Roma e del Patrimonio pontificio appartiene dunque ad una consuetudine plurisecolare, accolta anche dalla Fabbrica di San Pietro in Vaticano, istituzione preposta all'amministrazione finanziaria e tecnica del cantiere della Basilica dall'aprile 1506 e tutt'ora impegnata nella sua manutenzione, sorprendentemente rivelatasi tra le più all'avanguardia del suo tempo.[15] Più in generale, il contributo femminile all'architettura di area romana di XVII e XVIII secolo include l'attività svolta da operaie, carrettiere e 'muratrici', documentata, tra Cinque e Seicento, nei cantieri del Castello di Gaeta, del Duomo di Orvieto, delle fabbriche pamphiljane di Nettuno e Valmontone, di quelle barberiniane

9 Zanoboni, *Donne al lavoro*, pp. 91 e segg.

10 Goldtwaite, *La costruzione della Firenze rinascimentale*, pp. 449 e passim.

11 Zanoboni, 'Quod dicti denarii'.

12 Colesanti, 'Appunti per la storia dei cantieri', p. 212; Ait, *Donne in affari*, pp. 53–83.

13 Roff, 'Appropriate to her sex?', pp. 109–34.

14 Bellavitis, *Il lavoro delle donne*, pp. 97–159; Bellavitis, Martini, e Sarti, *Familles laborieuses. Rémunération*. Sull'esclusione delle donne da corporazioni e compagnie di mestiere si veda Wiesner-Hanks, *Le donne nell'Europa moderna*, pp. 112–17.

15 Di Sante e Turriziani, *Quando la Fabbrica costruì San Pietro*; Di Sante e Turriziani, *Donne a lavoro*. Il lavoro femminile nei cantieri romani di XVI–XVIII secolo è stato oggetto della Giornata di Studi su *Donne a lavoro. Arte, architettura, cultura e istituzioni in età moderna e contemporanea* e dell'omonima mostra, curate da chi scrive con M. Giannetto (Roma, Archivio Storico della Presidenza della Repubblica, gennaio-febbraio 2019).

di Palestrina e Monterotondo, nelle quali i registri di cantiere attestano pagamenti corrisposti a donne assunte per spicconare, traportare calcinacci e pietre, murare e fabbricare calce.

Non fa eccezione la tradizione edilizia vaticana. Strutturata su un rigido impianto amministrativo governato da una congregazione cardinalizia alle dirette dipendenze del pontefice, la Fabbrica di San Pietro si distinse per l'adozione di una politica assistenziale all'avanguardia, desueta per l'epoca, fondata sull'adozione di speciali misure di 'sicurezza', assistenza ai propri operai e alle loro famiglie, nonché su un'inaspettata apertura al lavoro femminile, in linea con posizioni già consolidate in ambito europeo. L'attività assistenziale della Fabbrica di San Pietro incluse indennizzi per quanti, a causa di un incidente, fossero risultati inabili al lavoro, ma anche aiuti alle famiglie di eventuali vittime, e molte se ne contarono. I registri di *Elemosine* e suppliche inoltrate alla congregazione petriana rivelano natura e consistenza dei sussidi elargiti, ammontanti a vitalizi monetari, oppure tradotti nell'assunzione di vedove, figlie e figli di sanpietrini, con ruoli e salari già assegnati ai loro congiunti.

Alle donne furono offerte le medesime opportunità lavorative riservate agli uomini, a riprova di un'inusuale sensibilità alle necessità dei dipendenti, scevra da pregiudizi di genere.[16] Grazie a tale apertura, anche figlie e vedove di sanpietrini, artigiani e fornitori del cantiere basilicale poterono rilevare le attività dei propri congiunti e proseguire nella gestione di botteghe e piccole imprese familiari.

Il ruolo delle donne nella Fabbrica di San Pietro fu dunque tutt'altro che marginale. I documenti rivelano un'attività lavorativa intensa, che concesse alle donne un ampio margine di espressione, nonché la possibilità di ingegnarsi e affermarsi in autonomia. Diverse furono le donne, che collaborarono attivamente all'edificazione della Basilica fino al primo Ottocento: intagliatrici, mosaiciste, 'capatrici di smalti' e 'vetrare', ma anche abili imprenditrici che rifornirono il cantiere vaticano di ferro, legno, pietra e laterizi. Le 'capatrici' di smalti destinati all'esecuzione delle opere in mosaico, ad esempio, praticarono un'attività oltremodo faticosa, restando per ore chine sulle taglienti macerie delle antiche decorazioni della Basilica costantinana che si andava demolendo, e rovistando con le loro dita affusolate alla ricerca di preziose tessere ancora integre. Le 'fornaciare' avevano invece il compito di preparare gli smalti per le minute tessere di mosaico policromo destinate all'imponente opera di decorazione dell'interno basilicale. La Fabbrica necessitava di enormi quantità di questi materiali vitrei di delicata lavorazione, che venivano lavorate fino a ricavarne minute tessere colorate. Questa attività proseguì anche nei secoli seguenti; nel primo Ottocento, Vittoria Pericoli, 'pittrice piena di spirito e di coraggio', ma anche 'cristallara' e fabbricatrice di smalti, lavorava in una bottega di vetri e cristalli di sua proprietà, rifornendo lo Studio del Mosaico Vaticano con prodotti di qualità definita perfetta. Una donna moderna, autonoma, indipendente, che fornì anche le tessere dei mosaici per la ricostruzione della Basilica di San Paolo fuori le Mura dopo il terribile incendio

16 Marconi, 'Sicurezza, assistenza e misericordia', pp. 137–81; con riferimenti alla documentazione in Archivio Storico della Fabbrica di San Pietro in Vaticano (AFSP).

LA PRATICA DELL'ARCHITETTURA AL FEMMINILE 221

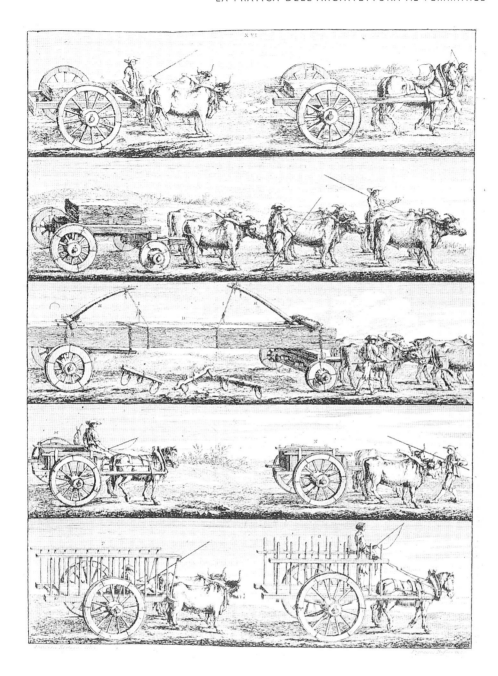

Fig. 1. *Carrette, bastarde, barrucole e barozze per il carriaggio del materiale da costruzione* (da *Castelli e Ponti di maestro Nicola Zabaglia con alcune ingegnose pratiche e con la descrizione del trasporto dell'Obelisco Vaticano e di altri del Cavalier Domenico Fontana*, Pagliarini, Roma 1743, tav. XVI).

del 1823.[17] È doveroso menzionare anche le numerose 'provvisioniere patentate', vale a dire donne come Marta Sannazzari, che fornì laterizi e vasi di terracotta, tegole e padellini per le migliaia di lanterne necessarie all'illuminazione della basilica e della cupola.

E ancora, ecco riaffiorare l'opera di intagliatrici di legno, come Lucia Barbarossa, che ereditata l'avviata bottega del marito Giuseppe Corsini, 'intagliatore di legno bravissimo', seppe tradurre nel legno con altrettanta maestria le invenzioni dei grandi artisti del suo tempo.

Altro esempio di capacità tecnica e abilità imprenditoriale fu la 'vetrara' romana Giovanna Jafrate. Per disposizione testamentaria del marito, Alessandro Agostino Luzi – vetraio patentato della Fabbrica e incaricato del montaggio di sportelli e finestre alle diverse quote della Basilica, ma attivo anche in alcuni cantieri barberiniani –, Giovanna ricevette in eredità la bottega di famiglia e la preziosa dotazione di attrezzi da lavoro, senza la quale non avrebbe potuto accedere ad alcun incarico[18] (Fig. 1). Alla morte del marito, nel 1704, Giovanna ne rilevò la bottega e iniziò il suo lavoro per la Fabbrica di San Pietro, documentato fino al 1737. Affascinante e degna di nota è l'opera dell'intagliatrice di lapislazzuli Francesca Bresciani, indagata da Assunta Di Sante, che si distinse per capacità tecnica, puntualità esecutiva e consapevole orgoglio professionale. Scelta da Gian Lorenzo Bernini tra altri quattro candidati, tutti uomini, per le sue qualificate competenze, tra il 1672 e il 1675, Francesca eseguì il rivestimento in lapislazzulo del Tabernacolo del Santissimo Sacramento, modellato dallo stesso Bernini nel bronzo dorato.[19]

Analoga, se non maggiore determinazione e forza d'animo, unite a disperata caparbietà, mostrarono le molte donne assegnate a più umili e gravosi compiti dell'inusitato cantiere basilicale, ma anche in diverse fabbriche minori, nelle quali ricoprirono ruoli fisicamente impegnativi, per i quali non erano richieste specifiche competenze tecniche. È importante sottolineare che il numero delle donne presenti nel cantiere di San Pietro fu certamente contenuto rispetto alla forza lavoro maschile, ma la loro remunerazione non registrò differenziazioni rispetto a quella degli uomini, come invece avveniva in altri contesti. Tale sostanziale omologazione, scevra da pregiudizi di genere, si rintraccia anche nella struttura delle relazioni tra la Fabbrica e i fornitori accreditati dei materiali da costruzione, tra i quali, tra XVI e XVII secolo, si registra una nutrita presenza femminile. La 'tinozzara' Pacifica De Cosciaris, ad esempio, associò all'attività di fabbricatrice di tini per il trasporto di materiali minuti quella di trasportatrice di travertino dalla cava dello Schella in Tivoli. Il trasporto del travertino, estratto dalle cave delle Fosse, delle Caprine e del Barco, presso Tivoli, ma anche da quelle più lontane di Orte, Civita Castellana, Ceprano e Fiano, godeva di specifiche disposizioni fissate dalla Fabbrica di San Pietro, nonché di una consolidata organizzazione, strutturata su un efficientissimo servizio di imbarcazioni e carri a capienza e conformazione differenziate, appaltato a operatori che seppero tradurlo

17 Di Sante e Turriziani, *Donne a lavoro*.
18 Marconi, 'Giovanna Jafrate', pp. 105–19.
19 Di Sante e Guido, 'Francesca Bresciani', pp. 73–103.

LA PRATICA DELL'ARCHITETTURA AL FEMMINILE 223

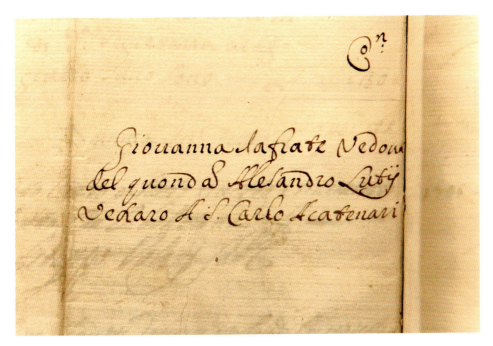

Fig. 2. *Conto di Giovanna Jafrate vedova del quondam Alessandro Lutij vetraro a San Carlo ai Catinari* (AFSP, Arm. 43, B, 61, c. 131ʳ, Liste mestrue dell'anno 1720).

in redditizia attività imprenditoriale, investendo nell'acquisto di mezzi e animali da tiro (Fig. 2). Il commercio della pietra tiburtina comportava faticose operazioni di movimentazione dei pesanti blocchi lapidei con il solo ausilio di leve, argani, canapi, curli e forza muscolare, che Pacifica riuscì a praticare con il supporto di un solo manovale. L'essenzialità di tali attrezzature esplicita fatica e impegno richiesti alle carrettiere, alcune delle quali operarono prive di qualsiasi aiuto. Queste energiche e volitive 'madonne' furono però ricompensate dalla garanzia di continuità lavorativa, per loro vitale.

Tra Cinque e Seicento, sono documentata anche Antonina de Pozzo, vedova di Giovanni Giacomo Carone, la quale, nell'estate del 1548, con due carrozze di sua proprietà, fornì al cantiere di San Pietro travertino dalla cava 'di mastro Luca (de Massimi) da Tivoli, e Marta Ponzino', anche lei moglie di un carrettiere e dal 1563 appaltatrice del trasporto 'di travertini dal Porto di Castello, dai Cerchi e dal Colosseo a San Pietro'. Alla morte del marito, nel 1565, un mandato della Fabbrica le consentì di proseguire nella consegna di pietra da taglio tiburtina e di usufruire delle attrezzature della Fabbrica, necessarie alle operazioni di carico e scarico della pietra.

Per solito ai carrettieri spettava anche la movimentazione dei materiali all'interno dello spazio di cantiere, con annesse faticose acrobazie richieste, ad esempio, dalle 'rivoltature' dei marmi, eseguite con diverse tirate d'argano e condotte con una quantità tale di attrezzi da richiedere addirittura l'affitto di un locale per la loro custodia (Fig. 3). Una mansione altrettanto faticosa fu svolta da alcune donne addette alle forniture di legname da lavoro, richiesto in grande quantità per la realizzazione di

Fig. 3. Carri per il trasporto del travertino e 'maniera di caricarli' (da *Castelli e Ponti di maestro Nicola Zabaglia con alcune ingegnose pratiche e con la descrizione del trasporto dell'Obelisco Vaticano e di altri del Cavalier Domenico Fontana*, Pagliarini, Roma 1743, tav. XV).

pontegi, centine e macchine da sollevamento per il cantiere vaticano. Tra loro, Porzia Cenci, rilevata l'attività del marito, tra il 1589 e il 1592 consegnò ingenti quantità di legname da lavoro destinato alla costruzione della cupola grande. Altrettanto fece Lucrezia Citara, moglie del pisano Orazio Cianti, fornitore di legname accreditato alla Fabbrica, per il quale completò le forniture indispensabili 'a far l'armatura della Cupola, e Ponti', come convenuto con la Fabbrica. Altre donne trasportarono nel cantiere petriano gesso, calce, mattoni e ferro: Attilia di Vincenzo fornì polvere di marmo 'per li stucchi del Cornicione grande e sotto la cupola', Giulia Arrigoni da Varese trasportò le pesantissime barre di ferro destinate alle cerchiature della Cupola Grande. Tra il 1590 e il 1593 dalla sua bottega giunsero in Fabbrica anche diverse migliaia di libbre di ferro utilizzate per fare spranghe, zeppe e 'catene per li Corridori'. Reiterando tale consolidata tradizione, ai primi dell'Ottocento, la Fabbrica concesse alle sorelle Palombi 'ferrare' la patente di fornitrici ufficiali di ferro. Tra il 1603 e il 1605, una certa 'madonna' Camilla fornì consistenti quantità di gesso 'per fare il pavimento della Cattedra', mentre un'altra 'madonna' Camilla, volitiva proprietaria di una fornace di laterizi, nell'agosto 1545 fu retribuita per la fornitura di diverse migliaia di mattoni.

Più rare risultano invece le testimonianze relative alla presenza di 'muratrici' nel cantiere petriano, attestata invece in diverse altre fabbriche seicentesche, dall'Abruzzo[20] ai feudi nobiliari laziali, tra i quali Caprarola[21] e Segni, ove l'opera di diverse 'mastre muratore' è documentata fino al Settecento.

In particolare, nella città di Segni, nel 1629, diverse donne furono impiegate per il trasporto dei materiali da costruzione e dell'acqua 'per smorzar la calce, [...] cavar la detta calce dalla calcara, [...] levare la terra, [...] votare pozzi, [...] crivellar la pozzolana', mansioni condivise senza eccezione alcuna con gli uomini. Analoga ripartizione dei ruoli è documentata, tra il 1661 e il 1668, nei cantieri segnini di ricostruzione della cattedrale e di palazzo Sforza Cesarini.[22] L'impiego femminile nei cantieri edili è documentato anche a Montefortino nel XVI secolo, dove una tale Angela è ricordata come conduttrice di una calcara, forse ereditata dal marito, a Montelanico, dove alcune donne furono retribuite 'ammanire al muratore', cioè per porgergli pietre, calce e acqua, ma anche per spicconare intonaci e montare ponteggi, nonché a Valmontone, ove tra il 1653 ed il 1658 furono impiegate costantemente ben 31 donne nel cantiere di costruzione di palazzo Pamphilj.

Se a Roma il reclutamento fu in larga misura dettato dalla contiguità familiare o da pregressi rapporti collaborativi, in provincia, dove le corporazioni di mestiere furono assenti o meno potenti, le assunzioni furono definite dalle necessità dei singoli cantieri e dalla disponibilità di manodopera femminile disponibile sul posto. Inoltre, a parità di mansioni e di impegno, a Roma vigeva una decurtazione dei salari femminili fino al 50% – con esclusione della Fabbrica di San Pietro, ove vigeva un identico

20 Zullo, 'Tra Abruzzo, Napoli e Puglia', p. 78.

21 Sturm, *L'architettura dei Carmelitani Scalzi*, pp. 209–45.

22 Calenne, *Giovan Battista Roderi*, che cita Archivio Capitolare di Segni, Amministrazione della Fabbrica della Cattedrale, 1630.

regime retributivo per uomini e donne –, mentre in provincia erano talvolta equiparati a quelli degli uomini, oppure fissati in cifre prestabilite (per solito 10 baiocchi al giorno), come documentato nelle citate fabbriche di Segni, Valmontone, ma anche in Palestrina. Qui, nel feudo acquistato nel 1630 da papa Urbano VIII Barberini (1623–1644) per il fratello Carlo (1562–1630), lavorarono diverse 'muratrici', spicconatrici e 'garzone'.

Come a Roma, Monterotondo, Santa Marinella e Castel Gandolfo importanti iniziative edilizie misero in scena il trionfante progetto barberiniano di autocelebrazione, declinato nell'adozione di precisi modelli tipologici e mirati programmi iconografici e allegorici, nonché dall'accurata selezione artisti e maestranze. Tra queste figurano anche diverse donne – artiste, artigiane e operaie – che si confermarono risorsa preziosa e irrinunciabile, come provano i rendiconti di costruzione del monastero di Sant'Andrea per le suore Oblate del Bambino Gesù, realizzato su progetto di Tommaso De Marchis (1693–1759) e finanziato dal cardinale Francesco Barberini juniore (1662–1738).

L'organigramma della fabbrica, che annovera diversi carrettieri prenestini, gli scalpellini Luca Berrettone e Girolamo Velluzzi, oltre a segatori, fabbri, 'chiavari' e stuccatori, imbiancatori e un pittore, Domenico Sforza,[23] include almeno sei donne con ruoli riconosciuti e con retribuzioni equiparate a quelle degli uomini (Fig. 4). L'ingaggio di operaie e muratrici rispecchia la consuetudine documentata nelle fabbriche laziali, come quelle pamphjliane di Nettuno e Valmontone, nelle quali, alla metà del Seicento, una ventina di donne furono retribuite con 10 baiocchi a giornata e stabilmente impiegate nella compagnia del mendrisiotto Cesare Bertolla da Novazzano, a sua volta legata ai connazionali Fontana e all'architetto Giovan Battista Mola.

Il *Libro di Introito ed Esito* del monastero, relativo agli anni 1733–1739, attesta la presenza di almeno sei donne inserite a pieno titolo nell'organico di cantiere, con stipendi e ruoli equiparati a quelli degli uomini.[24] Le mansioni loro assegnate inclusero il pericoloso spegnimento della calce e il carriaggio di materiali pesanti: Agata Coccia fu retribuita per 'portatura di undici carrette di tevole romane e mattoni' e 'per sei giornate date a carregiare sassi a l'orto del monastero',[25] Costanza Prioreschi per la 'portatura di sei carrette di tevole' e 'per aver smorzato con altre donne 65 pesi di calce per l'acqua';[26] Antonia Biancucci 'per aver trasportato il calcinaccio fori dal monastero',[27] lavoro per cui venne retribuita anche Marta di Julio, ingaggiata 'per trasporto di calcinaccio e sassi'.[28] Analogamente, è documentata la presenza costante e strutturata delle 'mastre muratrici' Flavia Martinucci, Maria Rosignolo e Maria

23 Domenico Sforza fu ingaggiato dal card. Francesco Barberini iuniore anche per la decorazione ad affresco con vedute paesaggistiche posta a ornamento della 'Loggia coperta' del Triangolo Barberini di Palestrina (Marconi, 'Palazzino di meravigliosa vaghezza').

24 ABP, 295/02, 8 novembre 1733, cc. 24–35.

25 ABP, n. 295/02-1733-1734, c. 36r.

26 ABP, n. 295/02-1733-1734, c. 36r.

27 Ivi, c. 43v.

28 Ivi, c. 48r.

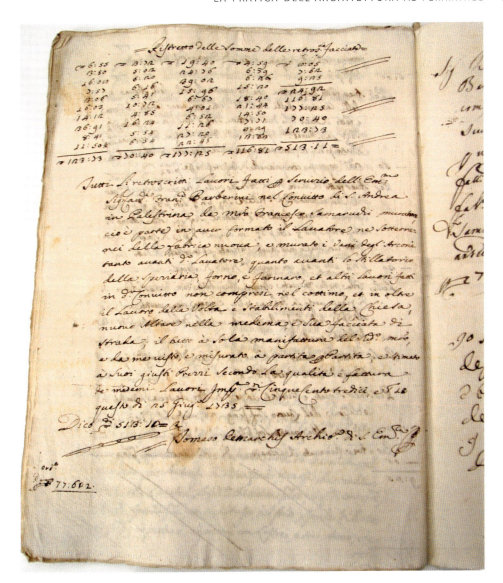

Fig. 4. Palestrina, Monastero del Bambin Gesù, organigramma del cantiere (da ABP, 295/02, 8 novembre 1733, cc. 24–35).

Antonia Cenci,[29] alle quali, nel 1734, furono assegnate incombenze identiche a quelle di altri esperti muratori della compagnia di Arcangelo Leonardi, inclusi l'esecuzione di diverse canne di muro, risarcimenti e 'riattamenti'.[30] Si trattò di collaborazioni continuative, con un impegno di ore lavoro identico a quello maschile. L'equiparazione dei salari non fu però misura costante, nemmeno per la città di Palestrina e per i

29 ABP, 295/02, 8 novembre 1733, cc. 24–35.
30 ABP, n. 51/1734; ivi, n. 181/1734; ivi, n. 189/1734.

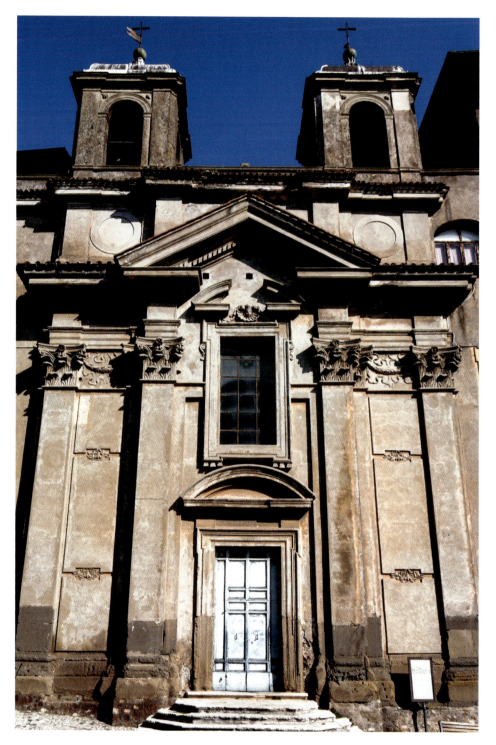

Fig. 5. Palestrina, Chiesa di Santa Rosalia nel palazzo Colonna-Barberini, facciata.

LA PRATICA DELL'ARCHITETTURA AL FEMMINILE 229

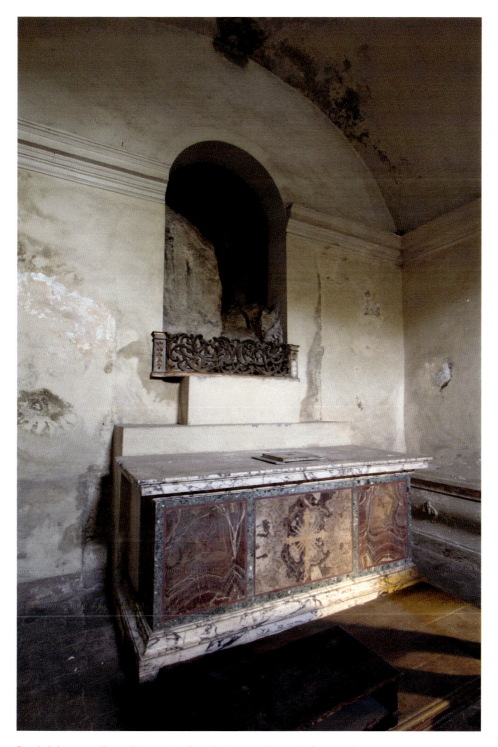

Fig. 6. Palestrina, Chiesa di Santa Rosalia nel palazzo Colonna-Barberini, Sala dei Depositi. Nella nicchia sovrastante l'altare si scorge il solido banco calcareo sul quale è stata fondata la chiesa.

cantieri barberiniani. Ciò emerge dai documenti di costruzione della cappella palatina di Santa Rosalia (1657–1660), che attestano retribuzioni differenziate per le 'donne che hanno servito à cavare e portar via la terra'; a queste furono corrisposti 10 baiocchi a giornata, a differenza dei 20 baiocchi assegnati agli uomini.[31] La chiesa fu edificata per volontà del principe Maffeo Barberini (1631–1685) su progetto di Francesco Contini (1599–1669) a partire dal 1657 e ultimata dal cardinale Francesco juniore agli inizi del Settecento (Fig. 5). Inglobata nel palazzo Colonna-Barberini, la chiesa sorge in parte sulle solide preesistenze murarie del santuario di Fortuna, e in parte sulla togliere roccia calcarea del colle Ginestro; l'esecuzione delle opere di fondazione risultò dunque impresa assai ardua e faticosa, alla quale attesero alcune donne del luogo, reclutate dai capomastri muratori e scalpellini assegnatari del lavoro. Tra i resoconti dei lavori eseguiti nel 1659 figurano il taglio del masso nella tribuna della chiesa, eseguito 'con ferramenti compri in Roma' da due scalpellini, due picconieri e da alcune donne impegnate anche 'à cavare e portar via la terra' di risulta. Anche nelle successive fasi di realizzazione della Sacrestia e dell'annessa Sala dei Depositi, uomini e donne attesero congiuntamente allo sterro, percependo analoghi compensi (Fig. 6). Altre fabbriche prenestine riflettono tale sostanziale omologazione, come provano, tra gli altri, i pagamenti corrisposti a uomini e donne che, tra il 1661 e il 1675, lavorarono alla realizzazione del giardino dei principi Barberini in Palestrina, come agli 'huomini e donne' che a Roma, nel 1671, furono ingaggiati per 'la nettatura di pozzolana, canali mattoni, tavole […] per servizio delli rifondamenti fatti alla Cancelleria e Palazzo di detta Eccellenza [palazzo Barberini ai Giubbonari]'.[32]

Per lungo tempo, dunque, il lavoro edile fu valutato non in base all'essere, ma in base al fare; un fare consueto e condiviso, che portò le donne a trasportare pietre e mattoni, a spegnere calce, crivellare pozzolana e a montare ponteggi, secondo il modello del cantiere petriano, caleidoscopio vivace e brulicante di vita, animato dalla pulsante energia di generazioni di uomini e donne con storie e vissuti diversi, segno certo e distintivo di capacità professionale e rassicurante solidarietà.

Differita conseguenza delle rigide formulazioni imposte dalla riforma protestante, la condizione femminile mutò nella seconda metà del Settecento, quando il progressivo allontanamento delle donne da imprese artigiane e cantieri coincise con l'affermarsi dell'ideologia dell'onore e della cosiddetta 'rispettabilità borghese'.[33] L'ambita afferenza al ceto medio di artigiani e piccoli imprenditori non fu più ritenuta compatibile con la partecipazione di mogli e figlie a lavori di bottega o di fatica. In un contesto sempre più rigidamente maschile, informato alla 'salvaguardia dell'onore', per le donne risultò più difficile lavorare in autonomia. Perfino nell'illuminato Settecento francese, Jean Jacques Rousseau (1712–1778) si trovò ad affermare che la donna 'est faite spécialement pour plaire à l'homme' e per essere a lui sottomessa e, pertanto, deve essere educata alla purezza, alla virtù e alla cura della casa.[34]

31 Marconi e Eramo, 'La chiesa di Santa Rosalia'.
32 Marconi, *La chiesa di Santa Rosalia nel palazzo*.
33 Wiesner-Hanks, *Le donne nell'Europa moderna*, pp. 89, 114–16.
34 Rousseau, *Émile ou l'éducation*, p. 641.

Lo Stato Pontificio rimase estraneo a simili restrizioni. La proverbiale rigidità ecclesiale si rivelò invero ben più aperta all'inclusione e all'equiparazione dei ruoli di molte realtà europee. Questo almeno fino agli anni della prima Repubblica Romana e dell'occupazione francese (1798–1799; 1808–1814), che obbligarono la Chiesa ad un indispensabile rinnovamento culturale e sociale; al ristabilirsi dell'autorità papale, però, la presenza delle donne nei cantieri edili non risulta più documentata.

Bibliografia

Manuscripts and Archival Sources

Archivio Barberini Palestrina (ABP)
Archivio Storico della Fabbrica di San Pietro in Vaticano (AFSP)

Primary Sources

T. Garzoni, *La piazza universale di tutte le professioni del mondo* (Venezia, 1585)
J. J. Rousseau, *Émile ou l'éducation* (Paris, 1762)

Secondary Studies

Ait, Ivana, *Donne in affari: il caso di Roma (secoli XIV–XV)*, in *Donne del Rinascimento a Roma e dintorni*, a cura di Anna Esposito (Roma: Roma nel Rinascimento, 2012), pp. 53–83

Bellavitis, Anna, *Il lavoro delle donne nelle città dell'Europa moderna* (Roma: Viella, 2016)

———, Manuela Martini, e Raffaella Sarti, a cura di, 'Familles laborieuses. Rémunération, transmission et apprentissage dans les ateliers familiaux du Moyen Âge à l'époque contemporaine en Europe', num. mon. *Mélanges de l'École française de Rome, Italie et Méditerranée*, 128.1 (2016)

Buttà, Giuseppe, *I Borboni di Napoli al cospeto di due secoli* (Bologna: Forni, 1877)

Calenne, Luca, *Giovan Battista Roderi, Camillo Massimo e la cattedrale di Segni. Storie incrociate di un architetto ticinese, di un giovane prelato e di un cantiere laziale del Seicento* (Roma: Annales, 2018)

——— e Belinda Granata, 'L'impiego delle donne nei cantieri romani della prima età moderna: una presenza nascosta o una rimozione ideologica?', relazione alla Giornata di studi su *Nuove scoperte su Plautilla Bricci, pittrice e architettrice nella Roma del Seicento*, a cura di Yuri Primarosa, Roma, Galleria Corsini, 11 aprile 2022 (in pubblicazione)

Chemotti, Saveria, a cura di, *Donne al lavoro. Ieri, oggi, domani* (Padova: Il Poligrafo, 2009)

Colesanti, Gemma Teresa, 'Appunti per la storia dei cantieri e salari nel XV secolo: fabbrica del castello di Gaeta tra 1449 e 1453', in *Memoria, storia e identità. Scritti per Laura Sciascia*, a cura di Marcello Pacifico, Maria Antonietta Russo, D. Santoro, e Patrizia Sardina, num. mon. *Quaderni Mediterranea Ricerche Storiche*, 17 (2011), 200–16

Di Sante, Assunta e Sante Guido, 'Francesca Bresciani tagliatrice di lapislazzuli per il tabernacolo di Bernini', in Di Sante e Turriziani 2017, pp. 73–103

——— e S. Turriziani, a cura di, *Quando la Fabbrica costruì San Pietro. Un cantiere di lavoro, di pietà cristiana e di umanità XVI–XIX secolo* (Foligno: Il Formichiere, 2016)

——— e ———, a cura di, *Donne a lavoro. Artiste, artigiane e operaie nel cantiere della Basilica di San Pietro in Vaticano* (Foligno: Il Formichiere, 2017)

Frommel, Sabine e Juliette Dumas, a cura di, *Bâtir au féminin? Traditions et stratégies en Europe et dans l'Empire Ottoman* (Paris: Picard, 2013)

Goldtwaite, Richard A., *La costruzione della Firenze rinascimentale: una storia economica e sociale* (Bologna: Il Mulino, 1984)

Groppi, Angela, a cura di, *Il lavoro delle donne* (Roma-Bari: Laterza, 1996)

Helfy, H. R., 'Lettere da Pest', in *Le prime letture*, a cura di Luigi Sailer (Milano: Agnelli, anno III, 1872), p. 70

Lollobrigida, Consuelo, *Plautilla Bricci Pictura et Architectura Celebris. L'architettrice del Barocco Romano* (Roma: Gangemi, 2017)

Marconi, Nicoletta, 'Sicurezza, assistenza e misericordia nel cantiere della Fabbrica di San Pietro tra XVI e XIX secolo', in Di Sante e Turriziani 2016, pp. 137–81

———, 'Giovanna Jafrate "vetrara"', in Di Sante e Turriziani 2017, pp. 105–19

———, *La chiesa di Santa Rosalia nel palazzo dei principi Barberini a Palestrina. Architettura e costruzione dai documenti della Biblioteca Apostolica Vaticana*, Collana 'Studi e testi della Biblioteca Apostolica Vaticana', Tipografia Vaticana, Città del Vaticano (in pubblicazione)

———, '"Palazzino di meravigliosa vaghezza". Il Triangolo Barberini, i Casini ai Prati e la chiesa di San Filippo Neri a Palestrina: novità dai documenti d'archivio', *AISTARCH*, 13 (in stampa)

——— e Elena Eramo, 'La chiesa di Santa Rosalia nel palazzo Colonna Barberini di Palestrina: committenza e cantiere', *Studi e Ricerche di Storia dell'architettura*, 2 (2017), 46–63

Roff, Shelley E., '"Appropriate to her sex"? Women's Participation on the Construction Site in Medieval and Early Modern Europe', in *Women and Wealth in Late Medieval Europe*, a cura di Theresa Earenfigth (New York: Springer, 2010), pp. 109–34

Sturm, Saverio, *L'architettura dei Carmelitani Scalzi in età barocca: la 'Provincia Romana'* (Roma: Gangemi, 2013)

Wiesner-Hanks, Merry E., *Le donne nell'Europa moderna* (Torino: Einaudi, 2017)

Zanoboni, Paola M., *Donne al lavoro nell'Italia e nell'Europa medievali (secoli XIII–XV)* (Milano: Jouvence, 2016)

———, 'Quod dicti denarii non stent mortui. Lavoro e imprenditoria femminile a Milano tra Quattro e Cinquecento', *Archivio Storico Italiano*, 165 (2007), 699–735

Zullo, Enza, 'Tra Abruzzo, Napoli e Puglia: tecniche murarie nell'edilizia storica del Molise', in *Terre murate. Ricerche sul patrimonio architettonico in Abruzzo e Molise*, a cura di Claudio Varagnoli (Roma: Gangemi, 2016), pp. 75–97

PART 4

Early Modern

ANNALISA RINALDI

Dalle Parasole a Claudine Bouzonnet Stella

Protagoniste e 'registe' nelle botteghe

▼ **ABSTRACT** This chapter studies the role of women in artistic families in early modern Italy. Specifically, the focus is on the significant contribution of women in the Parasole and Bouzonnet Stella family, highlighting their pivotal role as key figures and directors of family activities. Despite being overshadowed by their husbands, these women were highly skilled and actively cultivated relationships with princes, masters, and queens. As a result, they were able to establish themselves as leading artists, and even took on the role of head of the family, as exemplified by the life of Claudine Bouzonnet Stella, who was recognized as a respected artist by her peers.

Elisabetta e Girolama Parasole furono rispettivamente sposate con gli artisti Rosato Parasole e Leonardo Parasole. Confuse tra loro a causa di un errore di Giovanni Baglioni nelle *Le Vite de' pittori, scultori et architetti*,[1] sappiamo che furono entrambe 'tessitrici' di importanti rapporti con le maggiori personalità femminili dell'epoca. Nel caso della giovane Elisabetta Parasole il fitto *matronage* sembrerebbe dipendere dalle misteriose origini bergamasche. Infatti, Elisabetta o Isabella Cattaneo (1581? – Roma 1617) nasce da un certo barone Cattaneo di origini bergamasche e tale Faustina.[2]

L'artista, scelta dal pittore e mosaicista Rosato Parasole per la dote e per le sue capacità tecniche, crebbe nel Monastero di Santa Caterina della Rosa a Roma, dove le *pericolanti e figlie di donne di mal costume*[3] venivano educate al ricamo e ad altri mestieri per essere reinserite nella società. E, di queste abilità tecniche doveva essere consapevole la stessa Elisabetta che nella sua opera più celebre, dedicata alla regina di Spagna Elisabetta di Borbone, il *Teatro delle nobili et Virtuose donne* (1616) scrive: 'ben conosco l'ardire e la sproporzione che è tra la bassezza della donatrice, e l'altezza della real persona, alla quale si dona: dubitando però dell'esempio della animosa Aracne a me imitata nelli presenti disegni [...] con questo testimonio la

1 Baglione, *Le Vite de' pittori, scultori et architetti*, p. 278.
2 Pupillo, 'Gli incisori di Baronio', p. 846.
3 De Simone, *Archivio della Confraternita di Santa Caterina della Rosa o dei Funari*, p. X.

Women in Arts, Architecture and Literature: Heritage, Legacy and Digital Perspectives, ed. by Consuelo Lollobrigida and Adelina Modesti, Women in the Arts: New Horizons, 1 (Turnhout: Brepols, 2023), pp. 237–242
BREPOLS ❧ PUBLISHERS 10.1484/M.WIA-EB.5.134653

mia devozione e osservanza […] e umilissima servitù mia, supplicandola a gradire in questo picciol dono'.

Già da queste prime battute emergono aspetti interessanti sulle abilità relazionali dell'artista. Dalla dedica si intuiscono: la conoscenza della cultura classica e del mito di Aracne che rimanda ad un legame di lunga data,[4] rinforzato dai concetti quali 'devozione' e 'osservanza'. La destrezza nel saper gestire i rapporti è evidente nell'utilizzo di parole come 'real' che suggerisce una conoscenza diretta, quasi tangibile tra le due donne, e di rispetto, restituito dal grado di regalità Sua Altezza Reale.

Una chiara manifestazione di come le donne nella bottega avevano un ruolo tutt'altro che defilato, occupandosi principalmente di 'saldare i ponti' con i committenti. Ciò è ulteriormente confermato da un'altra opera dedicata alla regina di Spagna quando era ancora una bambina e principessa di Francia, quale *Fiori di ogni virtù per le nobil et honeste matrone* (1610). E ancora, *Lo Specchio delle Virtuose Donne* (1596) dedicata a Felice Maria Orsini Caetani, *Specchio delle Virtuose Donne* (1597) dedicata alla duchessa Juana de Aragóna, e molti altri lavori che suggeriscono l'esistenza di un vasto e complesso *matronage* entro cui la Parasole si inserì pienamente.

A consolidare questo discorso contribuiscono testimonianze pittoriche come il quadro di Jacopo Chimenti (1551–1640), conservato presso gli Uffizi a Firenze *Matrimonio per procura di Maria de' Medici con Enrico VI di Francia, rappresentato da Ferdinando I, granduca di Toscana* ove sono rappresentati personaggi di spicco della Roma del tardo Cinquecento in rapporti con le artiste Elisabetta e Girolama Parasole. Tra queste personalità si distinguono (oltre Maria de'Medici madre di Elisabetta di Borbone): il Granduca di Toscana, fondatore della Tipografia Medicea Orientale cui Leonardo Parasole – marito di Girolama – e l'incisore Antonio Tempesta (1555–1630) parteciparono con l'opera degli *Evangelium Sanctum Domini;*[5] a sinistra vi è dipinta Flavia Damasceni – nipote di papa Sisto V Peretti – mentre a destra è visibile il marito Virginio Orsini. Questi ultimi svolsero un ruolo importante tra la famiglia Parasole e il maestro Giuseppe Cesari, noto come il Cavalier D'Arpino (1568–1640). Infatti, è stata avanzata l'ipotesi che sia Elisabetta che la cognata Girolama abbiano gravitato nella bottega del maestro arpinate.[6]

A supporto di tale tesi la somiglianza tra i due puttini dipinti nel Giardino Segreto del Palazzetto di Sisto V a Roma in onore delle nozze tra Flavia Damasceni e Virginio Orsini, e quelli raffigurati nel frontespizio del *Teatro del Nobil donne* (1616) per la regina di Spagna; puttini che sono stati recentemente attribuiti ad un collaboratore del Cavalier d'Arpino, Rossetti Cesari.[7] Ancora, il marito di Elisabetta Cattaneo, Rosato Parasole, fu tra gli artisti che vennero chiamati dal maestro Giuseppe Cesari per terminare la decorazione dei mosaici della cupola michelangiolesca. Inoltre, attenzionando il dipinto del Cavalier D'Arpino, conservato in Accademia di San Luca, non possiamo fare a meno di osservare come i merletti dipinti con tanta meticolosità,

4 Lincoln, 'Invention, Origin, and Dedication', p. 351.

5 Tinto, *La tipografia Medicea Orietale*, p. 20.

6 Rinaldi, *La bottega Parasole nel tardo Cinquecento nuove ipotesi su Elisabetta Cattaneo e Girolama Cagnuccia*.

7 Calenne, *Prime ricerche su Orazio Zecca da Montefortino*, p. 176.

siano vicini a quelli che Elisabetta aveva reinventato nei suoi 'modellari' di ricamo, tanto apprezzati dal pubblico femminile, e non solo, proprio per la loro originalità. Precisiamo che al momento si tratta di una mera riflessione che crediamo meriti un maggior approfondimento.

Ma, a restituire una visione più ampia dei rapporti con l'élite della Roma di quegli anni è il Libro dei Battesimi, ove si possono individuare figure chiave come: Cristoforo Roncalli, artista e committente presente al battesimo dell'omonimo figlio nel 1600, il maestro di camera Ludovico Angelita e la contessa Barbara Bevilacqua ferrarese, rispettivamente padrino e madrina di Olimpia Parasole nel 1602.[8] Quest'ultima deve aver conosciuto Elisabetta Parasole quando viveva nel Monastero di Santa Caterina della Rosa, oggi distrutto, all'epoca eretto di fronte a Palazzo Mattei residenza della principessa Barbara Bevilacqua, moglie di quell'Antonio Bevilacqua collegato con la cerchia di papa Clemente VIII e di Cinzio Aldobrandini. Quest'ultimo risulta essere in stretto contatto con il bergamasco Maurizio Cattaneo,[9] forse parente della giovane Elisabetta Parasole.

Per quanto riguarda la figura di Girolama e il suo rapporto con il Cavalier D'Arpino, sappiamo che il figlio Bernardino Parasole (1600–1642) fu tra i più stretti collaboratori del maestro arpinate.[10]

Anche Girolama, come Elisabetta, venne scelta da Leonardo per la sua cospicua dote con la quale la bottega Parasole realizzò l'importante *Herbario Nuovo* di Castore Durante, archiatra di papa Sisto V, 'con Figure, che rappresentano le vive Piante, che nascono in tutta Europa, & nell'Indie Orientali, & Occidentali...' (1985).[11] Le affascinanti e suggestive immagini dell'erbario, come l'*Arbor Tristis* o *Arbor Malenconico*, i cui rami d'un tronco umano fioriscono sotto la luce della luna e delle stelle appassendo al sorgere del sole, presentano caratteri ben diversi dalle incisioni scientifiche che Girolama, inizialmente con il marito Leonardo, realizzò per il *Tesoro Messicano*, commissionato dall'illustre Federico Cesi (1585–1630), fondatore dell'Accademia dei Lincei.[12]

Girolama è sicuramente l'esecutrice dell'opera il *Giove Pluvio* per il secondo volume degli *Annales Ecclesiastici*, realizzato per la Tipografia degli Oratoriani fondata dal cardinale Cesare Baronio: quest'ultimo una figura assai controversa della Roma riformata, difensore delle nuove esigenze della Chiesa e allo stesso tempo amante delle ricerche galileiane.[13]

Alla morte del marito fu proprio Girolama Cagnuccia ad ereditare la bottega. Il testamento è indicativo della stima e fiducia che Leonardo nutriva nei confronti della moglie e del suo ruolo all'interno della bottega.[14] Alla luce di quanto esposto, le ultime riflessione sono dedicate all'artista Claudine Bouzonnet Stella (1636–1697),

8 Pupillo, 'Gli incisori di Baronio', p. 846.
9 Personeni, *Notizie genealogiche storiche, critiche e letterarie del Cardinal Cinzio Aldobrandini*, p. 65.
10 Röttgen, *Il Cavalier Giuseppe Cesari d'Arpino*, p. 202.
11 Masetti Zannini, *Stampatori e librai a Roma nella seconda metà del Cinquecento*, p. 215.
12 Finocchiaro, *Cesare Baronio e la tipografia dell'oratorio*, p. 8.
13 Zuccari, 'Cesare Baronio le immagini e gli artisti', p. 80.
14 ASR, *Trenta Notai Capitolini*, Uff. 10, pt 2, 1622, fol. 250[v-r] e 268[v-r].

punto di svolta, l'apice di un percorso che affonda le proprie radici nel tardo Cinquecento.

Figlia di un orafo Etienne Bouzonnet e di Madaléina Stella, Claudine fu la secondogenita di una ricca bottega di incisori francesi. Nipote del pittore e incisore Jacque Stella (1596–1657), alla morte dello zio, Claudine ereditò lo studio e tutti i suoi capolavori, compresi quelli realizzati insieme al celebre amico e pittore Nicolas Poussin.

Affiancata dalle abili sorelle Antoinette (1641–1676), François (1638–1691) e dal fratello Antoine (1637–1682), Claudine Bouzonnet divenne la capofamiglia, diresse i lavori in bottega e continuò a sperimentare l'arte del bulino e dell'acquaforte fino al 1697, anno della sua morte.[15]

Purtroppo sulla vita di Claudine sono in corso ulteriori approfondimenti e non è possibile fornire informazioni dettagliate, ma dalle fonti contemporanee è possibile carpire lo spessore di questa artista, stimata e ricordata dal collezionista d'arte Jean Pierre Mariette (1694–1774): 'elle s'est particulièrement attachée à en conserver le caractère, et, ce qui ne se peut presque jamais dire des graveurs et en général des imitateurs, bien loin d'affaiblir les beautés de ses originaux, elle leur en a prêté de nouvelles, de façon que le Poussin, quelque grand, quelque majestueux, quelque correct qu'il soit, le paroi peut-être encore davantage dans les estampes de Claudia Stella que dans ses propres tableaux'.[16]

Il testamento di Claudine, rispetto ai Parasole, rappresenta un passo avanti per comprendere il cammino verso l'emancipazione delle donne nell'ambito delle botteghe in epoca moderna. Scritto di suo pugno, il testamento è una dichiarazione dello *status* raggiunto.

Già ad una prima lettura emerge una personalità forte che, probabilmente, decise volontariamente di non sposarsi e avere figli, dedicandosi completamente alla carriera. Tutti i suoi beni, infatti, vennero donati ai cari più bisognosi e ai membri familiari con cui Claudine mantenne costanti rapporti.

Terminiamo con una riflessione dedicata ad un'opera del 1667, *Le Pastorales*. Per comprendere ciò è necessaria aprire una breve parentesi sulla Francia che nel Seicento, oltre ad essere tra le monarchie più affermate in Europa, è la culla della *querelle femme* e di *femmes forte* come la regina Anna d'Austria (1601–1666) committente di artiste intraprendenti come Virginia da Vezzo (1601–1638), Plautilla Bricci (1616–1705), etc.

Disegnata e incisa direttamente da Claudine negli anni più fertili e maturi, l'opera suggerisce nuove regioni di ricerca che vedono protagoniste le biblioteche e, dunque, le collezioni letterarie delle donne dell'epoca. Ci sembra interessante, e in linea con quanto trattato finora, domandarsi se *Le Pastorales* di Claudine Bouzonnet Stella sia stata, in qualche misura, influenzata – così come la sua carriera – da quella della nota scrittrice e celebre *femme forte* Lucrezia Marinelli (1571–1653), la quale

15 Mulheron, 'Claudine Bouzonnet, Jacques Stella, and Pastorales', p. 394.
16 Gauna, 'Pierre-Jean Mariette e le "connoissances multipliées"', p. 21.

precedentemente aveva pubblicato l'*Arcadia Felice*. Genere pastorale particolarmente apprezzato dal pubblico, il libro potrebbe aver fatto parte della collezione dell'artista, aver ispirato le sue opere e inciso sulla consapevolezza di svolgere un ruolo significativo all'interno della bottega.

Bibliografia

Manuscripts

ASR, *Trenta Notai Capitolini*, Uff. 10, pt 2, 1622, fol. 250^{v-r} e 268^{v-r}
ASR, Archivio della Confraternita di S. Caterina della Rosa o dei Funari (1470- 1947), inventario 62, ed. by De Simone Evelina (1966 -1970)

Primary Sources

Baglione, Giovanni, *Le vite de' pittori, scultori et architetti. Dal Pontificato di Gregorio XIII del 1572 in fino a' tempi di Papa Urbano VIII nel 1642* (Roma: Nella Stamperia d'Andrea Fei, 1642)

Secondary Studies

Calenne, Luca, *Prime ricerche su Orazio Zecca da Montefortino (oggi Artena). Dalla bottega del Cavalier d'Arpino a quella di Francesco Nappi* (Roma: Gangemi Editore, 2010)
Finocchiaro, Giuseppe, *Cesare Baronio e la tipografia dell'oratorio. Impresa e ideologia* (Firenze: Olschki 2005)
Gauna, Chiara, 'Pierre-Jean Mariette e le "connoissances multipliées". Classificazioni, gerarchie e valori', in *La sfida delle stampe. Parigi – Torino 1650–1906*, a cura di Chiara Gauna (Torino: Editris, 2017), pp. 7–31
Lincoln, Evelyn, 'Invention, Origin, and Dedication. Republishing Women's Prints in Early Modern Italy', in *Making and Unmaking Intellectual Property. Creative Production in Legal and Cultural Perspective*, a cura di Mario Bagioli, Peter Jaszi, e Martha Woodmansee (Chicago: Univ Chicago Press, 2011), pp. 339–57
Masetti Zannini, Gian Ludovico, *Stampatori e librai a Roma nella seconda metà del Cinquecento* (Roma: Palombi Editori, 1980)
Mulheron, Jamie, 'Claudine Bouzonnet, Jacques Stella, and Pastorales', *Print Quarterly*, 25 (2008), 393–406
Personeni, Angelo, *Notizie genealogiche storiche, critiche e letterarie del Cardinal Cinzio Aldobrandini* (Bergamo, 1786)
Pupillo, Marco, 'Gli incisori di Baronio. Il maestro "MGF". Philippe Thomassin. Leonardo Parasole e Girolama Cagnucci Parasole tra l'Oratorio e i Crescenzi. Da Isabella Parasole e Elisabetta Cattaneo: un saggio di ricostruzione', in *Baronio e le sue fonti. Atti del Convegno internazionale, Sora, 10–13 ottobre 2007*, a cura di Luigi Gulia (Sora: Centro di Studi Sorani 'Vincenzo Patriarca', 2009), pp. 831–66
Rinaldi, Annalisa, *La bottega Parasole nel tardo Cinquecento nuove ipotesi su Elisabetta Cattaneo e Girolama Cagnuccia* (Roma: Tor Vergata, 2017)
Röttgen, Herwarth, *Il Cavalier Giuseppe Cesari d'Arpino. Un grande pittore nello splendore della fama nell'incostanza della fortuna* (Roma: Ugo Bozzi Editori, 2003)
Tinto, Alberto, *La tipografia Medicea Orietale* (Lucca: Maria Pacini Fazzi Editore, 1986)
Zuccari, Alessandro, *La regola e la Fama di S. Filippo Neri e l'arte, Catalogo dell'esposizione del Museo Nazionale del Palazzo di Venezia Roma* (Milano: Electa, 1995)

CATERINA BAVOSI E ALESSANDRO SERRANI

Su un equivoco storiografico[*]

Ginevra Cantofoli e Luigi Gentile

▼ **ABSTRACT** By relying on new documentary material, a review of sources and some critical insights, this chapter sheds new light on the female painter Ginevra Cantofoli, inscribing her in the context of seventeenth-century Bolognese painting. This paper first dwells on the spread of art academies in Bologna, focusing on the 'Cenacolo' of Elisabetta Sirani, an entity comparable, while maintaining its own specificity, to the corresponding male. The second section re-examines Cantofoli's production starting from the only painting, recently emerged, that is with certainty referable to her, through which we will try to demonstrate how a group of works previously attributed to her should instead belong to the Flemish painter Luigi Gentile.

Particolari congiunture storico-sociali portarono la Bologna del XVII secolo a diventare un centro di vitale importanza per l'attiva partecipazione femminile alla vita pubblica, culturale e intellettuale.[1] Dopotutto, Bologna, sede della più antica Università d'Europa, era nota per la sua tradizione umanistica di donne erudite nelle arti, nella giurisprudenza e nelle scienze. Sul versante delle arti figurative, Lavinia Fontana, contemporanea dei Carracci e figlia di un pittore, Prospero, riesce a dare forma al proprio sogno di affermazione e di ascesa sociale secondo i modelli imposti dall'ideologia tridentina e da lei rigorosamente incarnati. Inoltre, a Bologna, vista la sua importanza per lo Stato Pontificio, la Controriforma aveva dato impulso a un fiorente mercato di opere sacre e ispiratrici di fede, come disposto dal *Discorso intorno*

[*] Della prima parte del saggio, fino a '…Chierici Regolari Minori', si è occupata Caterina Bavosi; dalla frase successiva ('La revisione, sia quantitativa sia tipologica…') in poi il testo è di Alessandro Serrani. A quest'ultimo si deve anche la ricerca condotta presso l'Archivio arcivescovile di Bologna e in particolare il reperimento dall'atto matrimoniale fra Ginevra Cantofoli e Francesco di Michele Facchini. L'elaborazione è avvenuta in due e le conclusioni a cui si giunge sono condivise da entrambi. Il testo riproduce fedelmente quello della relazione tenuta al convegno.

[1] Modesti in *Elisabetta Sirani. Una virtuosa del Seicento bolognese*, p. 107 rileva, difatti, come nelle fonti da lei consultate e da altri studiosi compaiano almeno centottanta donne scrittrici, artiste, compositrici, intellettuali e insegnanti attive a Bologna dal XV al XVIII secolo.

Women in Arts, Architecture and Literature: Heritage, Legacy and Digital Perspectives, ed. by Consuelo Lollobrigida and Adelina Modesti, Women in the Arts: New Horizons, 1 (Turnhout: Brepols, 2023), pp. 243–258
BREPOLS ❧ PUBLISHERS
10.1484/M.WIA-EB.5.134654

alle immagini sacre e profane dell'arcivescovo Gabriele Paleotti (Bologna 1582). Pittori e pittrici furono dunque chiamati a soddisfare un'alta domanda di committenze, pubbliche e private, con varietà di generi e temi, dalla pittura di storia alla ritrattistica. Nonostante l'*exemplum* di Lavinia Fontana, e quello precedente, nonché ancor più inimitabile, di Properzia de' Rossi, rimaneva pur sempre difficile per la maggior parte delle artiste intraprendere una carriera professionale se non provviste di un parente uomo che insegnava loro il mestiere nella bottega di famiglia. È proprio al modello del sapere patrilineare che l'Accademia di Disegno o 'Cenacolo'[2] di Elisabetta Sirani si costituisce come audace parallelo. Vero e proprio spazio di appropriazione femminile, questo tipo di laboratorio nasce dalla consapevole necessità dell'educazione e del coinvolgimento femminile all'interno della sfera pubblica e accademica. Il suo esperimento è stato spesso messo a confronto con il corrispettivo maschile, le Accademie; tuttavia, a nostro parere, oltre al pur corretto e stimolante raffronto con queste ultime, esso andrebbe piuttosto analizzato nella sua peculiarità ideale, strutturale e organizzativa.

Sirani, difatti, fu in grado di sviluppare un nuovo modello pedagogico, per cui le ragazze figlie di nobili e di artisti potevano imparare a disegnare e a dipingere da una pittrice anziché dai loro padri, mariti o fratelli. La scuola, dunque, si presentava come un *luogo sicuro* in cui le donne apprendevano l'arte e la pratica artistica – come nelle Accademie maschili – potendo cimentarsi anche in generi e formati che la storiografia aveva giudicato dominio esclusivo degli uomini, quale la pittura di Storia. In quest'ottica, la scuola rappresentava per loro l'opportunità di intraprendere una carriera artistica, una professione. Sirani interseca un forte ideale emancipativo – come verrà dimostrato attraverso l'*exemplum* di Cantofoli[3] – con un progetto pedagogico che rientrava nel più generale ambito dell'educazione umanistica propria di una 'donna di palazzo'.[4]

Prendendo le movenze dagli studi di Irene Graziani, possiamo pensare quest'accademia come un 'cenacolo', con diverse interpretazioni riguardo al legame che univa allieve e 'maestra perfetta'.[5] Si potrebbe ipotizzare, difatti, una minore rigidità nella gerarchia organizzativa, tipica delle accademie maschili, pur nella conservazione dei

2 Graziani, 'Il cenacolo di Elisabetta Sirani', pp. 119–33.

3 Nel suo testamento (ASBo, *Notarile*, notaio Camillo Felini, 29 marzo 1672, filza 4, n. 22: Testamento redatto in data 29 marzo 1672 da Ginevra Cantofoli; documento rintracciato e pubblicato da S. Sabbatini, 'Per una storia delle donne pittrici bolognesi', pp. 85–101, in part. 98–101, nota 58), Cantofoli dimostra una consapevole gestione dell'attività professionale, sottoscrivendo un preciso riferimento a 'denari da essa guadagnati col suo esercizio di pittura'.

4 La 'donna di palazzo', vivente espressione di un ideale di comportamento sociale, si rintraccia tra le pagine del *Cortegiano* (1529) di Baldassarre Castiglione, dove la donna non è più dedita all'obbedienza e alle virtù domestiche, ma deve acquisire un bagaglio culturale che consenta di conversare e di sapersi destreggiare in società 'voglio che questa donna abbia notizie di lettere, di musica, di pittura, e sappia danzare e festeggiare [...] così sarà nel conversare, nel ridere, nel giocare, nel motteggiare, insomma in ogni cosa graziatissima' (Castiglione, *Il Cortegiano*, p. 272). Inoltre, a Bologna, come non manca di descrivere e ricostruire in modo dettagliato Modesti, in *Elisabetta Sirani. Una virtuosa del Seicento bolognese*, pp. 71–103, l'istruzione femminile era un tema particolarmente sentito.

5 Modesti, *Elisabetta Sirani. Una virtuosa del Seicento bolognese*, p. 105.

ruoli istituzionali.[6] Di conseguenza, il rapporto che intercorreva tra queste donne poteva non essere vincolato dall'alunnato, bensì caratterizzarsi come paritario, soprattutto qualora le discepole fossero propense a intraprendere la carriera professionale. Tuttavia, potremmo anche supporre che il Cenacolo accogliesse altre ragazze, figlie della Bologna nobile, che invece mantennero la posizione di allieve. Come sottolinea Adelina Modesti,[7] le nobildonne bolognesi, essendo molto impegnate nella formazione sociale delle giovani, offrivano un particolare sostegno e patrocinio all'attività di Elisabetta Sirani e alla sua professione d'artista – soprattutto attraverso importanti committenze[8] – tanto che, a nostro parere, si potrebbe delineare una rete trasversale che le legava.

Venendo ora la nostra attenzione alle allieve e seguaci che proseguirono l'attività artistica,[9] queste furono in grado di dimostrare che la carriera nelle arti, anche per le donne che non appartenevano a dinastie di artisti, era accettata a tutti i livelli della società bolognese. Infatti, le discepole continuavano a dedicarsi alla pittura di soggetto religioso, 'capoletti', destinati alla devozione domestica, ma non erano affatto estranee anche a commissioni più prestigiose quali pale d'altare per le chiese della città e della provincia.[10]

A conclusione di questo sintetico excursus ci sembra di poter affermare che Elisabetta Sirani ebbe il merito di creare, istituzionalizzare e rendere professionale una specifica pratica artistica femminile permettendo alle allieve di ottenere una formazione solida grazie all'esperienza e all'insegnamento della loro 'maestra perfetta'. È in questo stimolante ambiente che si inscrive, e va dunque presa in considerazione, la figura di Ginevra Cantofoli.

Figlia di Francesco Cantofoli e Ottavia Buldrini,[11] si ritiene che la pittrice fosse più anziana della sua insegnante, una notizia che, nonostante non sia ancora stato rintracciato l'atto di nascita, rimane altamente probabile. Esistono infatti buoni

6 Le Accademie maschili, nate per ambizioni di autonomia operativa economica, avevano importanti scopi didattici nel tramandare la scienza e la tecnica dell'arte pittorica, in cui però, accanto a momenti di sperimentalismo, persisteva un 'autoritarismo' non troppo dissimile all'impronta della bottega rinascimentale. Inoltre, coesistevano due facies, una legata alla trasmissione di un patrimonio ideologico e una più professionale, poiché il soggetto collettivo era proiettato verso l'individuazione di una committenza e di una concorrenza. In quest'ottica, appare ancora più evidente la portata rivoluzionaria dell'Accademia del Disegno di Elisabetta Sirani, che intreccia una trasmissione del sapere pittorico matrilineare e una forte spinta emancipativa professionalizzante.

7 Modesti, *Elisabetta Sirani. Una virtuosa del Seicento bolognese*, pp. 79–82.

8 Tra queste figurano, ad esempio, alcune famiglie, quali i Caprara, gli Zambeccari, i Sacchetti e gli Aldrovandi, ma per un approfondimento si rimanda a Modesti, *Elisabetta Sirani. Una virtuosa del Seicento bolognese*, pp. 120–29.

9 Delle ventidue artiste bolognesi attive nel Seicento a Bologna, due terzi sono state messe in relazione con Elisabetta Sirani, grazie alle fonti, sebbene, per motivi anagrafici, non tutte poterono giovarsi direttamente dei suoi insegnamenti. Cfr. Bohn, *Women Artists. Their Patrons and Their Publics in Early Modern Bologna*.

10 Ad eccezione di Veronica Franchi e Elena Maria Panzacchi, che preferirono dedicarsi alla pittura allegorica e al ritratto, altre allieve e seguaci di Elisabetta Sirani predilessero la pittura di storia. Tra queste, rammentiamo Barbara e Anna Maria Sirani (quest'ultima precocissima è ricordata dai contemporanei per avere un talento pari a quello di Elisabetta, ebbe diverse commissioni per pale in sedi periferiche, quali Granarolo e Medicina) Maria Oriana Galli Bibiena, Teresa Maria Coriolani, Caterina Mongardi, Camilla Lauteri, Maria Lucrezia Scarfaglia.

11 Francesco Cantofoli e Ottavia Bultrini si erano sposati nel 1616, a questo proposito, si veda Pulini, *Ginevra Cantofoli*, p. 138 e Pulini, 'Ginevra Cantofoli'.

motivi, a partire dalle notizie fornite da due importanti storiografi bolognesi quali Antonio Masini[12] e Marcello Oretti,[13] per collocare quest'ultimo evento nel 1618. All'undici maggio 1653 risale il matrimonio con Francesco di Michele Facchini, dal quale avrà due figli, Orsola Catterina e Michelangelo, quest'ultimo nato il 10 febbraio 1658.[14] Una revisione, condotta presso l'Archivio arcivescovile di Bologna, dei documenti appena citati, non è mancata di fornire, oltre a necessarie precisazioni, alcuni spunti di riflessione. In particolare, l'assenza nei registri battesimali dell'atto di nascita di Ginevra, piuttosto che da ascrivere a una lacuna documentaria segnalata nella bibliografia recente ma da noi non rilevata,[15] induce a credere che la pittrice sia nata fuori dalle mura cittadine. Inoltre, dall'atto matrimoniale si apprende che il padre di Ginevra, 'l'illustrissimo' Francesco Cantofoli, a quel tempo deceduto, era di origine mantovana.[16] L'unione di queste due informazioni rende percorribile l'ipotesi, da approfondire in una prossima occasione, che Ginevra possa essere nata a Mantova anziché a Bologna; questo spiegherebbe l'assenza del suo atto battesimale dai registri dell'Archivio arcivescovile.

Pur essendo citata da Malvasia tra le allieve di Sirani, è verosimile che Ginevra Cantofoli abbia iniziato la propria attività prima di frequentare la casa della maestra,[17] anche se di questa sua attività giovanile non si hanno notizie. Si è ipotizzato che sia stata introdotta nella scuola di Sirani da una comune committente, la contessa Clemenza Ercolani Leoni.[18] La contessa, nobildonna di spicco della rete di bolognesi impegnate per l'educazione femminile, doveva essere strettamente legata ai Cantofoli poiché Ginevra ne fa menzione nel suo testamento definendola sua 'Protettrice'.[19]

Proprio il testamento, redatto in occasione della morte del marito, Francesco Facchini (4 ottobre 1668), si configura come un documento fondamentale per la comprensione della sua figura, poiché Cantofoli esprime in questa sede una consapevole gestione della sua attività in quanto artista professionale, autonoma dal punto di

12 Masini in Arfelli, 'Bologna Perlustrata di Antonio di Paolo Masini', pp. 188–242, in part. p. 219: 'Morì adì 12 Maggio 1672'.

13 Oretti, *Notizie de' Professori del Disegno* (1760–1780), ms B 129, c. 120, Bologna, Biblioteca Comunale dell'Archiginnasio, segnalato da Graziani, 'Il Cenacolo di Elisabetta Sirani', p. 131 nota 70.

14 Le due date esatte riportate sono state individuate in questa sede, per le quali: AGABo, *Parrocchie soppresse*, 42/2, 1653, c. 9r; AGABo, *Registro battesimi*, 1658, c. 33r. Per quanto riguarda la figlia cf. ASBo, *Notarile*, notaio Lorenzo Pellegrini, prot. 8, 10 ottobre 1688, fol. 75: 'Tutela e inventario tutelare di Orsola Caterina de Fachinis fatto da Ginevra Cantofoli sua madre'.

15 Pulini, *Ginevra Cantofoli*, p. 57.

16 L'origine mantovana del padre di Ginevra è appuntata dal compilatore del documento a sinistra del testo. Si apprendono anche le parrocchie di residenza dei contraenti: Michele risiede nella parrocchia di Santa Maria Baroncella, mentre Ginevra nella in quella in cui è stato celebrato il matrimonio, ossia San Tommaso di Strada Maggiore.

17 Malvasia, *Felsina Pittrice*., II, p. 407. Si veda anche: Oretti, *Notizie de' Professori del Disegno* ms B 129, cc. 119–20.

18 Modesti, *Elisabetta Sirani. Una virtuosa del Seicento bolognese*, p. 114.

19 Cf. ASBo, *Notarile*, notaio Camillo Felini, 29 marzo 1672, filza 4, n. 22: Testamento redatto in data 29 marzo 1672 da Ginevra Cantofoli; documento rintracciato e pubblicato da Sabbatini in 'Per una storia delle donne pittrici bolognesi' pp. 98–101; cf. anche Modesti, *Elisabetta Sirani. Una virtuosa del Seicento bolognese* p. 114. Nel documento ASBo, Notarile, notaio Lorenzo Pellegrini, prot. 8, 10 ottobre 1688, fol. 75: 'Tutela e inventario tutelare di Orsola Catterina de Fachinis fatto da Ginevra Cantofoli sua madre' si evince inoltre della tutela legale per la figlia sedicenne da parte della stessa Contessa.

vista economico e sociale, nel preciso riferimento ai 'denari da essa guadagnati con il suo esercizio di pittura'. Inoltre, nel medesimo documento possiamo rintracciare una serie di opere conservate in casa Cantofoli, tra cui vari ritrattini e miniature 'su cristallo', 'di mano della signora Ginevra', e un'acquaforte – la tecnica era solitamente praticata dalle allieve di Sirani – da lei stessa intagliata raffigurante un *San Tommaso di Villanova*,[20] opere che ci rimandano a un'artista poliedrica e versatile in grado di affrontare diverse tecniche e soggetti. Una complessità che guarda all'emulazione di Sirani, con la quale Ginevra aveva uno stretto rapporto, da assimilare più a quello di una collega che a quello di allieva.[21] Che Ginevra, come Elisabetta, avesse aspirazioni professionali audaci lo si può desumere dalle pur scarne notizie storiografiche locali, che documentano pale d'altare e dipinti realizzati per le chiese di Bologna: un'*Ultima cena* per San Procolo,[22] la *Sant'Apollonia in prigione* della chiesa di Santa Maria della Morte,[23] il *San Tommaso di Villanova* di San Giacomo Maggiore,[24] l'*Immacolata Concezione* della chiesa di San Lorenzo,[25] la *Santa Apollonia con sant'Antonio da Padova e angeli* per Sant'Andrea degli Ansaldi[26] e, infine, un'*Immacolata Concezione* per la chiesa dello Spirito Santo dei Chierici Regolari Minori.[27]

La revisione, sia quantitativa sia tipologica, della produzione pittorica spettante a Ginevra Cantofoli deve necessariamente partire, a nostro avviso, dall'individuazione di quanto si può sicuramente riferire alla sua mano. Il tassello principale è costituito dalla grande pala raffigurante *San Tommaso da Villanova* commissionatale nel 1658 dai padri agostiniani di San Giacomo Maggiore (Fig. 1). Il suo recupero si deve a Massimo Pulini, il quale, partendo dalle fonti, è di recente riuscito a rintracciarla nei locali dell'attiguo monastero, dove pervenne non prima degli anni cinquanta del secolo scorso in seguito a vari spostamenti all'interno della basilica.[28] La critica si

20 Nel testamento (ASBo, *Notarile*, notaio Camillo Felini, 29 marzo 1672, filza 4, n. 22: Testamento redatto in data 29 marzo 1672 da Ginevra Cantofoli) vengono citate: Una Madonna della Rosa (della sig.ra Ginevra), sette Testine su cristallo (della signora Ginevra), tre più grandi sul cristallo (della signora Ginevra), un Ritratto della Filosofia (della signora Ginevra), un Ramo in acqua forte con l'immagine di San Tommaso da Villanova intagliato dalla suddetta signora (che Pulini, *Ginevra Cantofoli*, p. 139 riconduce alla matrice per l'opera per la Chiesa di San Giacomo Maggiore), due Madonne col Bambino (della signora Ginevra), sei cristalli con Testine disegnati dalla signora Ginevra e non finiti.

21 Modesti, *Elisabetta Sirani. Una virtuosa del Seicento bolognese*, p. 114. Si ricorda inoltre in questa sede, la menzione di un ritratto di Ginevra e di uno della madre, ora perduti, del 1656 di Elisabetta Sirani, annotato dalla stessa pittrice in *Nota delle pitture fatte da me Elisabetta Sirani*, pubblicato da Malvasia, *Felsina Pittrice*, p. 393.

22 Masini, *Bologna Perlustrata*, I, p. 126; Malvasia, *Felsina Pittrice*, p. 407; Crespi, *Felsina pittrice*, p. 75; Oretti, *Notizie de' Professori del Disegno*, c. 120.

23 Malvasia, *Le pitture della città di Bologna*, p. 243; Malvasia, *Felsina pittrice*, p. 407; Masini, *Bologna Perlustrata*, p. 219; Crespi, *Felsina pittrice*, p. 75; Oretti, *Notizie de' Professori del Disegno*, c. 120. L'opera era stata commissionata dalla famiglia Leoni.

24 Masini, *Bologna Perlustrata*, p. 175; Malvasia, *Felsina pittrice*, p. 407; Crespi, *Felsina pittrice*, p. 75; Oretti, *Notizie de' Professori del Disegno*, c. 120.

25 Masini, *Bologna Perlustrata*, p. 46; Crespi, *Felsina pittrice*, p. 76; Oretti, *Notizie de Professori del Disegno*, c. 119.

26 Secondo Sabbatini, era il frontale di un'antica immagine della Madonna dipinta su muro, cf. Masini, *Bologna Perlustrata*, p. 219; Crespi, *Felsina Pittrice*, p. 76; Oretti, *Notizie de' Professori del Disegno*, c. 119.

27 Masini, *Bologna Perlustrata*, p. 219; Crespi, *Felsina Pittrice*, p. 76; Oretti, *Notizie de' Professori del Disegno*, c. 120.

28 La pala è documentata sopra l'altare per cui fu commissionata, il XXX, già della famiglia Vitali e dedicato a San Sebastiano e successivamente riscattato dagli Agostiniani, fino a circa la metà dell'Ottocento, quando fu sostituita da un dipinto recante il medesimo soggetto di Pietro Fancelli. In seguito, venne collocata sul XIV

Fig. 1. Ginevra Cantofoli, *San Tommaso da Villanova*, Bologna, monastero di San Giacomo Maggiore. Olio su tela, 250 × 200 cm. Su concessione del Ministero della Cultura – Direzione regionale Musei dell'Emilia-Romagna.

è dimostrata invece più restia ad accettare quale prova certa della pittrice un'altra pala, della Pinacoteca Nazionale di Bologna ma attualmente in deposito presso la chiesa delle monache di Santa Margherita, identificata con quella da lei eseguita per la chiesa di San Lorenzo. Se pochi dubbi sussistono riguardo l'identificazione del manufatto con quello effettivamente licenziato da Ginevra, più problematica sembra essere l'assegnazione dello stesso unicamente alla sua mano.[29] Raffrontandola infatti alla pala eseguita per San Giacomo, l'*Immacolata e insieme Madonna del Rosario* della Pinacoteca non può che apparire di fattura assai più raffinata. A giustificazione di tale scarto ci chiediamo se non possano intervenire le parole di Malvasia, secondo il quale Cantofoli, in occasione del suo esordio pubblico, si sarebbe avvalsa dell'ausilio di Elisabetta Sirani, la quale, per promuoverne la carriera, avrebbe fornito il disegno e 'per quanto si potea' corretto e aggiustato i dipinti della collega.[30]

Si confronti ad esempio il Gesù Bambino della pala per le monache di San Lorenzo con le figure dei putti in quella di San Giacomo: nonostante i patimenti subiti dalla pellicola pittorica di quest'ultima, i putti risultano meno aggraziati e quasi impacciati rispetto all'eleganza reniana del Bambino.[31] Anche il volto del san Tommaso, la cui ruvidezza dei lineamenti è comunque indotta dalla tradizionale iconografia, presenta una fattura troppo secca e assai meno tornita se paragonato a quello estremamente delicato della Vergine.

Altra potenziale testimonianza della produzione di Ginevra è costituita, seguendo una ricostruzione di Gian Piero Cammarota, da tre telette (*Presentazione di Gesù al Tempio*; *Ascensione di Cristo*; *Pentecoste*) oggi alla Pinacoteca Nazionale di Bologna,[32] ricondotte dallo studioso ai *Quindici Misteri del Rosario* che sembrano aver attorniato l'*Immacolata* della Pinacoteca.[33] Già Irene Graziani, riscontrando in essi una difformità stilistica rispetto alla tavola centrale, metteva in guardia dal considerare scontata tale associazione, risolta invece da Massimo Pulini chiamando in causa un aiuto di Ginevra Cantofoli che si sarebbe occupato dei quadretti in questione.[34] Per quanto ambizioso possa essere stato il desiderio di affermazione di Cantofoli, appare però poco probabile, stando allo stato attuale delle ricerche, che la pittrice abbia avuto dei collaboratori nello studio. Inoltre, le discrepanze stilistiche già evidenziate da Graziani, non giustificabili a nostro avviso all'interno di dinamiche di bottega, farebbero

altare, a fianco della *Madonna col Bambino in trono, Santa Caterina d'Alessandria, San Cosma, San Damiano e il committente Scipione Calcina* di Lavinia Fontana, dove rimase almeno fino agli anni cinquanta del secolo scorso. Gli spostamenti che interessarono la pala sono ripercorsi, con ricchezza di dettagli sulle vicende più recenti, da Pulini, *Ginevra Cantofoli*, pp. 63–66, 90–92, n. 11.

29 A sostegno dell'identificazione della pala con quella eseguita per San Lorenzo (cf. nota 25) e della sua attribuzione a Cantofoli si è schierato: Pulini, *Ginevra Cantofoli*, pp. 68–70, 108–10, n. 20. Maggiore scetticismo sembra invece emergere dalle parole di Graziani, 'Il cenacolo di Elisabetta Sirani', pp. 131 nota 77, alla quale si faccia riferimento anche per le vicende collezionistiche che interessarono la pala.

30 Malvasia, *Felsina pittrice*, II, p. 487.

31 Dal nostro punto di vista, non è un caso, a conferma di questa aderenza al linguaggio di Reni, che il dipinto sia entrato in Pinacoteca a seguito delle soppressioni napoleoniche con un riferimento a Giovanni Andrea Sirani: Cammarota, *Le origini della Pinacoteca Nazionale di Bologna*, I, p. 703 nota 356.

32 Bologna, Pinacoteca Nazionale, inv. nn. 1031 (olio su tela, 37,5 × 31,5 cm), 1032, 890 (olio su tela, 37 × 31 cm).

33 Cammarota, *Le origini della Pinacoteca di Bologna*, p. 738, nn. 891–93.

34 Graziani, 'Il Cenacolo di Elisabetta Sirani', p. 131 nota 77; Pulini, *Ginevra Cantofoli*, pp. 68–70, 110–12, n. 21.

Fig. 2. Luigi Gentile, *Venere e Apollo con le muse*, Collezione privata (già Vienna, Dorotheum, 22 ottobre 2019, n. 275). Olio su tela, 76 × 88 cm, con cornice. © The Phoebus Foundation.

considerare tali storiette non pertinenti rispetto alla pala e dunque da espungere dal catalogo della pittrice.

 Le due pale d'altare appena discusse, delle quali, a nostro avviso, solo la prima conviene per ora considerata in toto di Cantofoli, sono comunque acquisizioni recenti. Il corpus delle sue opere si era infatti fino ad oggi ampliato a partire dal presunto *Autoritratto* su tela della Pinacoteca di Brera, il cui riferimento a Ginevra poggia da sempre su basi tutt'altro che solide. Ad esso sono stati affiancati per via stilistica un numero considerevole di dipinti, tutti di piccolo-medio formato e aventi come soggetto autoritratti o allegorie. Non è questa la sede in cui ridiscutere tutti i dipinti che la critica ha a più riprese riferito alla stessa mano della tela braidense, anche perché, a parte qualche caso, tali attribuzioni risultano pienamente condivisibili.[35] Il fulcro della questione risiede nel fatto che tale gruppo, pur coerente, non

[35] Per il quadro complessivo delle attribuzioni a Cantofoli: Pulini, *Ginevra Cantofoli*, responsabile di un notevole ampliamento del catalogo della pittrice. Decisivo per la creazione del corpus è stato il riconoscimento, operato da Renzo Grandi ma comunicato da Degli Angeli, 'Il mito della donna artista', pp. 124–25, in part. p. 122, della stessa

poggia su una base salda, ovvero il riferimento a Cantofoli del quadro di Brera, il che non mette a rischio la compattezza della serie di dipinti riuniti dalla critica, ma il fatto che tutti insieme debbano essere riferiti a Ginevra piuttosto che a un altro artista. È bene innanzitutto precisare come l'attribuzione alla pittrice del dipinto braidense non si debba a fonti o a documenti antichi. Solo nei primi anni del secolo scorso tale riferimento inizia a emergere dai cataloghi della Pinacoteca, all'interno della quale l'opera era entrata il 9 luglio 1813. Agli inizi del XX secolo il nome di Cantofoli doveva essere sostanzialmente sconosciuto agli studi; pertanto, è sembrato ragionevole ricondurre l'attribuzione, piuttosto che a considerazioni stilistiche, alla documentazione cartacea che accompagnava il dipinto al momento dell'acquisizione o a vecchie iscrizioni sul telaio, entrambe oggi non più reperibili.[36] Pur plausibile, tale ipotesi presenta delle difficoltà, dato che se il dipinto fosse stato effettivamente dotato di iscrizioni o accompagnato da documentazione non si vede il motivo per cui non se ne sia dato conto né nella descrizione stilata in occasione dell'acquisto né nei cataloghi e nelle guide di Brera anteriori al 1902.

Data l'assenza di prove documentarie o di dati verificabili che consentano un riferimento a Cantofoli, l'annessione della tela di Brera al catalogo della pittrice andrebbe allora motivata su base stilistica, confrontandola cioè, come tutti gli altri dipinti che si legano ad essa, con la pala eseguita per San Giacomo: la secchezza delle fisionomie dei personaggi rappresentati in quest'ultima non trova però riscontro nei volti morbidi e delicati del dipinto braidense, come anche in quelli degli altri quadri ad esso accostati nel tempo dagli studiosi. L'inadeguatezza di tali confronti spinge dunque a ricercare una soluzione alternativa, in parte adombrata da Massimo Pulini in un recente intervento in internet[37] e alla quale, grazie al dialogo con Daniele Benati, siamo pervenuti in maniera autonoma anche noi.

I volti del dipinto di Brera, come anche quelli che caratterizzano le altre opere della serie, sembrano trovare una puntuale corrispondenza nella produzione di Luigi Gentile (nato Louis Cousin e conosciuto anche come 'Luigi Primo'[38]), pittore fiammingo attivo a Roma e in alcuni centri della costa adriatica. Osservando le opere riconosciutegli dalla critica come *Venere con Adone* ora al Kunsthistorisches Museum di Vienna, la pala in San Marco Evangelista al Campidoglio o quelle eseguite per Pesaro e Peglio, nonché i dipinti attualmente in mano di privati (Fig. 2–3), non si farà fatica a ravvisare le fisionomie che si incontrano nei quadri finora attribuiti a Ginevra Cantofoli (Fig. 4–5). Alla luce delle stringenti affinità che accomunano i due gruppi,

mano del dipinto di Brera nel cosiddetto ritratto di *Beatrice Cenci* conservato presso la Galleria Nazionale d'Arte Antica di Palazzo Barberini a Roma (inv. 1944; olio su tela, 64,5 × 49 cm). Su quest'ultimo dipinto torneremo in una pubblicazione apposita. Sulla vicenda di Beatrice Cenci, di recente e con ulteriore bibliografia: Masu, *Perché io non voglio star più a questa vita*; fondamentale resta: Ricci, *Beatrice Cenci*.

36 Pulini, *Ginevra Cantofoli*, pp. 99–102, n. 16. Il telaio che sosteneva il dipinto al momento dell'acquisto è stato sostituito nel corso di un restauro risalente probabilmente agli anni cinquanta del secolo scorso: Frisoni, in *Pinacoteca di Brera. Scuola Emiliana*, p. 153, n. 66. Non siamo riusciti a risalire ai motivi per cui Sabbatini, in 'Per una storia delle donne pittrici bolognesi' p. 99, sia arrivata considerare il dipinto 'sicuramente di Cantofoli'.

37 Pulini, 'Luigi Gentile "Virtuoso del Pantheon"'.

38 Sulle varianti del nome: Passeri, *Vite de' pittori*, p. 253. Inoltre: Terlinden, 'Identification d'un portrait d'officier espagnol', pp. 33–40, in part. p. 33.

Fig. 3. Luigi Gentile, *Galatea*, Roma, Galleria Megna. Olio su tela, 52 × 70 cm.

pare insomma non così azzardato riferire al pennello di Gentile la maggior parte dei quadri che solitamente veniva assegnata alla pittrice.

Tale slittamento, sul quale ci ripromettiamo di tornare con ulteriori dettagli in altra sede, comporta delle ricadute di non poco conto nella percezione odierna di entrambi gli artisti, Ginevra Cantofoli e Luigi Gentile. Il corpus delle opere di Gentile acquisirebbe una facies diversa rispetto a quella di autore di pale d'altare e di ritratti di personaggi illustri quale siamo soliti immaginarlo. Egli si qualificherebbe anche come pittore di una serie di quadri più intimi e delicati, quelli cioè finora associati al dipinto di Brera, eseguiti per una committenza privata e non destinati a ornare gli altari di importanti chiese. Suggestivo sarebbe a questo punto ricollegare tale produzione alle notizie fornite da Giovanni Battista Passeri, che ricorda come Luigi, appassionato corteggiatore, 'per allettarle [le sue amanti] maggiormente adornava loro la casa di quadri di sua mano'. Oltre che nell'eseguire opere di formato ridotto, di cui la critica ha già raccolto varie testimonianze, troverebbe inoltre maggiore riscontro la notizia della consuetudine del pittore col genere ritrattistico, ove 'era di assai valore' e 'forse più di ogn'altro'.[39]

39 Passeri, *Vite de' pittori*, pp. 251–52. A proposito delle opere di piccolo formato: Gash e Montagu, 'Algardi, Gentile and Innocent X', pp. 55–60; Ajello, 'Il "cornigiaro" Francesco Perone e il pittore Luigi Gentile'. Per la produzione di ritratti di personaggi illustri: Petrucci, *Pittura di ritratto a Roma. Il Seicento, 2.*, pp. 309, 310, n. 1.

Fig. 4. Luigi Gentile, *Sibilla*, Cambridge, Fitzwilliam Museum. Olio su tela, 66 × 49,2 cm. © The Fitzwilliam Museum, Cambridge.

Fig. 5. Luigi Gentile, *Donna con turbante*, Cremona, Museo Civico Ala Ponzone. Olio su tela, 65,5 × 51 cm. Archivio fotografico Musei Civici Cremona.

Il catalogo di Cantofoli, d'altro canto, andrebbe da questo momento ampliato a partire dall'unica opera certamente riferibile alla sua mano, vale a dire la pala in San Giacomo. In attesa di aggiunte, ciò che riceve una conferma dallo slittamento appena operato è la volontà di Ginevra di affermarsi nel contesto artistico bolognese quale pittrice di *historia*, dal momento che, seppur solo due siano giunte fino a noi, la sua produzione si concentra ora attorno a sei importanti pale d'altare. Tale tendenza sembra accomunare anche le altre artiste convenute all'accademia di Sirani, le quali, tramite l'intercessione della maestra – o talentuosa e riconosciuta collega –, pur continuando a dipingere quadri di medio-piccolo formato, ambivano ad acquisire uno status diverso da quello che era solitamente riservato alle pittrici, ossia di artiste dedite a una produzione 'domestica'.[40]

40 Quando questo intervento era già stato presentato oralmente e scritto nella sua interezza, sono apparsi alcuni contributi ove si conviene con la nostra ipotesi di slittamento delle opere già attribuite a Cantofoli nel catalogo di Gentile ma sui quali non è possibile soffermarsi in questa sede: Borgogelli, 'Giusto Fiammingo', pp. 61–97, in part. 95 nota 65; '"Di pittura buonissima del fiammingo"', pp. 97–106, al quale si guardi, oltre a Diamantini, 'Luigi Gentile', pp. 125–39, anche per un approfondimento sull'attività di Gentile nelle Marche; Pulini, 'Luigi Gentile pittore di Innocenzo X'. Fra gli aggiornamenti intercorsi dalla presentazione dello studio alla pubblicazione degli atti, si segnala, su indicazione di Daniele Benati, un altro dipinto in cui ravvisare l'operato di Gentile: si tratta di una tela (olio, 146,3 × 120,7 cm) passata a un'asta Christie's (online auction 20554, 24 giugno-8 luglio 2022, n. 181) con attribuzione a Giovanni Stanchi ed Elisabetta Sirani.

Bibliografia

Manoscritti, fonti archivistiche

Bologna, Archivio di Stato, Notarile, notaio Lorenzo Pellegrini, prot. 8, 10 ottobre 1688, fol. 75: 'Tutela e inventario tutelare di Orsola Caterina de Fachinis fatto da Ginevra Cantofoli sua madre'

Bologna, Archivio di Stato, Notarile, *Camillo Felini*, 29 marzo 1672, filza 4, n. 22: Testamento redatto in data 29 marzo 1672 da Ginevra Cantofoli

Bologna, Archivio Generale Arcivescovile, *Parrocchie soppresse*, 42/2, 1653, c. 9r

———, *Registro battesimi*, 1658, c. 33r

Bologna, Biblioteca Comunale dell'Archiginnasio, Marcello Oretti, *Notizie de' Professori del Disegno, cioè Pittori, Scultori et Architetti bolognesi e de' forestieri (1760–1780)*, ms B 129, cc. 119–20

Fonti primarie

Castiglione, Baldassarre, *Il libro del Cortegiano*, Aldo Manuzio: Venezia, 1528 (Roma: Bulzoni, 1987)

Crespi, Luigi, *Felsina Pittrice. Vite de' pittori bolognesi* (Bologna: Marco Pagliarini, 1769)

Malvasia, Carlo Cesare, *Felsina pittrice. Vite de' pittori bolognesi*, Bologna, 1678 (Bologna: Tip. Guidi all'Ancora, 1841, II)

———, *Le pitture di Bologna*, Bologna, 1686 (: Bologna: Andrea Emiliani, Alfa, 1969)

Masini, Antonio, *Bologna perlustrata, terza impressione notabilmente accresciuta, in cui si fa mentione ogni giorno in perpetuo delle fontioni sacre, e profane di tutto l'anno […]*, Bologna, erede di Vittorio Benacci, 1666, I

Passeri, Giovanni Battista, *Vite de'pittori, scultori ed architetti che hanno lavorato in Roma, morti dal 1641 fino al 1673, di G.B.P. pittore e poeta*, Roma, 1772

Studi secondari

Ajello, Lucia, 'Il "cornigiaro" Francesco Perone e il pittore Luigi Gentile, due nomi per un quadro custodito ad Alba de Tormes', *Osservatorio per le Arti Decorative in Italia*, 15 (2017) (DOI:)10.7431/RIV15052017

Arfelli, Adriana, '"Bologna Perlustrata" di Antonio di Paolo Masini e l'"Aggiunta" del 1690', *L'Archigiannasio*, LII (1957), 188–237

Bohn, Babette, *Women Artists. Their Patrons and Their Publics in Early Modern Bologna* (University Park, PA: Penn State University Press, 2021)

Borgogelli, Tommaso, 'Giusto Fiammingo. Nuovi elementi per la sua identificazione', in *Jean Ducamps alias Giovanni del Campo*, a cura di Gianni Papi (Roma-Napoli: Editori Paparo, 2021), pp. 61–97

———, '"Di pittura buonissima del fiammingo": Luigi Gentile per Matelica', in *Accademia Raffaello, Atti e Studi XX*, 20 (2021), 97–106

Cammarota, Gian Piero, *Le origini della Pinacoteca Nazionale di Bologna. Una raccolta di fonti*, 1. *1797–1815* (Bologna: Minerva, 1997)

Degli Angeli, Anna Maria, 'Il mito della donna artista nella Bologna del Seicento', *Il Carrobbio*, 13 (1987), 119–28

Diamantini, Lucia, 'Luigi Gentile: un pittore fiammingo nelle Marche del '600', *Notizie da Palazzo Albani*, 34–35 (2005–2006 [2007]), 125–39

Pinacoteca di Brera. Scuola Emiliana (Milano: Electa, 1991)

Graziani, Irene, 'Il cenacolo di Elisabetta Sirani', in *Elisabetta Sirani 'pittrice eroina' 1638–1665*, catalogo della mostra (Bologna, 2004–2005), a cura di Jadranka Bentini e Vera Fortunati (Bologna: Compositori, 2004), pp. 119–33

Gash, John e Jennifer Montagu, 'Algardi, Gentile and Innocent X: A Rediscovered Painting and Its Frame', *The Burlington magazine*, 122 (1980), 55–60

Masu, Alessandra, *Perché io non voglio star più a questa vita. La voce di Beatrice Cenci nei documenti conservati negli archivi romani* (Roma: GB EditoriA, 2020)

Modesti, Adelina, *Elisabetta Sirani. Una virtuosa del Seicento bolognese* (Bologna: Compositori, 2004)

Petrucci, Francesco, *Pittura di ritratto a Roma. Il Seicento, 2. Biografie, schede, apparati* (Roma: Budai, 2008)

Pulini, Massimo, *Ginevra Cantofoli. La nuova nascita di una pittrice nella Bologna del Seicento* (Bologna: Compositori, 2006)

——, 'Ginevra Cantofoli', in *Le Signore dell'Arte*, catalogo della mostra (Milano, marzo-luglio 2021), a cura di Annamaria Bava, Gioia Mori, e Alain Tapié (Milano: Skira, 2021), p. 172

——, 'Luigi Gentile "Virtuoso del Pantheon" e "Principe di san Luca": novità e inediti di un grande artista europeo', *About art online*, ultima modifica 23 luglio 2020 <https:// www.aboutartonline.com/luigi-gentile-virtuoso-del-pantheon-e-principe-di-san-luca-novita-e-inediti-di-un-grande-artista-europeo-in-u-nsaggio-di-massimo-pulini/> [last access: October 2021]

——, 'Luigi Gentile pittore di Innocenzo X, un idealista al tempo di Velázquez', *About art online*, ultima modifica 22 Dicembre 2022 <https://www.aboutartonline.com/luigi-gentile-pittore-di-innocenzo-x-un-idealista-al-tempo-di-velazquez/> [last access: January 2023]

Ricci, Corrado, *Beatrice Cenci*, 2 voll. (Milano: F.lli Treves, 1923)

Sabbatini, Stefania, 'Per una storia delle donne pittrici bolognesi: Anna Maria Sirani e Ginevra Cantofoli', in *Schede Umanistiche*, 2 (1995), 85–101

Terlinden, Victoire, 'Identification d'un portrait d'officier espagnol par Louis Primo', *Bulletin des Musées Royaux des Beaux-Arts de Belgique*, XVIII.1–2 (1969), 33–40

ANTONIO IOMMELLI

Per mano della pittrice Caterina Ginnasi (1590–1660) 'piissime ac religiosissime feminae'

▼ **ABSTRACT** This chapter delves into the life of Caterina Ginnasi (1590–1660), a painter and niece of Cardinal Domenico Ginnasi, who chose to dedicate herself to art and a contemplative lifestyle rather than marry. As documented by her biographer, Caterina was trained in the arts by Gaspare Celio and Giovanni Lanfranco, who created the ceiling frescoes of Palazzo Ginnasi in Rome. During this time, she established a wide cultural network and formed close relationships with men of culture, such as architect Orazio Torriani and sculptor Giuliano Finelli. She further pursued her interests in music, painting frescoes, and managed her estate independently. Caterina did not passively accept the choices made by the men in her family, but rather asserted herself as an independent woman.

'[Mai] Si è veduta una dama nata in Roma fiorire in un esercizio così difficoltoso, qual è la pittura'.[1] Così, con queste parole, Giambattista Passeri introduceva ai suoi lettori l'unico cameo da lui scritto in memoria di una donna incluso nella sua celebre raccolta dedicata agli artisti romani della metà del Seicento. Riguardava Caterina Ginnasi, pittrice nata a Roma nel 1590, discendente da una nobile famiglia di origini romagnole.[2] Come è noto, la donna, figlia di Dionisio e Faustina Gottardi, rifiutate le nozze, decise di dedicarsi alla pittura lasciando da parte ogni 'lavoro donnesco per non distogliersi da questo bell'esercizio'.[3] 'L'aco e il fuso', infatti, sarebbero stati per lei 'mortali nemici del toccalapis e del pennello', frase finta dallo scrittore sulla bocca della ragazza.[4]

1 Passeri, *Vite de' pittori*, p. 306.
2 Su Caterina vedi Melasecchi, *Dizionario Biografico degli Italiani* (d'ora in poi *DBI*), con bibl. prec. Per le notizie sulla famiglia Ginnasi vedi Grandi, *Il Cardinale Ginnasi*, pp. 9–11.
3 Passeri, *Vite de' pittori*, p. 306. Gigli, *Diario romano*, p. 296.
4 Passeri, *Vite de' pittori*, p. 306.

Women in Arts, Architecture and Literature: Heritage, Legacy and Digital Perspectives, ed. by Consuelo Lollobrigida and Adelina Modesti, Women in the Arts: New Horizons, 1 (Turnhout: Brepols, 2023), pp. 259–272

Ad accorgersi di questa sua naturale inclinazione fu lo zio, il cardinale Domenico Ginnasi, che affidò la ragazza al pittore Gaspare Celio, un artista poliedrico esperto di matematica e di architettura.[5] Il loro primo incontro dovette avvenire intorno al 1623 quando, grazie ai buoni uffici del porporato, Gaspare ottenne di lavorare nella cappella del Battesimo in San Pietro in Vaticano, accettando di buon grado la proposta del suo nuovo protettore.[6] Grazie a lui, dunque, Caterina avanzò nella pratica del disegno; non si sa, però, per quale ragione, sul finire degli anni Venti, tale rapporto si interruppe. Secondo Passeri, la causa fu l'improvvisa morte del pittore che costrinse il cardinale a trovare per sua nipote un nuovo mentore, dispiaciuto all'idea di non farla proseguire nell''incominciato esercizio',[7] notizia rivelatasi però falsa in quanto Celio morì nel 1640, un anno dopo rispetto al porporato.[8]

Ben altre, quindi, furono le ragioni di tale rottura, non da ultime le ambizioni di Gaspare, speranzoso di ottenere l'incarico di dipingere un'ala di palazzo Ginnasi alle Botteghe Oscure, commissione di fatto affidata a Giovanni Lanfranco nel 1629.[9] Quest'ultimo, infatti, proveniente da Parma, aveva da poco concluso l'affresco della *Navicella* in Vaticano, quando attirò le attenzioni del cardinale romagnolo, realizzando per lui la celebre *Pentecoste*.[10] Non è certo, ma verosimilmente fu proprio questo incarico a far tramontare la buona stella del maestro romano, spingendolo di conseguenza a rompere il sodalizio con la famiglia Ginnasi.

Caterina e Torriani

Stando alle parole del suo biografo, chiusa la parentesi 'Celio', Caterina passò sotto la guida di Lanfranco.[11] Tuttavia, dati gli impegni dell'artista parmense all'inizio degli anni Trenta, è probabile che per un breve periodo Domenico affidasse sua nipote all'architetto Orazio Torriani, quest'ultimo incaricato tra il 1629–1630 di ricostruire e inglobare all'interno di palazzo Ginnasi l'antica chiesa di Santa Lucia.[12] A suggerire tale ipotesi le parole di Giovanni Antonio Bruzio.[13] Nel suo *Theatrum Romanae Urbis*, infatti, lo scrittore allude a un'attiva partecipazione di Caterina al cantiere del bracciarese, circostanza di fatto comprovata dall'effettiva conoscenza da parte della pittrice di alcuni disegni dell'anziano architetto, uno dei quali citato nella realizzazione dell'altare maggiore della cappella dei SS. Protettori di Velletri innalzata dai Ginnasi, dove il motivo dell'edicola sembra richiamare un disegno di Torriani per la chiesetta romana.[14]

5 Gandolfi, *Le vite degli artisti*, p. 19.

6 Gandolfi, *Le vite degli artisti*, p. 19.

7 Passeri, *Vite de' pittori*, p. 307.

8 Gandolfi, *Le vite degli artisti*, p. 8. Sul cardinale Ginnasi, vedi Mezamici, *Notizie historiche*; Brunelli, *DBI*.

9 Schleier, *DBI*.

10 Schleier, *DBI*. Per la *Pentecoste* vedi Bernardini, *Giovanni Lanfranco*, pp. 69–71.

11 Passeri, *Vite de' pittori*, p. 307.

12 Marchionne Gunter, 'Cappella di Palazzo Ginnasi', pp. 18–21; Sturm, *L'architettura dei Carmelitani*, pp. 147–51.

13 Brizio, *Theatrum Romanae Urbis*, c. 245ᵛ.

14 Vedi nota 39.

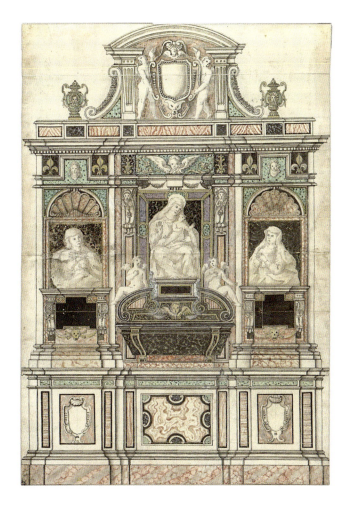

Fig. 1. Orazio Torriani, *Progetto per la tomba di Caterina Ginnasi e Faustina Gottardi*, Berlino, Staatliche Museen, Kunstbibliothek, 1646 ca. (crediti fotografici: Staatliche Museen zu Berlin Kunstbibliothek).

Questo loro sodalizio dovette durare negli anni; a confermarlo un singolare progetto, mai realizzato, ideato dal braccianese per la doppia tomba di Caterina e Faustina Gottardi (Fig. 1).[15]

Caterina e Lanfranco

Il primo incontro tra Caterina e Lanfranco avvenne intorno al 1629 quando quest'ultimo, assoldato per eseguire la *Pentecoste*, accettò la proposta dello zio cardinale - in quel momento decano del collegio cardinalizio - di seguire la donna. Tuttavia, la sua

15 Jacob, *Italienische Zeichnungen*, p. 69.

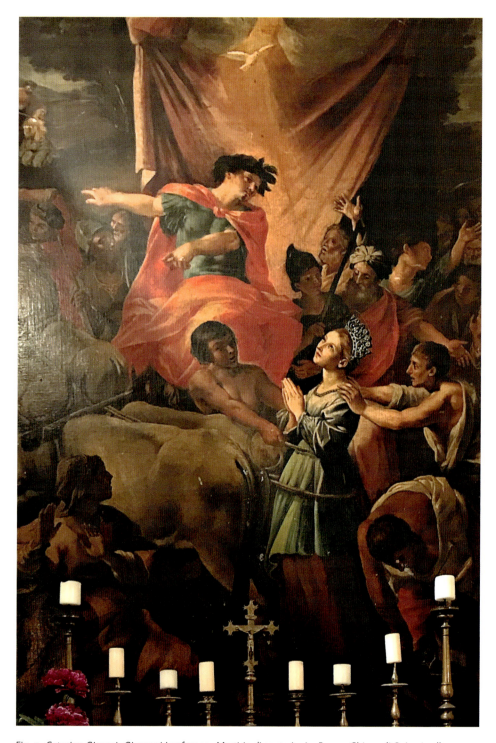

Fig. 2. Caterina Ginnasi, Giovanni Lanfranco, *Martirio di santa Lucia*, Roma, Chiesa di S. Lucia alle Botteghe Oscure, 1633. Foto autore.

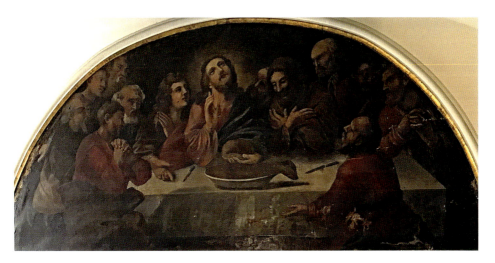

Fig. 3. Caterina Ginnasi, *Ultima cena*, Roma, Chiesa di S. Lucia alle Botteghe Oscure, 1633 ca. Foto autore.

nomina a Principe dell'Accademia di San Luca, giuntagli nel gennaio 1631 e rinnovata per un altro anno nel 1632, dovette tenerlo alquanto occupato da distoglierlo da tale impegno.[16] Fu solo quindi a partire dal 1633 che effettivamente Lanfranco affiancò Caterina, aiutandola nella realizzazione del *Martirio di santa Lucia* (Fig. 2) eseguito per l'altare maggiore della chiesetta alle Botteghe Oscure.[17]

Così Passeri descrisse la pala: 'ha espressa la santa ferma in atto orante, li manigoldi affaticati a sollecitare li giovenchi, ed uno prende una conca di acqua per bagnarla acciocchè si muova, e il Tiranno assiso su un trono assistito dalle guardie in atto di comando'.[18] Tuttavia, a ben guardare l'opera – firmata e datata dalla pittrice – molte figure sembrano di mano del parmense, come il giudice, il vecchio con il turbante, l'esile figura della martire siracusana e quella della donna in primo piano.[19] Risultano invece di mano di Caterina la scenetta con la decapitazione della santa e il resto dei personaggi la cui resa, stanca nel disegno e fiacca nel colore, risulta bloccata tra i modelli di Celio e i modi del Lanfranco.[20]

Che tra questi due pittori vi fosse un certo divario stilistico ne era sicuramente a conoscenza il vecchio cardinale, preferendo di fatto al Celio la tempra di Lanfranco, cui non a caso affidò i lavori nel proprio palazzo nonostante in quegli anni stesse artisticamente proteggendo il suo rivale. Quanto questa decisione incise negativamente sulla carriera di Celio è difficile stabilirlo; di certo, però, gravò su Caterina – all'epoca poco più che quarantenne – costretta di punto in bianco a cambiare maestro, una 'mutazione' per lei dannosa come tradisce in particolare l'*Ultima cena* (Fig. 3), una

16 Melasecchi, *DBI*.
17 Passeri, *Vite de' pittori*, p. 307; Titi, *Descrizione delle pitture*, p. 154.
18 Passeri, *Vite de' pittori*, p. 307.
19 Schleier, 'Charles Mellin', pp. 837–44.
20 Passeri, *Vite de' pittori*, p. 307.

Fig. 4. Caterina Ginnasi, *San Biagio vescovo*, opera dispersa (già Roma, Chiesa di S. Lucia alle Botteghe Oscure, 1633 ca). Tratta da Francesco Saverio Parisi, 'Chiese di Roma che scompaiono', p. 202.

tela destinata ad ornare la chiesetta romana di Santa Lucia assieme a una *Madonna* e a un ovato con *San Biagio vescovo* (Fig. 4).[21] Quest'opera, infatti, sebbene eseguita sotto l'attento sguardo di Lanfranco, manca di quella forza e ricchezza cromatica tipiche del parmense, risultando di fatto una copia di debole respiro di un noto dipinto lanfranchiano (Dublino, National Gallery of Ireland) che presenta quindi tutte le debolezze della pittrice.[22]

21 Passeri, *Vite de' pittori*, p. 307. Vedi inoltre Trinchieri Camiz, 'Nuns as Artists', p. 283 n. 96.
22 Schleier, 'Lanfrancos', p. 12.

Tra Roma e Velletri

Stranamente Passeri non accenna ai lavori avviati nel 1632 nella cattedrale di Velletri, dove Caterina abbellì con tele e affreschi la cappella dei SS. Protettori, voluta dallo zio Domenico e da questi affidata alla Confraternita del Suffragio.[23]

Secondo alcune descrizioni, tale sacello era rivestito con decorazioni in stucco, ornato da tele e pitture parietali 'undique sculptum et decoratum per manus Illustrissimae Dominae Catherinae Ginnasiae'.[24] Sull'altare le fonti ricordano la *Madonna con quattro santi protettori* e, ai suoi lati, due dipinti con i santi Eleuterio e Ponziano.[25] Non si conosce, invece, il soggetto degli affreschi della cupola – forse una Gloria di angeli – ai cui angoli erano raffigurati i *Quattro evangelisti*.[26]

Un'ulteriore descrizione della cappella compare in un testo di Alessandro Borgia dato alle stampe nel 1723.[27] Secondo l'autore, oltre a queste tele, si vedevano molte altre pitture aventi ad oggetto le storie di san Geraldo e 'tutti i Santi della famiglia Ottavia, e Anicia'.[28] Come è facile immaginare, tale sacello dovette dunque essere concepito come un vero e proprio pantheon di tutti i patroni della cittadina veliterna, ai quali si aggiungevano Biagio – titolare di un antico beneficio eretto precedentemente nella cappella – e Agostino di Ippona, protettore della diocesi di Ostia, unita fin dall'XI secolo a quella di Velletri.[29]

Purtroppo, nel 1824 tutte queste tele furono rimosse e la cappella interamente ridecorata da Aurelio Mariani.[30] In tale circostanza, le opere della Ginnasi andarono irrimediabilmente perdute, migrate certamente da una cappella all'altra prima di far perdere definitivamente ogni loro traccia.

Attualmente presso il locale museo diocesano sono esposti vari materiali provenienti della vecchia basilica. Tra i dipinti emerge una tela raffigurante i *Santi Biagio e Agostino* (Fig. 5) di cui nulla si sa sulla committenza e sul suo autore.[31] A giudicare dalle dimensioni, si tratta certamente di una pala d'altare, proveniente con tutta probabilità da una delle cappelle dell'antica cattedrale, spostata per un cambio di dedicazione e mai più tornata *in loco*. Da un'analisi stilistica si può ricondurla a un pittore di ambito romano della metà del XVII secolo, bloccato a metà strada tra gli echi tardomanieristi – evidenti nella resa dell'angelo al centro della scena – e le intonazioni di ascendenza emiliana, qui fortemente guercinesche e lanfranchiane. I vari accenti che connotano le figure, arginate alle spalle da una quinta classicheggiante, paiono

23 Cogotti, *La Cattedrale di San Clemente*, p. 114.

24 Cogotti, *La Cattedrale di San Clemente*, p. 333.

25 Stefano Borgia lesse il nome della pittrice sui due dipinti raffiguranti *Sant'Eleuterio* e *San Ponziano* (Borgia, *Istoria della Chiesa*, p. 488; Russo, 'Figure minori', p. 458; Trinchieri Camiz, 'Nuns as Artists', p. 283 n. 99).

26 Trinchieri Camiz, 'Nuns as Artists', p. 283 n. 99.

27 Borgia, *Istoria della Chiesa*.

28 Borgia, *Istoria della Chiesa*, p. 489.

29 Cogotti, *La Cattedrale di San Clemente*, p. 115. Sulla diocesi di Ostia e Velletri vedi Negro, in Sansone, *Museo Diocesano*, p. 11.

30 Cogotti, *La Cattedrale di San Clemente*, p. 115; Bruno, *Aurelio Mariani*, pp. 137–45.

31 Sansone, *Museo Diocesano*, pp. 107–09.

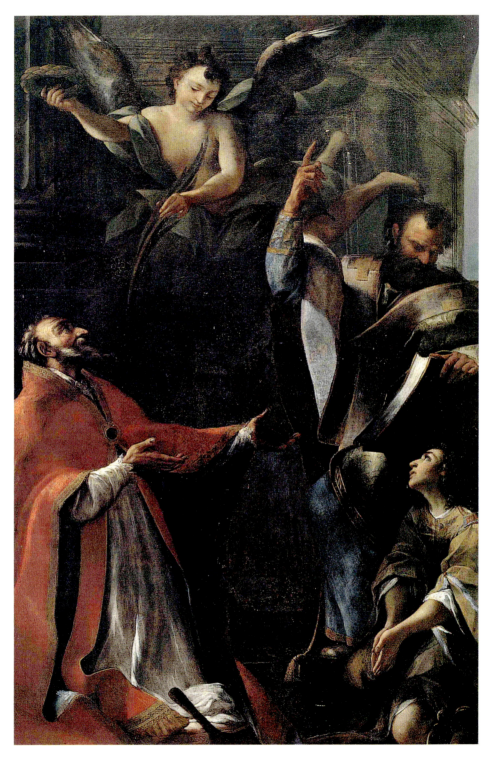

Fig. 5. Caterina Ginnasi (?), *Santi Biagio e Agostino*, Velletri, Museo Diocesano. Riproduzione con permesso

restituirle a più mani, realizzate invece da un medesimo autore, il cui stile fa fatica ad emergere nascosto dietro ai modelli da lui copiati.

Si potrebbe, forse, azzardare un'ipotesi. La commistione di uno stile antico-moderno, il soggetto e la provenienza della tela dalla vecchia cattedrale sembrano infatti suggerire una pista in direzione della pittrice romana, attiva per la comunità veliterna fino al 1660. Se così fosse, l'opera rappresenterebbe una testimonianza di un momento artistico fondamentale della carriera di Caterina, vissuto poco dopo quel 1656, quando un fulmine si abbatté sul campanile della chiesa, provocandone il crollo e la distruzione di una parte dell'edificio.[32] In quel frangente si sa, infatti, che la donna si adoperò attivamente per il ripristino della chiesa, promuovendo tra le altre cose il restauro di un preziosissimo organo, fatto ricollocare dalla stessa sulla porta della navata centrale.[33] Che in questo frangente la pittrice decidesse di eseguire un nuovo dipinto raffigurante due dei santi venerati dalla comunità locale non è impossibile da immaginare; un'ipotesi che, però, in mancanza di documenti e in assenza di opere coeve con cui fare un giusto confronto, resta soltanto un'affascinante supposizione. Ciò che è certo è che nel 1656, all'epoca di questi fatti, la pittrice era entrata già a far parte della nota accademia romana di San Luca, sinonimo di un'evidente maturazione avvenuta nel corso degli anni Trenta e Quaranta che artisticamente dovettero condurla lontana da quelle modeste esperienze vissute sotto la guida del Celio e del Lanfranco, di cui però artisticamente non si hanno tracce.[34]

I Ginnasi e Velletri

Negli anni Trenta, Velletri fu animata da un forte rinnovamento artistico e spirituale, cui Caterina dette un grosso contributo, dedicandosi alla confraternita di Santa Maria del Suffragio e ripristinando l'antico Monte di Pietà.[35] Nel 1633, per interessamento dello zio, giunse da Roma un dipinto di Gentile da Fabriano, conservato fino ad allora nella antica chiesa dei SS. Cosma e Damiano al Foro Romano rinnovata nel 1632 per volontà di Urbano VIII.[36] L'autore di tale rifacimento fu Luigi Arrigucci che per l'occasione si avvalse di un progetto di Torriani che, come è noto, dal 1629 stava lavorando per i Ginnasi non mancando in quegli anni di far sentire la propria voce: nel 1632, infatti, un suo disegno fu utilizzato per la costruzione dell'altare della cappella veliterna, mentre nel 1639 fornì un bozzetto per il monumento del cardinale Domenico.[37] Un suo progetto, mai realizzato, fu inoltre richiesto per la tomba di Caterina, testimonianza di un sodalizio mai tramontato con la famiglia romagnola.[38]

32 Cogotti, *La Cattedrale di San Clemente*, p. 118.

33 Velletri, Biblioteca Comunale, MS VII 17, fol. 167.

34 Melasecchi, *DBI*.

35 Russo, 'Figure minori', p. 464.

36 Theuli, *Teatro Historico*, p. 344. Vedi inoltre Russo, in Sansone, *Museo Diocesano*, pp. 71–74 (con bibl. prec.).

37 Dal Mas, 'Il reimpiego nell'architettura', pp. 420–24. Sturm, p. 150. Il progetto per il portale della chiesa si conserva a Berlino, Kunstbibliothek, Hdz 1113.

38 Vedi nota 15.

Nel 1637, sempre grazie ai Ginnasi, lo stampatore Lodovico Grignani impiantava in città la prima tipografia, iniziativa facilitata dai buoni rapporti intercorsi tra lui e il cardinale Domenico, per il quale un anno prima aveva stampato le *Enarrationes in omnes psalmos David*.[39] A riprova di questo legame, giunto a Velletri, il tipografo dette alle stampe il *Funerale del sig[nor] capitan Sisto Gregna*, un opuscolo pubblicato per la morte di Francesco Ginnasi, parente di Domenico e Caterina, già governatore della cittadina veliterna.[40]

È risaputo, infine, che per interessamento del cardinale, arrivò in città il busto di san Clemente, opera attribuita dalla critica allo scultore Giuliano Finelli, autore intorno al 1630 del *Ritratto di Domenico Ginnasi* (Roma, Galleria Borghese).[41] Grazie a un nuovo documento, datato 27 aprile 1636, si può ora ulteriormente restringere la forbice temporale ipotizzata dagli studi circa la sua esecuzione: l'opera, infatti, fu realizzata entro il 1636, anno in cui il simulacro risulta già presente nella cappella dei SS. Protettori insieme alle statue dei santi Ponziano ed Eleuterio.[42] È probabile che dietro tale incarico vi fosse proprio Caterina, rimasta in contatto con lo scultore carrarese anche dopo la morte dello zio avvenuta nel 1639; come è noto, infatti, fu lei a richiedere al Finelli il ritratto per il monumento funebre del cardinale, speditole poco dopo da Napoli, dove il carrarese aveva sposato la figlia di Lanfranco.[43] L'opera, pervenuta nella chiesetta alle Botteghe Oscure, fu infine collocata nel 1646 di fronte al monumento di Faustina Gottardi di Iacopo Antonio e Cosimo Fancelli,[44] quest'ultimo probabile autore di un busto in marmo raffigurante la pittrice (Londra, Victoria and Albert Museum, inv. 7330–1861) descritto nel 1660 tra i beni della donna.[45]

Caterina e la musica

Oltre alla pittura e alla scultura, un'altra passione coltivata in casa Ginnasi fu la musica, come suggeriscono i diversi cembali elencati negli inventari del cardinale e di sua nipote, entrambi dedicatari di due opere – la *Bella Clori* e le *Rime sacre* – composte dal musicista romano Giovanni Francesco Anerio e rappresentate con

39 Russo, 'Figure minori', pp. 454, 455 n. 4; Casetti Brach, Di Cesare, *DBI*.

40 Su Francesco Ginnasi vedi Ginnasi, *Storia della famiglia*, p. 31.

41 Per entrambe le opere vedi Dombrowski, in Sansone, *Museo Diocesano*, pp. 47–51 (con bibl. prec.). Sul busto vedi anche Cantalamessa, 'Una scultura ignota', pp. 81–88; Ciarlo, in Hagge, *Giuliano Finelli*, pp. 343–44 (con bibl. prec.).

42 Velletri, Archivio Vescovile, Sez. I, Tit. I, Vis. Pas. 2, 1636, c. 37. Sul busto e la sua esecuzione tra il 1635–1639 vedi Dombrowski, *Giuliano Finelli*, pp. 64–66, 106–12, 316–17; Dombrowski, 'Addenda', p. 826; Ciarlo (in Hagge, C.25) propone correttamente come datazione 1632–1634.

43 Passeri, *Vite de' pittori*, p. 267. Probabilmente l'incontro tra Caterina e Finelli risale al 1627 quando suo zio, prefetto della congregazione della Fabbrica di San Pietro, controllò la fornitura di bronzo per il baldacchino di Gian Lorenzo Bernini, entrando in contatto con Finelli. Nel 1629–1630, infatti, già posava per lui per il busto oggi alla Galleria Borghese (Faldi, *Galleria Borghese*, p. 10 cat. 2).

44 De Lotto, *DBI*.

45 'Testa di marmo di s[uor] Caterina sopra uno scabellone di noce' (Roma, Archivio di Stato (d'ora in poi AS), Trenta Notai Capitolini, uff. 28, vol. 277, c. 360v). Sul busto attribuito a Cosimo Fancelli vedi Pope-Hennessy, *Catalogue of Italian Sculpture*, II, p. 649 fig. 645; Martinelli, 'Novità Berniniane', p. 32.

buona probabilità nel palazzo alle Botteghe Oscure, in quell'ambiente descritto nei documenti come 'stanza dell'organo'.[46]

Anerio godette certamente delle simpatie dei Ginnasi: nominato da Domenico suo maestro di cappella, fu apprezzato soprattutto da Caterina che nel 1649 convinse Grignani a ristampare una sua composizione – la *Missa pro defunctis* – già pubblicata nel 1614.[47] Il motivo di tale ammirazione è forse da ricercarsi nel sodalizio stretto dal romano con i padri di san Filippo Neri, quest'ultimo già confessore di Alessandro Pallantieri, zio di Domenico Ginnasi.[48] Di certo, al di là di questo legame, il compositore seppe come farsi apprezzare dai suoi generosi protettori: nel 1620, infatti, compose le *Rime sacre*, un inno dedicato a Caterina Ginnasi e alle sue sante eponime: Caterina d'Alessandria e Caterina da Siena.[49]

La passione dei Ginnasi per la musica è inoltre testimoniata da Bonaventura Theuli nel suo *Theatro historico*: in aggiunta al busto di san Clemente e a una lampada d'argento per la cattedrale veliterna, lo scrittore cita l''ornamento di un organo', forse lo stesso messo in vendita nel 1639 in seguito alla morte del cardinale, riscattato poco dopo dalla pittrice insieme a un cembalo.[50]

Gli ultimi anni

Nel 1638 Caterina fu accettata tra gli artisti dell'Accademia di San Luca, un importante riconoscimento ottenuto dalla donna dopo aver raggiunto una certa maturità artistica, come conferma la commissione di un perduto *Angelo custode*, eseguito nel 1637–1638 per l'Arciconfraternita degli Angeli Custodi di Roma.[51]

Un anno dopo, il 12 marzo 1639, suo zio morì.[52] Tra i beni elencati alla sua morte, solo quattro risultano i quadri segnati come 'di mano di Caterina', tra cui una 'Santa Catarina della Rosa in piedi', forse una copia di un dipinto eseguito dalla pittrice per l'omonima chiesa romana.[53]

Al nucleo di opere finora individuate dagli studi, tra cui una *Natività* e la *Pietà* fatte per il cardinale Carlo Emanuele Pio di Savoia, quest'ultimo subentrato a Domenico nella diocesi veliterna, si segnala un'inedita *Sibilla*, elencata nell'inventario *post*

46 La passione di Caterina per la scultura e la musica è testimoniata dai numerosi rilievi di marmo e cembali dipinti citati nel suo inventario (Roma, AS, Trenta Notai Capitolini, uff. 28, vol. 277, cc. 335ʳ–369ᵛ). Sull'Anerio e le due opere dedicate ai Ginnasi vedi Pannella, *DBI*. Roma, AS, Trenta Notai Capitolini, uff. 28, vol. 277, c. 360ᵛ.

47 Casetti Brach, Di Cesare, *DBI*.

48 Pannella, *DBI*. Su Alessandro Pallantieri vedi Del Re, *Monsignor governatore*, p. 88; Feci, *DBI*.

49 Anerio, *Rime sacre*, p. i; Franchi, *Annali della stampa musicale*, pp. 328–30, 371–73.

50 Theuli, *Theatro Historico*, p. 156. Sulla vendita dell'organo vedi Roma, AS, Trenta Notai Capitolini, uff. 28, vol. 191, cc. 460ʳ, 461ʳ.

51 Melasecchi, *DBI*. Vedi inoltre Trinchieri Camiz, 'Nuns as Artists', p. 283 n. 91. Per un parere diverso Russo, p. 460.

52 Grandi, *Il Cardinale Ginnasi*, p. 50; Brunelli, *DBI*.

53 Gli altri dipinti raffiguravano l'*Assunzione della Vergine*, *San Michele Arcangelo* e una *Madonna con i quattro santi protettori*, quest'ultimo una copia della pala di Velletri (Trinchieri Camiz, 'Nuns as Artists', p. 160).

mortem di Caterina, passata in data imprecisata tra i beni di Nicola Martetti.[54] Dovette forse trattarsi di un ritratto della nobile pittrice, raffiguratasi verosimilmente come *Allegoria della pittura*, analogamente a quanto fatto da altre sue colleghe.[55]

Il 30 novembre 1660, Caterina morì. Come disposto nel suo testamento, fu sotterrata ai piedi dei due monumenti della madre e dello zio, sepolta sotto una semplice lapide di pietra.[56] A tramandarci la sua immagine restano soltanto un pallido ritratto su tela e una sofisticata testa di marmo che ritrae la pittrice muta, senza anima né espressione, nulla di quanto di più distante 'la Signora' desiderasse esprimere con l'arte e con la musica.[57]

54 Sul *Ritratto del cardinale Ginnasi* (già Carrara, coll. Del Medico), attribuzione qui non condivisa, vedi Cantalamessa, pp. 81–88. Sui ritratti del cardinale Ginnasi e Girolamo Pallantieri (Roma, coll. Ginnasi) vedi Petrucci, *Pittura di ritratto*, II, p. 258. Sulle tele lasciate in eredità ad amici e conoscenti vedi Trinchieri Camiz, 'Nuns as Artists', p. 282. Sulla *Sibilla* (Roma, AS, Trenta Notai Capitolini, uff. 28, vol. 277, c. 358ᵛ; Roma, AS, Antichità e Belle Arti, Camerale II, busta VII, fasc. 200, fol. 101).

55 I documenti parlano di 'Testa di Sibilla' e 'Sibilla in ritratto di Ginnasi'.

56 Trinchieri Camiz, 'Nuns as Artists', p. 282. Per l'epigrafe composta in suo onore vedi Passeri, *Vite de' pittori*, p. 309.

57 Vedi nota 48. Passeri, *Vite de' pittori*, p. 307.

Bibliografia

Manuscript

Bruzio, Giovanni Antonio, *Thetrum Romanae Urbis*, Città del Vaticano, Biblioteca Apostolica Vaticana, Ms Vat. Lat. 11884

Secondary Studies

Anerio, Giovanni Francesco, *Rime sacre concertate a doi, tre et quattro voci* (Roma: Giovanni Battista Robletti, 1620)

Bernardini, Maria Grazia e Eric Schleier, *Giovanni Lanfranco. Un pittore barocco tra Parma, Roma e Napoli* (Milano: Electa, 2021)

Borgia, Alessandro, *Istoria della Chiesa, e Città di Velletri* (Nocera: Antonio Mariotti, 1723)

Brunelli, Giampiero, 'Ginnasi, Domenico', *Dizionario Biografico degli Italiani, Dizionario Biografico degli Italiani* (Roma: Istituto dell'Enciclopedia Italiana, 45, 2001), ad vocem

Bruno, Sara, a cura di, *Aurelio Mariani (1863–1939). Sacro, contemporaneo e alla bella maniera* (Velletri [s.e.], 2014)

Cantalamessa, Giulio, 'Una scultura ignota del Bernini', *Bollettino d'arte*, 5 (1911), 81–88

Casetti Brach, Carla e Maria Carmela Di Cesare, 'Grignani, Lodovico', *Dizionario Biografico degli Italiani* (Roma: Istituto dell'Enciclopedia Italiana, 59, 2002), ad vocem

Cogotti, Marina, a cura di, *La Cattedrale di San Clemente a Velletri* (Roma: Gangemi, 2006)

Dal Mas, Roberta M., 'Il reimpiego nell'architettura tra Cinquecento e Seicento. La basilica dei SS. Cosma e Damiano', in *Il reimpiego in architettura*, a cura di Jean François Bernard e Philippe Bernardi (Roma: École française de Roma, 2008), pp. 419–30

De Lotto, Maria Teresa, 'Fancelli, Iacopo Antonio', *Dizionario Biografico degli Italiani* (Roma: Istituto dell'Enciclopedia Italiana, 44, 1994), ad vocem

Del Re, Niccolò, *Monsignor governatore di Roma* (Roma: Istituto Nazionale di Studi Romani, 1972)

Dombrowski, Damian, 'Addenda to the work of Giuliano Finelli', *Burlington Magazine*, 140 (1998), 824–28

———, *Giuliano Finelli (1601–1653). Bildhauer zwischen Neapel und Rom* (Frankfurt am Main: Lang, 1997)

Faldi, Italo, *Galleria Borghese: le sculture dal secolo XVI al XIX* (Roma: Libreria dello Stato, 1954)

Feci, Simona, 'Pallantieri, Alessandro', *Dizionario Biografico degli Italiani* (Roma: Istituto dell'Enciclopedia Italiana, 80, 2014), ad vocem

Franchi, Saverio, *Annali della stampa musicale romana dei secoli XVI–XVIII* (Roma: Ibimus, 2006)

Gandolfi, Riccardo, *Le vite degli artisti di Gaspare Celio. 'Compendio delle Vite di Vasari con alcune altre aggiunte'* (Firenze: Leo S. Olschki, 2021)

Ginnasi, Francesco, *Storia della famiglia Ginnasi* (Imola: Galeati, 1931)

Gigli, Girolamo, *Diario romano (1608–1670)* (Roma: Tumminelli, 1958)

Grandi, Paolo, *Il Cardinale Domenico Ginnasi. Una vita di esempio e di carità* (Faenza: Arti Grafiche, 1997)

Jacob, Sabine, *Italienische Zeichnungen der Kunstbibliothec Berlin: Architektur und Dekoration 16. bis 18. Jahrhundert* (Berlin [s.e.], 1975)

Lollobrigida, Consuelo, *Donne Artiste nella Roma Barocca: Plautilla Bricci, Maddalena Corvina, Caterina Ginnasi, Tesi di Dottorato* (Roma: Sapienza Università di Roma, XX ciclo, a.a, 2007/2008)

Marchionne Gunter, Alfredo, 'Cappella di palazzo Ginnasi – Cappella dell'Immacolata nell'istituto Maestre Pie "Filippini"', *Roma sacra: guida alle chiese della Città Eterna. Soprintendenza per i beni artistici e storici di Roma*, 4 (1998), 17–21

Melasecchi, Olga, 'Ginnasi, Caterina', *Dizionario Biografico degli Italiani* (Roma: Istituto dell'Enciclopedia Italiana, 55, 2001), ad vocem

Mezamici, Cesare, *Notizie historiche delle operationi più singolari del sig. Cardinale Domenico Ginnasio decano del Sacro Collegio* (Roma: Ignazio de Lazari, 1682)

Pannella, Liliana, 'Anerio, Giovanni Francesco', *Dizionario Biografico degli Italiani* (Roma: Istituto dell'Enciclopedia Italiana, 3, 1961), ad vocem

Parisi, Francesco Saverio, 'Chiese di Roma che scompaiono: S. Lucia de' Ginnasi', *L'illustrazione vaticana*, 8 (1937), 202–03

Passeri, Giambattista, *Vite de' pittori, scultori ed architetti che hanno lavorato in Roma* (Roma: Natale Barbiellini, 1772)

Petrucci, Francesco, *Pittura di ritratto a Roma, III, Repertorio* (Roma: Budai, 2008)

Pope Hennessy, J. Wyndham e W. Ronald Lightbown, *Catalogue of Italian sculpture in the Victoria and Albert Museum*, 3 voll. (London: Stationery Office, 1964)

Ricci, Maurizio, 'Ottaviano Mascarino e l'architettura del primo Cinquecento. Note su un disegno inedito per palazzo Ginnasi a Roma', *ArcHistoR*, 8 (2021), 32–51

Russo, Maria Teresa, 'Figure minori del Seicento romano: Caterina Ginnasi', *Strenna dei Romanisti*, 52 (1991), 451–68

Sansone, Renata, a cura di, *Museo Diocesano di Velletri* (Milano: Skira, 2000)

Santa Maria, Paola, 'Finelli, Giuliano', *Dizionario Biografico degli Italiani* (Roma: Istituto dell'Enciclopedia Italiana, 48, 1997), ad vocem

Schleier, Eric, 'Charles Mellin and the marchese Muti', *The Burlington Magazine*, 118 (1976), 837–44

——, 'Lanfranco, Giovanni', *Dizionario Biografico degli Italiani* (Roma: Istituto dell'Enciclopedia Italiana, 63, 2004), ad vocem

——, 'Lanfrancos "Elias und der Engel" und der Bilderzzyclus der Sakramentskapelle von San Paolo fuori le mura in Rom', *The Rijksmuseum bullettin*, 18 (1970), 3–33

Sturm, Saverio, *L'architettura dei Carmelitani in età barocca. La 'Provincia Romana'. Lazio, Umbria e Marche (1597–1705)* (Roma: Gangemi, 2015)

Theuli, Bonaventura, *Theatro Historico di Velletri* (Velletri: Alfonso dell'Isola, 1644)

Tersenghi, Augusto, 'Il Monte di Pietà di Velletri', *Archivio della Società romana di storia patria*, 41 (1919), 263–68

Titi, Filippo, *Descrizione delle pitture, sculture e architetture esposte al pubblico in Roma* (Roma: Marco Pagliarini, 1763)

Trinchieri Camiz, Franca, '"Virgo-non sterilis…": Nuns as Artists in Seventeenth Century Rome', in *Picturing Women on Renaissance and Baroque Italy*, a cura di Geraldine A. Johnson e Sara F. Matthews Grieco (Cambridge: Cambridge University Press, 1997), pp. 139–64

NADETTE XUEREB

Suor Maria de Dominici (1645–1703)[*]

The First Known Female Artist in the Maltese Islands

▼ **ABSTRACT** Born in 1645 into a family of artists, Suor Maria de Dominici trained with Preti throughout her teenage years, emerging as a talented even though not brilliant painter, who lived and worked in Malta and Rome. This contribution engages with the first known relevant Maltese female artist, who was a painter, sculptor and tertiary nun who lived during the seventeenth century. It aims to separate myth from reality and to place her within the context of art historical studies.

Suor Maria De Dominici (1645–1703): Between Myth And Reality

The status of Suor Maria de Dominici as Malta's best-known female artist of the Baroque has been celebrated from the eighteenth century. She lived and worked as a painter and sculptor in Malta and in Rome, and stands out as a tertiary nun and the best-known female artist in the Maltese Islands.[1] Her prominence also emerges in the fact that she trained and worked in the *bottega* of Mattia Preti,[2] and that contrary to most women in art history, she has a positive *fortuna critica*. Yet, most that has been written about her was largely based on romanticised fabrications.

Over the years, the identification of her works of art has situated her more appropriately within the context of Baroque painting.[3] Attached to the stylistic manner of Mattia Preti (1613–1699), she is survived by six paintings, one mutilated statue in Malta, and unfortunately no works in Rome.[4]

Maria de Dominici was born in Vittoriosa on 6 December 1645, into a family of artists: her father, Onofrio (*c.* 1622–1698), came from the de Dominici family,

[*] This paper is based on the research done by the author for her B.A. in History of Art (Honours) thesis at the University of Malta in 2017, under the supervision of Professor Keith Sciberras, and research and publications which followed. Acknowledgements: Professor Keith Sciberras, Mr Joe P. Borg.

[1] Xuereb, 'Suor Maria De Dominici', p. 19.

[2] De Dominici, *Vite de' pittori*, p. 382.

[3] Sciberras, *Baroque Painting in Malta*, p. 170.

[4] Literature by Keith Sciberras and Franca Trinchieri Camiz served as foundation to build on for this study. See: Sciberras, *Caravaggio to Mattia Preti*, p. 101; Trinchieri Camiz, 'Dominici, Suor Maria de', p. 462.

Women in Arts, Architecture and Literature: Heritage, Legacy and Digital Perspectives, ed. by Consuelo Lollobrigida and Adelina Modesti, Women in the Arts: New Horizons, 1 (Turnhout: Brepols, 2023), pp. 273–286

BREPOLS ❧ PUBLISHERS

10.1484/M.WIA-EB.5.134656

who were successful silversmiths based in Valletta, while her mother, Giovanella Protopsalti (d. 10/12/1714),[5] also came from a family of silversmiths. Thus, Maria was fully immersed into the art world from a young age.[6] Onofrio also worked as an appraiser for valuables for the Order of St John, which created a significant link with the Knights, and perhaps introduced Maria and her brothers to Mattia Preti. Two of Maria's brothers, Raimondo and Francesco, were also painters who trained and worked with Mattia Preti. Raimondo worked in Malta and Naples,[7] whilst Maria's youngest brother, Don Francesco de Dominici, is recorded to have travelled with his sister when she left Malta for Rome in 1682,[8] and mostly executed paintings around Gozo after his return.[9]

Together with her brother Raimondo, Maria was one of the artists in Preti's bottega. Even though not documented, she was old enough to possibly assist her master in his preparatory work for the programme of the life of St John the Baptist executed in the ceiling of St John's Conventual Church, in Valletta. Contrary to the many fabrications over the years, the young artist was not involved in the actual painting of the narrative, since the work was too well-executed to have had any bottega intervention in the physical act of painting.[10]

The first written source which cites Suor Maria as an artist is the *Vite de' pittori, scultori, ed architetti napoletani*, written by Raimondo's son, Bernardo de' Dominici.[11] In the biography of Mattia Preti, he described his aunt as a *pinzocchera* and a disciple of Preti. According to Bernardo de' Dominici, Preti encouraged her to go to Rome to pursue her studies on sculpture further.[12]

Fabrications on Maria de Dominici continued by later historians, enhancing a rather fictitious *fortuna critica*. In the eighteenth century, Giovannantonio Ciantar wrote that Preti soon recognised the young artist's abilities, and tutored her personally, even letting her paint some of the female figures within the *St John the Baptist* cycle, which she did in a better manner than her master.[13] The nineteenth-century writer Giuseppe Maria de Piro romanticises further, stating that de Dominici surpassed the ability of all other *bottega* students, and Preti thus chose to collaborate with her for the work in the ceiling of St John's Conventual Church, where she executed most of the female figures.[14] This is an interesting take on gender studies, in which a female artist is credited by biographers to have painted female figures in such a prestigious project, based on no foundations.

5 Vittoriosa, Status Animarum, Vide P.A. Vittoriosa Battistero, MS 94; Vide P.A. San Paolo Battistero 1637–1648 fol. 137, in Cutajar, *The Followers of Mattia Preti*, p. 44.

6 De Dominici's parents were married at Vittoriosa on 8 September 1641. Maria was the second of eight children. See also: Vittoriosa, Matrimonii 1626–1696, fol. 6ᵛ.

7 De Piro, *Squarci di storia*, p. 40.

8 De Dominici, *Vite de' pittori*, p. 382.

9 Cutajar, *The Followers of Mattia Preti*, p. 44.

10 Sciberras, *Baroque Painting in Malta*, p. 170.

11 De Dominici, *Vite de' pittori*, p. 382.

12 De Dominici, *Vite de' pittori*, p. 382.

13 Ciantar, *Malta illustrata*, p. 550.

14 De Piro, *Squarci di storia*, p. 40.

Maria de Dominici was involved in the execution of several works together with the *bottega*, but also started creating independent works, seven of which still survive: six attributed paintings and one documented sculpture. The six paintings have a distinctive style, which relies heavily on her master, and shows the artist's limited artistic capabilities.[15] Nonetheless, de Dominici seems to have been a popular painter, although possibly commissioned because she was a cheaper alternative to employing a male artist. Most of the works of art ascribed to Maria de Dominici are paintings created in Malta and Rome, but which may not exist to date.

The surviving paintings are (i) the *Virgin with Ss Nicholas and Roque* at the Attard Parish Museum (Fig. 1), (ii) *Christ receiving St Maria Maddalena de Pazzi* at the Carmelite Priory, Valletta (Fig. 2), (iii) *The Visitation of the Virgin* at the Żebbuġ Parish Church Sacristy (Fig. 3–4), (iv) *St Teresa of Avila*, (v) *St John of the Cross*, both in storage within the Żebbuġ Parish Church Sacristy (Fig. 4), and (vi) the *Crucifixion with Saints* (Fig. 5), located within a private collection in Malta.[16]

Maria de Dominici's best painting is the Attard *Virgin with Ss Nicholas and Roque*, an autograph work[17] that depicts the horrors of the plague, and dates to the immediate years after the 1676 outbreak. The *Visitation of the Virgin* and the *Christ Receiving St Maria Maddalena de Pazzi* were ascribed to the artist by various sources.[18] The painting located at the Valletta Carmelite Priory, of which de Dominici was a member, evidences the artist's difficulty in depicting the human figure. The *Visitation of the Virgin*, which is located at the Sacristy at the Church of St Philip of Agira in Żebbuġ is considered as one of Maria de Dominici's first paintings, commissioned as the titular for the Chapel of the Visitation at Wied Qirda at Żebbuġ. Although heavily overpainted,[19] it is evident that this painting drew inspiration from Mattia Preti's own *Visitation* at Żurrieq,[20] and bears similarities with the painting of the same subject located in a private collection by the *bottega*, of which Maria de Dominici was also a member.[21]

The *St Teresa of Avila* and *St John of the Cross* have recently been attributed to de Dominici through their original location, as the laterals to the *Visitation* at Wied Qirda, and their stylistic analysis.[22] The *St Teresa* is the smallest work that has been attributed to de Dominici, and is the weakest in composition and execution. This limitation in the modelling of the figure, which is hidden under large garments, is also evident in the *St John of the Cross*. The final painting ascribed to the artist, the *Crucifixion with Saints*, also shows de Dominici's difficulties when executing the elongation and foreshortening of figures.[23] This recently attributed work, located

15 Sciberras, *Caravaggio to Mattia Preti*, p. 142.
16 Xuereb, 'Suor Maria De Dominici', p. 19.
17 Mdina, Archives of the Cathedral Museum, MS 180, fol. 100.
18 De Piro, *Squarci di storia*, p. 74.
19 Sciberras, *Caravaggio to Mattia Preti*, p. 101.
20 Sciberras, *Baroque Painting in Malta*, p. 205.
21 Sciberras, *Mattia Preti: The Triumphant Manner*, p. 267.
22 This information was obtained from Keith Sciberras and Joe P. Borg through personal communication in January 2017. Borg, 'Suor Maria de Domenici (1645–1703)' pp. 128–46.
23 Xuereb, 'Suor Maria De Dominici', p. 101.

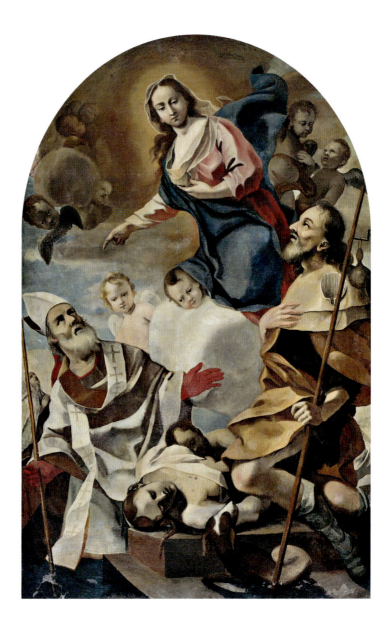

Fig. 1. Maria de Dominici, *Virgin with Ss Nicholas and Roque*, Attard Parish Museum, c. 1678–1680. Photo credits: Joe P. Borg.

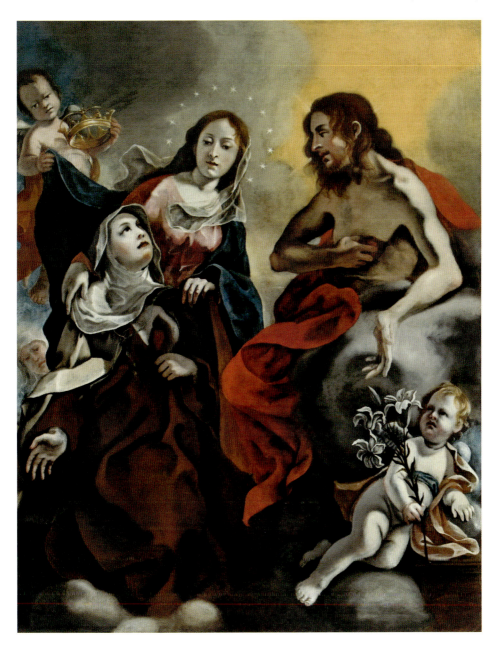

Fig. 2. Attributed to Maria de Dominici, *Vision of St Maria Maddalena de Pazzi*, Carmelite Priory, Valletta. Photo credits: Joe P. Borg.

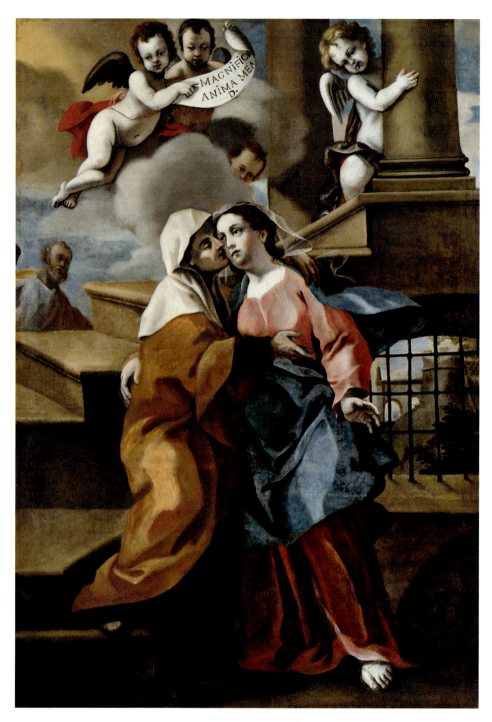

Fig. 3. Attributed to Maria de Dominici, *Visitation of the Virgin*, Żebbuġ Parish Church Sacristy. Photo credits: Joe P. Borg.

Fig. 4. The Chapel of the Visitation, at Wied Qirda. Photographic representation of the Chapel with Maria de Dominici's works. Photo credits: Joe P. Borg.

Fig. 5. Attributed to Maria de Dominici, *Crucifixion with Saints*, Private Collection Malta. Photo credits: Joe P. Borg.

within a private collection in Malta,[24] is also one of her smaller paintings, and like the *Virgin with Ss Nicholas and Roque*, utilises a *sacra conversazione* format.

As denoted from these works, Maria de Dominici was an artist of limited talent, especially when compared to foremost painters on the island, but surely exemplary and very significant as a female who managed to break into a man-centred world. For instance, the fact that she was given the commission for the titular and two side paintings of the small Chapel of the Visitation shows that she was well-esteemed. This, perhaps, may have also granted her an opportunity for future commissions.

It seems that Suor Maria was a talented sculptor and was commissioned for a number of works. None of these survive to date, except for the wooden *Immaculate Conception* (Fig. 6), the titular statue of Cospicua. It is this sculpture which highlights her artistic merits, however only her face, hands and feet survive, as the rest of the body was severely remodelled in 1905, by the renowned firm of *Antonio Ghezzi e Figlio*, in Milan, based on the design by the local artist Abram Gatt (1863–1944). An old photograph of the work showcases the sculpture in its original form, and through its modelling and iconography evidences a very able artist at work.[25]

Two other sculptures, *St Teresa's Transverberation* and a second *Immaculate Conception*, mentioned in writings on the artist,[26] do not seem to survive. She is also documented to have produced paintings and sculptures that served as cultic statues that were to be carried in religious processions on feast days.[27] There is also a sculpture of the *Madonna of the Pillar* at the Carmelite church mentioned within her oeuvre, yet there is not enough evidence for it to be considered as her work.[28] Beneath an ink and wash drawing of *Lo Sposalizio della Vergine*, located at the Mdina Cathedral Archives,[29] is an inscription stating 'Maria de Dominici', however the first name seems to have been a later addition. The style of the drawing is similar to de Dominici's works, but the draughtsmanship displayed in the drawing is superior to any other known works by the artist, and therefore it is likely that this attribution is erroneous.[30]

By the time she left Malta for Rome in 1682, at 37 years old, Maria de Dominici was a Carmelite tertiary nun, or *pinzocchera*, later affiliated with the Carmelites of Santa Maria di Transportina in Rome.[31] As a tertiary during the seventeenth century, Suor Maria abided by the vows of obedience and chastity, yet lived a relatively independent life, outside the convent walls and without any family ties, and hence working freely as an artist, even sharing her house with two female companions over the years.[32] Through this, her mobility was fairly easy, and although it was common for women to have more home-related jobs, it is evident that de Dominici

24 Sciberras, *Caravaggio to Mattia Preti*, p. 142.

25 Xuereb, 'Suor Maria De Dominici', p. 51.

26 Ciantar, *Malta illustrata*, p. 551; De Piro, *Squarci di storia*, p. 74.

27 Trinchieri Camiz, 'Dominici, Suor Maria de', p. 462; Aquilina, *Il-Ġimgha l-Kbira tal-Belt* p. 32.

28 Trinchieri Camiz, 'Dominici, Suor Maria de', p. 462; Hoe, 'Maria de Dominici', p. 116.

29 Azzopardi, *Elenco dei Disegni del Museo*, p. 14.

30 Xuereb, 'Suor Maria De Dominici', p. 56.

31 Ciantar, *Malta illustrata*, p. 551.

32 Trinchieri Camiz, 'Dominici, Suor Maria de', p. 462.

Fig. 6. Old photograph of the *Immaculate Conception* by Maria de Dominici at Cospicua, c. 1680. Photo credits: Cospicua Parish Church.

was well-educated and a respected artist, possibly gaining better access to potential patrons through her movement. Affiliations with the Carmelite Order in Malta and in Rome gave her a direct link if she required shelter or commissions for artworks.

Maria de Dominici spent the remainder of her life in Rome, where, according to Bernardo de' Dominici, she studied Antique sculptures and works by Gian Lorenzo Bernini. Sources over the years stated that Maria also worked with Bernini.[33] However, this is certainly not possible, since the Baroque master passed away in November 1680, whilst de Dominici is believed to have left Malta in March 1682.[34]

The limited information about Maria de Dominici's life and work in Rome mean that the quality of her artistic production and her contribution to the art world cannot truly be analysed, however, from the available sources, it can be affirmed that she was a successful artist. In a contract, she is noted to have executed works for the altar dedicated to San Andrea Corsini which hung in Santa Maria di Traspontina until

33 Ciantar, *Malta illustrata*, p. 550.
34 Trinchieri Camiz, '"Virgo-Non Sterilis…"', p. 156.

1911.[35] In her wills, she recorded various other works of art which she executed in Rome, including a *Last Supper*, a *Queen Sofonisba*, an *Ecce Homo* and the *Annunciation*. For the ambassador of the Knights of St John in Rome and her protector, Fra Marcello Sacchetti (1644–1720),[36] she sculpted a marble bust of the *Virgin*, whilst, for his family, she created various portraits and a picture of *St Stanislaus*.[37] De Dominici also records *gessi*, clay and wax *modelli* in her first will, and casting molds in her second will;[38] a collection which evidences her continuous propensity for sculpture, especially in bronze. Unfortunately, no works created by her during her Roman period are known to exist, although there must be other works by her, both in Rome and in Malta, that have survived but which have not been identified or which are currently erroneously attributed to another artist.

Works and *Fortuna Critica*

Maria de Dominici's known works fluctuate in quality, yet possess some similar idiosyncrasies and chromatic schemes, and show her as an inconsistent artist who studied under a great Baroque master, but lacks pictorial depth and inventiveness. Her subject matter seems to have been limited to religious works, perhaps due to her status as a tertiary and because most of her known works are public commissions. It is also possible that other secular or private commissions were lost or are unknown.

De Dominici looked at various sources for her paintings, taking inspiration from prints in circulation at the time, including those by foreign artists, and deriving inspiration from Mattia Preti, capitalising heavily on his compositions, gestures and iconography.[39] Although she was reliant on her master, there are also distinctive features in her oeuvre, such as the angular rigidity of drapery folds.[40] On certain occasions, she also succeeds in creating inventive compositions, but does not reach Preti's artistic level. Despite her artistic limitations, Maria de Dominici seems to have been well respected as an artist, and earned significant commissions, emerging most prominently as a sculptor. In fact, what is so fascinating about this artist is that unlike many other women, who were frequently dismissed because of their gender, de Dominici was lauded as a female artist, and she has acclaimed a very positive *fortuna critica* over the years.

35 Rome, Archivio Storico Dell'Ordine, MS 21, fol. 48. Source retrieved from: Trinchieri Camiz, '"Virgo-Non Sterilis…"', pp. 156, 280.

36 In Rome, de Dominici was placed under the protection of the Sacchetti family, whom she knew through her family and Mattia Preti's links with the Order of the Knights of St John. See: Scerri, Adrian, 'Fra Marcello Sacchetti, Hospitaller Ambassador to the Papal States: His Official Correspondence' (unpublished M.A. thesis, University of Malta, 2011).

37 Rome, ASR, MS 30, 9, fols 453v–453r, 474r–474v.

38 Rome, ASR, MS 30, 6, fol. 448v. See also: Trinchieri Camiz, '"Virgo-Non Sterilis…"', p. 157.

39 According to Bernardo de Dominici, Suor Maria owned drawings given to her by Preti, which she may have thus used as aid for her own works. See: De Dominici, *Vite de' pittori, scultori, ed architetti napoletani*, p. 382.

40 Sciberras, *Baroque Painting in Malta*, p. 170; Sciberras, *Caravaggio to Mattia Preti*, pp. 141–42.

In spite of not always being factual, the writings of Bernardo de' Dominici and Giovannantonio Ciantar have helped to shed a light on how Suor Maria was regarded as a female artist and tertiary nun in Malta and in Rome.[41] The many stories generated about the artist over the years have been verified, while others declared as erroneous, such as her painting the female figures of Mattia Preti's ceiling of St John's Co-Cathedral, and superseding her master, and training with Bernini in Rome. De Dominici benefited from this romanticisation of her life and works, which granted her significant popularity over the years, and in 2010 even saw her being dedicated a crater on Mercury.[42]

Suor Maria de Dominici died on 18 March 1703, and was buried in Rome.[43] Since none of her works in Rome survive, there is no knowledge on the way her art developed in the Papal city. What is known is that she was a strong-willed artist, who was proud of her artistic production and her identity.[44] Fortunately, in recent years her artistic œuvre has attracted more scholarly interest. There is, however, more scope for further study on the subject, particularly in the identification and study of her sculpture and paintings, and patronage patterns, with the hope of retrieving any surviving works that she carried out in Malta and Rome. Maria de Dominici merits more recognition and credit for her role as a female independent painter and sculptor in Late Baroque Malta and Rome.

41 De Dominici, *Vite de' pittori*, p. 382; Ciantar, *Malta illustrata*, pp. 295, 550–51.
42 Gazetteer of Planetary Nomenclature, 'Dominici', USGS Astrogeology Science Center, <https://planetarynames.wr.usgs.gov/Feature/14642> [accessed on 15 July 2022].
43 De Dominici, *Vite de' pittori*, p. 382.
44 Xuereb, 'Suor Maria De Dominici', p. 75.

Bibliography

Manuscripts and Archival Sources

Mdina, Archives of the Cathedral Museum, MS 180
Rome, Archivio di Stato, MS 30, 9
Rome, Archivio Storico Dell'Ordine, MS 21
Rome, ASR, MS 30, 6
Vittoriosa, Status Animarum, Vide P.A. Vittoriosa Battistero, MS 94; Vide P.A. San Paolo
Battistero 1637–1648

Secondary Sources

Aquilina, Ġorġ, *Il-Ġimgħa l-Kbira tal-Belt* (Valletta: Tau, 1986)
Azzopardi, John, *Elenco dei Disegni del Museo della Cattedrale di Malta* (Malta: Cathedral Church
of Malta, 1980)
Ciantar, Giovannantonio, *Malta illustrata, ovvero Descrizione di Malta isola del mare Siciliano e
Adriatico: con le sue antichità, ed altre notizie*, (expansion of Giovanfrancesco Abela's
volumes), II (Malta: Stamperia del Palazzo di S.A.S., 1780)
Cutajar, Dominic, *The Followers of Mattia Preti* (Malta: Mid-Med Bank Ltd., 1989)
De Dominici, Bernardo, *Vite de' pittori, scultori, ed architetti napoletani*, III (Naples: Stamperia del
Ricciardi, 1743)
De Piro, Giuseppi Maria, *Squarci di storia e ragionamenti sull'isola di Malta* (Malta: Miranda
Publications, 1839)
Gazetteer of Planetary Nomenclature, 'Dominici', USGS Astrogeology Science Center,
<https://planetarynames.wr.usgs.gov/Feature/14642> [Accessed on 15 July 2022]
Hoe, Susanna, 'Maria de Dominici', in *Malta: Women, History, Books and Places* (Oxford: The
Women's History Press, 2015), pp. 115–17
Scerri, Adrian, 'Fra Marcello Sacchetti, Hospitaller Ambassador to the Papal States: His Official
Correspondence' (unpublished M.A. thesis, University of Malta, 2011)
Sciberras, Keith, *Baroque Painting in Malta* (Valletta, Midsea Books, 2009)
———, *Caravaggio to Mattia Preti* (Valletta: Midsea Books, 2015)
———, *Mattia Preti: The Triumphant Manner* (Valletta: Midsea Books, 2012)
Trinchieri Camiz, Franca, '"Virgo Non Sterilis…": Nuns as Artists in Seventeenth- Century
Rome', in *Picturing Women in Renaissance and Baroque Italy*, ed. by Geraldine A. Johnson and
Sarah F. Matthews Grieco (Cambridge: Cambridge University Press, 1997), pp. 139–64
———, 'Dominici, Suor Maria de', in *Dictionary of Women Artists: Artists,* Delia Gaze ed, 2 vols,
II (Fitzroy Dearborn Publishers, 1997), p. 462
Xuereb, Nadette, 'Suor Maria De Dominici: The First Maltese Female Artist and her Presence in
Late Baroque Malta and Rome' (unpublished B.A. Honours thesis, University of Malta,
2017)

TORI CHAMPION

Pazienza e diligenza

Early Modern Women Artists in the Genre of Natural History

▼ **ABSTRACT** By pursuing careers as naturalist-artists, early modern women achieved a level of professionalism and recognition hitherto unseen in the fine arts and natural sciences, fields which were only beginning to emerge as distinct in Western Europe. These women slowly overturned received notions of women's capabilities as artists and as intellectuals which had been adopted by Renaissance writers from classical texts, at the same time as natural historical methodologies received from classical sources were being undermined by their limitations in the face of increasing globalisation. Over a timeline stretching from around 1570 to 1760, we find a group of women who strategically used the genre they were prescribed to further their careers as both artists and scientists. This chapter will consider as case studies a number of such female artists working in this genre, whose contributions to the study of natural history and the pursuit of lifelike depictions of natural specimens were considered highly valuable during their lifetimes. The work of each existed on the bridge between the arts and the sciences, paving the way for more and more women to enter professions in both interconnected fields. These women were able to take their work farther geographically and take their careers to more prestigious heights with each passing generation, forming an artistic lineage of expression and ingenuity that would have been denied them by historians of old.

Following the renewed attention and exaltation given to ancient philosophy during the Renaissance, early modern theorists in the arts and sciences alike displayed a devoted adherence to the ideas received from classical texts which proved difficult to shake, even as the information contained in these texts became more or less obsolete. Though the unquestioning absorption of classical 'knowledge' affected a vast range of intellectual disciplines, I will focus on two particular subsets of period scholarly discourse: the perception of women in the arts and the practice of naturalist illustration

Women in Arts, Architecture and Literature: Heritage, Legacy and Digital Perspectives, ed. by Consuelo Lollobrigida and Adelina Modesti, Women in the Arts: New Horizons, 1 (Turnhout: Brepols, 2023), pp. 287–302
BREPOLS ❧ PUBLISHERS 10.1484/M.WIA-EB.5.134657

in the sciences. For scientific illustration, a shift to new thinking away from classical precedent came about as a result of the expansion of global networks, and for female artists, it required centuries of subversion within approved genre boundaries. By examining the area where these two categories intersect, my contention is that it is the female practitioners of the discipline of naturalist illustration who, by utilising and advancing the new pictorial technologies that came to the fore in the age of exploration, began to turn the tide against the received notions of evaluating art by women.

Early modern writers on art, particularly those in Italy in the sixteenth and seventeenth centuries like Giorgio Vasari and Gian Paolo Lomazzo, were attempting to apply the newly-formed discipline of biographical history to the arts. To accomplish this they looked to classical prototypes, especially the writings of Plutarch and Pliny the Elder. In his encyclopaedic *Natural History*, Pliny rehearses the development of art by crafting a lineage of individual artists. In this chronology, Pliny traces a succession of male artists, each in their turn enacting 'technical invention and stylistic refinement', sequentially passing along the torch of creativity in the practice of painting and sculpture.[1] This genealogical narration complete, the author lists the names of six women artists of note, conspicuously without reference to dates, historical place, works, or innovations. The same organisational structure can be found in treatises by Cicero and Quintilian. Thus, when Renaissance and post-Renaissance writers, aspiring to the repossession of antique knowledge, sought models for discussing the arts, they adopted this scheme as their own. In her study, *Defining the Renaissance Virtuosa*, Fredrika Jacobs describes this strategy as a 'sixteenth-century updating of Pliny's relegation of female painters to a textual place with no historical significance.'[2] To these classical authors, women artists existed, and created significant work worthy of praise, but this work existed outside of, and did not offer a contribution towards, the evolutionary progress of art-making. The scions of the male artists of antiquity were declared to be the contemporary male artists of the Renaissance and post-Renaissance. For contemporary female artists, then, as Jacobs so succinctly concludes, 'to be the heir of someone without a historical place is to assume a like position.'[3] Male artists were 'agents of change', affecting 'collective advancement', while female artists were implicitly displaced, distanced, othered.[4]

In some cases, a woman might be elevated to the status of a male artist in the eyes of writers and critics, though even as she was considered extremely talented, she was perceived as an unnatural exception to her sex. This class of 'masculine' women artists includes such accomplished figures as Properzia De'Rossi, Lavinia Fontana, Sofonisba Anguissola, and Artemisia Gentileschi.[5] Over time, period texts became marginally more inclusive, though the compliment of inclusion was always back-handed. One problem among many within 'the exceptional woman' framework

1 Jacobs, *Defining the Renaissance Virtuosa*, p. 20.
2 Jacobs, *Defining the Renaissance Virtuosa*, p. 24.
3 Jacobs, *Defining the Renaissance Virtuosa*, p. 24.
4 Jacobs, *Defining the Renaissance Virtuosa*, p. 20.
5 Jacobs, *Defining the Renaissance Virtuosa*, p. 26.

is, as Mary Sheriff so brilliantly set out, that the exception proves the rule, and 'cannot become the ground on which the rule is changed or challenged, nor can it be a model for the majority who live under the rule.'[6] In early modern Europe, it is clear that women could attain a professional career in the arts. It is also clear that an artist's sex affected how their work was critically received, and that 'even when…a woman artist achieved critical parity with her male peers, her singularity served to underscore the deficiencies of all others.'[7] Many more women than those few who received public critique were working below the parapet of popular recognition.[8] Societal constraints and received assumptions about the female sex ensured that only a select few genres of 'low-style,' which required 'neither the gift of invention nor any great technical or stylistic virtuosity', were deemed acceptable outlets for women artists.[9] Those who found a way to exercise their artistic talent in genres other than these, including religious or mythological history painting, often did so in a 'semi-clandestine manner', either in family studios or in the seclusion of a convent.[10]

One of those subjects deemed appropriate was portraiture, and yet again we find that the prescription of portraiture as a suitable artistic pursuit for women was handed down from antiquity, found first in the writing of Pliny.[11] Sixteenth- and seventeenth-century writers consistently commend women artists for their capability to render a likeness, though praise tends to end there, without further congratulation for the artist's triumph in giving life to the subject or displaying a gift for creative invention.[12] In 1587 Armenini divided portraiture into two hierarchical categories: that which is merely copying (*ritrarre*), requiring coordination and focus only, and that which utilises the intellect (*imitare*) to bring a sitter's inner life and personality to the fore, and bestow upon figures a beauty that was creatively enhanced and invented.[13] This was, as Jacobs would have it, 'a qualitative distinction between mere technical facility and technical prowess.' Jacobs' close examination of primary sources reveals that a woman's hand came to be identified in an 'attention to detail, a preference for geometric pattern, a predilection for ornament, and a certain preciosity.'[14] The omnipresence of such descriptors as '*tanta pazienza*' and '*troppa diligenza*' in evaluations of art by women serves to underscore the deep-rootedness of centuries-old assumptions and biases.[15] Though the same patronising commentaries were certainly levelled at men, there was an underlying assumption that these weaknesses could be overcome by men through harder work and inherent capability for inventive genius.[16]

6 Sheriff, *The Exceptional Woman*, pp. 1–2.

7 Jacobs, *Defining the Renaissance Virtuosa*, p. 40.

8 Tongiorgi Tomasi, '"La femminil pazienza"', p. 159.

9 Tomasi, '"La femminil pazienza"', p. 160.

10 Tomasi, '"La femminil pazienza"', p. 159.

11 Tomasi, '"La femminil pazienza"', p. 159.

12 Jacobs, *Defining the Renaissance Virtuosa*, p. 44.

13 Jacobs, *Defining the Renaissance Virtuosa*, pp. 44–45.

14 Jacobs, *Defining the Renaissance Virtuosa*, p. 89.

15 Jacobs, *Defining the Renaissance Virtuosa*, p. 110.

16 Jacobs, *Defining the Renaissance Virtuosa*, p. 103.

Lucia Tongiorgi Tomasi very productively encapsulates the long-term implications of these patterns of thought, highlighting the gendering of media, scale, and professional characterisation. There is an indication here that women were seen to work with exactitude; that they were slow of speed and merely receptive, though meticulous, and able to reproduce truthfully a subject from life. Thus, those subjects perceived as peculiarly adapted to women artists were, in addition to portraiture, certain types of domestic scenes, still life, and the depiction of insects, birds, and flowers, making up the genre of natural history.

Just as the rediscovery, transmission, and assimilation of ancient texts in the later Middle Ages would shape the perception and reception of the female artist, so too did classical knowledge inform the scientific evaluation of the natural world.[17] Those who compiled knowledge of plants in the early modern period relied on the lists of species established much earlier by classical authors.[18] The earliest extant printed depictions of plant life in Europe arrived in the form of herbals, in the first quarter of the sixteenth century.[19] Herbals served a purely utilitarian purpose, as their importance lay in documenting the medicinal properties of particular plants and herbs. It was late Mediaeval and early-Renaissance physicians or apothecaries who were the first to cultivate gardens for the study of plants, and the first to produce printed and illustrated herbals.[20] The early woodcut illustrations in these works are simplistic and often inaccurate, with issues in scale and proportion, due to limitations in technology and knowledge.

At this point in Western Europe there was essentially no system of plant classification, and the images included, whilst at times quite decorative and whimsically imaginative in their embellishments, were subordinate to the text.[21] In works of the late-fifteenth century, the same woodcut might be used repeatedly as a representative image for wholly different plants. The woodcuts themselves were copies of classical manuscript illustrations, which were 'accepted without question as accessories to authoritative texts.'[22] The methodology behind plant identification consisted of finding a one-to-one match between an image or description of a plant in an ancient manuscript and the specimen which the author had to hand. Through the better part of the sixteenth century, as Gill Saunders demonstrates, 'there was not yet a conscious belief in the value of direct observation over existing images; the belief in established authorities remained strong, as evidenced by the reliance of all the herbals on classical authors whose work they supplemented but did not seriously challenge.' The development of botany as a distinct science separate from medicine, and the breaking away from the scholarly hegemony of classical texts, went hand in hand with European exploration and colonisation of distant lands.[23]

17 Jacobs, *Defining the Renaissance Virtuosa*, p. 34.
18 Kusukawa, 'Illustrating Nature', pp. 100–01.
19 Saunders, *Picturing Plants*, p. 18.
20 Saunders, *Picturing Plants*, p. 17.
21 Saunders, *Picturing Plants*, pp. 18, 24, 28.
22 Saunders, *Picturing Plants*, p. 12.
23 Saunders, *Picturing Plants*, pp. 17, 38.

A key example of a publication midway through this transition can be found in Leonhart Fuchs' *History of Plants* of 1542, which was the first to include images of plant life brought back from the Americas (Fig. 1).[24] The woodcuts used to illustrate Fuchs' volume are in large part still based on knowledge from antiquity, but the principal artists involved were drawing from direct observation, crafting a unique woodcut for each species, and enacting the shift towards direct observation as the premise for botanical illustration.[25] Early modern scientists found themselves increasingly debilitated by the impossibility of matching plants native to the Mediterranean regions (found in classical texts) with those of northern Europe, and with those introduced from other parts of the world. Those who recognised the geographical and historical limitations of classical scholars 'were able to take forward the work of studying, describing, and picturing new species, establishing botany as an independent discipline.'[26]

In the seventeenth century, as Elizabeth Cropper writes, '"natural history" was reconceived as the examination of experience and knowledge, not the compilation and reconciliation of authorities.'[27] With the introduction in greater numbers of rare and exotic species from afar, plant life, and flowers in particular, began to hold value for wealthy collectors.

Fig. 1. Albrecht Meyer, Heinrich Füllmaurer, and Vitus Rudolph Speckle, *Juniperus minor* in Leonhart Fuchs's *De historia stirpium commentarii insignes* (Basel: 1542). Woodcut, hand-coloured. 37 × 24 cm.
U.S. National Library of Medicine. Public Domain.

The cultivation of flower gardens, in addition to the kitchen and physic gardens already established on the grounds of affluent families, became fashionable, and the possession of such a plot served as a status symbol of both wealth and worldly intellect. A new type of botanical volume, the florilegium, emerged in the early years of the seventeenth century as a category within book publishing in which the plates were 'intentionally more significant than the text.'[28] These volumes could serve as both floral pattern books for the applied arts and catalogues of individual garden collections.[29] The veritable craze for flowers in seventeenth-century Europe, which of course reached its most extreme apex in the Dutch tulip bubble of the 1630s, was spurred by the flood of unfamiliar species arriving from faraway lands. With plant life came many other strange and wonderful curiosities, including shells, fossils, preserved fauna, and

24 Kusukawa, 'Illustrating Nature', pp. 100–01; Saunders, *Picturing Plants*, p. 12.
25 Saunders, *Picturing Plants*, p. 36.
26 Saunders, *Picturing Plants*, p. 24.
27 Cropper, 'Preface', p. 7.
28 Saunders, *Picturing Plants*, p. 41.
29 Tomasi, '"La femminil pazienza"', p. 162.

minerals, which altogether made up what came to be known as *kunstkammern* and *wunderkammern*, or *cabinets de curiosités*. In florilegia there was still no intent to analyse or classify; the purpose was to display exotic acquisitions.[30]

Greater scientific purpose would be established in the late-seventeenth and early-eighteenth centuries, first with Joseph Pitton de Tournefort's classification system, and then with that of Carl Linneaus in the mid-eighteenth century.[31] Until this point, taxonomy had been 'haphazard and inconsistent,' and a shift towards a more sophisticated system was made imperative by the influx of new plant varieties, which needed to be organised in relation to known species.[32] Across Europe, the seventeenth century also saw the development of technological innovations in observation with the microscope, and in representation with improved pigments and printmaking methods.[33] The picturing of nature, which 'was parallel to the process of scientific study in that it was dependent upon direct experience with objects and natural processes', became absolutely vital to the development and dissemination of knowledge in the natural sciences.[34]

Early modern women artists who pursued creative expression through natural history may have by definition worked within the genre limitations imposed upon them, but in doing so completely undermined received ideas about what a woman artist was capable of by breathing life into their subjects and working at breakneck speed against the clock of natural decay to preserve all manner of specimens in their drawings. These pursuits also required a high degree of scientific study and intellect. Among the female artists working in this genre, many received extraordinary success, and all existed on the bridge between the arts and the sciences, paving the way for more and more women to enter professions on both sides. In examining some of the most notable figures, my assertion is that these artists were not always forcibly stymied by so-called 'feminine genre' limitations; frequently this route was taken out of scholarly interest in the subject at hand. While they may not have attracted attention as traditionally 'exceptional women' with 'masculine virtues', these women excelled as both fully-fledged scientists and artists at a time when both professions were all but barred to them. The trajectory for scientific naturalist images from the abstract and diagrammatic at the beginning of the early modern period to the *trompe l'œil* lifelikeness in representations of the later seventeenth and eighteenth centuries provided fertile ground for women to subvert gendered assumptions. Over a timeline stretching from around 1570 to 1760, we see a group of women who strategically used the genre they were prescribed to further their careers as both artists and scientists. These women were able to take their work farther geographically and take their careers to more prestigious heights with each passing generation, forming an artistic lineage of expression and ingenuity that would have been denied them by historians of old.

30 Saunders, *Picturing Plants*, p. 48.
31 Meeker and Szabari, 'Inhabiting Flower Worlds', p. 2; Saunders, *Picturing Plants*, p. 89.
32 Saunders, *Picturing Plants*, p. 85.
33 O'Malley and Meyers, 'Introduction', pp. 9–12.
34 O'Malley and Meyers, 'Introduction', pp. 9–12.

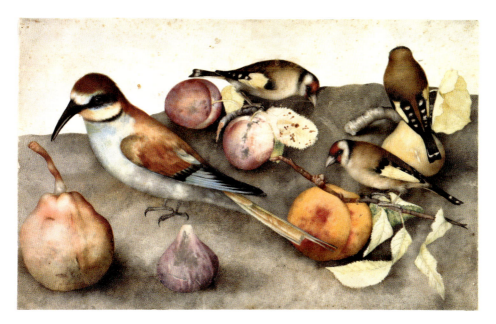

Fig. 2. Giovanna Garzoni (Italian, 1600–1670), *Still Life with Birds and Fruit*, c. 1650. Watercolour with graphite, heightened with lead white, on vellum. 25.7 × 41.6 cm. Cleveland Museum of Art. Public Domain.

At the turn of the sixteenth to the seventeenth century, Isabella Cattani Parasole was publishing a series of books as a designer of lace and embroidery patterns, and collaborating on botanical treatises as a scientific illustrator. The replicability of these types of publications, as opposed to lavishly illuminated, one-of-a-kind florilegia, meant that the reach of her work was fairly widespread amongst those of means.[35] She was commissioned to produce illustrations for the *Herbario nuovo*, first published in 1585, and later collaborated on a book of natural history of the Americas. Though working within pictorial parameters and limited space in these volumes, Parasole's drawings include all parts of each plant as well as original details, like the placement of a plant in its natural habitat, or in an ornamental pot in a garden, that show a capacity and enthusiasm for invention.

Parasole's slightly younger contemporaries, Anna Maria Vaiani and Giovanna Garzoni, took their practice beyond the frontiers of the Italian city-states. Vaiani became successful as both an engraver of drawings of antiquities and as a floral painter, and collaborated on *De florum cultura*, an important treatise on horticulture and gardening for which many notable artists in addition to Vaiani contributed illustrations. Later in life she would travel to England to produce floral pictures for various members of the English nobility. Garzoni was born into a family of artisans, and following a long period of training in botanical illustration in Rome during her adolescence, she

35 Tomasi, '"La femminil pazienza"', pp. 163–64.

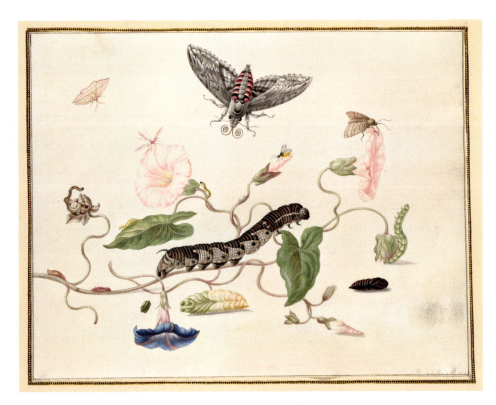

Fig. 3. Maria Sibylla Merian (German, 1647–1717 [active Holland]), *Convolvulus and Metamorphosis of the Convolvulus Hawk Moth*, c. 1670–1683. Watercolour with touches of opaque watercolour over indications in black chalk or graphite on vellum. 29 × 37.2 cm. Cleveland Museum of Art. Public Domain.

made a name for herself as painter of miniatures and still lifes, gaining support from the Medici family and many other illustrious commissioners across Europe.[36] Her unmistakable technique, often based on the application of minute dots and strokes of colour was one factor of many for which her portraits of plant and animal life were afforded a high value (Fig. 2).

In France, Catherine Perrot was instrumental in developing pedagogical manuals for the instruction of natural history painting to young students of art of both genders (Fig. 3).[37] To our great misfortune, no paintings that can be attributed with certainty have survived, but as we know that Perrot trained with the academic history painter Charles Le Brun and the royally-appointed painter of plants Nicolas Robert, we can infer some probable characteristics of her style. Notably, Perrot was one of seven women in the seventeenth century to be officially received into the Académie royale de peinture et de sculpture.

36 Tomasi, "La femminil pazienza", pp. 163–64.
37 Tomasi, "La femminil pazienza", pp. 169–71.

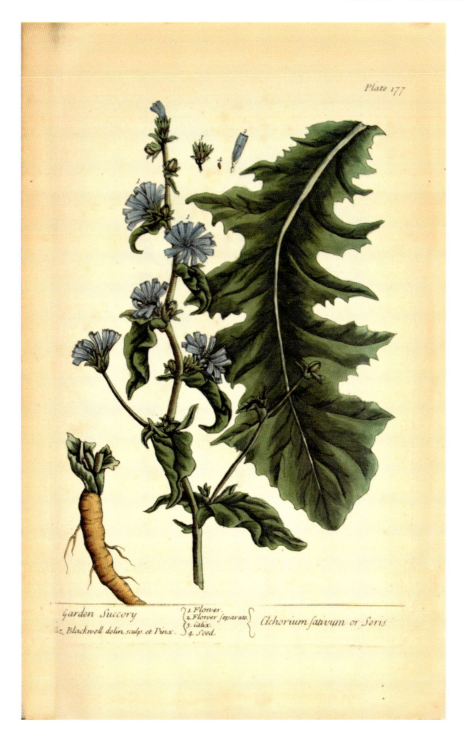

Fig. 4. Elizabeth Blackwell (Scottish, 1707–1758), *Garden Succory* from *A Curious Herbal* (London: 1736–1739). Etching and engraving, hand-coloured. 37 × 25 cm. U.S. National Library of Medicine. Public Domain.

Maria Sibylla Merian, Cornelia de Rijk, and Rachel Ruysch were simultaneously working in the Netherlands.[38] Merian was a draughtsperson, painter, embroiderer, and printmaker, who possessed an intense interest in insects from early childhood, and went on to travel extensively for her research, particularly in South America, and publish both botanical and entomological texts (Fig. 4).[39] Her working methods included the use of a microscope to study her specimens, and after studying with Merian in the 1690s, Rachel Ruysch went on to apply all that she had learned of scientific illustration to the production of exquisite still life paintings with a level of detail that is unsurprising given her training.[40]

In England, Elizabeth Blackwell, who was in fact untrained as an artist, produced illustrations for and published *A Curious Herbal*, after learning from Sir Hans Sloane, then president of the Royal Society, that English physicians and botanists lacked an up-to-date illustrated guide to medicinal plants.[41] Beginning in 1715, and working from the Chelsea Physic Garden, she compiled a portfolio of five hundred drawings of plant species which she engraved and hand-coloured (Fig. 5). Blackwell is an excellent example of the initiative that came to be more acceptable for women to exercise in developing, funding, and producing her project without a patron or commissioner. She saw a need, stepped in to provide a remedy, and came out of the process a popular public scientist able to save herself and her husband from impending destitution.[42] Barbara Regina Dietzsch, a Bavarian painter of both botanical and zoological subjects, was raised in a family of naturalist-artists and engravers who were all employed by the Nuremberg court.[43] By this time the convention of painting a plant specimen against a blank white or off-white setting was standard practice, but Dietzsch placed her subjects against a black background, enacting a Caravaggesque effect of bringing the image forward into three dimensions (Fig. 6). Dietzsch's artistic career shows that though she was primarily working in a family studio, her contributions and those of her colleagues were afforded equal worth and credit.

A final distillation of the pre-photographic trend towards hyperrealistic and expressive depictions of natural subjects can be found in the works of French artists Madeleine Françoise Basseporte and Marie-Thérèse Reboul Vien, who achieved great renown in their respective lifetimes in eighteenth-century France. Basseporte was a portraitist and botanical illustrator who became the French king's official *peintre des plantes* at the Jardin du Roi, the only woman ever to hold this position, which she kept for almost half a century. Reboul Vien was an illustrator of scientific volumes, a painter of natural history, and a member of the prestigious Académie royale, which admitted just fifteen women in its 145-year history. Both artists received commissions from private collectors as well as authors of scientific publications which were engraved and reprinted for a wider readership.

38 Lindkvist, 'Women Illustrators of Natural History in the Enlightenment', pp. 190–92.
39 Tomasi, '"La femminil pazienza"', pp. 171–76; Lindkvist, pp. 186–89.
40 Tomasi, '"La femminil pazienza"', p. 177.
41 Tomasi, '"La femminil pazienza"', p. 180.
42 Pardoe and Lazarus, 'Images of Botany', pp. 547–67.
43 Tomasi, '"La femminil pazienza"', pp. 169–71.

Fig. 5. Barbara Regina Dietzsch (German, 1706–1783), or Maria Sibylla Merian (German, 1647–1717 (active Holland)), *A Sprig of Flowers with Two Insects*, seventeenth – eighteenth century. Courtesy of Harvard University Art Museums.

Fig. 6. Marie-Thérèse Reboul Vien (French, 1735–1806), Plate I in Michel Adanson's *Histoire naturelle du Sénégal, coquillages* (Paris: 1757). Biodiversity Heritage Library.

Reboul Vien's husband, Joseph-Marie Vien, includes in his memoirs a story of her 'discovery' as an artist that gives us an insight into the character of her early work, as much of her oeuvre has been misplaced or lost entirely over time. According to the anecdote, the man who would become a lifelong protector and promoter of the Viens, the Comte de Caylus, came upon what he thought was a three-dimensional preserved specimen of a moth, only to find that it in fact was a miniature painted by the young Marie-Thérèse Reboul. Vien goes on to say that the painting's owner laughed at the Comte's error, remarking that he was 'taken in just like the others'. I imagine this picture to have been akin to one of Cornelia de Rijk's astonishing insect studies in terms of its trompe l'oeil potential to dupe the viewer, enacting a visuality that, as Diderot said of one of Reboul Vien's later pictures, does the same work as a preserved specimen to be scientifically examined in a collector's cabinet. One striking example of Reboul Vien's work which has survived is *Two Pigeons on a Tree Branch* (Musée du Louvre). Liveliness is captured not just in accurate portrayals of feathers and anatomical pose, but in the glint of each pigeon's small, dark eyes, and the picture serves as an excellent example of the level of detail Reboul Vien employed to vivify and dynamise her ornithological subjects. It is my supposition, too, that Reboul Vien had a hand in furnishing the natural elements, particularly birds and flowers, in her husband's work, much in the same way that Frans Snyders and Jan Brueghel the Elder had for Rubens a century earlier.

The naturalist women artists of early modern Europe, displaying undeniable aptitude for invention, rapidity of pace, and lifelikeness, overturned gendered assumptions of female artistry in such a way that, though they were not yet counted as equals, by the end of the period the criticism they received included praise for capabilities which were previously thought impossible for the feminine hand. In a period when admission to professional institutions was categorically denied, in the case of scientific academies, or severely limited, in the case of arts academies, to half of the population, the women who strategically navigated a career between and including both realms began to do the work of whittling away received classical ideas of gender disparity. We cannot ignore that though the widespread call for exactitude and direct observation in the making scientific images, capabilities that women were widely-acknowledged to possess, allowed women to work publicly in greater and more prestigious capacities, the language of criticism was slow to change, and it is only in the later twentieth century that we see the careers of these artists begin to be excavated, reevaluated, and given their due in both scholarly and popular literature. The role of the art historian now remains to carry on the legacy left us by these artist-scientists, who, patiently and diligently, affirmed that there are no natural relations of inferiority or superiority dictated by biological sex, and that the arts and the sciences were co-created by women and men.

Selected Bibliography

Primary Sources

Adanson, Michel, *Histoire naturelle du Sénégal, coquillages: avec la relation abrégée d'un voyage fait en ce pays, pendant les années 1749, 50, 51, 52 & 53* (Paris: C.-J.-B. Bauche, 1757)

Blackwell, Elizabeth, *A Curious Herbal* vol. I (London: Samuel Harding, 1737)

⸻, *A Curious Herbal* vol. II (London: Samuel Harding, 1739)

Castilhon, Jean, and Louis Poinsinet de Sivry, 'Notice sur Mademoiselle Basseporte, peintre du roi', in *Nécrologe des hommes célèbres de France, par une société de gens de lettres*, vol. XVI (Paris: Chez Moutard, 1781)

Ferrari, Giovanni Battista, *De florvm cvltvra libri IV* (Rome: Excudebat Stephanus Paulinus, 1633)

Fuchs, Leonhart, *De historia stirpivm commentarii insignes* (Basel: Officina Isingriniana, 1542)

Perrot, Catherine, *Les leçons royales, ou La manière de peindre en mignature les fleurs et les oyseaux* (Paris: Jean B. Nego, 1686)

Secondary Studies

Blunt, Wilfrid and William T. Stearn, *The Art of Botanical Illustration* (Woodbridge, Suffolk: Antique Collectors' Club in Association with the Royal Botanic Gardens, Kew, 1994)

Cropper, Elizabeth, 'Preface', in *The Art of Natural History: Illustrated Treatises and Botanical Paintings, 1400–1850*, ed. by Therese O'Malley and Amy R. W. Meyers (Washington; New Haven: National Gallery of Art; Yale University Press, 2008), pp. 7–9

Daston, Lorraine and Peter Galison, *Objectivity* (New York; Cambridge, MA: Zone Books; MIT Press, 2007)

Fidière, Octave, *Les femmes artistes à l'Académie royale de peinture et de sculpture, par Octave Fidière* (France: Charavay Frères, 1885)

Frasca-Spada, Marina and Nicholas Jardine, eds, *Books and the Sciences in History* (Cambridge; New York: Cambridge University Press, 2000)

Gaehtgens, Thomas W. and Jacques Lugand, *Joseph-Marie Vien: peintre du Roi (1716–1809)* (Paris: ARTHENA, 1988)

Gelbart, Nina Rattner, 'Adjusting the Lens: Locating Early Modern Women of Science', *Early Modern Women*, 11.1 (2016), 116–27

Heurtel, Pascale and Michelle Lenoir, *The Art of Natural History: Botanical Illustrations, Ornithological Drawings, and Other Masterpieces from the Age of Exploration*, trans. by Molly Stevens (New York; Paris: Rizzoli International Publications; Muséum National D'Histoire Naturelle, 2018)

Hottle, Andrew D., 'Present but Absent: The Art and Life of Madame Vien', *Southeastern College Art Conference Review*, 16.4 (2014), 424–42

Jacobs, Fredrika Herman, *Defining the Renaissance Virtuosa: Women Artists and the Language of Art History and Criticism* (Cambridge; New York: Cambridge University Press, 1997)

Kahng, Eik and Marianne Roland Michel, eds, *Anne Vallayer-Coster: Painter to the Court of Marie-Antoinette* (Dallas; New Haven: Dallas Museum of Art; Yale University Press, 2002)

Kusukawa, Sachiko, 'Illustrating Nature', in *Books and the Sciences in History*, ed. by Marina Frasca-Spada and Nicholas Jardine (Cambridge; New York: Cambridge University Press, 2000), pp. 90–113

Lafont, Anne, ed., *1740, Un abrégé du monde: Savoirs et collections autour de Dezallier d'Argenville* (Lyon: Fage éditions, 2012)

Lindkvist, Julia, 'Women Illustrators of Natural History in the Enlightenment', in *Science and the Visual Image in the Enlightenment*, ed. by William R. Shea (Canton, MA: 2000), pp. 185–212

Meeker, Natania and Antónia Szabari, 'Inhabiting Flower Worlds: The Botanical Art of Madeleine Françoise Basseporte', *Arts Et Savoirs*, 6 (2016), 1–15

O'Malley, Therese and Amy R. W. Meyers, eds, *The Art of Natural History: Illustrated Treatises and Botanical Paintings, 1400–1850* (Washington; New Haven: National Gallery of Art; Distributed by Yale University Press, 2008)

——— and ———, 'Introduction', in *The Art of Natural History: Illustrated Treatises and Botanical Paintings, 1400–1850*, ed. by Therese O'Malley and Amy R. W. Meyers (Washington; New Haven: National Gallery of Art; Yale University Press, 2008), pp. 9–16

Pardoe, Heather and Maureen Lazarus, 'Images of Botany: Celebrating the Contribution of Women to the History of Botanical Illustration', *Collections: A Journal for Museum and Archives Professionals*, 14.4 (2018), 547–67

Pomeroy, Jordana, Laura Auricchio, Melissa Lee Hyde, and Mary D. Sheriff, *Royalists to Romantics: Women Artists from the Louvre, Versailles, and Other French National Collections* (Washington, DC; London: National Museum of Women in the Arts; Scala Publishers, 2012)

Ratouis de Limay, Paul, *Le pastel en France au XVIIIème siècle* (Paris: Éditions Baudinière, 1946)

Tongiorgi Tomasi, Lucia, '"La femminil pazienza": Women Painters and Natural History in the Seventeenth and Early Eighteenth Centuries', in *The Art of Natural History: Illustrated Treatises and Botanical Paintings, 1400–1850*, ed. by Therese O'Malley and Amy R. W. Meyers (Washington; New Haven: National Gallery of Art; Yale University Press, 2008), pp. 161–88

Saunders, Gill, *Picturing Plants: An Analytical History of Botanical Illustration* (Berkeley: University of California Press in Association with the Victoria and Albert Museum, London, 1995)

Schiebinger, Londa L., *The Mind Has No Sex?: Women in the Origins of Modern Science* (Cambridge, MA: Harvard University Press, 1989)

Shea, William R., ed., *Science and the Visual Image in the Enlightenment*, European Studies in Science History and the Arts, 4 (Canton, MA: Science History Publications, 2000)

Sheriff, Mary D., *The Exceptional Woman: Elisabeth Vigée-Lebrun and the Cultural Politics of Art* (Chicago: University of Chicago Press, 1996)

LUANA TESTA

Women's Hands[*]

Female Art: A Story of Upheaval?

▼ **ABSTRACT** The aim of this article is to analyze the historical and philosophical ideas that led women to oblivion or to struggle to have access to the arts. In human history, women have not always been limited to achieve high profile social roles. During the Late Middle Ages many women attempted to free themselves from the roles imposed by classic and religious culture. That time was characterized by harsh conflicts which often ended in repression and *ad hoc* laws. However, it was also a time that laid the foundation for women's realization and a new conception of the man-woman relationship. Two centuries later, the patriarchal culture, supported by a ruthless alliance between religious and philosophical ideas, led them to a new time of oppression.

I would like to start this discussion by diving into the past. 'Women's hands' which gives this article its title, refers to the discovery made by the American archeologist Dean Snow. He revealed that most of the handprints found in prehistorical caves belonged to women.[1] His finding brought into question historians' beliefs about the female role in cave painting. As a result, archeologists hypothesized that at the dawn of humanity, men and women had equal roles in life. However, when archeology was born, this idea could have never been conceptualized due to the existence of multiple stereotypes about social organization in prehistorical times. This is what the French historiographer Marylène Patou-Mathis proposes in her recent publication *L'homme préhistorique est aussi une femme – Une histoire de l'invisibilité des femmes.*[2] She believes that the culture of the time had strongly affected researchers' interpretation. When prehistorical scientific studies were first carried out, Positivism had already negatively

[*] The Author wishes to thank Ilaria Rocchi for the translation of this work.

[1] Studies carried out by the biologist John Manning contributed to this discovery. By using morphometric measurements and algorithmic calculation, the researcher established that 75% of handprints belonged to women.

Snow, 'Sexual dismorphism in Upper Paleolithic hand stencils', pp. 390–404; Snow, 'Sexual dismorphism in European Upper Paleolithic Cave Art', pp. 746–61.

[2] Patou-Mathis, *La preistoria è donna. Una storia dell'invisibilità delle donne.*

Women in Arts, Architecture and Literature: Heritage, Legacy and Digital Perspectives, ed. by Consuelo Lollobrigida and Adelina Modesti, Women in the Arts: New Horizons, 1 (Turnhout: Brepols, 2023), pp. 303–314

BREPOLS ⚜ PUBLISHERS
10.1484/M.WIA-EB.5.134658

impacted beliefs about women. Consequently, one may wonder, what occurred after women's participation in the earliest forms of art was ascertained and the existence of equality between men and women in primitive populations had been hypothesized?

This question appears to be relevant, since many studies published in recent decades have brought to light the stories of many exceptional women in the fields of art, literature, and science. Despite the considerable fame and wide recognition achieved at the time, many of these women have been forgotten. This is what emerges from many articles in this volume as well as from the abundant literature which over the last decades has widened our knowledge on this topic.

I am a psychiatrist and psychotherapist and I believe that the reason why I have joined this collective project is related to the fundamental research carried out in my profession on both physiological and pathological human dimensions.

Firstly, the aim of this discussion is to investigate, by making use of my knowledge and personal experience, the reasons that led to this oblivion of women's creativity. Secondly, this research will try to elucidate what happened from a certain moment in history and especially the underlying causes.

By paraphrasing the famous question suggested by Nochlin,[3] one wonders why women struggled to succeed in the artistic field and even when they did during some historical periods, why the continuity of this process was not observed but rather a sort of *damnatio memoriae* of previous female artists was cast? In this contribution I will explore a different point of view, which will go beyond rigidly feminist positions and socio-economic interpretations. The latter has already been discussed both in scientific literature and in the text authored by Nochlin. During my research, I came across *Il calibano e la strega*, a compelling book written by the Marxist and feminist historiographer Silvia Federici.[4] This volume, which attempts to synthesize two positions, deals with the transition from feudal society to Capitalism during the Middle Age. The author claims that during this historical period the cruel and definitive affirmation of a paternalist and misogynistic culture occurred. On the other hand, the historiographers' analysis reports many stories of rebellion and emancipation against the feudal system. Both men and women strove to create communities based on principles such as equity between sexes, sharing of goods and solidarity at the base of social relationships. These were rural communities where a new vision of social relationship between sexes seemed to arise. Among them, the most famous included the Cathars, Albigenses, later the Taborites together with many lesser-known small communities. The late Middle Age was a time marked by these movements which, however, soon disappeared as a result of daily cases of violent repression and slaughter.

Nevertheless, crucial changes came about in the medieval cities around the fourteenth century. The establishment of a new social class took place together with an increasing phenomenon of female emancipation. This event was favored by the severe famine of 1315–1317 and by the well-known Black Death epidemic in the middle

3 Nochlin, *Perché non ci sono state grandi artiste*.
4 Federici, *Il Calibano e la strega. Le donne, il corpo e l'accumulazione originaria*.

of the century. On one hand this tragic event led to the death of more than 50 per cent of the European population and on the other to new work positions available for the survivors. Women started working as teachers, surgeons,[5] and being involved in activities traditionally considered as male professions which allowed them to become independent and live autonomously. However, the turn that social organization was taking frightened the political reality of that time. Consequently, many laws were introduced to negatively impact women, with the aim to bring them back to the role of procreation or, as specifically affirmed by Federici, to the role of factories of human beings which were used for labor and military exploitation in the nascent capitalistic society.

In those years, in many areas of Europe, rape and group violence was either decriminalized or tolerated. Prostitution was institutionalized and terror spread due to the witch hunt. This phenomenon particularly affected those women who had gained medical knowledge becoming able to assist childbirth.[6]

Therefore, it became increasingly difficult for women to manage themselves and to live independently. The bond of marriage and the protection offered by a man became more and more necessary for women to survive. Despite this, between the fourteenth and the seventeenth century, many women including not only the wealthy and aristocrats, courageously challenged the deadly atmosphere spread all over Europe and succeeded in the fields of arts and literature.

As an example of the historical period discussed, it is worth mentioning the famous Christine de Pizan. At the end of the fourteenth century at the early age of twenty-five, Pizan became a widow. Despite the difficulties she strove to support her three children, elderly mother, and niece with her profession as a writer. With her work *The Book of the City of Ladies* from 1405, she revitalized *la Querelle des femmes*.[7] This refers to the well-known debate on the nature and relationship between sexes which had been started by some female theologists and mystics in the twelfth century. In the fifteenth century the debate was fueled by Christine's bold statement who affirmed 'There are no differences in the spirit's value of men and women. Although more fragile, women's bodies are as perfect as men's bodies.'[8] Consequently, the debate spread in many cultural environments involving both male and female clerics, politicians, and philosophers.

Despite enduring considerable hardship, women established themselves in the artistic field from at least the second half of the fifteenth century. It is relevant to highlight how Federici, thoroughly analyzed and pinpointed the impact of four

5 However, it is relevant to mention that the famous Salernitan Medical school was established in the ninth century, and it was run by the *Mulieres salernitanae* among which Trotula de Ruggiero was the most important. Fumagalli and others, *Medioevo al femminile*. Greco, *Trotula. La prima donna medico d'Europa*.

6 I do not intend to expand on this topic. However, it is known so far that the first court process against witches was held at the end of the sixteenth century. Nevertheless, it wasn't until the subsequent centuries that the most cruel and violent persecutions against them began. The most famous treatise on this phenomenon *Malleus Maleficarum* was written in 1486. Federici, *Il Calibano e la strega. Le donne, il corpo e l'accumulazione originaria*, p. 73.

7 Duby and Perrot, *Storia delle donne, Il Medioevo*.

8 Bock, *Le donne nella storia europea. Dal Medioevo ai giorni nostri*.

centuries of violent culture and *ad hoc* legislation to bring back women into the domestic sphere and to reaffirm male control and dominance in private life. This clearly shows that the gender debate is a cultural rather than a biological issue, which is further demonstrated by the absence of the same debate in many Native American population free from certain ideologies.[9] With the aim of deeply understanding what happened, it is necessary to analyze the seventeenth century. This was a time of transition, full of contrasts and contradictions. By looking at the philosophical movements common at that time, two main currents can be identified.[10] On one hand, one movement attempted to free itself from religious influences by proposing a more secular approach in the observation of natural phenomenon. It was the time of Galileo, Bacon, Kepler, Newton who, with their studies based on experimental evidence, marked the origin of the modern scientific method. On the other hand, there was an attempt to establish a co-existence, soon turned into connivence, between religious principles and a more secular way of thinking. However, the result turned to be disastrous especially for women. With his negative and mechanistic idea about human beings, Hobbes claimed that both body and mind are governed by automatic and unmodifiable functioning mechanisms. Human beings would naturally tend towards self-affirmation and aggressive and violent dominance towards the other. These instincts can be controlled only by religious and political power which is in turn supervised by reason.[11] According to Descartes, the body represents an evil part, a burden and obstacle for the higher activity of the mind. This is considered as a direct divine manifestation, therefore defining a negative anthropology that pursues a split between body and mind. Everything belonging to the body weakens the purity of thought. Therefore, emotions and passions must be controlled and dominated. Moreover, one must distrust body sensibility since this is considered as misleading. Conscious thought is the only form of thinking considered reliable. This proceeds according to a rational logic and expresses itself through verbal language, which are all characteristics defining the modern Adam. The question that arises is how one may possibly experience a relationship with a woman, descendant of Eve, if men need to free their thoughts from their own body's passions. Desire experienced in a relationship with a woman, frightened sixteenth century thinkers, diverting their attention from important duties. Women are prey of passion, which make them vulnerable and fragile. Moreover, their physical biological creativity which makes them able to give birth to a new human being would uniquely be the result of men's activity. Because of their semen, men are turned into creators as God, who himself is male. Until the beginning of the nineteenth century, although many scientists

9 Naskapi from Quebec represent an example. They had been persuaded by Jesuit missionaries to exert violence against women and children with whom they had lived harmoniously. Federici, *Il Calibano e la strega. Le donne, il corpo e l'accumulazione originaria*, p. 162.

10 Federici, *Il Calibano e la strega. Le donne, il corpo e l'accumulazione originaria*, pp. 177–204.

11 As claimed by the philospher Marramao in the recent article *Linguaggio, civiltà, autoinganno*, the Hobbesian anthropologist considerably influenced the Freudian ideas originating from the book 'Totem and tabu' until the *Disagio della civiltà*. Marramao, 'Disagio della civiltà Linguaggio, civiltà, autoinganno. Da Freud a Hobbes'. Freud, *Totem e tabù*. Freud, *Il Disagio della civiltà*.

had hypothesized and supported with scientific evidence that fertilization must have occurred according to other physiological laws, it was still believed that the male was uniquely responsible.[12] This conception represented a modern revival of old ideas belonging to the Greek logos. This was dominated by the Aristotelian principle of non-contradiction which could not accept that body diversity would not lead to non-equal mental capabilities.[13] As a result of the establishment of monotheistic religions which had been historically interposed between the classical world and the century here analyzed, these ideas became reinforced even more. The bond between reason and religion was forged and at the same time the dichotomy between genders deepened: pregnancy, breeding of the offspring and physical reality belonged to women; thought, genius, spiritual abilities and natural talent, which women lack, belonged exclusively to men.

Men and women became associated respectively with rational and irrational dimensions. The latter was defined irrational since it was considered a negation of the rational form of thinking, a form of non-thought. This adjective was then used to define those lacking that kind of thinking, which were seen as non-human.[14]

Even if it is considered a turning point in western culture, the French Revolution did not bring significative changes to women's lives. The movement was profoundly influenced by the Enlightenment's principles that were also responsible for condemning Olympe de Gouges to the guillotine. This woman was not an aristocrat, but rather a daughter of the people, a writer, playwright, and politician. She was sentenced to death because of her harsh criticism towards an ideology which on one hand claimed that all men were equal, and at the same time neglected and disregarded women and slaves' lives.[15] The newspaper *Le Moniteur universel*, which had been the French Government's official organ since 1789, a few days after her execution in 1792 would publish an article about her:

> she was born with a wild imagination; she confused her delusion for a natural inspiration… the laws seem to have condemned this conspirator for forgetting the virtues innately inherent to her gender.[16]

12 At that time the ancient epigenetic Aristoteles theory was still widespread. According to this, the male sperm had an active role in fertilization compared to the passive role represented by the female matter. Nevertheless, many scientists had begun to be interested in the ovist theory. In contrast, this theory hypothesized the presence of a miniaturist embryo inside the oocyte. However, around the second half of the seventeenth century a further third theory was formulated by the Netherland School. According to this line of thought, the miniaturist embryo could be found also in the spermatozoa. This last theory remained prevalent until the second half of the XIX century. Barsanti, *L'età dei lumi: le scienze della vita*.

13 Aristotele, *Metafisica*.

14 Fagioli, 'La ragione che genera mostri genererà qualcosa di nuovo quando renderà libero ciò che non è sè stessa'. Fagioli, *Atti del convegno: Crisi del freudismo e prospettive della scienza dell'uomo*.

15 Mousset, *Olympe de Gouges e i diritti della donna*. The French revolution marked the end of female freedom: women who had been at the frontline of the demonstration were excluded from the right to obtain citizenship. After the Revolution, The Royal Academy was turned into the Academy of Royal Arts and in the statute, women had not been guaranteed any right to education. Last but not least, in 1804, Napoleon established the jurisdictional incapability of women in the civil code, which had drastic consequences on their opportunities in the artistic field. *Quattro secoli di arte al femminile*, ARTE France.

16 Mousset, *Olympe de Gouges e i diritti della donna*, p. 110.

According to that time, she seemed to be guilty of her own imagination. For the same reason, Franz Mesmer, the doctor who formulated the animal magnetism theory, had been condemned in 1784.[17] In *Leviathan*, Hobbes specifically referred to him when stating 'this sense has lost vividness and can be found in many living creatures, both in sleep and wakefulness'.[18] In these lines, the philosopher deprives imagination of creativity and human specificity. It can be inferred that Olympe was doubly guilty because of her imagination and gender. Why did this happen? It is necessary to investigate where and how images are formed. The lack of understanding of this process, leads to the false misconception about their origin, which is considered either supernatural and attributed to men or evil and therefore attributed to women. In the eighteenth century, positivism represented a point of no return. The movement exploited pseudoscientific speculation on anthropometric data to scientifically claim the inferiority of all those who were not men, adult, white and socially wealthy. Therefore, the logical and rational syllogism based on the idea that women, children and Native Americans were inferior human beings was strengthened further. Compared to men, they were characterized by a different body shape. Consequently, they were considered to have either a different form or complete absence of thinking leading to the assumption that they were not fully human.

Artists were also added to the blacklist in history; in their dissolute and irrational life, they gave shape to mysterious, deformed, and flawed images. The dramatic effects that this terrible ideology led to are well known.[19] Do we think that women were fooled by these ideas? It is crucial to recall that when Olympe de Gouges was executed, many women witnessing the event applauded, revealing the perverse alliance that existed between women and the same misogynistic culture that neglected them.[20]

The main issue was that women were immersed in that kind of culture, and I believe they still are.

The question arising is: how can we come out of this? In an effort to better understand what could allow to solve the millenary female question, it is important to trace some hints present in the historical period previously discussed. It is important to investigate what happened during the seventeenth century, a time in which women had been dramatically persecuted. In this historical period, it is possible to identify the roots of a philosophical movement that subsequently influenced the development of specific cultural ideas still present in our modern way of thinking. As often occurs in history, in this same period another current of thought *in nuce* could have potentially developed a new anthropological view. At the beginning of the century Giordano Bruno had been burnt at the stake. The philosopher who had been accused of heresy, was sentenced to death by the Roman Inquisition. He had claimed that thought stems

17 Ellenberger, *La scoperta dell'inconscio. Storia della psichiatria dinamica*. Armando, 'Il magnetismo animale tra scienza, politica e religione. Nuove fonti e linee di ricerca', pp. 10–30.

18 Hobbes, *Dell'immaginazione*.

19 Dario and Others, *Psichiatria e psicoterapia in Italia dall'Unità ad oggi*, pp. 101–07.

20 Bock, *Le donne nella storia europea*, p. 95.

from images and that 'intellect is either phantasy or it is nothing without it.'[21] Beyond this specific statement, most of the philosopher's work attempted to investigate the meaning of images and the way thoughts are formed. Bruno observed how '…core meaning which gather different contents, are not rational and abstract but rather channel together even when they stem from the so-called internal senses.'[22]

In other words, Bruno affirmed that imagination is a mental space in which a synthetical process is triggered between what is perceived through the senses in the outer world and personal internal elements linked to one's own memory. Fantasy is an essential mean through which the learning process takes place, involving emotional, affectional rational and intellectual elements.[23]

Bruno's research was abruptly interrupted by his death sentence which made the possibility of finding another way of thinking beyond religion and rationality disappear.

'Tell me where is fancy bred, or in the heart, or in the head?'[24] wondered Shakespeare around the same time in history when he wrote *The Merchant of Venice* between 1596 and 1598. This kind of thought was considered by Greek philosophers and sixteenth century thinkers as misleading because too closely linked to the body's sensations. This thought appears in the silent images of the night and artists are able to turn them into a reality in the conscious state. However, the mystery and incomprehensibility surrounding night's images turned them into evil for religion and unknowable matter for rationality. But it is precisely this kind of thought that makes us all equally human: men, women, children, white, blacks, Asians. The psychiatrist Massimo Fagioli, with his theory and practice, stated that all humans, regardless of their gender, have the capability to imagine. This capability originates at birth from a specifically human reaction to the light stimulus.[25] It is necessary to deepen this theory, whose comprehension and integration in culture would allow to overcome the split between body and mind and male and female. Fagioli's Human Birth Theory does not identify logical-rational thought as a unique human characteristic. This appears only sometime after birth and fully develops around the sixth year of life. In contrast, thought is conceived as a purely human activity which begins at birth as a capability to think through images. This capability does not come from nowhere and is neither divine, but rather originates from a specific reactivity of the human

21 'intelligere est phantasmata speculari, et intellectus est vel phantasia vel non sine ipsa': Bruno, *Explicatio triginta sigillorum*.

22 Matteoli, 'Intelletto, immaginazione e identità', pp. 147–66. Matteoli, 'Immaginazione, conoscenza e filosofia', pp. 17–38.

23 Matteoli , 'Intelletto, immaginazione e identità', p. 120.

24 Shakespeare, *Il mercante di Venezia* 'Tell me where is fancy bred, Or in the heart, or in the head?' In many editions, the term 'fancy' has been translated with the word 'love'. However, in those days the term was still used with its original meaning derived from phantasy as imagination although it encompassed meaning such as 'inclination, desire'. Rocchi, 'Dalla linguistica alla psichiatria', p. 95.

25 Fagioli, *Death Instinct and Knowledge*.
It is important to highlight that the whole theory of birth formulated by the psychiatrist Massimo Fagioli focuses on the origin and development of human thought. For further reference it is recommended to check the author's bibliography on the website: <http://www.lasinodoroedizioni.it/autori/1/massimo-fagioli>.

biological matter to light during childbirth. It is a defensive physiological activity against the extrauterine world which triggers a hormonal and neurochemical shock. The defensive mechanism against the light's *wound* triggers an annulment pulsion activity which makes the aggressive material reality disappear. However, the result is not a complete and irreversible *darkness*, because the cutaneous sensation which derives from the intrauterine interaction between the amniotic liquid and the biological fetal capability to react allows the newborn to realize in that moment the memory of one's own biological past. This becomes the image of one's own existence. What is realized is not only a physical but also a psychic existence. When talking about memory, Fagioli does not refer to a visual memory but rather to the creation of an image. This is considered as the first 'thought through images'. For many months before the acquisition of language, this unique and universal human characteristic will be the newborn's unique personal form of thought.

As if the process of closing the eyes against the light which suddenly hits the retina of the newborn who comes to the world, would allow the opening of the eyes towards an internal reality, which triggers the activity of the mind and the awareness of one's own existence. This transformative reactivity, which will occur in physiological condition throughout life is a mental creation that allows one to separate oneself from old personal dimensions. At birth, biological physical reality is strictly fused with the non-tangible but real form of thought. This is a non-conscious activity, which turns into fantasy when it develops in harmony with the awareness of conscious thought. This reality makes us creative human beings, unique among all species, who are certainly not the result of any divine activity.[26] This unique capability, which makes us all equal, becomes one's own originality and diversity in the way it expresses itself.

In physiological conditions, there is no division, conscious and non-conscious thought activity move together in harmony. In other words, even without awareness, oneiric thoughts which appear during the night are not in contrast with what is experienced in the conscious reality. They are two different forms of the same thought which physiologically move in different ways depending on the context. This separation between the oneiric and conscious dimensions is physiological. However, when the oneiric world is conceived as something frightening to disregard, or something dangerous or even non-human, a pathological splitting between these two dimensions may occur.[27] It is in the context of this thought-splitting, widely accepted and encouraged by the dominant culture, that appears even more clearly the deadly contraposition between rational and irrational. This has been historically transformed into a deleterious and often violent contraposition between men and women. On one

26 According to the Human Birth theory this transition occurs when the newborn recognizes him/herself in the mirror until the end of the first year of life. Fagioli, *Ricerca sulla verità della nascita umana*.

27 Some cultural ideas correlate rationality with healthy thoughts and irrationality with altered beliefs about reality. The latter would originate from deep fears or erroneous perceptions, therefore considering this form of thought as innately pathological. In physiological conditions irrationality expresses itself in two different forms which are in harmony with reality and behavior. Only with the onset of mental illness may thought alterations manifest in an irrational form if this is not in harmony with conscious thought. Or it may even manifest on a rational level in behavioral forms. Del Missier, 'Il femminile come immagine interna', pp. 215–22.

hand, rationality has always been considered as the only means to acquire knowledge for men; on the other, women have been associated with the irrational dimension of images and the body which was not considered valuable to gain knowledge. In contrast, only by avoiding the split between sexuality and knowledge is it possible to give back to men and women their creative potential. This was defined by Fagioli as *female image* which belongs to both. This internal image is denominated as *female image*, since it expresses itself in the conscious dimension through the biological characteristics of the female gender: receptivity, ability to be fertilized, and to give birth to a new human being. What happens on a biological level becomes the image of potential creativity of the human mind, which does not belong to any specific gender: letting yourself go in human relationships and being fecundated is at the base of the creative process which makes real outside oneself what has been internally transformed, giving origin to something that did not exist before.

In light of what has just been discussed, it may help to clarify why so much hostility was reserved for female and creative artists. It may be easier to understand the double guilt of Olympe: being a woman and capable of imagination, something unacceptably incomprehensible.

The human capability to react, determines the transformation of the relationship experienced through body sensibility, into images. This conception means to refuse any religious idea according to which images derive from Gods. However, it is destructuring for rational thought to accept that images are an elaboration of human experiences derived from body sensibility. This is because rational thought conceives images as the result of body and affection's annulment. This false assumption leads to the inability of rationality to answer to the millenary desire to discover where fantasy originates.[28] It subverts an idea, nurtured by secular ideologies which have never profoundly refused the Greek logos. An ideology absorbed by women themselves, who need to understand and refuse the principle that to realize our creativity is necessary to give life to a human being. The realization of our own creativity is profoundly connected to the recognition of our identity, equal and at the same time different from the man who we are in relationship with. And '…if the woman manages to realize her identity, if the man respects and supports her identity, the birth of human beings and the first year of life will probably allow the development of a man different from the one that has existed for thousands of years.'[29]

A new anthropology.

28 Montanino, 'Oltre il genere. Il femminile nell'arte', pp. 13–22.
29 Fagioli, 'La scultura blu', p. 15.

Bibliography

Primary Sources

Armando, David, 'Il magnetismo animale tra scienza, politica e religione. Nuove fonti e linee di ricerca', *Laboratorio dell'ISPF*, II (2005), 10–30

Barsanti, Giulio, 'L'età dei lumi: le scienze della vita. Dall'epigenesi al preformismo, all'epigenesi riformata', *Storia della scienza* (2002) <https://www.treccani.it/enciclopedia/l-eta-dei-lumi-le-scienze-della-vita-dall-epigenesi-al-preformismo-all-epigenesi-riformata_%28Storia-della-Scienza%29> [accessed august 2022]

Bruno, Giordano, '*Explicatio triginta sigillorum*', in *Opere mnemotecniche*, vol. II, ed. by M. Matteoli, R. Sturlese, and N. Tirinnanzi (Milan: Adelphi, 2009)

——, *Le ombre delle idee. Il canto di Circe. Il sigillo dei sigilli* (1582–1583), foreword by M. Ciliberto, trans. by N. Tirinnanzi (Milan: Rizzoli, 2008)

Freud, Sigmund, 'Totem e tabù', in *Opere 1912–1914*, 7 vols (Turin: Bollati, 1989)

——, *Il Disagio della civiltà, Opere 1924–1929*, 10 vols (Turin: Bollati, 1989)

Del Missier, Giovanni, 'Il femminile come immagine interna', in *Arte [eventualmente] al femminile*, ed. by V. Montanino and A. M. Panzera (Rome: Bordeaux, 2019), pp. 215–22

Di Leo, Mimma, *Olympe de Gouges, la causa delle donne e la Rivoluzione in Francia* (Venice: Centro Internazionale della Grafica di Venezia, 1990)

Dario, Mariopaolo, Giovanni Del Missier, Ester Stocco, and Luana Testa, *Psichiatria e psicoterapia in Italia dall'Unità ad oggi* (Rome: L'Asino d'oro, 2016)

Ellenberger, Henri Frédéric, *La scoperta dell'inconscio. Storia della psichiatria dinamica*, trans. by W. Bertola, A. Cinato, F. Mazzone, R. Valla. vol. I (Turin: Bollati, 1976)

Fagioli, Massimo, *Istinto di morte e conoscenza* (Rome: L'Asino d'oro, 2017)

—— (1972), *Death Instinct and Knowledge* (Rome: L'Asino d'oro, 2019) <http://www.lasinodoroedizioni.it/autori/1/massimo-fagioli>

——, *Atti del convegno Crisi del freudismo e prospettive della scienza dell'uomo, Napoli 8–9 ottobre 1999*, ed. by Fiori Nastro, Paolo, Homberg, Anna, and Masini Federico (Rome: N.E.R., 2000)

——, 'La scultura blu', *Il Sogno della farfalla* I (2006), 9–15

——, *Ricerca sulla verità della nascita umana. 40 anni di Analisi collettiva, Atti Aula magna, 'Sapienza' Università di Roma, 30 ottobre, 6 novembre 2015* (Rome: L'Asino d'oro, 2016)

——, *Left 2016/2017* (Rome: L'Asino d'oro, 2019)

Federici, Silvia, *Il calibano e la strega. Le donne, il corpo e l'accumulazione originaria*, trans. by L. Vincinelli (Sesto San Giovanni: Mimesis, 2015)

Hobbes, Thomas, *Leviatano*, foreword and trans. by R. Giammanco (Turin: Unione tipografico, 1955)

Marramao, Giacomo, 'Disagio della civiltà Linguaggio, civiltà, autoinganno. Da Freud a Hobbes', *Rivista di psicoanalisi*, LXVI.3 (2020), 697–709

Matteoli, Marco, 'Immaginazione, conoscenza e filosofia: l'arte della memoria di Giordano Bruno' in *Bruno nel XXI secolo. Interpretazioni e ricerche. Atti delle giornate di studio* ed. by Simonetta Bassi (Florence: Leo Olschki, 2012), pp. 17–38

———, 'Intelletto, immaginazione e identità: la forza della contractio in Sigillus sigillorum di Giordano Bruno', *Lo Sguardo Rivista di filosofia*, 10 (2012), 147–66

Merchant, Carolyn, *La morte della natura. Le donne, l'ecologia e la rivoluzione scientifica* (Milan: Garzanti, 1988)

Montanino, Veronica and Panzera Anna Maria, *Arte [Eventualmente] Femminile* (Rome: Bordeaux, 2019)

Mousset, Sophie, *Olympe de Gouges e i diritti della donna*, trans. by A. R. Galeone (Lecce: ARGO, 2005)

Nochlin, Linda, *Perché non ci sono state grandi artiste?*, foreword by M. A. Trasforini, trans. by J. Perna (Rome: Castelvecchi, 2020)

Patou-Mathis, Marylène, *La preistoria è donna. Una storia dell'invisibilità delle donne* (Florence: Giunti, 2021)

Quattro secoli di arte al femminile, movie directed by M. Blanco, produced by ARTE France- Ex Nihilo (2015), Online video recording, YouTube, 9 April 2019 <https:// www.youtube.com/watch?v=aq18wo7blLQ> [accessed august 2022]

Rocchi, Ilaria, 'Dalla linguistica alla psichiatria', *Il Sogno della farfalla*, I (2022), 91–106

Snow, Dean R., 'Sexual Dismorphism in Upper Paleolithic Hand Stencils', *American Antiquity*, 80 (2006), 390–404

———, 'Sexual Dismorphism in European Upper Paleolithic Cave Art', *American Antiquity*, 78 (2013), 746–61

Secondary Studies

Abbagnano, Nicola, *Storia della filosofia*, vols 3–4 (Turin: UTET, 1999)

Aristotele, *Metafisica*, Libro Gamma, 1005 b 19–20 (Milan: Bompiani, 2000)

Bertini, Ferruccio, Franco Cardini, Mariateresa Fumagalli, Beonio Brocchieri, and Claudio Leonardi, *Medioevo al femminile* (Rome: Laterza, 2018)

Bock, Gisela, *Le donne nella storia europea. Dal Medioevo ai giorni nostri* (Rome: Laterza, 2017)

Castellani, Carlo, *La storia della generazione dal mito alla scienza* (Milan: Longanesi, 1965)

Cosmacini, Paola, *Un legame sottile. Madame Boivin, Monsieur Tarnier e l'ostetricia* (Milan: Baldini, 2019)

Duby, Georges and Perrot Michelle, *Storia delle donne*, vol. 2, *Il Medioevo*, ed. by C. Klapisch-Zuber (Rome: Laterza, 1994)

Greco, Pietro, *Trotula. La prima donna medico d'Europa* (Rome: L'Asino d'oro, 2020)

Klapish-Zuber, Christiane, *Il Medioevo, Storia delle donne*, ed. by G. Duby and M. Perrot (Rome: Laterza, 1994)

Le Goff, Jacques, *Il corpo nel Medioevo*, trans. by F. Cataldi Villari (Rome: Laterza, 2021)

Lollobrigida, Consuelo, *Plautilla Bricci. Pictura et Architectura Celebris. L'architettrice del Barocco Romano* (Rome: Gangemi, 2015)

Shakespeare, William, *Il mercante di Venezia* (Rome: Garzanti, 1982)

Zemon, Davis and Natalie Farge Arlette, 'Dal Rinascimento all'età moderna', in *Storia delle donne in Occidente*, vol. 3, ed. by G. Duby and M. Perrot (Rome: Laterza, 1995)

PART 5

Modern and Contemporary

TANIA ALBA RIOS

'The Process of Sculpture'*

A Defense against Fraud Accusation

▼ **ABSTRACT** This contribution focuses on two brief texts by the Watertown-born sculptor Harriet Hosmer (1830–1908): a technical text entitled 'The Process of Sculpture' and the satirical poem 'The Doleful ditty of the Roman Caffe Greco'. The pieces were written in response to the controversy surrounding the professional success of a group of North American female sculptors living in Rome during the second half of the nineteenth century. These texts are an important source in art literature not only because they present the social landscape of sculpture and its practitioners during that period, but also for addressing technical and aesthetic aspects about the discipline's artistic language.

This contribution examines the writings of women artists and focuses, in particular, on two brief texts by the Watertown-born (Massachussets) sculptor Harriet Hosmer, born in 1830. The pieces were written in response to the controversy surrounding the professional success of a group of North American female sculptors in Rome. These texts are an important source in art literature for two reasons. In the first place, they present the social landscape of sculpture and its practitioners during that period. Secondly, they address technical and aesthetic aspects about the discipline's artistic language.

The aim of this contribution is to examine Hosmer's writings in order to unfold the situation of professional sculptresses in the mid-nineteenth century with a particular focus on the nature of the arguments used as a defense and vindication of equality. To begin with, let's outline the context of this controversy and the debates that ensued.

In the mid-nineteenth century, artist professionalization was very difficult to achieve for women. For the artistic discipline of sculpture, the troubles were even greater: resources for technical training in sculpture were scant. In addition, this artistic field was considered improper for women. When a group of American

* This work is framed by the research project 'Entre ciudades: el arte y sus reversos en el período de entre siglos (XIX-XX)'. Funded by the Ministerio de Ciencia e Innovación (PID2019-105288GB-100).

Women in Arts, Architecture and Literature: Heritage, Legacy and Digital Perspectives, ed. by Consuelo Lollobrigida and Adelina Modesti, Women in the Arts: New Horizons, 1 (Turnhout: Brepols, 2023), pp. 317–328

BREPOLS ❧ PUBLISHERS 10.1484/M.WIA-EB.5.134659

Fig. 1. Harriet Hosmer, *Zenobia in Chains*, Saint Louis, Saint Louis Art Museum. *c.* 1859. Photo released into public domain by Saint Louis Art Museum.

sculptresses began to arrive in Rome in 1852 under the protection of the prominent actress Charlotte Cushman, who provided them with artistic patronage, they found good marble quarries, skilled carvers, and they had the opportunity to study directly classical sculpture. There, they also found a good environment to live in and create with a freedom that they could not have in America. There was a little community of intellectuals, artists and businessmen, who mostly settled between Via del Corso and Via Gregoriana. Some of them were sculptors who had gone to Rome a few decades before in search of the traditions and material resources that were inexistent in America.

In the 1860s, the increasing success of sculptresses Harriet Hosmer, Emma Stebbins, Vinnie Ream, Edmonia Lewis, and others, sparked off professional jealousy among their male counterparts. They accused them both of not executing their own works and of a lack of true talent. Harriet Hosmer, however, had by then achieved international recognition. She had received some training from the sculptor Peter Stephenson in Boston. And, despite the fact that women were not allowed to attend medical school, she had had the opportunity to study anatomy at the Washington University medical school thanks to the help of her friend's father and patron, Wayman Crow. When Hosmer arrived in Rome, she became the pupil of the renowned-Welsh sculptor John Gibson. In addition to undertaking some private commissions, in 1857 she finished her *Tomb of Judith Falconet* for Sant'Andrea Della Fratte, becoming the first American artist to have a sculpture permanently installed in a Roman Catholic church. In 1862, she won a major competition for a bronze statue of Thomas Hart Benton, situated in the city of St Louis.

In 1857, she started working on *Zenobia in Chains* (Fig. 1), which represented the moment when the Queen of Palmyra was captured and taken to Rome in 274 by Roman Emperor Aurelian. Hosmer's intention was to exhibit officially her Zenobia at the London International Exhibition of 1862. However, the clay model was shown at her workshop in March 1859 during the Prince of Wales's trip to Rome. John Gibson was the prince's guide to various museums and artists' workshops, including Hosmer's. The New York-based journal *Harper's Weekly* reported this visit, presenting a brief review of the work, illustrating the event, and stressing the interest that the artwork had generated among both the general public and the prince, who followed Gibson's explanations with utmost interest (Fig. 2). Because of the high level of attention that the artist received, rumors about its authorship started to circulate. Hosmer speaks about this gossip in 1859 in her correspondence with her friend and confidante, the writer and supporter of women's rights, Anna Jameson. In these letters, Jameson encourages her to trust her own worth and to ignore the accusations of her dependence on Gibson,[1] a piece of advice that the sculptor welcomed, and replied: 'I mean to silence them, though not with my tongue, in return, but with my

1 'I know the malignant sarcasm of some of your rivals at Rome [...] I should think lightly of your good sense and your moral courage, if such insinuations, irritating to your self-esteem and offensive to your self-dependence, could prevent your availing yourself of all the advantages you may derive from the kind counsel of your friend.' (Carr, *Harriet Hosmer*, p. 150).

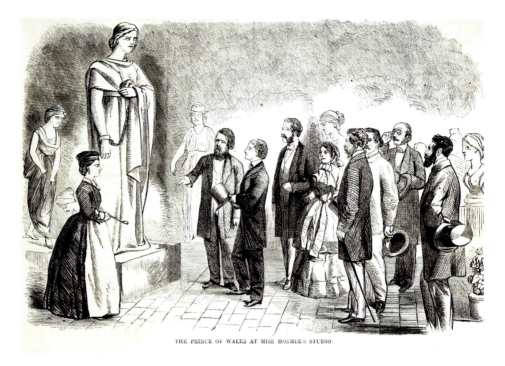

Fig. 2. 'The Prince of Wales at Miss Hosmer's Studio', p. 293. Digital version released into public domain by University of Michigan.

fingers'.[2] However, this was not only a matter of coffee talk, but a conversation that would reach the press when the anonymous obituary dedicated to the sculptor Alfred Gatley was published in the prestigious London magazine *The Art Journal*. The article regretted Zenobia's eclipsing of his work and attributed its authorship to an Italian carver:

> The Great Exhibition of 1862, where <Gatley> exhibited his magnificent [...] productions of modern Art, yet [...] they attracted little attention beside the more meretricious charms of 'The Reading Girl' and the 'Zenobia' — said to be by Miss Hosmer, but really executed by an Italian workman at Rome.[3]

Hosmer responded to the harsh criticism and unfair accusations by hiring a lawyer, and writing some texts, two of which deserve special attention as they offer an insight into the events. These consist of the open letter entitled 'The Process of Sculpture', a detailed technical explanation about the steps to be followed in order to create a statue, and the satirical poem 'The Doleful ditty of the Roman Caffe Greco', where she mocked the insecurity of male sculptors who yearned for the time when female rivalry didn't exist. Hosmer also had the support of Gibson, with whom she co-signed

2 Erskine, *Anna Jameson*, p. 245.
3 'Obituary. Mr Alfred Gatley', p. 181.

on 14 November 1865 the first letter to the *Art Journal* denouncing the accusations and stating that the work of artist's assistants was habitual in sculpture,[4] and from the sculptor William Wetmore Story, who wrote a letter to the British newspaper *Athenaeum* defending Hosmer's authorship.[5]

There are many theoretical-technical texts that address sculptural processes (from the writings of Alberti to Falconet, including those of Leonardo and Vasari, among others). A discussion by the art historian Hugh Honour broadens the topic by referring to the testimonials by the visitors of the famous Canova's workshop, under whose tutorship, incidentally, Gibson had learned the craft. Honour was interested, precisely, in discerning to what extent had the artist intervened in her own works. He noted: 'Nowadays it is widely assumed that Canova, so far from proceeding in this Michelangelesque fashion, did little more than produce clay models for statues which his many assistants subsequently rendered in marble'.[6] During the same period, in *Sculpture: Processes and Principles*, Rudolf Wittkower was engaging in historical accounts of sculpture and delving into the same questions.[7] About a century before, in December 1864, Harriet Hosmer had written the article 'The process of sculpture'. The text was addressed to the general public. Here, she offered far more details about the hands that intervene in the sculpture-making processes than the accounts offered by Wittkower and Honour. However, her text was not taken into account by the art history's cannon. Apart from providing technical notes, Hosmer refers to the aesthetic tradition that since Humanism had promoted this collective and common idea with the purpose of refuting it, and states: the 'very general impression, that the artist, beginning with the crude block, and guided by his imagination only, hews out his statue with his own hands'.[8] Worthy of notice is that this 'general impression' had its roots in Michelangelo's methodology. In fact, William Wetmore Story had also ironically referred to this method's excessive attention to carving, and argued: 'This is pitiable. This was not the work for a great genius like him, but for a common stone cutter. What waste of time and energy'.[9] Nonetheless, it is important to mention that Hosmer's defense of conceptualism in art echoes: first, the Neoplatonism associated to Michelangelo; secondly, the modern theories about artistic production and the originality of the artist. Let's look at this in more detail. Throughout her writings, Hosmer insists on the separation between the intellectual and creative work (of the artist) and the manual labor (of the assistants), echoing the ancient distinction between liberal and mechanical arts. She says, 'It is high time that some distinction should be made between the labor of the hand and the labor of the brain'.[10] And

4 Hosmer and Gibson, 'Miss Hosmer's Zenobia', p. 27. See also Cobbe, *Life of Frances Power Cobbe*, vol. II, p. 256, where Cobbe reproduces a letter by Gibson stating: 'If Miss Hosmer's works were the productions of other artists and not her own there would be in my studio two impostors – Miss Hosmer and myself'.

5 Story, 'Our Weekly Gossip', p. 840.

6 Honour, 'Canova's Studio Practice-I', p. 146.

7 Wittkower, *Sculpture*, ch. 4–5, 10.

8 Hosmer, 'The Process of Sculpture', p. 734.

9 Story, *Excursions in Art and Letters*, p. 38.

10 Hosmer, 'The Process of Sculpture', p. 737.

considers sculpture 'as an intellectual art'.[11] The 'concept in the artist's mind' harks back to the famous sonnet by Michelangelo:

Non ha l'ottimo artista alcun concetto, \ c'un marmo solo in sè non circonscriva \ col suo superchio; e solo a quello arriva \ la man che ubbidisce all'intelletto.

(Not even the best of artists has any conception \ that a single marble block does not contain \ within its excess, and *that* is only attained \ by the hand that obeys the intellect.)[12]

Albeit Hosmer diminishes the importance of the hand that addresses the stone without more mediation than intellect. This last part of the verse refers to the Neoplatonic conception of inspiration that drew on the collective image of the sculptor's processes. It would be displaced in eighteenth and nineteenth centuries art theory which constructed the artist's figure as a creative genius where the 'idea', the conceptual question already present in Leonardo and Michelangelo, would prevail above the technologies and materials used to materialize it. Even Hosmer herself uses reiteratively the lexicon associated with the modern theory of the artist as genius, namely, it draws on concepts of the 'original image', ideas configured in the mind, the imagination, taste or a sense of gracious refinement, uniqueness of style, and originality. As articulated by the artist:

In *originating* that small model, when the artist had nothing to work from but the image existing in his own brain, imagination, refined feeling, and a sense of grace were essential, and were called into constant exercise [...]. <The artist> is he alone who infuses into the clay that refinement and individuality of beauty which constitute his 'style', and which are the test of the greater or less degree of refinement on his mind, as the force and originality of the conception are the test of his intellectual power.[13]

Assistants are left to perform a 'mere' exercise of mechanical translation from the clay model into the stone. Even if they are sufficiently dexterous, there is no need to do the final touches that appear insistently in other texts about the practice of the sculptor and that allows the public to find 'traces of the sculptor's hand where they do not exist'.[14] Once freed from manual labor, she adds, sculptors such as Canova and Thorwaldsen could focus on the design of new works. Had these artists been women, she observes, the merit would have also been granted to their assistants. 'It is not a secret', — she says — 'and there is no reason why it should be so'.[15] Therefore, despite exposing the concepts associated to the figure of the artist that contributed to construct the aura that surrounds him in the face of the public, Hosmer opens

11 Hosmer, 'The Process of Sculpture', p. 737.
12 Michelangelo Buonarroti, *The Poetry*, 151, p. 302.
13 Hosmer, 'The Process of Sculpture', p. 735.
14 Hosmer, 'The Process of Sculpture', p. 735.
15 Hosmer, 'The Process of Sculpture', p. 737.

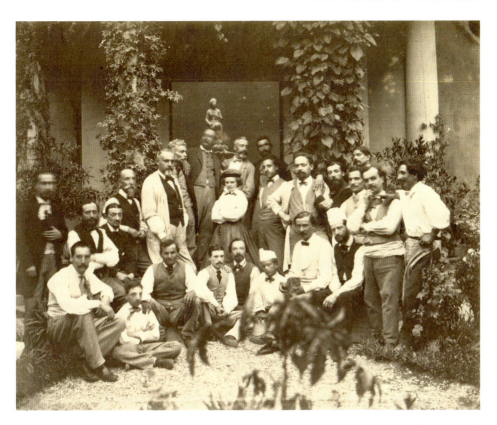

Fig. 3. Photography showing Harriet Goodhue Hosmer with her assistants and carvers in the courtyard of her studio in Rome, Washington D. C., Department of Image Collections, National Gallery of Art Library. 1867. Digital version released into public domain by National Gallery of Art Library.

the door — in a clear and assertive manner — to the backstage of the sculptor's workshop. In doing so, she overcomes the romanticization of this figure.

The letter published by *Art Journal*, ratified by Gibson, and also directed to the public's general knowledge, had offered a much synthetic report. Therefore, maybe it would have been unnecessary to widen the details offered in 'The Process of Sculpture'. However, the letter provides a valuable source where the claim of artwork by women is of no lesser importance. In this text, the sculptor insists on the fact that women do not work in a different manner to that of their male colleagues: 'we merely object to its being supposed that it is a system peculiar to *ourselves*.'[16]

According to her friend and biographer Cornelia Carr in the memoirs she dedicates to her, a few months before 'The Process of Sculpture', in the summer of 1864, Hosmer published the satirical poem 'The Doleful Ditty of the Roman Caffe Greco' in the *Evening Post*, a poem which is included in Carr's biography. In it, Hosmer provides a view of the artistic landscape of cafés and reveals the other side of the

16 Hosmer, 'The Process of Sculpture', p. 736.

creator's grandiloquence: the complaints due to envy that Hosmer situates on the same place where the rumors that accused her of fraud started. The poem deploys many elements of the theatre. Not for nothing, Hosmer's fictional companion in the poem's scene is Melpomene, the muse of theatre. There, she situates a dozen artists who are meeting to discuss their wretched situation:

> 'Tis [*sic*] time, my friends, we cogitate, \ and make some desperate stand, \ Or else our sister artists here \ Will drive us from the land […] \ We at last \ Have rivals in the clay, \ When for so many happy years \ We had it all our way.[17]

They miss the happy old days when such a rivalry with women did not exist. With this poem, Hosmer inverts expected gender roles by mocking male insecurities and anxieties. One of them explains his attempts to get rid of this pain but notes how his worry and strategy have not allowed him to do so. In spite of his failure, his fellow interlocutors continue to acknowledge him as their leader. Another character, a painter, finally speaks out and invites them jestingly to follow a different strategy: rather than fight women artists, they should accept the situation and credit them for their worth. The painter finishes his intervention with a final joke: it 'Would prove what seems a doubtful point \ You could, at least, be *men*'.[18] In this way, the painter silenced the male group and because Melpomene is a woman, as she declares, she will disseminate this ditty word by word. With this text, Hosmer proves she was disinclined to start a battle for the place men had established for themselves. Instead, what she and her sister-sculptresses wanted and what they built was a place and a space of their own.

The comical response of the poem finds a parallel in a photograph of 1867 (Fig. 3) where Hosmer is seen with her assistants. She is at the center of the composition and her assertive and proud bearing makes her figure stand out in a group of twenty-three men. In so doing, she recognizes the contribution of professionals in the processes of sculpture without diminishing her own role in it. According to Hosmer in a letter to Wayman Crow, the image was well-received, and stresses that despite its humorous tone the message was profoundly serious.[19] In another photograph taken around 1864 (Fig. 4), she can be seen working on her monument to the Senator Thomas Hurt Benton. In this way, she claimed that her own involvement in the production of the sculpture should not be disregarded. If many of the female artists in her circle, like Emma Stebbins,[20] preferred not to use outside help to produce their works in order to avoid fraud accusations, other artists, such as Hosmer or Vinnie Ream, made use of it openly and reclaimed their authorship by means of writing or photographic images.[21] In fact, Ream was also accused of fraud after her successful monument to Lincoln and had herself photographed working on several occasions. Still, it should be noted that several of these attacks were from women and that these showed, indeed, the rivalry

17 Carr, *Harriet Hosmer*, p. 194.
18 Carr, *Harriet Hosmer*, p. 197.
19 Carr, *Harriet Hosmer*, p. 250.
20 Milroy, 'The Public Career of Emma Stebbins', p. 10.
21 Alba and Mercader, 'En casa del fotógrafo', pp. 67–75.

'THE PROCESS OF SCULPTURE' 325

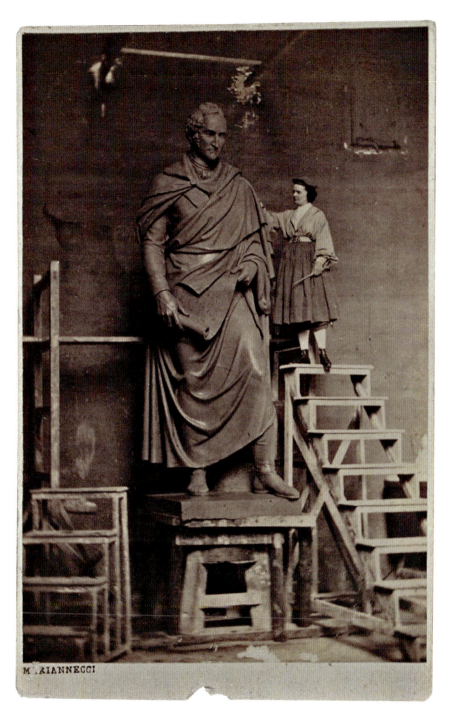

Fig. 4. Photography showing Harriet Hosmer on ladder with sculpture of Thomas Hart Benton, Cambridge, Schlesinger Library, RIAS, Harvard University. c. 1861–1862. Posted to Flickr by Schlesinger Library, RIAS, Harvard University under the terms of the No known copyright restrictions.

in artistic circles in various parts of the US.[22] Among the different personalities of the period, Hosmer intervened in Ream's defence in a brief letter published in the New York *Daily Tribune*, reminiscing about how she had been targeted by the press with similar allegations.[23]

In the texts examined, Hosmer vividly portrays the artistic system in mid-nineteenth century Rome where the presence of Anglo-American artists was having an important impact in the development of north American sculpture. While, as previously mentioned, there were cross-interests and rivalries, the artist posited important questions that affected the professionalisation of women artists. As the artist Patricia Cronin notes on her *The Zenobia Scandal* research, this 'didn't happen in a vacuum. The professional and social climate was ripe with restrictive attitudes toward women at the time.'[24]

To conclude, Hosmer was neither a theorist nor was she interested in writing treaties. However, her writings should be considered because of their above-mentioned importance as primary sources. In a recent study, the specialist in nineteenth-century art, Hilary Fraser, reclaims the role that women historians, critics, and chroniclers of this period had in the development of emergent disciplines in art history and criticism as well as in the construction of public taste. In so doing, Fraser rebuked the belief that these were predominantly masculine realms.[25] In spite of the fact that Hosmer is not actually included in this historiography, we must reassess the importance and impact of her texts. Beyond the specific polemic issues she refers to, her writings account for the general considerations about the artist's figure, as well as the processes and principles of sculpture. Furthermore, if we consider the fact that the so-called 'Zenobia Scandal' increased her popularity, their texts may have contributed notably in the knowledge and consideration of this artistic language by the general public.

22 Lemp, 'Vinnie Ream and "Abraham Lincoln"', pp. 26–27.
23 Hosmer, 'To the Editor of The Tribune', p. 5.
24 Cronin, *The Zenobia Scandal*, p. 127.
25 Fraser, *Women Writing Art History in the Nineteenth Century*, pp. 1–17.

Bibliography

Primary Sources

Buonarroti, Michelangelo, *The Poetry of Michelangelo: An Annotated Translation*, trans. by James M. Saslow (New Haven: Yale University Press, 1991)

Carr, Cornelia, *Harriet Hosmer: Letters and Memories* (London: John Lane The Bodley Head, 1913)

Cobbe, Frances Power, *Life of Frances Power Cobbe*, 2 vols (Boston: Houghton, Mifflin and Company, 1894)

Erskine, Steuart, ed., *Anna Jameson: Letters and Friendships (1812–1860)* (London: T. Fisher Unwin, 1915)

Hosmer, Harriet, 'The Process of Sculpture', *Atlantic Monthly*, December 1864, pp. 734–37

——, 'To the Editor of The Tribune', *New-York Daily Tribune*, 25 April 1871, p. 5

Hosmer, Harriet G. and John Gibson, 'Miss Hosmer's "Zenobia". To the Editor of the "Art-Journal"', *The Art-Journal*, 1 January 1864, p. 27

'Obituary. Mr Alfred Gatley', *The Art-Journal*, 1 September 1863, p. 181

Story, William Wetmore, *Excursions in Art and Letters* (Boston: Houghton, Mifflin and Company, 1891)

——, 'Our Weekly Gossip', *Athenaeum*, 12 December 1863, p. 840

'The Prince of Wales at Miss Hosmer's Studio, *Harper's Weekly*, 7 May 1859, pp. 293–94

Secondary Studies

Alba-Ríos, Tania and Laura Mercader-Amigó, 'En casa del fotógrafo: "performances" fotográficas de las escultoras Harriet Hosmer, Edmonia Lewis y Vinnie Ream', *Arte, Individuo y Sociedad*, 32.1 (2020), 59–78. <https://revistas.ucm.es/index.php/ARIS/article/view/62413> [accessed 30 June 2022]

Cronin, Patricia, *The Zenobia Scandal. A Meditation on Male Jealousy* (New York: Zingmagazine Books, 2013)

Fraser, Hilary, *Women Writing Art History in the Nineteenth Century: Looking Like a Woman* (Cambridge: Cambridge University Press, 2014)

Honour, Hugh, 'Canova's Studio Practice-I: The Early Years', *The Burlington Magazine*, 114.828 (1972), 146–59. <http://www.jstor.org/stable/876904> [accessed 30 June 2022]

Lemp, Joan A., 'Vinnie Ream and "Abraham Lincoln"', *Woman's Art Journal*, 6.2 (Autumn, 1985 – Winter, 1986), 24–29

Milroy, Elizabeth, 'The Public Career of Emma Stebbins: Work in Marble', *Archives of American Art Journal*, 33.3 (1993), 2–12. <https://doi.org/10.1086/aaa.33.3.1557502> [accessed 30 June 2022]

Wittkower, Rudolf, *Sculpture: Processes and Principles* (Harmondsworth: Penguin Books, 1979)

ELIANA BILLI

Art Restoration in Italy in the Second Half of the Twentieth Century[*]

A Woman's Expertise

▼ **ABSTRACT** The Central Institute of Restoration, founded by Cesare Brandi, was predominantly led by male figures for many decades. However, in the past 20 years, except for a brief interruption, women have held the position of direction in the historic institution. Restoration has become a profession dominated by women in Italy and beyond, with recent data revealing a presence of 9 to 1 in prestigious higher education schools such as ICR, OPD, and Venaria Reale. The reasons behind this gender disparity are worth exploring, and the story of the first female restorers trained at ICR provides valuable insight.

For decades after its foundation in 1939, the Istituto Centrale del Restauro di Roma (Central Institute for Art Restoration of Rome, or ICR) was led exclusively by men. However, in the past twenty years, except for a brief interruption, various women have been called on to lead the historic institution. Female art historians, and recently architects, as is the current case,[1] have taken the reins of one of the most prestigious institutions in our country, which is also an integral part of the Ministry of Culture.

Internationally renowned, Italian restoration is today almost entirely in the hands of women. And this is not a metaphor; quite literally it has been womens' hands that have been in charge of protecting and passing on both Italian and international cultural patrimony. The current numbers of the most prestigious schools of higher education for training in the field of art restoration speak clearly: entrance exams for the academic year 2021–2022 found only female winners at the Istituto Centrale del Restauro (19), the Opificio delle Pietre Dure (5) and the Centro di Conservazione e Restauro La Venaria Reale (20). This trend, which began in the mid-1960s,[2] provides

[*] I thank Marco Riccardi and Laura D'Agostino from the ICR Archives for their support to research, Costanza Mora and Simone Colalucci for having shared memories and photos of their mothers, and Kadi Peery for translating the text.

[1] The current director of the Istituto Centrale per il Restauro is the architect Alessandra Marino.

[2] Castellano, 'Le donne nel restauro', pp. 271–74.

Women in Arts, Architecture and Literature: Heritage, Legacy and Digital Perspectives, ed. by Consuelo Lollobrigida and Adelina Modesti, Women in the Arts: New Horizons, 1 (Turnhout: Brepols, 2023), pp. 329–338
BREPOLS ❧ PUBLISHERS 10.1484/M.WIA-EB.5.134660

a path of growth that can be further analyzed in order to offer more information on the role of women and female talent in the art world throughout the twentieth century.

The objective of this contribution is to highlight how women had an active part in the early stages of the Istituto Centrale del Restauro, and how they were a key element in the gradual definition of the professional identity of restorer, which was one of the very reasons for the creation of the Institute. In fact, begun as a project of Giulio Carlo Argan, the Institute promoted itself as a school to train professionals who knew how to behave around and respect works of art and their authenticity, ridding themselves of the creative ambitions that until then had characterized the figure of the predominantly male, restorer-artist. Women, then as today, knew how to make this respect a cornerstone of a value system that would gradually make them more suitable than men in a work environment which required two great female vocations: the transmission of memory and its guardianship.

From an institutional point of view, the official entrance of women into the world of restoration begins with the birth of the ICR, even if, naturally, women who dedicated themselves to restoration existed as a support to their restorer husbands long before. Recent studies, such as that of Michela Di Meglio,[3] are gradually bringing to light the lost histories of a few important figures such as Marie-Éléonore Godefroid and Margherita Bernini. Bernini, a German restorer who lived in Italy in the eighteenth century, became, together with her husband, a point of reference for many important art collectors in the area of Rome, and not only. The story of her professional achievement is not surprising; Bernini was only able to appear in the official circles of restorers when her husband, Carlo Bernini, became blind due to an illness and had her take over the business. It was another woman, the countess Cecilia Mahony, Irish consort of the prince Benedetto Giustiniani, who promoted her career, hiring her to restore the most prestigious works of the family collection.[4]

But back to more recent history. In 1941, when Cesare Brandi began the direction of the Istituto Centrale del Restauro, he had to create *ex novo* a technical and administrative staff and therefore chose the people who would have assisted him. Recently, Caterina Bon Valsassina, former director of the ICR from 2002 to 2009, pieced together the history of the first years of the institute, highlighting the key figures who, together with Cesare Brandi, gave life to the ambitions of the fledgling institution designed by Argan and much desired by then Minister of National Education, Giuseppe Bottai.[5] Initially, not one woman was considered for a role; the first organizational chart of the Institute didn't include even one woman, let alone among the management teams such as the Technical Committee which was, by statute, made up of the director of the ICR and 4 members chosen by the ministry of National Education. Many technical committees came and went between 1942 and 1975, without ever including a woman — not even a female art historian — even if the research

3 Di Meglio, 'L'attività di Carlo e Margherita Bernini e la polemica sulla vernice', pp. 47–70.
4 Ivi, p. 52.
5 Bon Valsassina, *Restauro made in Italy.*

Fig. 1. *Nerina Neri and Giovanni Urbani restore the Madonna di Coppo di Marcovaldo of the church Santa Maria dei Servi in Siena, 1947* (AFRICR, fasc. AS0850).

of Maria Mignini[6] brought to light time ago the important female contribution to the discipline in the early years of the 1900s; a contribution which, already in 1938, Adolfo Venturi took care to describe with his lecture at the Roman Lyceum at palazzo Theodoli entitled, 'Tributi femminili alla storia dell'arte nell'ultimo ventennio'.[7]

Of the restorers chosen by Brandi in 1941 to form the first professional staff, with the duty to oversee the training of the students of the fledgling State School of Restauro, not even one woman was included. The names chosen were Mauro Pelliccioli, Enrico Podio, Luciano Arrigoni and the Roman, Augusto Cecconi Principi. But however prestigious their names may have been, they only lasted a few months in their roles of training the first students; the low salaries established for the restorers, which were hired only temporarily by the Institute, together with the scarcity of the war years, made it impossible to remain and a progressive exodus began even before 1945. Working as a freelancer paid decidedly more.

During the Second World War, the Institute remained closed, opening again only in June of 1944, the year which saw the arrival of Paolo Mora and Giovanni Urbani, each of whom arrived almost casually. They were made responsible for the first works to survive the destruction of the war to arrive at the Institute: the painting of Lorenzo da Viterbo from Cappella Mazzatosta di Santa Maria della Verità in Viterbo and those of the Cappella Ovetari degli Eremitani in Padua. The first 'signorine' or 'misses'

6 Mignini, *Diventare storiche dell'arte*.
7 Venturi, *Tributi femminili alla storia dell'arte*.

(as Brandi called them) to enter the Institute also participated in the restoration work: Nerina Neri, already present from 1942, and Laura Sbordoni in February of 1945. The stories of the latter, better known in the world of restoration as Laura Mora, allow a reconstruction of this moment. In an interview given years ago to Theo Hermanes,[8] Sbordoni recalls how her arrival at the Institute had been quite casual, as she was mentioned to Cesare Brandi by a friend of the family for her artistic skill. Born into a middle-class family, she had received an education appropriate for her social status; she had studied piano, learned to embroider and frequented a lyceum for art. Sbordoni informs us that her entrance into the Institute was greeted with great enthusiasm by Brandi who, at the time, was short of personnel. Nerina Neri, according to Sbordoni, was already present and working as a restorer's assistant,[9] with the duty to teach the new arrivals to use the pigments and paintbrushes.

In the second half of 1944, and into the first months of 1945, the Institute continued in this fashion, enlisting new female and male students, but restorers to train them were few, seeing as though those hired in 1941 had gone off to find more lucrative, freelance work. These were the circumstances which pushed Brandi to ask the Ministry of Education to temporarily hire the 5 students, Paolo Mora, Laura Sbordoni, Carlo Matteucci, Nerina Neri and Giovanni Urbani.[10]

Once again the tragic circumstances of the war offer space and opportunity to women outside of the domestic sphere, and the first, real team of official restorers of the Istituto Centrale del Restauro is one that differs greatly from the traditional team, composed of only men.

To this new group of both male and female restorers, created by Cesare Brandi for the Institute, the most prestigious works of art of both Italian and international patrimony were entrusted; entrusted to men and women with equally distributed responsibilities and duties. From then on Nerina Neri and Laura Sbordoni, next to their male colleagues, were involved in often complex work that required advanced skill in organization as well as experimentation of both materials and methods. The first photographs of the two women see them busy at work on the already mentioned restoration of the fragments that had fallen from the Cappella Mazzatosta in Viterbo, which was for them a true on-site, training school. In 1947, Nerina Nerini was also involved in the restoration of the Madonna di Coppo di Marcovaldo from the church of Santa Maria dei Servi in Siena, which she continued together with Giovanni

8 Interview, recorded and filmed 19–20 Sept. 2001, in the context of the project entitled *La memoria vivente del restauro*, European Project 2000–2001, ed. by Associazione Giovanni Secco and the Hochschule fur Bildende Kunste of Dresda. I thank Costanza Mora immensely for having brought this to my attention and for all of the information she shared with me on the education and professional life of her mother.

9 Nerina Neri was chosen for the first 3-year-long course in restoration begun in 1942, which was then postponed for the war; she was 26 and had graduated from the Accademia di Belle Arti di Roma in 1939 in 'Decorazione' with Ferruccio Ferrazzi. In 1943 she was hired by the ICR as an apprentice. Cf. Roma, Archivio Storico dell'Istituto Centrale del Restauro (from now on ASICR), class. IB1, fasc. Nerina Neri.

10 Rome, ASICR, class. IB1, fasc. Giovanni Urbani, Letter by Cesare Brandi to the Ministero della Pubblica Istruzione, 13 June 1945.

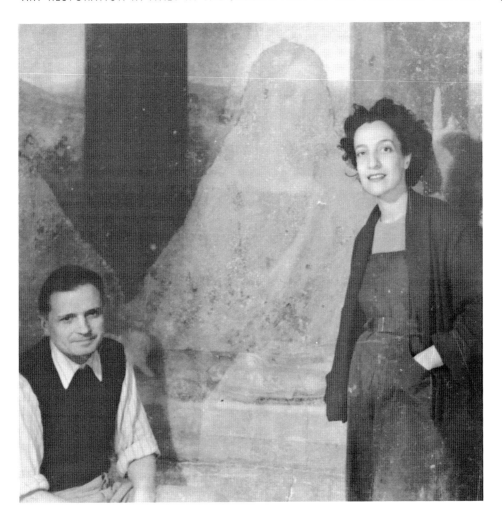

Fig. 2. *Luigi Pigazzini and Nerina Neri in the restoration site of Leonardo's Last Supper in Milan, 1950* (AFRICR, fasc. AS0012).

Urbani (Fig. 1), while with Luigi Pigazzini[11] she worked in Belgium in 1952 on the restoration of the Roman paintings from the Royal Museum of Mariemont[12] and then again on the complex intervention of the Cenacolo of Leonardo DaVinci in Milan[13]

11 Luigi Pigazzini became head restorer in January 1948, for the following 10 years, circa, replacing Mauro Pellicioli. This change was due to a modification in the members of the Technical Committee of the ICR after the controversy which opposed Brandi to Longhi (and Pellicioli). Cf. Rinaldi, 'Luigi Pigazzini e la tradizione lombarda del restauro pittorico', pp. 127–35.
12 Rome, ASICR, class. II A 2, b. Belgio, fasc. Museo Mariemont di Morlannelz Affreschi di Boscoreale. The file contains the entire collection of documents relative to the restoration. Cf. anche Cagiano de Azevedo, 'Il restauro degli affreschi romani del Museo di Mariemont (Belgio)', pp. 159–79.
13 Rome, Archivio Fotografico Restauri Istituto centrale del Restauro (from now on AFRICR), fasc. AS0012.

(Fig. 2). Afterwards it would be another woman to go down in history for the twenty-year-long restoration of this work (between 1977 and 1999): Pinin Brambilla Barcilon.

From the unpublished images preserved in the photographic archives of the ICR one can see that the first two female restorers of the Institute were involved in all phases of the restoration work, not only in that of retouching the images, which could remind one of that *art d'agrement*, an integral element in the training of young, well-bred ladies. Life on the worksite was hard and demanding, and once again, Laura Sbordoni informs us, and the photos prove, no difference was made between men and women. Another example which confirms this is an image of another woman (possibly Nerina Neri or Anna Maria Sorace[14]) high up on a beam in 1960, on the worksite of the restoration of the lower basilica of the church Santa Maria in Via Lata in Rome (Fig. 3). Brandi's ability to take note of and value Sbordoni's talents[15] (it was he who directed Giovanni Urbani towards the study of art history[16]), ensured that it was her, gifted not only technically but also with great communication skills, who became gradually through the years the person most suited to train the young students as well as assist Brandi in presenting and describing to those outside of the Institute how the practical and theoretical spheres of restoration were part of a single, critical process.[17] She appears often in photographs in periodicals next to Brandi, as in the one from 1957 that shows her at work on the Maestà di Duccio (Fig. 4). Unfortunately, it's not surprising to find that the journalist who writes the article names Cesare Brandi, and not Laura Sbordoni, who is identified generically in the description as 'young assistant' of the great professor. Some things were changing, others weren't!

Laura becomes a reference point for Brandi for international training and research and for the close collaboration with the director of ICCROM, Paul Philippot. And it's Bordoni the author (in marriage it was Mora) of the first manual in the restoration and conservation of wall painting[18] which was, and still is today, the reference text for the training of restorers, male and female; a student body which, beginning in the

14 Anna Maria Sorace, better known as Anna Maria Colalucci (the first wife of the well-known restorer of the Sistine Chapel) arrived at the Institute almost by chance. After having completed her diploma in classical studies she began attending the Department of Letters at the University of Rome after having met Giuseppe Ungaretti whom she asked to be her advisor for her thesis on Brandi, the poet. Simone Colalucci, Anna Maria's first born, whom I thank immensely for having shared his memories, tells how his mother was invited by Ungaretti to visit Brandi; the latter received her warmly and, after telling her of his poems, enlisted her as another one of his young students at the Institute. In 1946 Anna Maria graduated from the ICR as a restorer, and in 1948 was hired to be paid on a daily basis. Cf. Rome, ASICR, class. IB1, fasc. Sorace in Colalucci Anna Maria.

15 Mario Micheli spoke of Brandi in this sense as a real talent scout. Cf. Micheli, 'Il modello organizzativo dell'Istituto Centrale per il Restauro e le conseguenze sul piano metodologico', pp. 167–78: 176–77.

16 Zanardi, *Urbani, Giovanni*.

17 From the end of the 1950s, Laura Sbordoni Mora was an instructor of art restoration for many generations of students, male and female, of the ICR, and collaborated for many years with ICCROM, handling the training and research for international restoration. Her name appears together with those of Paolo Mora and Paul Philippot as author of one of the most well-known texts on the history of technique for restoration in the 1900s between France and Italy: *La conservation des peintures murales*, tradotto in Italiano nel 1999 e ristampato nel 2003.

18 The volume was published in 1977 in French with the title *La conservation des peintures murales*; it was translated into Italian in 1999 and reprinted in 2003.

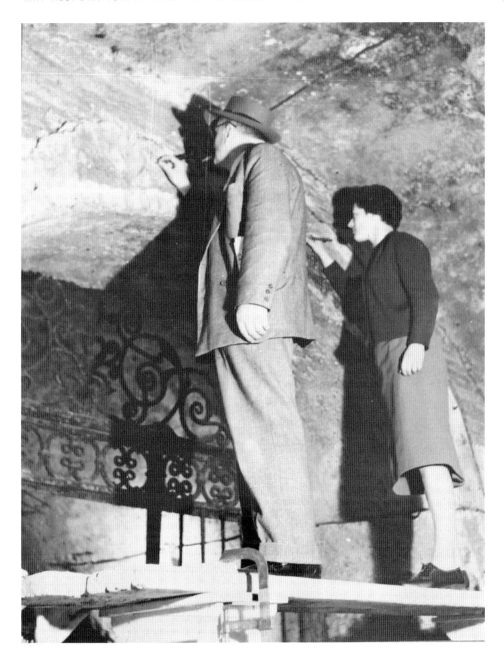

Fig. 3. *Tarcisio Spini and Nerina Neri (?) restore the mural paintings of the lower basilica of Santa Maria in Via Lata in Rome, 1960* (AFRICR, fasc. AS0600)

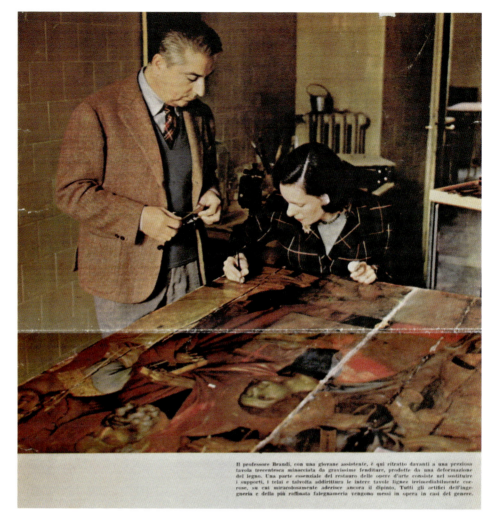

Il professore Brandi, con una giovane assistente, è qui ritratto davanti a una preziosa tavola trecentesca minacciata da gravissime fenditure, prodotte da una deformazione del legno. Una parte essenziale del restauro delle opere d'arte consiste nel sostituire i supporti, i telai e talvolta addirittura le intere tavole lignee irrimediabilmente corrose, su cui miracolosamente aderisce ancora il dipinto. Tutti gli artifici dell'ingegneria e della più raffinata falegnameria vengono messi in opera in casi del genere.

Fig. 4. *Cesare Brandi and his 'young assistant' (Laura Sbordoni) show the restauration of the Maestà di Duccio, 1957* (unidentified magazine).

1970s, continued to fill more and more notably the courses of the Institute. Times were changing and women, freer to make choices, joined in ever increasing numbers the lives of various public institutions — including those of education — in a process of democratization of knowledge that included the ICR. Maria Grazia Castellano,[19] who first dealt with the theme that I'm addressing today, informs us that in 1964 the female students of the ICR surpassed in number the male students, and in the same years the social status began to change of those who desired to become a restorer of the State. As the years went by, as was the case for many universities, the Institute was frequented by young men and women of well-to-do families. This situation was noted

19 Castellano, 'Le donne nel restauro', p. 272.

by Brandi near the end of his mandate as director; in a report written at the end of the 1950s, which took stock of 20 years of work, he reflected on the need for scholarships to be instituted by the Ministry, which would be won by students through a public exam, in order to avoid 'making the school (of restoration) a nursery of young, privileged men and ambassadorettes'.[20]

With the 1960s, and even more with the 1970s, the orders change; the great social and cultural transition of that period in time and its consequences for the identity of women and men were considerable. It's evident in photographs taken of the courses at the ICR in the 70s and 80s where the women far outnumber the men. In the same years, the applications for the state exam grew exponentially; in 1990, the exam attracted 900 potential students for just 15 available seats, with a clear preponderance of women. And today, as was already stated, women have taken each and every seat available in the most prestigious Italian schools of higher education for art restoration at the ICR, the Opificio delle Pietre Dure and at the Centro di Conservazione e Restauro La Venaria Reale. This is not the time or place, nor do do I have the expertise to perform a social and anthropological analysis of the data, but I believe it would be very interesting to examine further at least 3 aspects of the question which, in my opinion, were central in paving the way for women in this profession: firstly, the value given to the transmission of memory and a work of art's special role in this transmission, which historically involves women more than men; secondly, the related theme of the social value of objects, based on the recent branch of research headed by Appadurai; and lastly, the theme of the female vocation of looking after something or someone, where participating in the care of 'special products of human activity',[21] such as works of art, naturally instilled a certain respect for an authentic text, for the original value of an object, but also for its life — a theme which Argan and Brandi had hypothesized, only theoretically, at the end of the 1930s. A respect which in the predominantly male tradition of restoration hadn't found a lot of room, but which throughout the twentieth century found its place with the important contribution of women. A contribution which weighs most heavily during the passage from the theoretical to the practical, a moment when men often find themselves having to make way for women.

20 Rome, ASICR, Atti della direzione, Rapporto 1959.
21 Brandi, *Teoria del restauro*, p. 4.

Bibliography

Archival Sources

Rome, Archivio Fotografico Restauri Istituto Centrale del Restauro (AFRICR), fasc. AS0012
Rome, Archivio Storico dell'Istituto Centrale del Restauro (ASICR), class. IB1, fasc. Nerina Neri
Rome, ASICR, Atti della direzione, Rapporto 1959
———, class. II A 2, b. Belgio, fasc. Museo Mariemont di Morlannelz Affreschi di Boscoreale
———, class. IB1, fasc. Giovanni Urbani, Letter by Cesare Brandi to the Ministero della Pubblica Istruzione, 13 June 1945

Secondary Studies

Bon Valsassina, Caterina, *Restauro made in Italy* (Rome: Electa, 2006)
Brandi, Cesare, *Teoria del restauro* (Torino: Einaudi, 1963, n.ed 1995)
Cagiano de Azevedo, Michelangelo, 'Il restauro degli affreschi romani del Museo di Mariemont (Belgio)', *Bollettino dell'Istituto Centrale del Restauro*, 11–12 (1952), 159–79
Castellano, Maria Grazia, 'Le donne nel restauro', in *L'arte delle donne nell'Italia del Novecento*, ed. by L. Iamurri and S. Spinazzé (Rome: Meltemi, 2003), pp. 271–74
Micheli, Mario, 'Il modello organizzativo dell'Istituto Centrale per il Restauro e le conseguenze sul piano metodologico', in *La teoria del restauro nel Novecento*, proceedings of the international conference (Viterbo, 12–15 November 2003), ed. by Maria Andaloro (Florence: Nardini Editore, 2006), pp. 167–78
Mignini, Maria, *Diventare storiche dell'arte. Una storia di formazione e professionalizzazione in Italia e in Francia (1900–40)* (Rome: Carocci, 2009)
Mora, Laura, Paolo Mora and Paul Philippot, *La conservation des peintures murales* (Bologna: Compositori, 1977)
Rinaldi, Simona, 'Luigi Pigazzini e la tradizione lombarda del restauro pittorico', in *Caravaggio a Milano. La Conversione di Saulo*, ed. by V. Merlini and D. Storti (Milan: Skirà, 2008), pp. 127–35
Venturi, Adolfo, *Tributi femminili alla storia dell'arte nell'ultimo ventennio*: conference at the Lyceum Romano, 24 November, 1938 by Adolfo Venturi, Rome 1939
Zanardi, Bruno, *Urbani, Giovanni*, in DBI, vol. 97, 2020, pp. 541–45

PAOLA CARETTA E MARGHERITA FRATARCANGELI

I 'frutti' di Fede, Giovanna, Orsola alla prova della critica di primo Novecento[*]

▼ **ABSTRACT** The contribution investigates how and when Fede Galizia, Giovanna Garzoni, and Orsola Maddalena Caccia were included in the early history of still life; how Marangoni, Longhi, De Logu, Hoogewerff, and Sterling evaluated and validated them; and how many still lifes painted by women were included in exhibitions between 1922 and 1964. The contribution also investigates their presence as still-life painters in ancient biographies and inventories, and analyzes the female contribution to the origin and diffusion of this genre in Italy between sixteenth and seventeenth century. Considering whether there was an all-female curvature of the genre and its characteristics, and who the intended audience was, seem questions that can lead to a better understanding both of this specific production and of the society and culture of that period.

Quando, dove e come le nature morte con frutta realizzate nella prima metà del Seicento da Fede Galizia, Giovanna Garzoni e Orsola Maddalena Caccia sono state accolte a pieno titolo nella storiografia artistica? È la domanda che muove questo contributo e che ha in filigrana, per contro, una cronaca tutta al maschile. Per comprendere in che modo le tre pittrici siano state registrate all'interno dell'emergente attenzione per i soggetti inanimati, un aiuto può giungere ripercorrendo una pur breve *storia della storiografia* che si è interessata alla natura morta (si omette qui la consistente bibliografia di riferimento). Indagare gli studi che hanno toccato questi soggetti nei primi sessanta anni del Novecento per inserirli nel quadro più generale della critica d'arte è fondante per intendere cosa mosse i pionieri degli studi — da Matteo Marangoni (1917) a Giuseppe De Logu (1962)[1] – ad avviare la trasformazione di un genere da meramente pittorico ad artistico, tanto da spingerli verso un'equiparazione con altre ben più 'auliche' e accreditate tipologie artistiche. L'analisi

[*] Gli autori sono in ordine alfabetico. Fratarcangeli ha scritto la prima parte, Caretta la seconda; il contributo è paritetico.

[1] Marangoni, 'Valori malnoti' (rieditato in Marangoni, *Arte Barocca*); De Logu, *Natura morta italiana*.

Women in Arts, Architecture and Literature: Heritage, Legacy and Digital Perspectives, ed. by Consuelo Lollobrigida and Adelina Modesti, Women in the Arts: New Horizons, 1 (Turnhout: Brepols, 2023), pp. 339–350

BREPOLS ❧ PUBLISHERS

10.1484/M.WIA-EB.5.134661

su come determinati processi economico-sociali, filosofico-culturali ed evenemenziali siano stati di stimolo e di supporto alla nascita, o quanto meno alla sensibilizzazione, degli studi sulla natura morta nel primo Novecento è il punto di partenza per far emergere le correlazioni tra i diversi ambiti di ricerca nella sua definizione.

Dove si trovava la Storia dell'arte a quelle date (1910–1960) e cosa fece attecchire l'interesse per questi soggetti? Sono interrogativi che si pose nel 1959 Ernst H. Gombrich recensendo il volume di Charles Sterling, *Still Life Painting from Antiquity to the present time*.[2] Gombrich provò a rispondere e il suo giudizio critico divenne saggio di metodo: 'La natura morta come genere autonomo che si regge sul suo contenuto più che sull'estetica ha una ragione di nascere come risposta ad interrogativi posti dalla nostra esistenza sociale inevitabilmente inserita nella cultura alla quale appartiene' e ancora le 'opere comunicano un significato soltanto entro una tradizione articolata'.[3] In sintesi estrema, lo studioso indicò come la natura morta poteva divenire un argomento da investigare con l'ausilio della società e in quanto tale poteva restituire alla collettività un'altra possibile sfaccettatura interpretativa.

Era il 1917 quando, tra i primi, Marangoni pubblicava un articolo dintorno ai pittori di natura morta; lo seguirono nel 1924 Godefridus J. Hoogewerff,[4] nel 1930 e 1931 De Logu[5] e nel 1950, divulgando la locuzione di *natura silente*, Roberto Longhi nel numero d'esordio della rivista 'Paragone Arte'.[6] La prima monografia italiana sul tema, che cercava una catalogazione per aree geografiche e per scuole, uscì dalla penna di De Logu[7] ed era il 1962: questa divenne punto di arrivo per quanto era stato detto sino a quella data e punto di partenza per gli studi successivi.

Non va trascurato come, contestualmente a queste avanguardistiche pubblicazioni, vennero organizzate alcune esposizioni: nel 1922 a Firenze, nel 1947 a Roma, nel 1952 a Parigi, nel 1964 una mostra itinerante aprì in successione a Napoli, Zurigo e Rotterdam.[8] L'esposizione parigina del 1952 deve esser considerata, in ambito europeo, il punto di riferimento per tutte le ricerche successive. Curatore dell'esposizione fu Sterling, il catalogo dell'esposizione ebbe più ristampe, anche in altre lingue, e fu ampliato.

Alla base della riscoperta novecentesca della natura morta, non solo italiana, vi era anche l'influenza di un dibattito sull'arte contemporanea e ciò a partire dalle rivoluzioni post impressionista e cubista, che stavano reinterpretando il tema dell'inanimato come uno degli argomenti centrali della pittura: le nature morte di Picasso e di Braque sono del 1909; quelle di Cézanne risalgono alla fine dell'Ottocento; è datato 1931 il *Manifesto della cucina futurista*, in cui la natura morta era l'ingrediente principe

2 La prima edizione francese del volume di Charles Sterling era del 1952, *La Nature morte de l'Antiquite*, nel 1959 si pubblicava un'edizione riveduta e ampliata, dalla quale derivava la traduzione in lingua inglese uscita nel 1959. La recensione di Ernst H. Gombrich è in 'Tradition and Expression', pp. 175–80 (in lingua italiana è nella raccolta di saggi di Gombrich, 'Tradizione ed espressione', pp. 144–60).

3 Gombrich, 'Tradizione ed espressione', pp. 148, 152.

4 Hoogewerff, 'Nature morte italiane'.

5 Citiamo unicamente De Logu, *Pittori minori*.

6 Longhi, 'Un momento importante'.

7 Vedi nota 2.

8 *Mostra della pittura italiana del Sei e del Settecento*; *La Nature morte de l'Antiquité*; *La natura morta italiana*.

in quanto compendiava il rapporto di simultaneità e integrazione tra soggetto e oggetto. Nelle intenzioni di Filippo Tommaso Marinetti e degli altri firmatari del manifesto vi era la ricerca di integrazione tra vasellame e addobbo della tavola, tra sapori e colori delle vivande messe in mostra.[9] Da questa 'provocazione' era breve il passo per giungere al 1960, quando Piero Manzoni diede vita, o forse più propriamente morte, a una diversa idea di natura morta, ossia al suo *Uovo Scultura*. L'anno successivo si univa alla rivisitazione anche Lucio Fontana, con *Uovo nero orizzontale*; simultaneamente arrivarono le potenti immagini di Giorgio Morandi.

A fronte della scoperta e rivalutazione del genere pittorico, nonché dell'interconnessione di questo con la cultura pittorica d'inizio Novecento, cosa spinse alcuni individui a interessarsi, a studiare e organizzare esposizioni tra l'inizio del Novecento e il 1964? Andrà ribadito come quei decenni videro la formazione degli studi sul collezionismo e come il mercato d'arte fosse ben presente. Per contro furono anni di crisi: politica (da lì a poco scoppiava la Grande Guerra), economica (sappiamo che il *boom* economico post guerra resse per poco, nel 1929 cominciava la Grande Depressione), sanitaria (citiamo solo l'epidemia di spagnola che imperversò in Europa e non solo) e sociale (ovviamente connessa alla situazione politica ed economica). Queste congiunture d'inizio Novecento assomigliano a quelle del trentennio 1600–1630, momento in cui la natura morta si afferma come genere autonomo. Nei primi decenni del Seicento in Italia e in molte parti d'Europa imperversavano carestie e focolai di peste – così nel 1621 e nel 1630 –, nel 1618 si apriva la guerra dei Trent'Anni e tra il 1619 e il 1622 una grave crisi economica e commerciale investì il vecchio Continente. Non si vuole paragonare l'esistenza dell'uomo del secolo XVII a quello del XX, ma certamente delle assonanze storico-sociali vi sono, tali da farle ricadere sul tema natura morta e tali da far pensare che essa sia diventata un riconoscibile spazio mentale e scenico, ove gli individui si sono rifugiati e ove hanno trovato il modo di vedere la realtà per quello che era, per quello che offriva (o non offriva) e per quello che pareva offrire. Per dirla alla Pirandello, per quello che *Così è se vi pare*, *pièce* teatrale scritta e rappresentata la prima volta nel 1917. Proprio questo titolo viene echeggiato, non troppo velatamente, nell'articolo di Roberto Longhi del 1950, quando in merito alla natura morta caravaggesca, lo studioso avvertiva come questa non fosse accomodata, bensì apparisse 'com'è (o è come appare): una rivelazione di umori, di materia mutevole, di linfe che gemono fra i contrasti della luce passante'.[10] La natura morta in sostanza veniva a mostrare l'inconoscibilità del reale, di cui ognuno può dare una propria interpretazione, essendo impossibile conoscere la verità in assoluto. In definitiva Longhi suggeriva, al pari di Pirandello, come la verità assoluta si potesse cercare, e che questa forse si trovava esibita sul palcoscenico in cui i fiori, la frutta e gli oggetti erano accomodati. Le tele di natura silente diventavano per Longhi il luogo in cui l'umanità era in grado di scorgere il significato di ciò che realmente si vedeva e al contempo avvertirne l'assenza di contenuto. È forse lì e in quel momento

9 Il Manifesto è consultabile alla seguente pagina <https://www.memofonte.it/files/Progetti/Futurismo/Manifesti/II/204.pdf>.

10 Longhi, 'Un momento importante', p. 38.

che il genere pittorico aveva perso il ruolo decorativo, che pareva aver malamente incollato sopra, per entrare di diritto nel contesto contemporaneo.

Ma dove stanno le donne e la loro produzione di nature morte?

Nel Novecento, quando si tiravano fuori le nature morte e si cercava di comprenderne le istanze e si cominciavano a catalogarle per scuole e aree, la donna era in sostanza quella che doveva 'piacere, tacere e stare a casa' (come un vecchio proverbio tramanda ancora oggi), così come la donna che si affacciava al Seicento e che brandiva i pennelli era di fatto chiusa/protetta nella casa o nel convento ed era molto spesso muta e tacitata. Son poche in fondo coloro che urlarono la propria presenza; la trama di molte era ed è ancora carsica, e lo abbiamo compreso ancor più partecipando alle dense giornate del *First Annual International Women Arts Conference* (Roma 2021).

Se andiamo brevemente a ravvisare come le nostre tre pittrici compaiono negli articoli e volumi degli studiosi fin qui citati convalidiamo subito la loro indifferenza – o forse più propriamente dovremmo parlare di semplicistica inconsapevolezza – alla presenza femminile rispetto al tema della natura morta.

Nell'articolo pubblicato da Marangoni nel 1917[11] non vi è traccia di donne, forse comprensibilmente, visto che a quella data era tutto da fare e da ri-scoprire, ma forse non v'è traccia perché l'autore non contemplava minimamente che una donna fosse dedita alla natura silente. A riprova di ciò, può forse essere indicativo un passaggio del suo contributo in cui viene esaltata 'la semplicità e la mascolinità dei pittori' del Seicento. Termini che alla donna-pittrice non potevano certo calzare!

Nel 1950 Longhi citava Fede Galizia, incasellando la sua natura morta in una tendenza neomistica che si sviluppava post Controriforma; pertanto va da sé che le tele dell'artista divenivano per lo studioso 'nature morte attente, ma come contristate'.[12]

Ancora De Logu nel 1962 citava Fede Galizia,[13] limitandosi a segnalarne laconicamente un quadro in collezione milanese. Per il resto nessuna biografia era dedicata a pittrici e nessuna loro opera era pubblicata.

Nella mostra svoltasi a Napoli, Zurigo e Rotterdam nel 1964, coordinata da Bòttari,[14] le cose cambiarono (erano esposte un totale di quarantasei nature morte su oltre duecento opere): Fede Galizia era presente con sei dipinti (una delle tele era di proprietà Sterling), Giovanna Garzoni con sei pergamene, Orsola Maddalena Caccia con tre tele (di fiori). Quest'ultima veniva pure tolta dalla scia di Fede Galizia, in quanto ascritta a 'una cultura più antica, manierista, e intrisa di fiamminghismi [...] pur se Orsola sa infondervi i segni del suo temperamento delicato e verginale'. La narrazione pare ancora quella che gli avrebbero potuto riservare un Giovan Pietro Bellori o un Giovanni Baglione in pieno Seicento, a riprova di come, ancora a distanza di tre secoli, la situazione della critica al femminile non era poi granché cambiata. Le uniche altre artiste segnalate nel catalogo del 1964 sono le fioriste Caffi e Marchionni,

11 Vedi nota 1.
12 Longhi, 'Un momento importante', p. 35.
13 De Logu, *Natura morta italiana*, p. 62.
14 Vedi nota 11. Nel 1965 sulla pittrice Galizia usciva la monografia di Bòttari, *Fede Galizia pittrice*.

I 'FRUTTI' DI FEDE, ALLA PROVA DELLA CRITICA DI PRIMO NOVECENTO

ma con costoro si era sul finire del secolo XVIII e, dunque, ben oltre la nascita del genere.

Se leggiamo la pressoché totale mancanza di riferimenti alle pittrici negli studi sulla natura morta della prima metà Novecento attraverso la lente delle fonti antiche, non abbiamo difficoltà a riconoscervi la lunga eco di un'assenza all'interno della precedente letteratura artistica. In nessun testo a stampa edito tra Sei e Ottocento, infatti, le tre artiste vengono ricordate quali autrici di nature morte. Una significativa conferma è offerta dal noto componimento di Giovan Battista Marino, *Frutti di mano di una donna*[15] per il quale il riferimento a Fede Galizia è stato formulato a posteriori e in via ipotetica. Le più esplicite successive note di pugno di Cristofano Bronzini invece, riferite sempre alla pittrice, sono rimaste in forma manoscritta,[16] non comparendo nell'edizione a stampa *Della dignità et nobiltà delle donne* pubblicata tra il 1614 e il 1632. Stessa sorte è toccata all'anonimo componimento *In lode di Madonna Fede Pitrice sopra una frutera* del 1646.[17] Non stupisce dunque che, due secoli dopo, Stefano Ticozzi abbia sentito il bisogno di sottolineare come la pittrice avesse perso 'di mira il vero ed il naturale'[18] per un eccesso di ricerca di bellezza ideale. Non dissimili sono le considerazioni riservate a Giovanna Garzoni e ad Orsola Maddalena Caccia, la prima occasionalmente ricordata nel XIX secolo come pittrice di fiori,[19] la seconda definita da Adolfo Venturi una 'monachetta diligente [...] sempre più annacquata, più fioca, come sbiadita dall'ombra del convento di suore pittrici'.[20] Accade invece curiosamente che il seicentesco Filippo Baldinucci abbia assegnato alla più nota e amata Artemisia Gentileschi 'bellissimi Quadri di frutti, che uscivano dal suo pennello',[21] ad oggi non ancora individuati.

Questa sorta di *damnatio memoriae* legata alle fonti a stampa si ridimensiona un po' se ci si sposta alle note inventariali, indagate dagli studiosi solo in anni relativamente recenti: precocissima è la registrazione di 'Una tazza di persiche e mele della Milanese'[22] nell'inventario di Niccolò d'Oria del 1617, cui seguono tra Sei e Settecento altre dieci citazioni. Ne riconosce o conosce l'autografia anche l'informato Antonio Mariani Della Corgna, redattore dell'inventario del 1635 dei beni di Carlo Emanuele I di Savoia; egli, tuttavia, assegna a Panfilo Nuvolone opere oggi ricondotte da una parte degli studiosi alla mano della Galizia dimostrando come già *ab antiquo* l'opera dei due pittori lasciasse margine ad incertezze attributive. Nell'inventario di Agostino Doria del 1617 è precocemente registrata anche 'Una tazza di brococchi

15 Marino, *La Galeria*, p. 312.
16 Ricordate in Barker, 'The First Biography of Artemisia Gentileschi', p. 429. Le note relativa alla Galizia ('Famosa e celebre nell'arte della pittura fu anco Fede Galizia fanciulla milanese, la quale nel pinger del naturale ^et particolarmente^ frutti e piante, riuscì tanto rara') potrebbe essere stata scritta tra il 1630, anno di morte della Galizia, e il 1640, anno di morte dello stesso Bronzini.
17 Renzi, 'Regesto di Nunzio e fede Galizia', p. 345.
18 Ticozzi, *Dizionario dei pittori*, vol. I, p. 136.
19 Ticozzi, *Dizionario dei pittori*, vol. II, p. 147; Rosini, *Storia della pittura italiana*, tomo VI, p. 194.
20 Venturi, *Storia dell'arte italiana*, vol. IX, parte VII, p. 568.
21 Baldinucci, *Notizie dei professori del disegno*, p. 294.
22 Farina, *Giovan Carlo Doria*, p. 193.

di Lavinia Fontana',[23] artista di cui non è noto l'impegno nel genere; l'indicazione, sulla cui correttezza è possibile sollevare qualche dubbio, è tuttavia indicativa di come un certo tipo di composizioni, soprattutto di impianto semplice, autorizzasse la supposizione di un intervento di mano femminile a differenza delle più complesse ed esuberanti vedute di mercati e interni di cucina ascrivibili in quegli stessi anni a mani maschili.

Tanto le coerenze quanto le discordanze che si evincono dall'analisi delle fonti invitano a proporre alcune considerazioni sul genere, la cui origine coincide con una sempre più urgente necessità da parte delle donne, vittime di antichi e moderni *cliché*, di rivendicare la propria libertà, anche e soprattutto nella professione artistica. Sebbene a inizio Seicento Karel van Mander avesse sottolineato come solo un pittore non capace nelle figure e nelle storie potesse dipinger animali, cucine, frutti e fiori, in un breve torno di anni il numero di nature morte di mano maschile diventa tutt'altro che irrilevante. Non solo; queste divengono ben presto oggetto di un collezionismo, anch'esso in prevalenza maschile, che invita a rompere quel binomio donna-pazienza come inevitabile e scontata etichetta da apporre al genere. Ben nota è l'affermazione di Caravaggio in occasione del processo intentatogli da Giovanni Baglione: 'in pittura valent'huomo [è colui] che sappi depinger bene et imitar bene le cose naturali'.[24] Sarà lo stesso Baglione a ricordare poco dopo come 'Pietro Paolo Gobbo [...] diedesi a dipingere i frutti dal naturale, & in quel genio non si poteva far meglio; e quelli signori avevano gusto di fargli trovare di bellissimi frutti, e d'uve diverse, accioche al segno di valent'huomo egli giungesse [...] questi co' suoi frutti faceva arrestar le viste, & ingannava gli huomini; & il suo ingegno era un vivo Autunno d'ogni sorte di bei frutti'.[25] È a tal proposito interessante ricordare come nel 1843 due tavole di Fede Galizia siano state registrate nell'inventario del marchese Giuseppe Sigismondo Ala Ponzone proprio sotto il nome del Gobbo da Cortona, *ab antiquo* riconosciuto come uno dei più abili pittori di natura silente.[26]

All'interno di questo panorama tutto al maschile è interessante osservare come nella prima metà del secolo le artiste qui esaminate abbiano tutte dato avvio ad una produzione di nature morte squisitamente personale, intima e ravvicinata, con pochi frutti appoggiati su di un piano in uno spazio non sempre definito. Ed è bene ricordare che è proprio con la Galizia che la natura morta di frutti quale genere autonomo viene precocemente frequentata, inclusa nello spazio intimo dell'osservatore al di là del trionfo dell'illusione. Altra è la scelta compositiva degli artisti del *coté* realistico-caravaggesco, come pure lo era stata per i precedenti lombardi. Nel *Piatto di pesche* di Ambrogio Figino infatti, l'opera più prossima alla produzione di genere di Fede, i frutti si offrono all'osservatore come un'ammaliante apparizione, risultato di quell'*homo ludens* – che è poeta e pittore – che vive nella Milano di secondo Cinquecento giocando con le immagini e con la loro forza polisemica. Lo stesso dicasi per

23 Farina, *Giovan Carlo Doria*, p. 209.

24 In Macioce, *Michelangelo Merisi da Caravaggio*, p. 127.

25 Baglione, *Le vite de' pittori, scultori et architetti*, p. 343.

26 *Inventario giudiziale*, 1842–44, numeri 242 e 243, citato in Agosti e Stoppa, in *Fede Galizia mirabile pittoressa*, pp. 324, 328.

Caravaggio o per Arcimboldo, delle cui opere Lomazzo ricorda come fossero adatte a decorare le pareti di ambienti mercuriali quali 'alberghi e hostarie, dove d'altro non si ragion che di mangiare, bevere, barattare, giuocare, si ricercano [...] ruffiani che conducano fanciulle di partito, giochi, furti, pazzie, histrionerie, scherzamenti'.[27] Ben diverse di contro sono la funzione e la fruizione delle nature morte femminili qui prese in considerazione, attente piuttosto alla promozione di un dialogo intimo tra l'osservatore e gli oggetti raffigurati come pure tra l'osservatore e la stessa artista. Le nature morte di Fede, Giovanna e Orsola si offrono allo sguardo con la forza di un autoritratto per assenza: di un'artista di talento, una 'valente donna', quelle di Fede, in grado di misurarsi e contemporaneamente distanziarsi dagli esemplari di Figino e di Caravaggio; di un'artista cosmopolita e talentuosa, aggiornata su ricerche e novità scientifiche quelle di Giovanna; di una pittrice monaca devota, ma anche ricca di riferimenti al desiderio di una sessualità e di una creatività libere e felici, quelle di Orsola. La natura estremamente riservata e famigliare delle sue nature morte, come pure la loro antica collocazione, ne lasciano leggere un affioramento intimo e agalmatico. Non è d'altra parte fuori luogo ricordare non solo come ai frutti fossero dichiaratamente sottese allusioni erotiche e omoerotiche, ma anche come le donne – e solo loro – fossero considerate facilmente corrompibili con la sola frutta e dovessero resistere ai peccati di gola ritenuti un viatico per il peccato di lussuria. Non va in questo senso dimenticato come la caduta dell'umanità nel peccato sia stata a posteriori attribuita ad un'incapacità tutta femminile di continenza manifestata nei confronti di un frutto.

È anche attraverso la rappresentazione di frutti, dunque, che in Età moderna le artiste sembrano riappropriarsi di un mondo all'interno del quale gli uomini avevano loro assegnato ruoli ben precisi: erano quasi sempre le donne a raccogliere frutta e verdura nei campi; le donne se ne occupavano in cucina; le stesse donne la vendevano al mercato. La scelta di partecipare da subito alla nascita di un genere nuovo riflette molto probabilmente qualcosa di ben più complesso della relativamente facile accessibilità degli oggetti da dipingere. Occorre infatti ricordare come ancora in Età moderna la frutta, alimento riservato all'*élite* aristocratica, costasse molto e fosse difficile da reperire. Da venditrici di mercato o sguattere in cucina, da oggetti di rappresentazione e di desiderio erotico le donne paiono rivendicare una nuova libertà spostandosi davanti alla tela e riassegnandosi, pennello alla mano, quella capacità generatrice ed epifanica propria della Natura che, come ribadito dagli stessi contemporanei, 'pur'è femina anch'ella'.[28] Se nel Cinquecento Giovanni della Casa ancora poneva la donna 'tra noi uomini e le bestie, ma non a uguale distanza fra i due estremi; è infatti molto più vicina alla rozzezza delle bestie di quanto non si avvicini alla compiutezza e perfezione degli uomini',[29] ai primi del Seicento risalgono gli studi di Charles Butler dedicati alle api,[30] che avviano in quegli anni una crisi nella comprensione dei ruoli

27 Lomazzo, *Trattato dell'arte della pittura, scoltura et architettura*, p. 349.
28 Marino, *La Galeria*, p. 313.
29 In Muzzarelli, *Nelle mani delle donne*, p. 57.
30 Buthler, *The Feminine Monarchie*.

di genere in tutta Europa. La Galizia, ma soprattutto la Garzoni, inserendo nelle loro opere insetti che vivono in strutture governate da femmine si mostrano aggiornate sui primi studi di entomologia in chiave protofemminista. Analizzando la complessità del tema, Mary D. Garrard[31] ha interpretato il basso rango assegnato alla natura morta nel XVII secolo proprio come un riflesso della tensione tra i sessi, come un crescente pregiudizio che ha fatto sì che gli uomini manifestassero col tempo una avversione verso un genere man mano che questo si venne femminilizzando. Di qui alla rimozione del ricordo di artiste donne, il passo è breve.

Appendice documentaria

FEDE GALIZIA			
1617	Genova	Doria Niccolò	Una tazza di persiche e mele della **Milanese**
1630–1640	Firenze	Bronzini Cristofano (manoscritto)	Famosa e celebre nell'arte della pittura fu anco **Fede Galizia** fanciulla milanese, la quale nel pinger del naturale ^et particolarmente^ frutti e piante, riuscì tanto rara
1635	Torino	Savoia Carlo Emanuele I	Tazza di cerase con una farfalla. Di **Fede Galicia**. Buono. A. p. 0.7; L. p. 0.10
1642	Parigi	Bonnard Pierre	Un petit tableau peint à l'huile sur bois, barré par derrière, ancien sur lequel sont peints des pommes, des marrons et un lapin d'Inde, da la main de la **Signora Fede** d'un pied 7 pouces da large 30 livres, n. 59
1646		Anonimo (manoscritto)	In lode di **Madona Fede Pitrice** sopra una frutera
1650	Milano	Monti Cesare	Quattro quadreti bislonghi con frutti diversi di mano di **Mad. Fede**
1666	Milano	Settala Manfredo	Due uccelli in due quadri, pitturati da **Fede Gallitia**
1672	Milano	Mazenta Ludovico	**Madonna Fede** – 231 (n. 36) Un cesto di uva con passero che la mangia ed un tordo morto, br. 1, in tavola
1701	Milano	Visconti Giovanni Battista	Una fruttiera con un catino di maiolica pieno di magiostre con un ramo di rosa, una bacilletta con spolverino, cucchiaro e forcina d'argento. Originale di **Madonna Fede Galicia**, Cornice dorata
1701	Milano	Visconti Giovanni Battista	Un'altra fruttiera con varii frutti, cioè brugne, pere, fave. Originale di **Madonna Fede Galicia**. Cornice dorata

31 Garrard, 'The Not-So-Still Lifes of Giovanna Garzoni', pp. 62–77.

FEDE GALIZIA

1701	Milano	Visconti Giovanni Battista	Una fruttierina di bricoccole e brugne dentro d'un cesto di vimini, su l'orlo di cui v'è un uccellino, et dalli lati duoi vasetti di fiori, su l'assa. Originale di **Madonna Fede** in traverso, on 11, in alto on 7 1/4
1710	Milano	Visconti Ercole	Doi altri [quadri] con sopra fruttiere con cornice nera soglia di mano di **Madona Fede Gallizia**, stimati filippi 18 lire 126
1721	Milano	Besozzi Paolo	Altro quadro rappresentante una Fruttiera in tavola, originale di **madona Fede** con cornice intagliata et oro
1721	Milano	Besozzi Paolo	Altro quadro rappresentante un cesto pieno di frutti in tavola, originale di **madona Fede**, cornice intagliata

GIOVANNA GARZONI

1634	Torino	Savoia	2 Altri sopra la bergamina frutti Miniatura della Signora **Giovanna Garzoni**, che hanno le Cornici d'Hebano
1662	Firenze	de' Medici Giovan Carlo, cardinale	Due quadri in ottangolo entrovi sopra la Cartapecora, miniature di frutti, fiori, et vasi della **Giovanna Garzoni fiamminga** adornamento d'ebano braccia 2. doble 21
1662	Firenze	de' Medici Giovan Carlo, cardinale	Sette ovali in Cartapecora di Miniature di Frutti, Fiori et Animali et Vasi di **Gio: Garzoni** altezza braccia 1–1/2. doble 73–1/2
1663	Firenze	de' Medici Giovan Carlo, cardinale	Due quadri in Ottangolo, entrovi due Tazze, alte di Piede, che in uno Pesche, un fico; e tre Bazzaruole, al piede a nell'altro susine asparse, di gensomini, e foglie, et al piede di dette coppe, sono due pere e cinque ciriege, con ornamenti di ebano filettati di acciaio, di mano della **Giovanna Garzoni**, fiamminga
1663	Firenze	de' Medici Giovan Carlo, cardinale	Un quadretto in Cartapecora, con una Caraffa di diversi fiori, ed un vaso di Porcellana, pieno di Ciliegie, con una Ciliegia, che sta per cadere, et un'altra caduta, fra li piedi di detto vaso e detta Caraffa, con due Pesche intere, et una mezza Pesca, e altro con una Pietruzza scrittovi **Giovanna Garzoni**

GIOVANNA GARZONI			
1675–1676	Firenze	de' Medici, Leopoldo	Un quadro in cartapecora alto 5/6 largo 2/3, miniatovi di mano della **Giovanna Garzoni**, della maniera migliore, n. quattro augeletti che posano sopra rami di frutte, cioè una mela, due pere e fichi brogiotti, con adornamento di ebano scorniciato e tartaruga, con cristallo sopra, n. 1
1675–1676	Firenze	de' Medici, Leopoldo	Un quadro in cartapecora alto 5/6 largo 2/3, miniatovi quattro uccelli che posano ciascheduno di essi sopra un ramo di frutte, cioè pesche, susine, ciliege e pere moscadelle, di mano della **Giovanna Garzoni**, con adornamento simile, n. 1
1677	Torino	Savoia	Un piccolo quadretto in miniatura di un vaso bleu ripieno d'un cedro, fiori, e Citroni, con Cornice indorata solia di mano della **Sig.ra Giovanna Garzoni** e Altro quadretto di **Giovanna la Miniatrice** d'un piatto di frutti Gambari e lumache pur sopra la Cartapecora in cornice solia indorata.

Nelle tabelle sono elencati i documenti nei quali viene riconosciuta alle artiste esaminate la paternità di dipinti raffiguranti nature morte: si tratta di soli riferimenti inventariali o note conservate in forma manoscritta. Non viene registrata alcuna assegnazione di nature morte alla mano di Orsola Maddalena Caccia, che pure ne ha licenziato un numero non inferiore a Fede Galizia, ma per lo più destinato ad un ambito strettamente famigliare o conventuale.

Bibliography

Primary Sources

Baglione, Giovanni, *Le vite de' pittori, scultori et architetti. Dal Pontificato di Gregorio XIII del 1572 in fino a' tempi di Papa Urbano VIII* (Rome: Fei, 1642)

Baldinucci, Filippo, *Notizie dei professori del disegno da Cimabue in qua* (Florence: Manni, 1702)

Bronzini, Cristofano, *Della dignità et nobiltà delle donne* (Florence: Pignoni, 1624)

Butler, Charles, *The Feminine Monarchie* (Oxford: Barnes, 1609)

Della Casa, Giovanni, *Il Galateo* (Venice: Manuzio, 1558)

Lomazzo, Giovan Paolo, *Trattato dell'arte della pittura, scoltura et architettura* (Milan: Gottardo Ponzio, 1585)

Macioce, Stefania, *Michelangelo Merisi da Caravaggio. Fonti e documenti 1532–1724* (Rome: Bozzi, 2003)

Marinetti, Filippo Tommaso, 'Manifesto della cucina futurista', <https://www.memofonte.it/files/Progetti/Futurismo/Manifesti/II/204.pdf> [accessed 05.20.2022]

Marino, Giovan Battista, 'Frutti di mano di una donna', in *La Galeria* (Venice: Ciotti, 1620)

Secondary Studies

Agosti, Giovanni e Jacopo Stoppa in *Fede Galizia mirabile pittoressa*, a cura di Giovanni Agosti, Luciana Giacomelli and Jacopo Stoppa (Trento: Castello del Buonconsiglio, 2021), pp. 324–31

Barker, Sheila, 'The First Biography of Artemisia Gentileschi. Self-fashioning and Proto-femminist Art History in Cristofano Bronzini's Notes on Women Artists', *Mitteilungen des Kusthistorischen Insitutes in Florenz*, LX band, heft 3 (2018), 405–35

Bòttari, Stefano, *Fede Galizia pittrice (1578–1630)* (Trento: CAT, 1965)

De Logu, Giuseppe, *Natura morta italiana* (Bergamo: Istituto Italiano d'Arti Grafiche, 1962)

——, *Pittori minori liguri lombardi piemontesi del Seicento e del Settecento* (Venice: Zanetti, 1931)

Farina, Viviana, *Giovan Carlo Doria promotore dele arti a Genova nel primo Seicento* (Florence: Edifir, 2002)

Garrard, Mary DuBose, 'The Not-So-Still Lifes of Giovanna Garzoni', in *The Immensity of the Universe in the Art of Giovanna Garzoni*, a cura di Sheila Barker (Florence: Sillabe, 2020), pp. 62–77

Gombrich, Ernest H., 'Tradizione ed espressione nella natura morta occidentale', in *A cavallo di un manico di scopa. Saggi di teoria dell'arte* (Turin: Einaudi, 1971), pp. 144–60

——, 'Tradition and Expression in Western Still Life', *The Burlington Magazine*, 103 (1961), 175–80

Hoogewerff, Godefridus J., 'Nature morte italiane del Seicento e del Settecento', *Dedalo*, IV (1924), 599–624, 710–30

La natura morta italiana, catalogo della mostra Napoli, Zurigo, Rotterdam, ottobre 1964 – marzo 1965 (Milan: Alfieri & Lacroix, 1964)

La Nature morte de l'Antiquité à nos jours, a cura di Charles Sterling (Paris: Éd. des Musées Nationaux, 1952)

La Nature morte de l'Antiquité à nos jours, a cura di Charles Sterling (Paris: Tisné, 1959)

Longhi, Roberto, 'Un momento importante nella storia della "natura morta"', *Paragone*, I.1 (1950), 34–39

Marangoni, Matteo, 'Valori malnoti e trascurati della pittura italiana del Seicento in alcuni pittori di natura morta', *Rivista d'arte*, X.1–2 (1917/1918), 1–31

——, *Arte Barocca. Revisioni critiche* (Florence: Vallecchi, 1927)

Mostra della pittura italiana del Sei e del Settecento in Palazzo Pitti, a cura di Nello Tarchiani, Florence 1922 (Rome: Bestetti & Tumminelli, 1922)

Muzzarelli, Maria Giuseppina, *Nelle mani delle donne. Nutrire, guarire, avvelenare dal Medioevo a oggi* (Bari: Laterza, 2013)

Renzi, Giovanni, 'Regesto di Nunzio e Fede Galizia (1573–1809)', in *Fede Galizia mirabile pittoressa*, a cura di Giovanni Agosti, Luciana Giacomelli, e Jacopo Stoppa (Trento: Castello del Buonconsiglio, 2021), pp. 333–60

Rosini, Giovanni, *Storia della pittura italiana esposta coi monumenti. Epoca quarta dai Carracci all'Appiani* (Pisa: Capurro, 1846)

Still Life Painting from Antiquity to the Present Time, a cura di Charles Sterling (New York: Universe Books, 1959)

Ticozzi, Stefano, *Dizionario dei pittori dal rinnovamento delle belle arti fino al 1800* (Milan: Ferrario, 1818)

Venturi, Adolfo, *Storia dell'arte italiana* (Milan: Hoepli, 1901)

ELLI LEVENTAKI

Gender-biased Documentation of Women Visual Artists in Early Twentieth Century Greece, or Where did this Chapter go?

▼ **ABSTRACT** It was slightly after the foundation of the modern Greek state that the first school of arts was inaugurated in Athens (1837), admitting, however, only male students until the beginning of the twentieth century. Despite managing to eventually get accepted into the faculty and take part in art exhibitions, women weren't adequately documented since their presence was often perceived as temporary or incidental in this highly patriarchal context. Consequently, the problematic foundations laid at the time, along with modern labeling notions, placed these women outside the official art history. Aspiring to reconstruct lost narratives today, though, researchers can take advantage of the contemporary tools available for mapping and documentation, in order to disseminate this knowledge in a coherent, viable, and sustainable way.

Visual Arts at the Turn of the Twentieth Century in Athens, Greece

It was not long after the establishment of the modern Greek state, with the revolution of 1821, that the first School of Arts was founded in Athens (1837), suggesting a rather keen desire for people to start having professional training and education in order to create artworks and shape a local art scene. These future artists were the ones who were going to showcase a Greek cultural product, both within the framework of the country and abroad, and become the representatives of a newly-built national narrative and art history. However, this was the case for just half the population since women didn't have access to professional training in visual arts until the beginning of the twentieth century.

Women in Arts, Architecture and Literature: Heritage, Legacy and Digital Perspectives, ed. by Consuelo Lollobrigida and Adelina Modesti, Women in the Arts: New Horizons, 1 (Turnhout: Brepols, 2023), pp. 351–362
BREPOLS ❦ PUBLISHERS 10.1484/M.WIA-EB.5.134662

Fig. 1. Thalia Flora-Karavia, *Portrait of Sophia Laskaridou*, StoART Korai, post-1906. Archive of Neohellenic Art 'Sofia Laskaridou' – Portraits of Greek Artists, available in public domain at: <shorturl.at/hJNV5> [accessed 20/08/2022].

In particular, in 1894, the then director of the School of Arts,[1] Anastastios Theofilas, suggested the formation of the 'Department of Graphic and Plastic Arts for young ladies'[2] in the faculty, where women would be taught a few artistic courses, but wouldn't get the same diploma, nor share similar institutional vesting as men.[3] Despite his decision not providing equal rights to female students, it was not well-received either by students or teachers. Amidst the objections, the department opened up, welcoming approximately 80 women, only to stop its operation after a few years. The void that was created as a result of the lack of a public faculty, sparked private initiatives for women's artistic education, like *Kallitechniki Scholi Kyrion* [Women's Artistic School], which was founded by *Etaireia ton Filotechnon* [Society of Friends of Fine Arts] and opened its doors in 1900. Education-wise, things changed in 1901 when the young painter Sofia Laskaridou (Fig. 1), coming from a high-class family herself, called out to the king to interfere and end this injustice, something that he

[1] The faculty was initially called 'School of Arts' and included both technical and artistic courses, but was renamed in 1909 to 'School of Fine Arts' and became an autonomous department. In 1930 it was completely separated from the National Technical University and was acknowledged as a higher educational institution under the name Athens School of Fine Arts. For more see the official ASFA website <http://www.asfa.gr/idrima/istoria>.

[2] The decree was published in the journal 'Acropolis' on 25/02/1894 and can be found in Biris, *I Istoria*, pp. 333–34.

[3] Gotsi, 'O Logos', p. 251.

Fig. 2. Makkas Nikolaos, *The Zappeion Megaron*, c. 1905. E.L.I.A. Photographic Archive, available under CC BY 4.0 license (cropped horizontally) at: <http://archives.elia.org.gr:8080/LSelia/images_View/L143.337.JPG> [accessed 19/08/2022].

(surprisingly) did.[4] From that point on, there were mixed groups in the faculty, with women having access to the same courses and getting an equal degree, making it possible to actually practice their art professionally. In 1904, there was again an attempt to forbid their participation via a petition filed to the prime minister, with complaints on the grounds of 'decency and ethics'.[5] Apparently, men believed these qualities to be affected by professional training, but not if women were practicing arts in the privacy of their homes.[6] Fortunately, their request was turned down, and the subject closed for good.

At that point, however, there were already women taking part in group exhibitions, be they amateurs and home-schooled individuals, who had some kind of training, or professional artists, who had managed to study in academies abroad. A characteristic example is that of the *Kallitechniki Ekthesis Kyrion* [Ladies' Artistic Exhibition], an all-women show held at the offices of *Efimeris ton Kyrion* [Ladies' Newspaper] in 1891, featuring around 90 participants with more than 200 artworks.[7] Other than that, artistic exhibitions, but also of other kinds (ex. of agricultural products, tools, handicrafts, and more) took place in the prestigious Zappeion Hall (Fig. 2) in the

4 The official announcement of mixed attendance was published in the journal *Pinakothiki*, in April 1901.
5 Scholinaki-Chelioti, 'Ellinides Zografoi', p. 61.
6 Laskaridou has been reportedly treated with pure hostility, both by her professors and peers when started studying in the faculty. See Varika, *I Exegersi*, p. 248.
7 For the first of a series of announcements see Anonymous, 'Kallitechniki Ekthesis', pp. 1–2.

center of the city, as well as in other buildings gradually, like that of *Parnassos Literary Society*, in hotel lobbies, theaters, and eventually the first galleries. In most cases, women were outnumbered by far, both as individuals, and also artwork-wise, which meant that even if they could be almost one-third of the participants, their works were less than one-fifth of the overall exhibited pieces,[8] rendering the ratio all the more im-balanced. Despite a substantial number of women artists being properly educated, highly productive, and regularly active by then, they were not given enough space in the public sphere, nor were adequately documented compared to their male peers. Drawing from those cases whose presence was not so consistent, for social and/or practical reasons, the participation of the entire body of women in art exhibitions was at large perceived as incidental or temporal, a fact that had a direct impact on their commemoration in the course of time.

Documentation and Research Challenges

Keeping track of art exhibition records and documenting artistic work was challeng-ing at that point anyway, both due to lack of institutional support and practical tools, as well as expertise and resources. Nevertheless, men artists of the same generation did manage to secure a place in the official art history, through the pages of exhibition catalogs, newspaper excerpts, and other textual or visual evidence. Respective testi-monies can be found about women visual artists as well, but social conventions of the time and modern labeling notions, rendered the process and interpretation of such information much trickier, resulting in fragmented and/or unimpactful outcomes.[9] In patriarchal contexts, where art histories are written by men and the role of women is just complimentary next to the male protagonists, any references regarding their work are scattered around an overarching narrative, making it twice as hard to locate, put together, and make sense of them. Looking at the available material on the subject, the patriarchal limitations are reflected throughout the content, emanating mainly from the fact that women weren't seen as historical subjects for the most part of history, therefore enjoying little commemoration within the existing narratives. The problematic documentation we are facing is based on twofold grounds: on the one hand, the synchronous issues that were directly connected with social and family boundaries of the era and on the other, the asynchronous conventions that occurred along the way and affected women's position in art histories worldwide.

Starting with the first kind, one realizes the difficulty with which men were writing about women's works back then since there was no 'female art' category in which they could place them,[10] neither did women constitute one coherent group with similar characteristics to ease things out in terms of documentation. For men, who were writing all the stories at this point, mixing them up with their male peers seemed

8 See Syndesmos Ellinon, *B' Panellinios*.

9 It is suggested that gender criteria already established by the turn of the century, foreshadowed the silencing of women's contribution to twentieth-century art history. See Chamalidi, 'Ellinides Eikastikoi', p. 77.

10 Gotsi, '"Feminist Art"', p. 43.

ΕΠΑΜ. ΘΩΜΟΠΟΥΛΟΣ

Καθηγητὴς Σχολῆς Καλῶν Τεχνῶν (Πολυτεχνείου)

53.	Ὁ Γαϊδαράκος	2.000
54.	Ὁ Κόκκορας	1.000
55.	Κορινθιακὸς	2.500
56.	Στὴ βρύσι	3.500

ΓΕΩΡΓ. ΙΑΚΩΒΙΔΗΣ

Διευθυντὴς Σχολῆς Καλῶν Τεχνῶν

57.	Γαρύφαλλα	25.000
58.	Κυδώνια	20.000
59.	Nature morte	20.000

ΓΕΩΡΓ. ΚΟΣΜΟΣ

Ἀναγνωστοπούλου 10

60.	Nature morte	5.000
61.	Στὴν αὐλὴ τοῦ Μοναστηριοῦ (Σκόπελος)	15.000

ΓΕΩΡΓ. ΚΟΤΣΑΚΗΣ

Φαλήρου 39

62.	Καίκια	5.000
63.	Χωριάτικη Αὐλὴ	2.500
64.	Αὐλὴ Σπυριανὴ	2.000
65.	Μελτεμάκι	2.000

Κᴬ ΝΙΤΣΑ ΚΟΚΙΝΗ-ΜΑΚΑΡΟΝΑ

Ψαρῶν 47

66.	Ἐκκλησία Δαφνίου	2.500
67.	Χιόνια	600
68.	Ἀπὸ τὸ Κρανίδι	2.000

Δᴺᴵˢ ΜΙΝΑ ΚΩΛΕΤΤΗ

Σκουφᾶ 66

69.	Παραλία Σκύρου	3.500

ΘΕΟΔ. ΛΑΖΑΡΗΣ

Νέγρη 9

70.	Στὴν αὐλὴ	8.000
71.	Αὐλὴ Μοναστηρίου Πόρου	8.000
72.	Ἐρείπια Βυζαντινῆς Ἐκκλησίας	3.000

ΠΕΡ. ΛΥΤΡΑΣ

Ζφοδ. Πηγῆς 36

73.	Ἐκκλησάκι (Τῆνος)	12.000

Δᴺᴵˢ ΣΟΦΙΑ ΛΑΣΚΑΡΙΔΟΥ

Καλλιθέα

74.	Ἄποψις Σαντορίνης	
75.	Ἀνεμῶνες	
76.	Ἀνεμόμυλοι Πάρου	

ΠΑΝΑΓ. ΛΙΤΣΚΑΣ

Ἀριστονίκου 14

77.	Ἀνατολικὴ Ἀγορὰ (σπουδὴ)	3.500
78.	Τοπεῖον Καστοριᾶς	8.000
79.	Ὁ Χειμών	6.000
80.	Νεκρικὴ Πομπὴ (σπουδὴ)	4.000

Π. ΜΑΘΙΟΠΟΥΛΟΣ

Καθηγητὴς Σχολ. Καλῶν Τεχνῶν (Πολυτεχνείου)

81.	Τὸ Βενετσάνικο Βᾶζο	6.000

ΔΗΜ. ΜΠΡΑΕΣΣΑΣ

Δεινοκράτους 47

82.	Μύκονος	4.000
83.	Τὸ Ψάρεμμα	8.000
84.	Σκῦρος	4.000
85.	Τὸ ἄσπρο ἐκκλησάκι (Σκῦρος)	5.000
86.	Ὁ Γιαλὸς (Σκῦρος)	4.000

Δᴺᴵˢ Β. ΜΠΕΚΙΑΡΗ

Πατησίων 131

87.	Τουρκολίμανο	4.000
88.	»	4.000
89.	Nature morte	6.000
90.	Πορτοκάλλια	5.000

Δᴺᴵˢ ΑΙΚΑΤ. ΜΑΡΙΝΑΚΗ

Πατησίων 129

91.	Τσαντῆρι	1.000
92.	Τοπεῖον	700

Ν. ΝΑΚΗΣ

Ἑλληνοαμερ. Κολλέγιον

93.	Σπίτια ἀπὸ τὸ Πήλιον	1.000

ΜΙΧΑΗΛ ΟΙΚΟΝΟΜΟΥ

Δεινοκράτους 34

94.	Τοπεῖον	10.000
95.	»	10.000

ΠΗΝΕΛ. ΟΙΚΟΝΟΜΙΔΟΥ

Σαπφοῦς 172 (Καλλιθέα)

96.	Ἠπειρώτισσα	2.000

ΟΘ. ΠΕΡΒΟΛΑΡΑΚΗΣ

Φιλαδελφείας, 6

97.	Ἀπὸ τὸ Φάληρο	2.500
98.	Ἀπὸ τὴν Ἀττικὴ	4.000
99.	Ἐσωτερικὸν	5.000
100.	Ἐξοχὴ (σχέδιον)	2.500

Fig. 3. Syndesmos Ellinon Kallitechnon, Catalogue of *Z' Panellinios Ekthesis* [Seventh Panhellenic Artistic Exhibition], p. 4, The Library and Archive of National Gallery – Alexandros Soutzos Museum. 1929, Athens. Available in public domain at: <http://79.130.89.115/Pictures/1929/461_1929.pdf> [accessed 21/08/2022].

somehow challenging, and so did the attribution of qualities to their work. Apart from constantly being perceived from a male point of view, women's creations were also often rated in relation to their similarities to those of men, so for example, when it is stated that 'her work looks like a man made it',[11] it is supposed to be taken as a compliment. In other occasions, their artworks were expected to reflect their gender and its 'natural qualities',[12] in order to not be compared to that of men's, but to make sense as women's production. Additionally, most critics and journalists assumed that any female visual artist will soon give up their art to focus on having a family in accordance with social standards. Thus, presuming that women learned how to paint in order to become better wives and mothers and not because they wished to develop their skills or for financial/professional reasons, they were not paying enough attention to them in the first place, considering this situation to be temporary.[13] Such assumptions worsened when a woman got married and would probably take some time off (especially if they also had children), this way unwillingly confirming the patriarchal canon.

Moreover, in many of these cases, women changed their last name to that of their husband, making it almost impossible to trace them *post factum* unless they kept both last names after marriage, or there is adequate biographical information to connect the dots. To mix things up even more, in the exhibition catalogs of the time, it was common for the first name to be omitted or to have only its initial letter written down, when at the same time it was indicated if a woman was married or not. The prefixes 'Mrs.' or 'Miss' that were oftentimes preceding female names (Fig. 3),[14] may facilitate a researcher's task today in terms of suspecting a name change, but they also point out that women's marital status was considered public information, most probably affecting the way they were perceived. Namely, we know that women who were married to fellow artists had the chance to travel, network, and exhibit more easily,[15] as they were accompanied by a man. Single women had to try twice as hard to be accepted in artist's groups, and even if they were coming from very wealthy and educated backgrounds it was pretty daring to move around by themselves in order to pursue their art.[16]

On top of all this and due to reasons that occurred later on, many of the above-mentioned difficulties seem to be projected to art histories to this day, resulting in the perpetuation of initially problematic documentations that included very few women's names. For example, artists who were labeled as 'amateurs' in early-twentieth-century Greece may have had enough artistic training, but their original status was never

11 Two such examples are mentioned in Gotsi, 'O Logos', pp. 296–97 and 300–01.

12 'Natural qualities' refer to gender-biased characteristics, like 'sweetness', 'calmness', 'lightness', etc., and it is a request that keeps coming up in the bibliography of the time. For further commentary on this pattern, indicatively see Gotsi, '"Feminist Art"' and Chamalidi, 'Ellinides Eikastikoi'.

13 The same goes for any type of work, which was supposed to be given up when women were to have a family. For more see Perrot, *I Ergasia*, p. 29 and Avdela, 'Dimosioi', pp. 46–47.

14 See the indications 'Κᴬ' (for married) or 'Δᴺᴵᴬ' (for single) in front of women's names in Fig. 3.

15 For reference see *Kallitechniki Ekthesis en to Dim. Theatro Peiraios*. In the catalog of this group art exhibition, the sole participant woman (Mrs Stefanopoulou – Alexandridou) is married to another participant artist (Mr Stefanopoulos).

16 In this light, let's not forget that the issue of mobility for women artists is still relevant in some cases to this day.

ΕΛΑΙΟΓΡΑΦΙΑΙ

ΕΡΑΣΤΕΧΝΑΙ ΚΤΛ. ΚΤΛ.

201	'Αχμέτ-'Αλῆ	Νεκρὰ φύσις	Τουρκία
202	»	»	»
203	Γ. Χρηστίδης		»
204	Ν. Βαρβέρης	Τὸ μάθημα τῆς γιαγιᾶς	Ἑλλὰς
205	Κ. 'Αντωνιάδης	Ὀπῶραι	Τουρκία
206	»	»	»
207	Ν. Βαρβέρης	Ἐσωτερικὸν	Ἑλλὰς
208	'Αχμέτ-'Αλῆ	Κεράσια	Τουρκία
209	Δὶς Ε. Μέρτενς	Καιρὸς θυελλώδης	Βέλγιον
210	»	«Μαοῦρα»	»
211	'Αχμέτ-'Αλῆ	Ἄνθη	Τουρκία
212	»	»	»
213	Δὶς Ε. Πατριάνου	«Ζιπ»	»
214	Ν. Βαρβέρης	Προσωπογραφία γέροντος	Ἑλλὰς
215	Δὶς Ε. Μπροῦσκου	Τοπεῖον	»
216	Δὶς Α. Κοπέσκι	Ἄνθη	»
217	»	»	»
218	Δὶς Σ. Κοπέσκι	»	»
219	Δὶς Ε. Πατριάνου	Προσωπογραφία (χανούμισα)	Τουρκία
220	Σ. Παρθένης	Προσωπογραφία τῆς διασίμου χορευτρίας Σαχαρέτ	Ἑλλὰς

Fig. 4. *Katalogos Diethnous Ektheseos Athinon. Tmima Kallitechnias* [Catalogue of International Exhibition of Athens. Department of Fine Arts], p. 22, The Library and Archive of National Gallery – Alexandros Soutzos Museum. 1903, Athens. Available in public domain at: <http://79.130.89.115/Pictures/545_1903.pdf> [accessed 22/08/2022].

questioned, let alone reevaluated since then. In an exhibition catalog from 1903, under the prestigious category of 'Oil Painting', there is a random sub-section entitled 'Amateurs etc.' (Fig. 4) and afterward an all-women category dedicated to 'Artistic Stitching' (Fig. 5), while four years later, another catalog features all sorts of artifacts made by women under 'Decorative Arts' (Fig. 6). So, while the means of creation were retrospectively used as indicators for ranking, we see here that it is accepted to showcase oil painting by a range of artists, whereas stitching can be a type of exhibited art along with decorative artifacts of various materials (that may also include some sort of stitching/embroidery themselves). This kind of arbitrary classification, which was common at the time, set the tone for future documentations and was retrospectively enhanced by the international horizontal rules on what constituted 'high' art, hence *a priori* excluding the work of many women.

By taking into account women artists' precarious education process, along with societal/institutional limitations and a lack of gravity when it came to their works, and combining it with international fixations and labels, one can see why this information has been so marginalized and hasn't practically reached school or university curricula.

Fig. 5. *Katalogos Diethnous Ektheseos Athinon. Tmima Kallitechnias* [Catalogue of International Exhibition of Athens. Department of Fine Arts], p. 38, The Library and Archive of National Gallery – Alexandros Soutzos Museum. 1903, Athens. Available in public domain at: <http://79.130.89.115/Pictures/545_1903.pdf> [accessed 22/08/2022].

A major reason for this neglect, in Greece in particular, I believe has to do with the lack of historical references since the art histories that we still have as benchmarks do not include these women (yet), and the respective conducted researches are relatively few, very recent, and clearly extra demanding. If we wish to create an impact though, the persistent exploration of the subject is crucial, while using contemporary tools and methods to re-approach originally dubious documentations and surviving fragmentary narratives with fresh eyes and mindsets.

Fig. 6. Elliniki Kallitechniki Etaireia, Catalogue of *Proti Ekthesis* [First Exhibition], p. 5, The Library and Archive of National Gallery – Alexandros Soutzos Museum. 1907, Athens. Available in public domain at: <http://79.130.89.115/Pictures/546_1907.pdf> [accessed 23/08/2022].

Present and Future Approaches

Starting from the basis of an official public education for women artists, and then taking into account their participation in exhibitions in the public sphere, such poor documentation and/or acknowledgment of their work may come as a surprise at first, but can subsequently be understood as one of the various ramifications of patriarchy. Looking to comprehend and restore previous shortcomings and fill in the gaps of the past,[17] contemporary researchers need to locate scattered material and connect pieces of information lying here and there, within a vast historical spectrum that mainly consists of gender-biased narratives. In my ongoing study, I focus on the first so-called 'professional' women visual artists in Greece and their presence in art exhibitions, in order to comprehend their place in the history of art and eventually reevaluate it. It is a long and slow mapping process, which requires critical navigation within the given patriarchal framework, for the collection of both quantitative and qualitative data, using up-to-date methodologies.[18] Drawing from primary sources, like records of participation, archives, and exhibition catalogs, as well as secondary studies that hold relevant mentions, the aim is to bring all the information together in the form of a digital database, where it can be interconnected, searchable, and sustainable for future purposes and endeavors.

A proposed strategy for steering through such an amount of old and scattered information would be to go back to the sources and break them down into specific data by taking advantage of the digital tools we have at our disposal today (ex. spreadsheets, tags, platforms, etc.). In this regard, research may produce results beyond gendered subjectivities and contribute to the historicization of lost narratives, as well as to their dissemination in cohesive and practically convenient formats.[19] For this data to effectively reach a broad audience and have an actual impact on the way we learn, talk, and write about art history in Greece, it needs to be shared with accessible textual and visual means that can enhance its extensive understanding and ensure an effect both in academia and collective memory for the long-term. Through studies, discussions, and papers like this one, the goal is to exceed social conventions of the past and modern labeling notions, while offering stimuli for further approaches and initiatives to emerge toward the direction of a more inclusive art history.

17 For the proceedings of the first symposium dedicated to the gender-related gaps in local art history, see Omada Techni, eds, *Kena stin Istoria*.

18 For instance, according to the European Institute for Gender Equality, the use of 'Sex- or Gender-Disaggregated Data' allows for 'the measurement of differences between women and men on various social and economic dimensions'. Read more at <https://eige.europa.eu/gender-mainstreaming/methods-tools/sex-disaggregated-data>.

19 It is indicative that the dissertation of Scholinaki-Chelioti, which is one of the first and most complete publications on the subject, is written with a typewriter, and is available only in one hardcopy, in one library in Athens that is open for just four hours per day.

Bibliography

Primary Sources

Anonymous, 'Kallitechniki Ekthesis Kyrion A'' [Ladies' Artistic Exhibition], *Efimeris ton Kyrion* [Ladies' Newspaper], 211, 5 May 1891, pp. 1–2

Kallitechniki Ekthesis en to Dim. Theatro Peiraios [Artistic Exhibition in Piraeus Municipal Theatre] (Athens, 1923), available at <http://79.130.89.115/Pictures/1923/480_1923.pdf> [accessed 20 August 2022]

Syndesmos Ellinon Kallitechnon, *B' Panellinios Kallitechniki Ekthesis* [Second Panhellenic Artistic Exhibition] (Athens, 1915), available at <http://79.130.89.115/Pictures/1915/473_1915.pdf> [accessed 20 August 2022]

Secondary Studies

Avdela, Efi, *Dimosioi Ypalliloi Genous Thilykou. Katamerismos tis Ergasias kata Fyla ston Dimosio Tomea 1908–1955* [Civil Servants of Female Gender: Gender Division of Labor in the Public Sector, 1908–1955] (Athens: Research and Education Foundation of the Commercial Bank of Greece, 1990)

Biris, Kostas, *I Istoria tou Ethnikou Metsoviou Polytechniou* [*The History of the National Technical University of Athens*] (Athens: ATHENA Publications, 1957)

Chamalidi, Elena, 'Ellinides Eikastikoi stin Kampi tou 19ou pros ton 20o ai. kai ston Mesopolemo: Ypodochi tou Modernismou kai Emfyli Anaparastasi' [Greek Women Artists in the turn of the 19th to the 20th century and during the Inter-war period: Reception of Modernism and Gender Representation] in *Women's Literary and Artistic Activity in Greek Literary and Art Periodicals: 1900–1940*, ed. by Sophia Denissi (Athens: Gutenberg, 2008)

Gotsi, Chariklia-Glafki, '"Feminist Art", "Female Art", "Sexless Art" in a Modernist Context: Women's Collective Exhibitions in Greece, 1925–1937', in *Women's Contributions to Visual Culture, 1918–1939*, ed. by K. E. Brown (Aldershot, England & Burlington, VT: Ashgate Publishing, 2008), pp. 37–55

———, 'O Logos gia ti Gynaika kai ti Gynaikeia Kallitechniki Dimiourgia stin Ellada (teli 19ou – arches 20ou aiona' [The Discourse on Woman and Female Artistic Creativity in Greece (late 19th-early 20th century)] (unpublished doctoral thesis, Aristotle University of Thessaloniki, Department of History and Archaeology, 2002)

Omada Technis 4+, eds, *Kena stin Istoria tis Technis. Gynaikes Kallitechnides* [Gaps in the History of Art. Women Artists] (Athens: Ekdosis Govostis, 1993)

Perrot, Michelle, *I Ergasia ton Gynaikon stin Europi 19os-20os ai.* [Women's Labor in Europe, 19th-20th c.], trans. by Dimitra Samiou (Ermoupolis: Cyclades Scientific and Educational Foundation, 1988)

Scholinaki-Chelioti, Charis, 'Ellinides Zografoi 1800–1922' [Greek Women Painters 1800–1922] (unpublished doctoral thesis, University of Athens, 1990)

Varika, Eleni, *I Exegersi ton Kyrion. I Genesi mias Feministikis Syneidisis stin Ellada 1833–1907* [The Ladies' Revolt. The Birth of the Feminist Consciousness in Greece, 1833–1907], 6th edition (Athens: Papazisi publications, 2011)

ELIZAVETA V. MIROSHNIKOVA

Valentine Gross-Hugo

The First Female Artist in Surrealism

▼ **ABSTRACT** Valentine Gross-Hugo (1887–1868) began her career in the 1910s. as a fashion illustrator, but she was also attracted by ballet — a direct consequence of the performances in France of the Russian Ballets and the huge influence on the artist of the figure of S. Diaghilev himself, whom Gross met in 1909. Thanks to her acquaintance with Diaghilev and her marriage in 1919 to the artist Jean Hugo, the great-grandson of Victor Hugo, Valentine got into the epicenter of the Parisian artistic life, which allowed her to keep abreast of all new ideas and trends, one of which — from the mid-1920s. and there — was surrealism. Being familiar with many participants in the surrealism movement, she felt under their creative influence, and gradually, more and more interested in the ideas of surrealism became herself an active participant, taking part in the experiments of surrealists. However, V. Hugo left the official group of surrealists in 1938, but continued to work using the artistic and aesthetic principles and methods of surrealism, and her ties with the surrealists are not interrupted.

Valentine Marie Augustine Gross-Hugo was born on March 16, 1887 in the town of Boulogne-sur-Mer in the family of the pianist Auguste Gross. From 1907 to 1910 Valentina Gross studied at the École des Beaux-Arts in Paris at the studio of Fernand Humbert.[1] In 1909 she attended the first performance of Diaghilev's Russian Seasons. There is a legend that after the performance, plucking up courage, the girl approached the all-powerful impresario and asked permission to attend the ballet troupe's rehearsals and make sketches. Diaghilev allowed: from 1909 to 1914, the artist made sketches of the rehearsal and staging process of almost all Diaghilev's pre-war premieres.

1 Ribaud, ed., *Le Carnaval des Ombres*, p. 27.

Women in Arts, Architecture and Literature: Heritage, Legacy and Digital Perspectives, ed. by Consuelo Lollobrigida and Adelina Modesti, Women in the Arts: New Horizons, 1 (Turnhout: Brepols, 2023), pp. 363–372

Also, before the First World War, Valentina Gross actively collaborated as a graphic artist with the fashion magazine Gazette du Bon Ton.[2] She illustrated articles about Russian ballet, drew fashion pictures.

The most famous fruit of Valentina Gross-Hugo's work during the period of her collaboration with Diaghilev is, of course, the ballet Parade, the scandalous premiere of which took place on 18 May, 1917 at the Châtelet Theater. It was at Valentine's dinner that the young writer Jean Cocteau met the composer Erik Satie, who had a reputation as a staunch modernist. And than Satie offered his friend Picasso as an art director. Diaghilev supported the project, but it was Valentina who settled the endless disputes and tensions while working on the ballet, as evidenced by the correspondence.[3]

After the war, the situation changed: it was already impossible to live an ephemeral life, the horrors of the war seemed to have crossed out all past interests and hobbies. And the first half of the 1920s. becomes for Valentina Gross a time of active search for herself in art process. In addition, there have been changes in the artist's personal life. In 1919, Valentina Gross married the great-grandson of the writer Victor Hugo, the painter Jean Hugo, and the couple opened a sophisticated salon in their apartment in the Palais-Royal, where all the smart set of post-war artistic Paris was gathered. Among the friends and regular visitors of the salon was Count Etienne de Beaumont — the organizer of the annual luxurious fancy-dress balls and not a very successful entrepreneur — his theatrical venture 'Soirées de Paris' lasted only one season and, of course, could not overshadow Diaghilev's 'Ballets Russes' and even Rolf de Maré's 'Ballets Suédois'. Valentine, together with her husband, actively participated in all the Count's endeavors (Fig. 1). The spouses came up with decorations and costumes for balls, as well as for theatrical performances of the entreprise[4] Valentine was also a costume designer in Dreyer's famous film 'The Passion of Jeanne D'Arc'.[5]

In 1926, Valentine Hugo met the poet Paul Éluard and a friendship was struck between them, which would break only with the death of Éluard in 1952. It was Éluard who led Valentine Hugo to surrealism, a new artistic movement that began to gain strength in the 1920s. Éluard was André Breton's best friend and follower, and one of the brightest — by virtue of his talent — exponents of surrealist ideas. The main ideologue of surrealism, André Breton, published the Surrealist Manifesto in December 1924, where he formulated for the first time the aesthetic principles of a new art movement — 'surrealism'. Let us remind you that the very word 'surrealism' first appeared in Guillaume Apollinaire's advertising text for the ballet 'Parade'.[6] Growing out of the dada movement (and attracting many previously active dadaists to its side), surrealism relied on the philosophical concept of Henri Bergson in its theoretical basis. Bergson's intuitive theory asserted that the creative potential — intuition — of the artist should be directed not towards objects and phenomena of

2 e.g. Gazette du Bon Ton, 1915, N 8–9.

3 Cocteau Jean, *Petuh i arlekin: Libretto. Vospominaniya. St o muzyke i teatre*, pp. 157, 159, 160, 162, 163.

4 e.g. 'Romeo and Juliet', 'Les mariés de la tour Eiffel', 'Vogue'.

5 Hugo, 'Préface', pp. 5–6.

6 Appollinaire, 'Parade' et l'esprit nouveau', p. 5.

Fig. 1. Valentine Hugo dressed as a carousel, 'Bal des Jeux', 1922. Photo by Paul O'Doyé. Copyright: Fonds Etienne de Beaumont/Archives IMEC.

the external material world, but inside, into himself — i.e. the object of art is not objective reality, but the artist's own consciousness, his inner world. In addition, Bergson's ideas about the 'hypnotic' influence of art merged with Sigmund Freud's theory of the role of the unconscious in the formation of the human personality.

It is this fundamental discovery of Freud that is central to the surrealist theory, and the main goal of the surrealist is to penetrate into the free, mindless world of the unconscious, to live and create a new reality in it — on the edge of dream and reality. Two main ways of penetrating this world of the unconscious were proposed. The first — automatic writing — this concept Breton borrows from the book 'Psychological Automatism' by the French neuropathologist and psychiatrist Pierre Janet,[7] who was fond of Bergson. And the second — Breton obviously liked him much more and stemmed directly from the works of Freud — the interpretation of dreams, since it is dreams that act as mediators between the conscious and the unconscious.

Valentine was very sensitive to new ideas, which seemed to her as a way out of the creative impasse in which she — and not only she — found herself after the war. Therefore, the artist actively joined the emerging movement. For example, she took part in such experiments of the surrealists on automatic writing as 'Exquisite Corpse' (cadavre exquis). Painted with André Breton, Tristan Tzara and his wife Greta Knutson, 'Landscape' was exhibited at the grandiose exhibition Fantastic Art, Dada and Surrealism at the Museum of Modern Art in New York in 1936, along with three other works by the artist.[8] The creative method or experiment 'The Exquisite Corpse' — one of the expressions of the idea of 'automatic writing' — was invented around 1925 by a group of Parisian surrealists — Breton, Tanguy, Duchamp and the poet Jacques Prévert. He embodied the creative process 'without mind control'. In addition, there were also ideas of collective action and ideas of play — some of the most important in the methodological concept of surrealism. But what began as a game soon turned into a very useful method for reaching the collective unconscious and creating truly random juxtapositions — and such random connections of images and objects and the impression achieved by such connections are another cornerstone of the surreal concept — suffice it to remember the surrealist motto, borrowed from Lautréamont — 'As beautiful as the chance meeting on a dissecting table of a sewing machine and an umbrella!'.[9]

André Breton wrote in 'The Exquisite Corpse, Its Exaltation':'With the Exquisite Corpse we had at our disposal — at last — an infallible means of sending the mind's critical mechanism away on vacation and fully releasing its metaphorical potentialities.'[10]

Having worked for several years with the technique of automatic writing, it became clear to Valentine Hugo that she, like Breton, was more interested in another kind of surrealism — 'dreamlike' or 'atmospheric' surrealism.[11] In addition, along

7 Janet Pierre, *L'Automatisme Psychologique*.
8 *Fantastic Art, Dada, Surrealism*, pp. 108, 128, 220, 225.
9 Dempsey, *Surrealism*, p. 11.
10 Dempsey, *Surrealism*, p. 95.
11 Morris, *The Lives of the Surrealists*, p. 8.

Fig. 2. Portrait of Pablo Picasso, 1934–1948, oil on plywood, 140 × 140 cm, Centre Georges Pompidou, Paris.

with the graphic arts that previously prevailed in the work of Valentine Hugo, it was in the 'dreamlike' surrealist period of her work that oil painting works appeared, moreover, large-format ones — while earlier Valentina has been inclined towards more intimate forms. The portrait of Pablo Picasso[12] (Fig. 2) and the work 'Surrealists'[13] are just vivid examples of such a 'dreamlike' surrealism in the work of Valentine Hugo, where — as in the text — we can see the fundamental surrealist ideas. The composition of both works is quite realistic, but the unusual (excessive) intensity of the captured scenes and plots leaves the impression of a dream. This approach is due to the

12 Portrait of Pablo Picasso, 1934–1948, oil on plywood, 140 × 140 cm, Centre Georges Pompidou, Paris.
13 Surrealists (Éluard, Breton, Tzara, Crevel, Péret, Char), 1932–1948, oil on wood, 120 x 100 cm, private collection.

fact that the surrealists sought not so much to forget themselves in another reality — in the images of their dreams; how many tried to make beautiful and wonderful — like in a dream — the reality that surrounds us. Further, we note that only heads are depicted in the portraits — there are no bodies. The depiction of bodies dismembered into parts is typical of many surrealist artists (Arp, Belmer, Shtyrski, Ernst, etc.), and this motive of dismemberment is associated with the fear of castration, and, ultimately, with the fear of death. In addition, the surrealists have always been attracted by masks — African masks, carnival masks, etc., and the head separate from the body is also a kind of mask. The masks expressed fear of the living dead matter — dolls, automata — i.e. were another symbol of the fear of death. There are also other important symbols for surrealists — zodiacal signs and the zodiacal theme in general. It is known that André Breton compiled and published astrological charts of his creative associates,[14] and also actively used esoteric and alchemical terminology in his writings, including for writing Surrealist Manifestos. It can also be noted that the portraits combine both male and female features, there is a kind of oscillation between the sexes and blurring of sexual differences, which is also very characteristic of the visual series of surrealists. But this is not a denial of gender differences, but a search for androgyne. The myth of the androgyne reflects the eternal longing of man for the Unity that was once lost. And the ultimate erotic dream of surrealists is a monogamous heterosexual couple — the true limit of which — the 'ideal couple' — is the androgyne.[15]

The positive thinking of surrealists and the desire to see the miraculous in everyday things and thus create a new wonderful world — in contrast to the philosophy of destruction and denial of the dadaists, who only wanted to destroy the old rotten world, without offering anything in return — was very attractive to artists, writers and philosophers who were looking for new ways of transforming the surrounding world. However, Valentine Hugo, shocked by the suicide of her close friend, surrealist poet René Crevel in June 1935, and by the fact that the movement was abandoned by its co-founders René Char, Tristan Tzara and Paul Éluard, leaves the official Surrealist group in 1938. Nevertheless, Valentine Hugo continues to work using the artistic and aesthetic principles and methods of surrealism and her connections with the surrealists are not interrupted. Valentine Hugo discovers a new kind of creativity — book illustration, where she is also brought by Paul Éluard, who believed that 'the agile, thin and strong fingers of Valentine Hugo re-find the essence of words'.[16] It is worth recalling that surrealism began as a literary and philosophical movement, and one of the theorists and founders of the movement, the poet and philosopher Pierre Naville, generally believed that artists had no place in the surrealist movement, and most of the surrealists were writers and poets. The book, the text — all this was very important and played a big role in the popularization and promotion of the ideas of surrealism. For Valentine Hugo, turning to book graphics was not

14 The Museum of Art and History of Saint-Denis in the fund of Paul Éluard contains his personal horoscope, made by André Breton in 1937–1938.

15 Beguin, 'Androguine'.

16 Chadwick, Les Femmes dans le Mouvement Surréaliste, p. 226.

VALENTINE GROSS-HUGO 369

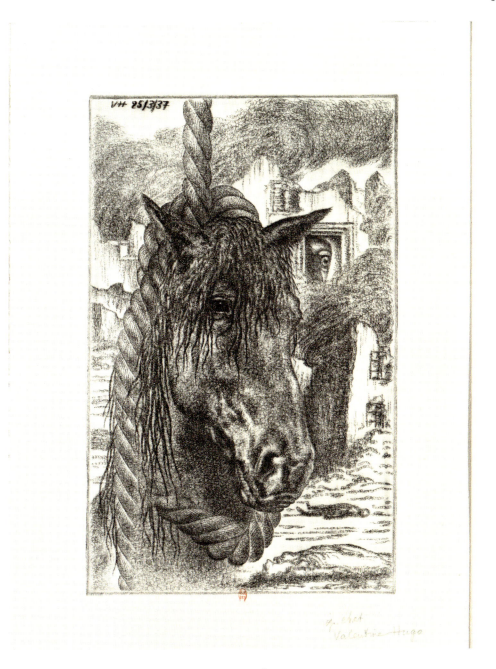

Fig. 3. Valentine Hugo. Drypoint to the book of Paul Éluard 'Les Animaux et leurs Hommes, Les Hommes et leurs Animaux', 1937, Bibliothèque Nationale de France.

something unexpected and alien — let us recall, for example, her experience in the Gazette du Bon Ton. In 1937, Paul Éluard, already in ideological and worldview terms, began to move away from the Surrealists, despite his close personal friendship with André Breton, and decides to republish his first post-war poetry collection — 'Animals and their people, people and their animals', written after demobilization from army and published in 1920.[17] According to the literary critic Velikovsky, it is the 'Animals ...' that 'opens Éluard's long-term searches on the paths of first dadaism, then surrealism'.[18] Perhaps the reprint of this book in 1937, when Éluard himself was again at a crossroads, was an attempt to return to the origins and find a way out of the creative crisis. The collection of poetry was published in a print run of only 19 copies (without specifying the publisher in the imprint), in octavo size. Each book was accompanied by a set of twenty two (according to the number of poems) drypoint prints, in the first eight copies of the book the prints were printed in different colors. The engravings were made by Valentine Hugo, and this was her first collaboration with Paul Éluard. At first glance, illustrations by Valentina Hugo are very far from the text (despite the fact that there is one engraving for each poem, which should have illustrated it): what is depicted seems to have nothing to do with Éluard's poems. But the fact is that, despite the simplicity and clarity declared by the poet himself, Éluard's poetry is primarily visionary, and Éluard himself is a visionary poet. In his own words, 'poetry [...] invents, it creates anew.'[19] As a result, according to Velikovsky, 'not a system of definitions, but a microcosm created by fiction'[20] is born. And Valentine Hugo just creates this microcosm, her own microcosm on the basis of visions and imaginary pictures that arise in front of her after reading Éluard's poems. Creates using the full range of surrealist techniques. For example, the absolute 'dreamlike' reality of the works: the painted images 'float out' to the viewer from the artist's subconscious. These images are drawn in a completely realistic manner, but fantastic in their essence — for example, on one drypoint a very realistic head of a horse is drawn (Fig. 3), then the viewer notices that the head is in a loop of rope (as when hanging), then the rope visually turns into a unicorn's horn. Again, it is appropriate to quote the words of Éluard himself, who believed that the poem 'like a living creature, makes you daydream',[21] and 'the poet is a vigilant dreamer.'[22]

Unfortunately, the limits of the article do not make it possible to tell in detail about other works of Valentine Hugo in the field of book illustration, which became the main direction in her further work. Valentine Gross-Hugo continued her collaboration with Paul Éluard, but not only — she illustrated poetry collections of her close friend René Char, the surrealist icon poets Lautréamont, Achim von Arnim, Arthur Rimbaud and others. She also designed several performances at the Paris Opera, and made a whole cycle of radio broadcasts, where she remembered the friends of her

17 Paul Éluard, *Les Animaux et leurs Hommes*.
18 Velikovskii, '*Pol Elyuar. Vehi zhizni i tvorchestva*', p. 375.
19 Paul Éluard, *L'Evidence Poétique II*, p. 102.
20 Velikovskii, *...k gorizontu vseh lyudei*, p. 75.
21 Paul Éluard, *Premières Vues Anciennes*, p. 81.
22 Paul Éluard, *Premières Vues Anciennes*, p. 81.

youth with great warmth, leaving important evidence of the era. The artist died at a very old age in 1968. After her death, part of the heritage — art and archives — was sold out, part — the entire body of ballet drawings — was transferred by Jean Hugo to the Victoria and Albert Museum in London. Of course, Valentine Gross-Hugo cannot be ranked among the main figures of the surrealist movement, both due to the small volume of her creative heritage and due to the intimate nature of her works, but there is no doubt that her work, vividly and even slogan like expressing — with a touch of didactics — the philosophical ideas of surrealism, is an integral and very interesting part of the surrealist heritage, without which this movement is difficult to imagine in its integrity.

Bibliography

Primary Sources

Appollinaire, Gillaume, '"Parade" et l'esprit nouveau', *Excelsior*, 11 may 1917, p. 5

Beguin, Albert, 'Androguine', *Minotaure*, 11 (1938), 10–13, 66

Éluard, Paul, *Les Animaux et leurs Hommes. Les Hommes et leurs Animaux* (Paris: Au Sans Pareil, 1920)

———, *L'Évidence poétique II, Le Poète et son ombre* (Paris: Seghers, 1963)

———, *Premières vues anciennes – Donner à voir* (Paris: Gallimard, 1939)

Fantastic Art, Dada, Surrealism, ed. by Alfred H. Barr, Jr., Exhibition's catalogue (New York: MoMA, 1936)

Gazette du Bon Ton, 8–9 (1915)

Hugo, Valentine, 'Préface', in *La Passion et la mort de Jean d'Arc*, by Pierre Bost, Le cinéma Romanesque, 7 (Paris: Gallimard, 1928)

Janet, Pierre, *L'automatisme psychologique: essai de psychologie expérimentale sur les formes inférieures de l'activité humaine* (Paris: F. Alcan, 1889)

Kokto, Zhan, *Petuh i arlekin: Libretto. Vospominaniya. St o muzyke i teatre* [Jean Cocteau, Cock and Harlequin: Libretto. Memories. Articles about music and theater], ed. by Mihail A. Saponov (Moscow: Prest, 2000)

Secondary Studies

Chadwick, Whitney, *Les Femmes dans le Mouvement Surréaliste* (Paris: Thames&Hudson, 2002)

Dempsey, Amy, *Surrealism* (London: Thames & Hudson, 2018)

Morris, Desmond, *The Lives of the Surrealists* (London: Thames & Hudson, 2018)

Ribaud, Nadine, ed., *Le Carnaval des Ombres*, Exhibition's catalogue (Boulogne-sur-Mer: Le Quadrant, 2018).

Velikovskii, Samarii I., *…k gorizontu vseh lyudei. Put Polya Elyuara* […to the horizon of all people. Path of Paul Éluard] (Moscow: 'Hudozhestvennaya literatura', 1967)

———, 'Pol Elyuar. Vehi zhizni i tvorchestva', in *Pol Elyuar. Stihi*, [Paul Éluard. Milestones of life and creativity, in Paul Éluard. Poetry] (Moscow: 'Nauka', 1971)

List of Contributors

Tania Alba Rios is Lecturer Professor at the University of Barcelona (Art History department, Fine Arts and Art History faculties), in the specialties of Art Theory, Aesthetics, Iconography, and Modern and Contemporary Art. She is the Associate Editor of the academic journal *Materia. Revista Internacional d'Art* (Art History department, University of Barcelona). She has participated in different research groups, such as GREGA, AASD, and GRACMON (University of Barcelona).

Caterina Bavosi graduated in Visual Arts at the University of Bologna in 2019. In 2021 she obtained a diploma in Archival, Paleography and Diplomatic at the APD School of the State Archives of Bologna. She currently works as archivist at the Alcide Cervi Institute.

Ana Ágreda Pino and **Carolina Naya Franco** are lecturers in the Department of Art History (Universidad de Zaragoza, Spain). As specialists in sumptuary and decorative arts, their field of research is the different manifestations of luxury in the Modern Era. Ana Ágreda Pino investigates embroidery, material culture and the work of women in the textile arts from a gender perspective. Carolina Naya Franco works in different manifestations of luxury in the feminine environment and historic cotidianity: fashion, jewellery, material culture and design. This work has been carried out within the Artífice research group (Gobierno de Aragón, FEDER).

Eliana Billi is Associate Professor in Museology, Art Criticism and Restoration at the Department SARAS, Sapienza University of Rome (Italy), where she teaches Theory and History of Restoration and History of Artistic Techniques. She received her PhD degree in Art History at Sapienza University of Rome in 2007. In 1998 she graduated in Restoration of Cultural Heritage from the Central Institute of Restoration. As a professional restorer and scholar Billi's research focuses on medieval art, the history of conservation and restoration in the modern and contemporary eras, the history of censorship, visual culture and recently feminist studies. She has participated in several national and international conferences and is the author of various academic journal articles and two monographs. She has co-operated with the Scuola Normale Superiore of Pisa as well as with the Istituto Centrale del Restauro in educational projects concerning the management, increasing value and preservation of Beni Culturali. Since 2018 Billi has been Sapienza University's referent for the cataloging and restoration of the artistic heritage of the University City of Rome.

Paola Caretta works as a secondary-school teacher of history of art and is an independent scholar. She has written about 40 contributions among journal papers and book chapters, mostly about sixteenth and seventeenth century painting.

Tori Champion is a doctoral candidate in the School of Art History at the University of St Andrews. She holds a bachelor's degree in Public Policy Analysis and International Business from Indiana University and a master's degree in Art History from the University of Washington. Her primary research interests include women as artists and subjects, gendered iconography, and the global reach and implications of natural history illustration. Her PhD dissertation, titled 'Marie-Thérèse Reboul Vien and the Origins of Neoclassicism', explores the biography, work, collaborations and networks of the eighteenth-century French naturalist-artist Marie-Thérèse Reboul Vien. Tori co-hosts and co-produces an online talk series entitled 'Looking North Through Art: Alternative Approaches to Landscape and Energy Ethics in Scotland' and is currently serving as the Postgraduate Intern for the Centre for French History and Culture at the University of St Andrews.

Katarzyna Chrzanowska is an art historian graduated from the Jagiellonian University in Cracow. Currently, as a PhD student at the Anthropos Doctoral School of the Polish Academy of Sciences, she is preparing her dissertation on the milieu of painters active in Cracow in the eighteenth century at the Institute of Art, Polish Academy of Sciences. Since 2018 she has been an editor of the scholarly journal *Artibus et Historiae* and editor of monographs published by the IRSA Institute.

M. Elena Díez Jorge is Professor of History of Art in the Department of History of Art of the University of Granada, Spain. She has a special dedication to Women's History, leading several research projects on this subject. This research has mainly focused on two areas: she highlights the role of women in architecture in past periods of history, for example, in her book *Mujeres y arquitectura: cristianas y mudéjares en la construcción* [Women and architecture: Christian and Mudejar women in construction] (2011) and in collective monographs such as *Arquitectura y Mujeres en la Historia* [Architecture and women in history] (2015). She also explores the role of women and peace in diferents books; the most recent book on the subject is *Las mujeres y los discursos de paz en la historia* [Women and Discourses on Peace through History] (2023). More information in https://www.ugr.es/~mdiez/index-en.html

Lynn Fitzpatrick teaches architecture and interior design studios in the Fay Jones School of Architecture and Design at the University of Arkansas. Her interest in lightweight architectural structures, particularly surface structures, influences her creative work in weaving. Fitzpatrick leads design electives using manual and digital looms, weaving software, and computational thinking games to introduce students to the weaving and the design process. Focused on structure and pattern making, she weaves to explore methods of inducing tension into the work that is visually retained and structurally convincing once it is off loom. Currently these explorations have led

to the study of ancient looms and their role in structuring woven textiles. Fitzpatrick holds a Bachelor of Science in Interior Design from Cornell University and a Master of Architecture from Rice University.

Margherita Fratarcangeli is an independent scholar and collaborates with Italian and foreign institutions and universities. She currently works with Sabap Roma-Rieti and Palazzo Chigi in Ariccia. She has written about 76 contributions among journal papers and book chapters.

Carolin Gluchowski studied *Art History* (M.A.) and *Medieval and Renaissance Studies* (M.A.) at the University of Freiburg, Germany. Currently, Gluchowski is pursuing a PhD in *Medieval and Modern Languages* at the University of Oxford, United Kingdom. Her PhD project is entitled: *Revising Private Prayerbooks. The Latin/Low-German Prayerbooks from the Cistercian Convent of Medingen in the Context of Late-Medieval Church Reforms* andexplores the reworkings of the Latin/Low-German prayerbooks from the Cistercian convent of Medingen in the context of late medieval church reforms. In doing so, her PhD project aims to contribute to more nuanced understanding of the role of women in late medieval church reforms.

Antonio Iommelli graduated in Art history at the University of Rome 'Sapienza' in 2009. He holds a diploma in Archival, Paleography and Diplomatic and a PhD in art history at the University of Rome in 2019. In 2020 Antonio won one of five scholarships announced by the Fondazione 1563 in Turin, working on a project on the figure of Cardinal Francesco Adriano Ceva, on which he has recently published several studies. He currently collaborates with the Galleria Borghese in Rome and the Gallerie degli Uffizi in Florence.

Elli Leventaki is an art historian, curator, and researcher. She is currently a PhD candidate at the Department of Theory and History of Art of the Athens School of Fine Arts, and is also involved in different art projects. She holds a Bachelor's degree in Art History and Art Theory, and a Master's degree in Art History and Curating, both from the Fine Arts Department of the University of Ioannina, Greece. Elli is interested in contesting historically dominant narratives and stereotypic notions, especially those deriving from national and/or patriarchal contexts, while aspiring to advocate for gender equality through culture and engage in discourses on art-based labour. She is a member of the Association of Greek Art Historians, AICA, and ICOM.

Nicoletta Marconi, Architect, PhD in Construction Engineering, is Associate Professor of History of Architecture at the University of Rome Tor Vergata, where she also teaches Architectural Restoration, at Faculty of Engineering. Her main research topics range from the formal and constructive analysis of Renaissance and Baroque buildings in the Roman area to the history of construction and restoration, building sites and building technology in the modern age. These include studies on the

construction site of the Fabbrica of St Peter's in the Vatican, and on the architectural patronage of the Barberini family in Rome and Palestrina. She's the author of some monographs, curatorship and a hundred papers published in collective volumes, scientific journals and conference proceedings.

Alexandra Massini holds a PhD from the University of Warwick, and MA and BA degrees from the Courtauld Institute of Art in London. Currently Alexandra is the Academic Director of CEA CAPA in Rome, where she also teaches History of Art. Additionally, she works as author and consultant for documentaries on art and history, collaborates with the Fondazione Torlonia, the Colonna and Doria Pamphilj Galleries in Rome, and the Academy Vivarium Novum in Frascati, and curates the Art Collection of the Rome Cavalieri Hotel (Waldorf-Astoria). In the past she has written for Blue Guides, has published her own guidebook to Rome, has worked for the Thyssen Museum in Madrid and Sotheby's Auctioneers and has organized events for international investor groups and institutional visits (G20 in Rome et al).

Laura Mercader Amigó teaches Art Theory and Feminist Art Theory at the University of Barcelona (Department of Art History, Faculties of History and Geography and Fine Arts). She is director of Duoda, Women's Research center at the University of Barcelona, co-director of the Master 'Women's politics' of the University of Barcelona and the scientific journal *Duoda. Estudios de la diferencia sexual.*

Elizaveta V. Miroshnikova holds a PhD in Geographical Sciences. She worked on 'Urban Resettlement in France: Features of Formation and Problems of Modern Development'. She is currently pursuing a PhD in art studies. She works on female artists and surrealism. More specifically she is studies the creative and social role of Valentine Gross-Hugo in the Parisian art life of the 1920s-1930s.

Silvia S. G. Palandri graduated in Women's Studies with a Postgraduate Specialisation Course at The National Research Council (CNR) of Rome. From about twenty years she is an independent scholar and collaborates with private Institutions and journals. She edited Colombi's *Racconti di Natale* (2020). Founder of the first Italian blog dedicated to Women's Studies: Opportunità di Genere OG (Gender Opportunity OG).

Catherine Powell-Warren is a FWO postdoctoral fellow in art history at the Faculty of Arts and Philosophy of Ghent University. She obtained her PhD in art history at the University of Texas at Austin in 2021. Her research has been published widely; her work on Agnes Block is under press as *Gender and Self-Fashioning at the Intersection of Art and Science: Agnes Block, Botany, and Networks in the 17th Century* (AUP). Her current project focuses on notions of mentorship, networking, and collectivity within the circle of women artists proximate to Rachel Ruysch (Project 'Hive Mind', ID 1289722N).

Annalisa Rinaldi, Rome 1988, graduated with a degree in Art History in 2017 from the University of Rome Tor Vergata. Her studies focused on Italian women artists in the sixteenth and seventeenth centuries. She holds a Master's degree in Management and Digitization of Cultural Heritage from John Cabot University, Rome. She has written for the *Enciclopedia delle Donne* and journals, and has collaborated with the Artemisie Team (www.artemisie.com) the first virtual museum of women in the arts.

Alessandro Serrani is a PhD Candidate at the University of Bologna under the supervision of Daniele Benati, and has held visiting researcher position at Boston College. Serrani has been awarded scholarships from the Fondazione Longhi in Florence and the Fondazione Cini in Venice. He has been a speaker at international conferences and has published scientific articles in *Paragone* and *Studi di Storia dell'Arte*.

Luana Testa has worked as a psychiatrist and psychotherapist in public and private services. She has co-authored many books and papers. She is a member of the Medical Psychotherapy Social Cooperative in Rome.

Nadette Xuereb (B.A. [Hons.], M.A. History of Art [Melit.]) is an art historian specialising on female artists and patrons during the Baroque period, with a particular emphasis on Malta. Her M.A. research focused on female patrons of the arts, whilst her undergraduate dissertation discusses Suor Maria de Dominici, the first known female artist in the Maltese Islands. She has published on this topic, and has also participated in and chaired local conferences focusing on women in the arts and on Maltese cultural heritage respectively.